A HISTORY
OF MODERN
JAPANESE
AESTHETICS

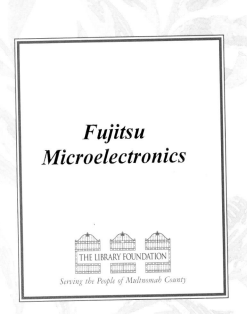

A HISTORY OF MODERN JAPANESE AESTHETICS

Translated and Edited by
MICHAEL F. MARRA

University of Hawai'i Press
Honolulu

Publication of this book has been assisted by a grant
from the Kajiyama Publications Fund for Japanese
History, Culture, and Literature at the University
of Hawai'i at Mānoa.

Library of Congress Cataloging-in-Publication Data
A history of modern Japanese aesthetics / translated and edited by Michael F. Marra
p. cm.
Includes bibliographical references and index.
ISBN 0–8248–2369–9 (cloth : alk. paper) — ISBN 0–8248–2399–0 (pbk. : alk. paper)
1. Aesthetics, Japanese—19th century. 2. Aesthetics, Japanese—20th century.
I. Marra, Michele.
BH221.J3 H57 2001
111'.85'0952—dc21 00–062950

Designed by Kenneth Miyamoto
Printed by The Maple-Vail Book Manufacturing Group

To Professor William R. LaFleur
without whose *Karma of Words*
my karma would have no words

CONTENTS

AESTHETICS AT THE UNIVERSITY OF KYOTO

ACKNOWLEDGMENTS

Since this is the companion book to my *Modern Japanese Aesthetics: A Reader*, I refer readers to the acknowledgments page of that book, where most of my debts are disclosed. To the long list of friends, relatives, and colleagues who have patiently assisted me during a lengthy journey on both sides of the Pacific and Atlantic Oceans, I would like to add the names of Professor Sasaki Ken'ichi of the University of Tokyo and Iwaki Ken'ichi of the University of Kyoto for offering valuable insights into the history of aesthetics at their universities. They both allowed me to discuss with them the history of their departments *(bigakka)* in the same offices that Ōtsuka Yasuji and Fukada Yasukazu had created a century earlier. At Tōdai, in particular, the presence of history is truly remarkable, since the visiting guest must endure the inquiring looks of Professor Sasaki's four predecessors whose pictures hang on the walls of his office. Thanks to him, I was also able to meet with the daughter of Ōnishi Yoshinori (the second professor of aesthetics at Tōdai), Mrs. Ōno Motoko, who shared with me moving memories of her father. I wish to thank her and her husband, Mr. Ōno Yoshirō, for taking me on a tour of sites related to Professor Ōnishi in Fukuoka. The UCLA Center for Japanese Studies sponsored my trip to Japan in September 1998.

I want to thank the Accademia Albertina delle Belle Arti in Turin, Italy, for giving me access to the Fontanesi file related to the departure of Antonio Fontanesi for Tokyo in 1876 and his return to Turin two years later. Thanks to the help of Professor Sergio Mamino, I had access to the original sketches that Fontanesi and a few of his Japanese students made during Fontanesi's stay in Japan, sketches that are now kept at the Galleria Civica d'Arte Moderna, Camerana fund, in Turin. A UCLA Council on Research award supported fieldwork in Turin in May 1998.

The staff of the Houghton Library at Harvard University was extremely gracious in giving me permission to peruse manuscripts of Ernest F. Fenollosa and other materials related to Fenollosa's stay in Japan. The Harvard University Archives provided me with further information on the history of the philosophy department at Harvard where Fenollosa was a student. During my stay in Cambridge, I was also able to retrace the steps of Okakura Kakuzō, who worked at the Museum of Fine Arts in Boston, and rested at Isabella Stewart Gardner's Fenway Court. Robert E. Buswell, chair of the UCLA Department of East Asian Languages and Culture, secured the funds for my trip to Massachusetts in March 1999.

I also want to thank Ms. Lisa Mikiko Hawes of the Department of Comparative Literature at UCLA for reading the entire manuscript and making numerous stylistic suggestions. Mr. Christopher Bush of the Department of Comparative Literature and Mr. Ulrich Bach of the Department of Germanic Languages at UCLA generously shared their knowledge of German.

The first name of the editor of this book, since it has recently become a source of confusion, needs a word of clarification. The name change reflects the editor's decision to embrace the New World, of which he has become a legal citizen, and to say goodbye to the Old. This should suffice to prove that Michael Marra and Michele Marra are not husband and wife, but the split subjects of the same person.

Introduction

In *Modern Japanese Aesthetics: A Reader,* I presented English translations of major works on aesthetics by leading Japanese aestheticians who applied their theoretical knowledge of the philosophy of art to discussions of Japanese art, literature, religion, and philosophy. Each translation in the *Reader* is preceded by an introduction in which I try to shed light on the historical context of each text while also attempting some sort of interpretation—a task made particularly difficult by the scarcity of hermeneutical attention paid to these texts even by Japanese specialists. While working on the *Reader,* I felt that readers would have benefited from at least an outline of the history of Japanese aesthetics; but this, unfortunately, was not to be found in any language, including Japanese. Japanese scholars of aesthetics had copiously and learnedly written on topics related to Western aesthetics —especially German—but had seldom historicized their efforts to explain themselves and their culture by using the language of aesthetics. It was possible to find scattered articles in scholarly journals and in book chapters, however, outlining the achievements of Japanese aestheticians in articulating discourses on the philosophy of art in relationship to Japan. The present book brings together a selection of such articles in order to provide readers with a "History of Japanese Aesthetics."

The reader might wonder why I relied on the work of others rather than writing my own history of Japanese aesthetics. Since, in order to write such a history, I would have had to rely on the works presented in this book, I thought the reader would benefit most from being given direct access to important secondary sources. Once the reader becomes familiar with the major issues introduced in this book, the interpretation of these issues will become a shared responsibility and, hopefully, a ground for discussion among all those who take an interest in

Japan. Above all, my choice was determined by my personal views of the field of aesthetics—a field I consider a footnote, albeit an important one, to the larger discipline of hermeneutics (in the sense of "transmission and translation of messages"). In my opinion aesthetics is a major stage in the history of interpretation—a stage that has shaped modern perceptions of art since, at least, the mid-eighteenth century. As a believer in the fundamental role played by interpretive acts in the formation of what we tend to perceive as "objective" realities, I consider the writing of a history of aesthetics another example of interpretation. Therefore, how could a chain of interpretations be better presented than by having major contemporary hermeneuticians from Japan interpret the founding fathers of the field of aesthetics?[1] Readers should pay attention to this double narrative. On the one hand, they might benefit from being introduced to a series of issues that make up the field of aesthetics in Japan. On the other, they are confronted with the act of creating what today we call "Japanese aesthetics," which is the result of the hermeneutical efforts of writers such as those presented here. In a sense, readers are confronted with a dialogue of aestheticians talking to and about other aestheticians and, in the process, creating the field of Japanese aesthetics.[2]

Although it would be presumptuous to seek a common denominator among the many aestheticians discussed in this book, all of them to a certain degree were faced with the paradox of voicing what they felt to be at the core of their subjectivity—the specificity of a local culture, a local art—by relying on a supremely alien language: the Western language of aesthetics. It is not only that Japanese thinkers are caught in the dilemma of articulating themselves through the otherness of an aesthetic discourse that was born in the West as a secularized version of theology. These thinkers also found themselves in the odd situation of relying on hermeneutical frameworks of foreign origin in order to represent to themselves, as well as to the world,

1. With the exception of an outstanding essay on Mori Ōgai originally written in German by Bruno Lewin, all the essays in the present book are by Japanese scholars.

2. By "Japanese aesthetics" I mean speculations on the philosophy of art on the part of professionally trained Japanese aestheticians who take Japan and the Japanese artistic production as their objects of study. I do not include work done by Japanese philosophers on aesthetics proper, that is, the Western philosophy of art. Such work should find its place in standard "Histories of Aesthetics," although, with the exception of Nishida Kitarō (1870–1945), this is rarely the case.

their own innermost "otherness"—their past and their ancient idioms. The German philosopher Martin Heidegger (1889–1976) has potently described such an impasse in his "Aus einem Gespräch von der Sprache" ("Out of a Conversation from Language," 1954), which he included in his *Unterwegs zur Sprache* (*On the Way to Language,* 1959). Written as a fictional dialogue between a Japanese and an Inquirer, this work was allegedly inspired by Heidegger's brief encounter with Tezuka Tomio (1903–1983), a professor of German literature at Tokyo University and a member of the Japanese Academy.[3] It might be more correct to say that Tezuka's visit at the end of March 1954 reminded Heidegger of the many conversations he had had in the past with Japanese thinkers who in the 1920s flocked to Marburg and Freiburg in order to study philosophy with him.[4] In the dialogue Heidegger—the Inquirer—highlights the danger of reducing the facticity of Japanese existence to European conceptual systems,[5] and he struggles to elicit from the Japanese answers that might help him understand how the articulation of otherness—in this case, Japan—can take place in spite of what Heidegger calls "the danger of language."[6]

3. Tezuka Tomio himself gives a description of this encounter in "Haidegā to no Ichijikan" (An Hour with Heidegger)—a text that Reinhard May includes in the original Japanese version, followed by a German translation, in his *Ex Oriente Lux: Heideggers Werk unter ostasiatischem Einfluss* (Wiesbaden: Franz Steiner Verlag, 1989), pp. 82–99. Graham Parkes provides an excellent translation of May's book, including "An Hour with Heidegger," in Reinhard May, *Heidegger's Hidden Sources: East Asian Influences on His Work* (London: Routledge, 1996), pp. 59–64.

4. Among Heidegger's best-known colleagues from Japan were Kuki Shūzō (1888–1941), Tanabe Hajime (1885–1962), Nishitani Keiji (1900–1990), and Miki Kiyoshi (1897–1945). See Michiko Yusa, "Philosophy and Inflation: Miki Kiyoshi in Weimar Germany, 1922–1924," *Monumenta Nipponica* 53(1) (Spring 1998):45–71. For a detailed examination of Heidegger's ties to Japanese thinkers see Hartmut Buchner, ed., *Japan und Heidegger: Gedenkschrift der Stadt Messkirch zum hundertsten Geburtstag Martin Heideggers* (Sigmaringen: Jan Thorbecke Verlag, 1989), and Graham Parkes, ed., *Heidegger and Asian Thought* (Honolulu: University of Hawai'i Press, 1987).

5. "Inquirer: Here you are touching on a controversial question which I often discussed with Count Kuki—the question whether it is necessary and rightful for East-asians to chase after the European conceptual systems." The English translation is by Peter D. Hertz. See Martin Heidegger, *On the Way to Language* (New York: Harper & Row, 1971), p. 3.

6. "Japanese: Now I am beginning to understand better where you smell the danger. The language of the dialogue constantly destroyed the possibility of saying what the dialogue was about. Inquirer: Some time ago I called language, clumsily enough, the house of Being. If man by virtue of his language dwells within the claim and call of Being, then we Europeans presumably dwell in an entirely different house than East-asian man" (ibid., p. 5).

Moved by the anxiety of a technological rationalism that is leading to the objectification of being and to "the complete Europeanization of the earth and of man," Heidegger points out the paradox of imprisoning the Japanese world in the "objectness of photography" by having the Japanese past framed by Western cinematic conventions as in Kurosawa Akira's movie *Rashōmon*.[7]

By being doubly critical of the aesthetic project in general, which according to Heidegger is deeply enmeshed in the metaphysics of objectification,[8] as well as the value that can be derived from casting a non-European reality into the language of aesthetics,[9] Heidegger framed the major questions that all the aestheticians cited in the present book had to confront head-on—beginning with the issue of compensation that led to the replacement of God with beauty and the work of art and to the displacement of the temple in favor of the museum.[10]

The aesthetic adventure began in Japan in the 1870s. At the time, the country was in the midst of a cultural revolution spurred by the threatening presence of the West—a presence that inspired attentive members of the Japanese intelligentsia to make "civilization and enlightenment" *(bunmei kaika)* their civil mission. Steeped in the cultural framework of Neo-Confucianism, these ambitious thinkers suddenly faced a reformulation of local artistic practices (such as theatrical performances of nō and kabuki) and ritual acts (such as the tea ceremony) in the new languages of Western philosophy. Japanese thinkers were confronted with a flood of thoughts and ideologies— idealism, positivism, materialism, utilitarianism—which provided

7. "Japanese: This is what I have in mind. Regardless of what the aesthetic quality of a Japanese film may turn out to be, the mere fact that our world is set forth in the frame of a film forces that world into the sphere of what you call objectness. The photographic objectification is already a consequence of the ever wider outreach of Europeanization" (ibid., p. 17).

8. "Japanese: Meanwhile, I find it more and more puzzling how Count Kuki could get the idea that he could expect your path of thinking to be of help to him in his attempts in aesthetics, since your path, in leaving behind metaphysics, also leaves behind the aesthetics that is grounded in metaphysics" (ibid., p. 42).

9. "Inquirer: The name 'aesthetics' and what it names grow out of European thinking, out of philosophy. Consequently, aesthetic consideration must ultimately remain alien to Eastasian thinking" (ibid., p. 2).

10. On this issue see Odo Marquard, *Aesthetica und Anaesthetica: Philosophische Überlegungen* (Paderborn: Schöningh, 1989).

them with methodologies to discuss their own performative and ritual past in terms of "culture" *(bunka)* and "art."[11]

One among these thinkers was Nishi Amane (1829–1897), who introduced modern aesthetics to Japan in a series of lectures titled *Bimyōgaku Setsu* (The Theory of Aesthetics, 1877).[12] Nishi was confronted with the task of reconciling eighteenth-century views of aesthetics, which stressed its autonomy from the spheres of ethics and logic, with modern, nineteenth-century utilitarian concerns that explained aesthetics' alleged lack of "purpose"—the Kantian "purposiveness without a purpose" or "finality without an end" *(Zweckmässigkeit ohne Zweck)*—as a project contributing to the formation of a civilized society. Nishi was forced to synthesize in a few pages centuries of Western aesthetic thought with all its paradoxes resulting from the combination of conflicting theories. At the same time, he was compelled to present convincing arguments to his listeners—members of the imperial family and leading bureaucrats of the Meiji period—on the "usefulness" of a science that was born as a form of knowledge free from pragmatic concerns of utility. Apart from the difficulty of providing heterogeneous theories with some sort of coherence, Nishi was also challenged by the lack of a vocabulary with which to discuss "beauty" in the context of a philosophy of art. New words had to be devised for conveying in Japanese the notions of beauty *(bi)*, art *(geijutsu)*, and fine arts *(bijutsu)*.

At the beginning of the Meiji period, "beauty" was usually indicated with the word *"birei."* Inamura Sanpaku (1759–1811) used this word as a translation of both the adjective *"schoon"* (beautiful) and the name *"schoonheid"* (beauty) in his Dutch-Japanese dictionary *Haruma Wage* (A Japanese Rendition of Halma's Dictionary, 1796).[13]

11. On the formation in Japan of the notion of culture *(bunka)* see Yanabu Akira, *Ichigo no Jiten: Bunka* (Tokyo: Sanseidō, 1995). On the birth in Japan of the notion of "fine arts" *(bijutsu)* see Satō Dōshin, *Nihon Bijutsu Tanjō: Kindai Nihon no "Kotoba" to Senryaku* (Tokyo: Kōdansha, 1996).

12. For a complete English translation see Michele Marra, *Modern Japanese Aesthetics: A Reader* (Honolulu: University of Hawai'i Press, 1999), pp. 26–37; on the paradoxes related to the expression "modern Japanese aesthetics" see the introduction to that work (pp. 1–14).

13. Also known as the *Edo Halma*, this work was "an adaptation of François Halma's eighty-thousand-word Dutch-French dictionary in which Inamura substituted Japanese translations for the French equivalents." See Hirakawa Sukehiro, "Japan's Turn to the West," in Bob Tadashi Wakabayashi, ed., *Modern Japanese Thought* (Cambridge: Cambridge University Press, 1998), p. 39.

Nishi Amane still used *"birei"* in his *Theory of Aesthetics* of 1877. An alternative expression to indicate "beauty" *(schoonheid)* in Japanese was *"utsukushisa"*—the word used in *Oranda Jii* (Japanese-Dutch Dictionary, 1833), published in 1855–1858 under the name of Katsuragawa Hoshū (1751–1809). The same word *"utsukushisa"* appears written with the Chinese character for "beauty" (*"bi"* in contemporary Japanese) as the Japanese translation of *"beauté,* beauty, and *schoonheid,"* in *Sango Benran* (Handbook of Three Languages, 1857) by Murakami Hidetoshi (1811–1890), who is considered the founder of French studies in Japan. It was not until the late 1880s that the Japanese word *"bi"* became the standard translation of "beauty," as we can see in the series of articles "Bi to wa Nani zo ya" ("What Is Beauty?", 1886) by Tsubouchi Shōyō (1858–1935).[14]

Prior to 1872 the word *"geijutsu"* was usually employed to indicate arts and crafts and to emphasize the technical skills *(gijutsu)* required in the creation of such arts. When "art" came to be defined as an activity pursued for its own sake, another word had to be created: *"bijutsu,"* which appears as a translation of "fine arts," for the first time, in the catalog written in 1872 under the auspices of Ōkuma Shigenobu (1838–1922) listing the objects exhibited at the Vienna Exposition of the following year. In his *Theory of Aesthetics,* Nishi Amane included in the category of *"bijutsu"* painting, sculpture, engraving, architecture, poetry, prose, music, Chinese calligraphy, dance, and drama. As late as 1883–1884, however, there was neither consensus nor clarity on the meaning of "art." In his translation of Eugène Véron's (1825–1889) *L'Esthétique* (Aesthetics, 1878), *Ishi Bigaku* (The Aesthetics of Mr. V.), Nakae Chōmin (1847–1901) used several expressions to indicate "art"—such as *gijutsu* (skills), *geijutsu* (art and craft), *gigei* (skillful art), and *kōgei* (ingenious art)—without ever explaining the different meanings these expressions conveyed. They were all variations of the basic notion of "skill" *(gijutsu)*—an indication of the unlikelihood that in the early 1880s the distinction between practical skills and autonomous arts was generally accepted.

Considering the confusion that the Western notions of "beauty" and "fine arts" were introducing to Japan, Nishi's struggle to find a

14. For a complete English translation see Marra, *Modern Japanese Aesthetics,* pp. 48–64. For the creation in Japan of the word and notion of *bi,* or "beauty," see Yanabu Akira, *Hon'yakugo Seiritsu Jijō* (Tokyo: Iwanami Shoten, 1982), pp. 65–86.

proper equivalent in Japanese for the word "aesthetics" comes as no surprise. As early as 1867, in an attempt to reconcile the ethical and aesthetic spheres, he called aesthetics "the science of good and beauty" *(zenbigaku),* using this expression again in *Hyakuichi Shinron* (New Theory of the Hundred and One, 1874). A redefinition of aesthetics in terms of the faculty of taste (and a judgment of taste) led Nishi to revise his translation as "the discipline of good taste" *(kashuron),* which he used in *Hyakugaku Renkan* (Encyclopedia, 1870). After being drawn into the modern philosophy of utilitarianism, he further revised his translation of "aesthetics," finally settling on "the science of the beautiful and mysterious" *(bimyōgaku)* in *Bimyōgaku Setsu.* But Nishi did not have the last word on this matter.[15] The word currently used in Japan to indicate "aesthetics"—"*bigaku*"—was created by Nakae Chōmin for his translation of the title of Eugène Véron's book (Chapter 1).

On the practical side, the official Meiji impulse toward modernization led to the foundation in 1876 of the Technological Art School (Kōbu Bijutsu Gakkō) within Tokyo's Engineering College (Kōgaku-ryō) and the invitation of several foreign scholars and artists to Japan. In 1876 the Italian painter Antonio Fontanesi (1818–1882) arrived in Tokyo with a teaching contract from the Japanese government; he was followed in 1878 by the American art historian and philosopher Ernest F. Fenollosa (1853–1908). The two men spearheaded opposite movements in the field of aesthetics. A painter in the style of the Barbizon school, Fontanesi was a driving force behind "Japanese painting in the Western style" *(yōga)* and the appeal to realist sketching that young Japanese painters, such as Yamamoto Hōsui (1850–1906), Asai Chū (1856–1907), and Koyama Shōtarō (1857–1916), eagerly embraced.[16] In contrast, Fenollosa played a

15. On the relationship between terminology and philosophy with regard to Nishi's translation of the word "aesthetics" see Yamashita Masahiro, "Nishi Amane on Aesthetics: A Japanese Version of Utilitarian Aesthetics," in Michael Marra, ed., *Japanese Hermeneutics: Current Debates on Aesthetics and Interpretation* (Honolulu: University of Hawai'i Press, forthcoming).

16. On Fontanesi see Marco Calderini, *Antonio Fontanesi: Pittore Paesista* (Turin: Paravia, 1901); L. C. Bollea, *Antonio Fontanesi alla R. Accademia Albertina* (Turin: Fratelli Bocca, 1932); Shōko Iwakura, "Note Biografiche Fontanesiane," *Il Giappone* 6 (1966):87–93; Andreina Griseri, "Fontanesi a Tokyo: Pittura e Grafica, Nuove Proposte," *Studi Piemontesi* 7(1) (March 1978):50–58.

major role in convincing the Japanese authorities of the greatness of their own artistic heritage, thus promoting a renaissance of "painting in the Japanese style" *(nihonga)*. In 1882, the year of Fenollosa's famous speech to members of the Dragon Pond Society (Ryūchikai), "Bijutsu Shinsetsu" (The True Conception of the Fine Arts),[17] the Technological Art School was closed and the government's interest in painting in the Western style began to fade. Seven years later, in 1889, the Tōkyō Bijutsu Gakkō (Tokyo School of Fine Arts) was founded and the country's artistic heritage was put at the center of the teaching curriculum. Okakura Tenshin (1861–1913), a disciple and collaborator of Fenollosa, was appointed head of the new school.[18]

With the establishment of art as the object of aesthetic contemplation, secularized versions of temples housing beauty were built in the form of museums in order to accommodate demands for the worshiping of art. Thanks to the efforts of Fenollosa and Okakura, who saw in the Asian counterpart of the Hegelian spirit the driving force behind the idealism of Japanese paintings, the entire country came to be seen as an art museum of Asiatic civilization: the privileged setting for preservation of cultures that had already disappeared from their country of origin. The "revalorization" of Asia's artistic heritage at a time when Japan was launching its victorious army against China (1893–1894) further underscored the deep political implications of aesthetic discourses and proved to the Japanese authorities that the Western language of metaphysics and idealism could be easily channeled into political action (see Chapter 2).[19]

17. See J. Thomas Rimer, "Hegel in Tokyo: Ernest Fenollosa and His 1882 Lecture on the Truth of Art," in Marra, *Japanese Hermeneutics,* forthcoming.

18. On Fenollosa see Lawrence W. Chisolm, *Fenollosa: The Far East and American Culture* (New Haven: Yale University Press, 1963). On Okakura see F. G. Notehelfer, "On Idealism and Realism in the Thought of Okakura Tenshin," *Journal of Japanese Studies* 16(2) (1990):309–355; Stefan Tanaka, "Imaging History: Inscribing Belief in the Nation," *Journal of Asian Studies* 53(1) (1994):24–73. For an English translation of Okakura's "Lecture to the Painting Appreciation Society" see Marra, *Modern Japanese Aesthetics,* pp. 71–78.

19. On this last point see Karatani Kōjin, "Bigaku no Kōyō: 'Orientarizumu' Igo," *Hihyō Kūkan* 2(14) (1997):4–55. On the political implications of aesthetics see Michele Marra, "The Complicity of Aesthetics: Karatani Kōjin," in *Modern Japanese Aesthetics,* pp. 263–299. The essay is followed by the English translation of Karatani's lecture, "Edo no Chūshakugaku to Genzai" (Edo Exegesis and the Present, 1985).

Such a language, however, did not go unchallenged, as Tsubouchi Shōyō's vehement attacks in "Bi to wa Nani zo ya" against both Fenollosa's idealism and Véron's anti-idealism amply demonstrate. Convinced that aesthetics should have a normative value and, therefore, should contribute concrete ideas to the formation of a modern literature, Tsubouchi took issue with the imponderable notion of "idea" *(myōsō)* that Fenollosa was espousing in his lectures. A series of debates ensued—based on a semantic confusion with the notions of "idea," "ideal," and "thought," which, when they are translated in Japanese, share the same second character: *"myōsō," "risō," "shisō."* The debate on "paintings of thought" *(shisōga)* between Shōyō and the educator Toyama Masakazu (1848–1900) was spurred by a lecture Toyama delivered in 1890, "Nihon Kaiga no Mirai" (The Future of Japanese Painting). Failing to properly interpret Fenollosa's notion of "idea" *(myōsō)* in the Platonic sense of "ideal" and the Hegelian sense of *Idee,* as Fenollosa himself had intended, Toyama took *myōsō* to convey the English notion of "idea or thought." As a result, he misconstrued Fenollosa's appeal to artists to give "ideal" representations of reality as an invitation to portray concrete ideas and thoughts. Therefore, Toyama argued that Japanese painters should portray "ideological paintings," or painting based on thought, thus inviting artists to turn to actual events and social problems when choosing the subject matters for their paintings. An early practitioner of naturalism *(shizenshugi),* Tsubouchi rejected Toyama's reasoning. Rather than paying attention to ideology, he said, artists should "reproduce human emotions as they are" (Chapter 3) .

Different interpretations of the notion of "ideals" *(risō)* by Tsubouchi Shōyō and Mori Ōgai (1862–1922) led to the debate of 1891–1892 between the two writers known as "the dispute on hidden ideals" *(botsurisō).* In this dispute between a "realist" and an "idealist," Shōyō argued in favor of the former: although realist art reflects the reader's ideas, it is not the purpose of art to accomplish the task of a philosophical work. In his view, rather than searching for greatness in Shakespeare's ideas, as if he were a great philosopher, we should admire Shakespeare's ability to convey his ideas imaginatively through the impartial representation of characters. Shōyō concluded that we should admire Shakespeare for his "submerged ideas." Ōgai accused Shōyō of underplaying the power of ideas in the formation of art, presenting Shōyō's theory of "submerged ideas,"

perhaps unfairly, as if this were a call to deny the necessity of ideals in the creation of art.[20]

Ōgai based his critique of Shōyō on an array of German philosophical works—above all the second part of Eduard von Hartmann's (1842–1906) *Aesthetik* (Aesthetics), or *Philosophie des Schönen* (The Philosophy of the Beautiful, 1888), which Ōgai translated in 1892 as *Shinbi Ron* (Theory of Aesthetics). This publication was followed by *Shinbi Kōryō* (Outline of Aesthetics, 1899), which Ōgai coauthored with Ōmura Seigai (1868–1927), and *Shinbi Shinsetsu* (A New Interpretation of Aesthetics, 1898–1899), in which Ōgai introduced the aesthetics of Johannes Volkelt (1848–1940). Ōgai was obsessed with "the subtle thoughts of novelists' imaginative life" and with the intuition that gives meaning to the analytical work of a writer. As he argued in *Shōsetsu Ron* (On the Novel, 1889), he realized that as a medical doctor he was committed to the search for truth: "The scalpel is never out of my grasp for long and my test tubes are always at hand. But this desire to seek real facts has never hindered dreams of visiting the infinite" (Chapter 4).[21]

Debates between defenders of naturalism *(shizenshugi)* and idealism *(kyokuchishugi)* informed Japanese cultural life at the end of the nineteenth century and the beginning of the twentieth. While the field of aesthetics was following the path of academic institutionalization, promoters of naturalism and idealism were divided into separate academic camps: Waseda University (then known as Tōkyō Senmon Gakkō), the University of Tokyo (then known as Tokyo Imperial University), and the University of Kyoto (then known as Kyoto Imperial University).[22] Shōyō was among the founders of the Department of Letters at Waseda University, as well as the journal *Waseda Bungaku* (Waseda Literature), from which he launched his attacks

20. On this dispute see Richard J. Bowring, *Mori Ōgai and the Modernization of Japanese Culture* (Cambridge: Cambridge University Press, 1979), pp. 63–87. For a modern reevaluation of Shōyō's position see Karatani Kōjin, *Origins of Modern Japanese Literature* (Durham: Duke University Press, 1993), pp. 145–151.

21. Quoted in Bowring, *Mori Ōgai and Modernization*, p. 67.

22. The development of aesthetics from within the walls of academia explains the overwhelming presence in the history of Japanese aesthetics of writers and scholars dealing with the fine arts from an academically oriented aesthetic perspective. The reader should be aware that there were Japanese thinkers from other disciplines writing on a variety of aesthetic issues—such as, for example, the geographer and political commentator Shiga Shigetaka (1863–1927), the folklorist Yanagita Kunio (1875–1962), and the philosopher of religion Yanagi Muneyoshi (1889–1961).

against Mori Ōgai. We find in the pages of the same journal articles by Waseda scholars who shared with Ōgai a belief in the importance of idealism, such as the Christian thinker Ōnishi Hajime (1864–1900). Perceiving a weakness of inner spirituality in the Japanese subjectivity, Ōnishi inquired into the work of thinkers of the Edo period, such as the literary scholar Kagawa Kageki (1768–1843), who had addressed the issue of the inner self. Ōnishi pointed out the need to complement the theory of interiority, which Kageki had developed around the notion of *magokoro* ("true, sincere heart"), in light of the findings of modern epistemology. Psychology and modern philosophy's emphasis on the notion of consciousness prompted him to revise Kageki's thought by pointing out the need to replace the belief that reality is the result of a natural process with the realization that the world is nothing but the product of a thinking mind. Ōnishi encouraged modern Japanese philosophers to reconcile traditional thought with the new ideas coming from the West.[23]

The same concern for a renewed spirituality led Ōnishi to launch his program of poetic reform: poetry, he urged, should express "religious thought"—a characteristic he thought was lacking in traditional *waka*. In his opinion, the inability of Shintoism and Buddhism to inspire such lofty thoughts in Japan should make people turn their attention to Christianity's potential to supplement the domestic religious heritage in this regard. Aesthetics was called to the task of promoting a "sense of beauty" in order to deepen the spiritual life of the Japanese people (Chapter 5).[24]

The issue of "inner life" was much debated in Japan in the 1890s when the poet, critic, and pacifist Kitamura Tōkoku (1868–1894) wrote the essay "Naibu Seimeiron" (The Inner Life). Here interiority is presented as the discovery of idealistic philosophy that, once it is translated into literature, incorporates ideas into reality. Tōkoku explains the inner life as the emanating spirit of the universe that penetrates the human spirit. Inspiration is crucial to such a life, since

23. Ōnishi developed this argument in "Kagawa Kageki Okina no Karon" (The Poetic Treatises of Master Kagawa Kageki, 1892), in *Ōnishi Hajime Zenshū*, vol. 7: *Ronbun Oyobi Kashū* (Tokyo: Nihon Tosho Sentā, 1982), pp. 499–537.

24. Ōnishi developed these ideas in the essays "Waka ni Shūkyō Nashi" (There Is No Religion in *Waka*, 1887) and "Kinsei Bigaku Shisō Ippan" (Outline of Early Modern Aesthetic Thought, 1897). For a complete English translation of the former see Marra, *Modern Japanese Aesthetics*, pp. 83–92.

it works as an echo bringing the two spirits in communication. Thus the absolute idea shows itself in concrete form in the interiority of the human heart, while transcendence is finally found in immanence.[25] The naturalists persistently condemned the idealist notion of transcendence—as shown in the critique of the poet and critic Iwano Hōmei (1873–1920), a vehement anti-Christian: "At the beginning of the nineteenth century, readers were satisfied only with the Wordsworthean view of nature. Poets saw the immortality of the soul in the rainbow, they heard the whisperings of gods in the rustling of the leaves; the view of nature changed completely. Yet this kind of religious tendency sacrifices the fecundity of nature to an insipid abstract concept."[26]

The idealism of Ōnishi Hajime left a deep mark on thinkers of the Waseda school, foremost among them Ōnishi's two most famous students: Tsunashima Ryōsen (1873–1907), who pursued his teacher's interest in ethical matters, and Shimamura Hōgetsu (1871–1918), who further studied the issues of aesthetic consciousness and aesthetic pleasure. Hōgetsu applied his knowledge of aesthetics to a parallel study of the beauty of the fine arts and the beauty of sentences in a major work on rhetoric titled *Shin Bijigaku* (New Rhetoric, 1902). After 1905, Hōgetsu became greatly influenced by the "philosophy of life" *(Lebensphilosophie),* whose popularity was rapidly increasing in Europe—a philosophy that reconciled Hōgetsu with naturalism in the latter part of his life (Chapter 6).

Perhaps no one at the time was more vocal in Japan on the issue of "life" than Takayama Chogyū (1871–1902), who replaced Ōnishi at Waseda University as lecturer in aesthetics after Ōnishi's departure for Europe. In 1898 Chogyū engaged in a famous debate with Tsubouchi Shōyō on the issue of "historical paintings." While promoting paintings "in the Japanese style" *(nihonga),* which had found in Fenollosa one of its earliest advocates, Chogyū defended the representation of historical themes on the ground that such paintings grasp the ideal beauty of history. According to Chogyū, the power of historical paintings resides in the beauty of the painting itself, not in

25. Kitamura Tōkoku, "Essai sur la Vie Intérieure," in Yves-Marie Allioux, ed., *Cent Ans de Pensée au Japon,* vol. 1 (Paris: Éditions Philippe Picquier, 1996), pp. 104–115.

26. Quoted in Earl Jackson, Jr., "The Metaphysics of Translation and the Origins of Symbolic Poetics in Meiji Japan," *PMLA* (March 1990):264.

the historical events portrayed. Historical events, he said, were simply expedients that artists used in order to express beauty. Shōyō, however, argued that since history preceded the beauty of poetic thought, the purpose of historical paintings was the representation of the beauty of history. Such a "historical beauty" was allegedly endowed with a greater degree of objectivity in comparison to other works of pure fantasy.

In this debate Shōyō confirmed once again his position on the issue of the subject: he believed the subject was a simple mirror reflecting an objectively reproducible external reality. Chogyū, by contrast, joined those who privileged the working of consciousness in the act of perceiving external reality—thus locating the beauty of historical paintings in the aesthetic perception of beautiful historical acts. Aesthetic consciousness played a major role in Chogyū's creation of an aesthetic state—a program that he called "Japanism" *(Nihonshugi)*, in which the state was considered an expedient to make human happiness concrete.[27]

Chogyū's encounter with the philosophy of Friedrich Nietzsche (1844–1900), which he helped introduce to Japan, led him to envision a concrete implementation of his aesthetics in a momentous article, "Biteki Seikatsu wo Ronzu" (Debate on the Aesthetic Life, 1901), that made a deep impression, especially on younger readers. The subordination of morality and knowledge to the power of instinctual life *(honnō)*—as well as the assertion that the purest aesthetic value is the satisfaction of the instincts—could hardly go unnoticed by the avid readership of the popular journal *Taiyō* (The Sun) (Chapter 7).[28]

Japan's adoption of the field of aesthetics during the Meiji period drastically changed the way that Japanese thinkers and readers thought of their own historical past. By applying to their own cultural heri-

27. On this issue see Chogyū's article, "Bikan ni Tsuite no Kansatsu" (Observations on Aesthetic Pleasure, 1900), a complete English translation of which appears in Marra, *Modern Japanese Aesthetics,* pp. 98–111.

28. On this issue see Graham Parkes, "The Early Reception of Nietzsche's Philosophy in Japan," in Graham Parkes, ed., *Nietzsche and Asian Thought* (Chicago: University of Chicago Press, 1991), pp. 177–199. See also Randolph Spencer Petralia, "Nietzsche in Meiji Japan: Culture Criticism, Individualism, and Reaction in the 'Aesthetic Life' Debate of 1901–1903" (Ph.D. dissertation, Washington University, 1981).

tage categories derived from Western aesthetics, Japanese thinkers ended by "creating" an indigenous past modeled upon the past of Europe—especially Greece, the land to which Johann J. Winckelmann (1717–1768) and Gotthold Ephraim Lessing (1729–1781) had turned in order to develop their aesthetic theories. Following the same approach taken by European aestheticians who had transformed ancient Greece into a comforting land, a safe utopia free from the anxieties of a burgeoning modern world, thinkers such as Fenollosa, Lafcadio Hearn (1850–1904), and Watsuji Tetsurō (1889–1960) searched for a land free from the ills of modernity in the past of the ancient capital Nara. Nara was transformed from a site of religious worship into an object of aesthetic contemplation, a symbol of human beauty, as we can see from Watsuji's best-seller *Koji Junrei* (Pilgrimage to Ancient Temples, 1919). Aestheticians worked together with literary historians in the creation of a "classical Japan" in which the southern capital of Nara was modeled on the image of classical Athens. Aizu Yaichi (1881–1956), a renowned second-generation aesthetician from Waseda University, saw in the land of Yamato the "South" of Japan in the same spirit that had led German romantic poets to "discover" Greece as the South of Europe (Chapter 8).

On September 7, 1893, the University of Tokyo (Teikoku Daigaku Bunka Daigaku, or "Imperial University, Faculty of Letters University") established a chair system on the model of Western universities. The Chair of Aesthetics was created together with the first twenty chairs forming the Division of Letters and Sciences (Bungakubu). In fact, this became the first university Chair of Aesthetics in the world. The first Chair of Aesthetics in Europe was established at the Sorbonne of Paris in 1919 with the appointment of Victor Guillaume Basch (1865–1944). At first the University of Tokyo hired several foreign lecturers, entrusting them with teaching a course in aesthetics: Ernest Fenollosa from 1883 to 1886, Ludwig Busse (1862–1907) from 1886 to 1892, and Raphael von Koeber (1848–1923) from 1893 to 1914. In 1900, however, Ōtsuka Yasuji (1868–1931) was offered a permanent, tenured position (Chapter 9).

Ōtsuka undertook a massive project in the study of "patterns" *(ruikei)*—types of clothes, architectural patterns, and the like—leading to typological studies of the structures, forms, and correlations of artistic phenomena. He also provided a solid foundation for a comparative method that led to the comparative typological explanation

of Eastern and Western aesthetic categories *(biteki hanchū)* on the part of his student and successor at the University of Tokyo, Ōnishi Yoshinori (1888–1959). Ōnishi authored perhaps the most original *Aesthetics (Bigaku,* 2 vols., 1959–1960) ever produced by a Japanese scholar. His analysis of expressions taken from the field of premodern poetics *(kagaku)* made words such as *"yūgen," "aware,"* and *"sabi"* popular terms in the aesthetic vocabulary of Japan.[29] His commitment to provide local epistemological categories with a universal foundation reflects Ōnishi's efforts to translate Japanese culture into an idiom that could be understood by an audience trained in Western hermeneutics. Ōnishi's work made a huge impression on Japanese historians of literature—who relied on his theoretical treatment of aesthetic categories in their classifications of literary texts—as well as on other Japanese philosophers who developed their own analyses of local aesthetic categories (Chapters 10 and 11).[30]

Ōtsuka and Ōnishi's preoccupation with adopting "scientific" methods to discuss Japan, and their drive toward systematic classifications, had a long-lasting effect on scholars of the University of Tokyo, who produced an array of typological studies beginning with Ōnishi's *Shizen Kanjō no Ruikei* (Types of Feelings for Nature, 1949). In this work the author classifies a variety of pathic approaches to nature, which he calls "sympathetic sensitivity, religious sensitivity, sentimental sensitivity, romantic sensitivity, and haikai-esque sensitivity." In *Fūdo: Ningengakuteki Kōsatsu* (Climate: An Anthropological Inquiry, 1935), Watsuji Tetsurō (1889–1960), a student of Ōtsuka Yasuji and Okakura Tenshin and, later, a professor of ethics at the University of Tokyo, undertook a typological study of climato-

29. For a partial translation of Ōnishi's essay on *aware* see Marra, *Modern Japanese Aesthetics,* pp. 122–140. See also Makoto Ueda, *"Yūgen* and *Erhabene:* Ōnishi Yoshinori's Attempt to Synthesize Japanese and Western Aesthetics," in J. Thomas Rimer, ed., *Culture and Identity: Japanese Intellectuals During the Interwar Years* (Princeton: Princeton University Press, 1990), pp. 282–299.

30. For the impact of the notion of "aesthetic category" on Hisamatsu Sen'ichi (1894–1976), probably the foremost authority in classical Japanese literature of the twentieth century, see Marra, *Modern Japanese Aesthetics,* pp. 141–142. On the role played by "aesthetic categories" in the study that Kusanagi Masao (b. 1900) made of *yūgen* and *yojō* in light of the existentialist philosophy of Karl Jaspers (1883–1969), see Kusanagi's essay "Yojō no Ronri" (The Logic of Passional Surplus), translated in Marra, *Modern Japanese Aesthetics,* pp. 148–167.

logical patterns in which he related differences in climate to social and cultural differences (Chapter 12).[31]

A typological approach to the arts of the Tokugawa period can be found in *Tokugawa Jidai no Geijutsu to Shakai* (Art and Society in the Tokugawa Period, 1948) by Abe Jirō (1883–1959), a graduate of the University of Tokyo and the author of a very popular *Aesthetics* (*Bigaku*, 1917) (Chapter 13).[32] A concern for typological studies is also at work in the writings of Ōnishi Yoshinori's disciple and successor, Takeuchi Toshio (1905–1982), who in *Bungei no Janru* (Genres of the Literary Arts, 1954) applied the notion of "aesthetic patterns," such as linguistic forms, experiential content, and expressive attitude, to a classification of literary genres. Takeuchi blended Ōtsuka Yasuji's idea of *Literaturwissenschaft (bungeigaku)* with Ōnishi Yoshinori's notion of "aesthetic categories" in his systematization of "the science of art" *(geijutsugaku)*. In 1979 Takeuchi published a monumental synthesis of his aesthetic system titled *Bigaku Sōron* (Survey of Aesthetics).

Takeuchi's successor to the Chair of Aesthetics at the University of Tokyo, Imamichi Tomonobu (b. 1922), has applied the typological/comparative method to the study of cultures.[33] At the same time, he has aimed at creating a new ethics derived from the combination of ethics, aesthetics, and science. The synthetic approach, which has characterized the discipline of aesthetics at the University of Tokyo from its inception, is very strong in Imamichi's thought. We see it sustaining his aesthetic project, which he has called "calonology"—a combination of "beauty" *(kalon)*, "being" *(on)*, "mind" *(nous)*, and "discourse" *(logos)*. Calonology, therefore, is an inquiry into the

31. On the complicity of universalism and particularism in creating a totalitarian subject, as well as the role played by Watsuji in developing such issues, see Naoki Sakai's articles "Return to the West/Return to the East: Watsuji Tetsurō's Anthropology and Discussions of Authenticity" and "Modernity and Its Critique: The Problem of Universalism and Particularism." Both articles are presented in Naoki Sakai, *Translation and Subjectivity: On "Japan" and Cultural Nationalism* (Minneapolis: University of Minnesota Press, 1997), pp. 72–116 and 153–176.

32. On the popularity of Abe Jirō's aesthetic thought during the Taishō period see Stephen W. Kohl, "Abe Jirō and *The Diary of Santarō*," in Rimer, *Culture and Identity*, pp. 7–21.

33. See, for example, his explanation of the West in terms of "representation" (mimesis) and the East in terms of "expression" in his lecture "L'Expression et Son Fondement Logique" ("Expression and Its Logical Foundation," 1962), translated in Marra, *Modern Japanese Aesthetics*, pp. 220–228.

realms of beauty, existence, reason, and science. Recently Imamichi has pointed out the need to replace "metaphysics," or the study of the transcendental explanation of the natural world of physics *(physis)*, with a "metatechnica," or a philosophy that answers the questions facing cities in an age of technology (what Imamichi also calls "urbanica"). In *Eco-Ethica: Seiken Rinrigaku Nyūmon* (Ecological Ethics: An Introduction to the Ethics of Livability, 1990), Imamichi insists on the need to reassess the notion of *oikos* (house) in order to redefine what he calls "the sphere of livability" *(seiken)* (Chapter 14).

The postmodern reader will undoubtedly take issue with the rigidity of aesthetic categories and the hermeneutics of comparative typologies that reduce the variety of particularity to absolute super-categories such as East and West. While still refusing to reject the heuristic value of such categories,[34] Sakabe Megumi (b. 1936), a professor of philosophy at the University of Tokyo, has called attention to the need to put aesthetics to the task of diluting totalitarian descriptions of categories and subjectivities and constructing "weaker," "softer" versions of philosophy that escape the temptations of totalization and essentialization.[35] Sakabe has fully embraced Heidegger's challenge to interrogate language. In his philosophy of the "Yamato language," Sakabe has developed original interpretations of ancient words that he has recently incorporated into his formulation of a new ethics (Chapter 15).[36]

Research in aesthetics was no less active in the ancient capital, Kyoto. The Kyoto Art Society (Kyōto Bijutsu Kyōkai) was founded in 1890 as the Kansai area counterpart of the Tokyo-based Dragon

34. See, for example, his commitment to "a dialogue between East and West" in Megumi Sakabe, "Surrealistic Distortion of Landscape and the Reason of the Milieu," in Eliot Deutsch, ed., *Culture and Modernity: East-West Philosophic Perspectives* (Honolulu: University of Hawai'i Press, 1991), pp. 343–353.

35. I have discussed Sakabe's philosophy in Michele Marra, "The New as Violence and the Hermeneutics of Slimness," *PMAJLS* 4 (Summer 1998):83–102, and "Japan's Missing Alternative: Weak Thought and the Hermeneutics of Slimness," in *Versus* (forthcoming). See also Sakabe's articles "Le Masque et l'Ombre dans la Culture Japonaise: Ontologie Implicite de la Pensée Japonaise" ("Mask and Shadow in Japanese Culture: Implicit Ontology in Japanese Thought," 1982), and " *'Modoki'—Sur la Tradition Mimétique au Japon" ("*Modoki*: The Mimetic Tradition in Japan," 1985), both offered in English in Marra, *Modern Japanese Aesthetics*, pp. 242–262.

36. See, for example, his recent book *"Furumai" no Shigaku* (The Poetics of "Behavior") (Tokyo: Iwanami Shoten, 1997).

Pond Society (Ryūchikai), which in 1887 had been renamed the Japanese Art Society (Nihon Bijutsu Kyōkai). Local newspapers and art journals became common venues for Nakagawa Shigeaki (1849–1917), a prolific writer and a popularizer of the philosophy of art. Nakagawa introduced major issues of contemporary Western aesthetics to readers who, thanks to his translations, became familiar with Karl von Lemcke's (1831–1913) *Populäre Aesthetik* (Popular Aesthetics, 1873) and *Aesthetik in gemeinverständlichen Vortragen* (Aesthetics in Popular Terms, 1890). Newly imported ideas, such as the notions of "aesthetic category" *(biteki hanchū)* and "emotional sphere" *(kanjō-ken),* allowed Nakagawa to develop his own aesthetic analysis of the art of Edo literati, especially their drawings *(haiga)* and prose in the style of haiku *(haibun),* in *Heigen Zokugo Haikai Bigaku* (The Aesthetics of Haikai in Plain and Popular Words, 1906) (Chapter 16).

Academic aesthetics began in Kyoto in 1910 with the appointment of Fukada Yasukazu (1878–1928) to the first permanent position in aesthetics at the Imperial University of Kyoto—a chair he occupied until the time of his death. A student of Raphael von Koeber at the Imperial University of Tokyo, Fukada received the call to Kyoto after returning from a three-year stay in Germany and France from 1907 to 1910. Fukada, who was also acquainted with the writer Natsume Sōseki (1867–1916), grounded his humanism in the belief that beauty is the result of cultural characteristics and universals are needed to combat people's loneliness (Chapter 17).

The teaching of aesthetics in Kyoto soon fell under the spell of the university's most distinguished philosopher: Nishida Kitarō (1870–1945). Nishida modeled the notion of "aesthetic experience" on what he called *junsui keiken* (pure experience)—"a present consciousness of facts just as they are" prior to the separation of subject and object.[37] Nishida attempted to synthesize Ernst Mach's (1838–1916) "analysis of sensations" and William James' (1842–1910) concept of "pure experience" with the Buddhist ideas of "selflessness" *(muga)* and "unity of body and mind" *(shinjin ichinyo)* that he had

37. Nishida developed the idea of "pure experience" in *Zen no Kenkyū* (An Inquiry into the Good, 1911). See Nishida Kitarō, *An Inquiry into the Good,* trans. Masao Abe and Christopher Ives (New Haven: Yale University Press, 1990), p. 4.

learned from practicing Zen. We find such a synthesis in the following statement at the conclusion of Nishida's essay "Bi no Setsumei" (An Explanation of Beauty, 1910):

> If I may summarize what has been said above, the feeling of beauty is the feeling of *muga*. Beauty that evokes the feeling of *muga* is intuitive truth that transcends intellectual discrimination. This is why beauty is sublime. As regards this point, beauty can be explained as the discarding of the world of discrimination and the being one with the Great Way of *muga*; it therefore is really of the same kind as religion. They only differ in the sense of deep and shallow, great and small. The *muga* of beauty is the *muga* of the moment, whereas the *muga* of religion is eternal *muga*. Although morality also originally derives from the Great Way of *muga*, it still belongs to the world of discrimination, because the idea of duty that is the essential condition of morality is built on the distinction between self and other, good and evil. It does not yet reach the sublime realms of religion and art.[38]

In his definition of art, Nishida moves toward an Eastern mystical experientialism: the secret of art, he contends, is found in the point of unification of subject and object. Nishida calls this point the "place of nothingness" *(mu no basho),* or "the experience of seeing the form of the formless and hearing the voice of the voiceless." According to Nishida, the true nothingness of artistic intuition culminates in the absolute free will of the artist (Chapter 18).

Nishida's thought had a profound impact on the philosophers and aestheticians of the University of Kyoto. One of his junior colleagues in the philosophy department, Nishitani Keiji (1900–1990), relied on Nishida's notion of "nothingness" *(mu)* and the Buddhist idea of "emptiness" *(kū)* as means to provide a positive response to the Western nihilism that had penetrated Japan during the cultural revolution of the Meiji period.[39] Nishida's philosophy also informed Nishitani's thought on aesthetics and the arts, as we can see from

38. Steven Odin, "An Explanation of Beauty: Nishida Kitarō's *Bi no Setsumei*," *Monumenta Nipponica* 42(2) (Summer 1987):217. See also Nishida Kitarō, *Art and Morality,* trans. David A. Dilworth and Valdo H. Viglielmo (Honolulu: University of Hawai'i Press, 1973).

39. On this issue see Nishitani Keiji, *The Self-Overcoming of Nihilism,* trans. Graham Parkes with Setsuko Aihara (Albany: SUNY Press, 1990). See also James W. Heisig and John Maraldo, eds., *Rude Awakenings: Zen, the Kyoto School, and the Question of Nationalism* (Honolulu: University of Hawai'i Press, 1994).

his interpretation of haiku in light of "emptiness" and "the logos of unhindered reason."[40]

Ueda Juzō (1886–1973), Fukada's successor and holder of the Chair of Aesthetics at the University of Kyoto until 1947, developed a philosophy of "visual perception" *(shikaku)* that is a blending of Nishida's transcendental aesthetics and the "theory of pure visibility" developed by the art historian Konrad Fiedler (1841–1895). Nishida's notion of "experience" returns in Ueda's phenomenological herme-neutics of vision, which addresses the formation of the work of art, as we can see in his *Geijutsu Shi no Kadai* (The Subject of Art History, 1936), *Shikaku Kōzō* (The Structure of Visual Perception, 1941), and *Nihon no Bi no Seishin* (The Spirit of Japanese Beauty, 1944) (Chapter 19).

Not even Kuki Shūzō (1888–1941)—who grew up in Tokyo, was educated at the University of Tokyo, and lectured in Western philos-ophy at the University of Kyoto only later in life—could escape the magic spell of Nishida. Kuki's education in the Kantō area is evident in his compulsion toward a geometrical systematization of aesthetic issues—a practice which is typical of the Tokyo school and which Kuki took to the highest level of sophistication.[41] Kuki combined the Buddhist notion of "resignation" *(akirame),* the military tradition of "brave composure" *(ikiji),* and the idea of "erotic allure" *(bitai)* to transform *iki* into an aesthetic category—a universal encompassing the particular elements of the cultural life of the Edo citizen. At the same time, Kuki was indebted to Nishida's philosophy when he described the love relationship between a man and a woman of taste *(iki)* as

40. See, for example, Nishitani's article "Kū to Soku" (Emptiness and Sameness), translated in Marra, *Modern Japanese Aesthetics,* pp. 179–217.

41. See, for example, his use of the hexahedron in summarizing the aesthetic values of the Edo period and the octahedron in discussing all the aesthetic categories that make up the notion of "refinement" *(fūryū)* in Japan. The use of the hexahedron is found in Kuki's essay "Iki no Kōzō" (The Structure of *Iki,* 1930). The octahedron makes its appearance in the essay "Fūryū ni Kansuru Ikkōsatsu" (An Investigation of Elegance, 1937). For an English translation of the first essay see Kuki Shūzō, *Reflec-tions on Japanese Taste: The Structure of Iki,* trans. John Clark (Sydney: Power Publi-cations, 1997). The English translation of the second essay is still in manuscript form: Kuki Shūzō, "A Consideration of *Fūryū,*" trans. Michael Bourdaghs. See also Hajimu Nakano, "Kuki Shūzō and *The Structure of Iki,*" in Rimer, *Culture and Identity,* pp. 261–272.

"transcendental possibility" *(chōetsuteki kanōsei)* rather than a "necessity of reality" *(genjitsuteki hitsuzensei)*. According to Kuki, the latter relationship characterizes the Western experience of love, one which culminates in fulfillment. Yet the tension that must be maintained to prevent the relationship from stagnating or becoming inauthentic was a guarantee of freedom from the shackles of love. While examining the aesthetics of the pleasure quarter during the Edo period, Kuki was actually confronting the same issues addressed by Nishida Kitarō and, later, by Nishitani Keiji. He was attempting to overcome the anxieties of Western modernity by searching in the local intellectual tradition for an antidote against Western nihilism. Kuki later engaged Nishida's "place of nothingness" in a dialogue with the Western idea of "negation" in a study on freedom and chance: *Gūzensei no Mondai* (The Problem of Contingency, 1935) (Chapter 20).[42] To this day Nishida's presence continues to influence aestheticians working at the University of Kyoto, as we can see from the work of Fukada's and Ueda's successors to the Chair of Aesthetics: Ijima Tsutomu (1908–1978), Yoshioka Kenjirō (b. 1926), and Iwaki Ken'ichi (b. 1944) (Chapter 21).

Japan continues to play a major role in the field of aesthetics. The fifteenth International Congress on Aesthetics—the first of its kind to take place in the twenty-first century—will be held in Tokyo. Sasaki Ken'ichi, president of the organizing committee, has indicated that topics for discussion will include cultural heterogeneity in the experience of art, the conflict of values in postmodern society, and the aesthetics of urban design in the midst of ecological challenges.[43] In this conference Japanese aestheticians will be called upon once again to confront the Heideggerian "bearing of message and tidings"

42. See Kuki Shūzō, *Le Problème de la Contingence,* French trans. Omodaka Hisayuki (Tokyo: University of Tokyo Press, 1966). On Kuki and Jean-Paul Sartre's (1905–1980) philosophies of contingency see Stephen Light, *Shūzō Kuki and Jean-Paul Sartre: Influence and Counter-Influence in the Early History of Existential Phenomenology* (Carbondale: Southern Illinois University Press, 1987), pp. 3–39.

43. The congress is scheduled to take place on August 27–31, 2001. Sasaki Ken'ichi has summarized the main issues of the congress in an announcement titled "Aesthetics in the Twenty-First Century." The announcement was distributed at an international conference, "Japanese Hermeneutics: Current Debates on Aesthetics and Interpretation" (December 13–15, 1998), that I organized at the University of California, Los Angeles.

coming from different "houses of being." Like the Japanese person-age in Heidegger's dialogue with the Inquirer, they will be challenged to find in the indigenous "house" the means to dilute the effects of what Heidegger called "the complete Europeanization of the earth and of man."[44]

44. "Inquirer: Because I now see *still* more clearly the danger that the language of our dialogue might constantly destroy the possibility of saying that of which we are speaking. Japanese: Because this language itself rests on the metaphysical distinction between the sensuous and the suprasensuous, in that the structure of the language is supported by the basic elements of sound and script on the one hand, and significa-tion and sense on the other. Inquirer: At least within the purview of European ideas. Or is the situation the same with you? Japanese: Hardly. But, as I indicated, the temp-tation is great to rely on European ways of representation and their concepts. Inquirer: That temptation is reinforced by a process which I would call the complete European-ization of the earth and of man" (Heidegger, *On the Way to Language,* p. 15).

THE
INTRODUCTION
OF AESTHETICS

1

Longing for "Beauty"

SAEKI JUNKO

"Beauty" as Proof of Being Human

In a previous article on the notions of nature *(shizen)* and reality *(shin-jitsu),* I discussed the role that nature and the search for truth *(makoto)* have played in shaping the Japanese value system during the "period of enlightenment" *(bunmei kaika).*[1] A third element that came to be inseparably connected with nature and truth was the notion of beauty *(bi).* I have already analyzed the relationship between truth, nature, and beauty that was underscored in Mozume Takami's *Genbun Itchi* (Unification of Spoken and Written Languages, 1886),[2] Tsubouchi Shōyō's *Shōsetsu Shinzui* (Essence of the Novel, 1885),[3] and Suematsu Kenchō's *Engeki Kairyō Iken* (Opinions on the Reform of the Theater, 1886).[4] In the present article I will be rethinking the notion of beauty and exploring the mentality of Japan's "enlightenment."

I have already indicated the links between truth and beauty in the works just mentioned. The argument according to which a demand for discussions of beauty is an integral part of the demand for explorations of truth is further strengthened by Tsubouchi Shōyō's following comment:

From Saeki Junko, " 'Bi' no Akogare," *Nihon no Bigaku* (The Aesthetics of Japan) 21 (1994), pp. 178–190.

1. [Literally this Japanese expression means "the opening to civilization." Ed.]

2. [Mozume Takami (1847–1928) taught Japanese linguistics at Tokyo Imperial University. Ed.]

3. [Tsubouchi Shōyō (1859–1935) was a major protagonist in the Japanese debate on the need for realism in fiction. Ed.]

4. [Suematsu Kenchō (1855–1920) studied literature and law at Cambridge University, where he worked on an English translation of the *Genji Monogatari* (Tale of Genji). Suematsu had a distinguished political career as a diplomat and became minister of the interior. Ed.]

25

If moral and political truths are essential objects of investigation, how can we avoid studying the theory of beauty?[5]

In "Bi to wa Nani zo ya" (What Is Beauty?, 1886),[6] Shōyō critically confronts the notion of beauty, explaining the inevitable links that questions such as "why beauty" and "what is beauty" have with truth. By rhetorically asking, "if human beings are obliged to investigate the truth thoroughly, how can they avoid investigating the truth of beauty?",[7] he argues that the act of searching for beauty is part of the pursuit of truth. On this issue Tsubouchi was in agreement with a point repeatedly made by Nishi Amane in his *Hyakugaku Renkan* (Encyclopedia);[8] according to Nishi the final purpose of learning was an exhaustive investigation of truth.

In a previous installment on the subject of Japan's enlightenment, I pointed out that the discursive intellectual space that made the act of searching for truth evidence of the opening to human civilization developed around this time. Here I want to observe that, for Tsubouchi, inquiry into truth made up the essence of a human being. A debate that confirms the opening to civilization inevitably presupposes a situation in which such an "opening" has not yet occurred and a method differentiating between such a situation and "civilization." Civilization was contrasted with barbarism, while human beings were opposed to animals other than human.[9] The coupling of the expression "beauty" with "truth" shows its effects as a means of clarifying the difference between the two concepts.

In *Bimyōgaku Setsu* (The Theory of Aesthetics),[10] which is representative of the initial stage of debates on beauty, Nishi Amane points out three elements that constitute human nature: the nature of

5. Aoki Shigeru and Sakai Tadayasu, eds., *Bijutsu*, NKST 17 (Tokyo: Iwanami Shoten, 1989), pp. 15–16.

6. [For a complete English translation see Marra, *Modern Japanese Aesthetics*, pp. 48–64. Ed.]

7. [Ibid., p. 15. Ed.]

8. [Nishi Amane (1829–1897), a committed scholar of Western studies, introduced to Japan several Western sciences, including the discipline of aesthetics. *Hyakugaku Renkan* was originally conceived as a series of lectures that Nishi delivered in his private English school a few years after 1870. Ed.]

9. I developed this point in the second article of this series in which I discussed the progress from "lust" to "love."

10. [For a complete English translation see Marra, *Modern Japanese Aesthetics*, pp. 26–37. Ed.]

morality, feelings of justice, and aesthetics. He indicates that each property is in charge of the judgment of, respectively, good and evil, right and wrong, beautiful and ugly. While human beings share the first two characteristics with animals, "it appears that only the element of aesthetics is absent from animals."[11] Nishi makes the perception of beauty a monopoly of humans. In that period, the argument that something is a specifically human faculty was meant as a proof of human civilization which made man different from savage animals— a fact that becomes clearly apparent in Shōyō's debate on beauty.

In *The Essence of the Novel*, in which he defines the novel as a "fine art," Shōyō, in addition to addressing the subject of novels, explains the nature of art, arguing that in "the barbarism of ignorance," aesthetic feelings—that is, art—do not exist. He also emphasizes that those who "are not barbarians" take pleasure in aesthetic feelings and maintains that this is "the constant nature of human beings":[12]

> Aesthetic feelings are truly lofty emotions. Unless one belongs to a country that opens up to culture and civilization, such emotions will never exist.[13]

If the pursuit of truth is a characteristic of a civilized society, the quest after beauty is proof of the civilization of human beings who have succeeded in extricating themselves from barbarism. Nishi and Shōyō adhere equally to this view.

"Beauty" as Goal

I have pointed out that for the Japanese people of the Meiji period, the value represented by the word "beauty" was a new discovery. Yanabu Akira argues that "in Japan prior to modernity the Chinese character indicating 'beauty' did not have the same meaning that we attribute to the word today."[14] He says that the first example in which the character for "beauty" was used by itself to translate the expressions *"beauté,"* "beauty," and *"shoonheid"* appeared in Mura-

11. Aoki Shigeru and Sakai Tadayasu, *Bijutsu,* p. 7.
12. Quotations are from *Meiji Bungaku Zenshū* (Tokyo: Chikuma Shobō, 1969), p. 22.
13. Ibid., p. 23.
14. Yanabu Akira, *Hon'yakugo Seiritsu Jijō* (Tokyo: Iwanami Shoten, 1982), p. 68.

kami Hidetoshi's *Sango Benran* (Handbook of Three Languages, 1857).[15] Why were the intellectuals of the Meiji period fascinated by an expression in existence since the end of the old regime? What did Nishi Amane and Tsubouchi Shōyō try to achieve by popularizing the notion of beauty among the Japanese? To answer these questions we must examine another related expression: "fine art" *(bijutsu)*.

In *The Theory of Aesthetics*, Nishi Amane provides the following explanation:

> Presently included in Western fine arts *(bijutsu)* are painting, sculpture, engraving, and architecture. But it is appropriate to say that the principle of aesthetics also applies to poetry, prose, and music, as well as to Chinese calligraphy. Dance and drama should also be included in the list.[16]

According to today's popular wisdom, all the disciplines mentioned in Nishi's list belong to the category of "art" *(geijutsu)*. What is new in Nishi's classification is the use of the term "fine arts" *(bijutsu)*, which was coined as a translation of a German term on the occasion of the 1873 World Exposition in Vienna.[17] In the catalog of the exhibited objects we read the following statement:

> Fine arts *(bijutsu)*. (In the West, music, painting, sculpture, and poetry are called "fine arts.")[18]

The grouping together of genres such as music, painting, sculpture, and poetry within the realm of the "fine arts" is referred to as a Western classification.

In *The Essence of the Novel* Tsubouchi Shōyō divides "what is known in the world as the fine arts" into two categories: "material fine arts" and "formless fine arts." To the first category belong "painting, sculpture, inlaid woodwork, textiles, copper, architecture, and gardens"; the second consists of "music, poetry, and drama"; "dance and theater" belong to both.[19]

This concrete articulation of the content of the fine arts and beauty bespeaks the novelty for the Japanese of the meaning of a

15. Ibid., pp. 66–67. [Murakami Hidetoshi (1811–1890) is considered the founder of French studies in Japan. Ed.]
16. Aoki Shigeru and Sakai Tadayasu, *Bijutsu*, p. 4.
17. Ibid., p. 3, headnote.
18. The text appears in Aoki Shigeru and Sakai Tadayasu, *Bijutsu*, p. 404.
19. *Meiji Bungaku Zenshū*, p. 5.

term such as "fine arts." Tsubouchi and Nishi, however, did not intro-
duce the concept of the fine arts simply because of its novelty. Nishi
declared: "It goes without saying that the fine arts foster the flourish-
ing of civilization and elevate the human world to a lofty realm."[20]
At the same time, Tsubouchi criticized the view that "the purpose of
the fine arts is to please the heart and to elevate the spirit," arguing
instead that "the elevation of the human character is a fortuitous act
and should not be considered the purpose of the fine arts."[21] Although,
according to Tsubouchi, the use of the word "purpose" with regard
to the fine arts was a mistake, he emphasized that "if you love the
fine arts and occasionally play with them, your aesthetic taste will
grow and your character will become more and more ennobled."[22] In
other words, both Nishi Amane and Shōyō took into serious consid-
eration the activity of the fine arts as a means to guide human beings
toward "loftier" and "more noble" realms. Since the attainment of
more noble realms is the purpose of civilization, the fine arts came to
be held in very high esteem as indispensable to an enlightened society.
This opinion is linked to the other view I discussed in the previous
section, according to which the aesthetic realm is evidence of a civi-
lization specific to those human beings who have liberated them-
selves from barbarism.

As Nishi Amane indicates at the beginning of *The Theory of Aes-
thetics*, when he states that "aesthetics is related to the fine arts,"[23]
concrete ways to reach the truth known as "aesthetics" are fine arts
such as music and painting. In short, fine arts *(bijutsu)* is the art *(jutsu)*
employed to reach the truth *(shinri)* known as beauty *(bi)*.

To put it this way might give the impression that I am simply pro-
viding a literal explanation of the term "fine arts" *(bijutsu)* based on
a separate examination of each of the two Chinese characters that
make up the word. This, however, cannot be done as a mechanical and
self-explanatory act. In other words, while the word "beauty" *(bi)* is
the translation of Western expressions such as *"beauté,"* "beauty,"
and *"shoonheid,"* the Japanese expressions indicating aesthetics *(bi-
myōgaku* and *bigaku)* are themselves translations of foreign words.
(The expression *"bimyōgaku"* appeared for the first time as a trans-

20. Aoki Shigeru and Sakai Tadayasu, *Bijutsu*, p. 14.
21. *Meiji Bungaku Zenshū*, p. 5.
22. Ibid., p. 24.
23. Aoki Shigeru and Sakai Tadayasu, *Bijutsu*, p. 3.

lation of "aesthetics" in Nishi Amane's *Bimyōgaku Setsu* (The Theory of Aesthetics), in which Amane indicated next to the Chinese characters the correct reading of the compound, "aesthetics," or "essechikku" in the *kana* syllabary.)[24] Moreover, the word *"bijutsu"* is the Japanese translation of "fine arts" as Nishi Amane again tells us by indicating the reading of the Japanese compound as "fain āto" in the *kana* syllabary. The presence of the Chinese character *"bi"* (beauty), which is used in all the Japanese words mentioned above, clearly indicates the efforts made by the intellectuals of the Meiji period to create a new, "noble," "enlightened" society by importing the value of "beauty."

We can understand how Japan learned from the West the idea that beauty is the realm which any newly "enlightened society" has to reach (or it might be better to say that Japan borrowed from the West in the process of making beauty a goal worthy of a human society). What is not clear is the vital definition of beauty. In other words, beauty as a goal was first posited as a word without any explanation of its meaning. Basically it would be more appropriate to first understand satisfactorily the meaning of "beauty" and then set it up as a goal. In fact, the opposite path was followed, since debates on the meaning of beauty came after the establishment (importation) of beauty as a goal. In a sense we can say the cart was put before the horse.

But we cannot wholly blame such a reversal on the shallowness of the hasty West-oriented policies of intellectuals during the Meiji period. The very definition of beauty was a major concern for the Western originators of aesthetics. It would be unreasonable to demand of Meiji intellectuals that they perform the powerful act of importing from the West the concept of beauty in a short period of time, only

24. Although several Japanese expressions were used to indicate "aesthetics," the matter was finally settled by using the currently employed word, *"bigaku,"* which was first used by Nakae Chōmin in his translation of Eugène Véron's (1825–1889) *L'Esthétique* (1878), which Nakae entitled *Ishi Bigaku* (1883–1884). Before settling on *"bimyōgaku"* (literally "the science of the beautiful and mysterious") as the Japanese counterpart of "aesthetics," Nishi Amane had used the words *"zenbigaku"* (the science of good and beauty) and *"kashuron"* (the discipline of good taste). Mori Ōgai used the expression *"shinbigaku"* (the science of the appreciation of the beautiful). See Aoki Shigeru and Sakai Tadayasu, *Bijutsu*, p. 2. Yanabu Akira argues that at the beginning of the Meiji period the word *"birei"* was used more often than the current term, *"bi,"* to indicate "beauty." See Yanabu Akira, *Hon'yakugo Seiritsu Jijō*, p. 68.

after having mastered the long history of debates on the subject and having clarified for themselves the meaning of beauty.

The imposing demand of bringing Japan to enlightenment required as a first measure the establishment of the noble goal of "beauty." At the same time, as a guideline for beauty, arguments on its content had to be pursued. In this context Shōyō wrote the critical essay "What Is Beauty?" The issues that this critique established for debate went right to the core of the problem faced by the Japanese at that time with regard to beauty.

Although it was understood that "once 'beauty' was set up as a goal of an enlightened society, it was necessary to clearly understand what beauty was about," it was impossible to formulate such a broad question for which no easy answer was in sight. This explains why Shōyō skillfully left his critique unfinished. As we can see from the failure of Shōyō's debate on "beauty," the cultural circumstances during the Meiji period were such that the word "beauty" worked as a guiding principle without the actual presence of a clear definition.

This situation, however, does not necessarily apply only to the Meiji period. Even in the art world of today there is no commonly shared understanding or definite answer to what makes something beautiful, yet we cannot deny that many artistic activities take place. In this sense we can say that the contemporary art world is not so different from its Japanese counterpart during the Meiji period.

The use in Meiji Japan of the notion of beauty—or, it might be more proper to say, of the catchword "beauty"—had a peculiar meaning we do not find in contemporary society. The expression "beauty" made the Japanese aware of an experience that was never before felt as beauty.

Novel and Drama as "Fine Arts"

One of Tsubouchi Shōyō's reasons for writing *The Essence of the Novel* was to make people aware that "the novel is a fine art."[25] In the preface to his essay Tsubouchi states that he wrote *The Essence of the Novel* to help the Japanese novel "excel over the novels of European countries and place it on the altar of the fine arts together with painting, music, and poetry" through the "advances brought

25. *Meiji Bungaku Zenshū*, p. 22.

about by the reforms of my novels."[26] A major goal of *The Essence of the Novel* was to bring the novel to the same rank as painting, music, and poetry. With regard to the meaning of such an epistemological move, Tsubouchi states:

> People in our country have underestimated novels as kinds of toys. Consequently writers have never considered the idea of reforming the novel and turning it into a fine art with which to entertain learned people.[27]

Tsubouchi pleaded for the elevation of the status of the novel, which used to be considered a simple toy. In order to have its status raised, the novel had to be included in the category of "fine arts." Tsubouchi deplored the fact that heretofore the Japanese novel "had been poor in refinement," and he suggested that a major cause for this flaw was "the mistaken attitude of looking down on novels as if they were playthings for women and children, instead of considering them fine arts."[28]

As I mentioned earlier, the act of searching for beauty was deemed an inevitable activity for an enlightened society. Tsubouchi urged people to change their values by trying to make them realize with his example that the writing of stories was an act of "fine art," although until then it was simply perceived as an act of consolation. Since, among writers, the awareness of operating in the realm of art was actually negligible, Shōyō pointed out that "among the novels written in our country, those that truly deserve to be called 'fine art' are extremely rare."[29] The criticism of the Neo-Confucian assessment of literature as the promoter of good and the chastiser of evil, which he expressed in *The Essence of the Novel*, was also motivated by Tsubouchi's desire to establish the novel as a form of art through a criticism of works that "sprang from the intention of praising and punishing"[30] on the part of writers of light fiction *(gesaku)*. By announcing that "the novel is a fine art," and by breaking through the ignorance of writers, urging them to develop a self-awareness of being producers of works of art, Tsubouchi struggled to raise the level and the status

26. Ibid., p. 4.
27. Ibid., p. 23.
28. Ibid., p. 23.
29. Ibid., p. 24.
30. Ibid., p. 3.

of the novel—of course, by providing contents befitting the values of an allegedly enlightened society. It was not enough, however, to urge other writers to do so. It was necessary to embark upon a creative activity that aimed at becoming a role model for the composition of novels to be judged as art.

Despite the desire to write novels as a form of art and thus illuminate others—and despite authors' willingness to follow Shōyō's doctrine—it was difficult to envision concrete goals so long as the meaning of "art" and "beauty" was unclear. Therefore Shōyō himself thought about the need to provide answers to the question of beauty, and he came up with the essay titled "What Is Beauty?" Shōyō clearly stated his motive for writing the essay in the following sentence: "To establish standards for later artists by providing interpretations of the notion of 'beauty,' and thus planning the development of the world of art," is what "the debate of true artists is all about."[31]

Shōyō pointed out that "aesthetics, which is at the root of the fine arts, establishes the goal of art," and he addressed quite vaguely the question of "how artists can reach such a goal."[32] Since no answer was given for the big question—"what is beauty?"—artists were actually at a loss. This situation explains Shōyō's attempt to clarify the meaning of beauty, which should be made the goal of the fine arts in an enlightened society.

As we can see from the fact that Shōyō included the word "artist" (bijutsuka) in the category of what he had been calling the "fine arts" (bijutsu), we understand that with the term "fine arts" (bijutsu) Shōyō meant what today we call "art" (geijutsu).[33] The fact that he did not use the latter expression unequivocally indicates his desire to make clear that he privileged a notion of fine arts (bijutsu) which was meant

31. Aoki Shigeru and Sakai Tadayasu, Bijutsu, p. 28.

32. Ibid., p. 17.

33. Aoki Shigeru and Kitazawa Noriaki argue that we can see that the term "fine arts" (bijutsu)—which was meant to indicate "arts and crafts" (geijutsu)—was squeezed into signifying what we today call "art" from the fact that the Technological Art School (Kōbu Bijutsu Gakkō, 1876) and the Tokyo School of Fine Arts (Tōkyō Bijutsu Gakkō, 1887) only had departments of visual arts. See Aoki Shigeru and Sakai Tadayasu, Bijutsu, p. 402, n. 1. At the same time, they point out that the word "geijutsu," which indicated technical skills (gijutsu), came to assume the meaning of "fine arts" (bijutsu). Sasaki Ken'ichi also points out the influence of the School of Fine Arts on "limiting the meaning of the word 'bijutsu' to indicate the plastic arts." See Sasaki Ken'ichi, "Geijutsu," in Kōza Bigaku, vol. 2 (Tokyo: Tokyo Daigaku Shuppankai, 1984), p. 156.

as a search for beauty. In other words, the expression "fine arts" *(bijutsu)*, which included all arts *(geijutsu)* in general, came to be increasingly applied to the visual arts only and to indicate what later would be referred to as art *(geijutsu)*—a topic that deserves separate treatment and will not be discussed any further here.[34] We should not forget that without an awareness of the notions of beauty and fine art *(bijutsu)* related to beauty, those whom today we call artists would not perceive themselves as artists and would not be valued and acknowledged as such by those around them.

I mentioned the example of Shōyō with regard to the elevation of the status of novels. The same point could be made with regard to drama. In *Engeki Kairyōron Shikō* (A Personal View on the Reform of Drama, 1886), Toyama Masakazu emphasizes the notion that since "drama is a kind of fine art," a "true actor" is a "true artist."[35] Moreover, in *Engeki Kairyō Iken* (Opinions on the Reform of the Theater, 1886), Suematsu Kenchō argued that drama is a search for "what is beautiful."[36] Takada Hanbō[37] argued in "Engeki Goran no Koto wo Kikite Tenka no Haiyū ni Tsugu" (Listening to the Debate on Drama and Announcing It to the Land's Actors, 1887) that the "drama" of Danjūrō and Kikugorō possesses "the thought of the fine arts."[38] In

34. Isoda Kōichi points out that the trend of settling on the word *"bijutsu,"* to indicate what today we call *geijutsu,* was "an intellectual product of the separation of 'art' with the meaning of 'fine arts' from 'technical arts,'" and says there was no inconsistency in calling *bijutsu* 'art' *(geijutsu).* The establishment of the Meiji Art Association and the opening of the Tokyo School of Fine Arts caused the newly established notion of 'art' *(bijutsu)* to abort." See Isoda Kōichi, *Ritsumeikan no Keifu* (Tokyo: Bungei Shunjūsha, 1983), p. 31. The word *"geijutsu"* is an ancient word that appeared in the *Hou Han-shu* (History of the Later Han Dynasty), in which it meant learning or arts and crafts. "The process by which the classical concept of *geijutsu* came to connote what today we mean by art and learning is the same in the history of Western thought as well." See Sasaki Ken'ichi, "Geijutsu," pp. 123–124.

35. [Toyama Masakazu (1848–1900), a member of the 1873 Society (Meirokusha) and a well-known educator, studied at the University of Michigan and became president of Tokyo Imperial University. He was active in a wide area including education, religion, politics, literature, art, drama, law, and science. Ed.]

36. See Saeki Junko, "Shizen to Shinjitsu" (Nature and Truth), *Nihon no Bigaku* 19 (December 1992):146.

37. [Takada Hanbō (1860–1938), the author of the first scientific treatise on rhetoric in Japan, became president of Waseda University. Ed.]

38. See Kurata Yoshihiro, *Geinō*, NKST 18 (Tokyo: Iwanami Shoten, 1988), p. 341. Here Takada includes "the grace of *nagauta*" and "the strength of *tokiwazu* (a kind of ballad)" among the forms of "noble, elevated beauty." On the other hand, I have discussed how such a traditional Japanese music ran counter to the "noble

"Engeki Kairyō Ronsha no Henken ni Odoroku" (Being Puzzled by
the Prejudices of the Reformers of Drama, 1889), Mori Ōgai states
that "comedy, drama, and theater must struggle to reach the beauty
of art" and "we must strive to make the drama of our country a pure
form of art that is not second to Western drama."[39] In all these state-
ments we see the same tendency to bring to Japanese drama the values
of beauty and art.

This last point was made in contrast to the position given to sumo
wrestling. When we look at Takada's comparison of sumo and drama,
we understand the position that drama occupied in those days.
Takada stipulates that "plays are civilized, while sumo is savage."[40]
He excludes sumo from the realm of art, arguing that "generally
speaking, things that are not related to art should not be called noble
. . . in other words, what kind of art can be found in sumo?"[41] At the
same time, he praises drama as art, saying: "Look at that play! How
can it not be called noble? How can it not be an example of excellent
beauty?"[42] Moreover, he argues that the view of noble drama "is
proper of a gentleman," thus taking great joy in the thought that
kabuki, especially the one performed in front of the emperor, is a
"noble art." This explains the excitement with which Takada begins
his essay with the exclamation, "Look at drama! Look at drama!"

Kabuki, like the pleasure quarter, was considered a "place of evil."
It was never thought to incorporate the values of beauty and art prior
to the modern period. Although they all represented forms of enter-
tainment, the destiny of kabuki was different from other activities
of the pleasure quarter that were excluded from "civilization." By
being incorporated into the category of beauty, the status of kabuki

beauty" of the enlightenment in the first part of this series, "Bunka Kaika no Asobi"
(Play in the Enlightenment).

39. *Ōgai Zenshū Chosaku Hen,* vol. 16 (Tokyo: Iwanami Shoten, 1953), pp. 31
and 33.

40. Kurata Yoshihiro, *Geinō,* p. 340.

41. Ibid.

42. Ibid., p. 341. The perception of sumo as "the ugly act of naked bodies" origi-
nated at the beginning of the Meiji period. Sumo came to be seen as "a savage, naked
dance" and at one time suggestions were made to banish it. When we look at the
establishment of a national arena for sumo at the end of the Meiji period, as a result
of the contribution made to society by sumo wrestlers, we see how skillfully sumo
was able to achieve a position as the "national sport." See Miki Teiichi, *Nihon Sumō
Shi* (History of Japanese Sumo) (Tokyo: Banzaikan, 1909); Yokoyama Kendō, *Nihon
Sumō Shi* (Tokyo: Fusanbō, 1943).

was raised to the sphere of "enlightenment."[43] With regard to what actually constituted beauty and art, standards were based on the model of what was judged to be "fine arts in the West." Since the pleasure quarter was not included in this sphere, arts that emerged from that environment were rejected as unrelated to the modern fine arts ("arts").[44]

We cannot say that prior to the Meiji period the Japanese completely lacked awareness of a notion corresponding to beauty. Yanabu Akira has mentioned in this regard Zeami's "flower" *(hana)* and *yūgen*, Rikyū's *wabi*, Bashō's *fūga* and *sabi*, and Motoori Norinaga's "pathos of things" *(mono no aware)*. He maintains that all these notions have something in common with the concept of beauty "in the form of nouns, in their ultimate implications."[45]

Even during the Meiji period there were people aware of Japanese native words corresponding to the notion of beauty. By saying that "when we say 'chic' *(shibushi)* and when we say 'refined' *(iki)* both are, in the realm of art, so-called beauty,"[46] Tsubouchi himself stated

43. According to the article previously mentioned by Takada, kabuki performed in front of the emperor was considered to be "the beginning of a society's enlightenment." See Kurata Yoshihiro, *Geinō*, p. 342. Suematsu Kenchō too embraced the cause of raising the quality and status of drama, announcing the need to "reform" it, since "contemporary Japanese plays are not worth the attention of spectators of the middle and aristocratic classes." See his *Engeki Kairyō Ensetsu* (Speech on the Reform of Drama, 1886) in Kurata Yoshihiro, *Geinō*, p. 38.

44. In Western aesthetics, as well, there were debates relating beauty to impulses toward amusement—as in the case of Schiller and also Huizinga's notion of *homo ludens*. But when we look at examples of the severe criticism of ballads and ditties that sang of prostitutes and "the situation in the pleasure quarters"—criticism that referred to them as "the obscenities of our country's vulgar tunes" [Yatabe Ryōkichi, "Ongaku Gakkō Ron" (Essay on the School of Music, 1891), in Kurata Yoshihiro, *Geinō*, pp. 350–352]—or when we consider the view that these entertainments played an unfavorable role with regard to civilization, we notice that among the intellectuals of that time there was no space for play within beauty. On beauty and amusement in Schiller see Miura Shin'ichirō, "Ningensei Kansei no Risō to Shite no Bi—Shirā no Bigaku" (Beauty as the Ideal of Human Perfection: The Aesthetics of Schiller), in Ōta Takao, Iwaki Ken'ichi, and Yonezawa Aritsune, eds., *Bi, Geijutsu, Shinri—Doitsu no Bigakushatachi* (Beauty, Art, Truth: German Aestheticians) (Tokyo: Shōwadō, 1987), pp. 54–55.

45. For other "concepts indicating the Japanese aesthetic consciousness" such as *miyabi* and *iki* see, for example, Sagara Tōru, Bitō Masahide, and Akiyama Ken, eds., *Kōza Nihon Shisō*, vol. 5: *Bi* (A Course in Japanese Thought: Beauty) (Tokyo: Tokyo Daigaku Shuppan Kai, 1984). For a survey of Japanese aesthetic principles see Kuriyama Riichi, ed., *Nihon Bungaku ni Okeru Bi no Kōzō* (The Structure of Beauty in Japanese Literature) (Kyoto: Yūzankaku, 1991).

46. Aoki Shigeru and Sakai Tadayasu, *Bijutsu*, p. 19.

that the expressions "chic," as in the case of "the Kiyomoto school of puppet theater," and "refined," as in the case of "Danjūrō's art," correspond to the notion of beauty. Moreover, Takada Hanbō has argued that the *iki* of Kiyomoto is "a noble, elevated beauty."[47]

But in order to explain why a new word, "beauty" *(bi)*, had to be used instead of more traditional expressions, we might consider such a need the result of associating the term "fine art" with what today we would call a creative activity and recategorizing such an activity as an act moving toward the common goal of civilization.

Since in the past the Japanese arts and the world of writing were not awake to the notion of beauty, it was impossible to produce works worthy of the name "art" that would have the strength to lead people to a higher realm. The goal of intellectuals during the Meiji period was to grasp as "fine arts" novels and plays that for centuries had been denigrated as simple pastime and entertainment and to foster the perception of creative activities as marks of civilization.

"Beauty" for an Ideal Society

The Japanese discourse on art, in relation to beauty and the issue of civilization, developed together with debates on truth and the good. Although I mentioned the unity of beauty and truth at the beginning of this article, I will reexamine such a relationship from the perspective of beauty, keeping in mind also the concept of "the good."

In *The Theory of Aesthetics*, Nishi Amane points out the three elements he deems necessary to the fulfillment of human nature: the "nature of morality" that allows human beings "to discern good from evil"; a "feeling of justice" that determines "what is just and what is unjust in law"; and "aesthetics," which "addresses beauty and ugliness." Moreover, Nishi states that "together with morality and law, aesthetics contributes to the civilization of societies."[48] In other words, the judgments of good and evil, just and unjust, beautiful and ugly, should be seen as components of the same process of civilization. Art is not simply confined to the specific realm known as art; it is related to a larger system of value judgments within a society—value judg-

47. See footnote 36.
48. Aoki Shigeru and Sakai Tadayasu, *Bijutsu*, p. 5.

ments that allow a human society "to move away from the stage of savagery."[49]

In an earlier essay I argued that in the debate on nature between Iwamoto Yoshiharu[50] and Mori Ōgai, their opposing positions were a result of a rift between Iwamoto's search for a unified value system composed of "truth," "good," and "beauty" and Ōgai's antithetical belief in the separation of beauty from morality. Although Iwamoto's stand reflects his attitude as a Christian, the fusion of truth, good, and beauty is not specifically a characteristic of a religious man but the general trend of opinion followed by leaders of the enlightenment movement. Shōyō's position on the artistic quality of novels—according to which the writing of novels as "fine art" led to the composition of works that automatically elevated human dignity—was the same. We saw that the reformers of drama made a similar argument.[51] By stressing the unrelatedness of "science that follows truth," "morality that obeys good," and "poetics that serves beauty," Ōgai tried to ground the existence of the fine arts ("art") on a different basis than the unified structure "truth/good/beauty" used by Nishi and like-minded intellectuals. He took an antithetical position to Iwamoto's and Shōyō's, arguing that "sometimes art of extreme beauty might well be accompanied by immorality."[52]

Setting up a system made of truth, good, and beauty, however, was not a characteristic unique to Japan during the period of enlightenment. In his investigation of the Japanese translation of the word "aesthetics" *(bigaku)* during the Meiji period, Imamichi Tomonobu has called attention to an idea that Schelling expressed in the *System of Transcendental Idealism* (1800), in which he points out how the work of art is similar to religion in its being a unity of finite and infinite. Imamichi indicates how Nishi's expression "science of good and beauty" *(zenbigaku)*, employed when he first translated the word

49. Ibid., p. 4.

50. [Iwamoto Yoshiharu (1863–1942), critic and educator, was the cofounder of the magazine *Nyogaku Zasshi* (Women's Journal), which played a major role in the education of women and promoting the women's movement. Ed.]

51. "Good drama automatically fits the purpose of promoting good and chastising evil, even when this is not its primary purpose" (Suematsu Kenchō, *Engeki Kairyō Iken*). Quoted in Saeki Junko, "Shizen to Shinjitsu," p. 146.

52. "Bungaku to Shizen" (Literature and Nature, 1889), in *Ōgai Zenshū*, vol. 16, p. 15.

"aesthetics" (*Hyakuichi Shinron*, or The New Theory of the Hundred and One, 1874), is similar in implication to the following quotation from Schelling's *Bruno:* "Truth and beauty are necessarily one thing."[53]

Imamichi also points out that in ancient Greece, a long time prior to Schelling, the word indicating beauty *(kalós)* was used in relation to perfection, usefulness, and morality, so that it became difficult to differentiate it from the concept of good.[54] In ancient Greece, art was considered an activity one pursued in order to move closer to "the god of beauty and good." It corresponded to the thought on *kalokagathia* (union of beauty and truth), as this was found in ideal deities. This argument—according to which art, although it was not made with the directly religious purpose of becoming one with the gods, actually led to the realm of religion as one of its by-products—was similar to Shōyō's perception that it was not the direct purpose of art to make people more noble, but this came as a result of the role played by art. The idea of the union of good and beauty was not unique to Japanese aesthetics during the period of enlightenment. It derived from Western sources of thought on beauty.

In fact, the expression "aesthetics" as used in the West, which served as Japan's model, was not so old, having been coined by Baumgarten in the eighteenth century in Germany. Feeling the need to set up a science of aesthetics that would complement the study of the intellect with an inquiry into the sensuous cognition of feelings of pleasure, Baumgarten authored a work titled *Aesthetica* (part 1, 1750; part 2, 1788). According to his definition, aesthetics is "the science of sensory knowledge" and therefore is poor in objectivity. Compared to logic, it is "an inferior form of knowledge" *(gnoseologia infe-*

53. [Imamichi Tomonobu, ed., "Joron: Bi to wa Nani ka" (Introduction: What Is Beauty?), in *Kōza Bigaku,* vol. 1 (A Course on Aesthetics) (Tokyo: Tokyo Daigaku Shuppankyoku, 1984), pp. 2–3. The quotation comes from a very influential work that F. W. J. Schelling (1775–1854) wrote in 1802: *Bruno; or, On the Divine and Natural Principle of Things.* Ed.]

54. Imamichi Tomonobu, "Gaisetsu: Seiyō Bigaku no Nagare" (An Outline: Currents of Western Aesthetics), in *Kōza Bigaku,* vol. 1, p. 30. Takemiya Akira has also examined the relationship between Eros, Beauty, and Truth in Plato. "Eros loves and desires Beauty and Good." [See Takemiya Akira, "Erosu to Bi" (Eros and Beauty), in *Bigaku Shi Ronsō* (Collected Essays on the History of Aesthetics) (Tokyo: Keisō Shobō, 1983), p. 11.] Takemiya points out that "within love, which always tries to make 'good' its own, there is also included a desire for what is beautiful" (p. 23).

rior), "the art of the analog of reason" *(ars analogi rationis)*.[55] Moreover, the Latin word *"aesthetica"* was the translation of the Greek adjective *"aisthetiké"* (sensitive), which is based on the Greek noun *"aisthesis,"* meaning "sensibility," "feelings." Thus the etymological meaning of "aesthetics" is "the sensibility of feelings." When we look at the original meaning of the Greek word, and at Baumgarten's usage, then the Japanese translation should be something like "sensibility" *(kanseigaku)* or "sensitivity" *(kankakuron)*.[56]

Why in Japan did it become "the science of beauty" *(bigaku)*? Imamichi has suggested three reasons. First, the time when Nishi Amane studied in Holland—the second half of the nineteenth century —followed a period of hypersensitive conceptualizations of art and beauty on the part of the aesthetics of romanticism and idealism. Second, aesthetics had already broken away from the simple meaning of "sensitivity." Finally, "after the nineteenth century, the importance of beauty and art was much more perceptible"—and the same thing could be said of the reality of "the philosophical nature of aesthetic consciousness in Japan."[57] As an "extreme" example of the second point, Imamichi introduces Schelling, whom he compares to Nishi Amane. We can certainly agree with Imamichi on Nishi's awareness that the word and the concept of aesthetics, to which he was profoundly indebted, came from Baumgarten.[58] Nishi distorted the real meaning implied by Baumgarten, taking instead a position that privileged a view of art as the unified ground of truth, good, and beauty. To argue that the Japanese possessed a specific philosophy with regard to aesthetic consciousness, however, easily lends itself to the misunderstanding that the Japanese already had a value system expressed by the word "beauty" prior to the impact of Western civilization on Japan. We need to realize that the current use of the concept of beauty

55. Imamichi Tomonobu, "Joron," p. 3. [The *Aesthetica* of Alexander Gottlieb Baumgarten (1714–1762) begins with the following sentence: "Aesthetics (theory of the liberal arts, doctrine of inferior knowledge, art of beautiful thinking, art of the analog of reason) is the science of sensory knowledge." See A. G. Baumgarten, *Estetica* (Milan: Vita e Pensiero, 1993), p. 17. Ed.]

56. Ibid. See also Kobata Junzō, *Shinpan—Bi to Geijutsu no Ronri: Bigaku Nyūmon* (New Edition—Beauty and the Logic of Art: An Introduction to Aesthetics) (Tokyo: Keisō Shobō, 1986), pp. 6–7.

57. Imamichi Tomonobu, "Joron," pp. 3–4.

58. Nishi Amane, *Hyakugaku Renkan*, in Ōkubo Toshiaki, ed., *Nishi Amane Zenshū* (Collected Works of Nishi Amane) (Tokyo: Munetaka Shobō, 1971), vol. 4, p. 168.

in relation to artistic activities is actually a product of modernity, which was brought about by the discourse on beauty following the period of enlightenment.

Comparing with the French original Nakae Chōmin's *Ishi Bigaku* (The Aesthetics of Mr. V.), in which the Japanese word *"bigaku"* (literally "the science of beauty") was used for the first time to translate "aesthetics," we see that the original author E. Véron was not pleased with the commonly accepted definition of "aesthetics" as "the science of beauty."[59] Véron redefined it as "the science of beauty in art," and later he even dropped the word "beauty," concluding that it should be called "the study of the manifestations of artistic genius."[60] As Ida Shin'ya has pointed out, however, "the fact that Chōmin defended to the end the expression 'science of beauty' *(bigaku)* in his translation of 'aesthetics' means that he did not support Véron's definition."[61] Chōmin's unwillingness to erase the character "beauty" *(bi)* from the Japanese word for "aesthetics" *(bigaku)* might have been motivated by the fact that the goal known as "beauty" was for Japan an indispensable sign of enlightenment. Even Nishi Amane, who in his *Hyaku-gaku Renkan* (Encyclopedia) had used the phrase "the discipline of good taste" *(kashuron)* as the Japanese translation of "aesthetics," argued that aesthetics is "the science of beauty,"[62] clearly indicating that it is the science in charge of beauty. Shōyō stated that without a knowledge of beauty artists would lose their sense of direction. At that time, an understanding of what constitutes beauty was deemed necessary in order to perceive the direction that all of Japan, not just its artists, was taking.

In the first installment of my series of articles titled "The Landscape of Enlightenment," I did not start from any specific definition of "enlightenment" as the reader might have expected from the title of the series. Instead I inquired about the values sought by people

59. Véron, *L'Esthétique*, p. 114.

60. Ibid., p. 129. For the Japanese translation see *Nakae Chōmin Zenshū* (Collected Works of Nakae Chōmin), vol. 2 (Tokyo: Iwanami Shoten, 1984), p. 157.

61. Ida Shin'ya, "Kaidai" (Introduction), in *Nakae Chōmin Zenshū*, vol. 3, p. 434.

62. Ōkubo Toshiaki, *Nishi Amane Zenshū*, vol. 4, p. 168. Under the heading of *"kashuron"* Nishi argues that "the three elements of truth, good, and beauty" are "the goals of philosophy" and that "knowledge requires truth, action requires good, thought requires beauty," thus defining "the discipline of good taste" *(kashuron)* as "what makes thought beautiful." Nishi included the set "truth/good/beauty" in the category of "philosophy" (ibid.).

whose names were associated with the process of civilization, since I believed that it might be proper to follow a methodology which explores the mentality of "enlightenment." My analysis focused on the life of those associated with this process as well as the traditional value system they discarded.

I applied the same methodology to the debate on beauty. In order to clarify the meaning of beauty during the enlightenment period, rather than defining "beauty" I tried to talk about what the intellectuals of that time pursued under the name of beauty. The enlightenment's mentality, which itself developed around the axis of translations, required me to use such a methodology.[63]

We should not be too critical of the "lovely" goal known as beauty that Japan sought during the enlightenment period; or the intellectuals' desire to link the novel, which used to be considered a pleasant entertainment, or a form of play, to the new concept of "art"; or the act of searching for beauty. We should not condemn Meiji intellectuals as unwise for discarding traditional values as a result of having been poisoned by a progressive view of history. At least we should acknowledge their determination. Longing for beauty during the age of enlightenment was a movement indicating a longing for a society that was fit to be called "civilized" . . . a better society . . . a more "beautiful" society.

63. If I may use the terminology "cassette effect" employed by Yanabu Akira, it would be like inquiring about the effects derived from listening to a cassette rather than talking about its content.

2
Japan as Art Museum
Okakura Tenshin and Fenollosa

KARATANI KŌJIN

1

The modernization of Japan during the Meiji period was basically a process of westernization that extended not only to the juridical system but also to cultural policies and the university system, to Chinese medicine and literature in Chinese (both of which had been rejected since the Edo period), and to national literature and Buddhism. That all these disciplines were able to survive is due only to their reorganization into Western categories of knowledge. Even if people later began to search for marks of local distinction, this process took place within a Western framework. And yet there was an exception, namely art. The Tokyo School of Fine Arts, for example, founded in 1888, revolved from the beginning around Japanese and Eastern arts—a tendency that only changed later under the pressure of the Western school. The difference becomes clear when we consider that the Tokyo School of Music did not include Eastern music at the start.

This does not mean, however, that only art was able to escape the process of westernization. The peculiar position of the field of art was actually brought about by an American, Ernest Fenollosa (1853–1908), who came to Japan in 1877 as an instructor of philosophy in order to teach Spencer's theory of social evolution and Hegel's philosophy. During his stay in Japan, Fenollosa found values in Japanese art that transcended those of the modern West. He accorded a great meaning to Japanese and Eastern arts, which he deemed superior to

From Karatani Kōjin, "Bijutsukan to Shite no Nihon," *Hihyō Kūkan* (Critical Space) 2(1) (1994):59–75.

the contemporary realistic trends in Western painting. At the same
time, Fenollosa provided a historical classification and systematization
of the Japanese arts. To this end he was helped by the young
Okakura Tenshin (1861–1913), whose English skills were outstand-
ing. The establishment of the Tokyo School of Fine Arts centered on
Fenollosa and Okakura; the latter would later become a bureaucrat
in cultural matters. As a result of this cooperation, the "traditionalist
school" took a dominant position.

This allegedly traditional art, however, was nothing but the dis-
covery of Fenollosa. Here it is important to note that, first of all,
Fenollosa introduced the notion of looking at Japanese art as "art."
Art cannot exist apart from something that makes it art or, to say it
differently, without a discourse on art. Although up until then Japa-
nese art did in fact exist, the process of perceiving it as "art" was actu-
ally the result of Fenollosa's activities. Moreover, Fenollosa and Oka-
kura thought it was essential to establish a school of fine arts and a
museum. In fact, both school and museum were founded in the same
year of the promulgation of the constitution and the opening of the
Imperial Diet. If we leave aside the "content" of the art school and
the museum, their form was modeled after the systems of the modern
West. Paradoxically we could say that the "traditionalist school," by
fervently propelling such systems, was actually the most modernistic
school of westernization.

A second key element is the fact that traditional art was discov-
ered by Westerners who were trying to "overcome" Western moder-
nity. In support of this we must point to the following evidence.
Fenollosa and Okakura Tenshin were not the only persons responsi-
ble for making Japanese and Eastern arts the focus of the art school.
Among Japanese products, most of the goods exported to the West
during those years were art objects. Prior to the Meiji period Japa-
nese paintings had already had a profound influence on Western im-
pressionism. Vincent van Gogh (1853–1890) repeatedly pointed out
in his letters that he "wanted to see things like a Japanese." For Euro-
peans, therefore, Japan meant "art" more than anything else—in con-
trast to the views on Indian philosophy and Chinese Confucianism
that the German romantics and members of the French enlightenment
respectively held as new logical and ethical principles.

As Oscar Wilde (1854–1900) pointed out, Japan was from the
beginning an aesthetic fiction. Even before anyone had speculated
what "Japanese art" was about, Japan itself came to be perceived as

an aesthetic object domestically and abroad. In a sense, the nationalistic trend of privileging the aesthetic side of Japan over the logical and ethical sides (which derived from India and China) had begun with the National Learning movement of the Edo period. This, however, was not something specific to Japan. Generally speaking, nationalisms develop from an aesthetic consciousness, since they are grounded in an emotional and physical community (an imaginary community), not in a logical or ethical one. In most cases, however, this process ends at the level of self-consciousness, as we see in the case of Japan's National Learning, whose foundations were grounded in classical literature. To put it concretely, the Japanese classics could not be read abroad.

In the instance of art, however, this was not the case, since it achieved—to use a Hegelian term—"the recognition of the other." In other words, Japanese paintings were already acknowledged as commodities prior to Fenollosa and from a different perspective than his. Fenollosa ignored the esteem accorded to Japanese paintings by the impressionist school, for example, seeing instead in the lines of clear contours their main characteristic. At the same time, he encouraged painters to repeat the clarity of clear delineation in their works. In fact, the "Haziness School" was having a great success in European markets. This is one reason behind Fenollosa's quick loss of influence when compared to Okakura's. Whether promoted by Fenollosa or by the impressionists, however, Japanese art came to be appreciated as a sort of vanguard among Western arts.

The fact that the "traditionalist school" held a dominant position in the Japanese art world of the Meiji period is filled with significance. It was not simply an issue related to the past and its importance. Ten years had not yet passed since the Tokyo School of Fine Arts was established when the "Western school," which Okakura had dismissed, replaced the "traditionalists." The Western school was destined to be plagued by a basic paradox. What in Japan looked avantgardist and antitraditionalist was actually seen in the West as simple reproductions. A regression to the "traditionalist school" was actually perceived as an avant-gardist move—a problem that continues to be felt to this very day. The "Western school," for example, which is revered in Japan, is not credited with any value in the West. Moreover, the artists who are in some fashion appreciated in the West are those who look back to the "traditionalist school," since they are perceived as the most avant-gardist.

The same argument can be made with regard to other disciplines as well. In the 1930s, for example, the literary counterpart of art's "traditionalist school" dominated the literary scene. Writers such as Tanizaki Jun'ichirō (1886–1965), Kawabata Yasunari (1899–1972), and Mishima Yukio (1925–1970) were seen in the West as "traditionalists," whereas originally they were modernist members of the "Western school." We could say that at a certain point in their careers these writers turned toward tradition not because of any sense of nostalgia but rather because they thought this was the thing to do in order to be perceived as the "avant-garde." "Japan" as an aesthetic object was the result of the discursive space relegated to art. The specificity that such discourse attributed to Japanese art during the Meiji period is the most important aspect of the discourse itself, as Okakura has shown in truly exemplary fashion.

2

Okakura must have learned a good deal about Hegelian philosophy from his teacher, Fenollosa. Unlike Fenollosa, however, he realized that art is based first of all on a discursive space and is filled with political meaning—a difference that eventually developed into a breakdown between Okakura and Fenollosa. Undoubtedly Fenollosa was not as Eurocentric as Hegel. His high praise of Japanese art attests to Fenollosa's conscious denial of any bias in favor of the West. His point of view was cosmopolitan. In his *Outline History of East Asiatic Art*, for example, Fenollosa dealt with Japanese art as part of a broader scheme going back to the arts of ancient Greece and the Pacific. The discovery of Greek traces in ancient Japanese art must have been for Fenollosa a reason for great joy. Okakura, however, probably perceived in Fenollosa's cosmopolitanism some hidden form of Eurocentrism. As a result, Okakura was moved to consider the "East" as a single, united world.

In 1902, during a stay in India right before the outbreak of the Russo-Japanese War, Okakura Tenshin wrote the following words in a book originally published in English, *The Ideals of the East:*

Asia is one. The Himalayas divide, only to accentuate, two mighty civilisations, the Chinese with its communism of Confucius, and the Indian with its individualism of the Vedas. But not even the snowy barriers can interrupt for one moment that broad expanse of love for the Ultimate and Universal, which is the common thought-inheritance of every

Asiatic race, enabling them to produce all the great religions of the world, and distinguishing them from those maritime peoples of the Mediterranean and the Baltic, who love to dwell on the Particular, and to search out the means, not the end, of life.[1]

This opening paragraph became a slogan of the pan-Asianism that later spread as far as the Arabic world thanks to the work of Tagore.[2] Okakura himself supported the Bengal movement for independence. Consequently, this book was profoundly informed with political meaning. Or it might be better to say that Okakura realized that art exists as a discursive space and its true nature is political.

In art, Okakura saw the oneness of the East or, we could say, he discovered such an "Orient." His vision of world history in aesthetic terms derives from the Hegelian philosophy he learned from Fenollosa. The word "ideal" in the title *The Ideals of the East* was not a goal to be reached but something that already existed, as in the case of Hegel's Idea *(Idee)*. According to Hegel, history is the stage for the self-actualization of ideas, while art is the form taken by ideas in their sensuous concretizations. Rather than positing aesthetics as part of philosophy, Hegel considered philosophy aesthetic. Okakura was Hegelian in the sense that he grasped the history of Asia as art history seen as the self-actualization of the idea. In an indirect way, however, Okakura reversed Hegel's Eurocentrism and also targeted Hegel's dialectics. In Hegel, contradiction plays an important role since it engenders struggle and causes history to develop. In contrast, Okakura brought into play the Indian philosophical notion of Advaitism (nonduality), or the oneness of what is different and manifold. As a result, the expression "Asia is one" came about.

In Hegel's *Philosophy of History*, India is perceived as the initial stage in which the spirit adheres to an abstract identity and from which no development derives. Development comes about as a result of contradiction, conflict, struggle. In a sense, we could argue that the so-called phenomenon of the Asian stagnation is actually the result of Hegel's explanation. Okakura denied Hegel's dialectics, positing instead an original identity shared by what is contradictory. This is not a simple identity but rather an identity that allows variety. To use

1. [Kakuzō Okakura, *The Ideals of the East with Special Reference to the Art of Japan* (London: John Murray, 1903), p. 1. Ed.]
2. [Rabindranath Tagore (1861–1941), a major Bengali poet, won the Nobel Prize for literature in 1913, its first award to an Asian. Ed.]

Okakura's words, this identity is "love"—an idea close to what the philosopher Nishida Kitarō (1870–1945)[3] later called the "absolutely contradictory self-identity" *(zettai mujunteki jiko dōitsu)*. In the 1930s Nishida followed the same logic in order to critique Hegel's dialectics and, at the same time, to give a philosophical foundation to the "Greater East Asia Coprosperity Sphere." Soon after, Okakura's book, which had only recently been translated into Japanese, entered the spotlight as a forerunner in the debate on "overcoming modernity." This use of Okakura's book was unrelated to the author's intentions, however, and it has given Okakura a bad name since the end of World War II.

And yet the oneness of the East was only possible as the identity of the Orient resulting from a process of colonization on the part of the great Western powers—a reality that was painfully known to Okakura. The "ideals of the East" did not exist; the "East" was an ideal that had to be uncovered from the standpoint of art. In fact, unlike Western Europe, the oneness of the East could not be posited from a political or religious point of view. Moreover, Okakura believed that art was the only sphere in which the East could compete with the West. Unlike Fenollosa's aestheticism, however, the aestheticism we find in Okakura's book clearly possesses a political aim.

Okakura's position notwithstanding, the Japanese victory in the Russo-Japanese War (1904) was made possible by the civilization imported from the West. There was nothing aesthetic about it; indeed it marked the exact opposite of "the ideals of the East." In *The Book of Tea,* for example, which Okakura wrote in Boston after the Japanese war with Russia, we read:

> The Westerner was wont to regard Japan as barbarous while she indulged in the gentle arts of peace; he calls her civilized since she began to commit wholesale slaughter on Manchurian battlefields. . . . Fain would we remain barbarians, if our claim to civilisation were to be based on the gruesome glory of war. Fain would we await the time when due respect shall be paid to our arts and ideals. . . .[4]
>
> The beginning of the twentieth century would have been spared the spectacle of sanguinary warfare if Russia had condescended to know Japan better. What dire consequences to humanity lie in the contemptuous ignoring of Eastern problems! European imperialism, which

3. [See Chapter 18. Ed.]
4. [Kakuzō Okakura, *The Book of Tea* (New York: Fox Duffield, 1906), pp. 7–8. Ed.]

does not disdain to raise the absurd cry of the Yellow Peril, fails to realise that Asia may also awaken to the cruel sense of the White Disaster. You may laugh at us for having "too much tea," but may we not suspect that you of the West have "no tea" in your constitution?

Let us stop the continents from hurling epigrams to each other, and be sadder if not wiser by the mutual gain of half a hemisphere. We have developed along different lines, but there is no reason why one should not supplement the other. You have gained expansion at the cost of restlessness; we have created a harmony which is weak against aggression. Will you believe it?—the East is better off in some respects than the West![5]

Okakura ignored Japan's military victory, and he did not speak complacently of the "superiority of the East." Even if he had mentioned it, he might have been ignored. Notwithstanding what Okakura personally thought, and notwithstanding any possible inspiration that Japan's victory over Russia might have provided the populations of Asia and the Near East, the Japanese at that time were not particularly interested in such things. This was because the Japanese "have gained expansion at the cost of restlessness." Undoubtedly Okakura was disappointed, and his disappointment included the disappearance of the meaning that the word "art" had had up to that time. In fact, besides "art" Japan possessed other things worthy of being exported. It is interesting to note that while Fenollosa was traveling from Boston to Japan, Okakura was moving in exactly the opposite direction, leaving Japan in order to work at the Boston Museum of Fine Arts.

3

Okakura was not a nationalist in the narrow sense of the word, since he always kept the "East" in view. Unlike other nationalists who emphasized the uniqueness of Japan, Okakura frankly acknowledged the indebtedness of Japanese thought and religions to the Asian continent—basically, Indian philosophy in *The Ideals of the East* and Chinese Buddhism (Chan) in *The Book of Tea*. In addition, he uncovered the "great privilege" of Japan, that is, the preservation in the Japanese land of what historically had originated in India and China but had since disappeared in the lands of inception. Buddhism

5. [Ibid., pp. 11–12. Ed.]

had ceased to exist in India, for example, in the same way that Zen Buddhism had vanished from its birthplace, China. They all survived only in Japan, and the same could be said about art.

Okakura argued that Japan's "insular isolation" made her "the real repository of the trust of Asiatic thought and culture."[6] He later adds: "The history of Japanese art thus becomes the history of Asiatic ideals—the beach where each successive wave of Eastern thought has left its ripple of sand as it beat against the national consciousness."[7]

> Thus Japan is a museum of Asiatic civilisation; and yet more than a museum, because the singular genius of the race leads it to dwell on all phases of the ideals of the past, in that spirit of living Advaitism which welcomes the new without losing the old. The Shinto still adheres to his pre-Buddhistic rites of ancestor-worship; and the Buddhists themselves cling to each various school of religious development which has come in its natural order to enrich the soil.[8]

Analogously, the political scientist Maruyama Masao pointed out this as well but in a critical fashion.[9] Since in Japan—he argued— there are no principles acting as the coordinate axis of the various individual thoughts, all external cultures are accepted. Since there is no confrontation with such an axis, however, there cannot be development, and new things are simply introduced without pause. All possible foreign thoughts dwell together spatially. The same thing can be said with regard to art. Okakura, however, sees in such a "Japan" what he calls a "great privilege." "Japan" is not some kind of substance. It is something similar to what Nishida Kitarō calls "the place of nothingness" *(mu no basho)*—an empty vessel that takes the form of what is contained. What Okakura tells us is called "Advaitism" in Indian philosophy is not actually India but refers instead to this kind of Japanese space. In other words, he constructed "the history of the East" within the space of Japan.

Here we must pay attention to Okakura's recognition that "Japan is a museum of Asiatic civilisation." As I mentioned earlier, Okakura set himself the task of building in Japan a museum of Eastern art. If it could not be accomplished in Japan, it would not have mattered to do it in Boston. The problem was that the art museum was a modern

6. [Okakura, *The Ideals of the East*, p. 5. Ed.]
7. [Ibid., pp. 8–9. Ed.]
8. [Ibid., pp. 7–8. Ed.]
9. Maruyama Masao, *Nihon no Shisō* (Tokyo: Iwanami Shoten, 1961).

institution. This implied, first of all, the fact that a "knowledge" which used to be the monopoly of the privileged class was made public. Second, a temporary sequence was exhibited spatially or, conversely, a spatial configuration came to show a temporal development. In this sense, Hegel's philosophy (the system of world history) was a kind of museum. After the creation of the modern "art museum," history became an arena in which the question was whether such and such a thing could be included and where it should be located.

At the same time it is important to note that Okakura considered Japan itself to be an "art museum." Fenollosa's ability to uncover "Oriental art" in Japan resulted from the presence of Eastern art in a country, Japan, which was seen as an "art museum." His task was to classify and to arrange. It was not by chance that Japan's art history was first "discovered" by an American who was educated in Boston. Fenollosa's cosmopolitanism followed an Emersonian transcendentalism.[10] Although he saw himself as a "Westerner," Fenollosa never considered himself a European.

It should be observed that we cannot reduce the encounter of Fenollosa and Okakura simply to a meeting between West and East, as the general theory has it. As Okakura pointed out, if Japan, the island country of the Far East, was an "art museum," America also, the island country of the Far West (albeit a giant one), was a kind of "art museum." In fact, America seized the cultural hegemony of Europe through the museum. The New York Museum of Modern Art was founded in 1929, and in 1931 Philip Johnson (b. 1906) brought modern architecture to the museum with the exhibit "International Style: Architecture Since 1922." Furthermore, the curator Alfred Hamilton Barr (1902–1981) organized in 1936 the exhibit "Cubism and Abstract Art," followed by "Fantastic Art, Dada, Surrealism." Besides dividing the European currents of modern art into the systems of geometrical abstraction and expressionism, Barr helped synthesize the two systems in America's abstract expressionism, which came to stand at the frontier of modern art. Later critics—such as, foremost among them, Clement Greenberg (1906–1994)—came up with logical paradigms to explain modern art, creating a process in which

10. [Ralph Waldo Emerson (1803–1882), minister of Second Church of Boston, Unitarian (1829–1832), is well known for his transcendental philosophy and poetry. His house became the center of philosophical meetings among American intellectuals who were moved by the spirit of revolutionary Europe between 1830 and 1850. Ed.]

the use of different forms of such a logic led to the formation of new subparadigms that came to compete with each other. In addition to the art museum and the critics, the art market was added to the process. In this sense we can say that art all over the world was absorbed into the "art museum" known as America to the point of saturation.

Fenollosa, of course, could not have been aware of such later developments. We cannot, however, consider a simple accident the fact that Eastern art was created in the "art museum" known as Japan by the cooperation of Fenollosa and Okakura. Modern Japanese art, ostracizing Fenollosa and Okakura, looked ceaselessly toward Europe. Theoretical conflicts, however, did not take place in Japan. Basically speaking, the chain of uninterrupted imports continued, building what Maruyama Masao has called "the space of mixed residence" *(zakkyo kūkan)*. If Japanese artists decide to emphasize "Japanese-ness" *(Japonisme),* they will have to return to the concepts that Okakura pointed to, that is, the space of nothingness, Advaitism. Their work will then be classified and located in the American "art museum"—a reality that the meeting of Fenollosa and Okakura anticipated.

3

Fenollosa and Tsubouchi Shōyō

Kaneda Tamio

We find a reflective essay on the literary arts during the mid-Meiji years in Tsubouchi Shōyō's *Shōsetsu Shinzui* (The Essence of the Novel), which he published in its completed form in two volumes in 1886. Tsubouchi's essay played a major role in the composition, the following year, of Futabatei Shimei's *Ukigumo* (Drifting Clouds), credited as being the first modern novel in Japan. *The Essence of the Novel* had a revolutionary impact at the time on a literary scene that was still drawn toward a confused taste for the playful fiction of the previous age *(gesaku)*. Starting from a critique of the Japanese arts at a time when a body of critical thought on the modern novel—or, more broadly speaking, on modern arts in general—had not yet been established, Tsubouchi developed a critical theory based on modern views of the arts. This became a direct driving force behind the development of modern arts in Japan, as well as the beginning of aesthetic thought there.

During the middle years of the Meiji period, scholars took issue with the uncritical importation of Western thought that characterized the beginning of Meiji. This trend applied to aesthetics, as well, which finally started to take on a more localized meaning based on the historical reality of Japan. The aesthetics of mid-Meiji started from a critical examination of the artistic phenomena at the time. In other words, this was the period when the foundations were laid for a Japanese aesthetics grounded in an act of reflective self-

From Kaneda Tamio, "Fenorosa to Tsubouchi Shōyō," in Kaneda Tamio, *Nihon Kindai Bigaku Josetsu* (Introduction to Modern Japanese Aesthetics) (Kyoto: Hōritsu Bunka Sha, 1990), pp. 18–30.

consciousness. While writing *Drifting Clouds,* Futabatei Shimei was reading Russian works on aesthetics.[1] For a new art to be born it was necessary to create an aesthetic theory upon which to ground the art. The foundations of Japanese aesthetics were laid exactly during this period.

In this sense we might want to think of the major aesthetician's

1. Tomi Suzuki, *Narrating the Self: Fictions of Japanese Modernity* (Stanford: Stanford University Press, 1996), pp. 22–23 and p. 193, n. 38. "Shōyō's younger contemporary Futabatei Shimei (1864–1909), who was more deeply involved with the Western literary tradition as a result of his extensive study of nineteenth-century Russian literature and who had a firmer grasp of European poetics and metaphysics, was largely responsible for Shōyō's shift from 'the depiction of human feeling' to the 'realistic depiction of the truth of human feeling.' Futabatei's theoretical essay, 'Shōsetsu sōron' (General theory of the novel; April 1886), written and published at Shōyō's encouragement, presents Futabatei's view of the novel and of realism, based on his reading of the early works of Russian literary critic V. G. Belinsky (1811–1848). In this concise essay Futabatei explains the relationship between 'form' *(katachi, fōmu),* a 'contingent and variable phenomenon,' and 'idea' *(i, aidia),* an 'invariable, universal essence, which is usually hidden or deformed in contingent form.' Futabatei argues that art *(bijutsu),* through inspiration *(kandō, insupirēshon),* grasps the 'idea concealed in form' and gives it appropriate form so that people can appreciate these 'ideas' easily. Only the 'mimetic or realistic novel' *(mosha shōsetsu)* based on 'realism' *(shajitsushugi, riarizumu)* is the 'true novel' that can accomplish this task. Referring to Shōyō's advocacy of *mosha* in a slightly ironical tone, Futabatei states: 'We can not simply intone *mosha, mosha:* we must define it in order to advocate it. What is called *mosha* represents invisible ideas [*kyosō*] through the use of concrete forms *(jissō).'*

"Around the same period, in 1886, Futabatei translated two essays on aesthetics by Belinsky and M. N. Katkov, both of whom had a profound impact on Futabatei's own view of art and the novel. [*Note:* Futabatei Shimei, 'Bijutsu no Hongi' ('The Essence of Art'—a translation of Belinsky's *The Idea of Art,* 1841); unpublished during Futabatei's lifetime; published in 1928 in *Meiji bunka zenshū* and now included in *Futabatei Shimei zenshū* vol. 5, pp. 136–155. It is assumed that Futabatei started to translate it before 1886. See also Futabatei, 'Katokofu-shi bijutsu zokkai' ('Introduction to Katkov's Aesthetics,' May–June 1886—a translation of Katkov's 'Practical Significance of Art' from the *Anthology of Russian Literature*), in *Futabatei Shimei zenshū,* vol. 5, pp. 12–21.] In both translations the word *shinri* (truth) is used to define what 'art' should be. 'Art is the direct observation of truth; in other words, art is cognition through Form or Image [*keishō*].' Futabatei has replaced the term *i* (idea), which he used in 'Shōsetsu sōron,' with the term *shinri.* In an introductory article, 'Introduction to Katkov's Aesthetics' (Katokofu-shi bijutsu zokkai), which was written in a less metaphysical manner, Futabatei again stressed *shinri:* 'What should be sought from art is above all truth [*shinri*]. What should be sought from exquisite thought or art [*bimyō no shisō*] is the pursuit of the essential relation among various phenomena and an understanding and revelation of the mysterious world of life. . . . We should believe in the revelation of truth and should expect the artist, like the philosopher, to devote himself entirely to the service of truth.' "

role played by Ōnishi Sōzan,[2] who participated in the Waseda scholarly meetings together with Shōyō. Unlike Shōyō, who abandoned the idea of being an aesthetician, Ōnishi Sōzan, during the last years of his brief life, which ended at age thirty-six, turned his attention to a full-scale study of the most up-to-date European aesthetics. His aesthetic thought, which began with an essay, "Waka ni Shūkyō Nashi" ("There Is No Religion in *Waka*," in *Rikugō Zasshi*, 1887), progresses toward the psychological aesthetics of Europe and the United States. *Shinrigaku* (Psychology), by Motora Yūjirō,[3] the first Japanese psychologist, appeared in 1900. Several chapters of the book are dedicated to physiological and psychological aesthetics—thus displaying a debt to the aesthetic thought of Ōnishi Sōzan. According to a recent study, "Ōnishi Hajime as an Aesthetician" by Ijikata Teiichi,[4] Ōnishi's limited aesthetic production was interrupted by his premature death. When we consider Ōnishi's impact on later developments in the field of aesthetics, however, if we call Motora Yūjirō the founding father of psychology in Japan then we should call Ōnishi Sōzan the Japanese curtain-raiser of aesthetics.

We can safely say that Ōnishi laid the foundations of aesthetics in mid-Meiji. The critical activities of Toyama Masakazu (1848–1900) and Mori Ōgai (1862–1922)[5] had to come to terms with Ōnishi's aesthetic theory. If we take the late 1880s to be the limit of what I have called mid-Meiji, then Mori Ōgai's attention to aesthetic matters, beginning with *Shinbi Kōryō* (Outline of Aesthetics, 1899) and *Shinbi Shinsetsu* (New Theories on Aesthetics, 1900), would belong to late Meiji. The same thing could be said with regard to Takayama

2. [Ōnishi Hajime (1864–1900) took the name Sōzan from the name of the mountain of his native Okayama. Born in a Christian family, he studied in the departments of English and theology at Dōshisha University, graduating in 1884. He then specialized in philosophy at the University of Tokyo. A lecturer at Waseda University, Ōnishi traveled to Europe in 1898, studying at the universities of Jena, Leipzig, and Heidelberg. Forced to return to Japan in 1899 due to illness, he died of peritonitis the following year. See Chapter 5. Ed.]

3. [Motora Yūjirō (1858–1912), a graduate of Dōshisha University, established the Tokyo English School (present-day Aoyama Gakuin). In the United States he specialized in psychology at Boston University and at Johns Hopkins University. He later became a professor at Tokyo Imperial University. Ed.]

4. In Ijikata Teiichi, *Kindai Nihon Bungaku Hyōron Shi* (History of the Criticism of Modern Japanese Literature) (Tokyo: Hōsei Daigaku Shuppankyoku, 1973), pp. 102–114.

5. [See Chapter 4. Ed.]

Chogyū's[6] study of the history of aesthetics, *Kinsei Bigaku* (Modern Aesthetics), which appeared in 1899, slightly after Ōgai's *Outline of Aesthetics*. I refer to the late 1890s or late Meiji as the time when aesthetics blossomed. This was the period when specialists of aesthetics began to appear in Japan—as in the case of Takayama Chogyū, whom Mori Ōgai praised, not without a degree of sarcasm, as "the aesthetician almost unequalled in our country."[7] This period witnessed the development of aesthetic theory by scholars who belonged to Ōnishi Sōzan's group at Waseda, such as Shimamura Hōgetsu[8] and Kaneko Chikusui.[9] It was also the time when professional aestheticians began their career, as in the case of Ōtsuka Yasuji[10] of the University of Tokyo and Fukada Yasukazu[11] of the University of Kyoto. But let me return to the issue of Japanese aesthetics in the mid-Meiji period.

When we look back on the aesthetic thought of mid-Meiji, we realize the sterility of Japanese aesthetics in Meiji's early years. There might be some truth to Mori Ōgai's statement that "in 1883 the Ministry of Education commissioned Nakae Atsusuke[12] to translate the anti-

6. [Takayama Chogyū (1871–1902). See Chapter 7. Ed.]

7. This is the title of an article in which Ōgai responded to a critique of his *Shinbi Kōryō*. See *Mori Ōgai Zenshū*, vol. 21, p. 353.

8. [Shimamura Hōgetsu (1871–1918) graduated from Waseda University with a thesis titled "The Nature of Aesthetic Consciousness" (Shinbiteki Ishiki no Seishitsu wo Ronzu). Together with Takayama Chogyū, he was one of the most influential critics of his time. See Chapter 6. Ed.]

9. [Kaneko Chikusui (1870–1937) graduated from Tōkyō Senmon Gakkō (currently Waseda University) with a thesis titled "Poetic Genius" (Shisai Ron). He was a major member of the literary journal *Waseda Bungaku* (Waseda Literature). Kaneko studied in Germany from 1900 to 1903 at Heidelberg, Leipzig, and Berlin universities. He taught philosophy, psychology, and aesthetics at Waseda University. Ed.]

10. [Ōtsuka Yasuji (1868–1931), upon the recommendation of Ōnishi Hajime, lectured on aesthetics at Waseda University. After a period of study abroad in England, Germany, and Italy, he replaced Raphael von Koeber (1848–1923) at the University of Tokyo, becoming the first Japanese professor of aesthetics. See Chapter 9. Ed.]

11. [Fukada Yasukazu (1878–1928) spent three years in France and Germany as a foreign student and became professor of aesthetics at the University of Kyoto in 1910. See Chapter 17. Ed.]

12. [Nakae Chōmin (1847–1901) studied French in Nagasaki and in Edo at the school of Murakami Hidetoshi. As a member of the Iwakura mission to the United States and Europe, he stopped in France and studied in Paris and in Lyon. After an absence of seven years, he returned to Japan, opened his own school of French, and introduced French liberal thought. Known as the "Rousseau of the Orient," Nakae was extremely distinguished himself as a journalist, translator, writer, and political activist. Ed.]

scholarly rather than antimetaphysical *Aesthetics* of Véron and had it published. This translation had almost no impact on the literature and arts of our country."[13] In mid-Meiji the thought of Ernest F. Fenollosa (1853–1908),[14] who in 1878 was invited to lecture at the University of Tokyo, had a greater impact on the nurturing of aesthetic thought and views on the arts. For an outline of Fenollosa's basic ideas I refer to a lecture he gave to the Dragon Pond Society (Ryūchikai), which was preserved through the notes and Japanese translation of Ōmori Ichū (1844–1908) with the title "Bijutsu Shinsetsu" (The True Conception of the Fine Arts, 1882). While providing an important guide to the Japanese art world, which at the time was in a state of confusion, Fenollosa's lecture also had the opposite effect of deepening the sense of perplexity of artists who were searching for new directions for Japanese art, following the importation from Europe of the concept of "art." One of the achievements of Fenollosa's lecture was the assertion that the self should guide the direction of the new Meiji art. In this sense Fenollosa's teaching was influential in establishing a modern view of art. Besides drawing attention to the ancient traditional arts of Japan, Fenollosa suggested ways to create a truly modern art by sweeping away the nonartistic forms of expression that had appeared in Japan since the Edo period. In this regard, "The True Conception of the Fine Arts" had an immense influence on the art world of the time and was a driving force behind the establishment of the modern novel. Through the mediation of Tsubouchi Shōyō's *Essence of the Novel*, which inherited Fenollosa's thought on art, Fenollosa's lecture became the point of departure for the rapid development of aesthetic thinking in Japan.

Since we have only the Japanese version of Fenollosa's lecture, it is difficult to establish its degree of reliability with regard to Fenollosa's true intentions. Additionally, the lecture is not the product of rigorous thinking on aesthetics and, rather than an announcement of original views, it is no more than a simple, general essay on modern aesthetics. And yet it had what we might call a revolutionary power to influence the Japanese world of fine arts and arts in general, a world that was in a state of confusion. According to "The True Conception of the Fine

13. [Mori Ōgai, Preface to *Tsukikusa*, in *Ōgai Zenshū*, vol. 23, p. 299. The reader should not take this comment too literally since it clearly indicates Mori Ōgai's partisanship in the matter. Ed.]

14. [See Chapter 2. Ed.]

Arts," the arts do not exist for any practical purpose. "Ornamenta-
tion" is their first characteristic, while skill alone does not produce
art. Although the meaning of "ornamentation" is not necessarily clear,
we can infer from the fact that it was used in opposition to the
expression "necessary need" that it indicated the self-sufficiency
and autonomy of the work of art—thus differentiating it from the
mechanical arts, which were meant for an external, practical purpose.
At that time, the Japanese did not make a clear distinction between
liberal and mechanical arts or between fine and applied arts. Even in
Nakae Chōmin's *Ishi Bigaku* (The Aesthetics of Mr. V.), in which the
Japanese word *"bigaku"* was used for the first time to translate the
French term *"esthétique"* (aesthetics), different expressions were used
to render in Japanese the word "art," such as "skill" *(gijutsu)*, "liberal
art" *(geijutsu)*, "skillful art" *(gigei)*, and "ingenuous art" *(kōgei)*, with-
out ever indicating any specific difference in meaning. They were all
used as variations of the basic notion of "skill" *(gijutsu)*. It is unlikely
that in 1882 the distinction between practical skills and autonomous
arts was generally accepted. The reason might well be found in the
originally vague nature of the "Japanese arts." When we observe the
position of "art" in the daily life of the Japanese, we must note that
traditionally Japan's debates on art do not warrant the establishment
of a concept of autonomy separate from the practicality of the ap-
plied arts. In this sense, Japan's traditional arts were basically "living
arts," or arts related to daily life. Even in the art world, at that time
we find only playful fiction *(gesaku)*, which had a propensity more
for producing jokes than serious entertainment, or narratives *(yomi-
hon)* with an ethical purpose, such as promoting good and chastising
evil. This shortcoming was a major motivation behind Tsubouchi
Shōyō's *Essence of the Novel*. Fenollosa's theory of the individual and
autonomous nature of art—a theory that was taken for granted in
Europe—sounded extremely new to a people striving after moder-
nity. "The True Conception of the Fine Arts" states the following:
"Ornamentation pleases the heart. Its purpose is to elevate the spirit.
I will call this ornamentation 'the fine arts.' "[15]

A second characteristic of art, according to Fenollosa, is that even
if it gives joy to the heart, it is not a tool for producing pleasure.
Although the arts are not related to any direct use in practical life,

15. *Meiji Bunka Zenshū*, vol. 12: *Bungaku Geijutsu Hen*, p. 160.

they are not a "toy" that pleases the eye. Fenollosa stated that "the goodness of the fine arts is not to bring joy to people. It is because of their goodness that the fine arts give rise to joy."[16] The production of joy should not be considered the standard of artistic evaluation, since "it is clear that what gives joy has no effect whatsoever in differentiating art from non-art."[17] In this type of statement we see the presence of the aesthetic thought of German idealism, rather than any physiological or psychological aesthetics. In other words, joy in art is a qualitative rather than a quantitative problem. Since joy does not contain prescriptions about the content of art, we cannot use it for inquiries into the essential meaning of art. Fenollosa was addressing artists and thinkers who were caught up in the joy given to them by the arts with no distinction as to the kind of joy—whether they were feelings of pleasure deriving from indecent scenes, or the inspiration arising from ethical works, or the curiosity elicited by a new artistic product, or the admiration for the perfect resemblance of the object portrayed thanks to a rigorous technical training. These were artists and thinkers who were groping after a new art without possessing the notion of "art." We can easily imagine how difficult it was for them to understand Fenollosa's ideas and how revolutionary the concept of the "purity" of modern art must have sounded. At the same time, Fenollosa's lecture must have made them painfully aware of the need to conduct aesthetic research into the nature of art. We can say, as well, that the tendency toward idealism we find in Fenollosa's thought was also influential in promoting a critical activity that was later pursued by scholars such as Mori Ōgai and his designating Eduard von Hartmann's aesthetics "the standard aesthetics" of the country.[18]

A third stipulation of Fenollosa with regard to the arts was that the analogy between sign and real object of representation is not an intrinsic characteristic of art but is mediated by the "ideas" of the fine arts to which the arts give expression. That is to say, the standard for distinguishing art from non-art is provided by the presence or absence of the "ideas" of art. By "ideas" of art Fenollosa probably meant what is known in European aesthetics as "aesthetic concepts,"

16. Ibid., p. 161.

17. Ibid.

18. [Eduard von Hartmann (1842–1906) is the author of *Philosophie des Unbewussten* (Philosophy of the Unconscious, 1869) and *Philosophie des Schönen* (Philosophy of Beauty, 1887). Ed.]

rather than directly referring to conceptual contents or ideology. This third stipulation, the one most deeply related to the essence of art, must have fostered enormous feelings of perplexity among the Japanese, who at that time had almost no grounding in European aesthetic thought. "Idea" was not a concept to be grasped on the basis of logic. The "idea" that appears in the fine arts is a kind of imaginative concept expressed only through the imagination. The notion that art was the expression of "aesthetic concepts" had already been developed by German idealism a century earlier. "Ideas" in art are not products of a simply subjective fancy, nor do they derive simply from an objective reproduction of nature. As Fenollosa stated in his lecture: "Take a look at Kōrin's painting of a plum tree.[19] Would you take it for a natural plum tree? Of course not! And yet you would not change a bit of it. That is because the painting possesses the idea of the plum."[20] According to Fenollosa, attention should be diverted from the sketches of Maruyama Ōkyo,[21] who was inspired by European realism, because of their lack of "idea." Fenollosa's lecture gave high marks to Japan's traditional arts, which differed from the realistic paintings of the nineteenth century. In the art world of Japan during the tide of cultural Europeanization, traditional arts were at odds with the tendency toward the development of a new realistic art. Fenollosa's "True Conception of the Fine Arts" redirected the course of Japanese art in ways that were difficult to fathom at the time. The direction taken by the post-Fenollosa art movements of the late 1880s became increasingly confused. It would be sufficient to examine, for example, Ōnishi Sōzan's "Waga Kuni Bijutsu no Mondai" (Problems of Art in Our Country), or the lecture that Toyama Masakazu gave to the Meiji Art Association, "Nihon Kaiga no Mirai" (The Future of Japanese Painting), or Mori Ōgai's response to Toyama's lecture.

"The True Conception of the Fine Arts" provided an opportunity for the budding of Japanese aesthetics inasmuch as, by evaluating the traditional arts of Japan highly, it awakened among the Japanese a

19. [Ogata Kōrin (1658–1716), a renowned painter of the mid-Edo period, established the Rinpa school of painting. Ed.]

20. *Meiji Bunka Zenshū*, vol. 12: *Bungaku Geijutsu Hen,* p. 163.

21. [Maruyama Ōkyo (1733–1795), a painter of the mid-Edo period, produced realistic paintings—natural landscapes, flowers, birds—that were highly influenced by European mimetic theories of art. Ed.]

desire to see with their own eyes and to think with their own heads. For example, we might say that Futabatei Shimei in an 1885–1886 translation titled "Berinskī Geijutsu Ron" (Belinsky's Views on Art) adopted the view that art is "the design of the imagination" because of the text's close connection with Fenollosa's aesthetic thought. The sentence in Fenollosa's lecture that states, "I will call the power to produce ideas the might of design," was probably the motivation behind Futabatei's admiration of Belinsky's work on art. We can guess the reason why Futabatei's translation was not published at the time, and why it was entrusted to Tsubouchi Shōyō instead, but we cannot provide a definitive explanation. We can only regret the fact that had "Belinsky's Views on Art" been published in conjunction with Tsubouchi Shōyō's *Essence of the Novel,* the history of aesthetics during the Meiji period and at the present time might have taken a different direction.

We cannot deny that Fenollosa's aesthetic theory presents a few inconsistencies. It would be hard to maintain that if the notion of "idea" shapes the essence of art, such a notion can only be found in Eastern art or in forms of Japanese traditional arts that differ from the realistic mode of Western paintings. It should be explained, rather, as a specific expressive form that exceeds the particularity of any specific artistic expression. Fenollosa rejected the paintings of the literati,[22] which he claimed poisoned art, praising instead the achievements of Sesshū[23] and the Kanō and Rinpa schools. Fenollosa argued that "at the beginning, when the literati movement first emerged in China, the notion of 'idea' was present in their paintings. In today's versions, however, all that is left is the mere transmission of the external form, thus making paintings nothing more than an attendant of literature."[24] From this perspective, the aim of "The True Conception of the Fine Arts" should be seen in its practical educational role of guiding the promotion of the artists' creative activity by stressing the original excellence of Japanese paintings, rather than serving the reader as a treatise on aesthetic theory. Moreover, in order to truly promote Japanese art, Fenollosa supported first of all the foundation

22. [Here the word *"bunjinga"* refers to the "Southern school" *(nanga)* of painting exemplified by the works of Ike no Taiga (1723–1776) and Yosa Buson (1716–1783). Ed.]

23. [Sesshū (1420–1506), painter of the late Muromachi period. Ed.]

24. *Meiji Bunka Zenshū,* vol. 12: *Bungaku Geijutsu Hen,* p. 172.

of an art school—an idea that led in 1886 to a survey on art education in Europe, conducted together with Okakura Kakuzō,[25] and to the establishment in 1888 of the Tokyo School of Fine Arts. In other words, rather than considering Fenollosa's lecture an introduction of Western aesthetics to Japan or a scientific discussion of the essence of art, we should see it as a guide for the production of a new art aimed at the Japanese art world in a moment of great confusion—a wake-up call to the artists of the time.

"The True Conception of the Fine Arts" had an epochal impact on the Japanese artistic scene of the period. At the same time, it planted the seeds of aesthetic investigation into the issues of beauty and art in Meiji Japan. In its critique of the status of the Japanese literary arts, as well as its emphasis on the need to produce more novels based on European views of art, Tsubouchi Shōyō's *Essence of the Novel* is indebted to Fenollosa's warnings. The Europeanization of the Japanese arts actually ran counter to Fenollosa's intentions. And yet, basically speaking, *The Essence of the Novel* is not at odds with the views on the literary arts expressed in "The True Conception of the Fine Arts."

Tsubouchi Shōyō's *Essence of the Novel* is structured around three axes. The first is related to the author's university education in English literature. Yanagida Izumi gives the following explanation:

> The motive behind the composition of *The Essence of the Novel* was the author's reaction to a bad grade he received on an exam in 1881 from the instructor of English literature, Professor William Addison Houghton (1852–1917), when Shōyō was a student in the department of literature at the University of Tokyo. Shōyō was asked to give his critique of the character of Queen Gertrude in *Hamlet*. Without giving the matter much thought, Shōyō offered a moralistic explanation based on standards used to judge Eastern literatures. As a result, he was given a poor grade and was for the first time awakened to the differences between Eastern and Western literatures. This prompted Shōyō to embark on an extensive reading of Western literary works in order to grasp the literary concepts used in Western criticism. Later he summarized the results of his readings by concentrating on the genre of "novels," and he produced *The Essence of the Novel*.[26]

25. [Okakura Kakuzō (or Tenshin) (1862–1913) became president of the school and later worked as a staff member of the Museum of Fine Arts in Boston. Ed.]

26. See the explanation appended to Tsubouchi Shōyō, *Shōsetsu Shinzui*, Iwanami Bunko, p. 6.

There might be some truth to this explanation. In those days, the Japanese fiction scene was dominated by narratives with an ethical purpose (the promotion of good and the chastising of evil) and by playful fiction for popular amusement. Tsubouchi wrote with the purpose of establishing a theory for the writing of modern novels based on European literary thought at a time when the country's artistic consciousness was rather weak.

When I say "Western literary criticism," I am not referring to some dependable and established work. Shōyō depended mostly on his knowledge and education in English literature, or, in order to supplement his own views and clarify them, he relied on quotations from Kikuchi Dairoku's translation, "Shūji Oyobi Kabun" (Rhetoric and Belles Lettres).[27] Moreover, his casual perusal of Fenollosa's "True Conception of the Fine Arts" also greatly influenced *The Essence of the Novel*. Here the second axis of Shōyō's work comes into view— its adaptation of the literary views expressed in Fenollosa's lecture. Although Shōyō did not spell out the name of the "learned man from America" that he mentioned on the first page of *The Essence of the Novel*, he was of course referring to Fenollosa. The provision about the purposelessness of the arts—that they are not practical endeavors and, therefore, do not possess any specific purpose—was basically the same as the one put forth by Fenollosa. Tsubouchi Shōyō formulated the notion of the self-sufficiency and purposelessness of the arts as an objection to Fenollosa's statement that the arts "have as their purpose to please the human heart and to elevate the spirit."[28] "This is the influence of nature," Shōyō argued, "not the 'purpose' of art."[29] Despite this critique, Shōyō must have sufficiently understood the real meaning behind Fenollosa's provision that the fine arts are not aimed at any specific purpose. From the statement Fenollosa made on the issue of joy—specifically, that far from setting standards for distinctions between art and non-art, joy is actually the result of art —he must have realized Fenollosa's intention to argue that the real

27. [Kikuchi Dairoku (1855–1917), mathematician, politician, and educator, studied in England and later became president of the University of Tokyo and minister of education. In May 1879 he published a translation of an anonymous article from Chambers' *Encyclopedia* introducing key aesthetic terms such as simplicity, taste, and elegance. Ed.]

28. *Meiji Bunka Zenshū*, vol. 12: *Bungaku Geijutsu Hen*, p. 160.

29. Tsubouchi Shōyō, *Shōsetsu Shinzui*, p. 27.

essence of the arts actually lies in the absence of any practical purpose. In fact we should say that the theory underlying *The Essence of the Novel* fully endorses Fenollosa's views. In other words, although Shōyō criticized the Japanese word used to translate "purpose" *(mokuteki),* he could not attack the aesthetic thought expressed in "The True Conception of the Fine Arts." As Shōyō himself states: "With regard to the meaning of art, with the exclusion of the word 'purpose' it is correct to argue that art pleases the human heart and elevates the spirit. To deny it would be a mistake. Although this might look like a trivial point, I have raised whatever little doubt I might have, and I have addressed my questions to the learned man."[30] From this attitude we can see that the Japanese of mid-Meiji correctly understood modern Western theories on the arts. We also understand that the point of departure of modern Japanese theories of art is found in Tsubouchi Shōyō's *Essence of the Novel.* Moreover, it was because of doubts regarding "trivial points" that the ideas in Shōyō's essay revolve around the ideas discernible in Fenollosa's lecture.

Shōyō's strong desire to develop his own art theory in opposition to "the learned man from America" can be seen in his previously mentioned attempt at critiquing Fenollosa. In order to do so, Shōyō needed to ground his understanding of art in something that would allow him to confront Western thought. He built a critical space from within Japan's traditional art theories: as a third axis of *The Essence of the Novel,* he grounded his arguments in Motoori Norinaga's *Genji Monogatari Tama no Ogushi* (The Jeweled Comb of The Tale of Genji).[31] In the section on the "Main Purpose" of *The Tale of Genji* Motoori states: "Several theories have been developed since ancient times with regard to the main purpose of this tale, but none of them actually investigates its meaning. They only offer explanations in the light of Confucian and Buddhist documents—an approach that goes against the author's true intention. Although occasionally there might be passages similar to Confucian and Buddhist writings, and points of agreement, the entire novel should not be reduced to these points. The general purpose of the tale is very different from the intention of

30. Ibid., p. 28.
31. [Motoori Norinaga (1730–1801) was a leading member of the National Learning movement (Kokugaku) and a major literary scholar of the mid-Edo period. Motoori drafted *Genji Monogatari Tama no Ogushi* in 1793 and published it in 1799. Ed.]

those writings. As I noted earlier, the purpose of *monogatari* is specific to the genre of *monogatari*."[32] The circuit of art and morality was the domain of didactic novels, so that Shōyō could ground his critique of playful fiction, in vogue at the time, on *The Tale of Genji* and on Motoori Norinaga. This art theory came to Shōyō from personal reflection, as well as from an environment that put him in touch with English literature and European views on art. If the modern novel was indeed supposed to be a pure creative activity free from practical purposes, then the morals of a novel could not be reduced simply to an ethical problem—"the Confucian and Buddhist ways" —but had to be supported by the notion of artistic value. Here the modern insight into art's intrinsic autonomy came to be established. When we consider that while learning modern art theory from "the learned man from America" Tsubouchi Shōyō was also inquiring into Japan's traditional theories of art, we must recognize that he was not simply absorbing Western thought, as was often the case with Japanese intellectuals in early Meiji, but he was also developing a new art theory on his own.

I have already mentioned that Fenollosa's thought on the arts does not bespeak a clearly structured modern aesthetics. In particular, his disavowal of the paintings in the literary artist's style was grounded in the problem of the domination exercised by the literariness of the arts. As Fenollosa stated: "In literature language should indicate meaning or thought; it cannot describe the purpose of painting. If literature dominates over painting, painting inevitably wanes."[33] Here Fenollosa pointed out differences between painting and the literary arts, which are both fine arts, but belong to different genres. Notwithstanding Fenollosa's acknowledgment that "the idea of poetry is not necessarily the same as the idea of painting,"[34] he did not clearly explain the difference between the literary arts and the fine arts. We might interpret such a difference by considering the literary arts expressions of individual thought. Moreover, the Japanese translation of Fenollosa's notion of "idea" led to the general trend of interpreting the world of artistic expression as a form of ideology. In a lecture delivered in 1890 and titled "Nihon Kaiga no Mirai" (The

32. *Motoori Norinaga Zenshū* (Collected Works of Motoori Norinaga), vol. 4 (Tokyo: Chikuma Shobō, 1969), p. 183.
 33. *Meiji Bunka Zenshū*, vol. 12: *Bungaku Geijutsu Hen*, p. 171.
 34. Ibid.

Future of Japanese Painting), Toyama Masakazu emphasized that with
regard to the reform of subject matter in paintings, Japanese painters
should portray what he called "ideological paintings" (or "paintings
based on thought," *shisōga*). While suggesting new directions in
modern art, Toyama's belief that Japanese painters should turn their
attention to actual events and social problems, issues related to the
real world, was actually grounded in a mistaken understanding of
the essence of art. In reaction to this point of view Tsubouchi Shōyō
was able to grasp accurately the essence of modern European art.
Namely, he succeeded in clearly explaining the meaning of realism in
modern art. As Shōyō wrote: "Those who are writers of novels entrust
their personal will to the psychology of their characters. Although
writers deal with fictional characters, so long as they bring their char-
acters even briefly onto the scene, authors must regard them as beings
of a living world, and they must reproduce the sentiments of their
characters. Writers should avoid creating emotions of good and evil,
right and wrong, according to their own designs. Instead they should
bring themselves to act like spectators and reproduce human emotions
as they are."[35] Unlike Fenollosa who pointed out that there was no
need to take the trouble to learn the techniques of Western oil paint-
ings, Tsubouchi was able to grasp the fact that modern realistic art
had to be understood in conformity with the structure of art. Further-
more, Shōyō's grasp of the subject occupied a different dimension than
Toyama Masakazu's theory of simply introducing ideology in paint-
ing, thus allowing Shōyō to position his views on a truly artistic basis.
Moreover, Shōyō set up the practice of perceiving novels as examples
of the "fine arts" *(bijutsu)* or "arts" *(geijutsu)*. While quoting from
"the learned man from America" and saying that "intellectuals since
ancient times have argued that in general the purpose of literature is
to conduct a critique of life,"[36] Tsubouchi Shōyō did not reduce liter-
ature straightaway to ideology. Instead he grasped its meaning in
the structure of the emotional world expressed in the literary arts—a
task that the theory of Motoori Norinaga helped him perform. In
other words, he concentrated on the basic system that justifies the
classification of a work as "art" rather than the issue of the ideolog-
ical meaning of language.

35. Tsubouchi Shōyō, *Shōsetsu Shinzui*, pp. 61–62.
36. Ibid., p. 66.

Shōyō quoted the following sentence from Motoori Norinaga: "Since all *monogatari* describe what happens in the world and talk about the life of people and their hearts, by reading them readers naturally understand what is going on in the world and come to know human actions and the human heart. This is the first purpose that readers should have for reading *monogatari*."[37] Tsubouchi Shōyō might well have seen the original form of the Japanese novel in *The Tale of Genji* and thus was drawn to use this text as his example of a traditionally Japanese emotion-based view of art. In order to discuss theories of the modern novel, the author of *The Essence of the Novel* took his examples especially from the genre of "books for reading" *(yomihon)*, such as Kyokutei Bakin's *Satomi Hakkenden* (Satomi and the Eight Dogs),[38] and from the genres of "human sentiment" *(ninjō-bon)* and "domestic pieces" *(sewamono)*. This was quite natural if we recall that the modern novel had not yet emerged in Japan and that the literary scene with which Shōyō was acquainted was basically made of playful writings which derived from the traditional styles of the Edo period. A knowledge of English literature came to Shōyō as a result of his university education. In other words, in order to set up a modern theory of the novel based on European models, Shōyō had to look back upon Japan's traditional views on art. In this sense we must say that *The Essence of the Novel* had the power to awaken the Japanese to modern views on art. Of course, it can be pointed out that the traditional artistic spirit which goes back to Motoori Norinaga's theory of *mono no aware* indicates a conservative attitude with regard to the movement of the westernization and modernization of art. Unlike later essays on art such as Toyama Masakazu's work which were purely speculative, however, *The Essence of the Novel* carried with it, in large measure, the power to persuade the general public. We can certainly consider it an excellent example of aesthetic thinking at that time.

37. *Motoori Norinaga Zenshū*, vol. 4, p. 184; Tsubouchi Shōyō, *Shōsetsu Shinzui*, p. 69.
38. [Kyokutei or Takizawa Bakin (1767–1848) was perhaps the most popular writer during the late Edo period. Ed.]

4

Mori Ōgai and German Aesthetics

Bruno Lewin

The concept of the beautiful *(bi)* and work on the beautiful was not alien, of course, to ancient Japan; terms such as *mono no aware, okashi, yūgen, wabi, sui,* and the like (see Hisamatsu 1963) refer to aspects of the beautiful that were discovered and described in Japan's traditional literature. Yet the "science of the beautiful" *(bigaku)* as a philosophical discipline was, like so many other goods (whether material or otherwise), first transplanted from the West during the Meiji period. The impulses that originated in German aesthetics were at the forefront of this movement—after all, this science was first brought into the canon of philosophical subdisciplines by the Berliner A. G. Baumgarten (1717–1762) and has had a tradition in Germany ever since. It is a well-known fact that German aesthetics has been represented in Japan in a fairly broad way and with contemporary advocates since the end of the nineteenth century, thanks largely to Mori Ōgai (1862–1922). As a young military doctor he studied medicine in Germany from 1884 to 1888. There he became acquainted with the work of Eduard von Hartmann and later several of his contemporaries;[1] he tried to introduce their philosophy of the beautiful through various Japanese translations and summaries. In this essay I retrace

From Bruno Lewin, "Mori Ōgai und die Deutsche Ästhetik," *Japanstudien: Jahrbuch des Deutschen Instituts für Japanstudien der Philipp-Franz-von-Siebold-Stiftung* (Japanese Studies: Annals of the German Institute of Japanese Studies of the Philipp Franz von Siebold Foundation) 1 (1989):271–296.

1. [Karl Robert Eduard von Hartmann (1842–1906), German philosopher, synthesized the views of Schopenhauer, Kant, and Hegel into a doctrine of evolutionary history based on the conflict of unconscious will with unconscious reason. Among his works are *Philosophie des Unbewussten* (The Philosophy of the Unconscious, 1869), *Die Phänomenologie des sittlichen Bewusstseins* (The Phenomenology of Moral Consciousness, 1879), and *Die Religionen des Geistes* (The Religion of Spirit, 1882). Ed.]

this complex of issues that were widely recounted in Japan,[2] but only marginally treated in the West,[3] trying to put them into context.

Western aesthetics was first introduced in Japan by Nishi Amane (1829–1897),[4] one of the leading enlighteners of the early Meiji period, who had previously studied in Leiden from 1862 to 1865 and had taken up the positivistic doctrines of Comte and Mill. In the lectures he held upon his return—*Hyakuichi Shinron* (The New Theory of the Hundred and One; Kyoto, 1867 [*sic*]) and *Hyakugaku Renkan* (Encyclopedia; Tokyo, 1870)—he developed, in confrontation with orthodox Confucianism, a modern, positivistically oriented method of observation and the first modern system of sciences (see Havens 1970:92ff.). In *Hyakuichi Shinron* he introduced aesthetics as the "science of the good and beautiful" *(zenbigaku;* to be read *"esutechīki").* In *Hyakugaku Renkan* he positioned it as the "theory of good taste" *(kashuron),* a subdiscipline in his system of sciences. Shortly thereafter, supposedly in 1872,[5] he composed the first Japanese treatment of aesthetics, *Bimyōgaku Setsu* (Theory of Aesthetics), in which he initially defined aesthetics "as a branch of philosophy. It deals with the so-called fine arts and investigates their principles."[6] In four chapters Nishi discusses, first, the position of aesthetics compared to that of the other sciences such as ethics and jurisprudence; second, the relationship between the objectively beautiful and its subjective representation; third, types of the beautiful and its sensory apprehension; and, fourth, aesthetic perception *(bimyōgakujō no jō),* which he opposes to ethical experience *(dōtokujō no jō).*

In contrast to this *Theory of Aesthetics,* which existed only as a manuscript for almost thirty-five years before being published in 1907, another presentation of Western concepts of art was published and rapidly became well known: "Shūji Oyobi Kabun" (Rhetoric and Belles Lettres), an anonymous article from Chambers' *Encyclopedia.*

2. See the incisive work of Yamamoto (1960), Kanda (1961 and 1968), and Kobori (1973).

3. One finds a brief but truly informative account in Bowring (1979).

4. [See Chapter 1. Ed.]

5. The manuscript, which was designed as a lecture for the emperor, was first published in 1907 in a special issue of the magazine *Taiyō* simply dated January 13. Asō Yoshiteru assumes that the lecture took place in 1872 (*Kinsei Nihon Tetsugaku Shi,* Tokyo, 1942). Compare *Nishi Amane Zenshū* (1966), vol. 1, p. 669ff.

6. Compare *Nishi Amane Zenshū,* vol. 1, p. 477. In *Bimyō Gakusetsu* (Theory of Aesthetics) and *Bijutsu* (The Fine Arts), a distinction is clearly made between "science" *(gaku)* and "art" *(jutsu).* See Havens (1970:95).

This article, which appeared in an advance copy in 1879, was translated by Kikuchi Dairoku (1855–1917), who would later become famous as a mathematician.[7] Although "Rhetoric and Belles Lettres" deals primarily with literature, the first part brings up, by way of treating stylistic characteristics, a number of key aesthetic terms—such as "simplicity," "taste," and "elegance"—which were unknown to Japanese literary and aesthetic criticism and whose novelty was intensified by their terminological exoticism.[8] While "Shūji Oyobi Kabun," with its section on literary theory, aroused great interest among the younger literati of the Meiji period—Tsubouchi Shōyō cited the second part extensively in his *Shōsetsu Shinzui*[9]—the literary-aesthetic first part enriched the beginnings of modern art and literary theory in Japan.

Stronger impetus for a modern aesthetics came during those Meiji years via the influence of the American Ernest F. Fenollosa (1853–1908),[10] a graduate of Harvard University who taught philosophy, economics, and politics at the University of Tokyo from 1878 to 1890. Fenollosa became an important connoisseur and admirer of East Asian art and took up the cause of preserving and reviving traditional Japanese art. In his lecture "The True Conception of the Fine Arts" (Bijutsu Shinsetsu), which he presented in May 1882 before the Ryūchikai art society in Tokyo,[11] he presented himself the task of "articulating the urgency of reviving Japan's own art and the concepts of its revival" (*Meiji Bunka Zenshū*, vol. 12, p. 160a). His conception of art, which is presented in his later *Epochs of Chinese and Japanese Art* (1912), as well, is based on Hegel's idealist aesthetics and incor-

7. The translation was based on the tenth Brockhaus edition of Chambers' *Encyclopedia* by the brothers Robert and William Chambers, which was published in 1859–1868 and enjoyed great popularity in Japan during the early Meiji period. The Japanese version of the complete encyclopedia was published in 1884 under the title *Hyakka Zensho*.

8. The translator used a common method to indicate technical terminology: adding the foreign reading in Japanese phonetic syllabary at the side of Chinese characters. See the text in Yoshino (1927–1930:vol. 12, p. 4ff).

9. "On the Art of Poetry" (Shibun no Jutsu), ibid., p. 30ff., is found in *Shōsetsu Shinzui*, chap. 1 ("Shōsetsu Sōron"). See also the translation by Nanette Twine (n.d.:8).

10. [See Chapters 2 and 3. Ed.]

11. The printed version of the lecture was based on notes taken by Ōmori Ichū. It is included in *Meiji Bungaku Zenshū*, vol. 12, pp. 159–174.

porates certain elements of Spencer's evolutionary thought.[12] Leading contemporary advocates of Japanese arts, including Inoue Tetsujirō, Okakura Kakuzō (or Tenshin), Toyama Masakazu, and Tsubouchi Shōyō, assimilated Fenollosa's statements.

Shortly after this epoch-making lecture, whose evaluation of East Asian arts would be carried on by Fenollosa's famous student Okakura Kakuzō (1862–1913), the first complete Western presentation of aesthetics appeared in Japanese translation. This was *L'Esthétique* by the French writer Eugène Véron (1825–1889). It had already appeared in Paris in 1878 and was translated with the title *Ishi Bigaku* (The Aesthetics of Mr. V.) in two volumes (1883–1884) under the auspices of the Japanese Ministry of Culture in Tokyo. The translator was the Romance languages scholar Nakae Chōmin (1847–1901), who had studied in Paris.[13] Véron's *Aesthetics* does not create a theoretical framework of the discipline; rather, it is pragmatically constructed and was for that reason suited to Japanese readers of the day. In the first part he treats the basic concepts of aesthetics; in the second part, the specific arts. In any event, the work seems not to have had a strong resonance in Japan,[14] perhaps because its exposition relied too strongly on examples taken from French art, which was still not very well known.[15] Even the supplement containing a critical sketch of Plato's aesthetics—presented for the first time in Japan—did not draw much attention. Nevertheless, it can be said that *Ishi Bigaku* used the term *"bigaku"* for aesthetics for the first time in Japan.

"Shūji Oyobi Kabun" and "Bijutsu Shinsetsu" were the most influential contributions toward the development of a modern aesthetics in Japan and gave a new impetus to literary theory. The scholar of English literature Tsubouchi Shōyō (1859–1935) cited from both

12. [Herbert Spencer (1820–1903), English philosopher, applied to sociology the doctrine of evolution in *Principles of Psychology* (1855). His *System of Synthetic Philosophy* (1860) covers metaphysics, biology, psychology, sociology, and ethics. Ed.]

13. Nakae Chōmin, or Tokusuke, accompanied the Iwakura mission to Europe in 1871 and remained in Paris as an exchange student. Prior to his journey to Paris he had already been trained in French. Chōmin's thinking was influenced by positivism and materialism. After he returned to Japan, Chōmin was active as a politician and writer. He has not left behind any work on aesthetics.

14. [The reader should take this statement with caution, since it is directly related to Mori Ōgai's negative assessment of Véron's work. Ed.]

15. In the preface to *Tsukikusa,* a collection of critical essays, Mori Ōgai censured Véron's *Aesthetics* because of an alleged lack of metaphysical depth and scientificity. See *Ōgai Zenshū*, vol. 23, p. 299.

works in his pioneering outline of literary art *Shōsetsu Shinzui* (Essence of the Novel, 1885–1886). In this work he refers to literature as one of the "abstract arts" *(mukei no bijutsu)*[16] and critically attacks Fenollosa's assertion that art "pleases the senses and ennobles the character," defining these as mere side effects.[17] The scholar of Russian literature Futabatei Shimei (1864–1909), who was friends with Tsubouchi, contributed pioneering art-theoretical observations on Tsubouchi's text in his "General Theory of the Novel" (Shōsetsu Sōron, 1886). He relied primarily on Russian authors, above all Belinsky and Katkov, whose works he had translated (see Lewin 1955: 21ff.). So in this way, too, Hegelian idealist aesthetics entered the aesthetic writings of the Meiji period.

Among contemporary philosophical thinkers in Japan, Ōnishi Hajime (1864–1900),[18] who belonged to the idealist movement and was concerned primarily with questions of ethics and logic (see Brüll 1989:145ff), has earned a special place in the foundation of aesthetics in Japan. Starting in 1891 he held lectures on philosophy, including aesthetics, at the Tōkyō Senmon Gakkō (later Waseda University), and he published essays in which he explained European conceptions of art.[19] In 1897 he went to Germany to study in Leipzig and Jena with Eucken, Wundt, Liebmann, and Volkelt, but he had to return the following year because of illness. He can be seen as the mentor of critics and scholars like Shimamura Hōgetsu,[20] Tsunashima Ryōsen, and Ōtsuka Yasuji,[21] who established the science of aesthetics as a division of philosophy at Japanese universities. One can say that in the 1890s—at the beginning of which Ōnishi began to address the field of Western aesthetics and at the end of which the first Chair of

16. Only after the publication of *Shōsetsu Shinzui* did Tsubouchi take notice of Véron's *Aesthetics* in his essay "Bi to wa Nan zo ya" (What Is Beauty?), which according to the *Tsubouchi Shōyō Jiten* (1986) was published in the journal *Gakugei Zasshi* in September 1886. See Yamamoto (1960:38). [For an English translation of Tsubouchi's essay and a discussion of Tsubouchi's reception of Véron's *Aesthetics* see Marra, *Modern Japanese Aesthetics,* pp. 38–64. Ed.]

17. See "Bijutsu Shinsetsu" (*Meiji Bungaku Zenshū*, vol. 12, p. 160a); see also *Shōsetsu Shinzui,* chapters "Shōsetsu Sōron" and "Shōsetsu Hieki," translated by Twine (pp. 4 and 35).

18. [See Chapter 5. Ed.]

19. "Kokkei no Honsei," in *Rikugō Zasshi* (1891:3); "Shinbiteki Kankan wo Ronzu," in *Rikugō Zasshi* (1895:3); "Bigaku Shinsetsu Ippan," in *Waseda Bungaku* (1897:11 and 1899:2); "Kinsei Bigaku Shisō Ippan," in *Waseda Bungaku* (1898:1–2).

20. [See Chapter 6. Ed.]

21. [See Chapter 9. Ed.]

Aesthetics, occupied by Ōtsuka, was established at the University of Tokyo—the second phase of aesthetics began, namely, aesthetics as a university discipline. Mori Ōgai's work in the theory of the beautiful appears at the beginning of this phase.

Mori Ōgai (actually Mori Rintarō; Ōgai is his most frequently used pen name), an army doctor by trade and literatus by inclination, was an extremely well educated man and thoroughly acquainted with German aesthetics. He came from the city of Tsuwano (Shimane prefecture) from a family of doctors; his family belonged to the lower feudal nobility and was in service to the daimyo family Kamei.[22] Immediately after the Meiji restoration he was sent to Yōrōkan, a school of the aristocracy in Tsuwano, where he enjoyed a traditional Confucian education but was also instructed in Japanese ancient culture *(kokugaku)* and learned the rudiments of medicine and the military arts. He also took private lessons in Dutch, still the language of Western medicine in Japan, as he was to follow family tradition and become a doctor. In 1872, after the closure of the school as part of the dismantling of the feudal system (1871), Ōgai went from the province to the capital with his father who, as a personal physician of the daimyo, followed him to Tokyo. There he studied further in a private school and began learning German, which was beginning to replace Dutch as the language of medicine. For several years (1872–1876) he lived in the house of his relative Nishi Amane. By 1874 Ōgai could take the preliminary courses at the First Medical College of Tokyo (now the Faculty of Medicine of the University of Tokyo) and completed his medical studies at a very young age during the years 1877–1881 (claiming to be two years older). As his studies, directed by German doctors, were conducted primarily in German and with German instructional materials, Ōgai graduated with a solid knowledge of German. In December 1881 he was enlisted in the army as military doctor with the rank of lieutenant. He worked for the Ministry of War on hygiene and for the medical administration of the Prussian army; finally, in 1884, he was sent to Germany to study hygiene. There he remained until the summer of 1888, studying in Leipzig, Dresden, Munich, and Berlin. He attended courses by Franz Hoffmann, Max von Pettenkofer, and Robert Koch but also read works of German

22. For a portrayal of Ōgai's life and work see the monographs of J. Thomas Rimer (1975) and Richard J. Bowring (1979).

and world literature extensively and immersed himself in German philosophy. He reports on these influential years in Germany in his diary sketches;[23] many events and impressions were later worked into literary products.[24] Mori Ōgai remained in the service of the Japanese army as a military doctor and rose to the position of surgeon general and head of the Sanitation Division before taking his leave in 1916.

Upon his return from Germany, Mori Ōgai was one of the best-educated Japanese of his day in the field of literature, and he began his activities as a writer, which, in the course of his thirty years of production, alongside his considerable medical-professional publications, produced an astonishing body of work. This includes a distinguished number of translations,[25] primarily of German literature, but also contributions on literary and art theory. Ōgai used his time in Berlin above all for the study of philosophy.[26] In the strongly auto-

23. Originally written in Chinese, *Zaidokuki* (Record of a Stay in Germany) was later translated into Japanese by Ōgai himself with the title *Doitsu Nikki* (German Diary). Other diaries such as *Kōsei Nikki* (Diary of a Journey to the West by Sea), *Kantō Nichijō* (Diary of My Return to the East), and *Taimu Nikki* (Diary of My Duties in the Army), all written in those years, were in *kanbun* as well—a language that Ōgai privileged when recording news and marginalia.

24. As in the novellas "Maihime" (The Danseuse, 1890), "Utakata no Ki" (Wave Foam, 1890), "Fumizukai" (The Messenger, 1891), and "Mōsō" (Illusions, 1911). See the German translations by W. Schamoni, *Mori Ōgai: Im Umbau* (Frankfurt, 1989).

25. For an overview of Ōgai's translations of poetry, prose, and drama see Bowring (1979:259ff).

26. According to Hasegawa Izumi (1965:240), in Germany Ōgai read J. J. Borelius' *Blicke auf den gegenwärtigen Standpunkt der Philosophie in Deutschland und Frankreich* (A Look at the Present Standpoint of Philosophy in Germany and France; Berlin, 1886) and Albert Schwegler's *Geschichte der Philosophie im Umriss* (Outline of the History of Philosophy; Stuttgart, 1882). Schwegler's work deals with the history of philosophy only up to Hegel. The eleventh edition was "enlarged to contain an account of Schopenhauer's system" by R. Koeber, in which Eduard von Hartmann was also mentioned. The short account of the Swedish Borelius (ninety-five pages)—originally two essays written in 1879 and 1880 and translated into German by Emil Jonas—talks about E. von Hartmann's *Philosophie des Unbewussten* (Philosophy of the Unconscious) (p. 26ff.) in relative depth, and this could well have been the source for Ōgai's interest in Hartmann and his philosophy. R. Koeber is the same person as the philosopher and musicologist Raphael von Koeber (1848–1923), who from 1893 taught philosophy at the Imperial University of Tokyo. An admirer of Hartmann, Koeber published *Das philosophische System Eduard v. Hartmann's* (The Philosophical System of Eduard von Hartmann; Breslau, 1884), disseminating his interpretation of Hartmann in Japan. According to Natsume Sōseki ("Professor Raphael Koeber," in *Nippon* 2:1, 1936), he was the first person who lectured on aesthetics in Tokyo.

biographical story "Mōsō" (Illusions) from 1911 he interwove his memories of studying philosophy in Berlin, his pessimistic attitude toward life, and his search for answers in the works of Arthur Schopenhauer, Eduard von Hartmann, Max Stirner, Philipp Mainländer, and Friedrich Nietzsche.[27] His philosophical interest was awakened by Hartmann's *Philosophy of the Unconscious* (1869); Hartmann's "Drei Stadien der Illusion" ("Three Stages of Illusion"),[28] which Ōgai presents in "Mōsō," obviously captured his attention. In "Mōsō" he also mentions Hartmann's *Ästhetik* (Aesthetics, 1886–1887), which he characterizes as "the most perfect and richest in creative insight of its day."[29]

Mori Ōgai encountered German philosophy as Hegelian idealism was losing ground to the methods of the natural sciences. At that time positivism—practiced above all in France and England and something Nishi Amane had come to know twenty years earlier—was the most representative speculative system in Europe. More than a few thinkers of the German philosophical scene in those days, such as Gustav Fechner, Hermann Lotze, and Wilhelm Wundt, had come from the natural sciences, but they made efforts to develop a metaphysical supplement to the image of the world created by modern factual sciences. Mori Ōgai was a natural scientist, like them, and one might have expected that Wilhelm Wundt, for example, who taught in Leipzig during Ōgai's studies there, would have influenced him more strongly, but only later did he immerse himself in Wundt's psychology. He was interested immediately in Eduard von Hartmann. Strongly influenced by idealism, Hartmann was a philosophical outsider who "starts with a synthesis of Schopenhauer and Hegel, in that he unites the pessimism of the former with the evolutionism of the latter, and, while the one considered the world to be based on a reasonless will, the other conceived it as a logical idea. Following the precedent of the late Schelling, he made will and representation into

27. See the translation "*Mōsō—Illusionen*" by Peter Pörtner, who gives an extensive explanation of the historical philosophical background (Mori 1984:71–104).

28. From *Philosophie der Unbewussten* (1869), pt. 2, on "The Metaphysics of the Unconscious."

29. See the translation of W. Schamoni (Mori 1989:124). It is uncertain whether Ōgai began studying Hartmann's *Ästhetik* (Aesthetics) during his stay in Germany or, more likely, studied it after his return to Japan.

equally powerful attributes of his Absolute, the Unconscious."[30] The popular and widely reprinted works of Hartmann, an independent scholar living in Berlin, were characterized above all by the fact that it was indeed an idealist philosophy, but it also promised to present "speculative results according to inductive-scientific methods" corresponding to the high reputation of the natural sciences. The *Philosophy of the Unconscious* was a kind of philosophical best-seller, but it was not uncontroversial, as Ōgai himself remarks in "Mōsō" ("praising and dismissive judgments"). And Ōgai's positive judgment, cited earlier, was not unanimous in learned circles.

After Baumgarten had founded a philosophical discipline of the beautiful with his *Aesthetica* in 1750, this discipline—which for its part looked back to the views on art of classical antiquity in the works of Winckelmann, Herder, Kant, Schiller, Schelling, and Hegel, to name only the most significant[31]—produced a multilayered theoretical basis for reflections on the beautiful and art. Later philosophical systems could critically relate themselves to these. And so appeared before the turn of the century the writings of F. Th. Vischer (*Ästhetik oder Wissenschaft des Schönen*—Aesthetics or the Science of the Beautiful; three parts, 1846–1858), R. H. Lotze (*Geschichte der Ästhetik in Deutschland*—History of Aesthetics in Germany; 1868), M. Schasler (*Kritische Geschichte der Ästhetik*—Critical History of Aesthetics; 1872), G. Th. Fechner (*Vorschule der Ästhetik*—A Primer of Aesthetics; two parts, 1876), E. v. Hartmann (*Ästhetik*—Aesthetics; two parts, 1886–1887), K. Groos (*Einleitung in die Ästhetik*—Introduction to Aesthetics; 1892), J. Volkelt (*System der Ästhetik*—System of the Aesthetic; three parts, 1905–1914), Th. Lipps (*Ästhetik*—Aesthetics; two parts, 1903–1906), and M. Dessoir (*Ästhetik und allgemeine Kunstwissenschaft*—Aesthetics and General Art Science; 1906). Hartmann's *Aesthetics,* which is composed of a historical-critical first part ("German Aesthetics since Kant") and a systematic second part ("Philosophy of the Beautiful"), is based on Hegelian aesthetics ("as aesthetic appearance and its content are purely ideal, so can the aes-

30. See Falckenberg (1927:622), who gives a lucid portrayal of E. von Hartmann's philosophical system (pp. 623–627).

31. Joachim Ritter, editor of the *Historischen Wörterbuch der Philosophie* (Historical Dictionary of Philosophy; Basel, 1971), outlines the history of German aesthetics since Baumgarten. See the entry "Ästhetik, ästhetisch" ("Aesthetics, aesthetic") (vol. 1, cols. 555–580).

thetic only be purely ideal, or it is no pure aesthetic").[32] The first book treats the "concept of the beautiful," which points through six levels of concretization of the concrete beautiful to the individual ideal, otherwise known as the art object. It then presents the modification of the beautiful and "its position in the human spirit life and in the world totality," in order to turn, in the second book, to the "existence of the beautiful"—that is, the beautiful in nature, the beautiful in art, and the arts. Hartmann's *Aesthetics* was attacked from many sides, but on the whole it found a supportive response.[33]

Mori Ōgai became familiar with the *Philosophy of the Beautiful* shortly after its appearance, but he worked closely with it only after his return to Japan. Hartmann's philosophy, primarily his *Aesthetics*, formed the basis of quite a few arguments Ōgai used, beginning in 1890, in his critical confrontations in the fields of literature and art.[34] Ōgai's dispute with Tsubouchi Shōyō, during the years 1891–1892, about "hidden ideas" *(botsurisō)* is especially well known.[35] Shōyō gives his understanding of the issue in "Shēkusupiya Kyakuhon Hyōchū" (Explanations of Shakespeare's Texts), which appeared in the first issue of *Waseda Bungaku,* a journal Shōyō edited. He had in mind the wealth of ideas latent in Shakespeare's dramas and the manifold interpretability through the reader which this permits. In the article "Waseda Bungaku no Botsurisō" (The Hidden Ideas of *Waseda*

32. *E. v. Hartmann's Ausgewählte Werke* (Leipzig, 1888, vol. IV, pt. 2), p. 20. Hartmann's disciple Arthur Drews gives a succinct description of Hartmann's aesthetics in *E. v. Hartmann's philosophisches System im Grundriss* (Outline of E. von Hartmann's Philosophical System, 1902), pp. 600–672.

33. In *Das Lebenswerk Eduard von Hartmanns: Den deutschen Studenten der Philosophie gewidmet* (1907) Arthur Drews offers an encomium of "Germany's greatest philosopher," who had died the previous year. Paul Moos (1931:422–424) reports negative critiques of Hartmann's *Aesthetics,* but he also gives his own positive judgment. K. E. Gilbert and H. Kuhn call Hartmann an "industrious and occasionally brilliant eclectic" (1972:512).

34. According to Bowring (1979:75), Ōgai mentioned Hartmann for the first time in an article dated April 1890, and he used Hartmann's views in "Toyama Masakazu Shi no Garon wo Bakusu" (A Confutation of Toyama Masakazu's Views on Painting) and in "Toyama Masakazu Shi no Garon wo Saihyō Shite Shoka no Bakusetsu wo Bōkyūsu" (A New Critique of Toyama Masakazu's Views on Painting and Other Contrary Views).

35. *Botsurisō ronsō* has been discussed, among others, by Okazaki Yoshie (1955: 618ff) and Bowring (1979:76ff). On the extensive literature in Japanese see Morita (1969:51).

Bungaku) in the journal *Shigarami Zōshi*,[36] Ōgai criticized Shōyō's position and a literary controversy with several essays broke out. Essentially the controversy centered on the many interpretations of the concept *risō*, which Shōyō, as an English scholar, primarily understood to mean "ideas" whereas Ōgai worked with the German *"Idee."* Ōgai's argument employs the aesthetics of Hartmann, who speaks in the essay as "Professor Fictive" ("Uyū Sensei"). These presentations were comparatively abstract and indeed often incomprehensible for his opponent Shōyō, as well as for other readers. If Ōgai reproached Shōyō for his lack of theorization *(danri)*, he himself produced it in excess. Ōgai was a polemical spirit, not without a certain intellectual arrogance, whose contours are clearly revealed in the critical essays from the beginning of his writing career.

The unsatisfactory outcome of the *botsurisō* dispute; Ōgai's desire to introduce aesthetics into the contemporary discussion about the basis of literature and literary criticism and make them more scientific; the hesitant reception of his argument—all provoked Ōgai to publish "Shinbiron" (Discourse on the Investigation of the Beautiful) in his *Shigarami Zōshi* shortly after the conclusion of his polemical dispute with Shōyō.[37] The five-part series appeared anonymously, but due to the content and because Ōgai was the editor, the work was associated with him. It was not an art-theoretical discourse by the author but, rather, a translation of the first fifty-nine pages of Hartmann's *Philosophy of the Beautiful,* in which "Aesthetic Appearance and Its Ingredients" are treated. Ōgai translated the entire first section ("Aesthetic Appearance") and the first two paragraphs of the second section ("The Feeling of Aesthetic Appearance"). In order to show Ōgai's terminological mastery of the philosophical original and his mastery of translation technique, the following paragraph titles and their translations are juxtaposed, as well as the first paragraph in the original and its retranslation back from the Japanese:[38]

36. Mori Ōgai founded *Shigarami Zōshi* in October 1889 as a journal of literary criticism. It continued publication until 1894. The dispute began with an article that Ōgai published in No. 27, December 1891. On Mori Ōgai and *Shigarami Zōshi* see Morita (1969).

37. *Shigarami Zōshi*, Nos. 37, 38, 40, 41, 45, October 1892–June 1895. See *Ōgai Zenshū*, vol. 21, pp. 1–57. Ōgai's writings on German aesthetics are gathered in vol. 21 of his *Collected Works.*

38. See *Eduard von Hartmann's Ausgewählte Werke*, vol. 4: *Aesthetik,* Second Systematic Part: *Philosophie des Schönen* (Leipzig: Wilhelm Friedrich, 1888), pp. 1–59; *Ōgai Zenshū*, vol. 21, p. 3ff.

1.

a. The Factors of the Beautiful: *Bi no shozai*[39]
b. Subjective Appearance as the Place of the Beautiful: *Bi wo ninahitaru shushō*
c. The Detaching of Appearance from Reality: *Kashō wo shite jitsu wo hanareshimuru koto*
d. The Uprightness and Purity of Aesthetic Appearance: *Bishō no sei to sui to*
e. The Ideality of Aesthetic Appearance: *Bikashō no sōnaru koto*
f. "Appearance" and "Intuition": *Kashō to kansō to*
g. "Appearance" and "Image": *Kashō to zu to*
h. "Appearance" and "Form": *Kashō to kei to*
i. The Disappearance of the Subject in Aesthetic Appearance: *Shu no bikashō chū ni bossuru koto*
j. Types of Aesthetic Appearance: *Bikashō no shubetsu*

2.

a. Aesthetic Feelings of Appearance in Distinction from Real Feelings: *Bikajō no jitsujō ni kotonaru koto*
b. The Alteration and Mixing of Aesthetic Feelings of Appearance with Real Ones: *Bikajō to jitsujō to no sakugo oyobi konkō*

E. von Hartmann's Text

Before one approaches the question of what beauty entails, one must discuss the question of where beauty is located or what is the conveyor of beauty. The most obvious opinion is that the things themselves such as they exist in the environment, independent of all perception, are the location or conveyor of beauty. This opinion corresponds to naive realism, which believes to be able to capture in its objects of perception the nature of things in themselves. We do not need to exercise much thought to realize the untenability of this opinion. One does not even need to turn to philosophy but could learn from the natural sciences that light, color, and sound simply represent subjective feelings to which correspond in physical reality only certain forms of the movements of molecules and atoms. Since the beauty of all perception relies on the combination of light, color, and sound, it is impossible for beauty to be located in the nature of things—in other words, independently from our perceptions. If there really is a world outside, beyond my sphere of consciousness, then this world would be without light, color, and sound. If modern physics is right and the world is indeed made of atoms—which are either unexpandable points of power or small points like stars in relation to the distance between them—then the real world misses the kind of continuity that sensual perceptions add to substances because of their inability to realize the gaps.

39. Here Ōgai substitutes "factor" with "position" *(shozai)*, reflecting the content of the paragraph. See the text that follows this list.

Ōgai's Translation

Before asking what is beauty, it is necessary to ask where beauty is found. It would be very naive to think that beauty is outside consciousness and that we find it in external objects. This is called naive realism. This is like thinking that what one sees (a place) in consciousness is the actual thing. There is no need to rely on philosophy to understand that this is not the case. This should be clear even from the natural sciences. A color or a sound is simply a subjective (perceptive) feeling to which corresponds a truth that is nothing but the form of the movement of atoms and molecules. If beauty is the product of the way colors and sounds are constructed, then beauty is found in subjective feelings and there is no way we can find it in a reality that is external to consciousness. If there were a world outside consciousness, then that world would be colorless and soundless. If today's physicists are not mistaken, the external world is made of ultramicroscopic atoms. Now, if these atoms were not unexpandable power points, they should be the same as unexpandable power points used in measuring distances. The relationships between their size and distance would be the same as the relationship between the distance of a star from another star and their size. At the same time, we ought not to think that there is any continuity in the external world. My consciousness is still green, however, and does not see the gaps.

(As in other translations on aesthetics, Ōgai used for his translation the standard written Japanese of his day *(bungobun, futsūbun)*, which was the appropriate format for scientific presentations. Ōgai represented the often difficult trains of thought of the original according to the meaning and in a paraphrased form, solving terminological problems through ad hoc constructions.)

The "Shinbiron" remained incomplete; Ōgai never finished translating the relevant first chapter of the first book ("The Concept of the Beautiful") of Hartmann's *Philosophy of the Beautiful*.[40] Nevertheless, it served as an essential landmark in Ōgai's statements on aesthetics. If previously he had brought his critical and polemical knowledge into the literary and artistic discussions of the Meiji period, from now on he would concentrate on the precise mediation of German aesthetics through the translation of individual works or summaries of the same. One observes a clear scientizing of his relevant production. This process is also to be seen in connection with

40. The following sections are missing: 2(c) "The Projection of Aesthetic Pseudo-Feelings in Appearance"; 3(a) "The Real Pleasure in Beauty"; 3(b) "The Self-Enacting of the Subject in the Object or the Aesthetic Illusion." See *Eduard von Hartmann's Ausgewählte Werke* (1888:59–71).

his teaching activities at the time at the Keiō-gijuku, founded by Fukuzawa Yukichi (1835–1901), where he had given lectures on aesthetics since September 1892. Moreover, somewhat later in 1893, Raphael von Koeber began his activities as a professor of philosophy at the University of Tokyo with a lecture on aesthetics. We might guess that the two admirers of Hartmann had some form of contact.

Ōgai's journal *Shigarami Zōshi,* in which "Shinbiron" appeared, ceased publication in 1894. The Sino-Japanese War had broken out, in which Ōgai participated as a high-ranking army doctor in Korea, on the Chinese battleground, and in occupied Taiwan. At the beginning of October 1895, he returned to Tokyo. Despite his professional obligations to the medical administration and the army medical college, Ōgai enthusiastically continued to pursue his literary interests and in January 1896 launched a new literary journal, *Mesamashigusa.* It continued to appear until February 1902, publishing not only literary-critical essays but also a series of contributions on the philosophy of art, with which Ōgai continued the series of translations of German aesthetics he had begun with "Shinbiron." At the end of 1896, Ōgai's critical works on literature, art, and theater from the years 1889–1895 appeared with the title *Tsukikusa* for the publisher Shunyōdō. In the foreword he expresses his views on contemporary trends in European art theories and outlines his contribution to the development of aesthetics in Japan through the mediation of Hartmann's *Aesthetics (Ōgai Zenshū,* vol. 23, p. 299f.):

> Even my opponents must admit that my work, with Hartmann's normative aesthetics *(hyōjunteki shinbigaku)* as the basis of my critique, has had a certain influence on the evaluation of scientific aesthetics in Japan and on scholars' estimation of Hartmann. . . . The fact that we have begun, at the universities and at individual schools, to give a value to lectures on aesthetics which they had not previously had, and we have begun to found chairs in aesthetics, and that recently there have even appeared specialists in aesthetics is, one might say without exaggeration, encouraged through the (indeed) richly naive articles which appeared in *Shigarami Zōshi,* put out from 1889 to 1894 by myself and several friends of similar sensibilities. At that time there appeared people who, directly or indirectly, paid attention to Hartmann's philosophy, and even the metaphysical tendencies of the philosophy began to be studied. These had been almost completely ignored in this country, suppressed by the empiricists. Even today, when people arrogantly assert that one should lock up men like Hartmann, who is a professional aesthetician, in a high tower, my name is mentioned when aesthetics is being discussed; and when my name is mentioned, Hartmann's name

immediately follows. People make fun of me as a critic who is fixated on Hartmann, and so they have begun to attack Hartmann, because in order to shoot someone down, you should first shoot out their horse from under them. This is burdensome to me, and I also feel an annoyance toward Hartmann. Am I really fixated on Hartmann? Am I really riding around on the Hartmannian aesthetic, and will I take a fall if my horse is shot?

Toward the end of this presentation it becomes clear that Ōgai does not want to be identified with Hartmann's aesthetics: he has not completely adopted what he called, earlier in the text, "the aesthetic metaphysics of Hartmann" *(sono shinbigaku no keijijōmon)*. Despite this, he furthered his studies of Hartmann's *Philosophy of the Beautiful* and in 1899 brought out an *Outline of Aesthetics (Shinbi Kōryō)* together with the art historian Ōmura Seigai (1868–1927).[41] This, as can be ascertained from the preliminary comments, reproduces Hartmann's *Philosophy of the Beautiful*—which both authors considered to be the most perfect work ever written on aesthetics—not in the form of a translation or excerpt but as a concise summary of the content.[42] The *Outline* followed the structure of the original closely with a detailed table of contents and the original terminology standing opposite the major chapter headings as follows:[43]

I. Aesthetic Appearance: *Bi no genshō*
II. The Concrete Stages of the Beautiful: *Bi no kaikyū*
III. The Opposites of the Beautiful: *Bi no hanmen*
IV–V. The Modification of the Beautiful: *Bi no henka*
VI. The Position of the Beautiful in Human Spiritual Life and the World as a Whole: *Bi no seken'i*
VII. The Naturally Beautiful and the Historically Beautiful: *Shizenbi oyobi rekishibi*
VIII. The Origin of Artistic Beauty: *Geijutsubi no seiritsu*
IX. The Unindependent Formally Beautiful Arts and the Unfree Arts: *Geijutsu no bunrui*
X. The Simple Free Arts: *Jiyū geijutsu*
XI. The Composite Arts: *Fukugeijutsu*

41. This work appeared in two booklets in June 1899 from the publisher Shunyōdō. In 1896, Ōgai and Ōmura had published the article "Indian Interpretations of Art" (Indo Shinbisetsu) in *Mesamashigusa* (no. 4). In 1898, together with Iwamura Tōru (1870–1917), they published "Introduction to Western Painting" (Yōga Tebikisō), an adaptation of Karl Raupp's *Katechismus der Malerei* (Leipzig, 1894).

42. See *Ōgai Zenshū*, vol. 21, p. 213. According to the preamble, the summary was "merely a hundredth of the original," although this seems to be an overstatement. It might be more accurate to say "approximately one-seventh of the original."

43. For a complete table of contents see Kobori (1973:11ff).

Terminological identifications were established throughout the text mostly with English equivalents (*hyōgen*—mimics; *hijō*—abnormity; *hirui*—monstrum per excessum; *tensai*—genius; *shōsetsu*—novel; and so on). Even Western proper names were given in *kana* and Latin scripts (*Gioote*—Goethe; *Sheruringu*—Schelling; and so on).

In the prefatory remarks to *Shinbi Kōryō*, both authors indicate that they want to edit *An Outline of the History of Aesthetics (Shinbi Shikō)* in order to present the history of aesthetics from Greek philosophy to Hartmann. They also indicate that the manuscript is half-finished (*Ōgai Zenshū*, vol. 21, p. 213). The manuscript from the year 1898 has survived as a fragment (and first appeared in the Ōgai collected works of the publisher Iwanami [1952] in the possession of the Ōmura family), with the omission of the additions by Ōmura Seigai. It was based on the broadly constructed *Ästhetik als Philosophie des Schönen und der Kunst* (Aesthetics as the Philosophy of the Beautiful and of Art, 1886) of Max Schasler (1819–1903)—a student of the Hegelian Karl Rosenkranz—who later published *Grundzüge der Wissenschaft des Schönen und der Kunst* (Basic Elements of the Science of the Beautiful and of Art, 1886). The first part of Schasler's *Aesthetics* appeared as "Critical History of Aesthetics: A Basis for Aesthetics as the Philosophy of the Beautiful and of Art. First Division. From Plato to the 19th Century" (Berlin, 1872). Out of this voluminous work, which treated topics from the "oldest aesthetic views of the Greeks" to "Herbart's and Schopenhauer's successors," the Japanese manuscript extracts details from the "First Book. First Period: History of Ancient Aesthetics," up to chapter IV ("Aristotle and the Aristotelians"),[44] and presents them in the form of excerpts or definitions taken from the content of the original; it can be seen as the beginning of a sketch for a historical presentation. In this manuscript, next to the proper name, appear the Greek terms as they were cited by Schasler.

Shinbi Kōryō and *Shinbi Shikō* make clear that Mori Ōgai, together with his friend Ōmura Seigai (who held a professorship at the

44. The manuscript ends with the following part of a rigorously arranged original: "Second Stage: Aristotle and the Aristotelians. (1) Aristotle. c. The Division of Arts. (1) Poetry; (b) Drama. (α) Tragedy." See Schasler (reprint Aalen 1971), pp. 68–172. The degree of the Japanese abridgment is apparent when we look at the size of the manuscript: twenty-five printed pages in Ōgai's *Collected Works* (*Ōgai Zenshū*, vol. 21, pp. 359–383).

Tokyo School of Fine Arts), wanted to offer a complete summary of aesthetics, its history, and its systems; for him Hartmann's aesthetics represented the current state of this discipline.

That Mori Ōgai followed contemporary German aesthetics attentively and did not limit his studies to Hartmann was already apparent before the appearance of *Shinbi Kōryō*. In a series of articles published the year before in the journal *Mesamashigusa* and titled "A New Interpretation of Aesthetics" (Shinbi Shinsetsu),[45] Ōgai presented to his readers a text by Johannes Volkelt (1848–1940). A professor of philosophy at the University of Leipzig since 1894, Volkelt had come to prominence with a series of studies on epistemology and metaphysics, as well as his studies on aesthetics, and later published a three-volume *System der Ästhetik* (System of Aesthetics, 1905–1914) with which he became the contemporary leader of this philosophical discipline.[46] Ōgai introduced Volkelt to Japanese readers through a collection of lectures that had appeared only a few years earlier under the title *Ästhetische Zeitfragen* (Current Questions in Aesthetics; Munich, 1895). These were five lectures that Volkelt gave in Frankfurt in 1894 and a sixth, his first lecture at Leipzig, from April 1894. The original titles, with Ōgai's translations, were as follows:

> Art and Morality: *Geijutsu to dōgi to no kankei*
> Art and the Imitation of Nature: *Geijutsu to shizen to no kankei*
> Art as Creator of a Second World: *Daini shizen to shite no geijutsu*
> Style in Art: *Yōshiki*
> Naturalism: *Shizen-shugi*
> Contemporary Tasks of Aesthetics: *Shinbigaku no genkyō*

In the preliminary notes to the book edition of *Shinbi Shinsetsu* (1900), in which Ōgai gave the author and original titles of the German publication with translation *(shinbijō jiji mondai),* he responds to the many complaints of readers about how difficult it was to understand his *Shinbi Kōryō,* which had appeared earlier that year, commenting that most of the difficulties could be traced back to

45. The series consisted of ten articles in ten numbers of *Mesamashigusa* from February 1898 until September 1899. The series appeared anonymously, but in February 1900 it was published as a book by the publisher Shunyōdō under the pen name "Mori Rintarō."

46. *Gewissheit und Wahrheit* (Certainty and Truth, 1918) is Volkelt's major accomplishment in the theory of knowledge. Volkelt taught aesthetics at the University of Leipzig for many years. For his life and work see Krüger (1930).

Hartmann's original. Volkelt's text, a collection of lectures, would not present such difficulties (*Ōgai Zenshū,* vol. 21, p. 69). Indeed, the Japanese version of Volkelt's lectures reads more easily than Ōgai's earlier translations, a fact that is due partially to the diction of the original. By reproducing the original, Ōgai proceeds as in the previous work: the reader is given a translation close to the original but in the form of a summary along with an introduction of many original terms (including the original writings for European names), this time completely without a *kana* transcription. The beginning of Volkelt's inaugural lecture ("Contemporary Tasks of Art") is as follows, again with the original text given first and then the translation of Ōgai's Japanese version (Volkelt 1895:197; *Ōgai Zenshū,* vol. 21, p. 133):

Volkelt's Text

While I intend to talk about the contemporary task of aesthetics, I am absorbed by the consciousness of how much, even today, it still battles among the sciences for its justification. Today we still encounter the opinion—even where we would not expect to find it—that aesthetics moves along the same track that was followed at the time of Schelling and Hegel. That is to say, aesthetics up to the present time has consisted in the production of ideas of beauty; its forms are found in the depth of metaphysics; and until today aestheticians have violated works of art with interpretations of philosophical profundity and the application of rigid and narrow measures.

Ōgai's Translation

I now want to talk about the present condition of aesthetics. I am distinctly aware of how much this science must fight today in order to establish its right of existence. People say that up to the present day aesthetics has followed in the footsteps of Schelling and Hegel. They say that those who practice it want to extrapolate the idea of beauty from the depth of metaphysics and that they bring to the interpretations of works of art deep philosophical meanings and strict rules.

During the first publication of "Shinbi Shinsetsu" in *Mesama-shigusa,* immediately after the appearance of *Shinbi Kōryō,* Mori Ōgai was transferred in June 1899 to Kokura in Northern Kyūshū (Fukuoka prefecture) as division doctor—de facto a punitive transfer stemming from quarrels and rivalries.[47] This move to the distant provinces separated him from the pulsing intellectual climate of the

47. The general-staff physician Koike Masanao was behind the transfer. Koike was jealous of Ōgai's accomplishments in the medical profession and the literary field. See Bowring (1979:89).

capital. Ōgai remained in "exile" without a break until March 1902, except for a short trip to Tokyo at New Year's 1901–1902, on the occasion of finalizing a marriage with his second wife Araki Shige. In the two and three-quarters years that Ōgai endured in Kokura, he did indeed suffer from isolation, and his productivity was limited, but he used the time to study, among other things, languages such as French, Russian, and Sanskrit. He also worked on lectures and journalistic articles and especially continued work on German aesthetics; during this time his work on this subject came to an end. Three lectures of widely diverse character came from the Kokura period: "Shinbi Kyokuchi Ron," "Shinbi Kashō Ron," and "Jōgaku wa Mote Kagaku to Shite Rissuru ni Taru ka." All turn out to be translations from German writings on aesthetics.

The title "Shinbi Kyokuchi Ron" (Treatise on the Highest in Aesthetics) is Ōgai's translation of "The Aesthetic Ideal" from Otto Liebmann's major work, *Zur Analysis der Wirklichkeit: Eine Erörterung der Grundprobleme der Philosophie* (On the Analysis of Reality: An Articulation of the Basic Problems of Philosophy), from the year 1876.[48] Otto Liebmann (1840–1912), who had given strong impetus to Neo-Kantianism with his early work *Kant und die Epigonen* (Kant and His Imitators, 1865), developed a critical realism in his *Analyses*. In three sections he discussed his views "On Epistemological Critique and Transcendental Philosophy," "On Natural Philosophy and Psychology," and "On Aesthetics and Ethics." Mori Ōgai translated Liebmann's presentation of aesthetics, specifically the introductory portion of the third section, "Ideal and Reality" ("Sōron: Jitsuzai to Kyokuchi to"), as well as the second section, "The Aesthetic Ideal."[49] The second section consisted of twenty-one subdivisions numbered throughout, which Ōgai supplemented with notes characterizing the content of each (1. "The Independence of Aesthetics and Ethics from Theoretical Philosophy and the Coexistence of Aesthetics and Ethics"; 2. "Vision and Hearing; Smell, Taste, and the Sense of Touch; the Arts of Space and the Arts of Time"; 3. "Subject and Object, Rela-

48. Ōgai used the third edition of 1900. I myself used the fourth, revised edition of 1911 (x + 722 pp.). The book was published by Karl J. Trübner in Strassburg, where Liebmann was an adjunct professor of philosophy from 1872 until 1882. He later became a professor in Jena.

49. Liebmann (1911:581–589 and 590–669). In Liebmann it is found at the end as the third part: "The Ethic Ideal."

tivity and Absoluteness of Art," and so on).[50] Ōgai emphasized in his preliminary remarks (*Ōgai Zenshū,* vol. 21, p. 389) that throughout his translation of the twenty-one chapters he had added or subtracted as few words as possible; he had, however, shortened the rather wordy last partial chapter on music; moreover, he treated the presentation of European words the same way as in *Shinbi Shinsetsu.* A comparison between the original and the translation shows that Ōgai stuck very close to the German text. He also carried over the author's annotations and added several explanations of his own that indicate his personal aesthetic views at the time. Ōgai's subsequent activity became remarkable (January 1901) soon after the publication of the third edition of *Zur Analysis der Wirklichkeit* (Liebmann's foreword is dated March 1900) and its publication in the six installments of the Tokyo journal *Mesamashigusa,* founded by Ōgai, from February to October 1901 (No. 49–54).[51] It is the most striking example of Ōgai's efforts to convey the current state of German aesthetics to Japanese experts in art and literature.

The "Shinbi Kashō Ron" (Treatise on Aesthetic Appearance)[52] is a partial translation of the *Einleitung in die Ästhetik* (Introduction to Aesthetics) by Karl Groos (1861–1946), which Groos had compiled as a private instructor at the University of Giessen.[53] Groos began with a study of Schelling (*Die reine Vernunftwissenschaft: Systematische Darstellung von Schelling rationaler oder negativer Philosophie*—The Science of Pure Reason: A Systematic Presentation of Schelling's Rational or Negative Philosophy; 1889) and then published numerous writings on aesthetics, taking a more psychologically oriented approach to the discipline. After the "Introduction" followed *Die Spiele der Tiere* (The Games of Animals, 1896), *Der Spiele der Menschen* (The Games of Men, 1899), and *Der ästhetische Genuss* (Aesthetic Pleasure, 1902). From the three-part *Introduction to Aesthetics* ("Aesthetic Appearance and the Monarchical Structure of Consciousness," "Aesthetic Appearance and Its Inner Imitation," "Aesthetic Modification"), Mori Ōgai translated into Japanese eight of the thirteen sections of the first chapter ("Shinbi Kashō Narabi ni Ishiki no Doku-

50. See the table of contents in *Ōgai Zenshū,* vol. 21, pp. 387–388.

51. The book version appeared in 1902 from Shunyōdō.

52. For the text see *Ōgai Zenshū,* vol. 21, pp. 465–496.

53. The work was published in Giessen by J. Ricker'sche Buchhandlung in 1892 (vii + 409 pp). Later Groos worked as a professor of philosophy in Basel.

saii") with painstaking accuracy, including the commentary of the original and additional commentary from the translator. The individual sections deal with "The Picture Puzzle" (Esagashi), "The Monarchical Structure" (Dokusaii), "Sensuousness and Understanding" (Kannō to Keisei), "Sensuousness" (Kannō), "Understanding" (Keisei), "The Imagination" (Naizōryoku), "Appearance" (Kashō), and "Aesthetic Appearance" (Shinbi Kashō).[54] Portions of these translations appeared again in *Mesamashigusa,* in the editions of December 1901 (No. 55) and February 1902 (No. 56), without mention of Ōgai's name. After the publication of *Mesamashigusa* came to an end with No. 56, the continuation of the translation appeared in the newly founded journal *Geibun,* starting in June 1902 (No. 1), this time crediting Ōgai.[55]

Mori Ōgai's last article on aesthetics appeared under the title "Can Aesthetics Be Established as a Science?" (Jōgaku wa Mote, Kagaku to Shite Rissuru ni Taru ka; see the text in *Ōgai Zenshū,* vol. 21, pp. 497–501). The work appeared in the first issue of the newly founded journal *Bungeika* (March 1902) precisely when Ōgai was permitted to return to Tokyo from his "exile" in Kokura. As he explains in his introduction (*Ōgai Zenshū,* vol. 21, p. 499), this was a translation of the introduction of a posthumous work by Heinrich von Stein (1857–1887), who had worked as a private instructor in Berlin beginning in 1884. Von Stein's lectures on aesthetics were given in the summer semesters of 1885 and 1886 and published by his disciples, "based on an existing manuscript," in 1897.[56] The lectures—comprising a systematic, a historical, and an "applied" part—contain an introduction of several pages titled "Is Aesthetics Possible as a Science?" It is von Stein who defined aesthetics as "the doctrine of feelings" (in reference to the original meaning of the word *"aisthetikos"*),[57]

54. Groos (1892:1–46). The remaining five sections that Ōgai did not translate are titled "The Aesthetic and the Beautiful," "The Artistic Imitation," "Plastic Arts," "Aesthetics and Morality," and "The Expression 'Appearance' " (Groos 1892:46–81).

55. The journal *Geibun* was jointly founded by Mori Ōgai, who resigned from *Mesamashigusa,* and Ueda Bin who left *Geien.* Only two issues of this journal were published (June and August 1902).

56. Heinrich von Stein, *Vorlesungen über Aesthetik: Nach vorhandenen Aufzeichnungen bearbeitet* (Lectures on Aesthetics Based on Extant Notes) (Stuttgart: Cotta'schen Buchhandlung, 1897). His major work, *Die Entstehung der neueren Ästhetik* (The Origin of Modern Aesthetics) appeared in 1886 from the same publisher.

57. *"Aisthetikos,"* or "relevant to the senses and to perception." In this article Ōgai translated "Ästhetik" as *"jōgaku,"* or "the science of (artistic) sentiment," with reference to von Stein's definition and terminology.

answering the question asked in the title by saying that the work of art as a "great manifestation of feeling" makes the aesthetic possible.

Heinrich von Stein, who accorded the aesthetic a central position in his philosophical work, had already passed away when Mori Ōgai was in Berlin (1887–1888). Thus Ōgai did not become acquainted with his aesthetics until the new edition of von Stein's *Lectures* appeared in 1897. When Ōgai translated the introduction to von Stein's *Vorlesungen über Ästhetik* (Lectures on Aesthetics) in Kokura, he pointed out in his preface that this work had not been previously mentioned by the specialists—he cited by name Takayama Chogyū (1871–1902) and Ōtsuka Yasuji (1868–1931)—and said that it was likely to be unknown in Japan. In general his contribution is marked by the effort to make the newest developments of German aesthetics known in Japan at a time when he himself was out of touch with the scientific and literary communities.

The expected benefits of his attempt at mediating German aesthetics failed to materialize. He came to be considered a follower of Hartmann, who was not particularly appreciated in Japan's newly established academic aesthetics (1900); the ambivalent assessment of Hartmann's work passed over to his Japanese mediator. Ōgai was seen by some critics and professors as a dilettante rather than an expert on scientific aesthetics. Obviously Ōgai's presentation of contemporary German aesthetic writings did not find a large audience in inner circles; even journals of literary criticism took slight notice of him. The negative critique of a leading critic of the time, Takayama Chogyū,[58] in a review of "Shinbi Kōryō" (1899)—the depiction of Hartmann's *Philosophie des Schönen*—which appeared in the journals *Tetsugaku Zasshi* and *Teikoku Bungaku* must have deeply hurt Ōgai in Kokura. In two replies that were published in the *Yomiuri Shinbun* on September 1 and 10, 1899, Ōgai rejected the critiques.[59] But "Shinbi Shinsetsu"—presenting Volkelt's aesthetic views—found a positive assessment in *Tetsugaku Zasshi*, while *Teikoku Bungaku* praised the

58. [See Chapter 7. Ed.]

59. The replies in the form of letters appear in *Ōgai Zenshū*, vol. 21, pp. 351ff. Takayama tried to point out Ōgai's misunderstandings and mistranslations. Takayama also criticized Ōgai's use of the word *"shinbigaku,"* which Ōgai himself had created to translate "aesthetics," instead of using *"bigaku"* introduced by Nakae Chōmin.

representation of Leibmann's *Ästhetik* in "Shinbi Kyokuchi Ron." Both journals kept fairly distant from Mori Ōgai.[60]

In his observations on the philosophical views of Mori Ōgai, the Kantian Kuwaki Gen'yoku (1874–1946) stressed once again Ōgai's admiration for Hartmann.[61] In his story "Mōsō" (1911), Ōgai described retrospectively Hartmann's *Ästhetik* as "at the time the most perfect and rich in creative insights," confessing that his study of this work was the source of continuous interest in German aesthetics. In a preface to his last short contribution to the knowledge of German aesthetics (1902), Ōgai himself described his entanglement with this science as a "chronic sorrow" *(shinbi no gaku wa yo no koshitsu)*[62] that had never left him since his return from Germany. In contrast to contemporaries who assimilated from the West their studies of aesthetics—such as Ōnishi Hajime, Takayama Chogyū, Ōtsuka Yasuji, or his disciples Shimamura Hōgetsu and Abe Jirō[63]—Ōgai never created his own work on aesthetics but let the German aestheticians speak for themselves. Moreover, his work remained a beginning, a partial view or abbreviation, which was not conducive to widespread diffusion beyond a small circle of interested readers. Ōgai's were authentic reproductions, however, since he rigidly followed the principle, "If one, while translating, misses the meaning, one cannot call it a translation."[64] From the sidelines of his creation comes Ōgai's great accomplishment of "translatory expression."

References

Bowring, Richard J. 1979. *Mori Ōgai and the Modernization of Japanese Culture.* Cambridge: Cambridge University Press.

Brüll, Lydia. 1989. *Die japanische Philosophie: Eine Einführung.* Darmstadt: Wissenschaftliche Buchgesellschaft.

60. For the reception of Ōgai's writings on aesthetics I follow Kanda (1961:60ff). The journals mentioned here were founded by members and graduates of the departments of philosophy and literature of the Imperial University of Tokyo. Takayama Chogyū played a major role in the early phase of these journals.

61. In "Mori Ōgai Hakase no Tetsugaku Shisō," published in the journal *Shinshōsetsu* (1922:8) immediately after Ōgai's death; reprinted in Yoshida (1960:46).

62. In "Jōgaku wa Mote, Kagaku to Shite Rissuru ni Taru ka." See *Ōgai Zenshū*, vol. 21, p. 499.

63. For the history of aesthetics in the Meiji period see Yamamoto (1960).

64. Quoted from the preamble to the Liebmann translation of "Shinbi Kyokuchi Ron." See *Ōgai Zenshū*, vol. 21, p. 389.

Drews, Arthur. 1902. *Eduard von Hartmann's philosophisches System im Grundriss*. Heidelberg: Winter.

———. 1907. *Das Lebenswerk Eduard von Hartmanns. Den deutschen Studenten der Philosophie gewidmet*. Leipzig: Thomas.

Falckenberg, R. 1927. *Geschichte der neueren Philosophie von Nikolaus von Kues bis zur Gegenwart*. Berlin: de Gruyter. First published in 1885.

Gilbert, Katharine E., and Helmut Kuhn. 1972. *A History of Esthetics*. New York: Dover. First published in 1939.

Groos, Karl. 1892. *Einleitung in die Aesthetik*. Giessen: Ricker'sche Buchhandlung.

Hartmann, Eduard von. 1888. *Ausgewählte Werke*. Leipzig: Wilhelm Friedrich.

Hasegawa Izumi. 1965. "Mori Ōgai." *Japan Quarterly* (Tokyo) 12(2):237–244.

Havens, Thomas R. H. 1970. *Nishi Amane and Modern Japanese Thought*. Princeton: Princeton University Press.

Hisamatsu, Sen'ichi. 1963. *The Vocabulary of Japanese Aesthetics*. Tokyo: Centre for East Asian Cultural Studies.

Kanda Takao. 1961. "Mori Ōgai to E. v. Hartmann." In *Shimada Kenji Kyōju Kanreki Kinen Ronbunshū*. Tokyo: Kōbundō.

———. 1968. "Ōgai to Bigaku." In *Mori Ōgai Hikkei*. Tokyo: Gakutōsha, pp. 57–68.

Kobori Keiichirō. 1973. "Ōgai Bigaku jō no Gyōseki ni tsuite." In *Ōgai Zenshū Geppō* (Tokyo) 21:8–15.

Krüger, Felix. 1930. "Nekrolog auf Johannes Volkelt." In *Berichte über die Verhandlungen der Sächsischen Akademie der Wissenschaften zu Leipzig, Philolog.-hist. Ch. 82*, V. 1:1–14.

Lewin, Bruno. 1955. *Futabatei Shimei in seinen Beziehungen zur russischen Literatur*. Hamburg: Gesellschaft für Natur- und Völkerkunde Ostasiens.

Liebmann, Otto. 1911. *Zur Analysis der Wirklichkeit. Eine Erörterung der Grundprobleme der Philosophie*. Strassburg: Trübner.

Meiji Bunka Zenshū. See Yoshino Sakuzō (1927–1930).

Moos, Paul. 1931. *Die deutsche Ästhetik der Gegenwart. Versuch einer kritischen Darstellung*. Berlin: Schuster & Loeffler.

Mori Ōgai. 1984. "Mōsō—Illusionen." Peter Pörtner, trans. *Kagami* (Hamburg) 1:71–104.

———. 1986–1989. *Ōgai Zenshū*. 31 vols. Tokyo: Iwanami Shoten.

———. 1989. *Im Umbau*. Wolfgang Schamoni, trans. Frankfurt: Insel.

Morita, James R. 1969. "Shigarami Zōshi." *Monumenta Nipponica* (Tokyo) 24 (1–2):47–58.

Natsume Sōseki. 1936. "Professor Raphael Koeber." *Nippon* 2(1):16–20.

Nishi Amane Zenshū. 1966. Ōkubo Toshiaki, ed. Tokyo: Sōkō Shobō.

Okazaki Yoshie. 1955. *Japanese Literature in the Meiji Era*. H. Viglielmo, trans. Tokyo: Ōbunsha.

Rimer, J. Thomas. 1975. *Mori Ōgai*. Boston: Twayne.

Ritter, Joachim. 1971. *Historisches Wörterbuch der Philosophie*. Basel: Schwabe.

Schasler, Max. 1872. *Kritische Geschichte der Aesthetik. Grundlegung für die Aesthetik als Philosophie des Schönen und der Kunst.* Pt. 1: *Von Plato bis zum 19. Jahrhundert.* Reprint Aalen: Scientia, 1971.

Stein, Heinrich von. 1897. *Vorlesungen über Aesthetik: Nach vorhandenen Aufzeichnungen bearbeitet.* Stuttgart: Cotta'sche Buchhandlung.

Tsubouchi Shōyō Jiten. 1986. Shōyō Kyōkai, ed. Tokyo: Heibonsha.

Twine, Nanette. n.d. *The Essence of the Novel: Tsubouchi Shōyō.* Occasional Paper 11. University of Queensland, Department of Japanese.

Volkelt, Johannes. 1895. *Ästhetische Zeitfragen.* Munich: Beck.

Yamamoto Masao. 1960. "Meiji no Bigaku—Bigaku to Nihon Seishin." *Kokubungaku Kaishaku to Kanshō* (Tokyo) 1:31–50.

Yoshida Seiichi, ed. 1960. *Mori Ōgai Kenkyū.* Tokyo: Chikuma Shobō.

Yoshino Kakuzō, ed. 1927–1930. *Meiji Bunka Zenshū.* 24 vols. Tokyo: Nihon Hyōronsha.

AESTHETICS
AT WASEDA
UNIVERSITY

Ōnishi Hajime
Criticism and Aesthetics

Watanabe Kazuyasu

Outline of His Philosophical Thought

For thinkers who were engaged in "enlightening" the country at the beginning of the Meiji period, an important duty was to introduce Western knowledge to the Japanese for the practical purpose of modernizing the state. Generally speaking, the nature of the reception of Western thought at that time was fragmentary and erratic. Scholars were little concerned with binding together the various strains of thought and organizing them into a system.

Beginning around 1877, however, they became aware of the importance of, on the one hand, revealing the contradictions inherent in the received knowledge[1] and, on the other, choosing from the mass of this fragmentary knowledge from the standpoint of the newly established academic philosophy and building up a systematic philosophy grounded in a specific point of view. Inoue Tetsujirō[2] talks about his resolution to build up a systematic philosophy at the beginning of his *Rinri Shinsetsu* (New Theory of Ethics, 1883): "First of all we must establish the standards of truth. Then, if we proceed from easy to more

From Watanabe Kazuyasu, "Ōnishi Hajime: Hihyōshugi to Bigaku," *Nihon no Bigaku* (The Aesthetics of Japan) 2(7) (1986):105–112.

1. Beginning in the late 1870s, the common agenda of the enlighteners—which until then had "remained focused on a single point" (Nagata Hiroshi)—began to break down and researchers pursued different projects. As various people pondered over issues that were only partly understood, such as the doctrines on the natural rights of men, Christianity, the theory of evolution, German idealism, and so forth, the differences between these doctrines came into focus.

2. Inoue Tetsujirō (1855–1944) was a first-time graduate of the philosophy department of the University of Tokyo, founded in 1877. In *The New Theory of Ethics* Inoue argues that "those who like me want to become scholars of philosophy must necessarily investigate the substance of ethics."

difficult and deeper points, no matter how different past and present theories are, and how numerous Eastern and Western arguments are, we should make an effort to classify them."

Inoue's philosophical system—known as "phenomenalism or realism"—ends, however, by subsuming different knowledge from past and present, East and West, under the versatile concept of "reality," in which difference is maintained as such. Inoue's thought is essentially a form of eclecticism. In other words, Inoue seized knowledge in its given "immediacy" without having it mediated by its own subject.

The first task of Ōnishi Hajime (or Sōzan, 1864–1900) was to critique simplified systematizations such as the one exemplified by Inoue.[3] Taking as an example *Tetsugaku Issekiwa* (A Night of Philosophical Thoughts, 1886) by Inoue Tetsujirō's beloved disciple, Inoue Enryō,[4] Ōnishi pointed out the eclecticism of that work, and he vented his indignation at the easy currents of the times: "Oh, how I used to dislike that little book; how I used to grow weary of that booklet which was read in a dash; how tiresome that so-called 'new discovery'!" ("Reading the Second Edition of *A Night of Philosophical Thoughts,*" July 1887, *Rikugō Zasshi*).

It would not be a correct assumption, however, to immediately conclude that Ōnishi was an isolated thinker cut off from the mainstream of Meiji thought.[5] In the introduction to *Seiyō Tetsu-*

3. Ōnishi Hajime, the son of a samurai of the Ikeda fief, was born in 1864 in Okayama. After studying in the English department of Dōshisha University, he enrolled in the philosophy department of the University of Tokyo. After graduating in 1889, Ōnishi went to graduate school. From 1891 he taught philosophy, psychology, logic, ethics, aesthetics, and the history of philosophy at Tōkyō Senmon Gakkō (now Waseda University). Together with a group of young scholars of ethics, he established and led the Teiyū Konwa Kai (1897 Social Gathering Society)—later called the Teiyū Rinrikai (1897 Ethical Society). In 1898 Ōnishi studied in Europe at the universities of Jena and Leipzig. He was scheduled to be appointed president of the newly founded Kyoto Imperial University after his return to Japan, but in 1899 he fell ill and was forced to return to Japan where he received medical treatment in Tokyo and Kamakura. In 1900 he returned to Okayama, where he died on November 2. In 1903–1904 the seven volumes of his collected works *(Ōnishi Hakase Zenshū)* were published by Keiseisha. All quotations in this essay follow the Keiseisha edition.

4. [Inoue Enryō (1858–1919), a prominent scholar of Eastern thought, advocated a nationalism based on Buddhism. Ed.]

5. In *Japan's Idealists,* Funayama Shin'ichi sees a line connecting Inoue Tetsujirō to Nishida Kitarō as representatives of the mainstream history of philosophy during the Meiji period but positions Ōnishi as a figure outside. Not only does this view ignore the fact that Nishida despised Inoue and praised Ōnishi, but it also overlooks the fact that Ōnishi searched actively for a systematization of philosophy.

gaku Shi (History of Western Philosophy, 1895), Ōnishi argues that at first he was satisfied with "fulfilling the many practical tasks of life," but following the "development of my power of thinking," he "could not remain satisfied with a vague notion of common sense." He "had to clarify it, reaching the point where, out of a desire to remove all self-contradictory points, one never rests." Then he searched "for basic principles in which to ground generalizations of individual phenomena," and he tried to create "a systematic knowledge" by "unifying the whole." This was nothing other than "philosophy." It is clear that Ōnishi aimed at creating a systematic philosophy.

We must ask why Ōnishi, who searched so vigorously for a system, felt compelled to deny the Inoue type of system. In the answer lies the essential meaning of Ōnishi's criticism. In "Hihyō Ron" (Essay on Criticism), which appeared in the May 1888 issue of *Kokumin no Tomo* and clarified for the first time his position on criticism, Ōnishi argued as follows: The future thought of our country will be the outcome of a process of "conflict" and "reconciliation" between a traditional Chinese and Indian thought and the new influx of Western thought. Accordingly, "today's scholars of our country must clarify Chinese thought, make an exhaustive study of Indian thought, and possess a thorough knowledge of Western thought for the sake of our country's future." Ōnishi shared with Inoue Tetsujirō the intention of choosing among various Eastern and Western thoughts to create a systematic philosophy. But in the latter part of his argument, Ōnishi largely departed from Inoue.

Of the three elements China, India, and the West, "today's critics must devote most of their attention to Western thought." The reason is that in traditional Japanese thought there are no such concepts as "to argue critically, to judge the value of such criticism, and to acknowledge the truth." Therefore, "first of all we have to adopt Western thought and emulate its critical methods." Ōnishi clearly differentiated between "Western thought" and "its critical methodology." For Ōnishi, Western critical methods were not to be found on the same plane as Chinese and Indian thought but were held to be ways to make meaningful all objects, including Western thought. In other words, Ōnishi arrived at a speculative methodology much larger than any specific Western thought, one that actually allowed him to grasp such a thought. This concept, which we could call "methodological awareness," is related to the fact that Ōnishi possessed a deep understanding of Kant's epis-

temology. Evidently Ōnishi's "criticism" corresponds precisely to Kant's *Kritik*.[6]

In the essay "Chishikiron Ben" (Debate on Epistemology), which appeared in the journal *Shisō* in October 1893, Ōnishi developed a full-scale argument on epistemology: "The right question in epistemology is to ask what is knowledge, and how knowledge is formed." In this way, "we advance beyond the childish belief of those who see knowledge as something first to be acquired," and "once we start understanding what knowledge is all about, then, upon reflection, we are in a position to correct such a mistake." In this passage we find a correct understanding of modern epistemology. Exactly this kind of feeling toward the subject that "makes" knowledge sustains what I have previously called "methodological awareness." If knowledge is "made" by the subject, then it is only natural to argue that we must grasp the relationship between knowledge and the method or principle that creates it. If one tries to join together given knowledges as if they were simply given, as Inoue Tetsujirō did, then one can only come up with a vulgar eclecticism. This explains why Ōnishi, starting from Kantian premises in his search for a system, had first of all to dismantle the easy systematizations of the Inoue school.

We see the methodological differences between Ōnishi and Inoue most vividly in the "conflict between education and religion" incident. In "Kyōiku to Shūkyō no Shōtotsu" of April 1883, Inoue Tetsujirō began his argument by referring to Uchimura Kanzō's lèse-majesté affair.[7] He continues by describing every way in which Christianity conflicts with the Japanese tradition, concluding his remarks with the statement that "in short, from the beginning, Christianity did not suit

6. Ōnishi consistently used the word *"chishikiron,"* but this was the translation of the expression "theory of knowledge" and was synonymous with "epistemology" *(ninshikiron)*. In order to see how accurately Ōnishi grasped the meaning of Kant's epistemology, it would be sufficient to look at the following quotation from the chapter "Immanuel Kant" of Ōnishi's *Seiyō Tetsugaku Shi* (History of Western Philosophy): "The standpoint of Greek philosophers and all later theories based on such a standpoint was premised on the fact that all objects of our knowledge are given from outside and our knowledge reflects those objects. With Kant, however, we witness a change leading us to see that the object of knowledge is nothing but the product of our intellectual activity based on the power of knowledge.[. . .] The rules of the natural world, therefore, are not given to us from the outside. We give those rules to the natural world. The legislator is not an outward thing; it is us."

7. [The author is referring to Uchimura Kanzō's (1861–1930) reluctance in 1891 to bow before the imperial portrait because of his belief in the Christian God. Ed.]

our country." This conclusion clearly indicates a lack of mediation in Inoue's thought. Given the vagueness of the notion of "reality" at the root of Inoue's system, no matter what he tries to bring to it or what he tries to expel from it, at the end the system remains at the mercy of Inoue's own arbitrary judgment.

In response to Inoue's position, Ōnishi published "Tōkon no Shōtotsu Ron" (The Debate on the Present Conflict) in the June and July 1883 issues of *Kyōiku Jiron,* in which he criticizes Inoue by saying that "a supreme reconciliation" is something "to be achieved by going though a conflict. . . . The presence of conflictuality in various aspects of our contemporary life following the entrance of Christianity into our country" is nothing more than "a conflict between progress and conservatism" generated by the "injection" of a "new concept."

> When they are received by old concepts, new concepts bring a transformation to the receiving old concepts. While being transformed into the receiving concepts, the received concepts transform in turn the receiving concepts. . . . While becoming Japanized, Christianity inevitably transformed Japan.

Unlike Inoue Tetsujirō, Ōnishi did not arbitrarily reject the non-matching elements; rather, he "longed for a point of union where many antagonistic directions would somehow come together." To use his own words, in order to reach "a rich union" he dismantled "a poor union"—an expression that well defines Ōnishi's position in the intellectual history of the Meiji period.

Ōnishi's reputation is vividly displayed in his *Rinrigaku* (Ethics), which contains the lectures he gave in 1896 at Tōkyō Senmon Gakkō (now Waseda University). In this work Ōnishi examines, one by one, several theories on ethics from "intuitivism" to "formalism," "authoritarianism" to "hedonism." He goes back to their a priori principles and analyzes their internal contradictions and confusions.

Ōnishi died without completing his system. As Tsubouchi Shōyō stated during the memorial service: "His fragmentariness was like a golden fish flickering in the rift between the clouds; it might suffice to imagine him a dragon in the shape of man. It is regrettable that he could show to us only his tail, or his leg" ("Ōnishi Hajime," in *Shōyō Senshū,* vol. 12). The achievements of Ōnishi, who criticized contemporary tendencies toward easy systematizations and sought out all the different principles that had to be mediated in the new

system, undoubtedly played an important role in the intellectual history of the Meiji period. In "Gakujutsu ni Okeru Sokuratesu no Jigyō" (Socrates' Scientific Activity), which appeared in *Rikugō Zasshi* in December 1895, Ōnishi made statements about Socrates that apply to Ōnishi himself. Socrates' "greatness was not in forming a specific theory but rather in his actions based on the spirit of research and the facts that he researched, as well as in his thorough judgment." Moreover, "the achievements of those who, although they do not create great scientific systems, open the eyes of later generations and show a new spirit and new ways of proceeding along the path of research, are in no way inferior to the achievements of the most outstanding systematizers."

On His Aesthetic Thought

The Early Period: A Critique of Traditional Aesthetic Perception

We can largely divide Ōnishi's work on aesthetics into two categories: first, the essays written between 1887 and 1889 on the relationship between art and religion and on the artistic spirit of the Japanese and, second, the essays produced between 1895 and 1897 that attempt to create, with the aid of philosophy, an aesthetic system.

First I will talk about the earlier essays. Ōnishi's first article on aesthetics, "Bijutsu to Shūkyō" (Art and Religion), appeared in April 1888 in the Christian journal *Rikugō Zasshi*. First of all, Ōnishi shows the "incompatibility" between art and religion in ancient times, taking examples from ancient Greece, the Holy Land, and ancient Rome. He explains the cause by saying that "the concepts of art and morality tend to take slightly different routes in this world of reality." Ōnishi argues, however, that the reason for the conflict between the notions of art and religion is the state of "imperfection" in which both find themselves: in an "ideal world," not only are "beauty" and "good" not in opposition to each other but they are actually inseparable. If art gets closer to the "position of the absolute," therefore, even in the real world religion or morality can be reconciled with art. As a concrete example Ōnishi mentions the painting of a Madonna that moves "an illiterate woman," arguing that "masterpieces of all ages, while they appeal to women's notions of beauty, also strangely appeal to their sense of morality and religion."

It was not simply a logical interest that led Ōnishi to pay attention to the relationship between art and religion. Exactly one year earlier,

on April 1887, he had written an essay that appeared in *Rikugō Zasshi* with the title "Waka ni Shūkyō Nashi" (There Is No Religion in *Waka*).[8] In this essay Ōnishi argues that whether it be Caedmon, Wordsworth, or Tennyson, English poets always express "religious thought" in their poetry. However, he says, "I must reach the unpleasant conclusion that in *waka* there is no religion." He concludes that in this sense the traditional literature of Japan is inferior to the literatures of India and China. Japanese literature "does not go beyond simply stating that I am moved by the moon, I am moved by the cherry blossoms, I long for my beloved."

> The reintroduction of Christianity, together with the recent importation into our country of Western culture and institutions, is on the verge of effecting great changes. Will Christianity remedy this lack which we find in *waka?* Will Christianity provide religious life to our national literature?

Ōnishi analyzed Japan's traditional arts from the standpoint of Christian belief, pondering the question of how to create a new art befitting the new age. The essay "Art and Religion," mentioned earlier, essentially discusses the relationship between art and religion from a practical perspective.[9] "Nihonjin wa Geijutsugokoro ni Tomeru ka" (Are the Japanese Rich with Artistic Spirit?) published in *Jogaku Zasshi* (December 1888), examines Japan's traditional aesthetic sense from the same perspective. Here Ōnishi argued that, apparently, many Japanese think that "generally speaking Japan falls behind the West."

8. [For a complete English translation of this essay see Marra, *Modern Japanese Aesthetics,* pp. 83–92. Ed.]

9. It is well known that in the academic world, Ōnishi's thought influenced Nishida Kitarō and provided inspiration to Takayama Chogyū. Here I want to point out also the possibility that Ōnishi's idealistic aesthetic thought and his critique of Japan's traditional arts might have influenced Kitamura Tōkoku. From Shimazaki Tōson's novel *Sakura no Mi no Juku Suru Toki* (When the Cherries Ripen) we know the respect that Literary World (Bungakkai), a group that revolved around Tōkoku, had for Ōnishi. In "Takai ni Taisuru Kannen" (Idea Against the Otherworld) (*Kokumin no Tomo,* 1892), Tōkoku makes the following remarks: "At the same time that the divine nature of God makes the idea go where Eastern spiritual thought cannot reach, the evil nature of Satan makes the idea reach the place where Eastern evil thought cannot go. . . . To conclude that our literature is delicate and clever but lacks sublimity and greatness is to say that it lacks the idea of the otherworld and concerns itself only with things near at hand" (*Meiji Bungaku Zenshū,* vol. 29, Chikuma Shobō, pp. 105–106). Tōkoku's belief that the legacy of Christianity in Japan was the fact that the nature of art is the idea—and his realization that, in this regard, the Japanese traditional arts were lacking—clearly points to Ōnishi's influence.

In one activity only do they excel, and that is art. Ōnishi brings up the problem that "further investigation" is needed on this point.

What is "beauty"? "Beauty" is said to be made of three elements: substance (stuff or matter), rules (law), and thought (ideas or form). It is necessary that the three elements "harmonize" into a whole, but the "protagonist" remains thought: "The more thought is elevated, clear, and noble, the more noble the type of art becomes."

The fact that "Westerners sometimes praise Japan as the country of art" refers especially to "lacquerware, porcelain, netsuke,[10] swords, screens, single-leaf screens, fans, clothes"—in a word, "fixture art." "So far as the most elevated arts such as poetry and music are concerned, we certainly cannot face Western countries with pride." This is not to deny any value to "fixture art," but it is to point out that it is a mistake to boast about the "Japanese artistic spirit" based on such achievements.

> In order to promote art, artistic education is important. . . . In order to avoid falling into the abuses of eccentricity, artistic education must be grounded in the science of aesthetics that is deemed today to be the most scientific.

Ōnishi stresses the need to create a new art through an education grounded in a correct aesthetics as opposed to those who simple-mindedly support Japan's traditional arts based on the evaluation of a few Westerners.

Ōnishi's argument follows the same lines in the essay "Wagakuni Bijutsu no Mondai" (The Problem of Art in Our Country), which he published in July of the following year (1889). In this article Ōnishi acknowledges that recently, because of "a tendency toward the preservation of the national character" and "the admiration of our country's art on the part of foreigners," the number of people calling Japan "the country of art" has suddenly increased. Ōnishi questions whether this is a correct assessment. Moreover, he stresses the need to examine this problem from different angles and emphasizes the indispensability of a theoretical inquiry grounded in a "philosophical aesthetics." Therefore, while encouraging the development of artistic techniques in our country, at the same time he "cannot stop from hoping to encourage the development of the science of art."

10. [An ivory carving worn above the girdle to hold the tobacco pouch in place. Ed.]

The Later Period: Striving after a Systematic Aesthetics

Ōnishi presents a thorough theoretical investigation of aesthetics in "Kanbigokoro to Nikukan" (The Heart of External Beauty and Physical Sensations), published in the May 1895 issue of *Rikugō Zasshi*. In this article he takes up the problem of "nude paintings," adding his own aesthetic considerations.

At the beginning of the article Ōnishi introduces the clash between the "sensationist school" and the "idealistic school," pointing out that although the "ideal" becomes the content of "beauty," in order for beauty to elicit "aesthetic pleasure" the senses must work as intermediaries. Moreover, Ōnishi argues that "the whole of that which is interesting in our spiritual life is the content of beauty; ultimately, our Spiritual Personality is the content of beauty."

Even the passions between a man and a woman and vice are "part of our spiritual life." "There is no reason to say that nude paintings are not true art" because they only arouse "carnal desire." It is necessary for this sensation, however, to be a detached sensation. "The necessity of aesthetic activity lies in the place that produces an image which has cut its ties with the real world and is isolated within the mind." On the other hand, "the nude painting which is perceived as pure physical sensation and carnal desire in the real world is not yet a work of art." Accordingly, when the nude painting harms the public morals, there arises the need to control it. Since "the decision as to what constitutes moral harm" is a matter of custom, however, "the expected impact on public morals will not occur if people are used to that kind of painting."

Ōnishi admits that "of course it is useless to paint a naked beauty to the point of harming public morals," but he makes clear that his primary object is not the matter of control but the public morals created by "Philistines who lack the aesthetic eye." Ōnishi criticizes the attitude that would restrict artistic expression for the sake of maintaining the Japanese sense of "public morality."[11]

11. Ōnishi consistently took the position of not hastily rejecting newly received things that collided with tradition and, as well, waiting for old and new elements to develop into a whole. Even in "the conflict between education and religion" incident of 1893, Ōnishi argued that the state should not intervene but should "quietly dwell within the situation." "We cannot say that the future holds great hope for weak people who cannot assimilate the new, even if, following their advice, Christianity and other thoughts are not let into our country" ("Tōkon no Shōtotsu Ron").

One month later Ōnishi published "Shinbiteki Kankan wo Ronzu" (Essay on Aesthetic Senses) in *Rikugō Zasshi.* This is the first essay in which Ōnishi abandoned his interest in current events in order to deal exclusively with issues of pure aesthetics. Ōnishi addresses the orthodox view of aesthetics according to which only the "higher senses (sight and hearing)" are related to "beauty," unlike the "lower senses such as smell, taste, and the like." What was the reason? Ōnishi developed the argument that it is not sufficient to simply state that such and such is the truth with regard to this topic. "I cannot refrain from asking about the reasons."

Next, in order to answer the question properly, Ōnishi analyzes the theories on "aesthetic appearance" *(aesthetischer Schein)* of Schiller, Hegel, and Hartmann, as well as Spencer, G. Allen, Guyau, and others. He then presents his own criticism of these theories and gives his own conclusions. "The distinction in aesthetics between fiction and truth is dependent on separation and the lack of it. . . . The aesthetic object is an image that is temporarily separated from the real world." Seen from this perspective, it becomes useless to make a "distinction" between "aesthetic" and "nonaesthetic" sense organs. Simply, when we "isolate" the senses, a mediation occurs mainly through "the intuition of space (an activity of sight)." Therefore, if we want to single out a specific sense organ, we should privilege "the organ of sight."

Here we can see a characteristic of Ōnishi's method, that is, his way of inquiring by going back to the "ground." Ōnishi did not simply accept uncritically the theories of Western philosophers; he sought out the a priori assumptions on which those theories were based, and he questioned them. Thus he was able to critique Hegel, Hartmann, and others and build up his independent point of view.

From January to February 1897, in *Waseda Bungaku,* Ōnishi published "Kinsei Bigaku Shisō Ippan" (Outline of Early Modern Aesthetic Thought) in which he developed the system previously introduced in "The Heart of External Beauty and Physical Sensations" and "Essay on Aesthetic Senses." Here we see a heightening of Ōnishi's concern for aesthetic theory.

Ōnishi distinguished broadly between the "idealist school" and the "psychological school." Based on idealistic philosophy, the idealist school interprets beauty as the discovery of the absolute and is represented by Hegel. The psychological school, on the other hand, tries to explain the experience of beauty within the sphere of experimental

psychology. In contrast to the psychological school, which had not yet produced sufficient results, the idealist school had come, with Hartmann, to the point of building "a majestic system" so that "we feel there is no ground left to reclaim, not even a little step."

After arguing along these lines, Ōnishi calls the reader's attention to the fact that the two schools, despite following different paths, almost reach the same conclusions. He then mentions several scholars representative of both lines of thought and examines their theories, reaching the conclusion that the elements of the spiritual life, in which the sense of beauty "comes apart" from "the real life," are various and diverse. Ōnishi sums up his article by stating his belief that "the results achieved by former scholars of aesthetics must be the departing points for future investigations."[12]

Ultimately, Ōnishi was unable to build an aesthetic system. We should recognize his work, however, as the foundation for a new system and acknowledge also the role that Ōnishi played in analyzing the a priori assumptions that were the ground of several aesthetic thoughts.[13]

12. From 1898 to 1899 Ōnishi published "Shinbi Shinsetsu" (A New Aesthetic Theory) in *Waseda Bungaku,* but the article remained incomplete because of the author's departure for Europe. The essay is simply an introduction of new works by George Santayana (1863–1952).

13. For further information on Ōnishi Hajime's thought see the chapter "Ōnishi Hajime and the Problem of Mediation," in Watanabe Kazuyasu, *Meiji Shisō Shi* (Tokyo: Perikansha, 1985).

6

The Aesthetic Thought
of Shimamura Hōgetsu

Yamamoto Masao

With regard to the legacy of Ōnishi Hajime (1864–1900)[1] in the cultural history of the Meiji period, we can say that if Tsunashima Ryōsen (1873–1907)[2] was the disciple who took over, for the most part, the ethical side of Ōnishi's research, it was Shimamura Hōgetsu (or Ryūtarō, 1871–1918) who inherited and developed the aesthetic side. Hōgetsu graduated from the Faculty of Letters of Tōkyō Senmon Gakkō (now Waseda University) in 1894 after he had already shown an interest in the study of aesthetics—a field in which he was trained by Ōnishi Hajime, whose explanation of aesthetic issues Hōgetsu recorded in his notes.

In the earlier stages of his thought on aesthetics Hōgetsu followed Ōnishi closely, as we can see from the articles he published at the time in the journal *Waseda Bungaku*. We find an example in "Shinbiteki Ishiki no Seishitsu wo Ronzu" ("A Discussion of the Qualities of Aesthetic Consciousness," September–December 1894, *Waseda Bungaku*), in which Hōgetsu examines "the steps in the order of formation of aesthetic consciousness from the standpoint of the subject." In his discussion he distinguishes between "qualities of consciousness" and "elements of aesthetic consciousness." In the category "qualities of consciousness" Hōgetsu listed (1) "the relationship between mind and thing"; (2) "consciousness"; and (3) "intellect, heart, and will." "Elements of aesthetic consciousness" are minutely classified as (1)

From Yamamoto Masao, "Shimamura Hōgetsu no Bigaku Shisō," in Yamamoto Masao, *Tōzai Geijutsu Seishin no Dentō to Kōryū* (Traditions and Interchanges of Eastern and Western Arts) (Tokyo: Risōsha, 1965), pp. 103–110.

1. [See Chapter 5. Ed.]

2. [Tsunashima Ryōsen, ethicist and critic, worked on the editorial staff of the journal *Waseda Bungaku*. Takayama Chogyū considered him, together with Shimamura Hōgetsu, one of the "two geniuses of Waseda University." Ed.]

"emotions"; (2) "sympathy"; (3) "aesthetic consciousness"; (4) "ideas"; (5) "real and provisional," "reality and phenomenon," "form and thought," "natural beauty and artistic beauty," "real and ideal," and so forth.

In summarizing Hōgetsu's main ideas we can say first of all that he viewed "mind and thing as the two sides of the same coin." He saw the act of being brought to consciousness as "discriminatory I"; the substance that produces consciousness he called "equal I." The harmonization of both brings about a perfect subject. With regard to the "elements of aesthetic consciousness," Hōgetsu argued that the most remarkable phenomenon in aesthetic consciousness is the emotion of pleasure: "What elicits the growth of the subject is pleasure; what makes it stagnant is displeasure." Moreover, he discussed the issue of "sympathy," in which "the I departs from a productive will, wearing the emotion of the outcome of production, and penetrates consciousness together with the object." Hōgetsu states that the height of aesthetics is the state of consciousness in which subject and object are harmonized and the I and other are flexible. Accordingly, aesthetic consciousness is "first a harmonized sympathy between the discriminatory I and the object by a unified idea. Second, and contrary to this, aesthetic consciousness contains these two conditions in which the equal I manifests its satisfaction." Furthermore, Hōgetsu, basing his discussion on the theory of sympathy, talked about the pleasure of sorrow, criticizing the theories of David Hume (1711–1776), Edmund Burke (1729–1797), and others. He also discusses the "perfection and universality" of aesthetic ideas, as well as the differences between natural beauty and artistic beauty that express these ideas and produce differences in taste. Along these lines, he concludes by stressing the need to harmonize real and ideal.

Around the same time, Hōgetsu analyzed from the same perspective the philosophy, beauty, and structure of tragedy in a comparatively shorter essay titled "Higeki Ron" ("Essay on Tragedy," April–May 1895, *Waseda Bungaku*). In "Kiin Seidō" ("Lifelike Refinement," June 1895, *Waseda Bungaku*) he referred to the theories of Schiller and others, stating that "things are alive in my heart." In "Henka no Tōitsu to Sō no Kagen" ("The Unification of Change and the Apparition of Thought," July 1895, *Waseda Bungaku*) he discussed the Hegelian process whereby thesis and antithesis come together. Moreover, in "Shinki no Kaikan to Bi no Kaikan to no Kankei" ("The Relationship between the Pleasure of Novelty and the Pleasure of Beauty,"

September 1895, *Waseda Bungaku*), he talked about differences be-
tween the two kinds of pleasure from the perspective of psychology-
based aesthetics. In "Ongakubi no Kachi" ("The Value of Musical
Beauty," May 1896, *Waseda Bungaku*) he quoted Arthur Schopen-
hauer (1788–1860), stating that the true character of music is found
in its formal beauty. We must pay particular attention to an essay titled
"Shinbiteki Kenkyū no Ippō" ("One Method of Aesthetic Research,"
May 1896, *Waseda Bungaku*) in which Hōgetsu articulates methods
for the study of aesthetics. He classifies them as (1) "studies from
the double perspective of the subjective and the objective"; (2) "his-
torical and comparative studies"; (3) "inductive and deductive anal-
yses"; (4) "studies of consumers and authors"; and (5) "linguistic
study," arguing that all these approaches should be used so long as
they do not contradict each other. Analogously, Hōgetsu supplied all
these methodologies to "Wakan no Biron wo Kenkyū Subeshi" ("The
Need to Study Debates on the Beauty of Japanese and Chinese,"
December 1896, *Waseda Bungaku*) in which he lists the standards of
(1) "tastes of beauty," (2) "purpose of beauty," (3) production of
beauty," (4) "nature of beauty," and (5) "place of beauty," stressing
the need to study, in particular, the Japanese history of aesthetics.

In 1902 Hōgetsu completed a one-volume manuscript, *Shin Biji-
gaku* (New Rhetoric; published in May by Tōkyō Senmon Gakkō),
and then he started a tour abroad. The volume was written from an
aesthetic perspective as a result of Hōgetsu's belief that "because a
composition is a kind of art, rhetoric, which discusses the principles
of art, should be immediately considered a kind of essay on the arts.
Moreover, from essays on art we deduct the science of aesthetics."
Accordingly, he directed his attention to "the study of beauty as it
appears in compositions made following the rules of rhetoric," and
he worked "to insert this research within the system of aesthetics."
He organized the book in a first section, "Introduction," which
comprises three chapters: (1) "The Name of Rhetoric," (2) "What Is
Rhetoric?" and (3) "Changes in Rhetoric." This is followed by a
second section, "Rhetoric," again in three chapters: (1) "The Struc-
ture of Rhetoric," (2) "Figures of Speech," and (3) "Style." The third
section, "Beauty," includes six chapters: (1) "The Project of Beauty,"
(2) "Emotional Activity and Pleasure," (3) "Pleasure and Beauty,"
(4) "The Philosophical Aspect of Beauty," (5) "The Scientific Aspect
of Beauty," and (6) "Conclusions." This book is now an amplifica-
tion, now a summary, of Hōgetsu's earlier views on aesthetics. Basi-

cally it draws attention to the fact that "there are two aspects to the analysis of beauty, a philosophical one and a scientific one," and notes that investigations into the psychological ground of beauty are related to the study of its philosophical ground.

In 1905, after his return to Japan, Hōgetsu clarified his increased inclination toward biological and psychological aesthetics in essays such as "Dōteki Bigaku" ("Dynamic Aesthetics," February 1906, *Waseda Bungaku*), "Bigaku to Sei no Kyōmi" ("Aesthetics and the Zest for Life," October 1907, *Waseda Bungaku*), and others. This tendency was grounded in a sort of hedonistic philosophy. "Dynamic Aesthetics"—an introduction to *Die Theorie des Schönen* (The Theory of Beauty, 1903) by the German Theodor Dahmen—is a short essay explaining "an aesthetics based on the principle of movement" from the standpoint of biological psychology. "Aesthetics and the Zest for Life" has three parts: "The Philosophy of Life," "A Theory on Play," and "The Promotion of Life and Beauty." From this essay the reader can obtain a fairly detailed picture of Hōgetsu's views.

According to this essay, there is no reality in the universe more important than life, nor a more desirable state of existence. Morality and religion are nothing but an increase and a fulfillment of life. Therefore, "the philosophy of life comes into being when every value, interest, and wish are included in the unity of life." Moreover, since this perpetual increase of life has as its aim "the psychological phenomenon known as pleasure, which results from the fulfillment of wishes," theories based on such a zest for life are connected to hedonism; they take a pragmatic, utilitarian stand. When we analyze this issue from the perspective of aesthetics, however, theories such as Kant's "lack of purpose," Schiller's "play drive," and, more recently, Spencer's[3] "luxurious activity" and Wilde's "estheticism" present sev-

3. [Herbert Spencer (1820–1903): "In the great organisms of nature and human society, each functional part and each structural feature is determined by its peculiar utility. All our bodily powers and mental faculties, the instincts and appetites as well as the highest feelings, subserve either the preservation of the individual or the maintenance of the species. There are only two activities which are exceptions to this rule and they belong together by their very exemption from the dominion of necessity: art and play. It is true that activities of these orders may bring the ulterior benefit of increased power in the faculties exercised. But they have this indirect effect in common with the primary actions of the same faculties. Art and play are, as it were, the luxury of life. The individual, pausing from his attendance on the serious business of his exis-

eral problems. After all, "the world of research on beauty is divided into two camps—those who argue that beauty and life are joined together and those who distance beauty from life, thus limiting the issue to either utilitarianism or to estheticism." The second position, however, according to Hōgetsu, has been criticized from four different angles. It is no wonder that it has become suspicious. Namely, it has been discredited by (1) the anthropological research on the origins of art on the part of Hirn;[4] (2) the ancient aesthetic thought of Plato and his followers; (3) the position taken by modern idealists in the aesthetic field; and (4) the emphasis on sociological research on the part of Guyau and others.[5] In order to formulate a judgment with regard to these two positions, Hōgetsu further expands on the evolutionary theory of aesthetic feelings formulated by Ribot,[6] stating that there is no other way than to ponder over the development of the following four stages: (1) "the period of close adhesion of beauty and utility"; (2) "the period of half separation"; (3) "the period of complete separation"; and (4) "the period of reunification." Accordingly, Hōgetsu basically followed Ribot in setting up, with regard to aesthetic feelings, the categories of "annexed practicality" and "basic vital function," expressing the need to privilege especially the latter. Hōgetsu argued that by using the word "utility," he was not referring to its secondary shallow meaning, "to promote good and chastise evil," but was instead referring to its primary deep meaning of "to directly aid in the improvement of life rather than merely sustaining it."

A short time later, Hōgetsu took up the challenge of writing an

tence, is allowed to enjoy the abundance of his energies. Taking 'play' for the general term denoting this type of useless exercise of energy, we may classify art as a kind of play." See Katharine Everett Gilbert and Helmut Kuhn, *A History of Esthetics* (Bloomington: Indiana University Press, 1954), p. 541. Ed.]

4. [Yrjö Hirn (1870–1952) wrote *Origins of Art* in 1900. "The author is critical of the play theory as a merely negative explanation. Art, he thinks, has to serve a twofold purpose. It makes us enjoy that rich and complete sensation of life for which we strive the more eagerly the greater our vitality. And at the same time we find in art deliverance from the oppression of overstrung feeling." See Gilbert and Kuhn, *History of Esthetics*, p. 543. Ed.]

5. [Jean-Marie Guyau (1854–1888) opposed the notion of art for art's sake. He is the author of *L'Art au Point de Vue Sociologique* (Art from a Sociological Point of View, 1887), which Ōnishi Yoshinori translated into Japanese in 1914. Ed.]

6. [Théodule-Armand Ribot (1839–1916) is considered the father of French scientific psychology. He is the author of *La Psychologie des Sentiments* (The Psychology of Feelings, 1896), *Logique des Sentiments* (The Logic of Feelings, 1905), and *Essai sur les Passions* (Essay on the Passions, 1907). Ed.]

introductory explanation of aesthetics in a book titled *Bigaku Gairon* (Outline of Aesthetics, 1909). The book is made up of the following chapters: (1) the history of aesthetics; (2) the autonomy of aesthetics; (3) methods and purpose of aesthetic research; (4) several essays on beauty; (5) the definition of beauty; (6) the sphere of beauty; (7) types of beauty; (8) expressions of beauty; and (9) general remarks. Hōgetsu contributed another volume to the same collection (*Bungei Hyakka Zensho,* or Encyclopedia of the Literary Arts) titled *Bungei Gairon* (Outline of the Literary Arts, 1910). Hōgetsu states that the name "literary arts" includes "literature, paintings, sculpture, architecture, drama, and dance." In other words, this work was an outline of the structure, purpose, and meaning of the arts. Accordingly, the content consisted of (1) the study of the arts; (2) the origin of the arts; (3) artistic instinct; and (4) the purpose of art. Around the same time, Hōgetsu published critiques of modern European art such as, for example, "Ōshū Kindai no Chōkoku wo Ronzuru Sho" ("Debate on Modern European Sculpture," April 1907, *Waseda Bungaku*), and "Ōshū Kindai no Kaiga wo Ronzu" ("Debate on Modern European Paintings," January 1909, *Waseda Bungaku*). At the same time, he was active in Japan's literary circle as an advocate of the theory of naturalism *(shizenshugi)* and became an influential voice in the field with articles such as "Bungeijō no Shizenshugi" ("Naturalism in the Literary Arts," January 1908, *Waseda Bungaku*), "Shizenshugi no Kachi" ("The Value of Naturalism," May 1908, *Waseda Bungaku*), and "Jinseikanjō no Shizenshugi" ("Naturalism in the Conception of Life," 1909, "Preface" to *Kindai Bungei no Kenkyū,* or A Study of Modern Literary Arts).

Earlier I mentioned that a characteristic of aesthetic thought in late Meiji can be seen in the autonomization of the field from the artistic trends of the time, as well as its concern for methodological reflection. And yet we must ask how Hōgetsu—a brilliant participant in the critique of the arts who eventually abandoned the teaching environment in order to dedicate himself completely to the art movements themselves and embraced a kind of utilitarian view in the aesthetic field—was finally able to interpret the relationship between aesthetics on the one hand and art criticism and actual artistic practice on the other. Hōgetsu formulated a clear answer to this question in an unfinished manuscript titled "Bigaku" ("Aesthetics," 1912, lecture at Waseda University), in which he brought to a conclusion his aesthetic thought. The manuscript includes an introduction; a first section, "The

Meaning of Aesthetics"; and a second chapter, "Research Methodologies in Aesthetics." It also mentions the following subjects: Chapter 1, "The Physical Structure of Aesthetics"; Chapter 2, "Psychological Aspects of Aesthetics"; Chapter 3, "Social Transformations of Aesthetics"; Chapter 4, "Art Drive." The answer to the question posed earlier is found in the introduction.

According to this work, there are three types of sciences: applied sciences, interpretive sciences, and value sciences. In applied sciences, "inquiries immediately connect with practical use"; they "include in their explanations their own rules of applicability." Under no circumstance do they become independent or separate, and they combine with interpretive sciences. Interpretive sciences "posit and infer a posteriori the rules that penetrate specific realities and, to the extent of their explanatory power, they usually try to unify their explanations into simple principles." The third type of sciences, value sciences, consists of "the study of values that see either individual or theoretical phenomena," which are examined by the other two sciences, "in relation to our lives." Assuming that we accept that the applied sciences directly help our lives, to which they are linked together with the interpretive sciences, we still need to explain the relationship between the interpretive sciences and the value sciences. Whether people call them factual sciences or value sciences, "they are remarkably like interpretive sciences inasmuch as both derive from knowledge the principles that regulate them and attempt at unifying and explaining those principles." "Unlike factual phenomena," however, "value-related phenomena are accompanied by the problem of origin from which they always derive." Accordingly, "since this origin is life, value sciences are related to life." In this sense value sciences, namely philosophy, "do not simply provide scientific explanations and are not simply the sum of principles;" they are "human sciences." From this perspective value sciences must "ground themselves in the understanding of the formation process of the phenomena they study." At this juncture "interpretive sciences make value sciences more reliable."

Once we apply to aesthetics the ideas mentioned above, "aesthetics as an applied science" becomes a "teaching of (1) the rules of appreciation, (2) the rules of creation, and (3) the rules of criticism." Aesthetics as an applied science, however, is "subordinated, conditional, and unnecessary; at this level aesthetics as a totality is of little value." Thus it becomes necessary to add the other meaning, namely "aesthetics as a value science." The research method that needs to be estab-

lished in order to study aesthetics as "one of the human sciences" is fourfold—the result of inquiries from different sides: "(1) a study from the physical side of the phenomenon of beauty; (2) a search for specific explanations from the psychological side; (3) an analysis of transformations from a sociological angle; (4) a study of the philosophical/spiritual content." Hōgetsu, however, argues that since all these approaches come together in the creation of one body of studies, prejudice favoring one side over the others should be avoided. Thus we come to see how aesthetics has progressed from a simple utilitarian technique in formulating judgments in the arts, to an enterprise performing various kinds of interpretations, and finally to a philosophical study of beauty as a value science.

7

The Aesthetician Takayama Chogyū

WATANABE KAZUYASU

It would be difficult, given the variety of fields he helped to develop, to define the main activity in which Takayama Chogyū (1871–1902) was engaged. This might also be due to the impetuous drive that led Chogyū to try his hand in different areas—attempts that led to a dispersion of talent. Nevertheless, if I am allowed to begin from the conclusion, I believe that a most appropriate definition would be to call him an aesthetician. We might elaborate upon this definition by arguing that the best way to grasp Chogyū's multifaceted activities is to analyze them in light of his being an aesthetician.

Chogyū's interest in aesthetics goes back to his middle school days when he wrote "Gikyoku ni Okeru Hiai no Kaikan wo Ronzu" (Debate over Feelings of Pleasure Elicited by Sorrow in Drama) after having been impressed by an essay written by Ōnishi Hajime—the pioneer of psychological aesthetics.[1] From the title of the research project that Chogyū pursued upon entering graduate school in July 1896, "Shinbigaku Ippan Oyobi Sekai no Bijutsu Bungakuchū ni Okeru Nihon no Bijutsu Bungaku no Ichi" (The General Notion of Aesthetics and the Position of Japanese Art and Literature in World Art and Literature), we know that at the Imperial University of Tokyo his interests gradually converged on aesthetics. In April 1898 he took over the course taught by Ōnishi Hajime, who had left for Europe, and began teaching aesthetics at Tōkyō Senmon Gakkō, publishing the book *Kinsei Bigaku* (Modern Aesthetics) in September of the

From Watanabe Kazuyasu, "Bigakusha to Shite no Takayama Chogyū," in Watanabe Kazuyasu, *Meiji Shisō Shi: Jukyōteki Dentō to Kindai Ninshikiron* (Intellectual History of the Meiji Period: The Confucian Tradition and Modern Epistemology) (Tokyo: Perikansha, 1978), pp. 210–230.

1. [See Chapter 5. Ed.]

following year. In June 1900 the university ordered Chogyū to go to Europe "to do research on aesthetics," but he fell ill and was unable to leave Japan. In 1901 he won acclaim as a lecturer at the University of Tokyo in a course called "The Characteristics of Japanese Art." In the same year he was granted a doctorate for his research on the art of the Nara Court.

Aesthetics was, for him, more than a simple research theme. Chogyū's consistent interest in this subject originated essentially in the deep relationship between his personal thought and the principles connoting beauty. In other words, we see a connecting thread between Chogyū's interest in beautiful prose that characterized the first part of his career, the study of aesthetics or the science of beauty in the middle part, and his interest in the beautiful life that we witness in the latter part of his life.

The Historical Paintings Dispute

Among Chogyū's major works in aesthetics, I must mention a dispute Chogyū had with Tsubouchi Shōyō (1858–1935),[2] in a series of essays on historical paintings, beginning in November 1898 with Chogyū's "Rekishi Gadai Ron" (Essay on the Subject of Historical Paintings). Among the background events of the essay were the creation in October of the same year of the School of Japanese Art (Nihon Bijutsu In) by Okakura Tenshin (1861–1913),[3] who advocated the reform of Japanese painting, and the holding of an exhibit in which products of the school were presented.[4] Chogyū chose to discuss the winner of the first prize, Yokoyama Taikan's *Kutsugen,* and he made the following argument: Recently the Japanese have been witnessing a "revival of historical paintings"—a most "delightful phenomenon in our world of pictures. . . . Paintings must be a unique moment of spatial art." While respecting this condition, historical paintings express "a temporal meaning" within the picture, "showing a life in a scene. . . . Historical paintings portray the unfolding of actions, something that should not be lost even in the most distinguished painting

2. [On Tsubouchi Shōyō see Chapter 3. Ed.]
3. [See Chapter 2. Ed.]
4. Although this exhibit was the fifth such event sponsored by the Association of Japanese Paintings (Nihon Kaiga Kyūkai), for the School of Japanese Art this was the first.

that explores the most intimate feelings." After arguing along these lines, Chogyū added the following:

> For three thousand years our ancestors have come to life and have died, spilling their blood. Isn't this country they have left to us as their legacy, this history, our most precious memory that we must treasure forever? If in this land poets and artists do not search for superlative topics, who will search for them? (*Chogyū Zenshū*, Hakubunkan, vol. 1, pp. 2–5; hereafter abridged as *Zenshū*)

Here the reader is unmistakably shown the spirit of "Japanism" that Chogyū so vigorously advocated in those days. For Chogyū, Japanism was predicated upon the idealistic search of romanticism—the search for the empty spot completely untouched by reality. Chogyū attempted to anchor such an ideal in the category of reality through the mediation of a middle ground consisting of state, ethics, knowledge, and history. In other words, the debate about historical paintings was an example of Japanism in the field of aesthetics—a struggle to position the ideal of beauty in the reality known as history. At one time Chogyū argued that "beauty permeates directly the ideals kept in the depth of our chest" without the intervention of "intellectual judgment" ("Gikyoku ni Okeru Hiai no Kaikan wo Ronzu," December 1892).

In "Shiteki no Ryōmen to Sono Rihei" (The Two Aspects of the Poetic: Its Advantages and Abuses), however, published in the March 1898 issue of the journal *The Sun (Taiyō)*, he developed the following argument: In "aesthetic fancy" there is a tendency toward "going into an ideal world separated from the time and place of reality." It is all right simply to "sympathize with the fanciful beauty of poetry and take pleasure in it." Abuses arise, however, "when poetic fancies are transferred and become the object of imitation in the real world." To avoid this problem, we must be "clearly aware of the difference between taking pleasure in beauty and the desire to translate such feeling into reality," thus establishing a relationship between the two elements with "composed rationality" (*Zenshū*, vol. 2, pp. 519–529). In Japanism it is necessary to control beauty and its free imaginative power with this kind of "composed rationality."

About one year later, in October 1899, Chogyū resumed the historical paintings debate in "Rekishiga no Honryō Oyobi Daimoku" (The Function and Titles of Historical Paintings), which he published in *The Sun*. This essay was a response to the debate on "The Topic of Eastern Historical Paintings" that the *Yomiuri Shinbun* had opened

to the public. According to Chogyū, there are two "interpretations of the function of historical paintings." One is the "explanation of the true aspects of historical characters and periods"; the other is the "display of the picture's beauty through the portrayal of historical characters and periods." Although differences between the two interpretations are not immediately apparent, these differences serve as "two antagonistic principles in establishing the purpose of historical paintings." The first interpretation "makes history the host and painting the guest," using painting as an "expedient to explain history." If we adhere to this explanation—Chogyū asks—how can we guarantee that beauty is "the so-called spirit and ideals of history"? On closer examination—Chogyū continues—the second interpretation is clearly the correct one. "The expressive power of historical paintings is undoubtedly located in the beauty of the painting itself and not in the historical events portrayed; historical facts are simply used as expedients to express beauty."

> The object of representation in painting—which is a liberal art—is located outside the beauty of painting itself, and it is not related to any specific historical event that is simply borrowed for the occasion. A landscape painting should not be conditioned by any relationship with any specific mountain or river. (*Zenshū*, vol. 1, pp. 38–44)

Chogyū's argument that history is "a means," while painting is the "purpose," corresponds to his declaration, geared to the promotion of Japanism, that "the purpose of human life is happiness" and the state is what to the very last "makes happiness concrete" ("Kokka Shijōshugi ni Taisuru Gojin no Kenkai," or "A Personal Opinion Against State Supremacy," January 1898 issue of *Taiyō*; *Zenshū*, vol. 4, pp. 351–356).

When Tsubouchi Shōyō leveled a critique against Chogyū's position, Chogyū responded immediately—thus beginning the so-called historical paintings dispute.[5] An earlier set of circumstances led to Shōyō's critique of Chogyū, circumstances involving Chogyū's review in August 1897 of Shōyō's historical play *Maki no Kata*. The dispute was ignited by the argument that today, after a long stagnation of dramatic literature, "how much stronger the author of *Maki no Kata* has made our heart!" ("Harunoya Shujin no *Maki no Kata* wo

5. Tsunashima Ryōsen (1873–1907) participated in the dispute on the side of Shōyō.

Hyōsu," or "A Review of Tsubouchi Shōyō's *Maki no Kata*," in *Taiyō; Zenshū*, vol. 2, p. 440). Despite several critical remarks, Chogyū must have felt that he gave a fair review, given his high morale at having been recently appointed chief editor of *The Sun*. Seen from Shōyō's perspective, however, the arrogant criticism of a green youth must have touched a sensitive spot. Shōyō brought forth a counterargument under the vaguely titled "Shigeki ni Tsukite no Utagai" (A Question About Historical Drama) in the form of a question addressed to the "preaching of all of you critics" without mentioning Chogyū's name (*Shōyō Senshū*, Shunyōdō, vol. 7, p. 534). An enraged Chogyū immediately rebutted by drafting "Tsubouchi Shōyō ga 'Shigeki ni Tsukite no Utagai' wo Yomu" (Reading Tsubouchi Shōyō's 'Question About Historical Drama'). By that time no honorifics accompanied Shōyō's name. Shōyō responded with "Shigeki ni Kansuru Utagai wo Futatabi Taiyō Kisha ni Tadasu" (Raising Another Question to the Journalist of *The Sun* About Historical Drama).

To come to the core of the historical paintings dispute, we might say, using the words that Chogyū himself employed in his cross-examination of Shōyō, that it was a question of whether "historical drama is history or poetry." In other words, is historical drama a representation of historical truth or is it literature? In his last article, however, Shōyō sidestepped the issue of "history the host, poetry the guest," stating that "it is useless to argue in terms of the primacy of poetry over the subordination of history." Shōyō changed the focus of the dispute by arguing that at first there was history and later poetic thought came about, not vice versa. This debate explains why Chogyū and Shōyō again raised the issue of "the primacy of history and the subordination of poetry" in the context of the historical paintings dispute. That such a dispute was a continuation of the debate on historical drama can be seen in Chogyū's "Function and Titles of Historical Paintings," mentioned earlier, in which we read that "we should not start our inquiry by asking which one came first and which one came later in the preparation process of the artist: whether he first wanted to express human passions and later decided to compare them to the historical events surrounding Sugawara no Michizane, or whether he was first moved by historical events and later succeeded in reaching the beauty of human emotions" (*Zenshū*, vol. 1, p. 42). There is no doubt that this was a repetition of the earlier dispute, as we can see from Shōyō's first critical essay against Chogyū in which he called the historical paintings dispute a "Problem of Primacy

and Subordination in Historical Painting" ("Rekishiga no Shuhin Mondai"). We can also see it from Shōyō's reference to his last article on the dispute over historical drama when, pressed for an answer, he concluded that "even now we are still unable to resolve this question."

According to Shōyō, it was Chogyū who started the dispute. In a recollection titled "Shigeki Oyobi Shigekiron no Hensen" (Changes in Historical Drama and in the Debates on Historical Drama), which he wrote in 1918, Shōyō stated:

> The response to this essay on historical drama came on December 1897. No definite answer was formulated, and we left the matter at that. A year later (it might have been the end of 1898 or spring 1899), Chogyū gave a lecture to the Association of the Humanities Students of Waseda University, unexpectedly on historical paintings. He discussed the debate on historical drama of the previous year, repeating his previous arguments with a few expansions, and then asked for my response. [. . .] I promised to respond after his article was published in *The Sun*. (*Shōyō Senshū*, vol. 7, pp. 646–647)

Chogyū's article appeared in *Taiyō* on October 1899 as "The Function and Titles of Historical Paintings"; Shōyō's response was published in *The Sun* the following year with the title "Geijutsujō ni Iwaiuru Rekishiteki to Iu Go no Shingi Ikaga" (What Is the True Meaning in Art of the Word "Historical"?). In the response Shōyō expressed the feeling that he could not "swallow the argument according to which, with regard to the composition of historical paintings, the painting is the host and history is the guest," denying "the primacy of poetry and the subordination of history" that he had simplemindedly acknowledged in the earlier debate concerning historical drama. Moreover, Shōyō argued that "the purpose of historical paintings is the representation of the beauty of history," thus introducing the notion of historical beauty. He stressed that historical beauty "possesses a great degree of objectivity in comparison to other special works of pure fantasy, so long as such beauty is derived from history" (*Shōyō Senshū*, vol. 7, pp. 579–588).

In the background of Shōyō's statements lies the presence of "truth," "good," and "beauty" within the reality of the "three powers of heaven, earth, and man," as well as the essential belief in man's ability to distinguish among them. In his scholastic and subtle logical structure, Shōyō somehow differentiates subject and object but, in the end, his subject is grasped altogether from within the object, mak-

ing the subject lose its function as epistemological subject. For Shōyō the subject was nothing but a mirror that simply reflected external reality. Clearly even his concept of "historical beauty" was sustained by a naive realism. When Shōyō criticized as "deceptive" Chogyū's argument that it was sufficient for history to provide paintings with plausibility, he was already simplemindedly predicating his critique on the belief that reality is located in the external world (ibid., p. 565).

The following month Chogyū suddenly rebutted with an article, "Futatabi Rekishiga no Honryō wo Ronzu" (Another Debate on the Function of Historical Paintings), in which he focused his entire argument on "Mr. Shōyō's so-called historical beauty." Shōyō called historical beauty "images that appeal to the heart as a result of their grasping with admiration events and people of the past." Chogyū, however, pursued the question of whether "the beauty of such images depends on their historicity, on their having actually happened in the past, or whether this is the result of beautiful human acts that are aesthetically perceived." "For a historian such as Doctor Denial," Chogyū continued, is the so-called historical beauty lost if "one tries to corroborate something that is historically without any evidence"? Chogyū absolutely denied it, stating that "the fact that something really existed in the past" does not "supply any special standard of beauty." Chogyū asked: "Normal fantasies and historical fantasies, should they not be judged according to the same aesthetic standards"? In other words: "There isn't any typological difference between the content of historical beauty and what is generally called beauty of human affairs and human affects" (*Zenshū*, vol. 1, pp. 78–80).

After denying the existence of any specific beauty known as "historical beauty," Chogyū continued to argue that the artist's act of "producing a kind of art called 'historical' is nothing else than a means to enrich as much as possible the content of art; it is not a means to elicit and express a beauty that is specific to history." Therefore, "the appreciator of true art should be concerned about the presence or absence of ideal credibility, rather than the presence of reality or nonreality that we witness in the real world" (ibid., pp. 86–89).

The dispute resumed in January 1900, after an interval of one year, when Shōyō's second criticism, "Futatabi Rekishiga wo Ronzu" (Another Debate on Historical Paintings), was made public. Apparently Shōyō was greatly dismayed by Chogyū's reference to him as "Doctor Denial," and he vindicated himself by stating that "I simply mentioned

the authority possessed by views of world history, notwithstanding whether the historical objects are real or not." Shōyō revised his explanation of the meaning of "objective" by saying that "many people who should be called wise have often included in their portrayals human emotions as they are commonly experienced, and the tastes of the masses," thus largely retreating from a position in which the object of historical paintings had to be "real" to one that contented itself with the representation of "real thoughts as they commonly exist in the world." At this point there was almost no difference between Shōyō's position and Chogyū's notion of credibility. As examples of "real thoughts," however, Shōyō gave "the shape of a tiger and the view of Matsushima," endowing them with "a kind of authority" (*Shōyō Senshū*, vol. 7, pp. 607–628). In other words Shōyō remained convinced to the end that beauty is separated from the subject and is located in the outside world, on the same level as tigers and islands. Here he clearly showed the naive realism that characterized his thought.

In April of the same year, Chogyū published "Tsubouchi Sensei ni Ataete Mitabi Rekishiga no Honryō wo Ronzuru Sho" (A Third Debate on the Function of Historical Paintings Addressed to Professor Tsubouchi). Since Shōyō never replied, we can consider this article to be the last word in the dispute under consideration. Chogyū rearranged all his previous statements and presented the following argument: If we take the first meaning of art "to be the expression of beauty," then "we should respect the rules of beauty as standards of art." The union between historical paintings and "the knowledge on the part of the viewer is not a requirement of history but the request of art." The use of history on the part of the artist is not the result of what Professor Shōyō calls "the union with a view of world history," but "an answer to the rules of beauty. What is left once the work of art has been assimilated is not the historical remains, it is beauty, so that the authority of the work of art is not located in the authority of history; it is the authority of beauty." Chogyū astutely asked the following question: If, as Professor Shōyō argued, historical paintings "are not free because they must somehow follow the world's views of history, which kind of paintings will ever be free for him?" (*Zenshū*, vol. 1, pp. 93–108).

Chogyū's last question penetrates deeply into the essence of the dispute. If beauty is inherent to the external world, as Shōyō had postulated, and man simply looks at it, all the arts, not just historical

paintings, will become "fettered" activities based on the external object. At the core of Shōyō's realist views of literature *(shajitsu-shugi)* lies a naive externalism. He definitely lacked awareness of a cognitive subject. Shōyō could not think of an object that is sustained by the subject. So long as he defended such a position, beauty depended on the object, and thus he could not grasp the internal principles inherent in beauty. This also explains why, in the end, *Shōsetsu Shinzui* (Essence of the Novel, 1885) did not lead to the creation of any literature with the exception of the works of the Ken'yūsha group.[6] Chogyū's argument concerning historical paintings did not simply stop at adapting Lessing's *Laocoön;*[7] it also contained deep insights into the epistemological issues at the core of Western modernity. It laid the foundations for a notion of the autonomy of beauty, for example, by locating the principles of beauty inside the human subject. This dispute clarified the basic attitudinal difference between the two intellectuals with regard to beauty, as well as the gap in the world-views sustaining their arguments.

Studies in Aesthetics

The dispute over historical paintings that started out as Chogyū's plan to ground the ideal known as beauty in the reality of history—a plan that Chogyū considered a step in the development of his Japanism and continued with the debate with Shōyō from 1899 to 1900—directed Chogyū's search toward the issue of the subjectivity of beauty. Chogyū's concept of interiority, profoundly affected by the notion of the self and by Western epistemology, came to be clearly exposed by means of the reversed refraction of Shōyō's optimistic and naive realism.

Parallel to the dispute with Shōyō—or, it might be better to say,

6. Rather than searching for Shōyō's achievements in his alleged establishment of modern realism, we should look at the role he played in providing new materials and methods to the world of light fiction *(gesaku)* of the Meiji period, which had reached its limits "in terms of both material and style." The literature of the Ken'yūsha group was precisely the new *gesaku* of the Meiji period. For a study of the situation of *gesaku* at the beginning of the Meiji period see Okitsu Kaname, *Itan no Aruchizantachi* (Artisans of Heresy) (Tokyo: Yomiuri Shinbunsha, 1973).

7. [Gotthold Ephraim Lessing (1729–1781), German dramatist and critic, became librarian of the ducal library at Worfenbüttel in 1770. For an English translation of his *Laocoön* (1766) see Gotthold Ephraim Lessing, *Laocoön: An Essay on the Limits of Painting and Poetry* (Baltimore: Johns Hopkins University Press, 1984). Ed.]

spurred on by the controversy—Chogyū published three important essays on aesthetics. This was the time when his interest in aesthetics was most pronounced. "Tsukiyo no Bikan ni Tsuite" (On the Sense of Beauty in a Moonlit Night) was published in *The Sun* in November 1899. By analyzing the beauty of a moonlit night psychologically, Chogyū harmoniously blended deep insights about beauty with exceptionally good prose, making this article the finest among Chogyū's works. The following month, replying to a critique of this article that had appeared in the newspaper *Yomiuri Shinbun,* he justified himself as follows: "I have been criticized and asked to prove why the moon's rays are blue, but this is an unreasonable request. The senses are absolute. If one feels, that is all that is needed, without any need for further proofs or anything similar." In addition, Chogyū said, "hearing my argument, you will probably say that aesthetics cannot come into being. But to tell you the truth, these are the unavoidable limitations of this science, no matter how hard you struggle to avoid them" (*Zenshū,* vol. 1, p. 572).

"Bigakujō no Risōsetsu ni Tsuite" (On Idealistic Theories in Aesthetics) was a lecture delivered in January 1900 at a meeting of the Philosophy Association and published two months later in *Tetsugaku Zasshi* (Philosophy Journal). After pointing out two idealistic theories in aesthetics—"the theory of abstract idealism" and "the theory of concrete idealism"—Chogyū presents the following argument: "The aesthetics of the idealistic school" tries to deduct everything from the "great principles based on pure philosophy." Here there is absolutely no "difficulty with regard to the subjectivity of beauty," such as "the difficulty of setting up objective standards for the judgment of beauty." This approach, however, "privileges intellectual rationality and neglects the emotions, which are an important element of aesthetic consciousness." Included in "the activity of the human mind" are the "intellect" and "feelings." Idealistic theories, however, "judge feelings by the intellect." "Without our first acknowledging the existence of pure philosophy," idealistic theories do not exist; for those who doubt "the possibility of a pure philosophy," such theories are nothing but "castles in the air." Aesthetics must always be built on "a direct experience of aesthetic consciousness" (ibid., pp. 246–249).

Chogyū was acutely aware that German aesthetics, which was very popular at the time (especially the aesthetics of Hartmann), concealed under the disguise of idealism a repression of the emotions by

the intellect. What surfaced clearly here was a distrust of a stable external order, or objective existence. It was, therefore, impossible to rationally build up an objective existence or ideal that lacked reflection on the subjective moment. This was due to the fact that the cause of the breakup between subject and object—the cause of the destruction of objective existence—was none other than the subject that constructed the "self," that is, the world, as an object. Chogyū argued that it was impossible to overcome the intellectual situation at the time without first realizing the role of mediation played by the subject. Chogyū's insistence on the need to ground aesthetics in a "direct experience of aesthetic consciousness" was rooted precisely in this belief. At this point Chogyū began to talk again about the superiority of emotions over intellect.

"Bikan ni Tsuite no Kansatsu" (Observations on Aesthetic Pleasure) was published in the journal *Teikoku Bungaku* (Literature of the Empire) in May 1900, one month after the end of the dispute over historical paintings.[8] Chogyū began with the proposition that "there are two facts a scholar of aesthetics must acknowledge at the beginning of his research: beauty is an emotion on the part of the subject, and such an emotion is a feeling of pleasure." He then developed the argument that as a general classification "the operation of the human mind" consists of "truth consciousness," which is related to the "intellect," and "aesthetic consciousness," which is connected to "feelings." In the case of truth consciousness, "it is natural to look from outside at an erroneous thought and recognize it as fallacious." "Since beauty is an emotion," however, "beauty is an absolute fact for the person experiencing it," and "no external judgment has the power to change that." Since this "difference" depends on "the ebb and flow of subjectivity and objectivity," "subjectivity culminates in feelings, while objectivity finds its extreme in the intellect." While "knowledge is regulated by objective standards," "emotions" are "an absolute reality of self-consciousness." The "consciousness of good is located in the middle between these two" (ibid., pp. 267–271).

Here the reason for Chogyū's obsession with "beauty" is clearly indicated. For Chogyū, who was seized by a distrust toward objective reality, "beauty" was the most reliable ground upon which he could entrust his own existence. Such a ground was not troubled by

8. [For a complete English translation of this essay see Marra, *Modern Japanese Aesthetics,* pp. 98–111. Ed.]

external judgments, and it affirmed his own emotions as an "absolute reality." His initial standpoint—that the "emotions transcend all external things and possess the reason and the morality of the self"—was securely revived.

At the end of the essay Chogyū cast away the scholarly attitude he had adopted up to that point and abruptly switched to an excited mood. He argued that "a naive science" finds strange the existence of "art which, as a matter of fact, should be regarded as the last refuge for those who hate smoke and the sound of gold." "The time has long since passed when people tried to restore the monopoly of beauty, sung as sacred by the ancient poets." For "people of the past, the blue sky was not empty and the stars shining in it were not lumps of earth." It was indeed a misfortune for us "to be born in a world that is unable to admire such beauty" (*Zenshū*, vol. 1, pp. 289–290).

It is clear that Chogyū's interest was no longer in the reconciliation of beauty and history. He had moved far beyond the point of protecting the subjectivity of beauty from the arrogance of the intellect: he was now at the point where he was censuring the intellect as the enemy of beauty. This attitude is completely unrelated to the aesthetic position known as art for art's sake. He keenly advocated the idea that the authority of beauty depends on the subject. The study of aesthetics had moved Chogyū far from "Japanism."

The Revival of the Poet

Chogyū repeatedly stated that Japanism was a means to make ideals real. As Uchimura Kanzō (1861–1930) has pointed out in his critique,[9] however, Chogyū was unable to see that such an attitude was "hypocritical" because at the time Chogyū was advocating Japanism with all his might, he was relying on ideals in the form of aesthetic research. As a result, Chogyū did not ignore the fact that the means he was employing to achieve his purpose were actually alienating the purpose.

9. This critique appeared in the November 1898 issue of *Tokyo Dokuritsu Zasshi* as "Bungakushi Takayama Rinjirō Sensei ni Kotau" (Reply to Professor Takayama Rinjirō), in *Uchimura Kanzō Chosaku Shū*, vol. 18, Iwanami Shoten, p. 404. This essay was a response to Chogyū's "Uchimura Kanzō Kun ni Atau" (Letter to Mr. Uchimura Kanzō). [Uchimura Kanzō, the Christian writer, is the renowned author of, among other texts, *How I Became a Christian*. Ed.]

Even in 1898 we can see Chogyū's criticism against a "tasteless society" where morals pull people back from "everything that is beautiful," where everybody has only "one face, one voice," and where "people who repress their feelings and are not moved by love are revered as great" (*Zenshū*, vol. 5, pp. 606–607). We see the same criticism raised again during the following year, 1899:

> Nowadays people are too serious, too argumentative, and too tightly bound by morals. Although we can only assume that life is not a dream, to frolic as if life were a dream is actually of great consolation. When people are too serious, hypocrisy will arise, will it not? (*Zenshū*, vol. 5, p. 764)

And yet we feel that until 1899 similar social critiques were hidden behind the loud scream of "Japanism." Starting from 1900, however, Chogyū's criticisms of society became more numerous and began to assume an inflammatory tone. It is no coincidence that this tendency was concomitant with the direction taken in his research on aesthetics.

In February 1900, Chogyū published in *The Sun* "Doi Bansui ni Ataete Tōkon no Bundan wo Ronzuru Sho" (Essay on the Contemporary Literary Circles Addressed to Doi Bansui). The "poet" Bansui[10] expressed his indignation at contemporary society in connection with his being forced to leave Tokyo in order to pursue a career as an English instructor. Chogyū refers to Bansui as "you":

> You! You are not of such an elevated rank as to encourage the decay of contemporary society. [. . .] Without an education from a national university, a scholar cannot make a living; without flattering the powerful, a man of letters cannot pursue his way. While an actor from a low-class theater rides in a lacquered carriage, the poet cannot even pay his rent with his poetry.

"Shouldn't a poet be able to make a living with his poetry?"—Chogyū asked. Today poets are "persecuted." Nevertheless, in the past "great poets would not give up their art until they fell under persecution, died after being chased, suffered the pains of poverty, and starved to death on the road." "The peace of mind that came to them from art," Chogyū continued, "would allow them to withstand the pain of the real world without making them stray a bit from their path"

10. [Doi Bansui (1871–1952), a scholar of English literature, became with Shimazaki Tōson (1872–1943) one of the leading Japanese poets of his generation. Ed.]

(*Zenshū,* vol. 2, pp. 586–588). In Chogyū's criticism of Bansui, who appears to yield to a situation in which the poet is persecuted, we feel a tension that is seldom heard in a simple and objective review. In fact, Chogyū was undoubtedly addressing this criticism to himself. In his insistence on Japanism he had engaged in a sort of persecution of the poet inside himself.

In "The Two Aspects of the Poetic: Its Advantages and Abuses," cited earlier, Chogyū makes a sharp distinction between "taking pleasure in beauty" and "making beauty concrete in reality." He confines beauty to a world of simple contemplation and demands that beauty be placed under the control of a "calm, rational mind." Undoubtedly, we have at work here a reflection on romanticism and an element of self-criticism. As a result, however, Chogyū's sensibility loses the brilliance and freshness we find in his essays on Chikamatsu and becomes more suitable for uncouth political commentaries. In other words, Chogyū's internal poet was confined to a prison and kept under strict surveillance.

In November 1898, Chogyū presented a public letter to Uchimura Kanzō in which he stated: "You speak of the things of the other world by using brush and paper of this world. The concept known as real existence is hastily disengaged from your thought since you look at all things as if they were illusions." To be truthful, "you are not a statesman, you are not a philosopher, you are not a man of religion; you are only a poet" ("Uchimura Kanzō Kun ni Atau," or "Letter to Mr. Uchimura Kanzō," *Zenshū,* vol. 5, pp. 597–598). Here the being of the poet is conceptualized as something to be despised.

Chogyū's interiorization of the persecuted "poet" is shown, as well, by the attitude he took toward Heinrich Heine (1797–1856) at around the same time. In December 1898, for example, Chogyū made the following statement with regard to Heine:

> The Germans have repeatedly planned to build a monument to Heine, but such a plan has not yet been carried out. The main reason is that in Germany, Heine is a disloyal poet. I hope I can develop such a firm national spirit. ("Nanshū to Heine," or "Southern Countries and Heine," *Zenshū,* vol. 5, p. 595)

It is clear what such a statement meant to Chogyū—who during his whole life "never left Heine's side" (Saitō Nonohito, "My Dead Brother Takayama Chogyū," in *Meiji Bungaku Zenshū,* vol. 40, p. 144)—during his Japanism years. In June 1900, when he realized

that he was actually a poet, Chogyū disclosed his true feelings on this matter:

> This might be something that only happens to me, but nothing has ever had as much influence on me as Heine's poetry. Whenever I read one line or one verse, my heart feels like a young man in an ancient tale touched by the magician's wand; tears of sadness flow down my cheeks. ("Umi no Bungei," or "The Literary Arts of the Sea," *Zenshū*, vol. 5, pp. 400–401)

In his statements on Japanism, Chogyū was urging a denial of his own internal "poet," a self-denial that we could also call repression. Then, in 1900, the internal poet who began to realize his own position through research in aesthetics undoubtedly started to feel the unbearability of being controlled by a rational mind or intellect that was closing him off from a world of simple contemplation. The pathetic warning he gave to Bansui was addressed to his own internal poet repressed within his Japanism.

"Kankōden" (The Biography of Sugawara no Michizane) which Chogyū published in April 1900, carries a much greater meaning than the simple history of Michizane's life. At the beginning of February, Chogyū confined himself to a temporary residence in Ōmori, and in nine days he wrote the entire work. So strong was the empathy felt by Chogyū that he presents the reader with a truly original portrayal of Michizane. Namely, Michizane is not seen as "the gentle and modest man everybody thinks he was; and he was not a refined man who rejected the thought of fame and profit." He was a man of "sensibility," a man "attached to the self." For Chogyū it is a great mistake to portray Michizane as "a man of endurance." He argues that to endure means "to tolerate the sun and resent the moon. This was not the case with Michizane. The true nature of Michizane was not to withstand and sadly retreat." Michizane "did not deceive himself, and this was the reason for his success as a poet."

Chogyū proceeds by talking about Michizane's career as a politician. He discusses Michizane's rejection of the position of chancellor and criticizes him by saying that "at a time when such an important issue for the country had to be decided, an exclusive concern with the formality of being humble meant losing touch with the world; to consider only one's personal risks is not the behavior expected from a loyal and brave gentleman." Then Chogyū abruptly adds: "Ah, was this the way of heaven? Here I see the greatness of that man's char-

acter. Had he not greatly failed politically, he would not have succeeded as a poet. We should not be so troubled by his banishment. By losing a small politician, the people were given a great poet" (*Zenshū*, vol. 3, pp. 252–323). The recognition that without the loss of the "politician" it is not possible to be an accomplished "poet" addresses Chogyū's own internal crisis: the crisis between intellect and sensibility, between the political commentator and the poet. Since the commentator of Japanism was repressing his own internal poet, the only way left to Chogyū was a clear choice, rather than a mediation, between the two. At this point Chogyū sympathized deeply with Michizane, and in Michizane's biography he saw his own destiny.

On June 1900, the Ministry of Education presented Chogyū with an official commission to travel to Germany, France, and Italy to conduct research in aesthetics. Chogyū was promised the position of professor at Kyoto Imperial University after his return to Japan. This prospect of lecturing on aesthetics at a national university might well have been the most practical solution to the anguish that had troubled Chogyū for such a long time. It should have led to a happy union of contradictory values, such as beauty and truth, ideal and real, art and worldly status.

On August 8, one month prior to his departure, Chogyū suddenly collapsed coughing blood. In a letter dated August 22 and addressed to Anezaki Chōfū (1873–1949), who was then residing in Germany, Chogyū wrote: "I will not be able to leave on the eighth of next month. Since the eighth of this month I have been faced with an unexpected bout of pulmonary tuberculosis; I entered the Sasaki hospital at Surugadai, where I have been prohibited from conversing and carrying on any kind of activity" (*Zenshū,* vol. 6, p. 370). On September 8, the passenger liner *Prussien* departed from the port of Yokohama with the government-sponsored students Haga Yaichi,[11] Fujishiro Teisuke,[12] and Natsume Kinnosuke,[13] leaving Chogyū behind.

11. [Haga Yaichi (1867–1927), a professor of classical Japanese literature at the Imperial University of Tokyo, was a leader in introducing the philological method in literary studies to Japan. Ed.]

12. [Fujishiro Teisuke (or Sojin) (1868–1927) is considered to be among the founders of the discipline of German literature in Japan. Ed.]

13. [Natsume Kinnosuke (or Sōseki) (1867–1916) is regarded as the most prominent Japanese writer of the Meiji period. Ed.]

Three days later, searching for better air in order to cure his illness, Chogyū left Tokyo.

This illness was decisive for Chogyū, who was feeling pressured by choices. The four months spent in convalescence provided him with an opportunity for deep introspection. He spent his days close to the Kiyomi beach in Shizuoka prefecture, playing Go with the inn's owner, taking long walks on the beach while contemplating Mount Fuji, and absorbing himself in reading. In a letter dated October 20, he conveyed the following news to Fujii Kenjirō:

> To think about it, these past few days were like a dream. I do not mean nightmares; I really mean a beautiful dream. I almost doubted that I was living in the same world as the present fastidious and meaningless world of ethics, truth, and education. (Ibid., p. 384)

On November 22, moreover, Chogyū stated in a letter to Kuwaki Gen'yoku,[14] "when I look back on my life, the present time will probably look like its happiest moment" (Ibid., p. 393). It was as if poetry were bursting from Chogyū's mouth:

> How wonderful those mountains and waters, free of lies, jealousy, hatred, and conflict. People are at a loss at the crossroads of life and death; the world goes about on rising and falling tracks. Mountains, waters, they do not change. To think about it, I start feeling ashamed of myself. To think that I am promoting the health of a body filled with bitterness . . . a thousand years of life, although it should not have been preserved from the beginning; how pitiful, soon it will suddenly disappear, like a dream, and with no one to know, it will turn into decomposed bones. ("Kiyomizudera no Shōsei," or "The Sound of the Bell of the Kiyomi Temple," in *Zenshū*, vol. 5, p. 349)

Unmistakably we see here the form of a Chogyū rising again as a poet. To use Chogyū's own expressions, we should not be saddened by his illness. Instead of mourning the loss of a minor scholar, the people should rejoice at the thought of securing a great poet. Chogyū was revived as a poet at the sanatorium of Kiyomi beach. Such a poet, however, was not the frail poet of the romantic period but the revolutionary "enlightener" who was critical of the present reality. After a silence of half a year, Chogyū argued as follows in an article published in January 1901 in *The Sun* titled "Bunmei Hihyōka to

14. [Kuwaki Gen'yoku (1874–1946), a professor at Tokyo Imperial University, was the founder of the Tokyo school of philosophy. Ed.]

Shite no Bungakusha" (A Man of Letters as a Critic of Civilization):
"In our country, men of letters are definitely not scarce." But, he con-
tinued, "I have yet to hear of anyone who has sung new ideals resist-
ing contemporary civilization." Their works are "light fiction" and
"meaningless words." Contrary to this situation, "those who leave
a mark as men of letters in Europe and America" are all critics of
civilization. Such critics "represent the spirit of the age, and they
either criticize it or oppose it; they are expected to lead the path of
civilization and to be role models for the masses." They possess the
"vigor of never quitting a fight and taking on the entire world in
order to accomplish whatever they believe in."

> Oh, Nietzsche is only a poet! And yet the intellectual world of Germany
> was actually shaken up by him. When I look at the impact that his
> individualism, which can only be grasped with difficulty, had on the
> civilization of an entire country, I realize that the might of the literary
> arts is several times superior to that of science and philosophy; in light
> of this, we must be all the more receptive to the sublime call of the
> man of literature. (*Zenshū*, vol. 2, pp. 821–836)

Conclusions

According to the perspective of modern art, where art is separated
from the external order of the object, everything is predicated on
the act of creating a specific logic sustaining the inner order of the
subject. Accordingly, any leaning toward "nature" is assumed to be
a naive realism and must be firmly discarded. To explain it in terms
of intellectual history, this process means the erosion, emptying, and
demolition of a traditional worldview based on the contiguity of man
and nature, as a result of a spirit in which, generally speaking, the
Western culture imported after the Meiji restoration was firmly estab-
lished—namely, an epistemological system centered on man seen as a
subject objectifying, knowing, and dominating nature.

Chogyū belonged to a generation that had been deeply challenged
by modern epistemology. He could not understand the uncomplicated
attitude of Shōyō, whose views on beauty were naively premised on
the external world. Chogyū considered such an attitude an example
of intellectual laziness. He thought the stable, classical world in which
Shōyō lived was groundless. Here we find the root of Chogyū's irrita-
tion. For him, that beauty was a subjective value was self-evident.

If we search for the cause of Chogyū's obsession with beauty

simply in his affirmation of modern epistemology, we miss a most essential point. It is true that he accepted modern epistemology as an undeniable truth. At the same time, however, if he only wanted to accept such an epistemology, he would not have begun a search for the roots of his own existence in a world that actually went beyond modern epistemology or even denied it.

In "Observations on Aesthetic Pleasure," after arguing in favor of the subjectivity of beauty, Chogyū made a turn in defending the aesthetic cognition of "people of the past" prior to the time of scientific cognition. Moreover, after his revival as a poet, he sang of the beauty of nature. Chogyū privileged the aesthetic consciousness of ancient people and the beauty of nature as principles overcoming scientific knowledge, that is, modern epistemology.

In other words, with the principle of "beauty" Chogyū tried to recover what modern epistemology had denied. If we agree with Kuwaki Gen'yoku that romanticism replaced metaphysics by relying on the "intellect" which Kant's critique of pure reason had taken apart, and that it attempted to rebuild metaphysics by relying on "the will of the emotions" (*Tetsugaku Gairon,* 1900, p. 233), then we could say that, for Chogyū, "beauty" was the principle of romanticism. Chogyū's obsession with beauty during his whole life bespeaks the essential role that beauty played in his thought.

The Aesthetics of Aizu Yaichi
Longing for the South

KAMBAYASHI TSUNEMICHI

Aizu Yaichi (1881–1956), the renowned poet and calligrapher, was also a pioneer of modern Japanese aesthetics and art science. His scholarly activities began with research on the poetry of John Keats (1795–1821) and on Greek lyric poetry—subjects to which this man of great erudition added a thorough knowledge of the Chinese and Japanese classics. Aizu is the type of universal man that created modern Japan; using a more modern terminology, we could call him a "multi-man." Accordingly, although I used the expression "the aesthetics of Aizu Yaichi" in the title of this talk, I will not diminish this giant by confining his thought to the narrow category of aesthetics.

And yet, looking at Aizu's life from the perspective of a coherent "philosophy of life," rather than the word "philosophy," I think it might be better to use the expression "aesthetics." It is usually said about him that in his youth Aizu Yaichi had a yearning for Greece and that he sympathized strongly with the English romantic school. Indeed, I personally believe that an interest in Greek and romantic cultures was the origin of Aizu Yaichi's aesthetics and that it became a source of inspiration and self-expression for the rest of his life. Today, however, I will focus my talk on the encounter or relationship between European views on the arts and Aizu's aesthetic consciousness.

In the eighteenth century, after a long period of isolation due to governmental policies during the Edo period, European science gradually entered Japan. And yet this penetration was limited to the field of practical learning whose sciences, such as medicine, physics, and

From Kambayashi Tsunemichi, "Aizu Yaichi no Bigaku: Nanpō he no Dōkei," *Shūsō* 11 (1995):26–32. This essay was originally the text of a lecture delivered at the Museum of Fine Arts in Niigata City on June 11, 1995.

astronomy, were not directly related to subjects such as religion and philosophy. Before long, together with the Meiji Restoration, the wave of modernization suddenly advanced toward Japan, which had meanwhile opened the country to foreign nations. At the same time came the trend of studying not only the sciences as simple technologies but also their underlying concepts.

Since ancient times, Japan had relied on the Confucian, Buddhist, and Taoist traditions, but these were not what Europeans called "philosophy." The same thing could be said about "aesthetics," which was a part of philosophy. The pioneers of Japanese modernization had first to translate these systems into Japanese and then digest them in order to grasp the meaning of European concepts. We are indebted to Nishi Amane[1] for the Japanese translation of the word "philosophy" (Jpn. *tetsugaku*). In imitation of the Greek theory of "the correspondence of beauty and good" *(kalokagathia)*, Nishi translated the word "aesthetics" as *zenbigaku* (literally "the science of good and beauty") and then revised his translation by using the expressions *"bimyōgaku"* ("the science of the beautiful and mysterious") and *"kashuron"* ("the discipline of good taste"). Mori Ōgai,[2] who came from the same village as Nishi, translated the *Aesthetics* of Eduard von Hartmann, calling it *An Outline of Aesthetics (Shinbi Kōryō)*. The word that is currently used in Japan to indicate "aesthetics" apparently derives from the title of Nakae Chōmin's Japanese translation of Eugène Véron's work, which Nakae entitled *Ishi Bigaku* (The Aesthetics of Mr. V). In the end, however, none of these studies went beyond the realm of translating Western works.

The first reflections by a Japanese thinker on the nature of art came with the publication of Tsubouchi Shōyō's *Shōsetsu Shinzui* (The Essence of the Novel).[3] The scholars who truly raised the curtain on modern aesthetics in Japan were Ōnishi Hajime[4] and his disciple Shimamura Hōgetsu,[5] both of Waseda University. In light of this, we can say that Waseda University was the first source of aesthetics and art science in Japan. Aizu Yaichi belongs to the second generation of scholars in art science at Waseda University.

1. [See Chapter 1. Ed.]
2. [See Chapter 4. Ed.]
3. [See Chapter 3. Ed.]
4. [See Chapter 5. Ed.]
5. [See Chapter 6. Ed.]

Aizu Yaichi's accomplishments as an art historian and theorist of the arts got off to a late start. His first essay goes back to 1929, when he published "Shōsōin ni Hozon Serareru Kugen Karabitsu ni Tsuite" (On the Chinese Container of Official Documents Preserved at the Shōsōin) in the journal *Tōyō Bijutsu* (Eastern Art). The name Aizu Yaichi became known in the academic world upon the publication of the article "Hōryūji Saiken Ronsō" (Debate on the Reconstruction of the Hōryū Temple), which was the beginning of his 1933 thesis: *Hōryūji, Hōkiji, Hōrinji Konryū Nendai no Kenkyū* (Study of the Date of the Construction of Hōryūji, Hōkiji, and Hōrinji). Aizu, however, had been lecturing on art history at Waseda University since 1926. His legendary lectures were packed with students coming not only from Waseda but also from other universities such as Tokyo Imperial University, Keiyō University, and the Tokyo School of Fine Arts (Tōkyō Bijutsu Gakkō). His classes covered a wide range of topics including painting, sculpture, architecture, calligraphy, epigraphy, and even the study of ancient tiles. In 1938, the discipline of the science of art was established in the philosophy department of the Faculty of Letters. Aizu became this discipline's first tenured professor.

When we look at Aizu's earlier personal history, we see that in 1906 he graduated from the English department of the Faculty of Letters and Sciences of Waseda University. At that time the topic of his graduation thesis was a study of the English romantic poet Keats. In 1913 he was appointed lecturer in that same English department, where he gave courses on the poetry of Keats and the Greek poets.

Apparently, ever since the 1920s Aizu had been captivated by the ancient art of Nara, Japan, and the East. Although Aizu had undoubtedly visited the cities of Kyoto and Nara prior to this time, it was not until 1921 that he visited Nara with the specific purpose of conducting a scientific survey of art. There is speculation as to whether or not the immediate motive or major incentive for Aizu's investigation of art in Nara was the publication in 1919 of Watsuji Tetsurō's[6] *Koji Junrei* (Pilgrimage to Ancient Temples). Aizu availed himself of this publication to form, in 1923, the Association of the Study of Nara Art (Nara Bijutsu Kenkyū Kai), of which he became president. Aizu's professional activity in English literature did not clash with his strong interest in art history; rather, both followed parallel courses.

6. [See Chapter 12. Ed.]

The most important thing to establish is why Aizu, who began his career as a scholar of English literature, felt compelled to study Eastern and Japanese ancient art. Moreover, why was he drawn to writing those many excellent poems that center on Nara? A primary factor is thought to have been his connection with Lafcadio Hearn or, to use Hearn's Japanese name, Koizumi Yakumo.[7] At that time, Hearn had been driven out of Tokyo Imperial University and had transferred to Waseda University where he worked several months delivering his last lectures on English literature. In other words, Aizu was literally one of the last students of Lafcadio Hearn. Although his exposure to Hearn was brief, apparently Aizu was profoundly influenced by Hearn's lectures.

As is well known, Hearn's father was an English military officer, while his mother was of Greek extraction. Throughout his life Hearn boasted of this injection of Greek blood. Moreover, Hearn, who loved Japan to the point of taking the Japanese name Koizumi Yakumo, claimed that he had found Greece in Japan. His last lectures at Waseda University concerned the poetry of John Keats, the English poet of the romantic period. It goes without saying that Hearn also mentioned in his classes the fiery example of George Byron (1788–1824), another poet of the romantic movement who took part in the Greek war of independence as a volunteer soldier before dying of illness at Missolonghi. These lectures must have produced in Aizu an immense yearning for Greece, birthplace of the Western culture that Aizu had not yet experienced firsthand.

Moreover, other works that inspired in Aizu a deep sympathy for Greece were the poems of the German poet Heinrich Heine (1797–1856), as Aizu himself mentions several times in his biography. He was particularly impressed by Heine's collection *Buch der Lieder* (Book of Songs) and by the poem in it called "Nordsee" (The North Sea).[8]

7. [Lafcadio Hearn (1850–1904) was born in Greece of Greek and British parents. He taught English at Matsue Middle School and then at the University of Tokyo and Waseda University. Hearn married into the Koizumi family and became a Japanese citizen. A prolific writer, he is the author of *Glimpses of Unfamiliar Japan* (1894), *Out of the East* (1895), *Kokoro* (1896), *Gleanings in Buddha Fields* (1897), *Exotics and Retrospectives* (1898), *In Ghostly Japan* (1899), *Shadowings* (1900), *A Japanese Miscellany* (1901), *Japanese Fairy Tales* (1902), *Kotto* (1902), *Kaidan* (1904), and *Japan: An Attempt at Interpretation* (1904). Ed.]

8. [For a bilingual edition of this work see Howard Mumford Jones, transl., *Heine's Poem "The North Sea"* (Chicago: Open Court, 1916). Ed.]

Aizu was born in the snowy city of Niigata. The province of Echigo is well known in the world as a land of deep snow covered for more than half the year by a lead-colored sky gloomily hanging over it—a land where the inhabitants almost never see blue sky. It is highly probable that Heine's poem "The North Sea" invoked for Aizu the scenery of the gloomy and rough Sea of Japan raging under the snowy storms of his own birthplace.

Traditionally, Northern Europeans, such as Englishmen, Germans, and the inhabitants of the Alps, develop an infinite yearning and love for the warm, opulent landscapes and the sunshine, brightness, and clear skies of Southern Europe. In other words, they have a "yearning for the South." A typical example would be Johann Wolfgang von Goethe's (1749–1832) "Mignon's Poem" from *Wilhelm Meister:*

> D'you know that land where the lemons grow,
> Midst foliage green the golden oranges glow,
> A gentle breeze beneath the azure sky,
> The laurel smiles, the myrtle rests nearby,
> D'you know it then?
> That's where! That's where
> With you, oh Master, I would like to go.[9]

Of course many people before Goethe yearned for the land beyond the Alps. The art historian Johann J. Winckelmann (1717–1768), to whom Goethe paid homage, is a classic example. Winckelmann left his native Germany and became a permanent resident of Italy. Not only did he become a perfect Italian, but he went even further and became a Greek. Following the example of the Renaissance painter Albrecht Dürer (1471–1528), romantic painters of the nineteenth century belonging to the "Nazarene school" settled down in Italy and came to be called "Romans born in Germany." Such was the degree of admiration felt by Northern Europeans for the South. As mentioned earlier, I believe that by projecting Heine's poem onto the stormy seas of his native Sea of Japan, Aizu Yaichi, a Japanese Northerner originally from Northern Echigo, developed an even sharper longing for Greece.

The notion of a "yearning for the South" in the Northerner Aizu

9. [I have followed the English translation by John R. Russell as it appears in Johann Wolfgang von Goethe, *Wilhelm Meister's Theatrical Calling* (Columbia: Camden House, 1995), p. 127. Ed.]

is already apparent in his excellent songs, which he collected in 1923 in *Nankyō Shinshō* (New Songs from the Southern Capital).

Yamatoji no	Clouds rising
Ruri no misora ni	In the lapis blue sky
Tatsu kumo wa	Over the way crossing the Yamato region,
Izure no tera no	Over which temple
Ue ni ka mo aramu	Are they passing by?

Aizu himself appended the following note to the poem: "The author was born in the Northern countries. I wonder whether the tendency to admire the clear sky of the Kinki and Kansai areas—and especially the translucent sky of the Yamato Kawachi area that always looks so beautiful—was the result of growing up in an environment with an overcast sky, one that was completely gray most of the year." When I read this poem, I feel that Aizu's yearning for Greece gradually developed into a desire for Yamato and Nara. Here, however, we must pay attention to the fact that Aizu's yearning was not simply aimed at the mild climate and landscape.

In this regard, I would like to examine a letter that Aizu addressed to a friend on September 2, 1906, shortly after graduating from Waseda University:

> *Humanity as a whole* consists of beauty, truth, and the divine; it is a search for the perfect and complete humaneness of each individual—this is the claim that I have been making for more than half of my life. This is the reason behind my joy at Greek life and my love for the "Age of the Gods" chapter from the *Record of Ancient Matters (Kojiki)*. My dissatisfaction with the civilization of the nineteenth century is not the result of an opinion which is as cold as ice. My mature tears of indignation for the pitiful scene of our present century, a century filled with *deformity* as a result of the abuses of the division of labor, are mixed occasionally with the cold smile of the cynic.

This statement by Aizu applies to our era at the end of the twentieth century as well. To explain further: modern scientific rationalism expedited the process of the division of labor and specialized production. This trend had an impact on the structure and organization of society, as well as on learning. In brief, Aizu advocated the rejection of the inhuman life resulting from specialization in narrow fields, and he discussed the need to turn to the perfecting of humanity as a whole. In this attitude we can see the image of a scholar who was trying to become a universal man himself. We might even go so far as to say that the incident of the Aum religious group that shook

up Japan last year was an example of the social *deformity* mentioned by Aizu.[10]

In 1920 Aizu created the Greek Society of Japan (Nihon Girisha Gakkai), of which he became president. At the outset of the society's general principles, Aizu states the following: "At the height of Greek civilization, everything was perfectly complete and full of life in itself." In other words, in order to correct the deformities of a crooked century, Aizu was asking people to learn from ancient Greece, which he regarded as the ideal of fulfilled life. Here Aizu was describing nothing but the ideal of European classicism.

Although it is not my intention to talk here about the tradition of European classicism, let me just mention that the point of origin of this process goes back to the Renaissance, a period that aimed at reviving the arts and sciences of the past. In the seventeenth century, French classicism inherited this tradition, adding to it a rationalistic element. To sum it up in one phrase, classicism is the "imitation of antiquity." By interpreting the meaning of "imitation of antiquity," we understand the position that German classicism took—a position that was rooted in the work of the art historian Winckelmann, especially his *Thoughts on the Imitation of Greek Art* (1755), which relativized French classicism.

French classicism conformed to a set of strict rules—such as, for example, the notorious "rule of the three unities." The works of art that derived from this kind of classicism were academic works in the bad sense of the word. In other words, they were cold and lifeless, and many, albeit beautiful, were a superficial imitation of ancient works. Against such formalism, Winckelmann advocated a kind of classicism that, while treasuring the notion of imitation, did not encourage the imitation of external forms, focusing instead on mastering the spirit that produced beautiful forms. In contrast to earlier formalistic aesthetics, Winckelmann found the essence of classicism in the for-

10. [On March 20, 1995, twelve people were killed and more than fifty-three hundred others were injured as a result of the release into the air of sarin nerve gas at the Shinjuku subway station in Tokyo. This incident followed a similar case that took place on June 27, 1994, in which seven people were killed and fifty-two people were injured. Asahara Shoko (real name Matsumoto Chizuo), the leader of a religious group known as "The Aum Supreme Truth," and six members of the group were charged with murder in connection with both incidents. Asahara defended himself by claiming that Buddha had appeared in a vision and instructed him to carry out the heinous crimes. Ed.]

mulation of a new aesthetics of content. Moreover, we must observe that, against the vague notion of "antiquity" which classicism had embraced until then, Winckelmann limited to Greece the past to be imitated.

Friedrich Schiller (1759–1850) was the one who developed rationally the ideals of German classicism while depending on the aesthetics of Immanuel Kant (1724–1804). The following is an excerpt from Schiller's *Letters on the Aesthetic Education of Man* (1795):

> In fullness of form no less than of content, at once philosophic and creative, sensitive and energetic, the Greeks combined the first youth of imagination with the manhood of reason in a glorious manifestation of humanity. . . . It was civilization itself that inflicted this wound upon modern man. Once the increase of empirical knowledge, and more exact modes of thought, made sharper divisions between the sciences inevitable, and once the increasingly complex machinery of state necessitated a more rigorous separation of ranks and occupations, then the inner unity of human nature was severed too, and a disastrous conflict set its harmonious powers at variance.[11]

There is clearly a startling resemblance between this passage from Schiller and Aizu's ideas expressed in the letter and in the passage from the general principles mentioned earlier. It would be difficult to establish whether Aizu, who specialized in English literature, ever read the German version of Schiller's aesthetic essays. Around the same time, however, Fukada Yasukazu (1878–1928),[12] then professor of aesthetics at the University of Kyoto, introduced Schiller's classical aesthetics, offering a unique and complete picture in a study titled "Shirurā ga Bigakujō no Kōseki" (Schiller's Achievements in Aesthetics).[13] It is likely that Aizu came across this essay. However, there is nothing more I can say here on this issue.

Apart from this matter, Schiller took his concrete examples of the ideal of humanity from ancient Greece, searching for it in the life of the reconciled man who is partial neither to the flesh nor to the spirit; Schiller calls it "the beautiful spirit." There are differences between

11. [I have changed the author's quotation of Schiller slightly in order to follow the English translation by Elizabeth M. Wilkinson and L. A. Willoughby. See Friedrich Schiller, *Essays* (New York: Continuum, 1993), pp. 98–99. Ed.]

12. [See Chapter 17. Ed.]

13. [Fukada originally published the article in the August and November 1923 issues of the journal *Tetsugaku Kenkyū*. Ed.]

the West and the East, and yet in the same manner Confucius, from the beginning of his quest for knowledge, described his own existence, as a person who had eventually attained such a reconciliation, with the following words: "Following the heart as it desires without ever departing from the rule."

We might call Confucianism the moral philosophy of the East. By the same token, we might call Schiller's aesthetics "aesthetic ethicism" or "aesthetic moralism." In his essays Schiller explained how to ful-fill the ideal of the "beautiful spirit." The answer is what Schiller calls "the aesthetic education of man." This, in short, is art education— the training of the heart to be inspired by the observation of splendid works of art, leading to the cultivation of beautiful behavior befitting a human being. Indeed, Aizu often spoke to his disciples of the "cul-tivation of taste." Aizu acknowledged students as his own disciples by giving them a set of "rules of learning." An important clause was "the cultivation of one's nature with the help of arts and sciences." This corresponds precisely to Schiller's notion of aesthetic education.

I have already mentioned that Schiller's classicist aesthetics inher-ited and developed Winckelmann's classicist view of the arts. At the same time, I must note the extensive influence that the thought of Jean-Jacques Rousseau (1712–1778) had on the formation of Schiller's aesthetics. In fact, the mediation between Schiller's aesthetics and Rousseau's thought took place through Kant's essay on the philosophy of history, "On the Speculative Origins of Human History"—a topic on which I will not be saying anything more here.

In regard to Rousseau, everyone remembers his famous "return to nature" thesis. Aizu deplored the "age of the division of labor" in which he lived. The abuses resulting from such a trend, however, had not begun with his age. They had already been felt by Rousseau's contemporaries. According to Rousseau, the various evils and dis-tresses experienced in the age known as "modern" resulted from man's resistance against a "natural" way of life and from an "artificial" organization and structuring of society. The only means left to escape from the evils of "artificiality" was a return to nature.

No matter how strongly we feel compelled to "return to nature," however, we are left with a sense of bewilderment. What is meant here by "nature" is not the savage, retrogressive nature of "returning to the forest and living with bears." Actually, Winckelmann's *Thoughts on the Imitation of Greek Art* was responsible for providing concrete images of the historical existence of such a utopian space—a "nature"

appropriate to human beings. The images of antiquity provided in this work abound in representations of a mild and languid climate; of people filled with beauty and strength; of Olympian festivals in which youths compete in contests of physical prowess; of sensitivity and intellect, resulting in outstanding literary works and fine arts; and, also, of the ideal political system, known as "democracy," that sustained all these activities. In truth, however, the ancient world celebrated by Winckelmann differed from the historical reality. In fact, it was the product of Winckelmann's imagination, based on the free use of sources related to the history of art. This was an idealized pseudo-historical world—or, to go even further, we could say it was a substitute for the image of a Paradise or an Elysium of religious or mythical origin. And yet, even today, our images of the ancient Greek world are still deeply indebted to Winckelmann's work. It is simply art history, you might say, and yet in my opinion art history is important.

Let us now return once again to the world of Aizu Yaichi. As mentioned earlier, Aizu's pilgrimage to the ancient temples of Yamato was inspired by Watsuji Tetsurō, and it started in 1921 as a kind of competition with Watsuji. With the passing of time, Aizu's yearning for antiquity grew, moving back and forth between the Greek world and the splendid land of Yamato. Eventually his sentiments crystallized in poems such as the following, which I personally believe to be a masterpiece:

Ohotera no	Stepping on the ground
Maroki hashira no	Over the moon's shadow
Tsukikage wo	Reflecting the round columns
Tsuchi ni fumitsutsu	Of the great temple,
Mono wo koso omohe	Absorbed in thoughts.

It is commonly believed that the "great temple" celebrated in the poem is the Tōshōdaiji, but actually Aizu is said to have polished his inspiration while strolling between a moonlit Hōryūji and the Tōshōdaiji. While stepping over the small yet powerful shade projected on the ground by the row of round columns lit by the moon—a colonnade, introduced to Japan with the eastward advance of Buddhism, that reminds him of a Greek temple—Aizu travels in his thoughts to ancient Greece.[14] Here Aizu succeeds in blending in one spot his yearn-

14. [Aizu himself gives the following explanation of the poem in his collection of essays, *Konsai Zuihitsu:* "Now that my episode has gone this far, there is one more

ing for ancient Greece, which remained an ideal throughout his life, and the Northerner's desire for the South. In other words, we might say that here Aizu has rediscovered Nara as the site of the artistic expression of himself as a whole person.

Aizu was not the first person to discover Greece in Nara. Examples of pioneers in this regard are Okakura Tenshin (1862–1913) and Ernest F. Fenollosa (1853–1908).[15] Fenollosa was a foreigner in government employ—one of those technicians or scholars Japan employed with the purpose of eliciting knowledge from the advanced Western countries in disciplines, such as scientific technology, in which these countries excelled. This was a method used by the Meiji government to positively advance Japan's modernization with the slogan "Civilization and Enlightenment" *(bunmei kaika)*. Fenollosa was employed as a professor of philosophy at Tokyo Imperial University, where he lectured on the philosophy of Hegel (1770–1831). At first, Fenollosa did not value the traditions of Japanese arts. His views on the subject changed completely, however, after he traveled to Nara and Kyoto in 1880. He was impressed by the ancient temples of Asuka and Nara and by the Buddhist statues of the early Heian period. Fenollosa acknowledged the unmistakable influence of the arts of ancient

thing I have to say. It is what the columns in my poem really are. Art scholars nowadays, as if by common assent, tend to offer elaborate explanations on such things as the height of the column, its diameter, its proportion, or whether it is thicker in the lower middle part or not. And since they eagerly try to discern the time when these two temples of Tōshōdaiji and Hōryūji were built and to ascertain the wide time gap of one hundred and several score years between them, it would certainly be no small matter worthy of contempt that I—who am regarded as one of the scholars—started to compose a poem at one temple and completed it at another. But I might be even more irreverent than that. The reason for this is that when I closely search for the cause of my deep love for the columns in the temples in Nara, it seems to me that it lies neither in Tōshōdaiji nor in Hōryūji but in a sanctuary in a distant country in the distant past, namely Greece. More than thirty years ago, though this has not much value to recommend in these advanced times, I had for a while very much longed to know Greece, and I read all the books I could get at that time, dozens of them. I managed to assuage my longing a little. The columns in the Parthenon and the Theseion seem to have made a very deep impression on my young heart, so that even now they seem to keep me interested in those columns in Nara. The question is not whether we can distinguish the Asuka period from that of Nara. To some people it may seem that I walked around Nara and composed a poem with these outrageous feelings. For my part, however, I do not know what else I could have done. And I even secretly believe that the reason some people show some fondness for my poem lies there." English translation by Ōno Michiko, " 'Tōshōdaiji no Marubashira' Eigoyaku ni Tsuite," *Shūsō* 11 (1995): 21–22. Ed.]

15. [See Chapter 2. Ed.]

Greece. Later he recorded the excitement he felt on those occasions in *Epochs of Japanese Art,* in which we read the following statements:

> It was apparently on the western side of the Nara plain, close up under the sand hills, and a little north of the present town of Koriyama, that the first great experiments in Japanese Greco-Buddhist art were made. . . . Here, amid a mass of broken statues and interesting refuse, I found in 1880 a life-sized piece that seems to have been one of the original Greco-Buddhist models, or at least experiments.
>
> The Dembodo statues [of Hōryūji] are mostly in guilded trinities and a little smaller than life. The best set of these has a grace and finish almost worthy of Giogi and his black bronzes. The topknot breaks with a special catch in the center part. In the Bodhisattva, whose topknot and left arm are broken, the beautiful plastic play of the drapery over the shoulder gives us the feeling of a Roman emperor's portrait statue. Since the day in 1880 when I first discovered it, I have always affectionately called it "Caesar."[16]

Of course, we cannot say that prior to Fenollosa the West held no artistic interest for Japan. For example, the immense influence that the Japanese prints of the floating world *(ukiyo-e)* had on impressionist painters such as Eduard Manet (1832–1883) and Vincent van Gogh (1853–1890) is well known. But this, after all, was a kind of taste for foreign lands—nothing more than an interest in the exotic. Fenollosa, however, discovered a big artistic wave uniting East and West in the history of art. In other words, Fenollosa pointed out the classicist tradition that reached Japan from ancient Greece by way of India's Ghandara, China (through the Silk Road), and the Korean peninsula. We can say that Fenollosa discovered for the first time the value of Japanese art from the point of view of world history.

For Japan, at a time when the country was washed by the waves of modernization surging from the West, traditional arts found themselves in a tragic situation since no one was taking them into account. Moreover, the anti-Buddhist policies of the Meiji government, which led to the destruction of Buddhist temples, had struck a ruinous blow to cultural properties. What is difficult to fathom is the fact that such policies were carried out in the most destructive way in the city of

16. [I have altered Professor Kambayashi's quotation slightly in order to match Fenollosa's original text. See Ernest F. Fenollosa, *Epochs of Chinese and Japanese Arts: An Outline History of East Asian Design,* vol. 1 (New York: Frederik A. Stokes, 1912), pp. 92 and 104. Ed.]

Nara. It was only after Fenollosa's reappraisal that the Meiji govern-
ment began to protect the ancient arts and cultural properties of
Japan. Fenollosa could count on the cooperation of Okakura Tenshin,
who later became a prominent figure in the art world of the Meiji
period. I believe that many people will remember the exciting account
these two scholars gave of the moment when the door of the Dream
Hall (Yumedono) of Hōryūji opened in front of them, revealing the
statue of Guze Kannon (Goddess of Mercy), which for more than one
thousand and several hundred years had been kept hidden from sight.[17]

But interest in Kyoto and Nara did not swell all at once after this
event. Although, like Nara, Kyoto was a former capital, Kyoto had
actually continued to be the country's political and cultural center
until the end of the shogunate. In the mind of the Japanese, however,
Nara is perceived as a past from which we are all severed. In *A Pilgrim-
age to Ancient Temples,* Watsuji Tetsurō calls Nara "the discarded
capital." The site known as Nara is somehow detached from the con-
text of the age in which we live. At the same time, we can say that the
more people are distanced from a certain reality, the easier it becomes
for them to idealize it. We could make the same argument with regard
to Winckelmann's idealized view of Greece. At the beginning of his
Thoughts on the Imitation of Greek Art, Winckelmann makes the fol-
lowing remark:

> The most pure wellspring of art is now uncovered; lucky is the person
> who finds it and has a taste of it. To search for this fountainhead in-
> volves traveling to Athens.

In those days, however, it was not easy to travel to Athens, since
Greece was under the control of the Ottoman Empire. In fact, Winckel-
mann himself never set foot on Greek land. His book was the product
of his imagination, and it was written with the help of secondary mate-
rials such as various replicas of the Roman period. Winckelmann was
employed in the Vatican Library. Seen from Rome, Greece remained
for him a utopian land—a faraway object of intense longing. The
more the longing grew, the greater the degree of idealization. Simi-
larly, we can see how the idea that Nara was the "discarded capital,"

17. [For an interpretation of this episode in English see Stefan Tanaka, "Imaging
History: Inscribing Belief in the Nation," *Journal of Asian Studies* 53(1) (February
1994):24–44. Ed.]

cut off from the reality of life, made the process of idealization an easy enterprise.

Despite the efforts of Fenollosa, Tenshin, and a few specialized scholars of art, the ancient temples and Buddhist statues of Nara were still objects of religious worship. The area known as Nara continued to be a Buddhist sanctuary. I believe that the scholar of ethics Watsuji Tetsurō, and his book *A Pilgrimage to Ancient Temples,* are the major causes behind the transformation of our perception of this ancient capital from a site of religious worship to a place of aesthetic contemplation, thus establishing Nara as a symbol of human beauty. At the same time, we could say that the superb poems Aizu Yaichi collected in *Rokumei Shū* (The Deer's Cries, 1940) are an effort through his own art to create an ultimate idealization of this "discarded capital" by establishing it as the capital of eternal yearning for the Japanese people. If so much interest is shown today in the ancient capital Nara, this is due entirely to the work of Watsuji Tetsurō and Aizu Yaichi.

And yet I think there is a subtle divergence in the art views and the aesthetic sense of these two scholars who addressed their thoughts to the same ancient capital. We understand it concretely when we look at how they appraised Buddhist sculpture. Earlier Winckelmann had characterized the classical beauty of ancient Greece as "quiet grandeur and noble simplicity" *(stille Grösse und edle Einfalt).* Watsuji applied these standards, originally devised to appraise masterpieces in Greek art, to Buddhist statues of the Tenpyō era (A.D. 729–767), such as Bonten in the Sangetsu Hall of Tōdaiji or the Eleven-Faced Goddess of Mercy (Jūichimen Kannon) in the Seirinji. These statues were made to correspond to the ideal of "beautiful form" that Winckelmann had devised in order to describe the climax of classical beauty.

If we look at Aizu's poems, by contrast, we see that his introduction to Buddhist statues began with the Guze Kannon of the Dream Hall at Hōryūji. He subsequently fell in love with Kudara Kannon, which he called the "Korean Buddha"; with the Asuka Buddha, which derived from the stylistic line of Northern Wei; and, skipping the Tenpyō period, with the Buddhas of the Jōgan years (A.D. 859–876), which exhibit the solemn elegance of the early Heian era. In the ancient Buddhas of Nara and Asuka, Aizu sought an inner spiritual beauty that he felt exceeded the beauty of form. We might say that while Watsuji praised "beautiful forms," Aizu privileged "solemn forms."

Fujihara no	Red lips,
Ōki kisaki wo	As if I were looking
Utsushimi ni	At the incarnation
Ahimiru gotoku	Of the great
Akaki kuchibiru	Fujiwara Empress.

This poem celebrates the Jūichimen Kannon of the Hokkeji, of which Aizu was particularly fond. The "great empress" praised in this poem is Empress Kōmei,[18] the attractive empress known for looking as if she was "releasing light" *(kōmei)*. Legend has it that this empress had vowed to rescue the ill and that she washed away the dirt and impurities of a thousand people, providing them with medicines as well. Undoubtedly this is an erotic poem. But we should interpret this eroticism as being related to the transcendentalism that is particular to Tantric Buddhism *(mikkyō)* and preaches the attainment of Buddhahood in this human life.

While staring at reality, Aizu turned his aesthetic eyes to a transcendental world beyond reality: the inner world of the spirit. There is a poem by Keats, "Ode on a Grecian Urn," which is the starting point of Aizu's aesthetics:

> Heard melodies are sweet, but those unheard
> Are sweeter.[19]

Undoubtedly this poem resonates with Aizu's aesthetic sense. Aizu loved the expression "to listen to the voiceless," an expression he used in his calligraphy. This expression clearly overlaps with Keats' "unheard melodies."

At the end of his life Aizu returned to his hometown of Niigata; after that he would seldom visit Nara. As a result, his yearning for that city became even stronger and more pure. There is a proverb that says, "The birthplace has to be viewed from afar." I wonder whether Aizu went back to the northern provinces, far from the ancient capital, with the purpose of sublimating into something more pure his thoughts for Nara, the place that, for the Japanese people, is the birthplace of the spirit. Maybe it was at that time that Aizu overlaid the image of Heine's "The North Sea" onto the sound of the waves of the Sea of Japan.

18. [Kōmei (701–760) was the second daughter of Fujiwara Fuhito (659–720) and the wife of Emperor Shōmu (r. 724–749). Ed.]

19. [For Keats' poem see Jack Stillinger, ed., *The Poems of John Keats* (Cambridge, Mass.: Belknap Press, 1978), p. 372. Ed.]

AESTHETICS
AT THE
UNIVERSITY
OF TOKYO

9

Biographies of Aestheticians
Ōtsuka Yasuji

IMAMICHI TOMONOBU

A Necessary Detour

When I am asked how many world-class thinkers in the field of aesthetics Japan has produced from the Meiji Restoration until today (thinkers who have developed their own independent theories within a comprehensive structure; thinkers who are absolutely worthy of being introduced to the public), I cannot help but feel a sense of hopelessness, so few are the aestheticians with their own original personality. This is not to say there were no exceptional aestheticians. Rather than establishing their own theses, however, these aestheticians absorbed and digested Western knowledge through an exhaustive study, accomplishing the complicated work of solving problems by using theories and methodologies that came from the West and were learned during their long educational stays in Western countries—theories and methodologies that were not yet familiar in Japan. This also holds true for the Japanese scientific community at large during the Meiji, Taishō, and Shōwa periods. At a glance we can say that in the realm of the arts (especially the literary arts)—in which Japan had excelled since ancient times thanks to an outstanding scholarly tradition, as we can see especially in the tradition of theoretical works on poetry *(karon)* since the Heian period—all efforts were concentrated on mastering Western theories, and these were introduced so pervasively as to give the appearance that a devolution took place. We must not forget, however, that this labor became a major cause in the rise of scientific standards in Japan to international proportions—immediately after an isolation that had lasted three hundred years. We cannot properly evaluate the accomplishments of these aestheti-

From Imamichi Tomonobu, "Bigakusha Hyōden: Ōtsuka Yasuji," *Nihon no Bigaku* (The Aesthetics of Japan) 2(8) (1986):83–90.

cians without noting the difficulties involved in the process of assimilation from the West.

Ōtsuka Yasuji (1868–1931) was among the group of outstanding Japanese aestheticians who found themselves caught in the process of westernization and "enlightenment" in the scientific world. Whenever sciences based on nonnative traditions are first introduced, we commonly witness that people fail to achieve the mark of objectivity despite strong personal efforts. Ōtsuka, however, was known for his seriousness and preciseness, as well as his ability to foster a taste for learning among his students. Ōtsuka did not leave a single book while he was alive. All his efforts were directed toward the preparation of lectures for the newly established course in aesthetics at the Imperial University of Tokyo—a field in which he became Japan's first tenured professor. This event remains central to discussions of Ōtsuka.

The Establishment of University Chairs and Ōtsuka Yasuji

On September 7, 1893, what was known at the time as Imperial University, Faculty of Letters University (Teikoku Daigaku Bunka Daigaku)—it was renamed Tokyo Imperial University, Faculty of Letters University, or Tokyo Teikoku Daigaku Bunka Daigaku in 1897, and is now known as the University of Tokyo, or Tokyo Daigaku)—established a chair system on the model of Western universities. At the same time, the Chair of Aesthetics was founded together with the first twenty chairs constituting the Division of Letters and Sciences (Bungakubu). As the year was 1893, this was the world's first university Chair of Aesthetics. As is well known, the word "chair" (*chaire* in French, *Lehrstuhl* in German, *kōza* in Japanese), referred to the professor's seat, which included the positions of full professor, associate professor, lecturer, and assistant. Since it also involved the presence of a research space *(kenkyū shitsu)* stocked with the necessary books, a "chair" did not simply mean a lecturing position. Although many European universities began to offer lectures in aesthetics in the latter part of the eighteenth century, the first chair officially dedicated to the field of aesthetics in Europe was created at the University of Paris (Sorbonne) with the appointment of V. Basch.[1] Since this appoint-

1. [Victor Guillaume Basch (1865–1944) is the author, among other works, of *Essai Critique sur l'Esthétique de Kant* (Critical Essay on Kant's Aesthetics, 1896) and *La Poétique de Schiller* (The Poetics of Schiller, 1911). Ed.]

ment took place in 1919, it actually came after the establishment of Japan's second Chair in Aesthetics at Kyoto University in 1909. Some consider the pioneering role played by the University of Tokyo in establishing the Chair of Aesthetics to exemplify the fractionalization caused by specialization in modern fields of learning, a practice with which Japan was effectively trying to catch up. Others see it as a continuation of the activities of men of discernment who happened to value aesthetics such as the foreign lecturers Fenollosa[2] and Koeber.[3] At the same time, however, we should not forget the importance that the Japanese tradition placed on the estimation of beauty as the highest value. This should be considered in combination with the advice that Fenollosa, a pioneer in the field of aesthetics, gave to the dean of letters and sciences of the University of Tokyo, Toyama Masakazu,[4] to develop the fields of philosophy and aesthetics, as well as the position taken by Inoue Tetsujirō (1855–1944) on this issue: obsessed with aesthetics, he viewed philosophy as a mark of distinction of a representative Eastern university. At the same time, we should also remember the distinct presence of the pianist and philosopher Koeber, whose activities created an overtly artistic atmosphere.

On April 1900, Ōtsuka Yasuji came back from Europe after three years of study abroad and immediately accepted an appointment to become the first tenured professor and Chair of Aesthetics. Thus both in name and in practice the chair entered a phase of full activities, since until then Raphael von Koeber had lectured on aesthetics part-time in addition to teaching philosophy. More research needs to be done on the preparatory role that Koeber and Fenollosa played in the field of Japanese aesthetics. Ōtsuka stood on the teaching platform for a period of thirty years building the foundations of the specialized field of aesthetics in Japan.

2. [See Chapters 2 and 3. Ed.]

3. [Raphael von Koeber (1848–1923), a Russian of German descent, graduated from the Moscow Conservatory of Music. He then studied philosophy at the universities of Jena and Heidelberg with Fischer and Hartmann. He was invited to lecture in philosophy at Tokyo Imperial University upon the recommendation of Hartmann. At the University of Tokyo he taught Western philosophy, aesthetics, Greek, Latin, German, and German literature from 1893 to 1914. Unable to return to Germany because of World War I, Koeber remained in Japan until he died, on June 14, 1923, teaching piano at the Ueno Music School (Ueno Ongaku Gakkō) and Russian at the School of Foreign Languages (Gaikokugo Gakkō). Ed.]

4. [Toyama Masakazu (1848–1900), a member of the Meirokusha Society, worked toward the reform of theater and played a fundamental role in education, rising to the post of minister of education in the cabinet of Itō Hirobumi. Ed.]

Characteristics of Ōtsuka's Aesthetics

If I had to summarize Ōtsuka's activities in a phrase, I would say that he addressed aesthetics as the science of art criticism. At that time in Japan, one first had to acquaint oneself with the Western standards of the science; thus Ōtsuka initially turned to English, German, and French sources. He then planned to digest and absorb, through exhaustive study, the European and American theories addressed in his lectures. Since he was totally absorbed in the intellectual development of his students, little time was left for external activities such as writing. He did not submit more than twenty articles to journals, and he did not leave a single monograph in published form. Around the time of Ōtsuka's tenure, many works appeared, one after another, such as Mori Rintarō (Ōgai) and Ōmura Seigai's *Shinbi Kōryō* (Outline of Aesthetics; a translation of Eduard von Hartmann's *Philosophie des Schönen,* 1899), Mori Rintarō's *Shinbi Shinsetsu* (A New Interpretation of Aesthetics; a summary of Volkelt's *Aesthetische Zeitfragen,* 1900), Mori Rintarō's *Shinbi Kyokuchi Ron* (Treatise on the Highest in Aesthetics; a partial translation of Otto Liebmann's *Zur Analysis der Wirklichkeit,* 1902), and Takayama Rinjirō's (Chogyū's) *Kinsei Bigaku* (Modern Aesthetics; taken from works by Schasler, Zimmermann, and others, 1900). Since the new intellectual trends in the arts had already been presented in journals such as *Teikoku Bungaku,* founded by Toyama Masakazu and others in 1895, and *Taiyō,* there was no need for Ōtsuka to introduce the elements of aesthetics; therefore, in his lectures he provided sophisticated critical explanations of all Western theories, developing aesthetic theories on works of art.

Two Statements

To convey the nature and appeal of Ōtsuka's lectures, I will quote from two scholars who attended them: Ōnishi Yoshinori (1888–1959),[5] the professor of aesthetics who succeeded Ōtsuka in his position at the University of Tokyo, and Watsuji Tetsurō (1889–1960),[6] a scholar of ethics and the author of many essays on aesthetics. In the introduction to *Ōtsuka Hakase Kōgi Shū* 1: *Bigaku Oyobi Geijutsu*

5. [See Chapters 10 and 11. Ed.]
6. [See Chapter 12. Ed.]

Ron (Collected Lectures of Dr. Ōtsuka, vol. 1: Essays on Aesthetics and Art; Iwanami Shoten, 1933), Ōnishi, who was the editor of the collection, writes:

> Usually he did not make use of a manuscript in his lectures; he only relied on extremely simple notes, jotting down the main concepts on a piece of paper. And yet it was a distinction of his teaching to spin out one after another penetrating remarks that were subtly based on a profound logic. It was not easy for students to take notes on his lectures; unless one had intimately participated in these lectures, it was impossible to get to their essence.

As for Watsuji Tetsurō, who, as an examiner, and along with Ōnishi, guarded the academicism of the Division of Letters and Sciences during the war years (a fact I noted when I entered the University of Tokyo in 1945), I will borrow a few of his remarks that moved me deeply when I first read them a long time ago and that I had long forgotten until Sakabe Megumi (b. 1936), who recently quoted them in his book *Watsuji Tetsurō* (Iwanami Shoten, 1986, pp. 152–153), brought them back to my memory. Let me quote from Sakabe's book:

> When *The Collected Works of Okakura Tenshin (Okakura Tenshin Zenshū)* were published, Watsuji contributed a short article to *Teidai Shinbun* titled "Okakura Sensei no Omoide" (A Recollection of Professor Okakura), which he later included in his book *Men to Perusona* (Mask and Persona). The following is an excerpt from Watsuji's work:
>
>> When Professor Okakura lectured on "The History of Eastern Technical Arts" during his last years at the Faculty of Letters and Sciences, I happened to be in attendance. The events that left the deepest impression on me during my student years were these lectures and the course of Professor Ōtsuka on "The History of Contemporary Literary Arts" (Saikin Bungei Shi). The lectures of Professor Ōtsuka firmly lit a fiery intellectual curiosity, and they instigated, unknown to me, a passion for our science. Although the lectures of Professor Okakura were equally impassioned, they inspired me with a *love for the arts* and not with intellectual curiosity. (vol. 18, pp. 352–353)

The same feeling will be conveyed to the reader of *The Collected Lectures of Dr. Ōtsuka.*

Ōtsuka's Aesthetics Seen from His Lectures

As I mentioned earlier, Ōtsuka was a scholar who did not produce any monographic publication in his lifetime. In 1931, however, after

his death, Associate Professor Ōnishi Yoshinori, in consultation with Fukada Yasukazu,[7] Sugawara Kyōzō,[8] Abe Jirō,[9] and Ueno Naoteru,[10] collected eight years of Ōtsuka's lectures prior to his retirement—namely, general considerations on aesthetics (1921, 1924, 1926), essays on the arts (1922), essays on architecture (1923), essays on sculpture (1925), essays on painting (1927, 1928). The lectures were based on notes taken by students as well as notes by Ōtsuka himself. The selection and collation was made by the rising scholar Takeuchi Toshio[11] under the supervision of Ōnishi. Two volumes were published as *The Collected Lectures of Dr. Ōtsuka*, vols. 1 and 2, with the subtitles *Bigaku Oyobi Geijutsu Ron* (Essays on Aesthetics and Art) and *Bungei Shichō Ron* (Essays on the Trends of Thought in the Literary Arts).

In these lectures, Ōtsuka stated that "it is a good idea to combine the study of philosophy and the study of science in the formulation of an aesthetic system; but since I cannot cover both areas here, I will make art the object of my research, while employing the scientific method" (*Collected Lectures*, vol. 1). Accordingly, Ōtsuka's aesthetics emphasized the scientific aspect of the arts. This basic idea coincided terminologically with what Etienne Souriau,[12] an authority in the contemporary world of French aesthetics, was stressing at the time, although he did not mean exactly the same thing. In fact, Souriau was advising his students to follow the method of the natural sciences—yet what he meant by "science" in the phrase "science of art" was philosophy rather than science. Souriau grounded his understanding of science in the roots of the Latin tradition. This did not apply to Ōtsuka who, as he himself repeatedly stated, declared that "I am

7. [Fukada Yasukazu (1878–1928) was the first professor of aesthetics at Kyoto University. See Chapter 17. Ed.]

8. [Sugawara Kyōzō (1881–1967) taught aesthetics and experimental psychology at Toita Women's University. Ed.]

9. [Abe Jirō (1883–1959) taught aesthetics at Tōhoku University in Sendai. See Chapter 13. Ed.]

10. [Ueno Naoteru (1882–1973) became president of Tōkyō Geijutsu Daigaku after a distinguished career in the field of aesthetics in Korea and as director of the Osaka Municipal Museum of Fine Arts. Ed.]

11. [Takeuchi Toshio (1905–1982) succeeded Ōnishi Yoshinori as professor of aesthetics at the University of Tokyo. The same chair was then held by Imamichi Tomonobu, the writer of the present essay. See Chapter 14. Ed.]

12. [Etienne Souriau (1892–1979) is the author of *L'Avenir de l'Esthétique* (The Future of Aesthetics, 1929), in which he called aesthetics "the science of forms," and *La Correspondance des Arts* (The Relationships of the Arts, 1947). Ed.]

going to lecture on aesthetics by making its main object art rather than beauty. Although we can count on two different research methodologies, the philosophical method and the scientific method, my plan is to conduct my research from the scientific perspective rather than the philosophical" (ibid., p. 18). Moreover, what Ōtsuka called "science" does not refer, understandably, to the natural sciences; nor does it refer to historical science (Rickert)[13] in the sense of a cultural science describing individual personalities—a conflicting methodology with regard to the one employed by the natural sciences. It was not even psychological science (Wundt),[14] which, though different from the natural sciences with regard to the object of its research, shares with them the purpose of setting up rules based on the logic of cause and effect—psychological causation in the case of psychology. "Science" for Ōtsuka was a typology that studied patterns; it was located midway between the cultural and the natural sciences (ibid., p. 33).

Essays on the Arts

Characteristic of Ōtsuka's work are his essays on art, on the history of Western art, and on paintings. According to him, aesthetics is the science of art and must be grounded in artistic experience. Ōtsuka stated that "the central point in the study of aesthetics is not a historical inquiry into the aesthetic consciousness of artists, nor is it a speculative metaphysics that privileges the artistic experience of objects in general; rather, it should be called the experience of the work of art *(Kunstwerk-Erlebnis)*" (ibid., pp. 59–60). Ōtsuka transformed the study of art into the study of the experience of the work of art—an idea that allowed him to develop an original "artistic science of art." I believe this was an unconscious variation and development of a work-centered appreciation of works of art similar to the judgments that were formulated in premodern poetry matches *(uta-awase)*. We find examples in works by Fujiwara no Kintō and Fujiwara no

13. [Heinrich Rickert (1863–1915) was a Neo-Kantian philosopher whose *Kulturwissenschaft und Naturwissenschaft* (Cultural Science and Natural Science, 1898) was translated into Japanese as *Bunka Kagaku to Shizen Kagaku* in 1939. Ed.]

14. [Wilhelm Wundt (1831–1920) established a laboratory of experimental psychology at the University of Leipzig. Ed.]

Teika[15]—a poetic practice within Japanese aesthetics known as "poetic essays" *(karon)*. These essays were at the root of the literary arts. Ōtsuka argued that "the pivot of aesthetic experience is the experience of art. Since creation and reception are at the center of the work of art, and they develop in absolutely opposite directions, even the theory of empathy, which is popular at the present time, while being appropriate to reception, is inadequate to explain the act of creation" (ibid., pp. 241–245).

The course on "The History of European Literary Arts" (Ōshū Bungei Shi), which Ōtsuka presented as special lectures over a period of more than ten years, was, together with the lectures of Koeber and translations by Mori Ōgai, a true entryway to Western artistic trends at a time between the late Meiji and Taishō periods when only a few translations of Western works on art and criticism were available. At the same time, these lectures played a pioneering role in the field of literary science in Japan. Moreover, they are well known for the fascination they engendered in audiences who understood, thanks to Ōtsuka's presentation of concrete works, new aesthetic trends out of Europe, such as aestheticism and symbolism. Such a fascination was the result, not only of the choice of fresh material, but also the elaborateness of Ōtsuka's own ideas.

Ōtsuka developed the essays on paintings in two series of lectures he gave in 1927 and 1928 immediately prior to his retirement. Here again he stated: "The study of the spiritual aspect of paintings has given way to psychology, sociology, and the like, but we should instead examine those aspects of art which are peculiar to art. The spiritual aspects should be analyzed only in relation to sensibility; after all, sensibility in a broad sense should be the focus of research" (ibid., pp. 505–506). Ōtsuka tried to reorient aesthetics by moving away from the metaphysical speculations of German idealism and toward its true etymological meaning of "senses," from the Greek word *"aisthesis."* Therefore, even with regard to paintings, he undertook a "sensology" of painting. Accordingly, the sense elements forming visual experience became the main focus of his search and led him to investigate them under the three rubrics of senses inspired by

15. [Fujiwara no Kintō (966–1041) is the author of a major theoretical work on poetry, *Shinsen Zuinō* (The Essence of Newly Selected Poems). Fujiwara no Teika (1162–1241) was perhaps the most distinguished poet and theoretician of the Japanese Middle Ages. Ed.]

light, color, and form. With regard to senses inspired by light, for example, in discussions of landscape paintings Ōtsuka analyzed the techniques employed by Claude Lorrain[16] and William Turner,[17] explaining, with the aid of a diagram, that their methods followed the law of progressive reduction *(progressive Reduktion)*. With regard to senses inspired by color, he discussed the mixing of oil pigments on the part of the neo-impressionists, which was achieved through an optical blend of colors *(optische Farbenmischung)* and thus was scientifically different from earlier techniques. In other words, painters in the past had painted mixed colors on the canvas, whereas the neo-impressionists painted different colors in different spots of the painting, letting the mixing of colors take place in the visual sensation of the observer.

Ōtsuka's attempt to develop a science of the senses was an introduction of theories discussed by foreign scholars such as Wundt, Utitz,[18] and Katz.[19] As the three leading aestheticians of the time Ōtsuka mentioned the names of Lipps,[20] Volkelt,[21] and Cohen,[22] whose major works he deeply assimilated. While using the recent results of psychologists and scholars of the science of art, Ōtsuka contributed analyses of both painting techniques and the appreciation of paintings from a scientific perspective based on the human senses. From this point of view he also researched Eastern painting techniques; in this research, we see the seeds of an original comparative aesthetics that stressed the superiority of Eastern painters over

16. [Claude Gellée (1600–1682), also known as Claude Lorrain, achieved fame as a French painter of idyllic landscapes and seascapes. He was noted especially for his mastery of light and his command of atmospheric effects and perspective. Ed.]

17. [Joseph Mallord William Turner (1775–1851), English painter, was perhaps the greatest landscapist of the nineteenth century. Ed.]

18. [Emil Utitz (1883–1956) is the author of *Grundlegung der allgemeinen Kunstwissenschaft* (Foundations of the Science of All Arts, 1914 and 1921). Ed.]

19. [David Katz (1884–1953) distinguished "formal patterns" and "color patterns" in the visual experience of the artist. Ed.]

20. [Theodor Lipps (1851–1914), a major theoretician of psychological aesthetics, was well known for his theory of empathy *(Einfühlung)*. He is the author of a famous *Ästhetik* (Aesthetics, 1903 and 1906). Ed.]

21. [Johannes Volkelt (1848–1930), another exponent of the theory of empathy, is the author of *Das System der Ästhetik* (The System of Aesthetics, 1905, 1910, and 1914) and of *Das ästhetische Bewusstsein* (Aesthetic Consciousness, 1920). Ed.]

22. [Hermann Cohen (1842–1918), a scholar of Kant, is the author of *Ästhetik das reinen Gefühls* (Aesthetics of Pure Feelings, 1912). Ed.]

their Western counterparts with regard to color and freedom of design (ibid., pp. 601–611).

As I mentioned earlier, during his lectures Ōtsuka did not use any manuscript drafts, just short notes with a list of major issues for discussion, "letting his many thoughts spin out in a web" (Ōnishi Yoshinori, *Tōkyō Teikoku Daigaku Gakujutsu Taikan*, p. 443). He retired from the university in 1929, and died in March 1931, leaving behind a deep regret among students but no printed book.

His pupils worked together to bring out the two volumes of his lectures published after Ōtsuka's death. Prior to that event, on the occasion of Ōtsuka's sixtieth birthday, his students planned a commemorative volume consisting for the most part of their own articles in praise of the scientific achievements of their teachers. The book was published in January 1931 with the title *Bigaku Oyobi Geijutsu Shi Kenkyū* (Studies in Aesthetics and Art History). Looking over these twenty essays and a thousand pages, we can say that this "bulky Festschrift was the most remarkable result of Professor Ōtsuka's guidance over many years" (ibid., p. 443). This publication is very precious as a historical document since it attests to the high standards of research that were reached after the consolidation of the Chair in Aesthetics, research that had finally begun to bear fruit. Among the students Ōtsuka supervised during his tenure were such controversial figures as Takayama Rinjirō (Chogyū) and Okakura Kakuzō (Tenshin). Since 1923, Ōnishi Yoshinori, who was to become Ōtsuka's successor at the University of Tokyo, had been a lecturer in the history of early modern aesthetics.

Since Ōtsuka spent his entire life at the university, I have limited my discussion to the groundbreaking work he did in the field of aesthetics in Japan. Now I would like to explore his thought on Japanese beauty by discussing one lecture and one article that he presented outside the university: "Nihonfuku no Bijutsuteki Kachi" (The Artistic Value of Japanese Clothes, 1903), a lecture presented to the Society of Bamboo and Oak Trees (Chikuhaku-Kai), and "Nihon Kenchiku no Shōrai" (The Future of Japanese Architecture; July 1909, published in *Teikoku Bungaku*). "The Artistic Value of Japanese Clothes" is the written record of a lecture that Ōtsuka presented during a gathering at the Chikuhakuen sponsored by Sasaki Nobutsuna.[23] Ōtsuka

23. [Sasaki Nobutsuna (1872–1963), scholar of Japanese literature and a distinguished poet, headed a learned society of tanka poets, the Chikuhaku-Kai, founded

divided clothing into two types: garments that adhere closely to the body, exposing to view the contours of the physical shape, and garments that wrap the body and let its movements be seen. Representatives of the first type are the clothes of Western gentlemen; the Japanese kimono exemplifies the second type. Ōtsuka argues that the second type shows the beauty of the body's posture. Since the spirit is mainly expressed by movement and posture rather than by a still frame—Ōtsuka continues—the Japanese kimono, being rich with expressive power, is better suited to show the wearer's spirit. Moreover, since it is difficult for us to separate Western clothes from the body's form, even in the case of male clothes, the visual focal point is divided between two spots: the chest and the waist. But in the case of garments worn by Japanese ladies—namely the kimono—the visual focal point is unified by the sash (obi) at the center of the body.

Ōtsuka also made a few comparisons with regard to colors. He argued that the clothes of Western ladies, which transform an evening party into a place of bright daylight, vigorously reflect the light; they are gaudily but vainly beautiful. Japanese ladies, by contrast, were deeply associated with sunshine during the daytime and, accordingly, many kimono have colors that absorb the beams of light; theirs is a graceful beauty. Ōtsuka listed several other examples indicating how the Japanese kimono excels as decoration and also as art. In light of trendy fashions toward westernization, he concluded, the practice of wearing the kimono should be maintained in order to preserve gracefulness in the spiritual climate of the country.

The Future of Japanese Architecture

In "The Future of Japanese Architecture," Ōtsuka begins by locating the aesthetic nature of architecture in objects, materials, and taste. If one focuses on public architecture, he argues, its objects are government offices, schools, museums, theaters, banks, and the like, to which are suited materials such as stone and bricks (including steel frames). The future of Japanese architecture, therefore, seems to have been established already with criteria other than taste. (This was an age

by his father Hirotsuna (1828–1891) in 1891. The Bamboo and Oak Tree Garden (Chikuhakuen) was where the society met. Most participants were members of the middle and high nobility. Ed.]

when no one was discussing concrete, glass, plastic, and such.) If this is the case, then the issue of taste should be addressed. This kind of architecture might well be labeled a purely Western style, but then the Japanese examples would not move beyond imitation. Since it is impossible to speak of a purely Japanese style from the point of view of materials, Ōtsuka continues, the only choice left for Japan is to develop a type of architecture merging Japanese and Western styles. In doing so, however, the Japanese style would not leave a trace on the exterior of public buildings—with the exception of the decoration of details—being appropriate only to the interiors.

Ōtsuka remarks that, if possible, the direction of Japanizing Western-style architecture should be avoided, and the attempt to adapt wooden architecture to new demands and new materials also should be discarded. Instead, he concludes by expressing a deep desire for a miracle to happen—for a man of genius to come and transform at a bound the wooden style into a new architectural style for public buildings in stone. It is interesting to observe how Ōtsuka's argument developed —from acknowledging the fact that in the past Japanese architecture gradually inclined toward smallness and gracefulness, in spite of its importing grand-scale styles from the Continent, to a desire to see in the future the construction of majestic and imposing buildings in stone. We might say that contemporary world-renowned Japanese architects, such as Tange Kenzō (b. 1913), Isozaki Arata (b. 1931), Kurokawa Kishō (b. 1934), Ashihara Yoshinobu (b. 1918), Itō Teiji (b. 1922), and the like, have made Ōtsuka's dream a reality.

There is an essay that well characterizes Ōtsuka's achievements, although it is contained in a publication not easily accessed by general readers. This is the sequel to the fifty-year history of Tokyo Imperial University, published on December 8, 1942, with the title *Tokyo Teikoku Daigaku Gakujutsu Taikan Sōsetsu Bungakubu* (Survey of Scientific Views at Tokyo Imperial University, Faculty of Letters and Sciences)—a commemoration of the two-thousand-six-hundredth year of the empire. Although Ōnishi Yoshinori was responsible for the publication, the essay was written by Takeuchi Toshio who later succeeded Ōnishi at the University of Tokyo. The following is an excerpt from Takeuchi's essay.

> Here I will not speak in detail of the transformations that took place in the content and research style of Professor Ōtsuka, observable in his classes and public lectures; I will, however, summarize what people heard who closely followed these lectures. Also, by referring to written

records of lectures that were published in several journals, I believe that I can formulate the following statement. Namely, at the beginning of his career, Professor Ōtsuka took the position of explaining issues in aesthetics by following methods of psychology and the natural sciences similar to those of Wundt. In later years, however, he increasingly emphasized the original qualities of the spiritual sciences, following Dilthey's theories,[24] seasoning them with a touch of phenomenology, and reaching the point of stressing aesthetics as a study of types—the so-called "typology" *(Typologie)*. It goes without saying that such a development was related to general trends of aesthetic thought in the West. (Ibid., p. 442)

It is possible that Ōtsuka searched for an example of "types" of Japanese beauty in the kimono and architecture. Even scholars such as Takeuchi, however, did not credit Ōtsuka with the development of original views on Japanese beauty, considering instead the tendency of importing and practicing Western aesthetics the result of a period of Europeanization. And yet we must admire, as an act of sincere resistance, Takeuchi's determination to include his remarks in a publication celebrating the two-thousand-six-hundredth year of the Japanese empire.

24. [Wilhelm Dilthey (1833–1911), philosopher and historian of culture, is the author, among numerous works, of *Die Einbildungskraft des Dichters—Bausteine für eine Poetik* (The Imagination of the Poet: Elements for a Poetics, 1887) and *Die drei Epochen der modernen Ästhetik und ihre heutige Aufgabe* (The Three Epochs of Modern Aesthetics and Its Present Task, 1892). Ed.]

10

The Aesthetic Thought of Ōnishi Yoshinori

Yamamoto Masao

When we reflect upon the development of Western aesthetic thought in this century, we notice that the major issues shaping the field centered on a synthesis of (1) the philosophical and the scientific, (2) the aesthetic and the artistic, and (3) the systematic and the historical. A corresponding development occurred in Japanese aesthetics on the lecture platform of the University of Tokyo during the Taishō years. An aesthetics in which the aesthetic consciousness of natural beauty and artistic beauty—seen as an aesthetic reality or an aesthetic phenomenon in a broad sense—"was made scientific" was based on the view that the character of aesthetics is located "midway between philosophy and the natural sciences." Concrete research in the field concentrated on the study of art, which was "the center in which the Aesthetic *(das Ästhetische),* as beauty in a broad sense, was best shown." The purpose of such research was the study of "aesthetics as one of the humanistic sciences, a new spiritual science that described and interpreted the phenomenon of beauty." In other words, aesthetic research aimed at the study of "typologies" of spiritual phenomena known as the aesthetic and the artistic. Types were made, for example, of the aesthetic categories of the sublime, the tragic, the comic, and so on; of artistic modes such as the pictorial, the sculptural, the lyric, the dramatic, and the like; of artistic styles such as the classic, the romantic, the symbolic, the expressive, and so forth. In an aesthetics seen as a typology, a path was established for "the study of models and norms as well as patterns of reality" (from Ōtsuka Yasuji's collected lectures, "Bigaku Gairon").

From Yamamoto Masao, "Ōnishi Yoshinori Sensei no Bigaku Shisō," in Ōnishi Yoshinori, *Tōyōteki Geijutsu Seishin* (The Eastern Artistic Spirit) (Tokyo: Kōbundō, 1988), pp. xiv–xxi.

Earlier Wilhelm Dilthey (1833–1911) had tried to explain the history of modern typological aesthetics from the viewpoint of the artistic functions of aestheticization, representation, and expression corresponding to types of worldviews. This trend toward typology was modeled on the even earlier typological research in the plastic and musical arts based on the conflictual relationship of Nietzsche's Apollonian and Dionysian artistic impulses. This will to typology was based on the issue of conflict between intuition and emotion in aesthetic experience, creation and appreciation, art and nature, and so forth. The field was cleared for a typological inquiry into the structure, organization, forms, and correlations of artistic phenomena.

In this article I examine the path followed in the development of a systematic aesthetics by Ōnishi Yoshinori (1888–1959), who continued to lecture at the University of Tokyo on the subjects just mentioned after he succeeded to the post held by Ōtsuka Yasuji (1868–1931).[1]

The Path Toward a New Aesthetic System

Generally speaking, to examine contemporary aesthetics we must first ascertain its starting point and then search for the central and essential issues of debate. Yet we must also proceed with an understanding of the systematic meaning that derives from the many issues raised by studies in today's field of aesthetics. In other words: "We need to look at history in its relation with systems and to look at systems with an eye to their relations with history" (Ōnishi Yoshinori, *Gendai Bigaku no Mondai*, or "Problems in Contemporary Aesthetics," 1927). This was the attitude toward research that Ōnishi Yoshinori consistently upheld.

Ōnishi argued that, first of all, the historical beginning of the view of contemporary aesthetics as an independent science can be found in Baumgarten, followed by the three historical revolutions of Kant, Hegel, and Fechner.[2] According to Ōnishi, contemporary aesthetics reflected the direction the field had taken in the past fifty years in fixing pivotal issues within the sphere of experimental, scientific aes-

1. [On the aesthetics of Ōtsuka Yasuji see Chapter 9. Ed.]

2. [Gustav Theodor Fechner (1801–1887) is the author of *Zur experimentalen Ästhetik* (Experimental Aesthetics, 1871) and *Vorschule der Ästhetik* (Introduction to Aesthetics; 2 vols., 1876). Ed.]

thetics. In other words, two basic directions developed: (1) a scientific aesthetics addressing "the aesthetic subject or, to say it differently, the problem of aesthetic consciousness," and (2) the science of art targeting "the aesthetic object, especially the problem of art." The limits of the scientific point of view, however, became increasingly clear with the arrival of new philosophical trends such as the development of the Neo-Kantian school that aims at a critique of science, the philosophical school of life that tries to grasp the truth of experience, the phenomenological school, and so forth. Moreover, we can see that even in the field of art history, a field deeply tied to aesthetics, major speculations were associated with the new philosophical trends—a fact that produced a new series of problems. In short, contemporary aesthetics "is related to the subjective and the objective sides of beauty and art. One the one hand, it explores the process of the object's purification; on the other, it follows the path of methodological reflection. Several very important issues developed between these two axes" (ibid.). These were the basic premises launching the development of a new system in the Japanese field of aesthetics that was based on a reciprocal study of system and history—a development that I will summarize.

As we can see from his *Bigaku Genron* (Theory of Aesthetics, 1917), at the beginning of his research Ōnishi attempted to study aesthetic consciousness, which he considered "a central problem in recent studies of psychological aesthetics and in art psychology." He argued that, basically speaking, aesthetic research must be experientially grounded in the concrete reality of art. For this study to succeed in creating a systematic knowledge, however, a methodology and a system were required. To develop a new method it was necessary, first of all, to clarify the object of study, in which case "the clarification of aesthetic consciousness, which forms the basis of the manufacture of the object of aesthetic research, must become the first step of aesthetics." Ōnishi considered the study of aesthetic consciousness, which constituted the main focus of contemporary psychological aesthetics, a preparatory stage toward an objective and systematic study of the arts and, as well, a premise for the development of a study of art's elements, character, and structure.

It goes without saying that a satisfactory examination of the systematic meaning of an experiential, scientific aesthetics and art science had to be accompanied by an explanation of its historical meaning. Ōnishi, who in 1922 was entrusted with the teaching of

aesthetics at the Imperial University of Tokyo, gave a lecture course titled "The History of Early Modern Aesthetics" (Kinsei Bigaku Shi) over a five-year period. In 1927, during a trip abroad, he collected the results of his research in a publication titled *Kanto Handanryoku Hihan no Kenkyū* (A Study of Kant's Critique of Judgment; published in 1931). In this study Ōnishi tried to "explain the logical path that led to the internal failure of the structure of the Third Critique, especially aesthetics, the methodological dualism found in the methodological structure of Kant's whole system"—transcendental evolutionism that Kant included in his philosophy of a priori and transcendental teleology. In other words, as in the remarkable works of Cohen and Odebrecht,[3] Ōnishi felt a necessity to avoid rebuilding the *Critique of Judgment* from the viewpoint of the philosophy of the self, interpreting and correcting it along those lines. Instead he felt the need "to study objectively the process that led to the coming into existence of the system from the standpoint of the structure of critical thought" in order to develop correctly the aesthetic issues discussed by Kant. As I will explain later, this critical study greatly affected the formation of Ōnishi's system.

We might be able to see a simple, rough sketch of such a system in the previously mentioned *Problems in Contemporary Aesthetics*. Here the study of aesthetic consciousness seen as the aesthetic subject, and the study of art seen as the aesthetic object, draw upon the work of many philosophical aestheticians such as Lipps, Volkelt, Cohen, Geiger,[4] Simmel,[5] and others who sublated the conflict between scientific aesthetics and art science. Ōnishi points to relationships that ought to be uncovered between aesthetics, art science, and the history of art, developing a systematic explanation of contemporary issues. This book deals with the notion of the aesthetic object, particularly natural beauty and artistic beauty, in relation to the process of

3. [Rudolf Odebrecht (1883–1945) developed a phenomenological aesthetics in *Grundlegung einer ästhetischen Wert-theorie* (Grounds for an Aesthetic Theory of Value, 1927). Ed.]

4. [Moritz Geiger (1880–1937) developed a phenomenological aesthetics in his *Beiträge zur Phänomenologie des ästhetischen Genusses* (Contribution to the Phenomenology of Aesthetic Pleasure, 1913) and in *Die psychische Bedeutung der Kunst* (The Psychical Meaning of Art, 1928). Ed.]

5. [Georg Simmel (1858–1918) is the author, among other works, of *Rembrandt —Ein kunst-philosophischer Versuch* (Rembrandt—An Attempt at the Philosophy of Art, 1916) and *Zur Philosophie der Kunst* (The Philosophy of Art, 1922). Ed.]

the object's purification, with the issues of the "aesthetic" and the "artistic," and with the issues of artistic form and artistic will in light of the relation between aesthetics and the history of art. Moreover, with regard to the process of methodological reflection, the book raises the questions of the autonomy and the normativeness of aesthetics that led to the issue of aesthetic categories.

In fact, the professed equality between system and history in studies of aesthetics requires not only the production of studies in the history of aesthetics but also the production of systematic studies. Albeit in a general fashion, *Bi Ishiki Ron Shi* (History of Debates on Aesthetic Consciousness, 1933) critically explored the development of aesthetic consciousness from ancient times to the present. In this book Ōnishi took the position that "the problem of aesthetic consciousness occupies an important place in aesthetics; so long as many other issues are somehow related to this problem, the history of debates on aesthetic consciousness is indisputably the axis of the history of aesthetics." But for a sharp and meticulous critique—both historical and systematic —of the new modernity, which in the West had already reached a remarkable height in the field of aesthetics, we must turn our attention to *Genshōgakuha no Bigaku* (Aesthetics of the Phenomenological School, 1937).

Here Ōnishi drew a line between current and former "modernities." From a historical and critical perspective he posited the idea that the main direction recently taken by aesthetics and the philosophy of art was toward the phenomenological viewpoint which "directly jumps into the experiential center of aesthetic value and the structure of art, making an effort to explain the true state of things." Then he proceeded to present a detailed analysis of the several directions taken by phenomenological aesthetics, and he explained the meaning of aesthetic systems such as the psychological standpoint of Geiger, the objective views of Conrad,[6] Meinong,[7] and Lützeler,[8] the intuitionism

6. [Waldemar Conrad is the author of *Der ästhetische Gegenstand—Eine phänomenologische Studie* (The Aesthetic Object—A Phenomenological Study, 1908–1909). Ed.]

7. [Alexius Meinong (1853–1920), Austrian philosopher and psychologist, is the author of *Über Möglichkeit und Wahrscheinlichkeit* (On Possibility and Probability, 1915). Ed.]

8. [Heinrich Lützeler (b. 1902) is the author of *Formen der Kunsterkenntnis* (Form of Art Perception, 1924). Ed.]

of Meckauer,[9] the transcendental position of Odebrecht, the existential stand of Becker,[10] and such.

At this point Ōnishi was ready to develop a new aesthetic system. We find the results in his posthumous work *Bigaku* (Aesthetics, 1959). With regard to this work, however, we must remember that Ōnishi set up a "system" through a critical study of Western aesthetic thought; but, at the same time, he expanded it along Eastern lines, rearranging it, and going so far as to revise aspects of the Western system. For an example one might refer to the following points with regard to the thought of Cohen and Odebrecht who, more than any others, had a deep influence on Ōnishi's aesthetic thought.

For a schematic explanation of such relationships, let me say that, since Cohen grasped the emotion of beauty as the principle of an autonomous object production, it had become difficult to explain in Cohen's aesthetics of "pure emotions," which represented contemporary "systematic aesthetics," the development of the various phases of aesthetics (aesthetic categories), and especially the development of art forms, from the perspective of differences between aesthetic perception and the reality of artistic creation. In Odebrecht's system of "aesthetic proved experience," by contrast, which spearheaded "experiential aesthetics," Odebrecht made an analysis of the moments of process and operation, in which an original emotion was sublimated in an aesthetic mood, producing an experience of aesthetic valuation. Odebrecht explained art forms with the help of a synthetic chart of these moments as the harmonization and unification of system and history. Following the emphasis on the value formation of the self, however, Odebrecht denied the beauty of nature and came up with the notion of "aesthetic neutrality."

Ōnishi's new system synthesized "systematic aesthetics" and the "aesthetics of experience" and comprehended the making of aesthetic experience as a mixture of various moments such as intuition and emotion, production and perception, beauty of art and beauty of nature. He explained the development of aesthetic categories and art

9. [Walter Meckauer (1889–1966) is the author of *Wesenhafte Kunst—Ein Aufbau* (Substantial Art—A Synthesis, 1920). Ed.]

10. [Oskar Becker (1889–1964) is the author of *Von der Hinfälligkeit des Schönen und der Abenteuerlichkeit des Künstlers* (The Frailty of Beauty and the Adventurousness of the Arts, 1929). Ed.]

forms as transformations of the mutual relationships between all these moments. Thus Ōnishi incorporated in his work the results of studies on Eastern, and especially Japanese, aesthetic consciousness and artistic spirit that Western scholars had never before mentioned. In the remaining portion of this essay I trace the order of methodological formations, which Ōnishi used in his systematic and historical overview, to Ōnishi's own reflections on the artistic spirit of the East.

Reflections on the Eastern Artistic Spirit

Since mid-Meiji there had been a desire to provide critiques of Japan's traditional arts from an aesthetic perspective in order to identify their original qualities. It soon became apparent how difficult such an enterprise was, however, since it was grounded in Western aesthetic thought. We can already see this in the work of Ernest Fenollosa (1853–1908),[11] who was actually responsible for beginning the aesthetic critique in Japan. Despite his admiration of Japanese traditional painting, for example, Fenollosa considered the paintings of the literati (bunjinga) a confusion of literature and the idea of painting, and he rejected it ("Bijutsu Shinsetsu"). All told, this judgment was nothing but a critique of the synthesizing approach that is characteristic of Eastern paintings, based on a notion of purity in the arts that was developed in the West in order to differentiate among the different arts. Earlier, Okakura Tenshin (1862–1913)[12] had pointed out expressive differences with regard to Eastern and Western arts, explaining that "the spiritual disposition toward nature in the East and the West, the concepts of art, the techniques, and the different societies, are all located in the traditions that are realized in art" ("Higashi Ajia no Kaiga ni Okeru Shizen," or "Nature in the Paintings of East Asia"). It is a well-known fact that Okakura explained the characteristics of the Japanese arts to the West by focusing on the tea ceremony, which he presented as an "art of life" standing on the philosophy of aestheticism (The Book of Tea, 1906). In short, we can say that Okakura's logic is still at work in today's views of comparative arts and comparative aesthetics. At this point, however, we cannot say that a systematic foundation of art science and aesthetics was already firmly established.

11. [See Chapters 2 and 3. Ed.]
12. [See Chapter 2. Ed.]

We must also recognize that in the case of Western comparative art sciences, the examination of differences was conducted at the level of artistic phenomena, not at the level of aesthetics. This methodology was equally shared by representative scholars in the field, such as Frey[13] and Sedlmayr,[14] who had inherited the basic standpoint of modern art science. Frey's comparison of the plastic arts of the cultural spheres of Egypt, the Near East, Greece, Western Europe, Eastern Europe, India, and East Asia, for example, posits as comparative categories physical emotions and emotions based on space. He arrives at these conclusions by looking at the basic types of art forms and seeing a correspondence between them and the basic types of the world experience of each race (*Grundlegung zu einer vergleichenden Kunstwissenschaft*, or Foundations for a Comparative Science of Art, 1949). In opposition to such a comparison between the arts of all races and places, Western comparative aesthetics compared the reciprocal elements of all arts, taking as its goal the formation of new art systems. Souriau[15] laid the existential foundations of art and later attempted to classify the arts based on the qualitative differences of the senses and on the distinction between presentation and representation. Moreover, Munro[16] came up with an "aesthetic morphology" from an experimental and scientific perspective in which he classified all contemporary aesthetic arts under four hundred categories of art and their types—which, as a whole, made up only "one section of aesthetics."

In this way, Ōnishi basically combined the aesthetic and the artistic in one category. He made possible a comparative typological explanation of East and West with regard to the development of art forms by studying all moments (starting from aesthetic categories) he arrived at by analyzing the value structure of artistic/aesthetic experience. This project toward the construction of an aesthetic system was truly monumental. It was made possible not only by Ōnishi's studies on the history of aesthetics, mentioned earlier, but also by the research

13. [Dagobert Frey (1883–1962) is the author of *Gotik und Renaissance als Grundlagen der modernen Weltanschauung* (Gothic and Renaissance as Foundations of Modern Views of the World, 1929). Ed.]

14. [Hans Sedlmayr (1896–1984) is the author of *Kunst und Wahrheit* (Art and Method, 1958). Ed.]

15. [Etienne Souriau (1892–1979), French aesthetician, is the author of *Catégories Esthétiques* (Aesthetic Categories, 1960). Ed.]

16. [Thomas Munro (b. 1897) is the author of *Towards Science in Aesthetics* (1956). Ed.]

he pursued on the topics of aesthetic consciousness and the artistic spirit in Japan.

I will begin by mentioning *Yūgen to Aware* (1939), in which Ōnishi states: "My original scientific interest was to put all aesthetic concepts belonging to Japan into logical correlation with aesthetic categorizations in a new way. Moreover, I wanted to integrate these aesthetic categorizations with a whole aesthetic system." *Yūgen and Aware* was a preparatory stage for Ōnishi's aesthetic inquiry from the perspective of materials. Here we find analyzed in great detail several aspects of aesthetics—from the general meaning of the notions of "profundity" *(yūgen)* and "pathos" *(aware)* to their psychological aesthetic meaning, the value or aesthetic meaning, up to a sort of metaphysical bearing. Starting from an analysis of basic aesthetic categories, such as "beauty" in its narrow meaning, the "sublime," and "humor," Ōnishi posited *yūgen* as a derivation from the sublime and *aware* as a derivation from beauty. Ōnishi referred particularly to the former, *yūgen,* as the general foundation of the experience of aesthetic value. Unlike Odebrecht, he took the position that *yūgen* was grounded in the polarity of feelings for nature and feelings for art, emphasizing the relationship between the specificity of the aesthetic consciousness of Easterners and the feelings for nature. Later, in *Fūga Ron* (Essay on Refinement, 1940), Ōnishi tackled the issue of "simplicity" *(sabi)* from an aesthetic perspective based on the same set of scientific concerns he had addressed in the previous book. He examined the artistic essence of seventeen-verse poems *(haikai)* and the concept of "refinement" *(fūga)*. In this book Ōnishi debated the internal connections between creation and reception, the issue of artistic specificity (drawn from the relation between intuition and emotion), the problem of the particularity of *haikai* (drawn from the moment of feelings for nature and the moment of artistic feelings), and the issue of *sabi,* which Ōnishi considered a configuration deriving from humor as an aesthetic category.

It was only natural that, as a result of his aesthetic study of the relationship between natural beauty and the beauty of art, the emphasis on the development of the specificity of the Japanese people would lead Ōnishi to the issue of feelings for nature. Moreover, to provide a satisfactory explanation of this issue, he was forced to use a comparative methodology. We could begin, for example, by looking at his *Man'yōshū no Shizen Kanjō* (Feelings for Nature in the *Man'yōshū,* 1943), in which Ōnishi tackled the issue from the view-

point that "what provides meaning to feelings for nature culturally is the spirit of art." In this book Ōnishi made a comparative study between the development of the Western sensibility for nature and several examples of a similar sensibility taken from Japan's poetry collection *Ten Thousand Leaves (Man'yōshū)*. He further developed his argument concerning "various aspects of sensitivity to nature, as these are expressed in Western and Japanese literature," in a book titled *Shizen Kanjō no Ruikei* (Types of Feelings for Nature, 1949) in which he provides a detailed analysis of "typological techniques and comparative methodology." In this study the author develops a comparative typological examination of several kinds of sensitivities for nature such as sympathetic sensitivity, objective sensitivity, religious sensitivity, sentimental sensitivity, romantic sensitivity, and *haikai*-esque sensitivity.

On a related topic, among the studies that Ōnishi made from an aesthetic and systematic perspective on the subject of sensitivity to nature, we must remember his work *Rōmanshugi no Bigaku to Geijutsu Kan* (The Aesthetics and Art Views of Romanticism; posthumous)—a detailed analysis of the West European romantic lineage in aesthetic and artistic matters centered on Friedrich Schelling (1775–1854). Ōnishi argues that, having developed in the West, aesthetics is undoubtedly a Western phenomenon grounded in the aesthetic consciousness of European peoples. In the East, however, and especially in Japan one finds "an ethnic aesthetic consciousness and view of art that have developed in specific, autonomous ways." Ōnishi states: "To exhaustively study the problem of aesthetics, we should reflect on the aesthetic consciousness that has advanced in the specific direction that could be called *Eastern*." Then: "We should make an effort to complement the inner core of Western aesthetics with our new findings and expand it" (from *Bigaku*). Ōnishi's journey toward a new aesthetic system, grounded in inclusiveness, ends with the posthumous work *Bigaku* (Aesthetics). Let me now return once again to Ōnishi's original system and indicate a few characteristics based on this posthumous publication:

1. A methodological synthesis of "systematic aesthetics" and "experiential aesthetics"
2. A standpoint of "philosophical aesthetics" unifying the results of scientific research on "aesthetics" and "art science"
3. The mutual integration of the "artistic" and the "aesthetic" as respectively "personalistic, creative value" and "purely contemplative value"

4. The stipulation of three moments as the structural nomology of aesthetic experience: the activity of "intuition and emotion"; the forms of "production (creation) and reception (contemplation)"; the contents of natural feelings and artistic feelings

5. The division of the arts into "production (contemplation)," "expression," and "representation" of the aesthetic concept in an attempt to set up a system of arts

6. The development of art forms grounded in a structural nomology of the aesthetic value experience

7. A stipulation of the "basic aesthetic categories" of beauty, the sublime, and humor according to the preferential and emphatic relationship between the structural moments of aesthetic experience, as well as the "derivative aesthetic categories" of the tragic, profundity *(yūgen)*, gracefulness *(yūen)*, the pathos of things *(aware)*, the comic, and simplicity *(sabi)*[17]

From this structure of systematic aesthetics came Ōnishi's study of the *Tōyōteki Geijutsu Seishin* (Eastern Artistic Spirit; posthumous). In the first part of the book deepening the notion of "pantonomy" developed by Cohn[18] in his cultural typology, Ōnishi describes the process by which the spirit of Eastern arts leads to the formation of a specific aesthetic culture and to the making of a vital art. In the second part, he clarifies the characteristics of the Eastern artistic spirit in all aspects of the three structural moments of aesthetic experience. In the third part, Ōnishi examines differences between East and West, taking his cue from the artistic spirit of romanticism. This last work represents the synthesis of Ōnishi's speculative efforts—a plentiful ripening of the great tree of Ōnishi's aesthetic system.

17. [For an English translation of Ōnishi's discussion of *aware* from his *Bigaku* (Aesthetics) see Marra, *Modern Japanese Aesthetics*, pp. 122–140. Ed.]

18. [Jonas Cohn (1869–1947) is the author of *Allgemeine Ästhetik* (General Aesthetics, 1901). Ed.]

Style in Japanese Aesthetics
Ōnishi Yoshinori

Sasaki Ken'ichi

Ōnishi Yoshinori's *Aesthetics*

It would be difficult to talk about a pragmatics of style without first asking this question: What is the style used in academic writings that we all share and recognize? In my analysis of style, I want to take as concrete examples essays that belong to the field of aesthetics. The style we have been using in writing philosophical essays has changed greatly during the last half-century. In this essay I present the "classical" style, which was commonly used in essays fifty years ago, and explain how such a style differs from contemporary styles.

As a classic example, I will take the book *Bigaku* (Aesthetics) by Ōnishi Yoshinori (1888–1959). The author was the second professor of aesthetics in the Faculty of Letters of the University of Tokyo (he remained in charge of courses from 1929 to 1949) and the scholar who built the foundations of academic aesthetics in Japan. Although *Aesthetics* was published posthumously, Ōnishi began writing it after his retirement from the university and completed it in 1957.[1] Considering that the theories Ōnishi presents in this work gradually developed from lectures he gave while actively employed, we can consider his *Aesthetics* an example of how scholarship was done nearly half a century ago. There are no major differences between this work

From Sasaki Ken'ichi, "Nihon no Bi ni Okeru Sutairu," in Sasaki Ken'ichi, *Esunikku no Jigen: "Nihon Tetsugaku" Sōshi no Tame ni* (The Ethnic Dimension: Toward the Foundation of "Japanese Philosophy") (Tokyo: Keisō Shobō, 1998), pp. 55–67.

1. See the "Introduction" that Takeuchi Toshio added to Ōnishi Yoshinori, *Bigaku: Jō, Ge* (Tokyo: Kōbundō, 1959–1960). This work was published with the author's permission thanks to the efforts of Takeuchi Toshio (1905–1982), who succeeded Ōnishi to the Chair of Aesthetics at the University of Tokyo. By the time the book was in print, however, the author had already passed away.

and other books and articles that Ōnishi produced during his active years, especially when we examine these works from the point of view of style. It is impossible to examine all of Ōnishi's work—nor would this be necessary in order to clarify his style. Instead I will concentrate my effort and closely examine the first chapter, "Intuition and Emotion," in the book's first section, "The Structure of Aesthetic Experience." Since this is the shortest chapter in the whole book, I believe it might provide an excellent sample.

"Intuition and Emotion" are not common topics in contemporary aesthetics. Both intuition and emotion have lost the power of being problematized as concepts; they seem to have been buried under a pile of colorless terminology. I almost feel as if I need to take a deep breath before presenting a topic such as "intuition and emotion" in order to convey what is implied in the problematization of this issue. We can explain such a topic as the contrast between an inclination toward the object in the act of aesthetic experience and a psychological situation in which the subject is fulfilled. To put it in the jargon of contemporary concepts, we can call it the conflict between difference and sameness. The underlying tone of nineteenth-century aesthetics tends to treat lightly aspects of experiential fulfillment, especially "emotions," at times even being prejudiced against them. Instead it moves toward an emphasis on the objectivity of perception and the moments of cognition and knowledge in the experience of art. As a result, "emotions," in particular, ceased to be regarded as a technical scholarly term and became instead a part of everyday language. Accordingly, the word "emotion" suggests that something unscholarly has been brought into the discussion. Now that I have established the distance separating us from Ōnishi, let me proceed to analyze Ōnishi's statements from the perspective of style.

I believe that in order to define the style of Ōnishi's aesthetics we must look at his central thesis. First of all, we must pay attention to the introductory part of the chapter (pp. 69–73), in which he explains his basic position. Here Ōnishi starts with a critique of psychology: the subject of aesthetics does not end with the analysis of its spiritual elements, he argues, but also includes a synthetic explication of the structure that realizes aesthetic values. When we look at aesthetic experience, especially from the perspective of spiritual activity, Ōnishi continues, we can define such an experience as the union of intuition and emotion. Such an experience displays the operation of what could

be called intuitive emotion or, also, emotional intuition. Intuition, which is the grasping of the object, is a static, clear, unifying, and formative mechanism; on the opposite side, emotion, which is the sympathetic resonance of the subject, is dynamic, dark, melting, and formally hidden. Several positions have been taken between these two extremes that either privilege or neglect one of the two. Basic pairs of conflictuality are the Apollonian and the Dionysian, for example, and the baroque or the romantic against the classic. There are also theories that emphasize the characterological contrasts of the same. If we go back to the past, at the basis of the conflicts between a cognitive aesthetics and an emotional aesthetics lies the fundamental difference between intellect *(Intellekt)* and sentiment *(Gemüt)*. After analyzing the ramifications of this issue, Ōnishi concludes his prefatory remarks with the argument that, at the present time, when psychology-based methodologies are no longer in vogue, it is sufficient to point out the primary role played by "the unified relationship" of intuition and emotion in aesthetic experience. In other words, he shows that the main topic of the whole chapter is the unification or combination of intuition and emotion.

The chapter continues with Ōnishi's classification of intuition in four categories and his development of the analysis of emotions corresponding to each of them. The clearest development of Ōnishi's stand on the issue of the unification of intuition and emotion appears in the next section (pp. 86–94), in which he discusses the relationship between intuition and emotion as a relationship in strict conformity with aesthetic symbolism. In other words, according to Ōnishi and as noted out earlier, not a few theories are prejudiced toward either intuition or emotion, which are seen as spiritual activities. And yet the theories that deepen philosophical reflection by pondering not only such activities, but also the aesthetic value content, are necessarily related to the issue of the aesthetic symbol. Which is to say: they escape the one-sidedness of either intuition or emotion, linking them together instead. (As examples Ōnishi mentions the theories of Walter Meckauer, Theodor Lipps, Rudolf Odebrecht, Gertrud Kuznitzky, Hermann Cohen, and others.) Seen from the viewpoint of the whole structure of aesthetic experience, the spiritual activity must be a unity (Ōnishi uses the expression *"kihitsu kankei"* or identity) of intuition and emotion. Such a unity, however, does not stand by itself but relies on two other kinds of unities. The third kind is the unity of the "artistic sense" and the "sense for nature"—a unity to which Ōnishi

refs only parenthetically. Instead he explains the second type of unity as one between "production" and "reception." With regard to the overlapping of this unity with the first type, Ōnishi argues that emotion, especially when it is seen as pure emotion (the term is taken from Cohen), is *"erōs."* It is not simply a passive mechanism, since it actualizes beauty in an active way. Moreover, he explains intuition as a productive, intuitive activity that is related to aesthetic symbols. Once these are purified aesthetically, a symbolic deepening occurs at the objective level while correspondingly "ecstasy" is achieved at a subjective level. Ōnishi concludes his explanation by introducing the words of the poet Dehmel,[2] according to whom the effect of art is "a miracle of love"—and such a miracle can only be explained as "the mediation of contradictions," such as "personal emotion and absolute emotion" or "self-consciousness and self-forgetfulness." Ōnishi welcomed Dehmel's statements as "words undoubtedly worthy of close attention." Moreover, as an example of contemporary research Ōnishi mentions an essay by his teacher Hans Resch.

The final "redundant obiter dictum" (pp. 94–99) is a supplement related to intuition. Ōnishi starts out by discussing the meaning of "seeing" in art (here he talks of creativity that builds the object) and by presenting a critique of the theory of K. Fiedler.[3] He then points out the characteristics of "artistic truth," which is said to be intuitively perceived, arguing that it is a mistake to consider it the only fundamental value of beauty and art. After calling "intuitive aesthetics," generally speaking, a mistake, Ōnishi concludes the chapter by indicating that the German word *"fühlen"* does not simply mean "to feel" subjectively but also includes the meaning of "touching" the object.

Ōnishi's *Aesthetics* Seen from the Viewpoint of Style

While I was reading Ōnishi's *Aesthetics* again, after a long time, in order to write this essay, I realized something new. In the past I felt this was the work of a severe aesthetician who seldom laughed, an

2. [Richard Dehmel (1863–1920) was a German poet and playwright. A forerunner of expressionism, he wrote *Erlösungen* (Redemptions, 1891) and *Weib und Welt* (Woman and World, 1896). Ed.]

3. [Konrad Fiedler (1841–1895) is considered the father of "the science of art" *(Kunstwissenschaft)*. Ed.]

embodiment of cold knowledge. I realized, however, how superficial my original view was. As we can see from my foregoing summary, Ōnishi pointed out that if we look at the issue from the realization that aesthetic experience is the working of the spirit, then the essence of such an experience is neither a simple inclination toward the object (intuition) nor a subjective self-perception (emotion): it is both elements unified into one. The problem is to figure out the sources from which Ōnishi derived his views. For a long time I had the vague feeling that Ōnishi was undoubtedly relying on some scholarly work. This time, however, I realized that Ōnishi relied on his own thought, based on personal experience. He showed that emotion produces an object which must be grasped by intuition—this being the pivotal idea of Ōnishi's theory. Ōnishi stated that, at times, "emotional acts such as, for example, 'sexual passion,' 'desire,' 'yearning,' stimulate the imagination very strongly and make the image of internal intuition vivid; everyone has experienced how lively such an image becomes" (p. 82). While borrowing from the vocabulary of H. Cohen,[4] but warning that he is attaching a different meaning to Cohen's terminology, Ōnishi bases his theory upon the stipulation of aesthetic emotion as *erōs*, that is, as production of the object. This is a formalization of Ōnishi's own experience. The theoretical range of this basic insight was wide and came to form the core of Ōnishi's aesthetic system—that is, the overlapping of the three types of "identities." Takeuchi Toshio[5] says that "the basis of this large-scale system consists of the insistence to the very end on unifying the extremes of several conflictual moments in aesthetic experience." Takeuchi also remarks that Ōnishi worked toward the unification of Western and Eastern aesthetics (pp. 3–4).

When we scrutinize the relationship between the Western aesthetic theories to which Ōnishi referred and his own enunciations, we realize that his discussions did not originate from such theories and his enunciations were the result of his own theory. Can we then consider his *Aesthetics* original thinking? Although Ōnishi did not build up a theory from imitation, his insistence on the "congruence of oppo-

4. [Hermann Cohen (1842–1918), German philosopher, is the founder of the Marburg school of Neo-Kantianism. Ed.]

5. [Takeuchi Toshio succeeded Ōnishi Yoshinori to the Chair of Aesthetics at the University of Tokyo in 1949—a post he held until his retirement in 1966. See Chapter 14. Ed.]

sites" (*coincidentia oppositorum,* Nicolaus Cusanus)[6] perfectly corresponds to modern Western aesthetics. This is not to say that Ōnishi's work concurs with the theory of any specific aesthetician. But we can say that if we think of a possible "modern Western theory" that results from a process of averaging individual theorists, then Ōnishi's aesthetics can be called an orthodox example of modern Western aesthetics. We must take note of the fact that modern definitions of beauty—such as "the unification of variety," "the sensual manifestation of the idea," "freedom in appearance," "the infinite expressed in the form of the finite"—all have the structure of the congruence of opposites. We must also remember that the congruence of opposites took form especially in aesthetic symbols. Schelling[7] defined symbol as "the absolute unity of the universal and the particular." (This definition also corresponds to Schelling's definition of beauty as the "infinite expressed in the form of the finite.")

Now we should ask why this kind of philosophy took place. The answer forces us to trace the formative process of Ōnishi's theory—an issue directly related to his style. As I pointed out earlier, Ōnishi saw in "passional *erōs*" one type of primary experience. Such an experience, however, did not have the capacity to become a principle of an aesthetic system as such. For experience in daily life to become a principle of aesthetics, it was necessary to read into it the structure of modern aesthetics' "congruence of opposites." The reference point or model for the theorization of a personal experience was strictly modern Western aesthetics.

In his "Preface," Takeuchi Toshio stresses particularly the following point, which Takeuchi admits he heard directly from Ōnishi:

> The consistent leitmotiv of Professor Ōnishi's research (at least from the time he was appointed professor) was a sufficient mastery of the aesthetic thought that had developed until then in the West. In addition to upholding the highest contemporary standards of the discipline and providing a thorough critique of all theories in the history of aesthetics, Ōnishi reflected upon the characteristics of art, especially those based

6. [Nicolaus Cusanus (1401–1464) is the author, among other works, of *De Docta Ignorantia* (Learned Ignorance, 1440) and *De Visione Dei* (The Vision of God, 1453). Ed.]

7. [Friedrich Wilhelm Joseph Schelling (1775–1854) is the author of *System eines transzendentalen Idealismus* (System of Transcendental Idealism, 1800), the dialogue *Bruno* (1802), and *Philosophie der Kunst* (The Philosophy of Art, 1802–1803, 1804, 1805). Ed.]

on an Eastern aesthetic consciousness, and he revised and expanded, from this Eastern perspective, earlier aesthetic systems that possessed only a Western dimension. By doing so, he built a purely autonomous aesthetic system. Recently Professor Ōnishi told me that his long-cherished desire was to structure this discipline "from the point of view of the Japanese" while incorporating Western aesthetics. (p. 3)

Ōnishi's intentions are clear. Moreover, whenever the creativity of Ōnishi's system is praised, references are made to his theorization of traditional concepts of Japanese aesthetics, such as "profundity" *(yūgen)*, "pathos" *(aware)*, and "simplicity" *(sabi)*, which are incorporated especially in the chapter titled "A Debate on Aesthetic Categories" in the second volume of his *Aesthetics*. It goes without saying that Ōnishi's claim of making an "aesthetics from the Japanese viewpoint" is the same as the one I am making in the present book.[8] In this sense, we can probably say this is an issue worthy of analysis. Although, taken at face value, our two positions might look the same, the real sense given to the expression "aesthetics from the Japanese viewpoint" differs between the two of us. Personally I do not consider the examination of Japanese concepts to be my first priority, nor do I regard this work to be the construction of an aesthetic system that incorporates those concepts. My first intention, I would rather say, is to realize an aesthetics of true motives grounded in my life and our[9] lives. The real nature of Ōnishi's aesthetics, at least as far as it relates to the chapter on "intuition and emotion" that I have analyzed, is driven completely by modern Western aesthetics.

In this regard we should point out, first of all, that Ōnishi's theory is not prejudiced toward any specific point of view. There is no doubt that, according to Ōnishi, any theory which is prejudiced in favor of either intuition or emotion, upon our contemplation of the totality of aesthetic experience through the mediation of a system, automatically frees itself of the prejudice and reaches the truth of the equality of intuition and emotion. From the beginning, Ōnishi never leaned toward either intuition or emotion. In his introductory remarks, Ōnishi produced the mutually antithetical pairs of Apollonian and Dionysian, classic and baroque (or romantic), and so forth, as examples of

8. [The title of Sasaki's book, from which the present chapter is taken, is eloquent: *The Ethnic Dimension: Toward the Foundation of "Japanese Philosophy."* Ed.]
9. [The author means "Japanese." Ed.]

formal types of similarly contrasting concepts. Moreover, he also referred to corresponding characterological types. In other words, was
it not natural for an aesthetician to follow the characteristics of such
characters and show some inclination toward intuition and emotion?
Or was not each case showing exactly opposite leanings that did not
result in any harmonization of opposites but left contradictions unresolved? I personally believe we should keep them unresolved. I do
not think that philosophy rejects one-sidedness. To present it from
the ethnic perspective of this book, philosophy should actually keep
this one-sidedness alive. There is no doubt, however, that Ōnishi perceived the presence of such one-sidedness as an antischolarly stand. To
avoid being partial to any of them, he presented a critique with each
and every theory he discussed. Such critiques did not derive from his
own theory. Moreover, they were not internal critiques targeting each
theory's contradictions and lack of logic. Ōnishi's critiques were probably reciprocal critiques. In other words, against the aesthetics of
intuition he gave a critique from the point of view of (the reality of
the existence of) the aesthetics of emotion, making the aesthetics of
intuition play a relative role with regard to the aesthetics of emotion.
This is the meaning of what Takeuchi calls a "thorough critique."
For Ōnishi, scholarship existed as the critique of theory.

Thus it becomes self-evident that what is left as a result of such a
critique of theory is necessarily a theory—Ōnishi's own—characterized
by the "congruence of opposites." This approach, even before becoming a theoretical issue related to modern aesthetics, directly reflects
Ōnishi's views on scholarship and, consequently, his research methodology. Then we must ask what kind of relationship exists between
the "congruence of opposites" that is reflected in Ōnishi's methodology and the congruence of opposites that Ōnishi adopted as the
standard theory of modern Western aesthetics. It would be only natural to explain such a relationship by saying that method and field
play a mutually causal role—or, to say it differently, that Ōnishi
chose the methodology of theory critique because he studied aesthetics
and, conversely, that his choice of aesthetics was the result of his
embracing this theoretical interest. Such an explanation, however,
would be cheap and lacking in evidence. First of all, it is not true that
modern Western aesthetics requires such a methodology. If we acknowledge the existence of such a cause-and-effect relationship, then
we should say that all Western aestheticians chose the same methodology followed by Ōnishi—a statement that would clearly be wrong.

Nor is the opposite relationship immediately acknowledgeable. The reason is that the scholarly technique of the critique of theory was shared by many scholars, at least among those who were contemporaries of Ōnishi, and not all of them aimed at aesthetics. Takeuchi Toshio, who inherited Ōnishi's style, tried to create a different theory.

Therefore, we can say that Ōnishi's methodology of the critique of theory was not specifically related to the issues of modern aesthetics. Rather, it was a direct syncretism of learning patterns, an honest reflection on the situation in which a culturally underdeveloped country was finding itself.[10] Anyone who confronts the challenge of new learning tries to learn the "content" of that science without any specific bias. A classic example would be the general knowledge obtained by consulting the entries of an encyclopedia. The first challenge of the Japanese pioneers of Western studies was the acquisition and the standardization of knowledge corresponding to the entries of an encyclopedia. As I pointed out earlier, Ōnishi's own aim was to provide a Japanese supplement to Western aesthetics. Indeed, this was an ambitious project compared to which the work of the standardization of Western aesthetics was not so important for him. Undoubtedly we can consider the process of standardization a means or a preliminary step toward the improvement of the system by Japanese scholars. The methodology that came to Ōnishi from the study of Western aesthetics, however, took this process of standardization to be an implicit concept. In other words: keeping a broad field of vision that would encompass the whole tradition of Western aesthetics and maintaining an equal distance from any specific thought were the primary requisites for his learning. This was the actual condition of what I have called the syncretism of learning patterns in a country culturally under-

10. Maruyama Masao finds one of the characteristics of "Japanese thought" in what he calls "unlimited embrace." Maruyama says: "We find examples of logic that were followed in order to rationalize the intellectual joining together of disparate elements, in widely popular secularized versions of Buddhist philosophical techniques, such as the patterns 'something = *(soku)* something' or 'something something oneness *(ichinyo)*' . . . a tradition of intellectual liberality that created a 'peaceful coexistence' in the spiritual history through the use of the 'unlimited embrace'—that is, to include everything that was mutually theoretically contradictory in philosophy, religion, learning, and so forth." See *Nihon no Shisō*, Iwanami Shinsho, p. 14. It is possible to suspect that this Japanese mentality lurks behind Ōnishi's "congruence of opposites." Ōnishi's foundation, however, was not the pathos of dissolving intellectual confrontations at a stroke. Rather, it was a retreat from pathos: reason trying to maintain a neutral position in research.

developed—something that becomes apparent when we look at the concrete examples mentioned earlier.

There is one point that should be stressed with regard to syncretism: the fact that Ōnishi, who made enormous contributions for those of us who followed the path of learning, was a master of such a method. I say this with a certain idea in mind: that the most convenient way to acquire an encyclopedic knowledge is to refer directly to the encyclopedia. If you think this method is too simple in the field of scholarship, then you can consult the elucidative manuals written in the West. For example, there are plenty of books tracing the historical development of the German golden age of aesthetics from Kant to Schiller, or from Hegel to Schelling, or the host of publications written to explain their theories. You read the book and you understand the content of their aesthetics. There is no doubt that Ōnishi himself did the same thing. He did not stop at this stage, however. He did not develop his own scholarly work simply by relying on the reading of texts by Kant and Schelling. This severe attitude was not only his own (we might want to remember Nishida Kitarō[11] and Watsuji Tetsurō,[12] who was very close to Ōnishi) but was probably the mark of the elite in Ōnishi's generation. For the following generation this attitude became a prerequisite. It was the same as attempting to surpass a record in sports. As a result, a feeling for the discipline took root in the world of Japanese scholarship.

Our topic is the relationship between this methodology and Ōnishi's aesthetic theory. Ōnishi chose aesthetics as his field of specialization, and within this field he practiced syncretism. By repeating time and time again the process of the syncretic critique of theory—trying to create a system and fashion one aesthetic theory that would comprise all critiques—he eventually had to balance out all the theories included in the process. In other words, he ended up by assuming the technique of the congruence of opposites. Moreover, when trying to clarify the principles of his systematization, it was only natural that he would come to employ this technique. I do not know whether he realized that this process was typical of modern Western aesthetics. Probably he did not think in these terms. He probably thought of his own methodology simply as a scholarly method and not as a syncre-

11. [See Chapter 18. Ed.]
12. [See Chapter 12. Ed.]

tism. In fact, Ōnishi's congruence of opposites stood on a completely different footing from the one expressed in modern Western aesthetic theories. To discuss this issue within the context of modern aesthetic theories, however, I would probably need the space of a monograph. Here I will give a simple outline of my thoughts on the subject.

This issue is closely related to a characteristic that is common to the entire modern thought of the West. Modern thought is a humanism that praises human creativity. The idea that man is an intermediate existential stage in the universe was a traditional way of thinking. The dualism mind/body was located at the root of this middle point. We see this worldview in Pascal immediately prior to modernity (or at the beginning of modernity).[13] "The crisis between reason and passion," which was the only theme of French classical theater, became the formative principle at the basis of Pascal's Christian worldview. Pascal's basic view of man was this: "We should not believe that man is like an animal; neither should we think him to be an angel."[14] Man is neither animal nor angel; he is an angel while being an animal, half-animal, half-angel. Therefore, while being a pitiful creature, man's existence is sublime (nos. 415–416). It is interesting to note that Pascal saw the rational/angelic reality that makes up human greatness in the working of reflective noesis: "In short, man knows he is a wretched creature. That is why he is wretched. The reason being that that is exactly the way he is. Therefore, he is truly great, since he knows he is wretched" (no. 416). Of course, this is what is meant by the famous expression "thinking reed" (no. 347). Within reflective noesis, the fact of being perceived and the mechanism of perception are two completely different things. The first is wretchedness; the latter is greatness. Rather than being one reality, man is a middle existence severed in two.

Pascal had yet to know human creativity. On this point he still held a premodern view of man. Modern man has realized his creative power, especially in art. Beauty, which is made concrete in art, has become the ideal image of man. Beauty came to be seen as the congruence of opposites. For example, we might remember Hegel's definition, which is the same as the traditional way of seeing man as an

13. [Blaise Pascal (1623–1662) is the author of a famous apology of Christianity: *Pensées*. Ed.]

14. Pascal, *Pensées*, no. 418. See also nos. 72, 412–413, 415–417, 431, 441, 525, 527, and so on.

intermediate stage, although in different garb. The definition of beauty as "the sensual manifestation of the idea" is, after all, the combination of reason and the passions. A difference, however, is also clear. In Pascal's reflective noesis, the two aspects of reason and passion coexist as contradictions. In beauty such a dualism is transcended. Only when reason and the passions are collapsed into one can we start calling it "beauty." It is well known that for Kant beauty was a particularly human phenomenon, and yet he pointed this out in such a way that we hear the echo of Pascal's words. If we follow Ōnishi's own translation of Kant, we read as follows: "Beauty is only fit for humans—or, to say it differently, for those who are animal and yet rational beings. Beauty is fit, not for beings who are only endowed with reason (for example, spirits), however, but for human beings who are animal at the same time."[15] Beauty is filled with tension, yet it is a harmonious reality. Beauty teaches us to live as men—free from the control of reason over the passions and the spirit over the body.

This is the meaning that the idea of "congruence of opposites" had in modern Western aesthetics. There is no doubt that Ōnishi understood this idea well, and most probably he even sympathized with it. This means, however, that his existence as a modern Japanese was grounded in the learning of Western culture. It is not the same thing as to say that his existence was rooted in the same historicity as modern Western historicity. His "congruence of opposites" was born from a completely different ground than the one that produced modern Western aesthetics.

15. Kant, *Critique of Judgment,* vol. 1, p. 5. In Ōnishi's translation (Iwanami Shoten, 1932) the passage appears on pp. 90–91.

12
Watsuji Tetsurō and His Perception of Japan

Koyasu Nobukuni

Watsuji Tetsurō (1889–1960) is a representative ethicist and cultural historian of modern Japan. He is the author of numerous works, including a renowned *Rinrigaku* (Ethics, 1937–1949) and *Nihon Rinrigaku Shisō Shi* (History of Japan's Ethical Thought, 1952). In this lecture I examine Watsuji's stand on Japanese culture and his perception of Japan based on two of his best-known works, *Koji Junrei* (Pilgrimage to Ancient Temples, 1919) and *Fūdo: Ningengakuteki Kōsatsu* (Climate: An Anthropological Inquiry, 1935).

Watsuji's Life and Achievements

Watsuji Tetsurō is famous in modern Japan as a philosopher and cultural historian. Since his most representative philosophical work is *Ethics,* it would be more correct to call him an ethicist. More than from *Ethics,* however, his fame comes from *Pilgrimage to Ancient Temples* and from *Climate: An Anthropological Inquiry.* Many people must have encountered Buddhist statues for the first time while visiting the ancient temples of Asuka and Nara with Watsuji's *Pilgrimage* in their hands. Moreover, a great number of people must have learned from his *Climate* how to look at foreign cultures and their own culture from a climatological point of view. Watsuji wrote *Pilgrimage* in his youth. *Climate,* the product of his late thirties, is based on his experiences as a foreign student in Europe. Today I will

From Koyasu Nobukuni, "Watsuji Tetsurō—Sono Nihon Ninshiki no Arikata," in Osaka Daigaku Hōsō, ed., *Nihon Kenkyū no Sendatsu* (Pioneers in the Study of Japan) (Osaka: Isshinsha, 1987), pp. 101–111. This is the text of a lecture broadcast by KBS Kyoto Radio on December 6, 1987.

be talking about his views of Japan and Japanese culture based on these two well-known books.

Watsuji was born in 1889, the second son of a medical doctor, in a rural village in the Kanzaki district, Hyōgo prefecture (today's Nibuno area of Himeji city). He attended the prefectural middle school in Himeji and the first high school. In *Jijoden no Kokoromi* (An Attempt at Autobiography; posthumous, 1961), Watsuji recorded in great detail his recollection of his upbringing as a village boy and his middle and high school years. He wrote *An Attempt at Autobiography* for a magazine at the end of his life, so that unfortunately he had to interrupt recording his recollections of high school because of illness. *An Attempt at Autobiography* is a truly interesting portrayal that goes well beyond being merely the autobiography of an individual named Watsuji. He scrupulously records the childhood of someone growing up in a home and a rural village that began to be effected by the industrial revolution of the 1890s. In this autobiography, Watsuji is able to capture the charm of Yanagita Kunio's *Meiji Taishō Shi: Sesō Hen* (History of the Meiji and Taishō Periods: Social Conditions).[1] Indeed, Watsuji shows outstanding skills and sensibility in portraying personal events based on recollection from within a tradition and the context of the age.

After his high school education, Watsuji enrolled in the philosophy department of the Imperial University of Tokyo, from which he graduated in 1911. At first Watsuji showed an interest in literature: while still a university student, he founded the second series of *Shin Shichō* (New Trends of Thoughts) together with Tanizaki Jun'ichirō.[2] Watsuji thus began his career as a writer and critic. Although his literary leanings belonged to the Aesthetic school (Tanbi-ha), Watsuji soon became a student of Natsume Sōseki,[3] thus turning toward a personalism with strong ethical connotations. Even when we look at Watsuji's philosophical interests, we see that he studied philosophers with deep literary roots, such as Friedrich Wilhelm Nietzsche (1844–1900) and Søren Aabye Kierkegaard (1813–1855), publishing the volumes *Niiche Kenkyū* (A Study of Nietzsche, 1913) and *Zeeren*

1. [Yanagita Kunio (1875–1962) is considered the creator of the field of modern Japanese folklore. Ed.]

2. [Tanizaki Jun'ichirō (1886–1965) is considered one of the major Japanese writers of the twentieth century. Ed.]

3. [Natsume Sōseki (1867–1916) is regarded as the leading representative of the modern Japanese novel. Ed.]

Kirukegōru (Søren Kierkegaard, 1915). Watsuji's youth was characterized by a contention between an ethical tendency under the influence of Sōseki and his father—"whose motto, 'medicine is a benevolent art of healing,' I have never been able to forget" *(Koji Junrei)*—and a passion for art and the world of beauty. *Pilgrimage to Ancient Temples* clearly shows Watsuji's mental attitude at the time.

Shortly afterward, Watsuji abandoned the literary path, choosing instead the field of cultural and intellectual history. The fact that he gave up the idea of being a literary man does not mean he closed his sensibility to art and beauty. In fact he traced the formation of Japanese and other cultures with an outstanding sensitivity toward culture, thus taking the path of the cultural historian who positions his own individuality in the world. From *Pilgrimage* we can see Watsuji's tendency to proceed as a cultural historian—an inclination that becomes even more prominent in *Nihon Kodai Bunka* (Japanese Ancient Culture, 1920), published the following year. The same trend continues in later publications such as *Nihon Seishin Shi Kenkyū* (Study of Japan's Intellectual History, 1926) and *Genshi Kirisutokyō no Bunkashiteki Igi* (The Cultural Meaning of Original Christianity, 1926). Watsuji received his doctorate with the publication of *Genshi Bukkyō no Jissen Tetsugaku* (The Practical Philosophy of Original Buddhism, 1927), which he wrote the same year that he left Japan in order to pursue his studies in Germany. *Climate* (1935) was the result of Watsuji's experiences abroad. This is a typological study based on the climatological characteristics of cultures all over the world and, as well, a clarification of the peculiarities of Japanese culture from a comparative perspective.

Thanks to his achievements in cultural history and intellectual history, Watsuji obtained a position at the Imperial University of Kyoto that he held from 1925 to 1934. Later he lectured on ethics as a professor at the Imperial University of Tokyo. After he published the outline *Ningen no Gaku to Shite no Rinrigaku* (Ethics as Anthropology), which is fairly well known for its definition of the notion of *ningen* ("man"), Watsuji turned to a systematization of ethics. The first volume of his major work, *Ethics,* appeared in 1937; the second volume was published in 1942; the third made its appearance in 1949. Moreover, the two volumes of *Nihon Rinrigaku Shisō Shi* (History of Japan's Ethical Thought), in which Watsuji gathered all his studies of the history of Japan's ethical thought, appeared in 1952. Watsuji wrote both *Ethics* and *History of Japan's Ethical Thought* during World

War II and completed them after the war. I heard from an older friend at the University of Tokyo his mixed feelings when, after reading the second volume of Watsuji's *Ethics* as a university student during the war, he left for the front having been drafted in the army and found himself reading the final volume of the same book after his discharge following the end of the war. This friend had gone through a deep value turnabout during the war. And beyond his own personal experiences, many people must have felt uneasy about Watsuji's whole ethical system, though it had survived the war. Following mandatory retirement from the University of Tokyo, Watsuji worked once more on studies of cultural history. He published the first volume of his *Nihon Geijutsu Shi Kenkyū* titled *Kabuki to Ayatsuri Jōruri* (Investigations in the History of Japan's Literary Arts: Kabuki and Puppet Theater, 1955) and *Katsura Rikyū* (The Katsura Detached Villa, 1955). In 1955 Watsuji received the Order of Cultural Merit from the emperor. The following year, as I mentioned earlier, he began serial publication of *An Attempt at Autobiography*, an effort he unfortunately had to interrupt because he fell ill. Watsuji fought his disease for a year, until he passed away in his residence in Nerima, Tokyo, in December 1960. His tomb is located in the precincts of Tōkeiji in Kamakura, next to the burial site of Nishida Kitarō (1870–1945)[4] and Suzuki Daisetsu (1870–1966).[5]

On *Pilgrimage to Ancient Temples*

I said that *Pilgrimage to Ancient Temples* and *Climate* are the two best-known works by Watsuji. Both are included in the popular "Iwanami Library" (Iwanami Bunko), and *Pilgrimage* was chosen as one of Iwanami's "Hundred and One Volumes"—a collection of the most consistently best-selling classics from the East and the West. In *Pilgrimage* we read the following statement:

> The Kudara Kannon is pierced by a straight line as if a filament of steel was running through the statue, as well as by a strong, sharp curve that looks as if it were incurvating a thin plate of steel.[6] Here we

4. [See Chapter 18. Ed.]

5. [Suzuki Daisetsu Teitarō (1870–1966), Buddhist scholar, is considered the chief interpreter of Zen Buddhism to the West. Ed.]

6. [A National Treasure, the statue of the bodhisattva Kannon (Skt.: Avalokiteśvara) known as the Kudara Kannon (or "Kannon from Paekche, Korea") is a wooden, polychrome statue produced in the seventh century and kept at Hōryūji temple in Nara. Ed.]

find simplicity and clearness. At the same time, there is an implication of haziness. While being rough, it does not lack a fine sensibility. While being sensitive to the coordination of form, it does not really aim at the beauty of form. Rather, it aims at something abstract that is suggested by form. Accordingly, the subject "Kannon" does not find expression through the beauty of the body. It finds expression through something mysterious suggested by the body's form.

This is a commendable portrait of the Kudara Kannon. Watsuji was probably among the first people who expressed, through a narrative, the impressions felt in front of a Buddhist statue. We might say that one of the reasons we always feel such vitality in *Pilgrimage* has to do with Watsuji's literary skills, which allowed him to express his thoughts with rich sensitivity. And yet his prose is never difficult; rather, it is clear and has a fresh literary tone. We see the same stylistic characteristics in almost all of Watsuji's works. If we read this passage on the Kudara Kannon once more, we realize that it does not limit itself to a superficial impression of the statue of Kannon. We understand that Watsuji's sensibility is the transfiguration of religious consciousness embodied by the statue of the Kudara Kannon and, moreover, that he grasped with great sensitivity a religious experience represented by this statue of Kannon. This explains why we find the following description of the statue:

> An abstract "sky" transmogrifies into a concrete "Buddha." We are susceptible to this wonder coming from the Kudara Kannon. The beauty of its body, the nobility of its benevolent heart—people living in a transitional period who greet such beauty and nobility with fresh emotions, as if they were children, finally succeed in understanding a superhuman being in human form. To feel as if a mystical presence were close to them—and still be able to see it with their own eyes—was for them as if their view of the world had undergone a drastic change. They scrutinized that body with new eyes, and they felt human passions with a renewed heart. They found there a depth that was difficult to fathom, a symbol of the Pure Land. As a crystallization of such feelings, a statue of the Buddha was made in Chinese style. . . . I am not saying that the Kudara Kannon was made by Chinese people. I am thinking of the stylistic meaning forming the Kudara Kannon. This was one of several styles that were available in China. By coming to Japan, however, this style assumes a decisive strength, so strong was the sympathy the Japanese people felt for the experience behind this style.

As we can see from this quotation, *Pilgrimage to Ancient Temples* has the merit of offering a narrative that keeps expanding—starting with the impressions that the ancient temples of Asuka and Nara stirred in the author's imagination, then describing the religious expe-

riences of ancient people brought about by images of ancient Buddhas, then moving even deeper into a presentation of the experience of cultural assimilation. The imagination of the author looking at ancient masks, for example, grasps the fluctuations of cultural exchange between China, the West, and Japan, as well as between India and, through the mediation of India, Greece. In this book of cultural history, I personally admire the skill with which *A Pilgrimage to Ancient Temples* delves into the experience of cultural exchange and cultural assimilation in Asia. Moreover, I believe that in *Pilgrimage,* Watsuji the cultural historian is at the height of his powers.

On *Climate*

Climate, after *Pilgrimage to Ancient Temples,* is Watsuji's second most widely read work. It is a truly interesting work that identifies cultural patterns all over the world according to a climatological typology. I believe, moreover, that the cultural interpretations of "climate"—something each of us confronts directly—are clearly convincing.

> If, leaving our land, we circle the earth from east to west, like the sun, first of all we experience the strong "dampness" of the monsoon zone. Next we experience the complete negation of dampness in the desert zone—that is, "dryness." Once we reach Europe, however, it is neither damp nor dry. Or, it might be better to say, it is both damp and dry. To say it arithmetically, while the quantity of rain in Arabia is one-tenth the rainfall in Japan, the amount in Europe can be one-sixth, one-seventh, one-third, or one-fourth of the Japanese amount. To say it experientially, Europe is the synthesis of dampness and dryness.

Watsuji based *Climate* on his experiences as a student in Europe in 1927 and 1928. Since, at that time, the voyage to Europe was by sea through the Indian Ocean, past the desert zone, and into the Mediterranean Sea, Watsuji's actual journey followed the description I quoted above: he crossed the monsoon area that he interpreted as the climatic type known as "dampness"; he passed through the desert zone that he called "dryness"; and he eventually reached Europe, "the synthesis of dampness and dryness." Watsuji was taken by Europe's "green," since he reached it in the morning after passing through the southern sea of Crete and seeing the land of southern Italy. At that time, he was impressed by the statement made by a professor of the Department of Agriculture who was on the same ship: "There are no weeds in Europe." These words—for Watsuji they

were almost a revelation—opened his eyes to the European climate. The following is a famous passage from the same book:

> The statement "there are no weeds in Europe" meant that in Europe you do not find, as you do in Japan, those open spaces covered with weeds that grow in the twinkling of an eye. These words referred to a process of growth of plants and trees very different from Japan. Accordingly, they expressed symbolically a different nature. Anyone who steps into a foreign country far away from one's own land realizes the heterogeneity of the natural environment, and seasonal transition, that make him think of different customs in a different natural world. Contemporary men who have lost sensitivity to nature, who jump from big city to big city, have no time for examining their relation with a different nature from a perspective of comparative culture.

Watsuji—the sensitive interpreter of religious experience and experiences of cultural assimilations to be found in the images of Buddhist statues of the Asuka period—confronted with European plants and trees, and with Europe's change of seasons, turned his thoughts to the customs of people in different climates and to their ways of thinking. Everywhere in *Climate* the reader discerns Watsuji's insights, which his sensitivity to culture and his rich knowledge made possible.

The methodology the author employs in *Climate,* however, is not a grasping of culture in its transformations but an attempt at a static, typological interpretation of culture based on climatological characteristics. In *Climate,* written from the methodological point of view of creating a typology of cultures, Watsuji's sensitivity to culture led to conclusions that are difficult to praise unconditionally. Watsuji presents the cultural typology of the "monsoon" pattern found in "dampness," the "desert" pattern found in "dryness," and the "pasture" pattern found in "the synthesis of dampness and dryness." Here, however, we must examine how Watsuji interpreted Japan according to this typological scheme based on climatology.

Watsuji called the lifestyle of people living in the monsoon zone "monsoonlike," characterizing them as receptive and resigned. Japan was unique among the countries of the monsoon zone, he argued, and he pointed out the dual nature of Japan's climatic characteristics —"the tropical and the frigid":

> Monsoon receptivity assumes a very unique form in the Japanese for it is, first of all, both tropical and frigid. It is neither the constant fullness of feeling of the tropics nor again the tenacity of the frigid and dull emotions of the cold zones. Although there is a plentiful outflow of emotion, there is a steady tenacity that persists even through change.

... Monsoon resignation also takes its own distinctive form in Japan. First of all, it is both tropical and frigid. In other words, it is neither the unresisting acquiescence of the tropical zone nor the persistent and patient doggedness of the frigid zone. For, although essentially resignation, through resistance it becomes mutable and quick-tempered endurance.[7]

Watsuji describes the nature of the Japanese people climatologically. Thus he bases that nature's alleged specificity upon its receptive and resigned "monsoonlike" cultural pattern. In classifying the Japanese character, Watsuji uses extremely literary expressions such as "calm passion and a martial selflessness." Then he turns to a description of how this "calm passion and martial selflessness" of the Japanese people appears in their human relations and in the formation of communal societies such as the family and the state. In this regard, there are a few ways in which *Climate* overlaps with later works such as *Ethics* and *History of Japan's Ethical Thought.* One can even postulate that *Climate* departs from *Pilgrimage to Ancient Temples* and becomes the starting point of Watsuji's work on ethics.

I have said that Watsuji's description of the Japanese character from a climatological standpoint is extremely literary in its expression. All of Watsuji's works tend to be sustained by such an exceptional narrative power that the reader feels the literariness of his prose more than his speculative philosophy. This literariness, however, ends by creating a problem in Watsuji's thought—a problem that surfaces, for example, in the expression "calm passion and martial selflessness."

Toward a Japanese Communal Society

Although I have argued that we find Watsuji at his best, literarily speaking, in *Pilgrimage to Ancient Temples,* I must bow to the degree of literariness that appears in his description of Japanese nature in *Climate.* I cannot keep from sensing a sort of fallacy here. I wonder whether this work actually comes into being only as literary expression.

There is no doubt that climatological conditions are important factors in the formation of an area's cultural characteristics. It is true,

7. [Adapted from Geoffrey Bownas, trans., *Climate and Culture: A Philosophical Study,* by Watsuji Tetsurō (New York: Greenwood Press, 1961), pp. 135–136. Ed.]

moreover, that heterogeneous climates offer a clue to understanding different cultures. Yet a debate that tries to construct a cultural typology—and infers the nature of people all over the world from broad climatological characteristics such as "dampness," "dryness," and "a synthesis between the two"—can hardly be anything but a record of impressions: it can only be taken as *a story*. A story requires plausibility. This is one reason why I feel the presence of a fallacy in the literariness of *Climate*'s narrative.

As I noted earlier, in *Climate* the description of cultural patterns corresponding to climatological characteristics known as "monsoon," "desert," and "pasture" develops into a depiction of Japan's climatological peculiarities, the character of the Japanese, and the distinctive traits of the communal societies formed by the Japanese people. Up to this point, the reader realizes the aim behind *Climate*'s cultural, typological point of view and behind the narrative based on such a view:

> Through every age, the Japanese strove to give up selfishness within *(aida)* the family. So there is a full realisation of the concept of the fusion *(lit., non-differentiation)* of self and other. . . . Hence, the Japanese way of life regarded as that of a household is none other than the realisation, through the family, of the distinctive in-betweenness *(aidagara)* of Japan—the fusion of a calm passion and a martial selflessness. This in-betweenness further became the basis of the conspicuous development of the "house" itself. . . . There is a good deal of historical sense in the assertion of unity between loyalty and filial piety, both of them directed towards an understanding of the nation as a whole in terms of the analogy of the house. This is *the specific trait of the Japanese:* the attempt to interpret the nation as a whole in terms of the *distinctive Japanese way of life* (Watsuji's emphasis).[8]

I wonder whether this is not a simple rhetorical reworking, through the use of the expression "calm passion and martial selflessness," of the state/family ideology that was advanced in modern Japan.

In *Pilgrimage to Ancient Temples,* Watsuji masterfully portrayed the images of the ancient Buddhas of Asuka and Nara, as well as ancient masks used in Buddhist rituals. At the same time, he broadened his inquiry to include East Asian experience of cultural assimilation embodied in these images and forms. He even proceeded to examine cultural exchanges between India and Greece, so that he ex-

8. [Adapted from Bownas, *Climate and Culture*, pp. 142, 143, and 149. Ed.]

panded his research to movements of global culture. In *Climate,* however, while embarking upon a journey that made him experience directly different cultures, Watsuji constricted his research to an examination of the specific being of the Japanese. Here I have tried to discuss these two views of Japan and Japanese culture by looking at two well-known works by Watsuji Tetsurō.

13

On the *Aesthetics* of Abe Jirō

HIJIKATA TEIICHI

By the *Aesthetics (Bigaku)* of Abe Jirō (1883–1959) I mean the well-known volume that Abe published in the "Philosophy Series" (Tetsu-gaku Sōsho) with the Iwanami publishing house in April 1917. In the introductory remarks, Abe makes the following statement:

> I based this book on Lipps' empathy theory and, particularly, on four publications by Lipps:[1] his *Aesthetik* (Aesthetics, 2 vols.), *Leitfaden der Psychologie* (Manual of Psychology), *Die ethischen Grundfragen* (The Basic Ethical Questions), and the chapter "Aesthetics" in his *Kultur der Gegenwart* (Culture of the Present Time). It is not my purpose, however, to introduce the aesthetic theory of Lipps. Rather, I wanted to examine several aesthetic issues myself, following the basic notions developed by Lipps.

As we can surmise from this statement, it may not be a mistake to call this work "Lipps' Aesthetics" rather than Abe Jirō's *Aesthetics*. At the same time, however, Abe Jirō himself would be annoyed to have his aesthetic system reduced to this single publication without any attention paid to his later, very profound, production. Nevertheless, I have chosen this specific text intentionally for my essay on Abe. Although the choice of such an old text might annoy some readers, I wanted somehow to clarify the role played by Abe's aesthetics at a time when the aesthetics of Eduard von Hartmann, which was first embraced by Mori Ōgai,[2] was playing an equally prominent role.

From Hijikata Teiichi, "Abe Jirō Shi no 'Bigaku' ni Kanren Shite," in Hijikata Tei-ichi, *Kindai Nihon Bungaku Hyōron Shi* (History of Modern Japanese Literary Criticism) (Tokyo: Hōsei Daigaku Shuppankyoku, 1973), pp. 138–147.

1. [Theodor Lipps (1851–1914) is a major theoretician of the notion of "empathy" *(Einfühlung),* together with Friedrich Theodor Fischer (1807–1887) and Johannes Vol-kelt (1848–1930). Ed.]

2. [See Chapter 4. Ed.]

I read this work for the first time around the years 1923–1924. At almost the same time I read Nishida Kitarō's *Geijutsu to Dōtoku* (Art and Morality; July 1923),[3] which came out not long after Abe's *Aesthetics*. I remember distinctly how moved I was by both works, despite my shallow understanding. This was the first time that I, not yet in my twentieth year, had encountered this kind of writing. I still recall the mixture of pure joy, doubt, and puzzlement with regard to the major issue in aesthetics: Where is beauty located? Is it within the object? Or, as Lipps argued, is it located in aesthetic emotions in the form of our inner conscious content, which is aroused by the object? When I think of the joy I felt when I first explored a field that until then had remained alien to me, I cannot free myself of my personal recollection of Abe's *Aesthetics*. More than the general outline, however, what truly inspired me was Lipps' personalism, which appears everywhere in the book. While presenting, on the one hand, aesthetic emotion psychologically as purely an emotion of pleasure, for example, on the other, Abe's *Aesthetics* introduces aesthetic values in which the inner attitude of the self that finds expression in such an aesthetic emotion is strongly questioned as an ethical value.

> What is the ground that makes the satisfaction of personal desire a nonvalue and places comic values beneath sublime actions? In order to exhaust the issue in one phrase, we may say that it is the presence and quality of the personalistic values which lie in them. . . . Why are personalistic values basic values? The answer is the following: Because, in a word, the value of the object is established according to the inner attitude that specific object arouses inside us. . . . The ultimate standard used to establish the value of all objects is whether the inner attitude that the object demands agrees with the life demands of our whole person. (*Bigaku*, pp. 37, 38, 39)

Now that I look back to this work, I realize that rather than simply teaching me specific issues related to aesthetics, Lipps or Abe Jirō's *Aesthetics* introduced me to the kind of personalism clearly exemplified by the foregoing quotation and inspired in me a sense of dignity and self-awareness as a human being. At times I had the impression that the book was not dealing with the field of aesthetics any longer. It presented, instead, Lipps' ethics of personalism—as we can see, for example, in the following passage:

3. [On Nishida Kitarō (1870–1945) see Chapter 18. Ed.]

Goodness . . . does not manifest itself only in combination with morality; it is also found inside what is extreme and dangerous. Therefore, goodness never fears these forms of expression. On the opposite end, to judge artistic values according to standards based on the amount of morality found in the characters and actions portrayed in art is no more than the work of timid moralists and censors. We can surmise how many crimes were perpetrated against aesthetic culture in the name of such wrong standards. (*Bigaku,* p. 72)

Nishida Kitarō raised the same issue in his *Art and Morality* with regard to expressive action. In the same way that Lipps' aesthetics instilled in me the sense of man's positive awakening to aesthetic appreciation, the notion of expressive action meant for me the same human awakening to the act of artistic creation.

The reason for my indulging in adolescent memories is not a simple sense of excitement. It is also a late reflection of the adolescent spirit during the Taishō period. If we follow the journal *Shirakaba* (White Birch), the spirit of the so-called Taishō democracy started to surge around the years 1909–1910. I use the word "late" because, when I first experienced the excitement of reading Abe Jirō's *Aesthetics,* a friend of mine brought to my attention an article, published in the journal *Warera* (Us), which was a critique of Abe's interpretation of Lipps. Recently I searched for that journal and found that the article by Takenouchi Masashi (1898–1922), "Rippusu no Jinkakushugi ni Tsuite" (On Lipps' Personalism), appeared in the February 1922 issue of *Warera.*

At the beginning of the article Takenouchi states that just as both he and Abe Jirō addressed Lipps as "Master" (Abe Jirō, *Rinrigaku no Konpon Mondai* (Basic Problems in Ethics), May 7, 1916), Abe Jirō, whose works Takenouchi encountered in his twenties, was for him a "master." But, the article continues, after reading Abe Jirō's statements based on his "Jinsei Hihyō no Genri to Shite no Jinkakushugiteki Kenchi" ("The Viewpoint of Personalism as a Principle of a Critique of Human Life," *Chūō Kōron,* New Year 1921), Takenouchi began to feel a sense of disappointment and dissatisfaction with the advocacy and defense of personalism that Abe put forth in several journals. Takenouchi pointed out several mistakes and weaknesses in Abe's thought. Moreover, in order to clarify whether these mistakes were of Lipps' or of Abe's making, Takenouchi proceeded to examine Lipps' personalism. I believe that Takenouchi's summary of Lipps' theory is concise and correct. At the same time, however, I feel that he was

strongly deploring Lipps rather than praising him. Repeatedly, for example, we read the following remarks: "Never had human dignity and human superiority been elevated to such heights. The thread uniting the self to others had never been described before in such bold fashion." If I am allowed to borrow from Otto Weininger's language,[4] this was a "heroic action—a truly rare sight in world history."

While rereading this article, I could not help noticing the exceptional influence that Abe Jirō and Lipps had on the same era. Moreover, at the end of the article we read as follows:

> We do not find elsewhere in the history of philosophy such an admiration and a devotion to the good expressed in such a strong and beautiful style. These broad and powerful notions of goodness and personhood are filled to the breaking point with rich content. It goes so far as to endorse the spilling of blood, and to make this a personal duty. This personalism, which even endorses violence and bloodshed in revolutions, is a bold and infinite leap from Kant to Nietzsche. This is a thought that not only lends its approval to Leninism, perhaps, but is not afraid to call it a moral duty. On this point, however, it is clear how far the personalism of Abe Jirō, who calls himself a disciple of Lipps, is from the thought of the Master. In this sense we can say that this is undoubtedly Abe Jirō's own thought—a sublime leap from Lipps to Kant; or a courageous retreat from Leninism to Tolstoyism.

Although personally I would not be able to formulate a judgment on who was right and who was wrong with regard to the interpretation of Lipps, I feel that, today, it is more interesting to note the generation gap leading to these interpretations rather than asking which interpretation is right and which is wrong. Once we reach the years 1922–1923, we can argue that there was enough time for a difference of opinions to mature. This is what I meant by "late" when I mentioned the late influence this thought had on me as a young man. Moreover, as the farewell to Lipps, which we find in the background of Takenouchi Masashi's article, indicates, the age was already preparing itself to break from Lipps and move forward. I will discuss this issue on a different occasion. For now I will turn to the aesthetics of empathy presented by Abe Jirō/Lipps.

4. [Otto Weininger (1880–1903), Austrian philosopher, converted from Judaism to Christianity in 1902 and published *Geschlecht und Charakter* (Race and Character, 1903), which contained controversial characterizations of the Jewish people. Ed.]

As is well known, Lipps argued that, like everything that has different kinds of values, whatever possesses aesthetic value provides us with feelings of pleasure. What he means by "like everything that has different kinds of values" is found, for example, in his theory of personalism in which he starts from a psychological reality known as the value emotion of fulfilled pleasure. Aesthetic value emotions are emotions of pleasure (*Bigaku,* p. 11). Lipps sets out from a subtle yet strong introspection of the psychological reality of a subject who cannot doubt emotions of pleasure. Generally speaking, there is something to be admired in the form taken by Lipps' deep introspection in becoming an object. The nature of the object that evokes in us these emotions of pleasure is the issue of Lipps' aesthetics (the principle of aesthetic form). I will start by examining Lipps' description of emotions of pleasure.

A quiet green color, for example, gives us a peaceful and refreshing feeling. We experience an emotion of pleasure which is "peaceful and refreshing" based on an inner activity that a "calm, free" object brings about. The awareness experienced in such an emotion of pleasure is not the object itself. It is our inner activity—the state of the self that is expressed in this inner activity (*Bigaku,* p. 17). Although I have been calling them emotions of pleasure, Lipps sees this pleasure as resulting from the fact that for us "peaceful freshness" is nature. He describes this naturalism, which "for us is an impossible mental desire, a psychological reality," as the ultimate ground even in aesthetics. In other words, if this activity corresponds to the real nature of the mind, it takes place in us freely, easily, and without hindrance. If, however, this activity does not match the true nature of our mind, then it inevitably contains inner contradictions and dissension. The former is the condition of pleasure; the latter is the condition of displeasure. The emotional activity, which is endowed with specific dispositions, moves entirely in the direction of either pleasure or displeasure according to the degree of correspondence (nature/unnaturalness) with the true nature of the mind (*Bigaku,* p. 24).

Therefore, just as with activities in general, the inner activity that is grounded in emotions of pleasure is made of intense, free, abundant —in a word, strong—emotions. It would be very interesting to study Lipps' psychological analysis of the nature of emotions of pleasure, but now, after looking at the psychology of aesthetic emotions, I want to examine the issues of value and aesthetic value. It goes with-

out saying that the simple clarification of the nature of emotions of pleasure as aesthetic emotions does not yet answer the question of value. As I noted earlier, what has value is what gives us the sensation of pleasure. We should not regard the two aspects as the same thing. Beyond this, we cannot attach any value to emotions of pleasure that give joy to our senses if they hurt other persons, regardless of whether they are indeed emotions of pleasure. Moreover, even among emotions with the same value, there are different ranks of value. Something that succeeds in being comical, for example, makes us cheerful and jolly. But when we think of a sublime action that is made real for the first time as a result of a person sacrificing his life over it, the degree of emotional *depth* contained in this sublime action that gives us pleasure has more value than the jolly emotion coming from the comic. The following is Lipps' answer to this issue:

> The value of the object is established according to the value of the nature (personalistic value) of the inner attitude that the object arouses in us. (*Bigaku*, p. 38)

> We attach aesthetic value to the object only when we become aware of the life (person) inside the object. (*Bigaku*, p. 66)

Here we might somehow feel that the issue of the aesthetic value of emotions of pleasure is finally resolved. But when we try to inquire into the meaning of value, the meaning of person that is the ground of aesthetic value, and the meaning of personalistic values, still no individual psychological entity appears. "Personalistic values are the nature of all inner attitudes that become the object of our positive, personalistic emotions" (*Bigaku*, p. 41). In other words, as before, the nature of a judging subject and the different types of aesthetic values are presented from the viewpoint of psychology. These types are "strength," "activity," and "effort," as well as "cheerfulness" and "depth." We cannot go beyond this and explain what the aesthetic emotion of "depth" is about. We can say that the issue of aesthetic value cannot be sufficiently answered by the hedonism of psychological aesthetics.

In what follows, the *Aesthetics* tackles the principle of aesthetic form, which explains the conditions required of an object to produce aesthetic emotions; then it turns to the theory of empathy, which is at the core of Lipps' aesthetics. As in the case of the principle of aesthetic form, even in aesthetic empathy we see that the object is the person considered as a psychological individual. With regard to the

issue of aesthetic empathy, Abe asks the following question: "On the whole, we acknowledge life within the object of the five senses. How is it possible to feel life within the objects of the five senses?" As we saw with regard to emotions of pleasure, the answer comes from a naturalistic stand: "Because in our nature there is a demand for humanization *(Vermenschlichung)*." As a solution, "aesthetic empathy as the experience of the object's life" is postulated (*Bigaku*, p. 156). Opposed to this view is Rudolph Odebrecht's (1883–1945) argument that the animistic attitude of mystical consciousness, seen as a first step in the development of the human spirit, is replaced by a psychological, reflective form of consciousness (Odebrecht, *Aesthetik der Gegenwart*, p. 36). Lipps himself acknowledged this theory in *The Manual of Psychology*, but he then proceeded to critique Odebrecht. While admiring the fact that the direct reflection on the content of aesthetic experience is skillfully given objectivity through empathy, Lipps stresses—as he had done before in the case of aesthetic value—the impossibility of completely grasping the objective nature of the object through a formal reduction of mental processes. (Later the theory of empathy went through several transformations, the discussion of which I defer to another occasion.)

Lipps' argument that psychological aesthetics is true aesthetics is clearly a one-sided overstatement. Even if we acknowledge his great success in overcoming the limits of psychological aesthetics, as well as providing a nomology of aesthetic consciousness, it was only natural that demands to solve unresolved questions would arise. Around this time, even in Japan, the aesthetics of the Neo-Kantian school, the science of art and the sociology of art, the aesthetics of phenomenology, Marxist aesthetics, and other ideologies, were coming on stage.

14

Aesthetics at the University of Tokyo after World War II

Imamichi Tomonobu

When Ōnishi Yoshinori (1888–1959) retired in 1949 from his pro-fessorship in aesthetics at the University of Tokyo,[1] the lecturer in aesthetics Takeuchi Toshio (1905–1982) was appointed associate pro-fessor. While studying "literary art" *(bungeigaku)* as a student of Ōtsuka Yasuji (1868–1931),[2] Takeuchi concentrated on the study of Hegel and also continued the academic tradition of Ōnishi. We could summarize Takeuchi's activities by saying that he planned a systema-tization of aesthetics as "the science of art" *(geijutsugaku)* by sublat-ing Ōtsuka's *Literaturwissenschaft (bungeigaku)* and Ōnishi's fun-damentals of aesthetics in the same way that Hegel's dialectic had sublated opposites.

With very few exceptions, scholars of Takeuchi's generation trav-eled to the West late in life, after they had reached age fifty; Takeuchi was no exception. This fact attests to the heightening of the role Tokyo Imperial University played by educating, even in fields such as Western modern humanities, scholars who received their education exclusively in Japan and whose standards were no lower than those of their Western counterparts. At the same time, confinement to his native land does not imply any narrowness on the part of Takeuchi's vision. While Ōnishi was winding up his scientific studies focusing on Japanese aesthetics, Takeuchi was conducting a highly detailed examination of works completed before and after the war on the sub-ject of Germany's "science of literature," and, as a result, he published

Based on Imamichi Tomonobu, "Bigaku Geijutsugaku," in *Tokyo Daigaku Hyaku-nen Shi: Bukyoku Shi,* vol. 1 (Centennial of the University of Tokyo: History of the Departments) (Tokyo: Tokyo Daigaku Shuppan Kai, 1986), pp. 189–196.
 1. [See Chapters 10 and 11. Ed.]
 2. [See Chapter 9. Ed.]

his *Bungeigaku Josetsu* (Introduction to the Science of Literature, 1952). In this book Takeuchi mentions 285 authors from Alfred Adler[3] to Paul Zincke.[4] Only one Japanese name appears—Okazaki Yoshie (1892–1982)[5]—a fact that evidences Takeuchi's efforts to cultivate himself by thoroughly exploring foreign research on the subject. In this publication Takeuchi looks at literature as a literary art, and he emphasizes the particular essence and rules of the field. He aims at "examining and critiquing the results of several earlier studies that considered the science of the literary arts to be one of several aesthetic sciences" and, as well, at "grasping in a sufficiently proper way the essence and value of the literary arts as a spiritual subject" (Takeuchi Toshio, *Bungeigaku Josetsu* [Tokyo: Iwanami Shoten, 1952], p. 194). He argues that "the science of the literary arts should not break off again from philosophy on account of the literary arts' special nature (ibid., p. 195). At the end of the book, after reviewing the existential approach to *Literaturwissenschaft* by Hermann Pongs (b. 1889) and arguing that "we necessarily enter into the realm of metaphysics" (p. 354), Takeuchi concludes by stressing the need to maintain "a synthesis of scholarly findings," thus showing his inclination toward aesthetics seen as the philosophy of art.

The first fruit of this approach was a book titled *Bungei no Janru* (Genres of the Literary Arts, 1954). Takeuchi argued that the genres of epic poetry, lyric poetry, and drama differ from the classification of natural history and that, "based on their essence as spiritual creations, the literary arts signify three possible basic patterns, or basic directions" (Takeuchi Toshio, *Bungei no Janru* [Tokyo: Kōbundō, 1954), p. 43]. With regard to the idea that in contemporary literary works the three genres "are mixed with one another in varying degrees," Takeuchi sided with Emil Steiger (b. 1908) and Wolfgang Kayser (1906–1960). The central part of the book is the second

3. [Alfred Adler (1870–1937), Austrian psychiatrist, advanced the theory of the inferiority complex to explain psychopathic cases in *Studie über Minderwertigkeit von Organen* (A Study of the Inferiority Complex, 1907). Ed.]

4. [Paul Zincke (b. 1879) wrote extensively on German writers, especially Paul Heyse (1830–1914) and Georg Forster (1754–1794). Ed.]

5. [Okazaki Yoshie authored a very popular *Nihon Bungeigaku* (Science of Japanese Literature, 1935) in addition to *Nihon Bungei no Yōshiki* (Styles of Japanese Literary Arts, 1939), *Bi no Dentō* (The Tradition of Beauty, 1940), *Nihon Geijutsu Shichō* (Currents of Japanese Art, 1943), *Nihon Bungei to Sekai Bungei* (Japan's Literary Arts and the World's Literary Arts, 1950), *Bungeigaku Gairon* (Outline of the Science of Literature, 1951), and other works. Ed.]

chapter, "A Division of Genres," in which Takeuchi discusses classifications according to linguistic forms, experiential content, and expressive attitude. He also deals with their compositional formation, adding his personal views, according to which didactic literature, pornographic literature, and the literature of entertainment "cannot be made into genres related to the literary arts and to their essential formative elements because their motives are mixed with elements other than art" (p. 168).

The publication that made Takeuchi famous as a scholar was *Arisutoteresu no Geijutsu Riron* (The Art Theory of Aristotle, 1959), a book that earned him a prize from the Japanese Academy. In this book Takeuchi examines almost all earlier theories on Aristotle and thoroughly explores the matter from the perspectives of aesthetics and the science of art. Indeed, we can call this work a vade mecum for scholars. It stands out as the first contribution in our country that clarifies the origins of the science of literature. Aside from this merit, the work is highly meaningful insofar as it contributes to the formation of Takeuchi's system. Through an examination of Aristotle's concept of *technē* (skill), Takeuchi establishes a distinction between the aesthetic and the technical—thus opening the path later developed in his major work, *Bigaku Sōron* (Survey of Aesthetics), in which he locates art in the middle between the two, considering it an "aesthetic technique."

When the time came for him to retire, Takeuchi collected his lectures under the title *Gendai Geijutsu no Bigaku* (The Aesthetics of Contemporary Art, 1967). As if to compensate for the classical studies noted earlier, he focuses on the beauty of evil in contemporary art (pp. 306ff), presenting evil as "something with a deeply existential meaning that comes into being when the dignity of the original human nature is violated and destroyed by the contradictions, failures, and negativity hiding deep at the bottom of human existence" (p. 394). He articulates the idea that "the tragedy of evil is particularly appealing since it makes us feel poignantly values that are particularly human." The negativity we find in art mediates our expectation of positivity. What Takeuchi hints at in the second chapter of this book, "The Aesthetics of Technical Beauty," materializes in the work *Tō to Hashi* (Tower and Bridge, 1971). Since ancient times towers and bridges had drawn attention in architecture—the first for symbolically uniting men and heaven, the second for bringing together humans on

a horizontal plane. Takeuchi looks at these structures from the aesthetic perspective of the beauty of technology.

We find the synthesis of Takeuchi's entire system in his *Bigaku Sōron* (Survey of Aesthetics, 1979), which is close to eight hundred pages long. Here Takeuchi argues that although they are necessarily related, beauty and art belong to different classes on account of their nature. Here he aims at synthesizing aesthetics and the science of art and establishing the philosophy of art as the scaffolding of aesthetic foundationalism and technology. In this book Takeuchi came up with his foundational theory and art theory. Exploring the ontological aspect of beauty, he promotes his own characterizations of beauty through such images as the rainbow-like nature of beauty because of its fleeting glint, the desert island-like nature of beauty because of its self-reliant autonomy, and the abysmal nature of beauty because of its depth (Takeuchi Toshio, *Bigaku Sōron* [Tokyo: Kōbundō, 1979], pp. 70–90). Takeuchi's specialty is displayed in the section titled "Art Theory," especially the first chapter, "Art as an Aesthetic Technique" (pp. 547–616). Here Takeuchi adopts the same scheme he used in a very well received lecture during the International Congress of Aesthetics in Amsterdam in 1964. At that time, he used the following scheme (p. 562):

Value content *(Wertgehalte)*
Model of operation *(Betätigungsformen)*
Method *(Wahrheit)*
To contemplate *(betrachten)*
Beauty *(Schönheit)*
To create *(schaffen)*
Utility *(Nützlichkeit)*
To act *(handeln)*
Morality *(Sittlichkeit)*

Takeuchi argues that "we should distinguish between three separate foundational sciences: a noetic philosophy that includes theoretical observations and aesthetic contemplation; a technical philosophy that includes aesthetic creation and utilitarian productions; and a practical philosophy that includes utilitarian and moral actions" (p. 566). Following the example of Ōnishi Yoshinori, who translated Kant's *Critique of Judgment,* Takeuchi provides an annotated translation of Hegel's *Aesthetics.* For Hegel, beauty held a special position in art as radiance in the sensibility of the idea. Takeuchi, who took all

theories on art seriously, found himself in agreement with Hegel on this point.

In addition to his excellent achievements as an academic scholar, Takeuchi also distinguished himself through his organizational skills. Together with Ijima Tsutomu (1908–1978) of the University of Kyoto, he formed the first Association of Aesthetics (Bigakkai) in Japan and served for a long time as its president. Takeuchi was also behind the creation of the quarterly journal *Bigaku* (Aesthetics) and was the organizer of the yearly National Congress of Aesthetics and the monthly East-West Meetings. Takeuchi was also a member of the committee of the Third International Congress on Aesthetics held in Venice in 1956—a fact that shows his commitment to the internationalization of research. Moreover, he created a research group sponsored by the Ministry of Education; this group became the springboard for the compilation of *Bigaku Jiten* (Dictionary of Aesthetics, 1961) and *Gendai Bigaku Shichō* (Trends in Contemporary Aesthetics, 1965–1968) in five volumes—works that were all edited by Takeuchi.

Takeuchi reached mandatory retirement age in 1966, thus becoming an emeritus of the University of Tokyo. In 1970 he was chosen as a member of the Japanese Academy. Takeuchi died of illness in December 1982 while still trying to dictate his notes.

In 1963 Imamichi Tomonobu (b. 1922), then an associate professor at the University of Kyushu, was given a joint appointment with the same rank at the University of Tokyo. Having lectured at the universities of Würzburg and Paris, Imamichi traveled to several European universities to teach intensive courses even after his appointment at Tokyo University. He thus aimed at the internalization of the department of aesthetics by inviting scholars he had met during his trips abroad and promoting cultural exchanges.

In 1966 Imamichi succeeded Takeuchi Toshio to the Chair of Aesthetics. He was appointed professor after producing two works in 1968—*Betrachtungen über das Eine* (Studies on Unity), which begins with a comparative study of East and West and then analyzes the aesthetics of Confucius and Chuang-tzu, and *Bi no Isō to Geijutsu* (Phases of Beauty and Art), in which Imamichi explains patterns of beauty in relation to the movements of consciousness. Imamichi was granted his doctorate in literature with the publication of *Dōitsusei no Jiko Sosei* (Plasticity of the Identical Self, 1971) in which, beginning with the logic of identity, the author reaches the point of inter-

preting the full experience that self-expression finds in a subjectless proposition as the precondition of creation. With the publication of *Arisutoteresu Shigaku Yakuchū* (Annotated Translation of Aristotle's Poetics, 1973), Imamichi continued the tradition that had begun with Ōnishi's translation of Kant and Takeuchi's version of Hegel. At the same time, he attempted to complete an original metaphysics that views aesthetics as the central element of philosophy with a speculation beginning from a logical analysis of the aesthetic judgment. Imamichi showed comparativism at work in academic writings such as *Tōyō no Bigaku* (The Aesthetics of the East, 1980), *Tōzai no Tetsugaku* (Eastern and Western Philosophy, 1981), and *Studia Comparata de Aesthetica* (1976).[6] He called attention to the necessity of broadening the field of aesthetics through international cooperation. In that spirit, the International Association of Philosophy and the International Association of Aesthetics appointed him head of the International Center for the Comparative Study of Philosophy and Aesthetics. Every year the center sponsors an international conference in Japan. Moreover, since 1974 Imamichi has also served as vice-president of the International Association of Aesthetics. Imamichi edited volumes 1 to 7 of the series *Bigakushi Kenkyū Sōsho* (Library of the Study of the History of Aesthetics), published by the Department of Aesthetics at the University of Tokyo, and has published six volumes of the *Tokyo Daigaku Bungakubu Bigaku Geijutsugaku Kenkyūshitsu Kiyō* (Bulletin of the Department of Aesthetics and Art Science in the Humanities Division of the University of Tokyo)—all originally published in European languages.

Imamichi values the disciplinary autonomy of aesthetics. In 1967, in agreement with Yoshikawa Itsuji (b. 1908), professor of art history at the University of Tokyo, Imamichi was able to divide the Chair of Aesthetics and Art Science into two chairs—thus finally bringing the two disciplines to full autonomy in 1973, when specialized areas of research were set up in each of the two disciplines.

Prior to Imamichi's retirement, two positions in aesthetics were filled by inviting, as associate professors, Sasaki Ken'ichi (b. 1943) from the University of Saitama in April 1980 and Fujita Kazuyoshi

6. [For an example in English of Imamichi's comparative work see Marra, *Modern Japanese Aesthetics*, pp. 220–228. Ed.]

(b. 1944) from Nanzan University in December of the same year. Sasaki is a specialist of seventeenth and eighteenth-century French aesthetics and is the author of *Serifu no Kōzō* (The Structure of Speech, 1982).[7] Fujita is a specialist in classical aesthetics. Sasaki Ken'ichi is the present holder of the Chair of Aesthetics at the University of Tokyo.

7. [In addition to *Serifu no Kōzō*, Sasaki has published *Sakuhin no Tetsugaku* (The Philosophy of Works, 1985), *Bigaku no Jiten* (Dictionary of Aesthetics, 1995), *Mimoza Gensō* (The Mimosa Illusion, 1998), and, in English, *Aesthetics on Non-Western Principles* (1998). Ed.]

15

The Pliant Philosophy of Sakabe Megumi

HIRATA TOSHIHIRO

Sakabe Megumi (b. 1936) has been presenting his thought in a flood of publications such as *Watsuji Tetsurō* (1968), *Kagami no Naka no Nihongo* (The Japanese Language in a Mirror, 1989), and *Perusona no Shigaku* (The Poetics of Personhood, 1989). At age fifty Sakabe "accepted the decrees of heaven"[1] and, after abandoning mundane concerns, has devoted himself to a life of philosophy.

It is interesting to note that Sakabe published his first essays— "Ningengaku no Chihei" (The Horizon of the Human Sciences) (in *Risei no Fuan,* or *The Anxiety of Reason*) and "Keimō Tetsugaku to Higōrishugi no Aida" (Between the Philosophy of Enlightenment and Irrationalism) (in *"Fureru" Koto no Tetsugaku,* or *The Philosophy of Touch*)—in 1966, at the age of thirty, when "a man stands firm." In 1976, at age forty, when "man has no doubts," Sakabe published his first monographs: *Kamen no Kaishakugaku* (The Hermeneutics of Masks) and *Risei no Fuan* (The Anxiety of Reason). By looking at these publications, we can see how Sakabe warmed up to his idiosyncratic speculations without ever catering to the trends of the day. It is no wonder that to this day Sakabe Megumi continues to publish works that uphold his trademark of individuality.

From Hirata Toshihiro, "Yawarakai Sakabe Tetsugaku," *Risō,* Special Issue: *Gendai Nihon no Tetsugakusha* (Contemporary Japanese Philosophers), 646 (1990): 67–75.

1. [The author builds this and the following paragraphs on a famous passage from Confucius' *Analects* (Book 2, Wei Chang): "The Master said, 'At fifteen, I had my mind bent on learning; at thirty, I stood firm; at forty, I had no doubts; at fifty, I knew the decrees of heaven; at sixty, my ear was an obedient organ for the reception of truth; at seventy, I could follow what my heart desired, without transgressing what was right.' " The translation from the Chinese is by James Legge, *The Chinese Classics,* vol. 1: *Confucian Analects, The Great Learning, The Doctrine of the Mean* (Hong Kong: Hong Kong University Press, 1960), pp. 146–147. Ed.]

Structure and Formation of Sakabe's Philosophy

The basic motif of Sakabe's inquiry, from his first publications up to the present time, is the definition of a ground that encompasses the speakable and the unspeakable, the rational and the irrational, the modern and what goes beyond the modern, like the Möbius strip whose top and bottom sides merge. Sakabe linked each moment with ties of reciprocity; in other words, he made each moment a vital requirement for the existence of another and as compensation for the other. If one element loses or excludes the other, both forfeit the ground in which they are rooted and fly in midair in the twinkling of an eye.

The verification of such a situation and the exact seizure of the place where such an event occurs are the starting points of Sakabe's philosophy, which brings to fruition one strain of original Kantianism. Moreover, the structural analysis of the working of modern reason that constantly produces such a situation—in other words, the so-called psychoanalysis of modern reason and spirit—is the overture of Sakabe's philosophy. (See the essay "The Anxiety of Reason," in *The Philosophy of Touch,* 1971.) We can reduce Sakabe's basic philosophical theme to the following description: a rethinking of contemporary reason (a distinctively modern reason) within the Western context of body/mind or reason and sensibility. Furthermore—we could add—a reading and interpretation by way of "mirrors set against each other" of Western *écriture* and the Japanese *parole* of the "Yamato language"—a language that has been regarded as primitive and savage for being originally unrelated to the Western context. The difficulty of the task consists in confronting the structure of Western thought, which is articulated by the phonetic symbols of Western languages (the marks of modernity), by way of the Chinese language used for translations (ideographic characters).

Accordingly, when we talk about Sakabe's philosophy we should pay attention to the following two points: first, Sakabe's thought does not aim at denying modern reason or the modern episteme, nor does he greatly object to them or try to replace them with a new episteme when an opportunity arises to do so; second, Sakabe's penchant for developing a philosophy of the Yamato language is not a version of a Japanese self-enclosed, nationalistic culturalism, as misinterpretations that either welcome or caution against Sakabe's thought might lead the reader to believe.

I will begin by addressing the first point. It would be safe to argue that, basically speaking, Sakabe inherits the typical position of existentialism with regard to the issues of modern subjectivity and individualism, which are centered on the individual's ability to think by and for himself. Sakabe, however, points out the paradox that should the individual known as the self be regarded as a firm origin, or as some kind of fixed term, then the individual would become captive of himself, fettered and spinning in the air without freedom and without subjectivity, to the point that, in the end, even the self would be lost. Sakabe asks the rhetorical question whether the other—that which is not *the* self—is not indeed *a* self, and, therefore, whether, to the other, the self is nothing but an other. Is it not the environment— Sakabe continues—and all the relationships which link the individual to others and to his environment that make a person an individual? As a result, seen from the viewpoint of such relationships, the individual is simply a ring in a chain. After verifying this basic condition, Sakabe asks, what are the boundaries that make self and individual possible? In this regard, in *Kamen no Kaishakugaku* (The Hermeneutics of Masks), Sakabe mentions "the boundaries of surface" *("omote no kyōi")*. The individual known as the "self" is nothing but a "mark" within the boundaries of "surface." It is a mark—an indication, a sign *(shirushi)*—that, while residing close to the "form" and "manifestation" of all kinds of others and all relationships, is ceaselessly modeled after them like their shadow *(kage)*. While taking on their meaning, this mark transfers *(utsushi)* their form and manifestation to its own form and then proceeds to constantly deconstruct them, restructure them vitalistically (organically), and provide them with meaning.

Next I would like to address the issue of the alleged Japanese culturalism in Sakabe's philosophy. Sakabe's extensive use of the "Yamato language" reflects his belief in the importance of comparative studies between the structure of logic articulated in Japanese (typically the Yamato language) and its counterpart in Western languages. He regards this task as a way to end the impasse into which Western thought has fallen. Although we undoubtedly find in Sakabe's attitude a tendency to rethink theories of the Japanese language, we cannot conclude that he was trying to assert a special monopoly for the Japanese language that would replace the specificity of Western languages.

In the third chapter ("For the Future of Thinking in Japanese") of

The Hermeneutics of Masks—whose subtitle is "Logic and Thought in Western Languages and in Japanese"—Sakabe emphasizes the idea that the thought which is generally articulated in daily language, whether Western or Japanese, is limited by the accidental structure specific to each national language and, moreover, that we find both logical and illogical moments in it which should not be reduced to notions of superiority and inferiority. In Western languages, thought definitely follows a division between a subject and a predicate, and it fits a logic of the subject, inasmuch as it forces the predicate to inhere unconditionally to the subject, as a property of the subject. But the predicate's surplus—that which cannot be contained in the subject— is always consigned to the outskirts of logic, since it threatens the subject and its logical structure. Semiotics has tried to remove the imperfection resulting from the structural constrictions of Western languages by conceiving an artificial symbolic language. As a result, however, language became an empty exercise alienated from the speakers and from the concrete circumstances surrounding the speakers. Semiotics posits the relationship between subject and predicate as relational and relative, and it privileges a logic that describes sentences as the relationship of two reciprocal predicates. This follows the fact that, in order to precisely define the relationship between subject and predicate, a group of concepts which privilege the subject is posited—an a priori that escapes logic. In any event, the logic of the subject, a logic that colors the thought of Western languages, exposes logical imperfections, not only from the side of the impossibility of speaking and conceptualizing the surplus of the predicate, but also from the side of going beyond logic in designating the subject.

Sakabe undertook his rethinking of the Japanese language as a compensation for the imperfections of subject theories articulated in Western languages and for the inhuman qualities of the ideal language of semiotics. Tokieda Motoki[2] had argued that the subject depends on the predicate, and it is wrapped up in the predicate as in a wrapping cloth. Mikami Akira,[3] however, pursued the argument

2. [Tokieda Motoki (1900–1967), a leading Japanese linguist of the twentieth century, is the author of *Kokugogaku Shi* (History of Japanese Linguistics, 1940) and *Kokugogaku Genron* (The Theory of Japanese Linguistics, 1941). Ed.]

3. [Mikami Akira (1903–1971) is the author of *Nihongo no Ronri* (The Logic of the Japanese Language, 1963) and *Bunpō Kyōiku no Kakushin* (The Reform of Grammar Education, 1963). Ed.]

even further, stressing that the Japanese sentence is complete even without a subject and is self-supported by the predicate. As a result, according to Mikami, from the viewpoint of semiotics, the Japanese sentence was even more logical. While accepting Mikami's view that the Japanese sentence adheres to a logic of the predicate, Sakabe did not interpret this as the victory of logic; instead, he regarded it as concealing the issues of "a different logic" and "cultural patterns." The thought articulated in Western languages, which relies on the double foundation of subject and predicate, is better suited to an objective, conceptual, and univocal logic of identity—in other words, it is more fit for expressing the logic of modern rationalism, which is endowed with "a strong denotative structure" *(Watsuji Tetsurō)*. The thought articulated in a language such as Japanese, however, which stands on the single basis of the predicate, is more suited to an emotional, metaphorical, polysemic logic of difference *(différentiel)*—in other words, it is more suitable for expressing the logic of poetics, which is endowed with "a weak connotative structure" (ibid.). Sakabe argues that the structure and logic peculiar to each language are not simply signs and instruments used to communicate words. They are living structures "in which man dwells in a limited existence evenly colored by death and time." Thus they are signs directly pointing at how to experience death and time, each in a different way.

In other words, as he stressed in the preface to *Kagami no Naka no Nihongo*, Sakabe is talking about "cultural pluralism." Unlike those who espouse cultural relativism, however, Sakabe regards each culture as something irreplaceable for everyone in it. Unlike versions of cultural monism—such as racism, which worships only the self—and Eurocentrism, Sakabe stressed the need to reflect on one's own culture while always looking in a "set of mirrors" at other cultures as well in order to adopt an "open attitude" that transcribes or transfers *(utsushi)* different cultures. By continuously exchanging oneself into another, and thus changing oneself, we make our culture and our language richer and more tolerant. Sakabe's cultural pluralism aims at such a cultural variety. From the standpoint of Sakabe—a Japanese scholar of Western philosophy—there is no other way to do so than raising the standards of Western studies in Japan, rather than confining them to a mere act of cultural importation. As in the study of Romance languages in Germany, or German studies in France, Western studies in Japan should elicit the praise and respect of people from different cultures as the "irreplaceable mirror that

has been presented by the other and should reflect the form of one's own culture."

By the act of "thinking in Japanese," Sakabe means the rewriting of Japanese language and Japanese culture in the language of modern subjectivity, which had begun with Kant's notion of "thinking by oneself." Thus, in addition to developing a cultural pluralism, Sakabe tries to open up Japanese philosophy to the possibility of being universal. In what follows, I will try to give a rough sketch of the "overture" and "basic themes," as I mentioned earlier, of Sakabe's "soft" philosophy—a philosophy based on ideas that are truly humble, as well as tolerant, pliant, yet strong, like water.

The Anxiety of Reason: A Psychoanalysis of Modern Reason

Basically speaking, contemporary reason is all the more justifiably termed "modern" given that the internal schism it had supported since its inception has broken apart and modern reason is now faced with the abyss of destruction. The cry of the flesh which cannot be reduced to the word "sensibility," a fragment of the senses that have lost the coherence and form given to sensibility since Hume[4]—is now trying to overflow from the fissure of a shattered modern reason. Sakabe calls this situation "the anxiety of reason." He chose as topic of his philosophy the interpretation and solution within his own language, the Yamato language, of this uncertain, modern reason as well as the clarification of the pathology of such an anxiety. It goes without saying that at the same time he seeks to resolve the anxiety of scholars of Western studies and "people aspiring to be such scholars," as well as the anxiety of modern Japanese reason—a reason based on translations in Chinese characters that easily change the meaning of things.

Before tackling specific issues, Sakabe begins by attempting a "psychoanalysis" of modern reason. As one might guess from his use of the expression "psychoanalysis," Sakabe usually calls modern reason "modern rational subject," and he starts from the understanding that such a subject or personality is embedded within a structure of stratification which is grounded in two independent elements:

4. [David Hume (1711–1776), Scottish philosopher, is the author of *A Treatise of Human Nature* (1739–1740). Ed.]

reason and sensibility. This a priori derives from Kant's critical philosophy, and one could argue that Sakabe's notion of modern reason is directly related to Kant's critique of reason. This also explains the subtitle of *Risei no Fuan* (The Anxiety of Reason): "The Formation and Structure of Kant's Philosophy." Sakabe thinks "the final framework of the reason of the modern subject" is modeled on Kant's system of critical philosophy.

Here the "psychoanalysis of modern reason" begins with a comparison between the system known as critical philosophy and a psychoanalysis of a patient. The first step in psychoanalysis is the opening and containment of the substratum that escapes from under the thought and discourse of the upper stratum known as the system. Psychoanalysis begins by positing the inevitability of supposing the thing itself—the possibility for coexistence of opposite opinions, for example, in arguments and counterarguments—as well as by paying close attention to the opacity of the relationship between pure reason and practical reason. Work at this stage had already been accomplished by the German school of idealism. Sakabe himself inherited many results from this school. Nevertheless, he made the acute observation that (modern) reason based on Kant's model is a limited reason conditioned by the senses, a simple human reason. Kant only discussed such a limited reason by relying on the systematic discourse known as critical philosophy. If, however, critical philosophy is a science describing the limitations of human reason, Kant himself should have established whatever is not reason—at least he should have provided an outline shading the limitations of human reason. Sakabe then addresses such issues as the examination of the limitations of Kantian modern reason from the side of irrationalism, the study of the boundaries forming critical philosophy, and the verification of the birth of critical philosophy and the birth of modern reason.

In his psychoanalysis of modern reason Sakabe took the second step with the realization that Kantian reason, penetrating the limits of human reason, is always threatened by anxiety and the recognition that Kant's thought faced at least three major identity crises. Accordingly, Kant should have addressed these issues in a fourth style. In this second period, Sakabe directly challenged individual enunciations of critical philosophy belonging to the three moments of Kant's thought—as well as other discourses leading to the formation of critical discourse and the discourse that had become the shade of critical discourse and finally disappeared after having been pushed to the

depth of thought. Sakabe proceeds to read the critical discourse of Kant's third period in light of the discourse of Kant's second period, in which Kant learned from Rousseau[5] to respect human beings and, thanks to Hume, woke up from dogmatic slumber.

In the third step of his psychoanalysis, Sakabe verifies that the discourse of Kant's second moment, which is based on a concrete interest in human beings—in other words, the discourse of the human sciences—is not a peculiarity of the second moment only but serves as the invisible support of Kant's intellectual style and system. If the second psychoanalytical step clarified the depth structure hiding behind the philosophy of the critique of reason along a temporal axis, as the history of the development of Kant's philosophy, the third step exposes the fact that such a depth structure is the synchronic structure of Kant's thought and, accordingly, is the basic structure producing critical philosophy and the critique of reason. The in-depth discourse of the human sciences sustains the critical discourse coloring the surface of critical philosophy. In fact, Kant began work on *The Critique of Pure Reason* almost at the same time he started lecturing on the human sciences. The discourse of critical philosophy, one that Kant never used in his lectures, pierces through his formalist, abstract *écriture*. The discourse on the human sciences, which never got published until Kant's very last years, is modeled upon commonsensical, concrete language *(parole)*. We can say that the critical discourse would be hollow without reading the discourse of the human sciences between the lines. By going through the gaps between the two discourses and listening to the voice of common reason behind critical reason (which appears to the eye as words) and to the voice of common sensibility behind critical sensitivity (which can equally be seen), modern reason, as Kant shaped it, is endowed with its meaning and its boundaries. The place of Kant himself is the horizon of the human sciences—a fertile lowland of experience. Here everything is filled with a concrete touch as experiential reality and everything exists experientially. The sudden rise of the natural sciences, however, represented by Newton's physics, and the rise of materialism that pretends to follow in the footsteps of the natural sciences, and the rise of

5. [Jean-Jacques Rousseau (1712–1778) is the author of *Discours sur l'Origine et les Fondements de l'Inégalité parmi les Hommes* (Discourse on the Origin and the Principles of Inequality Between Men, 1755) and *Du Contrat Social* (The Social Contract, 1762). Ed.]

spiritualism, fatalism, and skepticism, threatens experiential certitude. Here Kant exposed the transcendental ideality of such thoughts with his critical philosophy and came up with transcendental idealism in a form that might coexist with Newton's physics at least, if one excludes the theological elements. Transcendental idealism and experiential realism—the critical discourse and the discourse of the human sciences—regulate the sphere of Kant's thought like the top and underside of a Möbius strip, making possible the discontinuous compositional changes of Kant's system. As a result, as soon as it is cut off from its point of birth, critical philosophy and (modern) reason are immediately bound to carry the shadow of anxiety.

In the fourth step of his psychoanalysis of modern reason, Sakabe verifies the roots of the anxiety that totally encloses modern reason. For the Möbius strip that Kant himself created with great effort, by combining the top and bottom of the strip into one element, suffers a split: the general tendency of modernity. The logic of apparent reason, whose path Kant himself had walked, had reached the peak of development with Hegel after Descartes and via the Enlightenment. The human reason that used to be God's property—logos or ratio, the same reason which in the Renaissance (an era that regarded man to have been made in the image of God) was nothing but a shadow of the archetypal reason of God—had now become autonomous. It was now questioning the very existence of God in whom it used to be grounded. Not only this but it also became the ground for the existence of a new kind of God. God is humanized, and man becomes God. We reach a point where man is such because he is rational. Human sensibility, once deprived of its place, is dismantled to the point of becoming nothing more than a fragment of the light known as reason, secretly enlarging the energy, the entropy of darkness from the center of the fragment of light.

Sakabe pursued the fifth and last step of his psychoanalysis in an essay, "Risei no Fuan" (The Anxiety of Reason), which differs from the book carrying the same title and itself has the subtitle "Sade and Kant." We find the basic theme of Sakabe's philosophy in his rethinking of Kantian modern reason and the rational subject by bringing them back to the horizon of the human sciences from which they were born. In this fifth step Sakabe's philosophy emerges—in other words, this step becomes an overture. Here Sakabe deals with the present age: the age of darkness from which no future can be seen. He perceives that the roots of such an anxiety—the abyss where this dark-

ness originates—are planted in the same ground of reason that is supposed to be the light guiding man. From a historical point of view, we can say that Sakabe's insight basically echoes existentialism. Structuralism proclaims that such a light was absent from the beginning, or tries to prove that it did not exist, thus attempting to sever the roots of anxiety at the base. Such a position, however, does not provide any consolation once we become prey to anxiety. For example, even if God did not exist as light, since man, as bodily existence, is a social animal, reason always exists as social order—independent of whether it is within a civil society or an underdeveloped society—and it presumes human sensibility (the way we feel). The forgetting of such a fundamental fact is the reason for the impasse that Western modern reason is encountering today.

This is not to say that (Western) modern reason is guilty. We find "original sin" in the place that has lost sight of the human sciences— the formative ground of modern reason. When reason as system, as natural law, and as social law based on natural law, hardens into a fossil, human life itself is threatened. Reason and sensibility separate, and each runs the risk of being further disjointed. Sakabe explains this situation in the fifth step of his psychoanalysis of modern reason.

Readings and Interpretations in the Philosophy of the Yamato Language

Sakabe's books and chapters dealing with the philosophy of the Yamato language penetrate the heart of the Japanese reader deeply and are truly interesting as separate publications standing on their own merit. When they are read together as a group, however, these texts assume an even greater meaning. If, moreover, we read these works in light of Sakabe's work on Kantianism, then we truly enter into the depths of Sakabe's thought and, while mastering the real nature of his speculations, we have a feeling of actually philosophizing with him as opposed to simply learning his philosophy.

Up to this point I have presented the reader with a preliminary knowledge of Sakabe's philosophy as an introductory measure. Now it is proper *(iki)* to finally examine Sakabe's original philosophy without further delay. I believe, however, that I might be allowed to bring this essay to a conclusion by touching upon *(fure)* the philosophy of the Yamato language for the reader who is not necessarily a connoisseur *(yabo)*.

The philosophy of the Yamato language—the vernacular language of premodern times—looks slightly like a linguistic divertissement, a play on words that might be difficult to fully grasp for someone whose mother tongue is not Japanese.[6] One could argue that it is similar to the work of Jacques Derrida, who is extremely fashionable among young people in Japan. Derrida's thought tends to restore meaning to words that come from Plato's idealism and, through the theological metaphysics of scholasticism, have reached contemporary French and other European languages. Derrida's enterprise begins with the serious attempt to recuperate, even if only slightly, the original moment of thought. Similarly, one can say that philosophers of the Yamato language try to restore flexibility to thought through the mediation of the local Yamato language—beginning with an examination of the meaning that has been given to Chinese characters in translations of Western works since the end of the Edo period and with the study of a culture that has been systematized by the Chinese language and hardened to the point of paralysis.

At issue here is the question of what makes readings and interpretations in the philosophy of the Yamato language "official." A flexible point of view that is not constricted by any particularly "official" version of interpretation distinguishes scholars who promote cultural pluralism. Let me offer a few suggestions with regard to the study of Sakabe's work on this issue. To begin with I would suggest reading the first and fourth chapters of Sakabe's *Kanto* (Kant), followed by *Watsuji Tetsurō*, the section on "The Philosophy of Touching" (chapters 1 to 3) in *Kagami no Naka no Nihongo* (The Japanese Language in a Mirror), and *Perusona no Shigaku* (The Poetics of Personhood). Because of the difficulties involved in interpreting *Kamen no Kaishakugaku* (The Hermeneutics of Masks), which is Sakabe's major publication, I would leave it as the last reading. A shortcut to understanding Sakabe's thought is available by consulting introductory publications such as *Gendai Shisō: Nyūmon* (Contemporary Thought: An Introduction) and its continuation (*Gendai Shisō: Nyūmon*, vol. 2), *Gendai Shisō no Kīwādo* (Key Words in Contemporary Thought), *Gendai Shisō no 109 Nin* (One Hundred and Nine Contemporary Thinkers), and *Konsaisu Nijūsseiki Shisō Jiten* (Concise Dictionary of

6. [For an example of Sakabe's "philosophy of the Yamato language" see Marra, *Modern Japanese Aesthetics*, pp. 242–251. Ed.]

Twentieth-Century Thought). I would also suggest an attentive read-
ing of Sakabe's articles related to Kant. A repeated reading of the
philosophy of the Yamato language should then allow the motivated
reader to penetrate the world of Sakabe's philosophy.

Whenever we examine Sakabe's philosophy of the Yamato lan-
guage, we must remember that for him Kantian modern reason was
not simply a foreign thing of the past. One can say that, since the
Meiji period, Japanese society, institutions, culture, and language—
everything that shapes the surface of Japanese language today—have
been translations in the Chinese script of Western languages. Just look-
ing at the bulky size of a dictionary is enough to overwhelm one—and
this influence touches upon the thought that is articulated by language
and upon people who articulate thoughts. The presence in Japan of
Kantian modern reason was there from the outset. Yet the tradition of
Western metaphysics, and the horizon of the Kantian human sciences
that gave birth to this modern reason, were originally absent from
Japan. Consequently, in the same way that critical philosophy would
be hollow if read without the presence of the Kantian human sciences,
the Japanese are repeatedly alienated from all modern institutions,
which are based on modern reason, and from Kant's critical philos-
ophy, since the Japanese lack the Japanese version of Western human
sciences. Sakabe's philosophy of the Yamato language represents
the human sciences of the Japanese people—and an effort to replace
Kant with Sakabe Megumi.

AESTHETICS
AT THE
UNIVERSITY
OF KYOTO

16

An Aesthetician from Kyoto
Nakagawa Shigeaki

KANEDA TAMIO

The *Kyoto Bijutsu Kyōkai Zasshi* (Journal of the Kyoto Art Society) resumed publication as a monthly periodical in July 1892.[1] The first issue introduced the first part of "Kōgei Bijutsu Genri Hanron" (Outline of the Principles of Applied Fine Arts), signed by Nakagawa Shigeaki (1849–1917). The article was followed by an essay titled "Seiyō Chōkokujutsu" (Western Sculpture), with the author's name given as "Kajō Sanjin." In the second issue of the same journal, we find "Bi no Kankaku" (The Sense of Beauty) by Kajō Sanjin and the second part of "Outline of the Principles of Applied Fine Arts" by Nakagawa Shigeaki. Since the author did not present "The Sense of Beauty" as either a translation or an adaptation, he did not reveal the original source. But we know that in those days Nakagawa Shigeaki was translating passages from Lemcke's *Popular Aesthetics*.[2] From Lemcke's work Nakagawa took the two notions of "aesthetic category" *(biteki hanchū)* and "emotional sphere" *(kanjō-ken)*. Although at the moment I will not examine the profound relationship between Nakagawa Shigeaki and Lemcke, let me just point out that "Kajō Sanjin" and "Nakagawa Shigeaki" are two names indicating the same person. The aesthetician from Kyoto, Nakagawa Shigeaki, contributed trans-

From Kaneda Tamio, "Kyōto no Bigakusha: Nakagawa Shigeaki," in Kaneda Tamio, *Nihon Kindai Bigaku Josetsu* (Introduction to Modern Japanese Aesthetics) (Kyoto: Hōritsu Bunka Sha, 1990), pp. 84–95.

1. [The Kyoto Art Society (Kyōto Bijutsu Kyōkai) was founded in 1890 as a counterpart of Tokyo's Japanese Art Society (Nihon Bijutsu Kyōkai). The latter was founded in Tokyo in 1887 following the renaming of the Dragon Pond Society (Ryūchikai), which became the Japanese Art Society. Ed.]

2. [Karl von Lemcke (1831–1913) is the author of *Geschichte der deutschen Dichtung neurer Zeit* (A History of Modern German Poetry, 1871), *Populäre Aesthetik* (Popular Aesthetics, 1873), and *Aesthetik in gemeinverständlichen Vortragen* (Aesthetics in Popular Terms, 1890). Ed.]

lations and essays to almost every issue of *Journal of the Kyoto Art Society* and the journal that later replaced it, *Kyōto Bijutsu* (Kyoto Art; founded in September 1905), under the pseudonyms "Nakagawa Kanjō," "Nakagawa Shimei," "Shimei Rōjin," and others. Unlike his colleagues from Tokyo, however, Nakagawa did not develop spectacular critiques of art, and he did very little in terms of direct comments on works of art. He preferred, instead, to concentrate his attention on introducing and explaining European—especially German—aesthetics in order to make a contribution to a general aesthetic education. This might be due to a lack of people with whom he could debate. Nakagawa probably used different names in order to disguise the unsavory reality that the same contributor was presenting more than one article in the same issue of a journal. The opening article in almost all issues of *Kyoto Art* was the work of Nakagawa, who from September 1905 until April 1912 introduced in each issue a problem related to aesthetics—as we can see from his titles: "Is Art Nothing but the Expression of Feelings?" (issue 1); "Reaching the Illusion of the Power of the Pen from the Essence of Aesthetic Beauty" (issue 2); "Tolstoy's Theory of Art" (issue 3); "Natural Beauty and Its Appreciation" (issue 4); "The Basic Rules of Ornamental Patterns" (issue 5); "On Landscape" (issue 6); "An Essay on Nonartistic Illusion" (issues 7–8), and so forth.

Nakagawa kept producing essays and translations until he died on May 16, 1917. Today the name of Nakagawa Shigeaki has almost disappeared from our memory despite the role he played as an enlightener in the field of aesthetics and despite his prodigious activities during his life. With the exception of Tanaka Hisao, who very recently has mentioned Shimei in connection with Takeuchi Seihō (1864–1942) in his book *Takeuchi Seihō*, no one ever talks about Nakagawa as an aesthetic theorist. The reason why I mention someone who has been so completely forgotten is that I believe Nakagawa's legacy is very important and should not be ignored.

On May 16, 1917, the Kyoto *Sunrise (Hinode Shinbun)* reported the death at age sixty-seven of "Nakagawa Shigeaki (Shimei), who was prominent in the Kansai area as an aesthetician and a haiku poet." In "Nakagawa Shimei no Tsuioku" (A Recollection of Nakagawa Shimei), Awazu Suitō (1880–1944) gave a portrait of Nakagawa's activities and achievements as a poet and remarked that Nakagawa was born in 1850 and died at the age of sixty-eight. In the book *Kyōto no Monjin: Kindai* (The Literati from Kyoto: Modern),

Kōno Hitoaki quotes Awazu Suitō's publication and the *Nihon Jinmei Daijiten* (Dictionary of Japanese Names, published by Heibonsha) and says that, according to the latter, Shimei was born in 1849 and died at sixty-nine. My account of Nakagawa's achievements as an aesthetician is based on the obituary reported in the *Sunrise,* as well as several recollections the same newspaper published a few days later.

Nakagawa Shigeaki was born on February 2, 1849, in the guards' residence of Nijō Castle in Kyoto, where he apparently studied German at the school of Yasui Sokuken. Extremely talented in languages, Nakagawa eventually became an instructor at the Kyoto German School. As an employee of Kyoto prefecture, he was entrusted with the direction of the department of physics and chemistry of the normal school, eventually becoming a teacher at the preparatory school of the University of Tokyo. In 1877, while he worked at the Kyoto prefectural office, Nakagawa translated F. Schoedler's *Das Buch der Natur* (The Book of Nature), making it into a textbook for elementary schools whose copyright went to the Kyoto prefecture, with the title *Hakubutsugaku Kaitei* (Primer of Natural History). Although the subject of his course at the preparatory school of the University of Tokyo is unclear, we cannot rule out the possibility that Nakagawa taught German to the young philosophers of early Meiji. His language skills in the late 1870s and early 1880s must have already been quite respectable. In 1886, however, the preparatory school of the University of Tokyo was dismantled, forcing Nakagawa to enter the world of journalism. With regard to the time when he first began his study of aesthetics, I will rely on the following quotation from an article that appeared in the *Sunrise:* "Nakagawa pursued the study of aesthetics after he lost his job as an instructor at the preparatory school of the University of Tokyo in 1886, and he joined the staff of *Nihon Shinbun* (Japan Newspaper). This was clearly reported by Nakagawa himself in the curriculum vitae he presented to a certain office" (May 19, 1917). Nakagawa joined the staff of *Nihon Shinbun* in 1887, but three years later he returned to Kyoto and became a journalist with the *Chūgai Denpō* (Domestic and Foreign Telegraph; later known as the Sunrise). In other words, Nakagawa became interested in German aesthetics and started his aesthetic speculations when modern Japanese aesthetics was in its infancy.

The name of Nakagawa Shigeaki began to appear frequently on the stage of aesthetics after 1892. His untiring contributions to the

monthly *Journal of the Kyoto Art Society* came at an astonishing pace. The topics of his essays were didactic in nature, focusing directly on artists and the meaning of their art. We must admit that essentially they were almost all translations from basic texts of Western art theory. The essays "Sōmoku no Bi" (The Beauty of Trees and Plants, in *Journal of the Kyoto Art Society,* no. 3) and "Kinrui no Bi" (The Beauty of the Animal Species, no. 4), which Nakagawa published in 1892, were later collected in his book *Shinbi Sōdan* (On Beauty). According to the preface of this book, Nakagawa had prepared edited translations for these articles in 1889 and 1890 when he was in Tokyo, and he had published them in the journal *Nihon* (Japan). All translations on the theme of natural beauty come from Lemcke's *Popular Aesthetics.*

Lemcke was a professor at the Polytechnicum of Aachen. Rather than being a pure theoretician of aesthetics, Lemcke was deeply interested in concrete artistic phenomena, and he took the intellectual stand of scientific positivism. In Nakagawa's privileging the interconnectedness between aesthetics and the artistic object, and in the tendency of entrusting aesthetics with the task of guiding the art world, we can see how Nakagawa Shigeaki's aesthetics depended on Lemcke's *Popular Aesthetics.* Moreover, as a journalist Nakagawa took the position of the enlightener who struggles to make the field of aesthetics relevant to artists and the general public, rather than playing the role of the scholar of aesthetics. In this sense, we should interpret Nakagawa's reception of the adjective "popular" in the title of Lemcke's work not as a disparaging term but as an attempt to popularize aesthetics. At the same time, we cannot neglect Nakagawa's interpretation of Lemcke's work along the lines of the interest that Nakagawa himself had felt for the natural sciences at the beginning of his career and, as well, for the intellectual system standing behind *Hakubutsugaku Kaitei* (Primer of Natural History). The fact that Lemcke's work as an aesthetician has been forgotten may have contributed to the ill fortune of Nakagawa's fame.

In 1894, issues 20 to 31, the *Journal of the Kyoto Art Society* published a "Critique of Japanese Painting" (Nihonga no Hyō) translated by "Kajō" and based on the work of J. Brinckmann, curator of the Hamburg Museum. Moreover, starting in 1901 and continuing for three years, a long series of "Basic Essays on Western Painting" (Seiyō Gagaku Yōron) was published as a translation by "Nakagawa Kajō." The publication of such editorials, which were meant as guides

for the education of contemporary artists, coincided with the time when Nakagawa became a part-time instructor at the Kyoto Art and Craft School (Kyōto Shi Bijutsu Kōgei Gakkō) in 1899. It was a most fitting position for someone who later became an instructor of aesthetics at the same school. In 1909, the Kyoto Municipal Art College (Kyōto Shiritsu Kaiga Senmon Gakkō) was founded. Nakai Sōtarō[3] was invited as a lecturer to teach aesthetics at that school—a position he shared with Nakagawa Shigeaki, who died while still holding that position.

After he was appointed part-time instructor at the Kyoto Art and Craft School in 1900, Nakagawa's activities became even more remarkable. One year after assuming the position, he published the volume *Shinbigaku Kaitei* (Primer of Aesthetics), which he probably used as a textbook in his course. This text was a translation of Friedrich Theodor Vischer's (1807–1887) *Beauty and Art*. As Nakagawa himself states, this text was made of lectures given by F. T. Vischer, which his son Robert Vischer (1847–1933) collected in a book. Although there is evidence that Nakagawa published four books of *Primer of Aesthetics,* he apparently was unable to complete the translation, stopping at the seventh chapter of the first part of Vischer's work. The textbook that Nakagawa used with the students of the Kyoto Art and Craft School had the subtitle *Bigaku Nyūmon* (Introduction to Aesthetics), and it must have been difficult for students to understand. In any event, the book, which was originally published in Germany in 1898, was translated into Japanese in only three years.

In 1902 Nakagawa published the first part of *Shinbi Sōdan* (On Beauty), a collection of essays dealing with what could be called concrete issues. The second part appeared half a year later. The first part was made up of essays that had appeared on and after June 1900 in the literary column of the newspaper *Sunrise*. In the preface Nakagawa mentions that "the main arguments of the book are based primarily on the work of Friedrich Vischer, an idealist theoretician of subjectivity from Germany." The book consists of thirteen short essays discussing aesthetic categories: "three types of sublime," "the comic," "on the genre of haiku pictures," "humor," "wit," and the

3. [Nakai Sōtarō (1879–1966), a graduate from the philosophy department of Tokyo Imperial University, became president of Kyōto Shiritsu Kaiga Senmon Gakkō. An expert on Japanese and Western art history, he also taught at Ritsumeikan University in Kyoto. Ed.]

like. As Nakagawa himself admitted, his work was very much indebted to theories developed by F. T. Fischer. At the same time, however, he tried to bring issues of German aesthetics to bear on the understanding of traditional Japanese aesthetic consciousness by taking his examples from haiku poetry and by quoting Japanese classics such as the *Kojiki* (Record of Ancient Matters)[4] and the *Makura no Sōshi* (The Pillow Book).[5] Nakagawa's aesthetic speculation extended to the study of specifically Japanese art forms such as "drawings by literati" *(haiga)* and "haiku prose" *(haibun)*. In other words, in addition to seeing, in Nakagawa's simple and terse statements interspersed with quotations of haiku, a tendency to apply German aesthetics to a reading of Japan's traditional aesthetic consciousness, we must also acknowledge the educational aim on the part of aesthetic thought at the time, which is implied in such a tendency. Moreover, as an extension of this approach, we observe the publication of a unique work on aesthetics by Nakagawa Shigeaki, *Heigen Zokugo Haikai Bigaku* (The Aesthetics of Haikai in Plain and Popular Words, 1906).

Like the first part, the second part of *Shinbi Sōdan* (On Beauty) comprises thirteen short essays discussing such issues as "On light," "On the blue color of the moonlight," "The seven colors of Goethe," and so forth. As Nakagawa states in the preface, he privileged issues related to natural beauty and, as a result, included theories based on early work by Lemcke such as "The Beauty of Trees and Plants" and "The Beauty of the Animal Species." But when we look at, for example, "On the Beauty of the Human Body" (Jintaibi ni Tsuite), in which Nakagawa quotes from an article on Jōchō[6] that Takamura Kōun[7] had published in the journal *Kokka* (no. 6) and in which Nakagawa reflects over the principle of the "golden section" *(goldner Schnitt)* introduced by Adolf Zeising (1810–1876),[8] we see how Nakagawa Shimei's aesthetic thought is integrated with his views on

4. [For an English translation see Donald L. Philippi, trans., *Kojiki* (Tokyo: University of Tokyo Press, 1968). Ed.]

5. [For an English translation see Ivan Morris, trans., *The Pillow Book of Sei Shōnagon*, 2 vols. (New York: Columbia University Press, 1967). Ed.]

6. [Jōchō (d. 1057) was a leading sculptor of wooden Buddhist statues. In 1053 he created the statue of Amida Nyorai for the Hōōdō of the Byōdō-in in Uji, the only fully authenticated work by him in existence. Ed.]

7. [Takamura Kōun (1852–1934) was a sculptor who led the sculpture department at the Tokyo School of Fine Arts, which was founded by Okakura Tenshin. Ed.]

8. [To cut up a whole so that the proportion between the whole and the large parts equals the proportion between the larger and smaller parts. Ed.]

art—much more than in "Jintai no Bi" (The Beauty of the Human Body), which he published as a translation of Lemcke in the *Journal of the Kyoto Art Society* (nos. 15, 16, 17, 19). Even in "The Beauty of the Animal Species" we can see Nakagawa's attitude of familiarizing the reader with European aesthetics by using quotations from Chinese poems *(kanshi)*.

In 1894 Shiga Shigetaka (1863–1927) published *Nippon Fūkei Ron* (Essay on the Japanese Landscape), which became a bestseller. In this book Shiga brought the natural sciences under discussion with the issue of natural beauty. Despite an undigested aesthetic approach in which aesthetics joins with geology and meteorology, Shiga's peculiar methodology must have stunned contemporary readers as a unique approach to the problem of natural beauty. We might say that Nakagawa Shigeaki's bulky work of the years 1904–1906, *Geiyō Dōbutsugaku* (Zoology for Artistic Purposes; three volumes), shares a unique approach with Shiga Shigetaka's study of the beauty of landscape. Here Nakagawa's knowledge of natural history, gained in the late 1870s, comes together with Lemcke's aesthetics of nature, and he stipulates objective rules for natural beauty. Undoubtedly Nakagawa compiled this book as a text for students of the Art and Craft School. At the same time, however, this was a true attempt to unite zoology and aesthetics that led to discussions of poetic forms such as Chinese poems and *haikai,* as well as the forms of animals—a true contribution to the appreciation of natural beauty.

Nakagawa Shigeaki reached the high point in his work on aesthetics with the book *The Aesthetics of Haikai*. The book's cover records the title as *Heigen Zokugo Haikai Bigaku* (The Aesthetics of Haikai in Plain and Popular Words) and gives the author's name as Shōjizaian Shimei. As the author himself states, this is a theoretical work on aesthetics, a brief introduction to basic concepts in the field of aesthetics. The title, *The Aesthetics of Haikai,* is followed by the expression *"in Plain and Popular Words,"* which positively incorporates the implicit goal of both Lemcke's popular tone and Fischer's design to write a simple aesthetics for the people. The author states that the meaning of *The Aesthetics of Haikai* was "to produce a kind of aesthetics by helping with phonetic transcription the reading of the complexities of haiku" ("Introductory Remarks"). We count more than five hundred quotations that Nakagawa took from haiku, starting from those by Matsuo Bashō (1644–1694) and Yosa Buson (1716–1783). Moreover, Nakagawa states that "although I mentioned as

reference material works by German scholars such as the aesthetics of illusion by Konrad Lange[9] and the pure aesthetic conceptualizations of Stefan von Czobel,[10] the present work is simply an outline of beauty." The book consists of ten chapters covering theories on "the senses," "the beauty of form," "the beauty of essence," "the beauty of mutual sympathy," and the like, as well as essays on the aesthetic categories of "ugliness," "sublime," "tragic," "comic," and so on. Nakagawa follows a very personal methodology that is sustained by German aesthetics, especially works by Lemcke, Fischer, Hartmann, and Lange. In this book, however, Nakagawa does not simply introduce European aesthetics. Despite his modest remarks, he reflects upon issues of Japan's traditional arts and evinces his aim to clarify *haikai* from the point of view of aesthetics. In other words, he does not simply use haiku poems as examples cited in order to talk about aesthetic principles. Instead, Nakagawa aims at clarifying aesthetically the meaning of haiku by dealing with basic issues of aesthetics that he himself experienced in his acquaintance with haiku.

With regard to the issue of "ugliness" in aesthetic categories, Nakagawa argues that "among artists, poets are those who deal mostly with ugliness, while sculptors are the least inclined to do so" (*The Aesthetics of Haikai,* p. 3). Moreover: "In poetry, our *haikai* has a particular tendency to use ugliness from a variety of points of view or, it would be more correct to say, *haikai* actually has a predilection for ugliness" (ibid.). He quotes Bashō's verse, "Plagued by fleas and lice / I hear the horses staling — / What a place to sleep,"[11] and he argues that a characteristic of *haikai* is its plebeian tone made of plain and vulgar gossip. With regard to "*haikai* and the tragic," Nakagawa mentions the principle of "crisis resolution," finding an illustration in a verse by Kubutsu:[12] "Scattering time / Is floating time: / Lotus flower." Moreover, he states: "What we call the religious point of view deriving from the principle of rise and fall, and the view of

9. [Konrad Lange (1855–1921) followed the methods of psychology in *Das Wesen der Kunst* (The Essence of Art, 1901) and argued that aesthetic pleasure is an illusion of "conscious self-deception" *(bewusste Selbst-täuschung).* Ed.]

10. [Stefan von Czobel is the author of *Gesetze der geistigen Entwicklung* (Laws of Spiritual Development, 1907). Ed.]

11. [The translation is by Donald Keene, *Anthology of Japanese Literature: Earliest Era to Mid-Nineteenth Century* (New York: Grove Press, 1955), p. 370. Ed.]

12. [Beside being a well-known haiku poet, Kubutsu (1875–1943) became the twenty-third patriarch of the Higashi Honganji temple. Ed.]

bleached bones, must carry a sense of sorrow toward nature" (ibid., p. 204). And he says, what we call *wabi* and *sabi* "after all, are feelings that are born from a sorrowful view of life and from a religious outlook" (ibid., p. 203). Only "possession of such a religious point of view and view of life lead to a first understanding of the mood deriving from Bashō's verses, especially 'The ancient pond,' which everybody should know" (ibid., p. 204).[13] In other words, Nakagawa emphasizes that the tragic which is found in *haikai* is different from the tragic elements accompanying vehement crises in the West, since "the former derives from a view of life pointed toward nature" (ibid., p. 186). "Tragic beauty" he defines as "the smashing beauty of the jewel," reserving to comic beauty the image of a life of ease and inactivity. *Haikai* is strictly related to comic beauty. The comic derives from corrupt ugliness; the tragic is the product of the sublime. *Haikai*, which is basically grounded in vulgarity, can easily be linked to the comic rather than the sublime. Nakagawa analyzes the structure of "common humor" by quoting Buson's verse: "Learning / Is a firefly / Escaping from the buttocks" (ibid., p. 207). To summarize Nakagawa Shigeaki's views on *haikai*, we could rely on the following statement: "*Haikai* is a portrait of society, a picture of the floating world. If we call sublime the solemn beauty that we find in poems in Chinese *(kanshi)*, and grace the refined beauty that we find in *waka*, in *haikai*, whose characteristics are laughter and ugliness, we will not find much beauty. Even when we say 'ugliness,' it is not absolute ugliness. There is no sense of fear, only the presence of something that easily changes into humor" (ibid., p. 143).

Detailed discussions of the aesthetic category of *kokkei* (comic) were usually elicited by an analysis of the nature of *haikai*. The Japanese expression *"ujō kokkei"* (living comic) appeared as a translation of the word "humor" in Takayama Chogyū's *Kinsei Bigaku* (Modern Aesthetics) and in Mori Ōgai's *Shinbi Kōryō* (Outline of Aesthetics). It is curious to note that in Shimei's *Aesthetics of Haikai*, a title that was followed by the expression, *"in Plain and Popular Words,"* we find several crabbed expressions by Ōgai which Takayama attacked. In his translation of the word "parody," for example, Nakagawa follows both Ōgai and Takayama's use of the Japanese expression *"kan'i."* With regard to caricature, Nakagawa employs Ōgai's *"sadai"*

13. ["The ancient pond / A frog jumps in, / The sound of the water." Ed.]

(to make something big) rather than Takayama's *"kochō"* (exaggeration). Nakagawa's use of the word *"yōsan"* (to praise the sun) for "irony" is the same as Ōgai's. Although there is no question that Nakagawa read *Outline of Aesthetics,* whose style is quite cramped despite Ōgai's superb mastery of the Chinese language, it is unclear whether Nakagawa was unable to find adequate terms for translation or whether he simply paid homage to Ōgai's translations. Although Ōgai's *Outline of Aesthetics,* published in 1899, was a monumental presence in the history of modern Japanese aesthetics, it is hard to believe that people in those days could easily understand it. In an essay written to remember Nakagawa Shigeaki, we read the following statement: "It was very cynical of Master Shimei to say that no matter how many times he read Hartmann's *Aesthetics* in Ōmura Seigai's translation, he was unable to understand anything and thought the original text was considerably clearer than the translation" (*Sunrise,* May 18, 1917). Compared to *Outline of Aesthetics,* which was a direct importation of German aesthetics through the medium of the Chinese language, Nakagawa Shigeaki's *Aesthetics of Haikai* was most probably much better known—thanks to the author's efforts to insert European aesthetics into Japan's traditional thought on the arts. This makes us think of Nakagawa's relationship with Kyoto's painting circles and the strong presence of a pervasive taste for *haikai* in society at large. This context explains the large number of editions *The Aesthetics of Haikai* enjoyed.

Originally published in March 1906, the book was reprinted four months later and reached the third printing in May 1912. The publication and republication of *Aesthetics of Haikai* had a social impact similar to the sale in 1899 of Takayama Chogyū's *Modern Aesthetics.* We must keep in mind, however, that while Chogyū's work was a specialized publication in aesthetics, Nakagawa Shigeaki's *Aesthetics of Haikai* concerned itself with haiku and was targeted to the general reader interested in receiving an aesthetic education. It was an odd destiny—for a book that had such a strong pedagogical influence on the bearers of Japanese culture at the time—to be forgotten without a second thought. This might be due to the fact that the turn of the century had already witnessed the beginning of systematic scholarly research in Western aesthetics. As a result, scholarly works in the field had already gone well beyond the review-like attitude of Nakagawa's *Aesthetics of Haikai.* By the end of the Meiji period, the figure of the enlightenment aesthetician was already disappearing.

Following the positive reception of *The Aesthetics of Haikai*, in 1911 Nakagawa published *Keiji Shin'in Shokuhai Bigaku* (The Aesthetics of Formal Elegance), which appeared with the subtitle *Ichimei Shin Haikai Bigaku* (The New Aesthetics of Haikai). Nakagawa explained the meaning of the title in the first chapter, "Enticement," as follows: "I have already explained the notions of 'distance' and 'sameness' with regard to *haikai*. Now I am going to add a reading of Lange's aesthetics of illusion, whose main gist is nothing but the notion of 'no separation, no sameness'" (*Aesthetics of Formal Elegance*, p. 2). The reference to the principle of "no separation, no sameness" derives from a principle of *haikai* that Bashō had discussed centuries earlier. Namely, it is based on a passage from *Bashō Igo* (Last Words of Bashō),[14] which reads: "In general, *haikai* should not be separated from the previous verse; and yet, while being separated, it looks as if it were not." Here we see Nakagawa's basic attitude in aiming to unify European aesthetics and traditional Japanese thought on the arts. We might also say that a tendency had emerged: the tendency to approach all forms of Japanese art from the point of view of European aesthetics and regard them as objects of aesthetic speculation. By this time, moreover, the aesthetics which until then had been the object of simple importation from Europe had finally begun to take root in the soil of modern Japanese aesthetics.

While discussing essays by Takayama Chogyū, Matsumoto Matatarō (1865–1943), and Kuwaki Gen'yoku (1874–1946)—as well as Ōtsuka Yasuji's "Shi no Bi Ishiki" (The Aesthetic Consciousness of Death) and other contemporary Japanese works on aesthetics—*The Aesthetics of Formal Elegance* was deeply indebted to "the aesthetics of illusion" of Konrad Lange (*Das Wesen der Kunst*, 2 vols.) with regard to its basic structure and content. Nakagawa discusses Lange's distinction between unconscious and conscious illusions and his tripartition of aesthetic beauty as an example of conscious illusion. Nakagawa mentions (1) the illusion of forms, (2) the illusion of elegance, and (3) the illusion of the movement of life, corresponding to what Lange calls, in *The Essence of Art*, (1) the illusion of contemplation, (2) the illusion of feeling or mood, and (3) the illusion of movement. The phrase accompanying the title of Nakagawa's *Aes-*

14. [*Bashō Igo* is attributed to Shūkyo, whose postscript to the work records the year 1811. Ed.]

thetics, "of formal elegance," was rooted in Lange's classification and was widely circulated in the art world at that time. The book consists of four chapters dealing with the tripartite division of illusions, to which are added three chapters on "The Illusion of Non-Art," "An Essay on Semi-Art," and "The Contemplation of Nature." In addition to *haikai,* Nakagawa examined all sorts of arts, including painting, sculpture, music, and architecture, expanding the debates on the past and the present, or East and West, and thus showing a stunningly wide knowledge. At the root of his arguments, however, remains an aesthetic speculation that is deeply grounded in the author's experience of *haikai.* In other words, we must say that *The Aesthetics of Formal Elegance* is rooted in a desire to give an aesthetic explanation of the essence of *haikai* which is centered in the experience of nature and, as well, the desire to develop an aesthetic which searches for the principles of "separation and sameness in nature." This attitude explains the subtitle of the book, *The New Aesthetics of Haikai,* despite its much more varied content focusing on the phenomenon of art. One might even say that the standpoint of Konrad Lange's aesthetics of illusion was nothing but a method or a device for Nakagawa's description of his own views on the arts. This attests to how widely European aesthetics had spread among Japanese intellectuals by the end of the Meiji period.

From the "Author's Preface" to *Aesthetics of Formal Elegance* we can glimpse Nakagawa's confidence in the publication of this book: "No matter which theory we should follow in our debates on artistic beauty, when we ask whether the principle of 'no separation, no sameness' is indeed the essence of artistic beauty, or whether, as I say, we can logically argue about the two being one, and the one being two, at the root of the matter we shall always find the embryo of separation and sameness." As a result, Nakagawa argues that the principle of separation and sameness clarifies "the triangular alliance of nature, the work of art, and the artist or appreciator" and connotes the relationship between the "ever-changing" *(ryūkō)* and "unchanging" *(fueki)* in *haikai* ("Author's Preface"). We witness the consolidation of the field of modern Japanese aesthetics at the end of the Meiji period while the process of assimilating Western aesthetics was still going on. At that time, modern scholarly research had already started in Japan. Nakagawa Shigeaki visited Matsumoto Matatarō's residence at Hyakumanben in Kyoto, bringing with him a manuscript of the book in order to ask Matsumoto for his opinion. In his intro-

ductory remarks, Nakagawa reports the answer he received from Matsumoto. Nakagawa recounts that "later I received a letter from him stating: 'I have read with great interest the whole *Aesthetics of Formal Elegance* and I was truly delighted by your explanation of many arts in light of the principles of separation and sameness. I was particularly pleased by the great attention you pay to the Japanese arts.' Although I certainly did not achieve what Matsumoto says I actually did, the thought of having acquired a friend fills me with the desire to express my deepest gratitude to him." Aside from the content of Matsumoto Matataro's letter, Nakagawa could not avoid thanking Matsumoto, since the letter came from someone who was a professor at Kyoto Imperial University and, at the same time, president of the Kyoto Municipal Art College. Matsumoto, who specialized in psychology, played a major role in creating the Chair of Aesthetics and Art History at Kyoto Imperial University. Scholarly research in the field developed in Kyoto in the mid-1910s mainly around the university. In this respect one could say that Nakagawa Shigeaki was the last "enlightener aesthetician" of the previous generation.

We cannot say that in late Meiji there were no works on aesthetics until Abe Jirō (1883–1959) published his *Bigaku* (Aesthetics).[15] In order for serious research in aesthetics to begin, knowledge about the field had to become rooted among intellectuals in general. We can certainly count Nakagawa Shigeaki among those who laid the foundations of the field. Therefore, rather than consigning him to oblivion, we should remember Nakagawa for his role as a developer of modern Japanese aesthetics. My aim in talking about Nakagawa's aesthetics has been to fill a blank in the history of the field in late Meiji.

15. [See Chapter 13. Ed.]

17

The Thought and Times
of Fukada Yasukazu

Yoshioka Kenjirō

Fukada Yasukazu (1878–1928) died just after his fiftieth birthday. The writer Natsume Sōseki (1867–1916) died at the same age. When we consider that the average life span of the Japanese prior to World War II was a little over forty, we cannot say the life of these writers was brief. Rather, we should marvel at the impressive amount of work that people who died at fifty were actually able to accomplish in those times.

In Fukada's case, however, although he produced a large number of essays, he did not leave a single monograph. After his death, Fukada's disciples collected all the articles he had published in scholarly journals—from the time he returned to Japan in October 1910 after a three-year period of study in Europe (and was appointed, at age thirty-two, full professor at Kyoto Imperial University, Faculty of Letters, or Kyōto Teikoku Daigaku Bunka Daigaku, where he was entrusted with courses in the history of aesthetics and art) until his death in November 1928. Fukada's works appeared between 1930 and 1931 in *Fukada Yasukazu Zenshū* (Collected Works of Fukada Yasukazu), and they were published by Iwanami. Almost his entire production found its way into this collection. Since no reprints of this work appeared after the initial date of publication, however, the name of Fukada has remained relatively unknown.[1] With respect to the fact that none of his books appeared during his lifetime, Fukada resembles his senior colleague Ōtsuka Yasuji,[2] who taught aesthetics at the University of Tokyo until 1929 and was a good friend of

From Yoshioka Kenjirō, "Fukada Yasukazu no Shisō to Sono Jidai," in *Fukada Yasukazu, Bi to Geijutsu no Riron* (Theories of Beauty and Art) (Tokyo: Hakuōsha, 1971), pp. 349–372.

1. [In fact, Fukada's *Opera Omnia* was reprinted in 1973–1974 by Tamagawa University Press (Tamagawa Daigaku Shuppankyoku). Ed.]

2. [See Chapter 9. Ed.]

Natsume Sōseki. Ōtsuka's works, too, were collected by his disciples after his death and were brought out by the same publisher, Iwanami, in two volumes: *Ōtsuka Hakase Kōgi Shū* (Collected Lectures of Dr. Ōtsuka).

It comes as a surprise that Ōtsuka and Fukada—the founders of the study of aesthetics in Japan—did not publish a single book. When we look at the matter from a contemporary standpoint, however, we can consider this event the result of a scholarly conscience that was shared equally by these two scholars. In Fukada Yasukazu's case, we might also want to advance the hypothesis of an extremely introspective nature. Both he and Ōtsuka devoted themselves to achieving a correct understanding of Western aesthetic thought and introducing this thought to Japan. Rather than proclaiming loudly the fashionable trends of new thought and new arts from other countries, they preferred to build in Japan the spiritual climate that would lead to a serious and comprehensive speculation on issues of beauty and art.

As is well known, from the time of the Meiji Restoration the Japanese people looked at Europe and the United States as advanced countries and struggled to assimilate Western civilization—a process that became the policy of the whole nation. Japanese culture, which had evolved under the policies of the closed country advocated by the Tokugawa regime, was in its own way a refined culture whose unique elegance scholars such as Lafcadio Hearn (1850–1904) and Raphael von Koeber (1848–1923, the teacher of Fukada) pointed out in a sympathetic manner. For people who had lived in a culture characterized by a sense of distinctiveness and organic unity, the gap between spirit and form was hardly felt. The Japanese of the Meiji period, however, experienced an inevitable fragmentation resulting from contact with a totally alien culture.

The world was renewing itself daily, thanks to technologies learned from developed countries, leading to the rejection of earlier social systems. Before Japan had enough time to become familiar with change, new forms were imported again. Despite the Japanese ability to adapt, it was impossible to respond to all the new and unrelated phenomena. Although it was possible to make sense of these changes rationally, it was hard for the heart to come to an accommodation since, as a rule, the heart does not easily change overnight. As a result, a disharmony was created between content and form among the Japanese of the Meiji period—shattering the inner consistency of life. Mori Ōgai (1862–1922) compared Japan's enlightenment process to the con-

fusion of a building under construction. Natsume Sōseki saw it as a superficial opening forced upon Japan from the outside. When we think of culture as an issue of inner values, then we realize that Japan after the Meiji Restoration lacked a sense of harmony. Despite the energy of the times, there was no settling down. A roughness marks that age. Since people who looked at the external world with calm rationality (like Ōgai, who took up the medical profession) pursued aesthetic emotions within a context of reason, a healing of the fracture between content and form, inner and outer, became possible. For people like Sōseki, however, it was difficult to take the path of reconciliation. We still feel in our heart an echo of the words that Sōseki pronounced with regard to the enlightenment of Japan.

Sōseki argued that a world perfectly fitting our hearts is not something we can borrow from outside. In other words, it must be a world that we ourselves build while making strenuous efforts and giving ourselves enough time. Instead, after the Meiji Restoration, we have worked on the importation of foreign technologies and systems as well as thoughts, sciences, and arts. We did not care whether these novelties were suited to us or not. We were unconcerned with the fact that we did not have enough time to even reflect upon this issue. This blind energy was somehow the driving force for the construction, at least superficial, of the first modern nation in Asia. The reverse side of this process, however, indicates the great losses that came with it. The organic unity of our native culture and life was shattered, and this process grew to the point of inviting upon us inner confusion. Once we realize that we brought upon ourselves such a vulgarity—and once we start contemplating this loss with composure, searching for a new unity between content and form—a new spiritual vitality will emerge in modern Japan.

To this day many readers love Sōseki because he did not hold a position of authority, like Ōgai, nor did he live in obscurity, despite his critical spirit, like Nagai Kafū (1879–1959). He spent his entire life trying to fulfill the responsibilities of the age in which he lived. If you will allow me an aside, I would like to refer to a lecture, "Gendai Nihon no Kaika" (The Enlightenment of Contemporary Japan), which Sōseki gave in Wakayama in 1911 under the auspices of the publisher of the *Ōsaka Asahi Shinbun* (Osaka Morning Sun). Sōseki explained the differences between the general definition of enlightenment and Japan's alleged enlightenment during the Meiji period—namely, while Western enlightenment was a movement produced from the

inside, the Japanese counterpart had been forced from the outside. In other words, Japan's enlightenment did not follow the natural process of a flower's bloom in which the buds crack open and the petals turn outward. Instead, it was forced to take a specific shape by a power that imposed itself from the outside, so that it had to adapt itself willy-nilly to an external command. This did not happen only on the occasion of enlightenment. We cannot say that everything went back to normal after enlightenment was forced on Japan. We have been pushed around time and time again up to the present day, and I wonder how many more years—perhaps forever?—we will be forced in this manner. Whereas enlightenment abroad first matured in one shape and then, after the decay of this shape, gradually took on another form, in Japan the plate was taken away, even before we had completed our meal, and a new plate was given to us. Inevitably peoples who are under the influence of the latter kind of enlightenment must feel a sense of emptiness as well as some dissatisfaction and a great deal of anxiety. This self-complacency—this pretending that the present enlightenment is a process internal to the country—is not good. It is a lie. It is also a frivolity. And yet the feeling that we are obliged to do so makes the Japanese a truly pitiable people. . . . I should not need to remind readers that Sōseki's words did not come from the point of view of a bystander who was alien to the process described. To use his own words, Japan's enlightenment was superficial—and the country's inability to stop it on account of its being bad was truly painful to witness. Sōseki argued that he was skating on thin ice while suppressing his tears.

As a young man, Sōseki became familiar with Chinese poetry and writings in Chinese (kanbun) and explored the worlds of the Southern school of Chinese painting (nanga) and haiku. While always treating these pursuits as his spiritual home, Sōseki also undertook the study of Western arts, especially English, and the cultural roots that produced such arts. In other words, while longing for the world of ancient Japan, which was rooted deeply in his heart, he applied his intellect to the study of Western arts. This fracture was an issue that the Japanese after Meiji could not escape from feeling to some degree. In a general sense, we could speak in terms of a crisis between the value system that had sustained Japanese culture in an earlier age and the new set of values that developed during the Meiji period. Several systems and institutions were modeled after the West, so that it actually became impossible for Japan to maintain a respect for tradition.

The relationship between content and form constitutes an insepara-ble combination from the start. By coming into contact day and night with an external form, the content is gradually absorbed and assim-ilated into the content that has produced such forms. If one stub-bornly protects old contents, however, it will be impossible to accept the new form at all. Since art and beauty are actually the transfor-mation of content into form, and since both are the intuitive read-ing of content in form, we found it difficult to create beauty and art when content and form were fragmented. At the same time, we must remember that art feels tension in its effort to bring together content and form and that it comes to life as existence.

Culture is not something that can be imported. Culture is a har-monic whole that is born of itself out of everyone's effort to pursue values. Contacts between heterogeneous cultures are not simply clashes of material forces; they are clashes of the spirits forming those cultures. The greatness of Ōgai and Sōseki does not lie in a return to ancient Japan; nor does it lie in developing manias for the West. I believe that their greatness is found in their search for a new meeting point of content and form within the clashes between two uncom-promising cultures. Among those who suffered this fragmentation and experienced it firsthand in the scholarly world of beauty and art were Ōtsuka Yasuji and Fukada Yasukazu.

In Sōseki's *Wagahai wa Neko de Aru* (I Am a Cat), an aesthetician appears by the name of Waverhouse.[3] We cannot prove that Waver-house was modeled exactly after Ōtsuka. The friendship between Ōtsuka and Sōseki, however, is a proven fact. Moreover, as a student at the University of Tokyo, Fukada was a younger colleague of Ōtsuka, ten years younger than him. It is not yet clear when exactly Fukada Yasukazu and Natsume Sōseki had their first meeting. But from a letter Sōseki sent to Fukada, dated August 12, 1906, we can guess that their association predates that time. The year 1906 was when Sōseki published *Kusamakura* (The Three-Cornered World). Based on a letter from Sōseki to Fukada, dated September 5, 1906, we know that Fukada had sent Sōseki a detailed description of his impressions of Sōseki's book.

In the letter of August 12, Sōseki reports that he had completed

3. [This translation of "Meitei Sensei" (Professor Meitei) appears in Natsume Sōseki, *I Am a Cat,* trans. Aiko Itō and Graeme Wilson (Rutland: Tuttle, 1972–1986), vol. 1, p. 69. Ed.]

The Three-Cornered World three days earlier in a period of fifteen or sixteen days. He also says: "I hope that you will take a look at it, since in this book I expressed some of my views on art and of my philosophy of life." Not only did Fukada read *The Three-Cornered World;* as we can see from Sōseki's letter of September 5, Fukada considered this work a masterpiece and conveyed his impressions to Sōseki. Despite its length, I will quote from Sōseki's letter to Fukada:

> Thank you very much for your letter. I cannot tell you enough how deeply moved I was to receive your kind remarks on my *Three-Cornered World.* In your comments your words of praise are certainly unfit to describe my poor work and yet, by knowing that they do not come from an insincere scholar who wants to please me and oblige me like an elder brother trying to be polite, I have paid great attention to your words and am deeply grateful to you. Actually, I was so happy that I read your letter twice. To tell you the truth, I never thought the book was as much a masterpiece as you say. Although I was unable to achieve in the book what you say I did, in truth that at least was my intention. Please, let me know in the future all your thoughts, good and bad, without restraint. . . . You address me as Professor. Although I am much obliged, from now on I would like you to address me as an absolute equal. I have no doubts that your knowledge by far surpasses mine—first of all in philosophy and then, of course, in German, and many other disciplines. I am simply older than you. To be called Professor only on account of age somehow makes me feel ill at ease. . . . I wrote all this in order to thank you. I shall defer further details to the time when we meet.

In a letter of September 6 to Morita Yonematsu,[4] Sōseki stated as follows: "Many comments on *The Three-Cornered World* have come, right up to today, from many people. Every time one arrives I read it with joy. . . . The longest and most serious comment came from Professor Fukada Yasukazu." We understand from letters written on the fifth and sixth how pleased Sōseki was to read Fukada's remarks. We feel the warmth of this exchange between two giants of the Meiji period.

Among the shorter pieces of Sōseki there is an essay titled "Kēberu Sensei" (Professor Koeber) in which Sōseki describes a visit that he paid, together with Abe Yoshishige,[5] to the house of Dr. von Koeber

4. [Also known as Morita Sōhei (1881–1949), as a writer he enjoyed the patronage of Sōseki. Ed.]

5. [Abe Yoshishige (1883–1966) studied philosophy, especially Spinoza and Kant, at the University of Tokyo and distinguished himself as a critic and essayist. Ed.]

(located in present-day 2–3 Surugadai, Chiyoda-ku, where the Franco-Japanese Institute now stands). In another essay, "Kēberu Sensei no Kokubetsu" (Farewell to Professor Koeber, 1914), Sōseki talks about von Koeber's departure from Japan. Dr. von Koeber was unable to leave Yokohama because of the outbreak of World War I. He died in Japan on June 14, 1923, and was buried in the foreign section of the Zōshigaya cemetery in Tokyo.[6]

When Sōseki entered graduate school in 1893, he attended the lectures of Dr. von Koeber. Fukada Yasukazu was von Koeber's favorite disciple. He lived in his teacher's house for five years after his graduation until he left for Europe as a foreign student. Von Koeber is known to readers in Japan thanks to *Kēberu Hakase Shōhin Shū* (Collection of Dr. Koeber's Shorter Pieces, 1919) published by Iwanami. A Russian of German descent, he completed his studies of music at Moscow Conservatory and then left for Germany, where he studied philosophy and literature at the universities of Jena and Heidelberg. He was granted a doctorate in philosophy in 1882 at age thirty-four. Once von Koeber arrived in Japan in June 1893, upon the invitation of Tokyo Imperial University, Sōseki became one of his first auditors, as Sōseki himself has stated. All accounts of Dr. von Koeber's character agree in portraying him as quiet but warm. When we read the piece titled "Tsuioku" (Recollection), which Fukada wrote when von Koeber died in August 1923, we are impressed by Fukada's devotion and respect for his teacher.

When Fukada entered the department of philosophy at the University of Tokyo in 1899, Ōtsuka Yasuji was still abroad. A short while after his matriculation at the university, Fukada was already visiting the private residence of von Koeber and seeing him personally. Eventually, after graduation, he lived on the second floor of his teacher's house. Fukada's skills in foreign languages, German, English, French, Greek, and Latin, are well known. This was certainly the result of von Koeber's guidance, as Fukada himself recognized. Despite his deep affection and respect for von Koeber, however, Fukada followed his own scholarly path to the point where we see him deviating from his teacher. Fukada expressed his mixed feelings at the time:

6. [In the same cemetery are buried Natsume Sōseki, Lafcadio Hearn, and Shimamura Hōgetsu. Ed.]

Professor von Koeber often told me, "Maybe you will leave me; yes, you'll leave me; but I will never leave you." To be truthful, I cannot say that I did not try either consciously or unconsciously to part from him. There was a time when I thought I should consider myself an apostate and, therefore, suffer the pain. The Professor, however, never withdrew from me. I feel this particularly strongly now. So far I have spent exactly half of my life together with him. I might have lived next to him or far away from him, and yet I always lived with him. I always lived only in him. I only wish I could have told this to him in person when he slept the final sleep. ("Recollection")

As a rule, Fukada Yasukazu did not express his emotions in his writings. This might be the result of his nature or the result of the education he received as an offspring of a samurai family in the Meiji period. And yet we feel the depth of his sadness for the loss of Professor von Koeber surpassing any restraint. In the same "Recollection" Fukada talks about keeping watch over an ailing von Koeber and tells of his sadness when he confessed to his teacher, who thought Fukada had read all his essays, that he had actually missed some of them, thus causing regret in von Koeber's heart:

I could not do anything but admit honestly that I had not read that passage. It was a particularly difficult moment for me to make such a confession. I wanted to demonstrate that I belonged to him at least by expressing my knowledge of every page he had ever written. His response hurt me deeply. "It is regrettable. Even you are not my reader, although I write for you all. I am my only reader . . . besides, maybe, the translator."—I returned to Kyoto and, while thinking of his state of health, his words kept coming back to me. Then I read all his essays again from the beginning. Though I never had a chance to tell him in person.

Apparently Fukada read *Amiel's Diary* on the recommendation of von Koeber. Fukada wrote an essay on Amiel,[7] in which he quoted from the diary's entry of September 20, 1866, and then says:

When I read this passage, all alone deep in the night, I am taken by the spirit of Amiel expressing without embellishment the results of his dissection of the self, and I examine my own heart. This passage is also important because it explains to us why a person with so much talent was unable to leave anything behind while he was alive. It would be impossible not to be deeply touched by his confession.

7. [Henri-Frédéric Amiel (1821–1881) was a Swiss philosopher who taught at the University of Geneva. Ed.]

Amiel lectured on aesthetics at the University of Geneva. His feelings were exactly Fukada's feelings. As I have mentioned, Fukada did not leave behind one single monograph.

We should ask why such excellent talents as Ōtsuka Yasuji and Fukada Yasukazu did not write a book. One reason might be that in 1900, when Ōtsuka was appointed professor in the department of aesthetics at Tokyo Imperial University, aesthetic thought in Japan had entered a moment of great reflection—a period of rethinking that started from basic speculations concerning the goals of aesthetics. In Japan there was no shortage of speculation on beauty and the arts. There were many examples of poetic treatises *(karon)* and essays on the arts that equaled in quality Western views on art. Despite the deep commitment the Japanese had made to beauty and the arts, the logic that was followed in those writings was not strongly convincing, and no major effort was made to construct anything intellectually solid. Western modernity started with an act of human self-awareness that led to the conflictual dualism of a subject observing the world and an object being observed. The subject came to assume the form of one's possession of the self as positive knowledge, grounded in observation of the object's laws and experimentation. We cannot say that the Japanese necessarily lacked the notion of self-consciousness. We must acknowledge, however, that this was never structured in the form of logic. Neither was it perfected into a method with which to grasp the world. From the works of a Leonardo da Vinci (1452–1519) and an Albrecht Dürer (1471–1528) we can surmise the efforts of modern Western artists to create an individual art based on a firm theory and prove that art is a science aimed at the knowledge of nature. It is no exaggeration to say that the artists of the Renaissance paved the way to Western modern science.

When the Japanese came into contact with Western civilization at the end of the shogunate, they took it to be novel knowledge and a useful tool. While trying to make it their own, few among them realized that the West's perspective on the world was completely different from the one held in Japan. When the painter Takahashi Yūichi (1828–1894), looking for an intermediary, entered the group of Kawakami Tōgai (1827–1881), head of the painting department at the School of Western Studies in Edo, his learning of Western techniques in painting was not simply a search for new drawing techniques. Takahashi marveled at the new ways of looking at the world. Although Kawakami Tōgai had absorbed the techniques of Western painting as

knowledge, his artistic feelings found full satisfaction in the world of the Southern school of Chinese painting *(nanga)*. Accordingly, in a sense, we can say that intellect and emotions were cut asunder. For Takahashi Yūichi, however, Western painting was truly compelling and also a kind of taste (mood). In other words, Western painting was for Takahashi not a simple issue of technique but an art that involved the whole personality. He thought that an accurate portrait is an accurate observation of the object and that a realistic portrait produces artistic value. Although art and reality are different, the view that artistic truth first comes to life when grounded in the faithful observation of reality is different from seeing art from the beginning as a representation of things by the imagination and the entertainment of the heart away from the present vulgar world. Takahashi Yūichi must have understood intuitively that, in the world of art, content and form are one. He knew well that art was not simply an issue of knowledge. At the same time, we must remember that at the start of the Meiji period, Western art and thought came into Japan as forms of knowledge.

Until the Meiji period, we Japanese did not know the word "aesthetics" *(bigaku)* and never studied beauty as a scholarly subject. Not only the word "aesthetics" but also "art" *(geijutsu)* is a product of Meiji. Nowadays by "art" we mean paintings, sculpture, architecture, music, the literary arts, dance, film, and such. In a certain sense, art is the act of making real aesthetic values, and it also indicates the epitomization of the works that are produced in the process. Such general use of the word *"geijutsu"* was standardized in the mid-Meiji period. During the Edo period, *"geijutsu"* referred to the military arts and to miscellaneous accomplishments. In other words, together with the Meiji enlightenment, the Japanese gradually became aware that in Western countries the term "art" indicated painting, sculpture, and the literary arts—and that people involved in these activities were respected socially, their works were collected together, and they were shown to everybody independent of the social status of the observers. Moreover, when they imported Western sciences, the Japanese also understood that in the West there was a science known as "aesthetics" *(esutetikku, bigaku)* that aimed at clarifying beauty.

In *Hyakuichi Shinron* (New Theory of the Hundred and One) and in *Hyakugaku Renkan* (Encyclopedia), Nishi Amane (1829–1897), who introduced Western philosophy to Japan and played a major role as an enlightener, translated the word "aesthetics" with the com-

pounds *"zenbigaku"* (the science of good and beauty) and *"kashuron"* (the discipline of good taste).[8] In the notes for a lecture he delivered around 1872, Amane used the expression *bimyōgaku* (the science of the beautiful and mysterious). Moreover, in 1883 Nakae Chōmin (1847–1901) translated and published under the auspices of the Ministry of Education the instructional aesthetics of the French Eugène Véron (1825–1889) with the title *Ishi Bigaku* (The Aesthetics of Mr. V.). This is considered the first instance in which *"bigaku"* was used to translate the word "aesthetics." This expression did not become standardized, however, until the turn of the century. Even Ōgai, who in the late 1890s introduced the aesthetic thought of Eduard von Hartmann (1842–1906) in the journal *Shigarami Zōshi*, did not use the word *"bigaku."* Instead he employed the expression *shinbiron* (theory of the judgment of beauty). Ōgai began introducing Hartmann in 1892. In the late 1890s, Ōnishi Hajime (1864–1900) and Shimamura Hōgetsu (1871–1918) began publishing articles on aesthetics; a history of aesthetic thought by Raphael von Koeber (1848–1923), mentioned earlier in this essay, appeared in English in 1896.

In 1899 Takayama Chogyū (1871–1902) published his *Kinsei Bigaku* (Modern Aesthetics). Although there is no need for me to mention here the history of aesthetics in the Meiji period, I will simply say that at that time there was no room for basic speculation on the issue of the object of study in aesthetics. From start to finish, all efforts were turned to the introduction of foreign aesthetics. Although we cannot fault the act of introducing new thoughts, we cannot deny the tendency to move aimlessly with the tide. Nor can we ignore the signs of opposition to contemporary Japanese views of the arts at a time when the thought of Western developed countries had become the imperial banner. In an age when basic words such as "aesthetics" and "art" had not yet taken root in the intellectual world, there was probably no spare time for serious thinking on these issues. Moreover, as people lacked understanding of the real content of the science of aesthetics, the field was burdened with exaggerated expectations. The illusion was born that the study of aesthetics would enable people to grasp and clarify the meaning of beauty and art.

Even Ōtsuka Yasuji, at the beginning of his study of aesthetics, believed that such research would lead to a free evaluation of art. Only

8. [See Chapter 1. Ed.]

later did he realize that in fact he could not use his knowledge as he had anticipated. Although the world of aesthetics was endowed with a series of logical standards of criticism, once these were applied to individual works of art they simply did not work. On the contrary, often a mutual discrepancy arose between the judgment coming from an aesthetic point of view and the emotions felt in front of the work of art itself. Ōtsuka stopped analyzing the various phenomena of reality in light of aesthetic theories previously created by someone else. Instead, he felt the need to create a theory from the accumulation of psychological and social studies of the phenomena themselves.

Ōtsuka Yasuji was very frank in his remarks. At first he wished what simply was not there—that is, the demand for standards to be used in the act of aesthetic judgment. Ōtsuka went abroad, from 1896 to 1900, at the very close of the nineteenth century. At that time, even in Europe, philosophical aesthetics was in decline, leaving the stage to psychological and positivistic aesthetics. Ōtsuka thought that by making a positive science out of aesthetics it might be possible to rescue artists and critics from the charge of being useless to society. Before making such an aesthetics public, however, Ōtsuka engaged in the formation of a methodological ground for the study of aesthetics and, as noted earlier, died without producing a single monograph.

Once we reach the age of Fukada, who was ten years younger than Ōtsuka Yasuji, a general knowledge of aesthetic thought had already spread and deepened. For someone like Fukada who had lived for five years with von Koeber (from 1902 to 1907), had spent three years in Germany and France (from 1907 to 1910), and had already read foreign works on aesthetics extensively, the task of introducing new knowledge to Japan was far from appealing. He must have been rather intrigued with the problem of how to cultivate aesthetic thinking on Japanese soil. His laborious Japanese translation of the painstaking sentences of Kant's *Critique of Judgment,* a work that had laid the foundations of modern aesthetics, must have been aimed at facilitating the understanding of a work which was essential reading for anyone interested in aesthetics.

Fukada had already ceased searching for something in aesthetics that might be practically useful to the contemplation and creation of beauty and art. Through their reading of theoretical works on aesthetics, people who were concerned with speculations about beauty and the creation of art added a new layer of reflection to their personal views and groped for new creations. Yet it was impossible to contem-

plate beauty and produce fine arts in conformity to scholarship. Beauty could not be deduced from scholarship; it could not be induced from experience. Art, as well, could not be created according to fixed rules.

Then how could Fukada dedicate his whole life to a field, such as aesthetics, that was in fact without any practical use? Although we have no essay in which Fukada directly confronted the question of the meaning of aesthetics, there is a passage in "Jimon Jitō" (Monologue) in which he explains the meaning of thinking. Here he argues that the act of thinking is completely different from the occupation of someone like, for example, a driver of a tramway running at a fixed speed on a fixed track. To think is not to measure what is yet unknown by what is already known. It is to know the unknown: to grasp what is new. It is not to wrap the new in the old, but to wash the old with the new. Therefore, we can say that thinking is a constant creation. We must say that thinking is not a play of logic taking place in a corner of our head; it is the continuous life of our whole existence.

Fukada knew that a thorough study of something was a kind of creation. He also knew the difficulty of such an activity. He believed that, together with the activities of contemplation and creation, the act of thinking over the essence of beauty and art was one kind of creation. Or perhaps we should say that as a skeptic he tried to believe it. In any event, although theory was not of any immediate practical use, this was not the fault of theory. It was not necessary to erase everything that was not of any real use. In fact, wasn't this drive toward theorization a way of eliciting spontaneous thought and creating enthusiasm for the sterile attempt to transplant a foreign culture? It was exactly because of a lack of theoretical clarity and structure in Japanese thought on beauty and the arts that people kept playing the comic act of irresponsibly jumping into what was new, then distancing themselves from it, and then jumping into it again.

After all, Fukada reflected over the contents with which the words "aesthetics" and "art," which had begun to be fixed in the Japanese language, should be filled. Once people realized that thinking is a constant creation—and an act which gives weight to our whole existence —the issue was no longer whether or not aesthetics was useful to guide us to contemplation and creation. This was not simply an issue of knowing about foreign beauty and art and possessing foreign thought as knowledge; the issue was to think how we ourselves feel with regard to beauty and art. It would be meaningless, however, to simply proclaim one's personal thoughts loudly. It was important to trace the

history of the paths that different people followed when talking about beauty and art, to confront all these thoughts with one's personal beliefs, and to reach the point where one could claim one's own way of thinking. The act of thinking is a personal, inner issue. Considering the fact that everybody thinks, we should not ask others to think for us. When we read Natsume Sōseki's lecture "Watakushi no Kojinshugi" (My Individualism), we understand how long it took for people to interiorize such an issue. Sōseki argued as follows:

It was then that I realized that my only hope for salvation lay in fashioning for myself a conception of what literature is, working from the ground up and relying on nothing but my own efforts. At long last I saw that I had been no better than a rootless, floating weed, drifting aimlessly and wholly dependent upon others—"dependent" in the sense of an imitator. . . . Why do you think you hear so much about Bergson[9] these days, or Eucken?[10] Simply because Japanese see what is being talked about abroad and, in imitation, they begin shouting about it at home. In my day, it was even worse. Attribute something—anything— to a Westerner, and people would follow it blindly, acting meanwhile as though it made them very important. Everywhere, there were men who thought themselves extremely clever because they could fill their speech with foreign names. Practically everybody was doing it. I say this not in condemnation of others, however: I myself was one of those men. I might read one European's critique of another European's book, for example. Then, never considering the merits of the critique, without in fact understanding it, I would spout it as my own. This piece of mechanically acquired information, this alien thing that I had swallowed whole, that was neither possession nor blood nor flesh of mine, I would regurgitate in the guise of personal opinion. And, the times being what they were, everyone would applaud. No amount of applause, however, could quiet my anxiety, for I myself knew that I was boasting of borrowed clothes, preening with glued-on peacock feathers.[11]

Fukada Yasukazu, who was eleven years Sōseki's junior, must have realized that theory does not become lived theory until it gushes forth from the inner self. He must have felt that beauty and art cannot be the borrowed clothes of somebody else's theory, since both are affected

9. [Henri Bergson (1859–1941), French philosopher, is the author, among other works, of *Le Rire* (Laughter, 1900) and *Essai sur les Données Immédiates de la Conscience* (Essay on the Immediate Givens of Conscience, 1889). Ed.]

10. [Rudolph Eucken (1846–1926), German philosopher, opposed materialism and naturalism, advocating instead a new idealism. Ed.]

11. [This translation is by Jay Rubin, "My Individualism *(Watakushi no Kojinshugi),*" *Monumenta Nipponica* 34(1) (Spring 1979):33. Ed.]

by the subjective judgment of every individual. Fukada argued that in the background of all scholarly articles lie the author's emotions, the scholar's convictions and beliefs. Fukada's definition of exhaustive thought includes the presence of the highest possible objective elaboration while unceasingly filtering the innermost feelings and beliefs through the net of reflection.

By reading the essays that Fukada published in scholarly journals, we understand that he was endowed with an extremely penetrating analytical power. At the same time, we realize how powerfully sensitive he was in his fascination with beauty and art. In an essay titled "Koyama Teiho wo Omou" (Thinking of Koyama Teiho),[12] Fukada argued that "at that time I felt a profound distaste for academic matters. Although I would go to the library, I would feel a desire for Western poetry collections despite my inability to understand them. This was a time when I would borrow Keats' *Endymion*[13] and Andrew Lang and Samuel Henry Butcher's translation of *Homer,* and I would bury myself in them with an uncommon sense of excitement. . . . Our ideal was a complete education. There was nothing we despised more than the deformity of the specialist." From the aesthetic intoxication of his early days, Fukada gradually turned to aesthetic knowledge. This knowledge, however, was continually characterized by the kind of intoxication Fukada had felt in his youth. While developing a thought that would be true to the self in unraveling all the doubts of the inner self, and while penetrating with determination an unreliable world by making thought a kind of creation, Fukada was always very much alone. He wondered if someone like himself, who had no friends and did not understand himself perfectly, might ever have a close friend. And yet, according to the accounts of people around him, Fukada was a very warm and mild person. (See the recollection by Naruse Mukyoku[14] and Shinmura Izuru[15] in *Geibun,* 1929.) He must have felt in person what Sōseki described as the loneliness of modern man—the loneliness of the individual who realizes his own individualism. Fukada's essays on art are deeply characterized by the presence of a theory that is rooted in such self-conscious individualism.

12. [Koyama Teiho (1879–1919) was a poet, critic, and politician. Ed.]

13. [John Keats, *Endymion: A Poetic Romance,* 1818. Ed.]

14. [Naruse Mukyoku (1884–1958) was a scholar of German literature. Ed.]

15. [Shinmura Izuru (1876–1967), linguist, was editor in chief of the most popular Japanese dictionary, the *Kōjien* (1st ed., 1955). Ed.]

As Fukada argued cogently in *Bi to Geijutsu no Riron* (Theories of Beauty and Art),[16] art was first universally acknowledged as a world with an independent value when the value of man as individual began to be held in esteem. In its broadest sense, art is the human ability to make things. Such a skill has always accompanied man through his long history since the birth of humanity. Attention to this skill and praise of it, however, are relatively new values. Art as a special skill was first celebrated by the artists of the Renaissance and was more and more acknowledged by society at large beginning in the seventeenth and eighteenth centuries; the praise of art reached its peak in the art theories of the romantic school. While comparing ancient and modern views on art—and showing a deep understanding of the ancient views—Fukada clearly positioned himself on the side of the modern, which recognizes the value of the individual, the key role played by emotions, and the autonomy of aesthetic values.

Theories of Beauty and Art is an essay on the essence of art. Since art is a kind of human action, this essay becomes a theory centered on man. When we consider Fukada's convictions, we see that the issue of man is always at the center of his thought. He declared that beauty and art cannot live apart from man. Even with regard to natural beauty, he argued that since it would be impossible to talk about it while leaving aside the human eye that perceives nature as beautiful, in the end natural beauty had to be reunited with the issue of artistic beauty. Fukada had a deep understanding of Kant's aesthetics, as we can see from his translation of Kant. With regard to his inclination toward the monism of artistic beauty, however, Fukada joined Hegel, as he himself admitted.

Nature exists independently from man; it existed prior to man's life on earth. Is it possible, however, to argue that natural beauty exists objectively aside from man? Beauty does not exist apart from human intuition. When we hear from someone else about the existence of something beautiful that we've never seen, this is a sort of knowledge; it is not beauty. Since we confuse knowledge and beauty, are we not convinced that something we do not understand is beautiful only

16. [The book was originally published in 1930 as *Geijutsu Ippan* (A General Concept of Art) by Iwanami in the third volume of Fukada Yasukazu's collected works. In 1948 it was published again as a monograph with the title *Geijutsu ni Tsuite* (On Art). Hakuōsha republished the book in 1971 with a new title: *Theories of Beauty and Art*. Ed.]

because we rely on the knowledge of westerners who say it is beautiful? Beauty is the object of each and everyone's intuition; it is not knowledge borrowed from somebody else's intuition. Fukada argues along the same lines as Sōseki when he says he had no other option but to fashion a concept of literature by himself: valuation was his responsibility and his alone.

Fukada took the basic stand that without first establishing the individual as subject, the autonomy of aesthetic and artistic values did not come into being. Even in *Theories of Beauty and Art,* he contrasted Plato's views on art with those of Oscar Wilde (1854–1900)—and sided with Wilde despite the abundance of Wilde's paradoxical expressions. After all, Fukada took as the starting point of his speculation the irreplaceable notion of the sanctity of the individual. Since he knew, however, that individual originality lacking an opening to universal human values would simply stop at the level of eccentric expression, Fukada addressed the issue of art's universality. In other words, the problem of the universality of art was related to the general issues of particularity and universality. Fukada discussed this point by introducing the conflict between objective and impressionistic criticisms: between Brunetière[17] and Anatole France.[18]

According to Anatole France, in the same way that a thing such as an objective work of art (a work of art that is created according to objective rules and exists without a subject) does not exist in the world, the so-called objective criticism has no place. Moreover, art and beauty are something to be felt; they cannot be reduced to a scholarly explanation or definition. Furthermore, what is called objective criticism relies simply on calling something a masterpiece, as many people do. At worst it is nothing but a subjectless, irresponsible evaluation by blind followers. Brunetière, by contrast, argued that feeling is already a choice based on like and dislike. So long as a choice is made, a standard of values is presupposed that unconsciously depends on these feelings. Tradition authoritatively exists as these standards of value operating when a choice is made. Since tradition is the working and the original form of the human spirit, we can judge the value of the work of art in the light of tradition.

17. [Ferdinand Brunetière (1849–1906), a defender of genre criticism, fought against the new literary movements of naturalism and symbolism. Ed.]

18. [Anatole France (1844–1924), French writer and critic, was active in the socialist movement of World War I. Ed.]

This is how Fukada summarizes the stands of France and Brunetière. He argues that criticism is not simply a matter of feelings; it is not the expression of feelings. Likewise, however, it is not a judgment based on objective rules. Instead, it must be the discovery of what is objective within feelings. According to Fukada, France's position reflects the stance of a young man who easily sympathizes with modern man. At the same time, he feels that from such a standpoint sprang the sorrow of loneliness that alienated everyone from everyone else. The greater the taste for the solitude of the self, the more impossible it becomes to bridge the gap between self and other. Fukada thinks this is the reason many modern poets embrace religious and mystic thought. In other words, people search for the absolute in order to escape loneliness. This demand for the absolute is necessarily a demand of a strong personality. The individual can only relate to other individuals through the mediation of the absolute.

For Fukada the issue of art is a search for the point where particularity comes into contact with universality. The only way to find this point is by intuiting such a point as the feeling of the individual's subjective life. On this issue Fukada argues as follows in *Theories of Beauty and Art:*

> We can say that in artistic creation and artistic contemplation, we truly live and experience life because to live means to feel. This must truly be a peculiarly individual thing. To live means that I live; to feel means that now I feel these feelings. Art, however, is not simply what everyone feels at a specific time. The difficult issue with art is the fact that it requires the presence of something generally and universally human.

After all, according to Fukada, the problem of the essence of art must be sought in the point of phenomenonization within the subjective intuition of the individual. In short, every discussion of the essence of art is a discussion of what is universal in the emotions and what is objective in impressions.

Fukada deals with this problem in terms of the harmony of content and form. Usually—he argues—when we refer to something with the name of "content" we are referring to something objective, like nature and life, or to something spiritual. With form we indicate sensorial elements. We can see this, for example, from the following classification: novels and paintings (especially portraits) are arts that privilege content; music and architecture lay emphasis on form. But, Fukada continues, can a painting whose content (a landscape or a portrait) is modeled after an outstanding natural scene or a rare beauty

be called a painting with an excellent content? When we call painting a content art, the value of the painting depends on how the model is treated with pigments, brush, and canvas. The content of a painting is not the imagined nature or action apart from representation. It is nothing but the form of the picture: the impression, on the canvas, of the painter's view of an object. Although we hear the expression "imitation of nature," it is impossible to represent and reproduce nature faithfully. Even if we could do it, it would be meaningless. Art is a thin membrane standing at the border where the observing subject and the observed object come into contact—in other words, the picture.

Without establishing an observing subject, the observed object does not come into existence. Without a tension between observer and observed, we would not feel the inner necessity to search for mediation. The artistic activity begins for those who think that the world visible to the eye is a mystery. To those people who are at home with custom, and do not feel a sense of wonder with regard to the surrounding world, art is useless. The person known as "painter" is someone who fixes to one picture the world as he sees it without preconceptions. In our daily life we are removed from such a visual activity. Rather than actually seeing an object, we simply see the sign of its concept. This is why Fukada argues that the world of daily life is more abstract than art. We can say that Fukada's thought on this issue is similar to that of Fiedler (a German art theorist)[19] and Bergson.

Fukada believes that what can be said about paintings applies to novels as well. When we ask where the art of the novelist lies, we see that the basic answer is found in his writings. Although common people consider language a simple image of things, a representing sign, things are more complicated. Fukada argues that in fact nothing is more true or more real than language.

The heart and feelings of the artist are the heart and feelings that exist only in the forms he produces in his painting and writing. They do not exist anywhere aside from the form of the work of art.

With regard to those arts that privilege form, however, Fukada points out the sentimental meaning that sensitive forms and color bring to the world. Form, color, and sound are not simply the object

19. [Konrad Fiedler (1841–1895) is considered the founder of the "science of art." Ed.]

of the senses. We perceive them with our sentiments as lived form and sound. Form and sound, in short, are expressive. Such expressions are not emotions related to fixed objects as in the case of, for example, joy and anger; they are more primordial, vague feelings. Although they are conceptually unclear, in terms of experience they are extremely clear to the point that, as feelings, they cannot be mistaken for anything else. The formal arts are such because they become symbols of deep inner things. In summary, then, Fukada locates the essence of art in a "significant form" (Clive Bell): a form endowed with meaning.[20] This is an issue that Langer has recently discussed.[21]

To look at Fukada's *Theories of Beauty and Art* today, almost half a century after he wrote it, we are surprised that this work has not aged at all. To deal with the essence of things is perhaps an example of how to overcome the currents of time. Fukada spent his whole life looking at art from the side of man's subjective judgment and action. He chose beauty as the value to which such human judgment and action aim—the value that distinguishes these actions and judgments from all other human values. Naturally, he took beauty to include the meanings of elegance, the sublime, and the comic—and to indicate all feelings moving the human heart. He believed that the essence of art is located in the pursuit of beauty taken in this broad sense. At the center of his speculation, Fukada always located man as a subject. The problem of beauty and art was always brought to unity by the notion of what beauty and art mean for man. The monism of artistic beauty that Fukada discusses in the tenth chapter of *Theories of Beauty and Art* might look like an oversimplified account; yet it was the inevitable conclusion of his humanistic stand. The Japanese, who admit to be a people who love nature, would rather think that natural beauty is superior to artistic beauty. According to Fukada's explanation, however, even the love of natural beauty is a cultural characteristic. So long as it is a cultural issue, it is an issue related to the awareness of human values. If we proceed by refining these values, we return to the issue of artistic beauty. Moreover, we find many instances of people who, while praising natural beauty, mistake for beauty the sense of relief and comfort we all feel when coming in contact with nature. Nature

20. [Clive Bell (1881–1964) explained his notion of "significant form" in *Art* (1914). Ed.]

21. [The author refers to Susanne Langer's (1895–1985) *Feeling and Form* (1953). Ed.]

is found in goodness, badness, beauty, and ugliness. The view of nature as beautiful nature is already premised on the existence of human beings. Once the problem is posited in this light, we must turn to the realm of individual worldviews and metaphysics.

Fukada Yasukazu held that to perceive in its presence the world that can be seen by the eye means to live in the world of the unseen toward which we aspire. He argues: "In my opinion, the heart's desire for the world of the unseen does not exist in order to pull us away from the world of the seen; indeed, it is given to us in order to fascinate us with the world of the seen. . . . We think we are living in the real world, but actually we do not see the present as real. While living in the world of the seen, in reality we live without seeing." Even with regard to love, there are many cases in which we love nothing but what we have reconstructed in our selfish imagination. This is like using the world of the unseen in order to distort the world of the seen. Fukada loathed the idea of judging the visible world with the arbitrary meter of the fancy. Therefore, he regarded as dreadful fanatics those parents who whip their children while forcing upon them doctrines and ideals, or those who force an idea in the name of an age that will come, or those religious people who teach contempt of earthly treasures in order to accumulate heavenly riches. He believed that the visible world would not reach perfection in a world yet to be seen and that the world of the unseen begins to find its fulfillment in the present visible world. After developing this argument Fukada quotes the saying, "Why then would God become a man?" Fukada must have felt eternity in the intuition of the present.

18

Nishida Kitarō and Art

Iwaki Ken'ichi

Beginnings

In the preface to *Zen no Kenkyū* (An Inquiry into the Good; new ed.,
1937) Nishida Kitarō (1870–1945) retraces the steps of his philosoph-
ical research. According to the preface, Nishida developed the idea of
(1) "the notion of pure experience," which he introduced in *Inquiry
into the Good* (1911), until it became (2) "the notion of absolute
will through the mediation of Fichte's act *(Tathandlung)*" in *Jikaku
ni Okeru Chokkan to Hansei* (Intuition and Reflection in Self-
Consciousness, 1917). Then (3) in the second half of *Hataraku Mono
kara Miru Mono he* (From the Actor to the Seer, 1927), he further
developed this notion through the mediation of Greek philosophy
into the "idea of place," which was then seen as the beginning of the
construction of a logical base for his ideas. Next Nishida (4) "con-
cretized as a dialectical universal" the logic of "place" *(basho)*, giving
that idea a direct expression in terms of "action intuition" *(kōiteki
chokkan)*. Moreover (5) what he had called in *Inquiry into the Good*
"the word of direct or pure experience" became "a world of histor-
ical reality"; ultimately Nishida concluded that "the world of action
intuition—the world of poiesis—is none other than the world of
pure experience" (*Nishida Kitarō Zenshū*, Iwanami Shoten, vol. 1,
p. 6).[1] This temporal classification of Nishida's philosophy, one that

From Iwaki Ken'ichi, "Nishida Kitarō to Geijutsu," in Iwaki Ken'ichi, ed., *Nishida
Kitarō Senshū* (Selected Works of Nishida Kitarō), vol. 6 (Kyoto: Tōeisha, 1998), pp.
408–437.
1. [The English translation of this passage follows Nishida Kitarō, *An Inquiry into
the Good*, trans. Masao Abe and Christopher Ives (New Haven: Yale University Press,
1990), pp. xxxii–xxxiii. Ed.]

Nishida himself provided, has become standard practice in research on Nishida.

Strictly speaking, this classification is simply a means. It does not allow us to neglect each previous stage. When a concept is replaced by a different world, it is made more concrete. The so-called ideas of "dialectical universal" and "action intuition," for example, are there from the beginning. What is truly important to understand is that the content of the first term, "pure experience" *(junsui keiken)*, becomes clear for the first time when it is seen from the viewpoint of the expression "action intuition." New words rearrange Nishida's thought and open to him a new speculative world. In this regard, the transition from steps (3) and (4) to (5) is more important than the one from (3) to (4), since later Nishida came to speak of "pure experience" as "historical being" *(rekishiteki jitsuzai)*. This transition took place in 1932, as the "Preface" (December 1932) to *Mu no Jikakuteki Taikei* (The Self-Conscious System of Nothingness) indicates. There Nishida argued that at the basis of "the self-conscious determination of the universal there must be a meaning of social and historical determination" (*NKZ* 6:11; see also the "Introduction" to *Tetsugaku no Konpon Mondai*, or "Fundamental Problems of Philosophy," 1933, *NKZ* 7:187).

We do not find in Nishida an independent "philosophy of art." When we look at Nishida's entire speculative system, however, we see that he always took up the issue of art, together with religion, at important junctures of his career as examples with which to validate his thought. Nishida's "philosophy of art" is intertwined with his entire philosophical speculation. Despite possible objections, I will divide Nishida's intellectual journey into four periods corresponding to steps (1), (2), (3–4), and (5). And while unraveling the major concepts of each period, I will examine how these concepts relate to the notion of art.

"Pure Experience" and Art

To know Nishida's view of the arts prior to the publication of *Inquiry into the Good*, we can refer to a short article titled "Bi no Setsumei" (An Explanation of Beauty, March 1900) that Nishida wrote as a young man and published in the journal of the alumni of the Fourth High School, *Hokushinkai Zasshi* (Journal of the North Star Association). In this article Nishida turns his attention to Kant's notion of the "disinterestedness" of beauty. Nishida calls beauty "a pleasure

apart from the self," a pleasure "forgetful of advantages and disadvan-
tages," against "British psychologists" who considered beauty the
same as types of "pleasure deriving from selfish desire." Nishida
shows an understanding of the matter from the perspective of the
Eastern, Zen tradition. He considers the sense of beauty "the boundary
of pure selflessness," "a kind of religious salvation," "art's inspira-
tion," and "an intuitive truth" different from "logical truth." The dif-
ference between beauty and religion is that beauty is a "temporary
selflessness" whereas religion is "eternal selflessness" (*NKZ* 13:78ff).

We cannot say that the interpretation of Kant's "disinterestedness"
(Interesselosigkeit) as "a forgetfulness of advantages and disadvan-
tages" is a total misunderstanding. Nishida's explanation might well
be more fitting than his decision to translate the German word with
the Japanese expression "indifference" *(mukanshin)*. The problem is
this: as soon as a Western word is translated into an Eastern word,
Eastern expressions and the images associated with them come to the
fore as if they were attracted to a magnet. The expression "forgetful-
ness of advantages and disadvantages" carries with it notions of "self-
lessness" *(muga)*, "salvation" *(gedatsu)*, "intuitive truth going beyond
intellectual discrimination." Thus "beauty" in this context is linked
to Buddhist, Confucian, and Taoist expressions—which would have
amazed Kant if he could have heard Nishida's language. As this essay
indicates, Nishida was fond of this language.

According to Ueda Shizuteru,[2] in Nishida's thought the "mag-
netic field" is located in the "fracture" between Zen and philosophy
(*Nishida Kitarō: Ningen no Shōgai to Iu Koto*, or "Nishida Kitarō:
What Is Called Human Life," Iwanami Shoten, 1997, p. 122). To say
it more precisely: language is what creates the "magnetic field." The
notion of "pure experience" in *Inquiry into the Good* moves within
the magnetic field of Eastern and Western languages. It would be
impossible to understand this concept by approaching it from one
side only. We must enter the magnetic field personally and face the
concept head-on.

Kant used the word "pure" strictly with a transcendental meaning.
To say that space and time are "*pure* intuition" and "*pure* form" is

2. [A major scholar of Nishida, Ueda Shizuteru is professor emeritus of religious
philosophy at Kyoto University and the author, among other publications, of *Nishida
Kitarō wo Yomu* (Reading Nishida Kitarō) and *Keiken to Jikaku* (Experience and Self-
Awakening). Ed.]

the essential prerequisite for the coming into being of "intuition" (to see things as "something endowed with form") and, consequently, "form" (image). We cannot "perceive" space and time in themselves as form. In other words, we cannot grab them or see them. And yet we cannot think of "form" without the presence of these two concepts. Space and time make possible the experience that always accompanies form as an "absolute background" for the formation of intuition (experience). (I would like the reader to keep in mind this word "background.") "*Pure* intuition" and "*pure* form" are not things that can be acquired experientially if intuition and form are purified. We cannot help presupposing them as a transcendental condition for the formation of specific "intuitions" and "forms" (Kant, *Critique of Pure Reason*, "Transcendental Aesthetic").

Yet "experience" is the cognition of things ("phenomena" to use Kant's word) as "something endowed with form," and it is *foregrounded* in consciousness. As a personal rule, when a phenomenon has form, a mechanism is already at work that cuts off phenomena as "something endowed with form"—in other words, "discrimination" (understanding). This mechanism (understanding) regulates "the rule." By ordering experience through this system, it participates willy-nilly in the formation of experience as "background of consciousness." At the bottom of "experience" the a priori of "pure discrimination" and "pure reason" intervene together with "pure intuition" as the "absolute background of experience." As a result, I can see flowers as "flowers." "Experience" is always mediated by a rule that cannot be experienced. It cannot be "intuitive"; nor can it be "pure." Therefore, from Kant's point of view, an experience—as Nishida says— "without the least addition of deliberative discrimination" does not exist (*Inquiry into the Good*, NKZ 1:9). Even "the moment of seeing a color or hearing a sound" participates in the mechanism (discrimination) that separates it from a different color and sound. We cannot experience the "pure" (Kant, *Critique of Pure Reason*, "Transcendental Logic").

How did Nishida confront this issue? To explain "pure experience," he introduced first Ernst Mach's (1838–1916) "analysis of sensations"[3]

3. [Ernst Mach (1838–1916) was an Austrian physicist and philosopher who in his *Beiträge zur Analyse der Empfindungen* (Contributions to the Analysis of Sensations, 1886) moved toward a scientific study of mental phenomena seen as given facts. He is one of the founders of *Empiriokritizismus*, a realistic philosophy based on the analysis of sensations. He also wrote *Erkenntnis und Irrtum* (Understanding and Misunderstanding, 1905) and *Kultur und Mechanik* (Culture and Mechanics, 1915). Ed.]

and then William James' concept of "pure experience."[4] In a lecture bringing together the basic ideas of *Inquiry into the Good*, however, Nishida pointed out the failures of Mach's theory and James' "pure experience" (*NKZ* 13:97). According to Ueda Shizuteru, with regard to Mach, Nishida's dissatisfaction derived from the issue of "thinking of experience as a product of the senses" (*Nishida Kitarō wo Yomu,* or "Reading Nishida Kitarō," Iwanami Shoten, 1992, p. 72). In fact, Nishida argued that Mach's "senses which perceive directly" were not "really pure experience" but "indirect notions processed by concepts" (ibid.). Moreover, Nishida's displeasure with James derived from the "total confusion" of James' "pure experience," which in Nishida's opinion was nothing but material for reflection (p. 119). On the one hand, Nishida did not regard "pure experience" as a primeval psychological element; on the other, he did not see it as a totally formless and "chaotic stream of consciousness." Rather, he interpreted as "pure" the "experience" that, according to Kant, could only be "impure."

All this is important in order to understand the slippage between the common sense of Western philosophy and Nishida's speculation. Mach's and James' concepts of "experience" were attracted by the same magnetic force that had attracted Kant's. As a result, while talking about the origin of experience, it was inevitable to call "direct experience" (pure experience) the situation of a "confusion of elements that had not yet become form." According to Nishida, however, since such a situation could absolutely not be experienced in real life, it was neither "direct" nor "pure." It was nothing but an "abstraction" (an argument) that could not be called experience. In fact, we always experience things as "something endowed with form." No matter whether "discrimination" and "reason" enter into the process, experience comes into being regardless of them and peremptorily. This is the "actual place of experience." Therefore, it would be impossible to abandon this place if we want to think about expe-

4. [William James (1842–1910), American psychologist and philosopher, is known especially as one of the founders of pragmatism. He is the author of *The Principles of Psychology* (1890), *The Varieties of Religious Experience* (1902), *Pragmatism* (1907), *The Meaning of Truth* (1909), and other works. In *An Inquiry into the Good* Nishida refers to James as follows: "Thinking and pure experience traditionally have been considered totally different mental activities. But when we cast off dogma and consider this straightforwardly, we see that, as James said in 'The World of Pure Experience,' even the consciousness of relations is a kind of experience—so we realize that the activity of thinking constitutes a kind of pure experience." See Nishida Kitarō, *Inquiry into the Good*, p. 13. Ed.]

rience. Western philosophy locates the truth of experience ("pure experience," "true reality") exactly in this "impure" place. Here what cannot form theoretically becomes formed as experience. If we rethink the issue without yielding to the magnetic force of Western philosophy, then we witness the appearance of Nishida's concept of "pure experience." If we use the yardstick of Western philosophy, we will certainly fail to understand. This slippage comes out in Takahashi Satomi's critique of Nishida[5] and in Nishida's reply (1912). Takahashi doubted the absolute nature of Nishida's "pure experience." Nishida opposed this doubt: despite "the unifying power," he responded, "pure experience" is "pure experience" (*NKZ* 1:300).

Nishida did not deny that reason enters into pure experience, or that pure experience is mediated by a system, or that pure experience is a unification of all these elements; he actually stressed all these points greatly. Nishida argued as follows: "The directness and purity of pure experience derive not from the experience's being simple, unanalyzable, or instantaneous, but from the strict unity of concrete consciousness. . . . It constitutes a single system from the start. The consciousness of a newborn infant is most likely a chaotic unity in which even the distinction between light and darkness is unclear. . . . Even so, no matter how finely differentiated these states may be, at no time do we lose the fundamentally systematic form of consciousness. . . . But *behind* the perceptual activity *an unconscious unifying power* must be functioning" (*NKZ* 1:13; emphasis is mine).[6] This "unconscious unifying power," this "system," unconsciously creates experience and, at the same time, the object ("thing") of experience. This is the "logos" of things (p. 75), "the essence of nature" (p. 82), and "principle" (p. 148; for the notion of "system" see also *NKZ* 13:96ff).

"Pure experience" is the experience of such a "logos." Here it becomes clear why Nishida, in addition to explaining and developing the notion of "pure experience," paid attention not to Western "empirical psychology" but to German idealism and also to German mystical thought. At every moment, "reason" works unconsciously in experi-

5. [The philosopher Takahashi Satomi (1886–1964) is the author, among other works, of *Zentai no Tachiba* (The Standpoint of the Whole, 1932), *Taiken to Sonzai* (Experience and Existence, 1936), and *Rekishi to Benshōhō* (History and Dialectics, 1939). Ed.]

6. [The English translation from Nishida's *Inquiry into the Good* is by Abe and Ives, pp. 6–7. Ed.]

ence, and it creates experience. It is not the I that creates "reason." Rather, the "concealed power of the individual" (p. 26) known as "reason" creates at all times the "individual" known as "I." This is what is meant by the sentence which appears in the preface: "it is not that experience exists because there is an individual, but that an individual exists because there is experience."[7] This explains Nishida's attention to Hegel's notions of "reason" and "idea." Nishida interprets the notion of "idea," which Hegel presented in his *Logic,* as the "truly universal" "behind the actualization of the individual" (p. 26). From this point of view Nishida also pays attention to the "bottomless," "objectless will" of J. Böhme (p. 190).[8] Experience is born out of this "bottomless" reason and is put in motion by this "objectless will." Here we can already see Nishida's later notion of "dialectical universal." From the beginning, Nishida saw experience from the standpoint of the universal. In this sense, Nishida stood on the transcendental ground of German idealism, since pure experience is *behind* "the actualization of the individual" (individual experience).

Nishida passed his transcendental point of view through the magnetic field of Eastern language in use since the times of Confucius and Lao Tzu, however, and spoke of the "experience" of principle. Each consciousness is a "formative," "active" mechanism that develops by itself coherently (pp. 13, 26, 58). At the same time, "the limitless, sole reality develops the self from small to big, from shallow to deep" (p. 77). "The deepening of knowledge" is at the same time "an objective joining with nature," a "fusion with the substance of the universe," "a dark encounter with the divine will" (pp. 90, 167). The principle of "behind" (background), which originally cannot be experienced, becomes an experience (stage) to be attained through training. Art is such a stage. Everywhere in *Inquiry into the Good* Nishida expresses his views on art that we find in "An Explanation of Beauty." "The point of unification of subject and object" is the "secret of religion, morality, and art" (p. 168), while "a delicate stroke of the artist's brush shows the true meaning of the whole" (p. 43). The "mystery" is *actually* experienced. Or to focus upon the "real," which has forgotten everything, is the mystery of pure experience. At this point, everything appears as "one simple reality," a "peerless actuality of

7. [*Inquiry into the Good,* p. xxx. Ed.]

8. [Jakob Böhme (1575–1624), German mystic and philosopher, described God as an *Ungrund*—a bottomless abyss. Ed.]

heaven and earth," which does not translate into words (p. 10, 37). The reason why such an "actuality" cannot be put into words is that it is completely "individual." As a result, we must "discard devices" and take leave of "discrimination." "The artist, rather than the scholar," reaches "the truth of reality" (pp. 37, 60).

If we accept Kant's theory, pure experience is a transcendental condition that cannot be experienced under any circumstances. Even Nishida acknowledges the impossibility of experiencing "reason," since pure experience is "behind the unconscious." He argues that reason is seen as "an intellectual intuition"—"an insight that is usually beyond experience" (*NKZ* 1:44). Kant postulated that an "intellectual intuition" cannot be found in human experience. Johann Gottlieb Fichte (1762–1814) and F. W. J. Schelling (1775–1854) attached great importance to "intellectual intuition." Nishida was aware of Fichte's and Schelling's use of this concept (*NKZ* 4:42), although he could not accept their definitions. By calling the transcendental something "behind," the situation changed. (Earlier I drew attention to this point by using the word "background.") We can experience things only as they appear in the foreground of consciousness. When we say "look at the background," the "background" has already become the "foreground," thus ceasing to be a background. Therefore, what continues to be the background of everything is an "absolute background" which never becomes foreground. And yet, since it possesses this "absolute background," everything can become foreground. "Experience" comes into existence when "foreground" and "background," which can never be totally joined, become one. A "foreground" consciousness which is only "foreground" is like someone sticking his head in the sand or someone who is knocked unconscious and washed away in a muddy stream. This is not the uproar of "pure experience." Undoubtedly this is what Nishida thought of James' notion of "pure experience." It was the same as calling it "a mystical state." Nishida conceived of pure experience while maintaining the notion of a relationship between absolute background and foreground. Since the "absolute background" is the absolute condition for the formation of the "foreground," we can also say that the background produces the foreground and that the foreground is the actualization of the background itself. As a result, Nishida calls the reality of pure experience "the concretization of the self on the part of the universal" (*NKZ* 1:26). While stating, on the one hand, that we cannot experience the "universal" or "reason" (in other words,

"the background"), on the other Nishida implies that it is actually possible. How could this be?

He answers as follows: "The background is experienced always together and simultaneously with the foreground as what cannot be experienced." No matter how many components "foreground" is reduced to, or how many "foregrounds" are piled up, we are not able to see reason as background forming such a "foreground." In fact, such a move would cause the "background" to escape. The "present consciousness" (*NKZ* 1:10) is concentrated on the foreground. Whenever the foreground is entrusted to it, the background is experienced at the same time. This is the meaning of Nishida's "experience of pure experience." Here we find the preparation for Nishida's later thought of the "absolutely contradictory self-identity" *(zettai mujun no jiko dōitsu)*. Actually, "pure experience" always comes into being in daily experience, since there is no foreground without background. As a result, Nishida opposes Takahashi with the notion of "unifying power." Such a unity becomes weak when we unreasonably chase after the background (reason), so that the background becomes the foreground and the background behind escapes. Here Nishida suggests the notions of "nothingness" *(mu)* and "place" *(basho)* that he develops later. This is all the background of experience, the coming into being of all knowledge, the background that contains all experiences.

While experiencing what is known as "the experience of pure experience," as soon as we try to stop it in words, it escapes us. In order to explain this, Nishida found some help in the notion of art. Although Nishida's "pure experience" originates in Zen, it could not be clarified by Zen. While constituting the point of departure of his explanation, the vocabulary of Zen—for example, "the unspeakable in words" *(furyū monji)*—could not be relied on for an explanation. Nishida searched for a way out in art, since he was familiar with Eastern art. This is what he meant by the expression "a delicate stroke of the artist's brush shows the true meaning of the whole," which I mentioned earlier. He resurrected the tradition of "the will lying on the tip of the brush," which appears in theoretical works on Eastern paintings. Haiku, *waka* poems, calligraphy, Indian ink paintings, do not privilege only the foreground—the object, words, form. They draw attention to the background that emerges simultaneously. This is known as "surplus of feelings" *(yojō)* or "blank space" *(yohaku)*. Calligraphy is the art of "blank space" par excellence since,

literally, every single brush stroke is the concrete realization of the "true meaning of the whole." The meaning of a written letter comes into being as meaning in the relationship (unity) between the movement of the drawing brush and the "blank space" this movement highlights. By being transposed into the linguistic magnetic field not only of Eastern religions but of art, the transcendental "reason" of Western philosophies becomes an issue of "experience," a "stage," "one simple truth." While endorsing Hegel's notion of "idea," Nishida was actually searching for "immediacy" (*NKZ* 13:308). He could say that "I want to begin from a given experience" (*Self-Consciousness*; *NKZ* 2:181) because he was standing in the field of Eastern language.

Nishida also touched upon Baruch Spinoza's (1632–1697) thought that "reality is the will of God" (p. 182). This is an expression that can be understood as a reverberation between the traditional Eastern and Western vocabularies. While in our heart the traditional Eastern vocabulary begins to vibrate when we look at Western works, Westerners might well awaken to their own tradition by listening to Nishida's language, since the "system," which works subconsciously, brings experience into existence.

The "Absolute Free Will" and Art

"Pure experience" lies at the core of individual experiences and thus forms them. It is transcendental "reason," the experience of "true reality" as the essential prerequisite of all realities. As a result, Nishida calls "pure experience" an intuition that scholars cannot explain (*NKZ* 1:24, 44). The philosopher Nishida, however, had to explain it with words—thus facing the philosopher's paradox: to put into words what words cannot express. Such a paradox is solved only when "pure experience" is demonstrated to be a mechanism that, as a self-conscious activity, reaches the linguistic world. According to Nishida, the key for the solution of this problem is to be found in the concept of "expression." Expression is a continuous development of the creation of vision (intuition), since in this process, by which intuition is born, we bear witness to the deepening of the act of immanent reflection (self-consciousness). If we accept the notion that the act of expression is the most primeval among the sensory acts—in other words, if we posit it as the act of "self-consciousness" in which intuition and reflection work together—linguistic expression, as a continuous development, comes to be related to intuition, thus allowing a philosophical expla-

nation of intuition. In this period Nishida emphatically repeats the active nature (autonomous act of self-consciousness) of the senses. As Ueda has pointed out, at that time Nishida aimed at synthesizing Henri Bergson's (1858–1941) "pure duration" and the Neo-Kantians' notion of reflection, searching for a solution in Fichte's "act" *(Tathandlung)* (Ueda, p. 262). With regard to the "active nature of the senses," Nishida refers to Hermann Cohen's (1842–1918) notion of "anticipated perception" that Cohen had taken from Kant (*NKZ* 2:127). According to Nishida, perceptions are not simply passive; within them is located a kind of "self-conscious" act that actively regulates the given phenomena. This act is called "anticipation" (first cognition) (*NKZ* 2:129). Nishida escaped dualistic theories by elucidating the self-conscious act of sensations (the reciprocity of act and reflection upon it). In Western thought he found a key that would allow him to demonstrate the reciprocity (continuity) of the relationship between subject and object (mind and body). Once he had understood the "self-consciousness" of pure experience in strict conformity with experience, Nishida found a ground for his argument in the art theory of Konrad Fiedler (1841–1895), as we can see in Nishida's "Bi no Honshitsu" (Essence of the Beautiful, in *Geijutsu to Dōtoku,* or "Art and Morality"). After mentioning Wilhelm Dilthey and Fiedler, Nishida argues that insofar as the explanation of "expression" is objective, he wants to follow the latter's *Über den Ursprung der künstlerischen Tätigkeit* (On the Source of Artistic Activity, 1887) (*NKZ* 3:268).

The following is a simple summary of Fiedler's theory of expression. Expression is not simply a copy of what exists (nature and spiritual phenomena). Prior to expression, what we think indisputably "exists" is actually nothing but an image or a thought that floats and disappears. The visible world and man's interiority take on a stable form for the first time in expression. Thanks to expression, we are at last liberated from a situation of instability and finally grasp actuality (the real) in its true meaning. By simply drawing the contours of something with a clumsy line, we lend stability to the visible world. The further we proceed with expression, the clearer becomes the consciousness that sees actuality. Independent of their autonomous methodologies, linguistic expressions and artistic expressions are mechanisms that create actuality—mechanisms which for the first time make possible reflection upon reality. Through the mediation of body movements such as speech, gesture, description, the mind becomes actual,

so that we cannot separate mind from body, interiority from exteriority, subject from object. Body and language do not depend on mind and meaning; mind and meaning depend on body and language. (We understand the importance of expression when we think of how much we fret whenever we forget a word; *On the Source of Artistic Activity.*)

Fiedler's theory of expression played an important role, not only in Nishida's later understanding of the arts, but in his thought as a whole. Thanks to Fiedler's theory of expression, Nishida could provide concrete explanations of the "development and differentiation" of reality and the "formation" of consciousness, which he had discussed earlier in *Inquiry into the Good.* "Art," which he had originally explained simply as a "mystical" experience in which "subject and object were united," is finally understood as a dynamic relationship between a reciprocal subject and object, mind and body, and as the outcome of such a relationship—the real world. Moreover, we must also know that, following Nishida's reception of Fiedler, the Kyoto school accepted Fiedler's theory of expression as an important philosophical thought. We see the influence of Fiedler's theory in Miki Kiyoshi's "Hyōgenteki Sonzai" (Expressive Being)[9] and in Kimura Motomori's "Hyōgen Ai" (Love of Expression).[10] Fiedler's theory also became the foundation for the work of Ueda Juzō (1886–1968), who succeeded Fukada Yasukazu (1878–1928)[11] to the Chair of Aesthetics at the University of Kyoto. Through the activities of Ueda's disciples, Fiedler's theory established one aesthetic tradition in the Kansai area. Although Fiedler was acknowledged in Germany in the field of art, he was not particularly recognized as an academic philosopher. He was received in Japan essentially as a philosopher mainly because of the similarity that his thought shared with the Eastern notion of the "oneness of body-mind" *(shinjin ichinyo).*[12]

In fact, Nishida understood Fiedler's theory of expression as an example of the "oneness of body-mind" (*NKZ* 3:269). Moreover, he read Fiedler's theory, which made a point of the specificity of artistic

9. [Miki Kiyoshi (1897–1945), Marxist and existentialist thinker, taught at the universities of Otani and Hōsei. Ed.]

10. [Kimura Motomori (1905–1946), a scholar of German idealism, taught philosophy at the University of Kyoto. Ed.]

11. [See Chapter 17. Ed.]

12. [For further information on this topic see Chapter 19. Ed.]

expression, as a theory that dealt transcendentally with human experience—in other words, as a theory explaining "pure experience." An experience that is "pure" is the "absolute free will" (*Self-Consciousness; NKZ* 2:281, 330)—the "meaning behind," which brings experience into being in a form that is hidden to individual human experiences (ibid., p. 136). Opposite to this, Nishida interpreted human cognition as the concretization of the "self-identity will" that makes active the act of knowing, the "point of contact" with such will, as well as the "point of self-realization of transcendental will" (*Art and Morality; NKZ* 3:396).

Nishida also explained the activity of vision from this perspective. According to him, "the world of pure visual perception" is a "world of concrete experience that develops by itself upon the ground of the act of vision, as the act of acts" (ibid., p. 272). "Pure vision" is a transcendental activity that, as the "act of acts," makes possible individual visual acts. Through a "split" in this activity, a relationship between the subject of vision (the seer) and the object of vision (the seen) is established. "The world of pure vision" is a world in which the "a priori of sight" (the will that urges to see from behind) is made actual as "concrete experience." This is the world of the "act of artistic creation." Here as well art is understood as an activity that lights up "the act of acts," the reason "behind" experience. While developing his argument on the act of vision, Nishida privileged the arts. He clearly incorporated Fiedler's thought into his explanation of the mutual relationship between mind and body in artistic activities, arguing that "one visual act, accompanied by the movement of the muscles, produces the motion of the entire body" and that "our hand becomes part of the eyes. . . . In other words, the entire body becomes the eye" (ibid., pp. 271–272). The "body" is not a simple substance. As the a priori that forms the relationship subject/object, it is "the union point of several worlds." By taking the body as our point of departure, "we can travel through several worlds" (ibid., p. 543; see also *Self-Consciousness, NKZ* 2:238).

The artistic activity is an unparalleled example of the appearance, through man, of the "absolute free will." But here the word "example" means that the artistic activity was not the target but only the signpost of Nishida's speculation. The target was "the meaning behind" human experience, so that the artistic activity as well was nothing but a "specialization" about "the meaning behind." As the actualization of the "absolute will," art, together with the world of "moral

acts," is one moment of the "world of cultural phenomena," but it is located one step below moral acts (*NKZ* 3:499). "Morality" is what unceasingly strives to find "absolute freedom," as a world of "limitless oughtness." Contrary to this, art (the work of art) is "nothing but an incomplete, accidental fragment" (ibid., pp. 477, 488). Seen from this perspective, what distinguishes art is actually art's weakest point.

> It can be thought that the end of artistic creation is the product of the subjective imagination, which is not real. Poetry and painting thus reflect only one aspect of human life. They offer no criticism of moral good or evil whatsoever; even evil things can become beautiful as objects of art. In moral behavior duty faces the self as a unique duty that must be followed, whereas we can find infinite beauty in an object. In the beautiful we are free. Art ultimately cannot avoid a playful mood. (*NKZ* 3:479)[13]

The standpoint of "self-identity-will" does not actively understand the particularities of art. This is pointed out in the preface Nishida added later to *Geijutsu to Dōtoku* (Art and Morality). Nishida criticized the notion of "art for art's sake" on the grounds that "true beauty is not separated from the true and the good and a superficial art without content is not true art" (ibid., p. 239).[14] But thanks to the "playful mood"—the special freedom that transforms evil into beauty —art exceeds the established order. In other words, when reality is brought into the order specific to art, art transforms our way of looking at reality. The method of "severance" is what actually unites art and reality. The progress from eye to hand in artistic activity is never only a simple continuity; as Fiedler had emphasized, it was rather a leap, a rupture. Because of such a severance, man can posit a distance from reality. Nishida also referred repeatedly to the notion of "flow of life" (élan vital), which he took from Bergson ("The Essence of the Beautiful," *NKZ* 3:272f.) Nishida, however, did not clarify the structure of the "flow of life" that is characteristic of art. As a result, in the end, Nishida's speculation on art from *Self-Consciousness* to *Art and Morality* reduced art to a self-identical, continuous "will" that drives men and to the concretization of this will—an acting "person-

13. [The English translation is by David A. Dilworth and Valdo H. Viglielmo, trans., *Art and Morality* by Nishida Kitarō (Honolulu: University of Hawai'i Press, 1973), p. 163. Ed.]

14. [Ibid., p. 3. Ed.]

ality"—thus confining his interpretation of art to an example of the will. By looking at art from the standpoint of personality, Nishida understood the work of art as a simple "image of life" ("The True and the Beautiful," *NKZ* 3:477). While depending on Fiedler, in the end Nishida accepted the view of intuition that Fiedler had actually rejected. This was the result of Nishida's inability to depart from the magnetic field of Eastern art theories, which had united religion and moral theories in idealizing the "oneness of body/mind." Consequently, Nishida was unable to properly understand the most radical aspect of Fiedler's theory: the transformation of reality by means of expression.

Eastern "personality" views of the arts—views that consider art a symbol of personality and an expression of individuality—constituted the deep-rooted framework for the reception in Japan of Western art and art theories. In this respect, it was possible for Nishida's views of the arts to become the center of art movements and critiques of art. Further work needs to be done to clarify the relationship between the philosophy of the Kyoto school and art criticism. Relevant to this issue are Nishida's essays "Shōchō no Shin Igi" (The True Meaning of Symbols, 1918) and "Keiken Naiyō no Shujunaru Renzoku" (Several Continuities in the Content of Experience, 1919). In the former essay Nishida sees Charles Baudelaire's (1821–1867) "Man and the Sea" from *Les Fleurs du Mal* as the union of man and nature in a "transcendental world." In the latter, Nishida quotes from Fiedler and Ludwig Coellen (b. 1875) in order to give a "personality-based" interpretation of Vincent van Gogh (1853–1890), Paul Gaugin (1848–1903), and Henri Matisse (1869–1954). It is the same with the essay "Geijutsu no Taishōkai" (The Object World of Art, 1919). We cannot say that Nishida made erroneous statements with regard to art. We cannot deny that art is linked to personality. Great harm can be done, however, if "personality theories" are seen as authoritative and applied to art criticism. Such universals apply to everything—thus obscuring the specific difference of the phenomena that are actualized precisely in art experience. Both in his writings and in his poetry, Nishida was never free from such a discourse on personality. (On the issue of the Japanese reception of Western "personality" art in Nishida's time, see Nagai Takanori, "A Fragment in the History of the Reception of Cézanne in Japan—Formation and Directions in Personality Interpretations of Cézanne in the 1920s," in *Yuriika* 9:1996).

In those years Nishida basically grounded himself in Fichte's

Theory of Science. Fichte put at the bottom of all consciousness "the absolute I" as pure activity. Man is driven toward the perfection of the self's absolute activity. Whenever he meets with resistance and is forced back, "reflection" comes into being, which produces the experience of an object. At the bottom of theoretical reason, which is based on a relationship between self and nonself, lies a world of practice, the action of the self that is driven to "absolute activity." The self, which is originally active, reflects upon one's own actions through the things one has done. In strict conformity with this "event" (relationship between behavior and its result), the object shows its form. In addition to discussing the philosophy of will in the world of experience, Nishida adopted Fiedler's theory of expression and directed the philosophy of will toward Eastern thought, which searched for "oneness of body-mind." The notion of following the workings of the "absolute free will" meant for Nishida the "unification of all things and the self into one body" (*NKZ* 2:251), "a return directly under the self" (*NKZ* 2:283). To understand the major points in Nishida's philosophy and art theory at that time, we should look at the essays "Ishiki no Mondai—Shukaku no Kankei" (The Issue of Consciousness —The Relationship of Subject and Object, 1915), "Chikakuteki Keiken no Taikei—Seishin to Buttai, Ishi no Yūi" (The System of Intellectual Experience—Spirit and Substance and the Superiority of the Will, 1916) and "Zettai Jiyū no Ishi" (The Will of Absolute Freedom, 1917). In these essays Nishida argues that "true reality" as reason drives experience, and he interprets it as the "will of absolute freedom" that brings experience about. The "pure experience" that Nishida describes in *Inquiry into the Good* is seen in these essays as a fusion with the act of will.

In the preface to *Hataraku Mono kara Miru Mono he* (From the Actor to the Seer, 1927), however, Nishida states: "I turned from a Fichtean voluntarism to a kind of intuitionism" (*NKZ* 4–5). This means that Nishida thought the standpoint of "absolute free will" was not sufficient for laying the foundation of experience.

"Place" and Art

Theoretical knowledge ("consciousness") is confined to the point of view of the subject; the subject is premised on the existence of the object—the standpoint of "being." On the opposite side, the "I" as "absolute free will" that brings to formation the relationship subject/

object is the "bottom of nothingness" of consciousness where "no gimlet can reach" (*NKZ* 2:268, 274.) The "foreground" known as consciousness forms as "background" to the will, which cannot know this bottom. The action of the "free will" as "nothingness" *(mu)*, however, is perceived as being in strict conformity with this action. Since we are dealing with a "nothingness" that is opposed to a "being," it is actually a "confrontational nothingness." What makes it possible to talk about the action of the will as "nothingness" is the working of the "place" *(basho)*, which is tacitly assumed. From there, the will is actually seen. This absolute background, which also becomes the foreground of will, is "true nothingness," or the "place." There "even free will disappears" (*NKZ* 4:250). Even on this issue Nishida activates the magnetic field of Western philosophy, which questions all transcendental conditions of existence and experience. At this time Nishida pulls back from Fichte's philosophy to Greek philosophy and the phenomenology of the twentieth century, eventually returning once again to Kant's positions.

"Place," as the background of all acts and the background of consciousness, is the place where acts are seen as acts, the place that includes the entirety of acts within itself, the field of consciousness in which all individual consciousnesses appear (ibid., p. 210, 237). The expression "field of consciousness" calls to mind phenomenology. In this field of consciousness, all predicates of judgment are formed. It is impossible for the field itself to become a predicate (to become consciousness). In other words, it cannot become the subject that does the explanation, since it is a "transcendental predicate" beyond predicates (ibid., p. 5). Here Nishida refers to Aristotle's "substratum" *(hypokeimenon)* as "what becomes the subject of judgment, but not the predicate." Nishida reads the "absolute subject" as a "transcendental predicate." By making the substratum a self seen as an "absolute subject," the substratum reminds the reader of something like a "point," since its background must once more be questioned. Therefore the absolute subject must be a "transcendental predicate," which cannot conceivably become a predicate, and in which predicates form for the first time, and which includes all predicates. This becomes the "field of transcendental consciousness": the "place." It is the self that sees all acting. The title itself, *From the Actor to the Seer,* directly illustrates the diversion of Nishida's thought from *Self-Consciousness.*

In this diversion, moreover, Nishida goes back from Fichte's theory of the absolute self, seen as "pure activity," to Kant's theory of the

self seen as "transcendental apperception." Here Nishida reverses the basic stand he had taken until this time—that is, "behind pure experience there must be included the will" (*Art and Morality; NKZ* 3:472). The self now becomes the subject as "place" in which even the will is formed. In other words, the self must become a "place" on the other side of the will.

For me to say that all my experiences are actually experiences of myself, a "self" must be supposed at its bottom as the mechanism which unifies these experiences. Kant considered "transcendental apperception" to be the "background of all experience," that is, the "place." For Kant, however, this "self" was nothing but "a transcendental subject—X," which, as he argued, "once it was separated from the predicate (experience), was impossible to understand, so that we can only go around it" (*Critique of Pure Reason*, A 346, B 404). Kant conceived of the self as the absolute background of experience—it never comes out in the foreground—as something that produces experience or something similar. Here we find in Kant's philosophy the revolutionary aspect of his critique of traditional theology. Nishida, however, interprets this as "creative nothingness," "a concrete universal" (*NKZ* 4:238, 274). While understanding Kant profoundly, Nishida was drawn to Fichte's theory of the self. Fichte had foregrounded the Kantian "self" (transcendental apperception) as a background, seeing it as the "absolute self" that produces all experiences. Despite the name "absolute nothingness," Nishida's "concrete universal" suggests the Fichtean view of the self by being presented as the *ground* that makes individual experiences possible. This results from the fact that the language giving voice to the *experience* of Eastern "nothingness" pulled Nishida from transcendentalism toward an "Eastern mystical experientialism." Here again the artistic culture of the East warranted this experience.

This is clearly articulated in the preface to *From the Actor to the Seer,* where Nishida develops the idea of the "experience of seeing the form of the formless and hearing the voice of the voiceless" concealed "at the root of Eastern culture." What gives the argument a "philosophical ground" is also the subject of Nishida's theory of "place" (ibid., p. 6). For Nishida, artistic intuition is the reflection of the object on a consciousness that has become "true nothingness" (ibid., p. 286). "To reflect" means "to bring things to being as they are without distortion" (ibid., p. 226). Nishida returned to Kant's theory of the subject from within the linguistic field of the East

in which art, religion, and views on life had become entirely one. In "Sōda Hakase ni Kotau" (Reply to Dr. Sōda, 1927),[15] we see Nishida's Eastern understanding of Kant. Nishida argues that if a "return to Kant" is needed, he would like to think of a "return to the Kant of Kant." What is left at the end is "a truly direct heart that has gone beyond intellectual discrimination" (*NKZ* 4:312, 318). Nishida's understanding of Kant, which he made in light of Eastern philosophical theories, structured Kant's theory of the "self"—necessarily, we could say—to fit within a Fichtean understanding (misunderstanding). In fact, Nishida read "transcendental apperception" as "a big self—emptiness." The issue of "transcendentalism" became the issue of the mind and human life. This was not a problem concerning only Nishida. All of us who think by using Eastern languages are faced with the issue of the structures (mechanisms) of our thinking.

"Historical Reality" and Art

Starting in 1932, Nishida modified his understanding of "true reality" and began to consider it a "historical reality" rather than a "concrete universal" behind experience. The historicity of human experience became Nishida's main topic. The changes that took place in Nishida's thought around this time were elicited less from Western philosophy than from the work done by disciples of Nishida who were learning new Western philosophies. Particularly important was the thought of Miki Kiyoshi, which he made public in journals in 1931 and transformed, the following year, into the monograph *Rekishi Tetsugaku* (Philosophy of History). In this book Miki argued that human beings, while being regulated by the "environment," actually contribute to the formation of a new environment. He articulated the view that people are historical, "expressive" beings and that the concepts which hermeneutics devises for purposes of understanding are not sufficient to describe humans in their wholeness. Moreover, Miki explained how the human body is a "historical body." From 1933 this thought overlapped with Nishida's—for example, in the introduction of *Tetsugaku no Konpon Mondai* (Fundamental Problems of Philosophy, 1933). This fact illustrates the relation of mutual intellectual exchange between teacher and disciple. To search for the first to come up with an

15. [A reference to the philosopher Sōda Kiichirō (1881–1927). Ed.]

idea would only impoverish the debate. What is important to note here is the reaction to a new thought and the impact of such thoughts in bringing to fruition one's own philosophy. At least we can say that Miki never thought Nishida was taking advantage of his achievements. The same thing applies to Nishida. In the two debates that took place in 1935 and 1936 between the two thinkers, Nishida expressed to Miki almost the same ideas that Miki was entertaining at that time, and Miki agreed with him. In fact, Miki was delighted that his teacher concurred with his own thinking (*Miki Kiyoshi Zenshū,* vol. 17).

In "Benshōhōteki Ippansha" (The Dialectical Universal, 1934) Nishida argued that the I and the other, the individual and the historical environment, are contiguous but "severed." This dialectical relationship of reciprocity comes into being through an "expressive" act. Even the creative act of art is understood as a "self-limitation of the social and historical world" (*NKZ* 7:313ff.) In "Kōiteki Chokkan" (Action Intuition, 1937) Nishida presented even more concretely the thought of the "dialectical universal" seen as "the continuity of discontinuity." The following is a quotation from this work:

> The present, while being determined, is something whose determination should be denied. What is made, while being something that has gone by, goes to make what makes. Here we find the *continuity of discontinuity,* the self-limitation of nothingness. . . . The individual formation of the self is not a continuity from act to act but, rather, should be a continuity from what is made to what makes. In other words, it must be a historical continuity. (*NKZ* 8:546; the emphasis is the author's.)

Rather than emphasizing "contiguous" self-identity as he had done earlier, Nishida now concentrates on historical discontinuity, arguing that expression ceaselessly produces new forms through the mediation of severance while reinterpreting expression as a cultural, historical act. Here Nishida turns his attention to Hegel's *Phenomenology of the Spirit.* Dialectic is "concrete thinking"—"thinking that, once the self enters into the world of things, becomes these things." Nishida argues that "Hegel called such a dialectical movement experience" and says that "philosophy is the science that comes out of concrete reality through the mediation of the self of such reality. . . . We can say that Hegel was the first to fix his gaze on this point" (ibid., p. 552)

From this standpoint we can finally see properly the meaning and limitations of Fiedler's art theory. Nishida's essay "Rekishiteki Keisei Sayō to Shite no Geijutsuteki Sōsaku" (Artistic Creation as an Act of

Historical Formation, 1941) is the high point of his philosophy of art. In this essay, while pointing out the depth of Fiedler's theory of expression, Nishida criticizes the meager significance Fiedler accorded to the "historical" aspect. Then Nishida turns his attention to the "style theories" of A. Riegl[16] and W. Worringer,[17] who associated Fiedler's theory with the history of art. Nishida argued that "style" "finds articulation in history and becomes the paradigm of our behavior" (*NKZ* 10:181, 220ff.) The world of art provided Nishida with concrete explanations of how art is at all times an activity that creates the "paradigms" by which we look at things. Nishida's philosophy of art suggests this relationship, but he does not go any further. By stressing the notion of historicity, Nishida turns his attention to a search for the *origin* of art rather than to the novelty of art (the force leading to changes in our perception of reality). This explains why Nishida refers to Jane Harrison's (1850–1928) *Ancient Art and Ritual* (1913) (ibid., p. 182ff). We can assume that an analogous operation was at work in Miki Kiyoshi's essay on mythology in his *Kōsōryoku no Ronri* (The Logic of the Power of Ideas, 1939), given the attention that Miki paid in these same years to the anthropological results which were forthcoming, starting with Harrison's work. Miki talked about "action intuition" (*MKZ* 8:8), as well, and he also paid attention to the work of Riegl and Fiedler (*MKZ* 5:105ff; 12:41ff).

In his search for origins, Nishida once again spoke of the essence of Eastern art in opposition to Western art. This became the justification of his theory of "place." Against Western art, which is oriented toward grasping the "space of things," Eastern art was allegedly trying to grasp the "space of the heart." This was not "the space against the self" but "the space within the self." The "spirituality of Eastern art" is not to be found in the "pinnacles of Gothic style expressing infinite life" but in "the ordinary heart," which "includes heaven and earth in a tea bowl." The "line of Eastern painting" is like "the natural process of things as they are" (*NKZ* 10:162–163).

16. [Alois Riegl (1858–1905) wrote a study of decorative patterns from ancient to medieval times known as *Stilfragen* (Questions of Style, 1893). He also authored *Die spätrömanische Kunstindustrie* (Late Roman Art Industry, 1901). Ed.]

17. [Wilhelm Worringer (1881–1965) is the author of *Abstraktion und Einfühlung* (Abstraction and Empathy, 1908) and *Form-problem der Gothic* (The Problem of Form in Gothic Art, 1911). Ed.]

Here Nishida develops his thought from within the field of the Eastern philosophy of the way of art *(geidō)* and also from within the discursive space of the critique of ceramics that was popular at the time—for example, Yanagi Muneyoshi (1889–1961). This space was grounded in a view of "nature" that was melted into one with human life—the faith of "intuition." (On this issue see Iwaki Ken'ichi, "Longing for Nature—The Mechanism of Violence," in *Sheringu Nenpō,* or "Annual Bulletin on Schelling," 6, 1998.)

In Lieu of a Conclusion

Art—as conceived within the dual discursive space of Eastern and Western thought—played a particularly important role in Nishida's speculation on the theorization of "true reality." "True reality," which in the East was realized through salvation *(gedatsu,* "escape from intellectual explanation"), had a transcendental meaning in Western thought, which denied the experience of "true reality." So long as Nishida remained in the realm of Western thought, there was no way for him to return to Eastern "experience." Eastern art, and the language surrounding it, helped Nishida steer clear of this difficulty, moving once again toward the discursive space of the East. In the East, art was entrusted with the duty of serving as "essential intuition" departing from the finite self. Moreover, since "essential intuition" was a view of art that was also grounded in traditional Western thought, it was easy for Nishida to see the correctness of his beliefs in art. He read the new philosophy of art that had started with Fiedler as an Eastern philosophy of the oneness of thing and subject.

We now must ask whether it is possible to understand today's art through Nishida's philosophy of art. There is no positive answer to this question. Nishida's philosophy of art always stood on the ground of the universal. Nishida always grasped art from the perspective of the Eastern/Japanese spirit (psyche), anticipating the appearance in Japan of an art historian like M. Dvořák.[18] Such an approach, however, would be too simplistic to apply to a detailed description of a work of art today or to an explanation of its historical background. In fact, the aesthetician Ueda Juzō, who admired Nishida, had already

18. [Max Dvořák (1874–1921) is the author of *Idealismus und Naturalismus in der gotischen Skulptur und Malerei* (Idealism and Naturalism in Gothic Sculpture and Painting, 1918). Ed.]

criticized Dvorák's *Kunstgeschichte als Geistesgeshichte: Studien zur abendlandischen Kunstentwicklung* (The History of Art as the History of Ideas: Studies on the Development of Western Art, 1924). Today it would be impossible to apply Nishida's philosophical thought to any of the issues he discussed, including his understanding of Kant. We should abandon the idea of simply repeating Nishida's thought as he developed it.

In my opinion, there are two reasons for discussing Nishida's thought on art these days. The first relates to the fact that from Nishida's thought we can understand precisely what kind of art theories developed later on, and the role that art theory, which began with Nishida, played in the creation and criticism of art at the time, as well as on art education. This point stems from a reflection on the cognitive framework that allows us to think of art in the natural way we think of it today. Compared to this proposition, which seems relatively straightforward, the second reason might look reactionary. I believe, however, that this is something we must now do. I am referring to the idea that we might want to take another look at the tradition of the Eastern literatus—a tradition to be found in Nishida's thought—and make art once again relevant to our life. In the tradition of the Eastern literatus, the analysis of works of art, and the extraction of knowledge from such an analysis, were not material for the literati's livelihood. Neither were works of art simply objects of visual pleasure. The work of art induced conversation among those who sat around it while informing them culturally. The legends written on paintings in India ink bespeak this reality. This was not simply an analysis of the work; it was the creation of intellectual associations by observers who had come to experience those paintings, and it was praise of the work that elicited such associations. Today, from the point of view of art theory, this practice would be considered a laughable joke. And yet there is an unfathomable depth to intellectual play and a sense of joy that might be good to remember. Nishida's intellectual output possesses the depth of such a knowledge.

In Nishida's calligraphic writings we find quotations from Eastern philosophical works, such as the sayings of the Chinese patriarchs of Zen, Lao Tzu, and Mo Tzu. We also find poems by Tao Chien, Li Po, Tu Fu, Liu Tsung-yüan, Su Shih, and others, as well as his own poetry in Chinese and Japanese. Since his youth, Nishida was well versed in Zen thought. In Nishida's times, the process of westernization was progressing but the Eastern tradition was still alive and well. More-

over, the tradition of Eastern thought was reconsidered in dangerous ways in order to support the tendency to "ultramodernity" that stood opposed to the individualism of Western modernity. We should evaluate Nishida's work by contextualizing it within such a living tradition. In "Sho no Bi" (The Beauty of Calligraphy, 1930), Nishida himself underlined the fact that calligraphy is not "an imitation of the object" but rather "the revelation of the rhythm of a free life." He pointed out that the value of calligraphy is not "technique" but "man," and he emphasized "the manifestation of personality." If, however, from Nishida's calligraphy we only extrapolate Nishida's "personality" and "the rhythm of life," we would be indulging in an exercise of amnesia and modern evaluation. The meaning of calligraphy is not something that can be drawn from how interesting form is. Calligraphy is filled with deep meaning. It comes to life for the first time within the associations we elicit from this meaning. "The holy man has no merit," for example, is a quotation from the chapter "Free and Easy Wandering" of the *Chuang Tzu*.[19] With regard to the implication that the holy man has escaped discrimination, this quotation is linked by association to Nishida's notion of "pure experience." The source of the quotation "the true man without rank goes in and out freely," is *Li-chi Lu* (Record of Li-chi), and it conveys the master's invitation to look at the man of wisdom who penetrates the body of the unenlightened. This "true man" derives from and is the same as "the holy man" of the *Chuang Tzu*. Zen is located in the linguistic field of Lao Tzu. The poetry of the Six Dynasties, as well as the poetry of the Tang and Sung dynasties, is not simply a direct portrait of nature and the human heart. Since nature and the heart were sung in conformity to the language used since the time of Confucius and Lao Tzu, they became one with Eastern views on religion. There is no doubt that this captivated Nishida.

Nishida Kitarō Iboku Shū (Collected Autographs of the Late Nishida Kitarō; enlarged edition, 1983, Tōeisha), first published in 1975, contains calligraphic samples and poems. Unfortunately, there is no indication of the sources from which Nishida originally took these quotations. We can only refer to an essay by one of the editors, Nishimura Kisaburō. According to a letter addressed to Hisamatsu,

19. [The English translation is by Burton Watson, *The Complete Works of Chuang Tzu* (New York: Columbia University Press, 1968), p. 32. Ed.]

the samples with the sketches of Bodhidharma and Fukurokuju[20] are probably from 1933. We read two inscriptions: "This Bodhidharma is pointed like a penis" and "Long life means many shames." The second quotation comes from the "Heaven and Earth" chapter of the *Chuang Tzu*.[21] In these works we find a "world of laughter" we usually do not see in the thought, calligraphy, and poems of Nishida. In the essay mentioned earlier, Nishimura points out the link between the latter sketch and the work of Ike no Taiga (1723–1776), which Nishida saw in 1933. Regarding the inscription on the drawing of Bodhidharma, a relationship between this and the Zen master Hakuin (1685–1768), who lived in the mid-Edo period, has been pointed out. (See Karaki Junzō, "In Relation to Professor Nishida's *Collected Autographs*," in Karaki Junzō and Shimomura Toratarō, eds., *Nishida Kitarō no Sho*, Tōeisha, 1987, p. 37.) When we consider the year this sketch was produced, the laughter of the Zen master Sengai (1751–1837) of mid-Edo surfaces. In fact, two years earlier Nishida had seen, together with Tsuda Seifū (1880–1978), the works of Sengai (*Nikki*, or "Diary"). There are two drawings by Sengai: one of "Bodhidharma" with a truly humorous inscription; the other with the "Old Six Poetic Geniuses." The inscription of the former makes the aura of Zen evaporate with a big laugh. It says: "Mourning Bodhidharma / A boil in my buttocks / How it hurts!" The source of Nishida's inscription "This Bodhidharma is pointed like a penis" might well have come from here. In Sengai's inscription on the "Old Six Poetic Geniuses," we feel the author's merciless satisfaction at poking fun at the illnesses of old age:

> Wrinkled, his back bent, bold and with a white beard, the hands shaking, unsure on his legs, toothless, his ears are deaf, his eyes blind, his head wrapped in a hood, helping himself with a stick, and glasses on his nose, wants to hear everything, sad at the thought of death, the heart filled with desire, garrulous, short-tempered, stupid, wants to go out all the time, imposes on everybody, repeats himself infinite times in praise of children, everybody hates him for boasting his skills—the song of the old man!

Nishida's "Long life means many shames" is a moderate rendering of Sengai's humor. When we locate Nishida's work in this context, a

20. [See Iwaki Ken'ichi, *Nishida Kitarō Senshū*, p. 392. Ed.]
21. [See Watson, *Chuang Tzu*, p. 130. Ed.]

completely different world from "personality" and "the rhythm of life" appears before us.

For further information on Nishida's stand on the arts we should look at his *Jisen Shika Shū* (Collection of Personally Collected Poems), which he included in his diary of 1931. In his essay "Tanka ni Tsuite" (On Poetry), Nishida states that 31-syllable poems are "lyrical" forms that "seize human life from the center of reality" and "show the rhythm of the emotions." Nishida's poems, like his calligraphy, cannot be called masterpieces. Most of his poems are rather a venting of his feelings. Although he calls it a diary, it is not really what we would expect of a diary. In the case of a diary in prose, words try to express the depth of the writer's pain. But when we celebrate our heart in a set number of words, the pain is absorbed by the tone and the heart is entrusted to natural phenomena and the seasons through the use of the seasonal expressions required in this poetry. In this way the heart comes to be scrutinized. In his poetry, the personality and mind of Nishida fail to emerge. When Nishida tries to express his heart in verses with simplicity, the power of the linguistic form which is peculiar to *waka* stands out because of that simplicity. This is the same result achieved in his calligraphy, which is put into movement by the special strength of brush and ink. The "simplicity" of a work is not the result of the author's mind and personality. It depends on the structure of the work that comes to life when the author is moved by the special strength of the material he employs.

19

The Logic of Visual Perception
Ueda Juzō

Iwaki Ken'ichi

Ueda Juzō (1886–1973) was born on March 11, 1886, in the village of Fugenji in the Tsuzuki district of Kyoto prefecture. In 1908 he graduated from the Third High School and entered the philosophy department of Kyoto Imperial University, Humanities University (Kyōto Teikoku Daigaku Bunka Daigaku)—the present-day Humanities Division (Bungakubu) of the University of Kyoto. The following year the Chair of Aesthetics and Art History was instituted at Kyoto Imperial University. In 1910 Fukada Yasukazu (1878–1928),[1] who had just returned from a trip to Europe, became the first tenured holder of that chair. In 1911 Ueda took his B.A. under Fukada and entered graduate school. Ueda was appointed assistant the following year—a position he kept until 1919 (during this year Bunka Daigaku was renamed Bungakubu). In 1916, while Ueda was an assistant, the journal *Tetsugaku Kenkyū* (Philosophical Studies) was founded. At this time, *Bungei* (Literary Arts) and then *Philosophical Studies* drew attention to the philosophy of the Kyoto school, which had started with Nishida Kitarō (1870–1945)[2] and which these journals helped to publicize. Ueda was a dedicated editor of *Philosophical Studies* from the time of its foundation until 1919. During that period he turned to Nishida's thought. Ueda recorded his memories of this time in "In Lieu of a Preface" in his late work *Kaiga no Ronri* (The Logic of Painting, 1967). In 1919 Ueda became a lecturer in the Humanities Division and then, in 1921, an associate professor lecturing on

From Iwaki Ken'ichi, "Shikaku no Ronri: Ueda Juzō," in Tsunetoshi Sōsaburō, ed., *Nihon no Tetsugaku wo Manabu Hito no Tame ni* (Introduction to Japanese Philosophy) (Kyoto: Sekai Shisōsha, 1998), pp. 197–232.

1. [See Chapter 17. Ed.]
2. [See Chapter 18. See also Marra, *Modern Japanese Aesthetics,* pp. 171–217. Ed.]

aesthetics at Kyoto Imperial University. In 1924 Ueda made public his first work, *Bijutsu Tetsugaku* (The Philosophy of Art), in which he recast the thought of Nishida's middle years as an aesthetic theory. He then went to study in Germany, France, and England from 1925 to 1927, inspecting the arts of several European countries and deepening his understanding of Western art. In November, one month after his return to Japan, Ueda was appointed professor of aesthetics and art history at Kyushu Imperial University (Kyūshū Teikoku Daigaku)—a position he filled while still lecturing at Kyoto Imperial University. In 1929 Ueda obtained his doctorate. The following year, after the death of Fukada Yasukazu, he was appointed professor at Kyoto Imperial University. (He also kept his post at the University of Kyushu until 1933.) Ueda remained the leading figure in the fields of aesthetics and art history at Kyoto Imperial University until his retirement in 1946, dedicating his time thereafter to his own theoretical work. He died on November 27, 1973.

Ueda's thought developed under the influence of Nishida's philosophy. His main subject was a discussion of the artistic phenomenon and its relationship with aesthetic experience. With the deepening of his understanding of this subject, we see in Ueda's work a strengthening of a tendency toward concrete development of transcendental thinking—a tendency he assimilated from Nishida. We already see this characteristic at work in Ueda's *Geijutsu Shi no Kadai* (The Subject of Art History) of 1936. In *Shikaku Kōzō* (The Structure of Visual Perception) of 1941 and *Nihon no Bi no Seishin* (The Spirit of Japanese Beauty) of 1944, however, differences from Nishida's thought come to the fore. Against Nishida's understanding of art as one part of "culture," Ueda stressed the particularity *(différance)* of art and severely criticized the limiting of art to the category of culture. In the war years, he published extensively on Japanese and Eastern artistic thought. Even Ueda's aesthetics was not immune from the tendency, quite common at the time, to deal with issues related to race. Ueda, however, questioned the reduction of art to the question of culture. His theory, which aimed at clarifying the particularity of aesthetic experience while discussing characteristics of East Asian art, escaped the danger of linking notions of art directly to the Japanese spirit and using this linkage to celebrate the racial spirit. In this respect, Ueda's aesthetics was a "weak theory" without the support of an ethics—a theory which at the time was actually considered morally questionable. And yet we can say that this "weakness" pro-

vided Ueda with a special position in the philosophy of the Kyoto school and shows a critical distance from that age. Ueda's aesthetics challenged the validity of reducing art to questions of moral content and religious truth. We can articulate a discourse on art more clearly, he argued, if we realize unequivocally the speculative structure of the self that tries to explain art according to aesthetic experience. In his book *Geijutsu no Ronri* (The Logic of Art, 1955), Ueda called this phenomenon "the transpracticality of art." In a chapter titled "Did Zen Influence Art?" from *The Logic of Painting,* which Ueda wrote during the last years of his life, he leveled a strong critique against the reduction of art to Zen thought. This chapter shows that Ueda drew a line between himself and the many philosophers of the Kyoto school who inherited Nishida's philosophy, as well as between his work and the art criticism that was supported by the theories of these philosophers and grounded its thought in Buddhism, especially Zen Buddhism. Ueda must have reached this belief after he realized, from his concrete interpretations of the peculiar structure of art experience, the impossibility of eliciting the explanation of such experience from one single principle. I believe we must reflect carefully, and therefore logically, on the specific formation and meaning of every single cultural sphere. As a result, we will finally awake to the heterogeneity of this heterogeneous world, since a path will open to a scientific study of the relativization of the self, one that scholars are carrying out today. Ueda introduced the possibility of such a new speculation.

With regard to influences on the aesthetics of Ueda, I must mention the reception of Konrad Fiedler (1841–1895). As I have discussed elsewhere,[3] on this point we should not forget the influence of Nishida. The meaning of Fiedler's thought on art, which came to Ueda through Nishida, was eventually handed down by Ueda's disciples, leading to the formation of one aesthetic tradition in the Kansai area. One hundred years after his death, Fiedler's thought has been revisited in Germany. More than in the philosophy of Western Europe, however, where attention to Fiedler's work has not been so extensive, Fiedler

3. For Nishida's reception of Fiedler and the impact of this influence on the Kyoto school see Iwaki Ken'ichi, "Nihon ni Okeru Fīdorā—Chokkanteki Genjitsu no Shinsō wo Megutte," *Sekai Shisō* 22 (1995). Miki Kiyoshi's positive assessment of Fiedler against Dilthey depended on Miki's understanding of Nishida; see Miki Kiyoshi, "Hyōgen ni Okeru Shinri" (1935), in *Miki Kiyoshi Zenshū,* vol. 5 (Tokyo: Iwanami Shoten, 1967), p. 105ff.

has left a mark for more than a hundred years, first in the field of philosophy and then in aesthetics, in a small East Asian country where his work continues to be read, taught, and handed down from generation to generation. Rather than a thought of identity, we find in Fiedler a thought of subtle difference. When we follow Ueda's thought, we realize that despite his debt to Nishida and critique of him, in reality he practiced and tried to convey a philosophy of *différance*.

Ueda's aesthetics focused on an examination of the plastic arts and addressed the question of a "logic of visual perception." In "Lieu of a Preface" from his *Logic of Painting*, Ueda celebrated the five hundred issues of the journal *Philosophical Studies* (founded in 1916) for which he had worked as an editor in his youth, and he expressed his gratitude, calling this journal "the soil that gave purpose to most of my life." He also made the following remarks:

> Because of the gratitude I felt, I imposed on the attention of the academic world during the past twenty years with a few articles, pursuing the meaning of "visual perception" *(shikaku)* which I believe to be at the origin of art. I did nothing but think in some detail about a problem I had already tried to address forty years ago. . . . Now that I am reaching the end of a life that has spanned over eighty years, my efforts have finally reached fruition. (Ueda Juzō, *Kaiga no Ronri* (Tokyo: Sōbunsha, 1955), pp. 2–3)

The reference to the attempts made "forty years ago" indicates Ueda's first publication, *The Philosophy of Art* (1924). In almost all respects, such as the speculative method, the technical vocabulary, and so forth, this book is indebted to the middle phase of Nishida's thought spanning from *Jikaku ni Okeru Chokkan to Hansei* (Intuition and Reflection in Self-Consciousness, 1917), through *Ishiki no Mondai* (The Issue of Consciousness, 1920), and up to *Geijutsu to Dōtoku* (Art and Morality, 1923). Following Nishida's thought, Ueda approached the issue of the particular logic of "visual perception," not from the perspective of experiential psychology, but from the possibility that visual experience comes into being as visual experience—in other words, from the perspective of transcendental philosophy. The time when the young Ueda was a student at Kyoto Imperial University, working as an editor of *Philosophical Studies,* coincided with the time when Nishida published, one after another in the same journal, the essays that were eventually collected in the three books mentioned earlier. From the essays Ueda published during his life, we can trace the reference to the "soil that gave purpose to most of my life"

back to Nishida's philosophy. Until his later years, Ueda continued to defend the perspective of an aesthetics grounded in a transcendental logic of visual perception that he introduced in *The Philosophy of Art,* and he continuously emphasized the importance of his position. We can say that Ueda's efforts during his whole life were directed to making increasingly concrete a transcendental aesthetics whose preliminary ideas Nishida had sketched out while clarifying the artistic experience of the self. Ueda's comment that "my efforts have finally reached fruition" indicates that the transcendental aesthetics prepared by Nishida had finally borne fruit, thanks to Ueda's extensive efforts over the years, as an aesthetics that concretely explained the particular nature of works of the plastic arts as visual objects. Therefore, we must address the following important questions with regard to Ueda's aesthetics as an example of "Japanese philosophy": What kind of relationship exists between Ueda's aesthetics and the middle phase of Nishida's thought (which informed Ueda's own thought)? From there, how did Ueda conceive his aesthetics? Later on, how did Ueda's aesthetics develop, and which characteristics of art did it clarify? How did Japanese and East Asian art and art theories influence Ueda's aesthetics? Moreover, what are the distinguishing characteristics of Ueda's thought in his interpretation of Japanese and East Asian aesthetics?

Ueda's Reception of Nishida's Philosophy: The Formation of a Transcendental Aesthetics

An Outline of Nishida's Middle-Period Thought on Art

According to Ueda Shizuteru, Nishida's journey from *Zen no Kenkyū* (An Inquiry into the Good, 1911) to *Jikaku* (Self-Consciousness) corresponds to a turn from "the standpoint of pure experience" to "the position of self-awakening."[4] In Nishida the so-called pure experience is a transcendental act (the act of acts) that is found at the bottom of all experiences and brings experiences (acts) into being. Thanks to this "act of acts," the relationship between the object as a specific entity and a subject as an act of cognition becomes possible. In this sense, pure experience is the "true being" as the sine qua non

4. Ueda Shizuteru, *Nishida Kitarō wo Yomu* (Tokyo: Iwanami Shoten, 1991), p. 254. Quotations from Nishida come from his collected works, *Nishida Kitarō Zenshū* (Tokyo: Iwanami Shoten, 1978–1980), with an indication of the volume and page in question.

of all entities. Linguistic cognition as well (the act of reflection) comes into being for the first time as a specific cognition thanks to this transcendental act. This is why language is prior to the self and cannot reach the pure experience that makes the self possible. In order to demonstrate reality philosophically, however, "pure experience" must be made into language. This contradiction between pure experience and language, one that cannot be avoided in a linguistic practice such as philosophy, can only be resolved after the act of reflection (self-consciousness) has been proved to be immanent in pure experience itself (intuition). For Nishida, the explication of the immanence of the act of self-consciousness in pure experience means an explanation of the act of self-expression of pure experience. This results from Nishida's interpretation of expression as a continuous development —as the development of the act of reflection (self-consciousness) that is found inside intuition, which in turn is the product of the imagination. Nishida's attention to the expressive act was a search for the possibility of a new philosophy. This speculation was related to a critical rethinking of an understanding of man as a split (a dualism) of the active and passive elements of experience—subject and object, mind and body, meaning and speech—as well as to a rethinking of the sciences, institutions, and cultures that are based on such dualisms.

In *Self-Consciousness* Nishida repeatedly stresses the active nature of the senses (an individual self-conscious act). As Ueda Shizuteru has pointed out, during this period Nishida aimed at combining Henri Bergson's (1858–1941) "pure duration" with the Neo-Kantians' notion of "reflection," and he searched for a solution in Fichte's "act" *(Tathandlung)*.[5] Nishida had detected the key to escape dualisms in Western thought in an explanation of the self-conscious act of sensations (the reciprocity of act and reflection upon it)—a key that would allow him to prove the immediacy (continuity) of the relationship between subject and object (mind and body). In the context of this effort, Fiedler's artistic theory supplied, together with Bergson's *L'Évolution Créatrice* (1907), a powerful argument to clarify Nishida's idea of the "self-consciousness" of pure experience in conformity with experience itself. We find confirmation of this in "Bi no Honshitsu" (The Essence of the Beautiful; in *Geijutsu to Dōtoku*) of 1920. Here Nishida refers to Wilhelm Dilthey (1833–1911) and Fiedler.

5. Ueda, *Nishida Kitarō wo Yomu*, p. 262. See also the "Introduction" of Nishida's *Self-Consciousness*.

Arguing that he "wanted to follow" the latter's *Über den Ursprung der künstlerischen Tätigkeit* with regard to the explanation of "expression," he indicated the reasons for such a choice:

> If we follow Fiedler, a thing does not become the object of our knowledge by its mere existence. We are able to receive only the result of what we have structured into our own world. Hence, we must say, if we carry this idea through more thoroughly, that reality is constituted by the images that are the expressions of the results that we have constructed. Spiritual acts do not stop as events within the mind but must seek expression in the body. Expressive movements are not external signs of spiritual phenomena but are states of their development and completion. The spiritual act and the expressive movement are one act internally. Thus, our language is not a sign of thought but is an expressive movement of thought. Thought perfects itself through language. However, our world is not merely one that has been expressed by thought and language. Our spiritual acts are infinite activities, and each possesses its own world of expression. As the act of pure visual perception develops into language, it naturally moves our body and develops into a kind of expressive movement. This is the creative act of the artist *(künstlerische Tätigkeit)*. In this standpoint the world of concepts suddenly dissolves, and the prospect of a world of infinite visual perception opens up. I think that the most profound meaning of Dilthey's idea of artistic expression that cannot be limited to either internal or external will can be clarified by this. Dilthey's explanation goes no further than the subjective meaning of the creative act of the artist, but Fiedler clarifies its objective meaning. (Nishida Kitarō, *Geijutsu to Dōtoku*, in *Nishida Kitarō Zenshū* 3:268–269)[6]

Nishida superimposed Fiedler's art theory upon the boundaries of the Eastern notion of the "oneness of body-mind" *(shinjin ichinyo)* (*NKZ* 3:269). Even in the "Introduction" to *Self-Consciousness*, Nishida confesses that here lies his true motive for referring to Fiedler:[7]

> In Sections 19 and 20, following Fiedler, I show that perceptual experience, in its pure state, is a formal activity, and that the continuous is the truly real. (*Self Consciousness*, in *NKZ* 2:7)[8]

6. [The English translation is from Nishida Kitarō, *Art and Morality*, trans. David A. Dilworth and Valdo H. Viglielmo (Honolulu: University of Hawai'i Press, 1973), pp. 23–24. Ed.]

7. The name of Fiedler first appeared in Nishida's diary the year after the publication of *An Inquiry into the Good*—June 16, 1912, which corresponds to the beginning of the middle period of Nishida's thought (*NKZ* 17:294).

8. [The English translation is by Valdo H. Viglielmo with Takeuchi Yoshinori and Joseph S. O'Leary. See Nishida Kitarō, *Intuition and Reflection in Self-Consciousness* (Albany: SUNY Press, 1987), p. xxi. Ed.]

Nishida found, in the thought of Bergson and Fiedler, a key to elucidate the "formal activity" (expressive power) immanent in pure perception. Accordingly, he grasped the true reality known as pure experience, not as the "beyond" of language or a human experience regulated by language, but as the basic activity (continuity) immanent in individual experiences, and one that makes experience possible—a creative evolution of the Bergsonian type (*NKZ* 2:66, 277). Even at this time, Nishida clearly stood on transcendental ground. He regarded pure experience as "the meaning behind" that brought experience into being, while being hidden in each human experience (*NKZ* 2:136) as "the absolute free will" (*NKZ* 2:281, 330). The human act of cognition, by contrast, he considered to be the concretization of the "self-identity will" as what moves cognition to act, "the point of contact" with it (*NKZ* 2:281), "the point of self-realization of transcendental will" (*Art and Morality, NKZ* 3:396). Nishida also discussed the act of visual perception from this point of view. According to him, the world of pure visual perception is the "world of concrete, personal experience, in which a visual act develops itself in the standpoint of the act underlying all acts" (*NKZ* 3:272).[9] As the act underlying all acts, pure visual perception is a transcendental act that makes possible individual acts of visual perception. Through a "split" of this act, a relationship is formed between the subject of vision (the seer) and its object (the seen). To explain this point, Nishida often alluded to the perception of colors:

> For red to be distinguished from blue, there must be a unity of the two. This unity is both red and blue and at the same time must be thought to be neither red nor blue. And it is precisely this unity that is the perceptual act in the true sense. . . . The visual act is thus an internal relationship in which colors distinguish themselves, so to speak, and it is the a priori upon which color experience is based. Every concrete experience possesses the two inseparable aspects of content and act in this way. However, when we have reflected upon this a priori from the intentionality of free will, which is the act underlying every act and the a priori underlying every a priori, the synthesis of these noetic acts creates an independent, objective world. The "self" is precisely the point of synthesis of such acts. (*NKZ* 3:248)[10]

9. [Nishida Kitarō, *Art and Morality*, p. 26. Ed.] See also *Art and Morality* (*NKZ* 3:244, 255).

10. [Nishida Kitarō, *Art and Morality*, pp. 9–10 Ed.] See also *Art and Morality* (*NKZ* 3:255, 519); *Self-Consciousness* (*NKZ* 2:86, 102, 120, 157).

"The world of pure visual perception" is the world in which the act of transcendental vision (the a priori of visual perception) is actualized into concrete experience—that is, the world of "the act of artistic creation." Therefore, art is understood as an activity that forms the relationship subject/object (mind/body) and brings into motion the diverging points of both—one activity that illuminates the a priori (the immanent transcendental) of immanent experience in the experience known as "the act underlying all acts" (*NKZ* 3: 254ff). Nishida's discussion of art mainly privileges the act of visual perception. He clearly brings Fiedler's thought to bear upon the identity relationship of body and mind in artistic activities, arguing that "the one visual act accompanied by its own muscular sensation produces movement in the whole body," "the hand becomes one with the eye; the entire body becomes the eye" (*NKZ* 3:271–273).[11] The body is "not simply a substance." It is "the synthesis of several worlds" as the a priori behind the formation of the subject/object relationship. By taking this body of ours as "our point of departure, we can go in and out of different worlds" (*NKZ* 3:543; see also *Self-Consciousness*, in *NKZ* 2:238).

For Nishida the artistic activity was an unparalleled model of "behavioral subjectivity," which is the basic act in the formation of the subject/object relationship (*Art and Morality, NKZ* 3:530ff). The expression "model," however, indicates that the artistic activity is not the target of Nishida's speculation; it is no more than a signpost. Nishida's target is "the meaning behind" human experience. The artistic activity as well is nothing but a branch of "the meaning behind." Nishida uses several expressions to indicate the "meaning behind" as the act underlying all acts. Besides using such terms as "absolute free will," "free will," and "transcendental will," he also employs the expressions "unified identity" (*Self-Consciousness, NKZ* 2:67), "creative synthesis lying behind" (ibid., *NKZ* 2:80), "personalistic synthesis" (ibid., *NKZ* 2:290), "free self" (*Art and Morality, NKZ* 3:245), "the big self" (ibid., *NKZ* 3:264), and "absolute will" (ibid., *NKZ* 3:272). Together with the world of moral action, the artistic activity is a moment of "the world of cultural phenomena" as the realization of the "absolute will," although Nishida locates it in a subordinate position with respect to moral action (*NKZ* 3: 499). The subordination

11. [Nishida Kitarō, *Art and Morality*, pp. 26–27. Ed.]

depends on the fact that for man the world of will, as "the world of act" that searches after a ceaseless development toward perfect realization, is the world of "the unlimited what ought to be" and the morality that perfectly befits such a world. The world that produces art (works of art), however, "is nothing but an incomplete and accidental fragment" (*NKZ* 3:477, 488). For Nishida, who looks at human experience from the perspective of identity will, what distinguishes art as art actually becomes the weak point of art.[12]

There is no doubt that Nishida perceived the difference between art and morality. The standpoint of "identity," however, could not positively provide an understanding of the particularity of art. The preface that Nishida later added to *Art and Morality* clearly indicates this problem. Nishida criticizes "aestheticism" on the grounds that "true beauty is not separated from the true and the good and a superficial art without content is not true art" (*NKZ* 3:239).[13] But thanks to the particular freedom that makes evil into beauty, and to its "playful mood," art goes beyond the established order of good and evil. In other words, art transforms the way of looking at reality by transforming reality into the particular order of art. Art and reality are actually brought together by their way of being separated. The progress from eye to hand in the artistic act is never simply a "continuity"; it is a leap, a "rupture," as Fiedler emphasized. Because of such a rupture we can actually separate ourselves from reality.[14] Nishida also pointed out repeatedly the notion of élan vital in artistic creation (*NKZ* 3:272ff). Nishida, however, did not identify the structure of the élan vital peculiar to art. Thus Nishida's speculation on art from *Self-Consciousness* to *Art and Morality* in the end reduces art to an identical "will" forming the subject/object relationship despite the prominent attention that Nishida gives to aesthetics. Nishida limits himself to regarding art as one example of this will. In order to see art from the perspective of "human life," Nishida considers the work of art to be nothing but "the image of life" rather than "life itself" (*NKZ* 3:477). While absorbing Fiedler, Nishida in the end confines himself

12. [I have eliminated a quotation that appeared in the previous chapter. See Chapter 18, note 13. Ed.]

13. [Nishida Kitarō, *Art and Morality*, p. 3. Ed.]

14. On problems related to the meaning of Fiedler's debates on art see Iwaki Ken'ichi, "Gendai Kanseigaku to Futatsu no Shin Keijijōgaku—Sono Atarashisa to Mondaisei no Mekanizumu," in Iwaki Ken'ichi, ed., *Kansei Ron: Ninshiki Kikairon to Shite no Bigaku no Konnichiteki Kadai* (Tokyo: Kōyō Shobō, 1997).

to defending the notion of commonsensical "intuition," a position that Fiedler criticized. The aesthetics that succeeded Nishida had to clarify the special structure of artistic experience which Nishida had not sufficiently explored. Ueda Juzō dedicated his whole life to this task.

Ueda's Philosophy of Art

Ueda applied the expressions "representation," "visual perception," and "visual act" to the transcendental condition forming the object/ consciousness relationship that is found in the working of "seeing." "Representation" indicates the transcendental condition of universal perceptive experience; "visual perception," "the act of visual perception," and "the idea of visual perception" indicate the transcendental condition of universal visual perception. (See Ueda Juzō, *Geijutsu Tetsugaku* [Tokyo: Kaizōsha, 1924], p. 280.) According to Ueda, the representation of an object is the "basic, a priori synthesis of the consciousness outside and the consciousness of an object (p. 15). Each representation is sustained by "the a priori synthesis" of "outside" (space) and "object" (phenomenon). Ueda calls the "visual idea," acting as an a priori in the working of seeing, "what makes the act acting" (p. 17). He argues that "we must think of a deep will at work in the idea of visual perception in bringing into action the special act as visual perception" (p. 18).

Clearly Ueda has assimilated Nishida's thought, including his technical language. With the expression "absolute free will," he is referring to the "highest unifier"—"the idea of ideas" that unifies all sorts of ideas (pp. 19 and 23). From this standpoint, individual visual acts are not something that makes man free. To be a man is "simply to follow the essence" of the concept of visual perception that makes the act acting. The "eye" is "the idea of visual perception . . . in its embodied form" (p. 18). Ueda also understands individual existence in Nishidean fashion. The individual is "a tiny shadow of the absolute free will"—"a simple joint of an infinite creation" (p. 187). The "I" is the "point of the union of ideas" as a "concretization of the artistic idea eternally unfolding" (p. 124). The notion of "artistic idea" in the foregoing expression derives from Nishida. Nishida had taken from Fiedler the idea of artistic activity seen as an act of visual perception developing into a body movement—the progress of visual perception from the eye to the hand. Nishida considered art the original realization of the act of visual perception. Ueda borrows this idea

from Nishida and argues that "even in a finger we find the tension of visual perception" (p. 133). The work of art, which materializes through the development of visual perception into the movement of the hand, is "higher" than nature (p. 155). The artist pays his respects to nature since he sees the "artistic idea" in it (p. 158). The "truth of nature" is the "artistic idea." The problem of "controlling the meaning of painting" is to find out "what kind of life, colors, and forms it possesses in presenting its objects as direct concretizations of ideas" (p. 171). Nishida had prepared the path to Ueda's understanding of the relationship between nature and art. Nishida had unceasingly criticized the "dogmatism" of the fracture subject/object in the natural sciences, arguing that such a perspective reduces the natural world to nothing but "a projection of the will."[15] Nishida emphasized that in art the object was made each time in conformity with its relationship with the subject. He pointed out that in natural sciences the object was located outside the subject as a result of discarding and ignoring their relationship. Within the context of a critique of such a dualism, Nishida had turned his attention to Bergson and to the art theory of Fiedler. Ueda transferred to transcendental aesthetics Nishida's thought and the thought that Nishida had borrowed from Fiedler. The idea that "color and form" exist against visual perception indisputably belonged to Fiedler.[16] Ueda, however, interpreted "color and form" as the transcendental limit of visual perception.

When seen from the point of view of the act of transcendental visual perception, the "materials" of art secure a different meaning than that of being a simple, external means. The materials are the "ideas of art made into substances." The existence of pigments is carried a priori in the idea of visual perception. By foreseeing this, the work of art comes into being (pp. 185–186). Artistic understanding as well—that is, the representation of nature (the subject) existing in advance—depends on a mixture of "artistic truth" (creation) and "scientific truth" (knowledge) (p. 169). Ueda argues that "to see is to make with the eyes; to make is to see with the hands" (pp. 286–287). The work is the "concretization of the artistic idea" in this process— a process that further "develops as the experience of the observer."

15. *Self-Consciousness* (NKZ 2:53, 345); *Art and Morality* (NKZ 3:362, 492, 503, 532, 543).

16. K. Fiedler, *Über den Ursprung der künstlerischen Tätigkeit* (1887), in Konrad Fiedler, *Schriften zur Kunst*, vol. 1 (Munich, 1971), p. 255.

Ueda regards the act of contemplation, not as a simple issue of knowledge and aesthetic pleasure, but as "the development of the act of visual perception"—"the extension of creation" (p. 277ff). Thus Ueda properly grasps the creativity of the hermeneutical act. In order to stress the "continuity" between contemplation and creation, Ueda speaks of the "novelty" of a world deriving from the development of the act of visual perception, but like Nishida he leaves unresolved the theorization of its structure. As a result of overemphasizing the creativity (identity of contemplation and creation) of contemplation (intuition), the difference between contemplation (eye) and production (hand) disappears, so that the structure of the leap from contemplation to production actually becomes obscure.

Nishida is right to pay attention to Fiedler and argue that language is not a "sign" of thought but rather "an expressive movement." But he abandons Fiedler's basic idea of assigning different dimensions to the two realities derived from the unbridgeable rupture between the thought prior to language and the thought that is made into language. Moreover, Nishida interprets the difference in power among the senses (vision and touching)—to which Fiedler had given serious consideration (pp. 264–265)—as something that should be reduced to "the synthesis of the individual" (*Self-Consciousness; NKZ* 2:290–291). Ueda's emphasis on the "continuity" between contemplation and production presents the same problem. Following Nishida, Ueda criticizes Fiedler's clear distinction between contemplation (intuition) and production (expression), emphasizing instead their continuity and the creativity of contemplation itself (Nishida, *Art and Morality, NKZ* 3:241; Ueda, *Geijutsu Tetsugaku,* p. 299ff; Ueda Juzō, *Bi no Hihan* [Tokyo: Kōbundō Shobō, 1948], p. 1ff). For the philosopher Nishida, the main object of consideration is the comprehension of all of human activity from the point of view of identity. In other words, this was "the transcendental desire" to put transcendental philosophy into motion. To this end Nishida mobilized the thought of Fiedler despite the latter's opposition to this stand. In opposition to Nishida, the aesthetician Ueda takes as his main subjects of research the act of visual perception as the actualization of identity and the special structure of this phenomenon. Differences in subject matter appear as differences between Ueda's and Nishida's speculative structures.

In the same period that Ueda wrote *The Philosophy of Art,* he published *Kindai Kaiga Shiron* (Historical Treatise on Modern Painting, 1925). In this book Ueda takes a lead from reproductions of

nineteenth-century paintings from Jacques-Louis David (1748–1825) to Paul Cézanne (1839–1906) in order to represent the individual as one aspect of the infinite act of an "absolute free will" (Ueda Juzō, *Kindai Kaiga Shiron* [Tokyo: Iwanami Shoten, 1925], p. 14). In *A Historical Treatise on Modern Painting,* in which he interprets the work of art as "the most important element on which must be based" the study of the history of paintings, as well as in *Millet* (1949) and *Kindai no Kaiga no Hōkō* (Directions in Modern Painting, 1951), in which he writes about paintings from Giotto to the impressionists, Ueda provides detailed analyses of works of art, recovering the complex web of influences that includes references to even more ancient works. In these publications Ueda focuses on differences in figurative structures rather than the continuity of images (a search for origins). Moreover, Ueda's own artistic experience develops in accordance with the notion of a split linguistic expression created between itself and visual perception. He does not simply apply to works of art the knowledge that came to him from his extensive readings of foreign materials. His analyses follow the path of critical examination and are shaped by his personal experience.

In the preface to *Millet,* Ueda says that the book began as a "small, rough sketch" of an essay he wrote based on a twenty-year-old reproduction and that for twenty years he kept "rethinking, reviewing, and rewriting" before finally "coming up with the present study" (p. 3). Ueda's understanding of painting in this book develops on the assumption that detailed verbal descriptions of images contribute to a deepening of understanding. The "rupture" of the flow of visual perception caused by linguistic expression rearranges each time experience, making it the object of a leap.

In *A Historical Treatise on Modern Painting,* Ueda himself argues that "art history is not an effort to imperfectly regenerate works of art. . . . It is rather a new creation . . . a real reconstruction" (p. 61). As a result, Ueda's emphasis on "continuity" and the critique of Fiedler indicates that he inherited all the problems inherent in Nishida's thought. In truth, however, Ueda's own understanding of art was a product of Fiedler's thought since Fiedler, while stressing the leap between production and reception, did not concretely speak of the "creativity" of interpretation that such a leap makes possible. Therefore, Fielder did not go so far as to develop hermeneutically a theory of the self. Ueda, by contrast, put into practice Fiedler's theory by applying it to hermeneutics.

The positive aspect of Ueda's transcendental aesthetics, which he inherited from Nishida, is first of all the distinction between "creation" and "knowledge." Ueda emphasizes creation, and he proceeds to the removal of the confrontation between "form" and "content" (*Geijutsu Tetsugaku*, p. 197ff). This becomes a criticism of an understanding of art based on a knowledge that is cut off from visual reality (color and form). For Ueda, to ask art history "to stand on the ground of general cultural history," which talks about "landscape paintings" with a "knowledge of geography," is "a dreadful mistake, like trying to produce oil by squeezing sand." He argues that such a position is "built on the astounding mistake" of studying the environment, age, and people, which are thus made into causes, before even examining the meaning and the history of painting (p. 221). Such criticism became even more specific in later writings.

We find a second positive meaning of Ueda's reception of Nishida in Ueda's grasping of the ideas of time and space in art. Ueda shares Nishida's point of view, and he criticizes the idea that regards space and time as "empty bottles" existing outside sensorial activity—indeed, he holds time to be instead "the very process that forms the senses" (p. 37). In *Art and Morality*, Nishida had argued as follows:

> If we consider the objective world of transindividual objectivity—that is, the negative aspect of absolute will—to be the material world, then, just as the development of pure visual perception includes the hand within the pile of iron filings, as Bergson states, so, too, may we think that the act of visual perception advances by cutting through the material world (*Geijutsu to Dōtoku*, NKZ 3:272; see also *Self-Consciousness*, NKZ 2:261).[17]

Following Nishida, Ueda calls time and space "the form of the act of absolute free will" (*Geijutsu Tetsugaku*, p. 31). But he applies this understanding specifically to artistic phenomena. In other words, Ueda pays attention to the "contour line" and regards it as a "time consciousness" that includes the awareness of direction (p. 43). This indicates that Ueda concentrates on the inseparable relationship of time and space—the fact that in the creation of a contour, space is experienced together with time, and time is experienced through spatial movement. Ueda expresses the idea that the contour is not a boundary: it is "what creates boundaries." He tries to grasp time

17. [Nishida Kitarō, *Art and Morality*, p. 26. Ed.]

and space, which are realized in conjunction with the creation of a contour, as a problem of the inner structure in the formation of visual acts.[18]

Ueda discusses form from the standpoint of its relationship with "contours." He argues that "the movement as the act of looking at the contour" is not "simply a forward movement" but is, at the same time, "a forward movement that includes on the side a special tension." The contour is a movement forward and also toward "something that is held on the side"—a strain turned toward "something that has yet to be determined" (pp. 50–51). Ueda grasps the characteristic of aesthetic experience with regard to the contour line. The eye following the contour is strained (and relaxes) according to the "place" of the line's direction and also, at the same time, according to the "place" where the space of either side (on the side) is cut by the line's movement. This is what Ueda means when he says that "form" is the union of "the consciousness of contour" with the infinite (will) searching for a limit (p. 51). Therefore, the tension of form becomes one with "the deep tension of the self working in our eyes" (p. 52). While abiding by a transcendental viewpoint, Ueda gives a concrete description of the psychological meaning of form's tension and relaxation.

He also grasps "horizontality" ("ground"), "perpendicularity" ("height"), and "profundity" ("depth") as transcendental moments in the formation of "the act of visual perception."

Ueda points out that no contour exists that does not include an awareness of the relationship between horizontality and perpendicularity. He regards horizontality/perpendicularity as "the manifestation of the absolute free will as space" (p. 64). This is a criticism of psychological and biological explanations (August Schmarsow[19] and Adolf von Hildebrand[20]) that reduce the foundation of judgment of horizontality/perpendicularity in visual perception to the verticality

18. *"Grenze"* (boundary) and *"Begrenzung"* (limit) are expressions that we find in Fichte's *Theory of Science* and Schelling's *System of Transcendental Idealism*. Here, however, Ueda is referring to Wilhelm Schapp's *Beiträge zur Phänomenologie der Wahrnehmung* (Contributions to the Phenomenology of Perception, 1910); see *Geijutsu Tetsugaku*, p. 43. Here Ueda is probably reading Schapp in a Nishidean way.

19. [August Schmarsow (1853–1936) is the author of *Grundbegriffe der Kunstwissenschaft* (Principles of Art Science, 1905). Ed.]

20. [Adolf von Hildebrand (1847–1921) is the author of *Das Problem der Form in der bildenden Kunst* (The Problem of Form in the Plastic Arts, 1893) and *Elementargesetze der bildenden Kunst* (Elemental Laws of the Plastic Arts, 1908). Ed.]

of real bodies and the horizontality of both eyes. Ueda states that "we perceive a certain contour as horizontal, not because of an alleged parallelism between such contour and the position of our eyes, but because it is seen within the demand of what is horizontal" (p. 70). Ueda makes the same point with regard to perpendicularity. In other words, Ueda tries to say that in visual perception, horizontality and perpendicularity come into being in relationship to the form (contour) in which they are located. They are not judgments based on bodies that are external to the work of art. He cites the examples of looking from below at a person who has been painted in an upright position on a ceiling and, in addition, an inclined stage painted by Edgar Degas (1834–1917). We do not see them as a tilted person or an inclined stage. If we follow Ueda, "these two directions must come into being prior to the position of eyes and body" (pp. 69–70). We must pay attention to this remark. Here resides Nishida's thought on "the eye being the whole body," which I mentioned earlier. The body prior to the act of visual perception does not become a standard for the act of visual perception. In the world of visual perception, the whole body rids itself of reality and becomes the organ of vision (the eye). This is most clearly formulated in the perception of depth.

With regard to depth as well, Ueda rejects psychological explanations based on the structure of the real eye and the position of the body, and he talks about the ineffectiveness of an account of depth according to the "distance" from the body. Hence it is impossible to explain depth in a flat painting that is located at a distance from the body, since this distance is already a rejection of the standpoint of visual perception looking at such "depth." Ueda argues that "depth appears for the first time from a particular standpoint" (p. 89). Moreover, he regards paintings as the phenomenological form or flattening of real space. Ueda also rejects the explanation of Theodor Lipps (1851–1914) that the perception of depth in paintings depends on a "reconsideration" of the phenomenon. For Ueda, real depth is "an experience of direct depth" (p. 75). Ueda also maintains that an explanation of depth based on changes in the eyes' angle and on a "tensional sensation of the eye tendons" (Edward Bradford Titchener)[21]

21. [Edward Bradford Titchener (1867–1927), American psychologist, is the author of *Experimental Psychology* (1901–1905) and *A Textbook of Psychology* (1909–1910). Ed.]

is not convincing, since flat surfaces do not produce such differences (p. 71ff).

Then what actually produces the perception of depth? According to Ueda, "my boundless encounter with the representation of an object is actually the encounter of a distant background with a nearby object" (p. 84). We must rethink this statement in relation to experience. The I that participates in the visual object is no longer the I that happens to be in the motionless body; it is an item in the relationship of visual perception (eye). By "seeing" the object, the object and the space of the object's "infinite background" appear contemporaneously to the I as a visual reality. The I is infinite because the I as eye happens to be in a visual world that willy-nilly unfolds in front of the eyes. Visual reality is always in front of the eyes. The I that as eye confronts such a reality is an infinite background presence whose purpose is to let the visual world unfold in front of the I's eyes. Ueda sees "depth" as the a priori moment of the visual act. Furthermore, under the influence of Nishida, he explains it as the demand of the "absolute free will." Ueda, however, goes one step beyond Nishida's philosophy by developing the theory in a concrete way. In other words, he tries to elucidate specifically the formation of visual experience in relation to the possibility of this experience.

This stand anticipates Ueda's demand for a special way to understand art that is not a simple formalism. Ueda does not extrapolate from various works of art objective characteristics that they allegedly share. Instead, he traces the origin of works of art beyond the individual authors to the realization of the visual act controlling the process of the formation of the work of art:

> The infinite world of unconsciousness widens around our consciousness. There we see traces of individual creation, rich with a long creative past that cannot be realized as the author's personal work. (Ibid., p. 187)

The individual work of art and the author who produces it are the "connecting point" (or joint) of the realization of the visual act as "absolute free will." In this connecting point, the visual act maintains a deep relationship with the visual perception of the past. Such a relationship, however, is a historical self-limitation as a one-time event. The history of visual perception flows unconsciously in the individual. The standpoint of Ueda's aesthetic differs from Nishida's

"philosophical tendency toward sameness," which claims a higher position for "culture" than for art. Such a standpoint gradually comes to assume a more concrete form.

The Theory of Visual Perception as Phenomenological Hermeneutics

In *Geijutsu Shi no Kadai* (The Subject of Art History, 1935; later abbreviated as *Kadai*) Ueda confronted, from the standpoint of transcendental aesthetics he had developed in his earlier writings, the methodology that was used in the past in the field of art history. At the outset Ueda states that vision is "visual representation" (a transcendental limitation of vision) (Ueda Juzō, *Geijutsu Shi no Kadai* [Tokyo: Kōbundō Shobō, 1935], p. 7). Moreover, he acknowledges again that art is the "pure form of representation" (p. 12), and he criticizes speculations that understand art from the perspective of "subject matter." He does not say that themes are useless. In fact, he attaches great importance to subjects. Even with regard to the same theme, however, Ueda privileges the different guises that art takes when changes in color and form occur (p. 42). According to Ueda, such changes express "the inclusion of spiritual elements in color and form" (p. 44). This is a critique against Nicolai Hartmann's "theory of levels."[22]

Here we see Ueda taking a persuasive stand he arrived at through the mediation of Nishida. Ueda confronts the distinction that Hartmann posited between the two levels of the work of art: the perceived form (foreground) and the spiritual content that such perception brought to objectivization (background). Against this view, Ueda posits the perceived materials of the foreground as the already present and necessary moment of visual perception ("the workshop of vision," p. 89), "the spearhead of sight," "the will of the artist's eyes projected onto the external world" (p. 94). In *Shikaku Kōzō* (The Structure of Visual Perception, 1940), as well, Ueda makes the point that the spiritual elements are not "outside form" but "come for the first time to life in that very form." He concludes by

22. [Nicolai Hartmann (1882–1950) is the author, among other works, of *Das Problem der geistigen Seins* (The Problem of Spiritual Being, 1932) and *Ästhetik* (Aesthetics, 1953), which was published posthumously. Ed.]

saying that the separation of the two levels is a "simple result of abstraction" (Ueda Juzō, *Shikaku Kōzō* [Tokyo: Kōbundō Shobō, 1941], p. 342).

This is a critique against the reversal of the cause-and-effect relationship in the understanding of the work of art. Ueda constantly cautions the reader against such a reversal. In the plastic arts the content (cause) changes according to the form (effect) and, thus, understanding is not a recognition of a spiritual meaning preceding the work of art or a recognition of the author's "intentions." (On the notion of intention see *Kadai*, p. 136.) The reduction of the work of art to its "environment," critiqued by Ueda in *The Philosophy of Art,* is revisited in a critique of Taine.[23] Ueda regards an understanding of art based on cultural history (spiritual history) to be an example of "the misunderstandings of the past," and distinguishes it from art history. He also criticizes Max Dvořák's (1874–1921) *Kunstgeschichte als Geistgeschichte* (The History of Art as the History of Ideas, 1924) for clear mistakes involving cause-and-effect thinking. Ueda's insertion of a chapter titled "Art History and Cultural History" points to the deep-rootedness of such a misunderstanding. He argues as follows:

> With regard to character . . . we know character by way of visual perception, but we do not come to know visual perception by the way of character. Likewise, as long as we think about the history of art, for the first time we come to an understanding of an age by knowing about the art of that age. It is the same thing with the character of a people. (*Kadai*, pp. 312–313)

> The history of art is the history of the nature of art. (Ibid., p. 314)

There is no doubt that in *The Subject of Art History* Ueda inherited Nishida's thought, thanks to which the book carried great persuasiveness. In this book Ueda shows that the relationship between religion and art should be addressed as "the will of a higher cultural dimension" (p. 288). By concentrating on concrete works of art, however, Ueda shows an interest in the specificity of the work of art—a specificity that is seen as more important than a cultural sameness. In this regard Ueda comes close to Fiedler's position despite his

23. [Hippolyte-Adolphe Taine (1828–1893) authored *Philosophie de l'Art* (Philosophy of Art, 1865) in which, as an exponent of French positivism, he applied the scientific method to the studies of the humanities. Ed.]

critique of Fiedler. Weisbach's interpretation of Rembrandt's "religiosity" also becomes the object of Ueda's criticism.[24] Ueda talks about a leap from faith to creation into "a completely new world" (p. 287), and he emphasizes that the "depth" of Rembrandt and, furthermore, of religious art should be addressed as a problem of visual perception —in other words, in accordance with the color and form of the work of art (p. 282ff). At this point "leap" is privileged over "continuity." This position constitutes an interesting aspect of Ueda's thought— freedom from morality. Although Ueda does not mention this directly, the fact that a grasping of art history as the "history of the nature of art" spontaneously frees art from moral responsibility indicates that Ueda unintentionally practiced this freedom. This emerges as the difference between the "Japanese spirit" and the "spirit of Japanese art." Ueda mentions the need to "avoid the mistake" of regarding these two spirits as the same thing (pp. 290–291).

Ueda also says that undoubtedly the spirit of the age as a whole, or "higher cultural will," produced the details known as religion and art (p. 304). If we follow this interpretation, we see that he definitely followed in Nishida's footsteps. From the middle period of *Self-Consciousness* to the essays on "place" *(basho)* that he wrote in his later years, as well as the articles on "historical being" written after 1930, Nishida chose as his main subject of research human experience as expressive being, paying more attention to leaps and ruptures than to continuities in such experiences. One can say that in this regard, as well, Ueda came under Nishida's influence.[25] But unlike Nishida, whose main concern at the time was the "concrete universal" behind experience, Ueda focuses on the details of concrete experience. Ueda stresses that the whole "shows for the first time its face in the details" and that "it would be impossible to know the whole before knowing the details." Moreover, the details known as religion and art make the process of production different, so that it would be impossible for one side to produce the other side. Attention to the

24. [Werner Weisbach (1873–1953) wrote, among other works, *Der Barok: Die Kunst der Gegenreformation* (The Baroque: Art of the Counter-Reformation, 1921). Ed.]

25. For the development of Nishida's thought and his understanding of art at every stage of this development see Ōhashi Ryōsuke and Noe Keiichi, eds., *Nishida Tetsugaku Senshū*, vol. 6: *Geijutsu Tetsugaku: Ronbun Shū* (Kyoto: Tōeisha, 1998). See also the introduction by Iwaki Ken'ichi, "Nishida Kitarō to Geijutsu" (translated as Chapter 18 of the present book).

details known as art is actually resistance against a silent acceptance of cultural hierarchies and against the erasure of details based on prejudice. Such attention becomes a critique of "simplistic" thoughts such as the mythologization of the Japanese spirit—something that took place in Ueda's time and continues to this very day.

Ueda praises A. W. Schlegel[26] for holding artistic forms ("style," to use Ueda's word) in high regard. Moreover, he warns that the achievements of stylistic analyses that were championed in the twentieth century by Wölfflin[27] "should not vanish" (p. 189). For someone like Ueda, however, who echoes Nishida in opposing the separation of content and form, so-called stylistic studies are nothing but a means of attaining abstract knowledge. Ueda regards form (style) as "one aspect of the nature of art." Since art realizes itself as conflict (or relationship) between "represented content" (being) and "representing subject" (act), it is impossible to keep these two elements separate when approaching the issue of art. Ueda issues his critique of Wölfflin from this perspective. Wölfflin privileged the history of "seeing" and made his "subject of scientific art history" the explanation of the historicity of "visual schema" ordering the visual perception of every single individual. For Ueda, however, this methodology is "insufficient" (pp. 207–208) because it only pays attention to "one aspect of visuality" (the act). Ueda clearly criticizes formalism. If studies privileging content erase the difference of form, formalism neglects the difference of content.

In *Principles of Art History*, Wölfflin distinguished five sets of antonyms (sketchy/pictorial, flat/deep, closed form/open form, multiplicity/unity, clarity/unclarity) and discussed sixteenth-century "classical art" and seventeenth-century "baroque art" in light of these principles. Ueda analyzes these opposite concepts. He argues that Wölfflin's preference of differences in pictorial styles (because they are considered to be "deeper"), over considerations based on common nations, epochs, and individual authors, "appears to be correct" (p. 202). According to Ueda, however, these two styles do not indicate differences that are necessarily peculiar to the sixteenth and seventeenth

26. [August Wilhelm Schlegel (1767–1845) is the author, among other works, of a series of lectures entitled *Über schöne Literatur und Kunst* (On Fine Literature and Art, 1801–1804) and *Über dramatische Kunst und Literatur* (On Dramatic Art and Literature, 1804). Ed.]

27. [Heinrich Wölfflin (1864–1945) is the author of *Kunstgeschichtliche Grundbegriffe* (Fundamentals of Art History, 1915). Ed.]

centuries. But they are found "in a specific age, school, and particular style of an individual," so that, rather than styles *(sakufū)*, these are actually types *(ruikei)* (pp. 202–206). Types are "universals with a specific form" (p. 206). In other words, Ueda argues that Wölfflin's stylistic principles were arrived at by abstracting common impressions from a specific form and that the result of such a process of abstraction was substituted for the cause of the structuration of the work of art. Later, in *The Structure of Visual Perception,* Ueda reexamines the concepts of the five antonyms and reduces them all to "clarity/unclarity" (p. 174) since, according to Ueda, this is the reality of primeval visual experience and the concept from which all the others derive. Standing opposite to this is the notion of style—that is, "a repeated form that is characteristically distinguished from everything else" (*Kadai,* p. 206). If we follow Ueda, we could say that a history of forms ("styles") is the clarification, not of how to abstract universals from particulars, but of how universals become concrete in particular visual perceptions.

By paying attention to the a priori of visual perception known as "vision" and "art," history also, together with nature, becomes the visual object of the subject of vision. Ueda says that "the development of the way of seeing is at the same time the development of the object; both are the two aspects of one artistic reality" (p. 224). The subject of vision is related to history as visual object, and here such a subject finds its own self. A new vision inserts past visions (ways of looking at things) into the production and contemplation of the self, and it realizes itself by renewing the visual perception of the self. Ueda calls this "the artistic environment" (p. 217). Wölfflin lacked an opinion on this relationship. Visual perception is permeated from the beginning by sociality (historicity). Ueda argues that "sociality is the essential form of representation, the will of representation" (p. 65). Production is "to make the act of seeing" (to make the way we see things) (p. 75). "People with their eyes continue the production" that the artist has begun with his brush (p. 76). As a result, art history cannot become the history of a straightforward progress. To borrow a definition from Hans-Georg Gadamer's *Wahrheit und Methode* (Truth and Method, 1960), it becomes a history of the "act of influences" on how people look at things. This is the reading of art history that Ueda's work elicits. Ueda is searching, not for a static typology, but for a theory of vision as phenomenological hermeneutics centered on the history of vision.

Ueda's Aesthetics and the Artistic Spirit
of Japan and the East

In *Shikaku Kōzō* (The Structure of Visual Perception) and *Nihon no Bi no Seishin* (The Spirit of Japanese Beauty, 1944), Ueda referred to Japanese and Eastern works of fine arts, Japanese poems *(waka)*, haiku, gardens, flower arrangement (ikebana), nō theater, and to several records related to these arts, in order to reformulate questions on the basic structure of the realization of visual acts and the meaning produced according to such a structure.

Even in *The Structure of Visual Perception* Ueda maintains a transcendental standpoint, and he takes into serious consideration "representation" as the "subject of background," which reminds the reader of Nishida's word "background" *(haigo)*. Ueda stresses the development of vision as a progress from eyes to hand (Chapter 1). Here Ueda quotes from the second volume of Tanomura Chikuden's (1777–1835) *Sanchūjin Jōzetsu* (Talks of a Person from the Mountains): "Going through heart and eye, brush and eye become one; in other words, the will is on the tip of the brush" (*Shikaku Kōzō*, p. 39). This expression, "the will is on the tip of the brush," is well known to those acquainted with East Asian treatises on painting. Accordingly, it would be hard to believe that Ueda, who was pursuing his research in aesthetics, was unaware of these ideas prior to this period. Surely such ideas were deeply rooted in Ueda's heart. This explains why Fiedler's art theories appealed more to a Japanese such as Ueda or Nishida than to Westerners—not so much as a new, multidimensional body of thought but rather as an approachable and sympathetic one that was accepted as an explanation of the traditional notion of "the oneness of things and self." Epochal coercion might well be the reason for the appearance of Eastern thought in Ueda's philosophy at this time. As I mentioned earlier, however, Ueda did not reduce Japanese art to the "Japanese spirit." In Chapter 5 on "the structure of visual perception in decorative garden stones," Chapter 6 on "mountains," and Chapter 7 on "depth," Ueda gives a phenomenological interpretation of "horizontality," "perpendicularity," and "profundity," while referring to Japanese and Eastern art views.

In Chapter 5, Ueda points out that the "tension" and "strength" of what stands perpendicularly, as well as the "tranquility" of what lies horizontally, rather than being associations deriving from the knowledge of gravity, are the "reality of direct visual perception." He

considers perpendicularity and horizontality to be "height" and "ground." From the very use of this language, the reader realizes Ueda's attempt to rethink the abstract concepts of horizontality and perpendicularity as a visual reality within the relational structure of subject of vision and visual object. At this point Ueda quotes from *Sakutei Ki* (The Record of Garden Building):[28] "When laying stones in a garden there is no fault if one avoids placing a stone on a stone that lies flat on itself; on the side and front stones, located on the left and right of a standing stone, there must necessarily be a fallen stone." Ueda interprets this passage as follows:

> Similarly to the demand for a horizontal ground on the part of what stands perpendicularly, standing stones require the presence of fallen stones. The fact that the ground has a life of its own, and does not presuppose anything else, means that it is safe in itself, it is unmovable, and the consciousness of the ground—namely, the visual perception of a horizontal line—is tranquil. (pp. 181–182)

In the visual relationship between "ground" and "height," the ground is an infinite entity containing all possibilities—that is, what brings existing things into existence. Moreover, what stands perpendicularly is "one particular limitation" and, as a result, is filled with tensions. To use Ueda's words: "What exists stands" (pp. 182–183). Furthermore, Ueda turns his investigation to the nature of form and observes that "what stands" has necessarily width and height—in other words, it has a form that is surrounded by a "contour." The reason for this is that although width and height cannot be seen, they determine the quality of form surrounded by the contour. Ueda calls the invisible perpendicular line that prescribes the height of a configuration "the central line." He states that "the central line is the will that tries to draw—that is, the direction that the will takes in order to bring into existence one visual object; it is not one peculiar object of this will." The fact that we see "height" means that the contour veering upward from the ground is getting closer to the tip of this central line. Such a veering upward produces "tension" (relaxation), thus becoming a "call." The "answer" (response) to this call is an acceptance of the rising upward—in other words, "a contour is painted that unites the central tip to the extremity of the earth's bottom." Thus

28. [*Sakutei Ki* is a secretly transmitted treatise on how to build gardens next to buildings in the court style *(shindenzukuri)*. It is attributed to Tachibana no Toshitsuna (1028–1094). Ed.]

the tension ceases. Ueda regards the union of tension and tranquility (immediate relationship) as "the basic structure of rhythm" (pp. 184–190). The degree of tension of the rising configuration changes according to the quality of the movement of the contour line that proceeds while anticipating the ground and the tip of the central line. Here the individuality of the artist appears. The ground is never a special place where the visible object rises.

To explain this Ueda uses the image of the cliff. He has in mind the overhanging cliffs that are often portrayed in ink paintings. He cites the "bamboo root" stretching down from the ground of the cliff and the longitudinal line of the cliff, for example, pointing out that we say they "descend." By using the word "descend," we mean that we see the ground of the cliff not as a ground on which things exist—as a transcendental, structural moment of visual perception—but rather as the "tip of height," with the consciousness of such a ground in the background. Ueda points out that to see the perpendicular line as something descending, "we must stand on a surface that is located in a position known as 'descending'; the ground that is expressed by the lines related to this surface is actually this spot" (p. 191). Ueda argues that the surface on which we stand is not the real surface outside the painting. The surface on which we stand is our ground that has become the eye—the ground that makes the rising image rise, the ground as transcendental background. Thanks to this ground, the visual object exists; and thanks to the existing image, the ground is anticipated. As a result, we become a moment of visual perception and play freely inside the picture. The ground is not the surface of earth; it could be a surface of water. In paintings of mountains and waters, often a wide expanse of water plays the role of the ground that makes the whole scenery rise. In *The Spirit of Japanese Beauty* Ueda mentions surfaces of water (p. 238).

We understand the importance of Ueda's interpretation of "ground" for a comprehension of works of art in his rethinking of this issue in terms of visual experience. Ueda says that the ground is "infinite." Infinite means that a bottom as being does not exist. Therefore, if we add this understanding to Ueda's interpretation, the ground is originally bottomless. It becomes a ground exactly because it is bottomless. Nishida had proclaimed the bottomlessness of being by studying Böhme (*Jikaku, NKZ* 2:275). Here, however, the bottomless had to be articulated, not as a concept, but at the level of visual perception. How was the bottomless perceived in terms of visual percep-

tion? Visual perception only comes into being according to what is seen. But by following Ueda's thought up to this point we have ascertained that in conformity with its relationship with the invisible, the visible makes us realize and produces the invisible (for example, the space born out of a contour).

But let us return to the notion of "ground." We could paint a hole on the surface that is the ground in the painting. Then the first ground in the painting would descend to the bottom of the hole. Furthermore, what happens if the two downturned contour lines that were drilled into the earth's surface pierce the base of the picture? As subjects of visual perception, are we going to fall down into a bottomless darkness? Or do we float inside the hole? I have already explained why Ueda rejects explanations based on the "weight" of configurations and the "gravitation" of the earth (*Shikaku Kōzō,* p. 207). In the reality of visual perception, when a hole piercing the bottom of the picture is shown, the various objects on earth are transformed into existences floating for an instant in a bottomless ground. And if we think that the surface allotted to the painting is not sufficient, the artist (as well as the interpreter), if needed, can keep adding as much as he wants. Here it becomes possible to understand, as a concrete problem of visual reality, what Ueda means when he refers to painting materials as "visual concepts made into substances" or "the workshop of visual perception." This is because, for example, in interpretations of paintings and in restoration projects dealing with how to arrange sheets of paper and paintings on sliding doors, as well as in debates over varnish and glazing, materials participate deeply in visual reality.

Ueda clearly dismantles Hartmann's theory of levels. Works of art cannot be split into "foregrounds" and "backgrounds," since foregrounds are backgrounds and vice versa. In the world of plastic arts, everything becomes a moment of visuality. This is Eastern wisdom. Ueda calls the following words of Tung Chi-chang farsighted:[29] "In order to convey the deity, you need to rely on form" (Ueda Juzō, *Nihon no Bi no Seishin* [Tokyo: Kōbundō Shobō, 1944], p. 239). He refuses to search for a spiritual meaning inside form and explain the work's "depth" accordingly. Ueda argues that depth must be discussed as a visual reality—that is, as the relationship between the visible ("form") and the invisible ("background"). Ueda makes this point repeatedly

29. [Tung Chi-chang (1555–1636), was a famous painter and calligrapher of the Ming dynasty. Ed.]

(*Shikaku Kōzō*, pp. 290–291, 298, 301), and he criticizes Krueger's[30] and Lipps' explanations of depth as a "personalistic thing," a "human thing" (ibid., p. 253ff). Depth is a "reality of aesthetic experience," and what should be done is a clarification of the "structural characteristics" of this reality (p. 267). It is impossible to separate form from background. The background is the transcendental condition of form, "the source standing prior to it," what "protects" form, the "unmovable and formless." Depth comes into being as the "reality uniting" what exists (form) and what makes it exist (background) (p. 287). Moreover, the eye that actually sees this relationship belongs to this reality. Without it, this relationship does not come into being.

Although Ueda does not state it directly, the "vanishing point" of perspective shows how essential the participation of the eye is to the formation of depth. As the mental reconstruction of the eye's participation, perspective is the realization of a visual depth. The realization of several other depths is possible. When a form materializes, a relationship with background—depth— is born. The term "vanishing point" captures aptly the characteristic of the eye that takes part in depth. The vanishing point becomes the point in the picture that goes disappearing toward an infinite distance: the point of escape *(Fluchtpunkt)*. This distance is the projection of my eye that retreats (escapes) in the infinite in the face of form. Not only perspective but all kinds of depths come into being thanks to the relationship with my eye that I do not see. Here lies the secret of depth. To use Ueda's words: "The line signifying the direction of depth is to bring the eye to one end of the line. The eye cannot see itself. Depth . . . is not the length between two visible points, but rather the union as one thing with what cannot be seen—that is, with the infinite" (p. 296). Exactly because one's eye, which cannot see itself, is an essential moment ("background") in its participation in the perception of depth, depth sends back to the observer the spiritual meaning known as "depth." Spiritual depth in art—background according to form—realizes itself by inducing consciousness more than form. Ueda says: "The thing that is the most deep . . . retreats from the foreground of consciousness to the place that is the most distant" (p. 288). The depth of the work of art is born out of the conspicuousness of what escapes consciousness.

30. [Felix Krueger (1874–1948) is the author of *Gefühl und schöpferische Gestaltung—Leitgedanken zu einer Philosophie der Kunst* (Feeling and Creative Configuration—Basic Ideas for a Philosophy of Art, 1929). Ed.]

Persons (form) in a landscape are the "items." The fact that a scene has no details means that a motionless nature in the background (in the East, "mountains and rivers") stands out as a subject. Ueda argues as follows:

> Basically the mountain stands behind him as background to human existence. . . . As long as we understand this relationship between man and mountain, man keeps the mountain outside the contour as infinite space that always protects him from the background. The "formless" always exists at more of a distance and more deeply than "what has form." (*Nihon no Bi no Seishin*, pp. 234–235, 240)

Differences in the visual structure deriving from the relationship between form and background distinguish "illustrated stories," "ink paintings," and "paintings of flowers and birds" (p. 231ff). All these genres and their subjects come for the first time to a visual actualization following their structural differences. The fact that in ink paintings the landscape becomes the "item" depends on the demand of the visual act in ink paintings. In his later years Ueda quoted from Huang Kung-wang's (1269–1358) *Hsieh shan shui chüeh* (The Secret of Sketching Mountains and Waters): "The distant mountain has no ink, the distant person has no eye" (*Kaiga no Ronri*, p. 33). When we formulate questions paying attention to this self-evident truth, the visual structure finds for the first time a concrete clarification.[31]

The actualization of depth through formlessness takes several forms. Ueda compares "darkness" and "vapor" to the silence before and after sound. He says that "to paint the infinite . . . is to paint the infinite and what sustains it by painting an object that is located in different realms. This is 'to go beyond the image' in beauty" (*Shi-kaku Kōzō*, p. 291). The "depth" of the characters in Rembrandt and in Cézanne's landscapes is not located from the beginning outside the relationship between form and background; rather, it is indebted to the technique of introducing "darkness" into the picture. Ueda touches upon the "mouth" of Rembrandt's *Jesus of Emaus,* and he argues that "at the bottom of the contour an infinite space—that is, the darkness

31. Here Ueda's theory is supported by Nishida's later theory of "place" *(basho).* Nishida sees the grounds of his own theory of place in the Eastern art view of "seeing the form of the formless, hearing the voice of the voiceless" (*Hataraku Mono kara Miru Mono he,* "Preface," in *NKZ* 4:6). Nishida's thought on "Absolute Nothingness," as the place in which all experiences (Being) come into being, is given a concrete interpretation by Ueda, who makes it into a problem of artistic experience.

of the background—looks in." The same thing could be said with regard to the expression of the eye. Moreover, Ueda points out the "depth" that is made concrete in accordance with the image in Cézanne's *Window's Hole* as well (pp. 318–319). With regard to color, Ueda turns his attention to Johann Wolfgang von Goethe's (1749–1832) grasping of blue as "not stimulating," calling blue "the background in tonality" and saying that "depth is a gaze at a standstill" (pp. 316–317). Since background as "undetermined depth" emerges from the image, there is resistance to our clear perception of images and darkness comes to be realized as a motionless depth that stares at us. Ueda tries to clarify the "psychological structure of the artistic meaning of depth" (p. 330) as the relationship between image and background.

As opposed to darkness, Ueda refers to the "vapor" or "air" covering the contour as "the second formula of vision as what is unborn" and cites the examples of "air, mist, and haze" (p. 328). A suggestion for the interpretation of depth comes to Ueda from the notion of darkness and, even more so, from the airy expressions of Eastern ink paintings. With this technique, the background appears as a result of the gaps of the image through the mutual permeation of image (drawing) and background (earth)—that is, according to the ink's light and shade, roughness and fineness. Depth appears by having the image melt into the background. Ueda calls this phenomenon "transparency":

> Not to paint the natural contrast of light and darkness . . . is not to paint the opacity of objects. The object looks as if it were becoming transparent. A world without darkness is a world filled with light. This is the world of Japanese paintings. A world of peculiar lightness is created that we should not look for in the real world. (p. 362).

Mist and haze are the traditional techniques actualizing a special depth through the mutual permeation of image and background. They make depth come into being, not only by covering the earth, but also by making it transparent. A ground strewn with gold dust also accomplishes this end. The use of this technique by Sōtatsu (d. 1643?) and Ogata Kōrin (1658–1716) is "one spiritual development of the works of artists of the Momoyama period such as Eitoku (1543–1590), Tōhaku (1539–1610), and Yūshō (1533–1615)" (*Nihon no Bi no Seishin*, p. 257).

Conclusion

The transcendental aesthetics of Ueda, who has cultivated Nishida's "prepared land," translates Nishida's transcendental "background" into a theory of visual experience in conformity with artistic phenomena. We can say that the result of Ueda's inquiry is a theory of vision as phenomenological hermeneutics addressed to the formation of the work of art. While transcendentalism questions experience from the perspective of the possibility of experience, phenomenological hermeneutics explains the possibility of experience according to experience. We cannot say that Ueda consciously chose "phenomenology" and "hermeneutics" as his own methodologies. And yet his aesthetics attempt to put these methodologies into practice. To these efforts the Japanese and Eastern artistic spirit always continued to provide rich nourishment.

As he himself points out, Ueda's aesthetics is basically an explanation of "the theory of visual perception." This does not mean that Ueda is completely indifferent to other artistic genres. He talks about gardens, nō theater, Japanese poems (waka), and haiku (Nihon no Bi no Seishin), and he examines the "transpractical" structure of the literary arts (novels) (in Geijutsu no Ronri or "The Theory of Art," 1955). Moreover, Ueda also analyzes the structural differences of all categories related to the "comic," applying his findings to a hermeneutics of the structure of paintings (Shikaku Kōzō). In all his attempts, Ueda always privileges the special structure of the formation of artistic experience and its phenomenological interpretation.

Ueda discusses the notion of "loftiness" (take)—one of the standards of evaluation in waka—as "a new key in the interpretation of the structure of the sublime" (Nihon no Bi no Seishin, p. 116). He tries to rethink the structure of aesthetic categories as the structure of artistic experience. Through an analysis of waka, Ueda is able to see the relationship that the notion of "loftiness has with the spatial height of mountains and sky" (p. 118). He explains the notion of loftiness in poems lacking such concrete images by analyzing the structure of waka—as in the case of his concrete interpretation of Fujiwara Teika's (1162–1241) judgment of the following poem by Fujiwara Ariie (1155–1216) that Teika describes as a poem "with a lofty aspect" (take aru sama):

Shirazaritsu	When did autumn
Itsu hata aki no	Apparently arrive
Kinikerashi	Without being noticed?
Fukaku mi ni shimu	The sound of the wind
Kaze no oto kana	Deeply piercing my body.[32]

Ueda comments as follows:

> In this poem we do not see the loftiness in connection with the images
> of its objects. Therefore, we must search for loftiness in how words are
> strung together, in the structure of the poem—that is, in the external
> form of the poem. . . . The poem does not say *"shirazariki"* or *"shira-*
> *zarishi."* It stops instead with *"shirazaritsu."* The upper verse consists
> of sounds coming from the first line of the Japanese alphabet—the
> *"a"* line, with a succession of closed *"u"* and equally refreshing *"a"*—
> sounds suitable to the expression of a lofty distance. It stands in con-
> trast to the lower verse that deeply conceals the poet's thoughts, thus
> achieving a clearly lofty tone. (Ibid., p. 32)

Poetic words are not representations of natural phenomena (simple
designations). From the reverberation of words, nature appears,
accompanied by such a reverberation, changing its form. Thanks to
the sounds that Ueda points out, a lofty, distant autumn wraps a
small body squatting down according to the sound *"u"* of the word
"mi ni shimu." The wind comes blowing everywhere, and here "a
lofty aspect" appears.

I do not mean to deny the presence of problems in Ueda's theory.
Ueda highly praises, as a realization of "darkness," Rembrandt's *Man*
Wearing a Golden Helmet (*Shikaku Kōzō*, p. 322ff)—a work located
in Berlin that recently has been conclusively proved not to be the
work of Rembrandt. Moreover, in Ueda's interpretation of works of
art there is clearly a lack of contextualization that is deemed essential
today in the study of individual works. These shortcomings, how-
ever, do not nullify Ueda's achievements. There is no guarantee that a
person who has new evidence can come up with more creative inter-
pretations than earlier theorists. The effort to explain the structure of
individual works of art is an unceasingly interpretive practice that
continues to produce new subjects of research. Awareness of the degree

32. [This is the second poem of a poetic match that took place at the Imperial Palace
(Dairi Utaawase) on the sixteenth day of the Eighth Month, 1214, under the sponsor-
ship of Emperor Juntoku (r. 1210–1221). See *Shinpen Kokka Taikan*, vol. 5 (Tokyo:
Kadokawa Shoten, 1987), p. 535. Ed.]

of subjects available, however, paves the way to a clarification of the historicity of newly advancing visual perceptions. Essays on works of art based on photographic plates elicit a theory in conformity with the visual act, so long as this is realized as picture. Ueda also examines the meaning of originals and reproductions to come up with a theory of the visual act (*Geijutsu Shi no Kadai*, p. 159ff). Ueda's aesthetics constitutes a new theory protective of "details." Rather than considering the problems left by Ueda to be faults of his aesthetics, we should see them as areas of inquiry it is now our duty to pursue.

Kuki Shūzō and the Phenomenology of *Iki*

Tanaka Kyūbun

The Free and Playful Heart

The Union of Spirit and Flesh

In 1926, during his stay in Paris, Kuki Shūzō (1888–1941) wrote the unpublished essay " '*Iki*' no Honshitsu" (The Essence of *Iki*). In 1930, one year after his return from Europe, the journal *Shisō* (Thought) published Kuki's essay "*Iki* no Kōzō" (The Structure of *Iki*), which he revised and published as a book that same year. There is almost no difference between the basic structure of "The Essence of *Iki*," which Kuki wrote during his studies abroad, and *The Structure of Iki*, which he completed after his return to Japan. We might well conclude that Kuki had already formulated his most important ideas on the issue of *iki* (taste, refinement) during his stay abroad. Tada Michitarō has pointed out that Kuki conceived the philosophy of *iki* in Paris and that we find in it "a preparation to somehow confront European culture, especially the culture of Paris, and, above all, to confront a desire for the women of Paris." Tada argues that such an attitude was the main cause for the creation in this book of several dualistic tensions, such as the one between West and East, Paris and Edo, men and women.[1] Furthermore, Kuki's choice of the language of philosophy in writing *The Structure of Iki*, as a way to make the book understood internationally, is seen by Tada as an effort to create such a tension.

From Tanaka Kyūbun, " '*Iki*' no Genshōgaku," in Tanaka Kyūbun, *Kuki Shūzō: Gūzen to Shizen* (Kuki Shūzō: Contingency and Nature) (Tokyo: Perikansha, 1992), pp. 61–94.

1. Tada Michitarō, "Explanation" (Kaisetsu), in Kuki Shūzō, *Iki no Kōzō* (Tokyo: Iwanami Shoten, 1979).

Both in "The Essence of *Iki*" and in *The Structure of Iki*, Kuki interprets the word *"iki"* as the infinite move of a man and a woman toward each other without their ever becoming united in one body and, moreover, as a state of mind that actually takes pleasure in such a tension. In other words, *iki* indicates a situation in which a man who is held by "loneliness" *(sabishisa)* tries to take pleasure in the encounter with and separation from the other while being held by loneliness. Thus Kuki detects in the world of *iki* a movement toward a new philosophy of the self.

We still need, however, to examine the circumstances that led Kuki to develop an interest in the notion of *iki*. Kuki was dissatisfied with the theory of love developed by the Neo-Kantian Heinrich Rickert (1863–1936) with whom Kuki studied at the beginning of his stay abroad.[2] Kuki took issue with the fact that Rickert had neglected the issue of carnal drive. Moreover, he realized that Rickert's thought was grounded on general views on love and marriage common in the modern West. When we look at the collections of essays on Japanese culture that Kuki wrote in French during his study abroad and titled "Choses Japonaises" (Things Japanese), we find an article by the title of "Geisha" in which he criticizes the hypocritical theory of love that is based on the dualism of body and soul of Western modernity:

2. ["As both a student and colleague of Wilhelm Windelband (1848–1915), Heinrich Rickert (1863–1936) was committed to a Neo-Kantian theory of values along transcendental lines. But where Windelband's relation of disciplinary research to problems of value was still tied to a preliminary methodological debate, Rickert's defense of value-philosophy became a full-scale struggle against what he perceived as 'the modish philosophical currents of our time': life-philosophy, historicism, biologism, Spenglerism, and the other expressions of crisis-thinking in the postwar era. Rickert began his epistemological labors with technical works on the theory of definition and epistemology—*The Theory of Definition* (*Die Lehre von der Definition*, 1888) and *The Object of Understanding* (*Der Gegenstand der Erkenntnis*, 1892)—developing his craft as a careful logician in the process. In 1896 he published the first edition of his major work, *The Boundaries of the Formation of Natural Scientific Concepts* (*Die Grenzen der naturwissenschaftlichen Begriffsbildung);* in 1899, the shorter, more accessible *Cultural Science and Natural Science* (*Kulturwissenschaft und Naturwissenschaft);* and in 1903, *The Problems of the Philosophy of History* (*Die Probleme der Geschichtsphilosophie).* After the war, however, he revised these works and published some newer, more polemical pieces such as *Kant as the Philosopher of Modern Culture* (*Kant als Philosoph der modernen Kultur,* 1924) and *The Philosophy of Life* (*Die Philosophie des Lebens,* 1920). In 1921 he also completed the first volume of his aborted three-volume systematic work on axiology, *The System of Philosophy* (*System der Philosophie).*" See Charles R. Bambach, *Heidegger, Dilthey, and the Crisis of Historicism* (Ithaca: Cornell University Press, 1995), p. 84. Ed.]

Christianity condemns the flesh. One of the most unfortunate consequences of this has been the pitiable and perverse state into which certain women in Europe have fallen. Abandoned, they are left without hope. Absolute degradation is the result. And with few exceptions most Europeans have lost, it seems, the capacity to judge these things without prejudice. . . . To sell the flesh in sin is an avarice undignified of God, as transforming wine into poison an absurdity undignified of men. . . . An idealism excluding realism is a pseudo-idealism. It contents itself—with astonishing facility—with dualism. (*Collected Works of Kuki Shūzō*, or *Kuki Shūzō Zenshū* 1:455; hereafter referred to as *KSZ*)[3]

In modern Western views on love and marriage, such as those that can be seen directly in England during the Victorian age, love was rigidly premised on marriage and limited to the purely spiritual side from which the flesh had been divided. As a result, sexual relationships were allowed to take place only between husband and wife—thus repressing and concealing in a world of shade the allegedly evil sexual intercourse that occurred outside marriage. In the modern West, according to Kuki, flesh and spirit were completely separated. He saw, on the one hand, an empty and hypocritical spiritualism intersecting, on the other, an overgrown materialistic world of the flesh that the spirit had totally abandoned.

Kuki criticized the Western dualism of body and soul and indulged in the sensuous world of life. In his own life, however, he could only find an uncanny, irregular form. At this juncture, Kuki gave up his simple addiction to the senses and aimed at working out a synthesis between spirit and flesh in a new form. At this time, he found his ideal in the form of the Japanese geisha. Kuki's mother came from the demimonde of the pleasure quarter, so that for Kuki the world of the geisha was particularly close. In his poetry collection we find the following verses in which he sings of the geisha:

Ōkawa no	On the surface
Suimen ni iki na	Of Big River a stylish
Nageshimada	Coiffure
Utsurite kururu	Is reflected—
Yanagibashi kana	Willow Bridge at dusk.

3. [The English translation is from Stephen Light, *Shūzō Kuki and Jean-Paul Sartre: Influence and Counter-Influence in the Early History of Existential Phenomenology* (Carbondale: Southern Illinois University Press, 1987), pp. 87–88. Ed.]

Iroppoki	One more
Uta mo hitotsu to	Erotic poem—
Katsutarō	What is it saying,
Utaishi kouta	The little song that
Nani to iiken	Katsutarō sings?

Ishimaru yo	Oh, Ishimaru!
Iki na sanosa wo	Are you singing a refined
Utae kashi	Popular tune?
Yanagibashi ima	Now they must be lighting the lamps
Hi no tomoruran	At Willow Bridge.

Even during his studies abroad, whenever his thoughts went back to his native town Kuki must have been confronted with the world of "refined" geisha:

Furusato no	The shape of Renée
Iki ni niru ka wo	Sniffing the fragrance
Haru no yo no	Of a spring night
Rune ga sugata ni	Similar to the refinement
Kagu kokoro kana	Of my native town.

Furusato no	I long for the tunes
Shinmurasaki no	Of Shinmurasaki
Fushi koishi	In my native town—
Kano Utazawa no	Also I long for the famous mistress
Shishō mo koishi	Utazawa.

In the essay "Geisha," mentioned earlier, Kuki describes the essence of the Japanese geisha by comparing her to the Western prostitute:

> In Europe the *demi-mondaines* are the "half-dead." They are exiled from the world, *hors-mondaines*. People are thus astonished to learn that in Japan the *geisha* play a certain role in society. . . . It is important to know that in order to become a *geisha*, a rigorous examination in music and dance must be undergone. The ideal of the *geisha*, at once moral and aesthetic, that which is called *iki*, is a harmonious union of voluptuousness and nobility (*KSZ* 1:455).[4]

According to Kuki, the Western prostitute is alienated from the spiritual world: she is confined to the world of the flesh. The Japanese geisha, by contrast, lives a heterosexual relationship within a harmonious unity of spirit and flesh.

4. [Ibid., p. 87. Ed.]

A Free Male/Female Relationship

According to Kuki, the Japanese geisha conducts a life free of love and marriage. *Iki* is, above all, the aesthetic consciousness of a male/female relationship taking place in the pleasure quarter. In other words, *iki* came into being in the arena of play between men and women—the farthest possible place from serious love and marriage.

Other Japanese intellectuals, such as, for example, Watsuji Tetsurō (1889–1960),[5] added their critique to modern Western views on love and marriage. In the chapter "The Communal Body of Two People" from his *Rinrigaku* (Ethics), Watsuji criticizes Western dualistic views of body and soul in the same manner as Kuki, and he launches a rehabilitation of the flesh by offering a philosophy of love that is founded on the theory of the "oneness of body/mind" *(shinjin ichinyo).* That Watsuji interprets the male/female love relationship as sacred, however, and sees in the form of marriage the ultimate realization of such a relationship, stunningly shows how deeply Watsuji's "The Communal Body of Two People" appropriates from the West modern theories of love. Watsuji describes superbly the male/female, husband/wife, division of labor and shows how the absolutely inviolable holiness of love, which originally takes place between two people, smoothly and naturally merges, following the production of children, into a Japan-like communal body.

In opposition to this idea, Kuki's notion of *iki* is a much more basic and thorough critique of modern Western theories on love and marriage. According to Kuki, *iki* is free not only from marriage but also from the love relationship between a man and a woman. In *The Structure of Iki,* Kuki describes such a freedom as follows: "In its realism and impossibility, love with its earnestness and obsession is contrary to the being of *iki. Iki* must be the free spirit of caprice which has transcended the shackles of love" *(KSZ* 1:22).[6]

In the world of *iki* there is absolutely no guarantee of permanence in a male/female relationship. Kuki argues that in order to live in such a world, it is necessary to be resigned to the fact that love is ever changing, unsteady. Women of the demimonde cannot lack an under-

5. [See Chapter 12. Ed.]

6. [The English translation of Kuki's *Iki no Kōzō* is from John Clark, trans., *Reflections on Japanese Taste: The Structure of Iki* (Sydney: Power Publications, 1997), pp. 44–45. Ed.]

standing of the "constant mutation, impermanence" of the human heart, "the heartlessness which is just the fickle villain in any man," "the universal fate of a tie thinner than thread, easily torn and rent," "people's hearts which are like the Asuka river—to change is the habitude of the profession." Kuki continues by saying that in order to reach the "bewitching, lightly-worn smile" of *iki,* it is necessary to repeatedly shed "warm and sincere tears." Indeed, you cannot become a person of *iki* unless you have accumulated the experiences of a geisha who has been practicing for a number of years.

> The lament that "we meet so rarely, but now you say we must part. Your appearance is that of Buddha, but are you a devil, Seishin?" is probably not just Izayoi's lament. A heart forged by distress experienced when sincere devotion is cold-bloodedly betrayed many times will eventually learn not to believe in the objective of which it is so easily cheated. The completely resigned heart which has lost naive trust towards the different sex is certainly not acquired without cost (*KSZ* 1:19).[7]

It goes without saying that changes of heart do not take place only in the other person. As Nagai Kafū (1879–1959) has pointed out: "No one is more unfeeling than a woman after you have actually conquered her." It is not rare to wake up after one's love has had its will and to see that same love change into "boredom, despair, and aversion."

Kuki argues that the world of *iki* opens up for the first time when a realization is achieved of the ever changing, unsteady nature of the relationship between the self and the other. Here we understand how this world of *iki* became the best possible world for Kuki's philosophical inquiry. During his studies in Europe, Kuki investigated the roots of the self and found at its bottom the flow of life, similar to "a meteor, a flash of light," which had lost identity. Kuki found a sense of loneliness known as sadness (*sabishisa*) with "nothingness" (*mu*) at its bottom. Despite this bleak destiny, Kuki chased after a way to make relationships possible, a way that would open the self to the other. Kuki's attention to the world of *iki* was a result of superimposing the problem of the self bereft of identity upon the issue of the ceaseless betrayal taking place in male/female relationships—the issue upon which *iki* was premised. In other words, Kuki addresses the problem of *iki*—or the formation of male/female relationships

7. [Ibid., p. 42. Ed.]

despite the assumption of a ceaseless heterosexual betrayal—as if he were dealing with the problem of how humans who held "nothingness" in their arms and had lost the principle of self-identity could actually open to one another.

Kuki, who had repeatedly experienced failure in the field of love, was groping after new types of relationships that would not be binding. Accordingly, although at first sight *The Structure of Iki* might look like a regression toward Japan's past, it actually contains a stunningly radical and experimental body of thought.

The Trilogy of *Iki*

Coquetry (Bitai)

For Kuki *iki* was the product of three transformational moments: coquetry *(bitai)*, brave composure *(ikiji)*, and resignation *(akirame)*.[8] Of these three elements, coquetry provides *iki* with its material content while brave composure and resignation give a polish to coquetry, thus bringing it to completion. In this sense, Kuki argues, coquetry is the material cause of *iki;* brave composure and resignation are its formal causes. We can say that—through the formal causes of ethical idealism, which characterize Japanese culture, and religious nonrealism—coquetry, the material cause, brings to completion the materialization of the existence of the self.

What Kuki calls "ethical idealism" corresponds to brave composure; "religious nonrealism" is resignation. He derives the former from the way of the warrior *(bushidō)* and the latter from Buddhism. Since *iki* materializes in male/female relationships that take place in the pleasure quarter, carnal relationships are necessarily at the heart of *iki*. At the same time, however, Kuki tries to find in *iki* the heightened spiritual content of ethical idealism, in which the way of the warrior is grounded, and religious nonrealism, which defines Buddhism. We can say that Kuki's material cause and formal cause correspond to body and spirit. To argue that coquetry is the material cause means that coquetry is preceded by physicality. But unless spirituality, which is known as a formal cause, is woven into this pattern, *iki* is not realized.

In what follows I will analyze in detail the three moments of

8. [Although the word "triad" would be more appropriate to describe Kuki's three main components of *iki*, I follow Tanaka's original text *("torirogī")*. Ed.]

coquetry, brave composure, and resignation. First of all, let me begin with Kuki's definition of coquetry:

> Coquetry is a dualistic attitude which constitutes the possible relations between the self and the different sex, where a non-relational self posits a sex different to that of the self (*KSZ* 1:17).[9]

As I noted earlier, Kuki considers the essence of the self to exist in the feeling of sadness. This is "the feeling which realizes the fragment as fragment" and inevitably searches for the other side of the fragment. In other words, "the non-relational self" is never complete by itself. It necessarily "posits a sex different from that of the self." By itself alone, the non-relational self cannot determine its reality. It provides itself with meaning in the dualistic relationship with the other sex that is posited against the self. Moreover, Kuki argues that this dual relationship with the other sex is a "possible" relationship. He says that this possible relationship is "the continuation of the relational." In other words, the continuation of the dualistic relationship in which self and other do not come together, keeping between them a fixed distance constantly, defines what Kuki calls "possible relationship." Namely, Kuki ventures to search for a denial of the union of man and woman in one body as a way of maintaining a free relationship while presupposing the inconstant nature of male/female relationships.

It goes without saying that self and the other sex aim at mutually coming together with the other and conquering the other. Kuki, however, points out a paradox: should such a union become concrete in reality, coquetry would in fact disappear:

> Where the tensions are lost when different sexes achieve complete union, coquetry will be extinguished of its own accord. Coquetry has made the conquest of the different sex its hypothetical purpose and this has the fate of extinction when that purpose is actualized (*KSZ* 1:17).[10]

Kuki thinks that a male and female union is, ultimately, a mutual constraint, a mutual deprivation of freedom:

> Nagai Kafū says in *"Kanraku"* ("Pleasure") that "there is nothing more pathetic than a woman one has had after the successful attempt to have her." Such a feeling signifies the "boredom, despair, and aversion"

9. [Clark, *Reflections on Japanese Taste*, p. 38. Ed.]
10. [Ibid., p. 38. Ed.]

brought about by self-extinction of the coquetry which had flourished on both sides between the sexes (*KSZ* 1:17).[11]

The reference to "boredom, despair, and aversion" indicates a backlash against the stagnation in which a person who is by nature a creature of ceaseless change is forced against his will into a fixed relationship.

It would be interesting to compare this debate on coquetry with the discussions that Jean-Paul Sartre (1905–1980) held on the relationship between self and other. During his studies abroad, Kuki had employed Sartre as a private tutor, thus receiving an initiation to French philosophy. In the library of Kuki Shūzō[12] we find notes by Kuki titled "Monsieur Sartre" as well as several memos in Sartre's hand.[13] There is an astonishing proximity between the philosophies of these two thinkers with regard to the problematization of the self/other relationship from the perspective of "chance" encounter. In *Being and Nothingness* (1943), however, Sartre actually describes the self/other relationship as a "relationship of the conqueror and the conquered" and a conflict between self and other at the level of "look." After all, in Sartre the relationship between a man and a woman is found in masochism at the level of extreme subjugation and in sadism at the level of extreme conquest. Here we find the union between men and women existing in a will toward "unidimensionalization." Sartre problematized the perverse "pleasure" that derives from the unidimensionalization of men and women. To Kuki, however, who mourned the world of identity, the pleasure deriving from such a unidimensionalization is alien. To avoid falling into the trap of unidimensionalization, Kuki speaks of a ceaseless tension with the other sex:

11. [Ibid., p. 38. Ed.]

12. [The library of Kuki Shūzō is currently housed at Kōnan University in Kobe. For a catalog of the books that Kuki collected over the years see *Kuki Shūzō Bunko Mokuroku* (Catalog of the Kuki Shūzō Library) (Kobe: Kōnan Daigaku Tetsugaku Kenkyūshitsu, 1976). Ed.]

13. On the relation between Kuki and Sartre see Naitō Toshihito, "Kuki to Sarutoru," in *Kuki Shūzō Zenshū, Geppō* 12 (Tokyo: Iwanami Shoten, 1982). See also Hirai Hiroyuki, *From Rimbaud to Sartre (Ranbō kara Sarutoru he)* (Tokyo: Kiyomizu Kōbundō, 1968), for essays on Arthur Rimbaud, Paul Valéry, Marcel Proust, and Jean-Paul Sartre from the perspective of contingency, as well as the relationship between Kuki's philosophy of contingency and contemporary French philosophy and literature. [A reproduction of Kuki's manuscript "Monsieur Sartre" appears in Light, *Shūzō Kuki and Jean-Paul Sartre*, pp. 99–141. Ed.]

The "voluptuousness," "raciness," and "passion" and so forth which may be found in *iki* are thus the tensions whose foundation is this relational possibility (*KSZ* 1:17).[14]

The pleasure of *iki* is born only in the ceaseless tensional relationship between a man and a woman.

Brave Composure (Ikiji)

I now want to discuss the notion of brave composure. Kuki explains the idea of brave composure as that which sustains the tensional relationship of coquetry and polishes it. He argues that brave composure is a "strength of heart" that does not oppress others.

> "Brave composure," with its strength of heart brought about by idealism, contributes further tension and staying-power to the relational possibility of coquetry. It also attempts to maintain its possibility as a possibility (*KSZ* 1:21).[15]

In other words, brave composure is "a strong consciousness that, despite its being coquetry, opposes a kind of resistance to the other sex." It brings about a "dignity and a grace which ought not to do violence" to people.

But no matter how much "strength of heart" and "resistance" against the other we find in it, brave composure is rigidly premised upon the presence of the other. Kuki also uses the word "pluck" *(hari)* to express the notion of brave composure. The fundamental truth that makes the self a "self" is not found in the innermost heart of the self but in the exterior border conjoining the self to the other. Kuki, who suffered a loss of identity and the uncanniness of an unregulated life, searched for a new form of self in the notion of brave composure, which he saw as a tension in the relationships between human beings who find themselves pitted against each other. Kuki's notion of brave composure is deeply related to the structure of the Japanese self that has been traditionally composed of shame and pride—a structure that, in fact, developed independently from Western ideas of the self.

The psychiatrist Uchinuma Yukio has tried to clarify the structure of shame in the Japanese. He bases his inquiry on a study of fear of

14. [Clark, *Reflections on Japanese Taste*, p. 38. Ed.]
15. [Ibid., p. 44. Ed.]

other humans, which is considered to be a mental disease almost peculiar to the Japanese.[16] Uchinuma questions several stipulations that often appear in essays with regard to the nature of the Japanese, such as a lack of self, a tendency to be other-oriented, collectivism. He points out the existence of a tensional relationship between self and other as a characteristic of the Japanese people. From Ruth Benedict's reduction, in her *Chrysanthemum and the Sword*,[17] of the conflict between "cultures of guilt" and "cultures of shame" to a conflict between "individualism" and "collectivism," we can see that in Western analytical studies of psychology shame is generally perceived as impotence of the self, a paralysis, an inferiority, that never measures up to the ideal notion of the self that is expected from others. Such a perception, however, makes shame a simple awareness of appearance. Against this position, Uchinuma argues that shame is composed of two sides: the side of modesty and reverence toward the other as well as the side of pride and reputation toward the self.

There is no doubt that shame implies anxiety about the gaze of the other and an adjustment of the self to meet the expectations of others. In this respect we can say that shame is a mode of being centered on the other. Yet shame is also the sensation that one's pride has been injured. Consequently, shame also implies a movement toward the recovery of self-honor. In this other respect, shame is a mode of being centered upon the self. These two aspects of shame always constitute the front and back of the issue. Shame does not come into being by simply following the other and without a sense of honor toward the self. Nor does it develop if, conversely, the self is made absolute and the gaze of the other is ignored. Uchinuma argues that shame materializes in a peculiar tensional relationship between two self-contradictory moments: between "a disjunction of self and other" and "a unification of self and other" or between "egotism" and "self-effacement."

By following Uchinuma's interpretation of shame *(haji)*, we can say that the meaning of shame is very close to the meaning of pride

16. See Uchinuma Yukio's books: *Taijin Kyōfu no Ningengaku* (Tokyo: Kōbundō, 1977), *Shōki no Hakken—Paranoia Chūkaku Ron* (Tokyo: Iwanami Shoten, 1987), and *Taijin Kyōfu*, Kōdansha Gendai Shinsho (Tokyo: Kōdansha, 1990).

17. [Ruth F. Benedict, *The Chrysanthemum and the Sword: Patterns of Japanese Culture* (Boston: Houghton Mifflin, 1946). Ed.]

(iji).[18] Pride means "the feeling of carrying out to the end one's wishes" *(Iwanami Kokugo Jiten)*. Taken in this sense, pride is the Japanese version of self-assertion. This, however, is clearly different from a merely straightforward self-assertion. When, wishing deep in the heart to enjoy the approval of one's partner, one's wishes are not granted, paradoxically feelings of pride find expression and the person grows stubborn *(iji ni naru)*. This is why pride is fundamentally a sentiment that a weak person feels toward a stronger. Accordingly, the self-assertion known as pride always requires the presence of the other, who is a vital element for pride to exist. In other words, pride is always an "obstination" *(iji wo haru)* against the other. Seen from this perspective, we understand how pride results from a special balance between the two self-contradictory moments of "disjunction of self and other" and "unification of self and other" or "egoticism" and "self-effacement."

By "brave composure" Kuki probably means an ethically and aesthetically refined version of the structure of the self that is peculiar to the Japanese—a mixture of shame and pride in which is grounded the tensional relationship between self and other. Kuki searched for the origin of brave composure in the way of the warrior *(bushidō)*. It goes without saying that both notions of shame and pride were privileged in the lifestyle of the warriors. In *Nihon Rinrigaku Shisō Shi* (History of Japanese Ethical Thought), for example, Watsuji Tetsurō argues that the samurai in the age of civil strife searched for an ideal way of life in the notions of self-respect and reverence for others. According to Watsuji, the samurai despised the greediness of those who held their life dear: The samurai himself always strove to prove he was not a coward—"not because the world viewed him as a coward, but because he himself did not want to feel like a coward." In other words, the samurai acted valiantly because "he wanted to show to himself that he did not fear death and treasured his honor more than his life." In this sense the ethic of the samurai is sustained by the idea of self-respect. As a result, we can speak of a "morality centered on the nobility of feelings." Watsuji says that this noble morality abhors not only one's own vulgarity but also the vulgarity of others. Thus

18. With regard to the structure of pride among the Japanese, I have taken several hints from the following publications: Satake Hiroto and Nakai Hisao, eds., *"Iji" no Shinri* (Tokyo: Sōgensha, 1987), and Yamano Tamotsu, *"Iji" no Kōzō* (Tokyo: Sōgensha, 1990).

was born the ethos of never accepting as enemy a vulgar person or anyone unworthy of respect. Together with the need for self-respect, a samurai must also develop respect for his enemy.

Shame and pride do not always overlap in the ideal life of the samurai. Shame easily slides into simple anxiety over appearances, while pride often becomes the stubbornness and prejudice we find in the idea of obstinacy *(kataiji, ijihari)*. Pride confines the self to a hard husk and ties the self to a particularly perverse relationship with the partner by immersing the self in masochistic feelings, so that one easily loses a broad view of things. To avoid this situation, one must recognize the separation of self and other and unceasingly pull the self up. We can say that Kuki's notion of brave composure, based on the code of the samurai, while rooted in the life patterns of shame and pride, is a more polished and idealized version of these patterns.

In fact, Kuki understands *bushidō*-based brave composure as a kind of idealism—something that "ignores the theses of cheap reality." From the beginning, Kuki holds the way of the warrior in deep esteem, probably because of his pride at being born in a house of warriors with a good lineage, one that reached far back in the middle ages. This interest in the way of the samurai, however, is not exclusive to Kuki; he shares it with many modern Japanese thinkers. Whenever they grapple with the Western notion of self, these thinkers often revive the idea of *bushidō* as an example of a self that was absolutely the opposite of the Western self and something peculiar to the Japanese. Natsume Sōseki and Mori Ōgai, for example, were deeply moved by the ritual suicide of General Nogi at the time of the death of Emperor Meiji,[19] and they saw in this act the spirit of selfless sacrifice. Generally speaking, thinkers of the Meiji period were deeply absorbed by the way of the samurai. After all, by *bushidō* they often meant the ethic of self-sacrifice.

In Kuki's case things were different: in his version of *bushidō* this ethic never appears. For example, he mentions the way of the samurai in all essays from his "Choses Japonaises" (Things Japanese) as a most representative element of Japanese culture. Among them there are references to the self-immolation of General Nogi, who comes to the stage as a mirror of the *bushidō*. The sacrifice of General Nogi to the emperor is never glorified, however. The idealism stemming from

19. [Nogi Maresuke (1849–1912) was president of Gakushūin University. Ed.]

"the nobility and heroism of human spirit" is admired. Kuki explained the idealism of *bushidō* in a lecture he gave at Pontigny: "La Notion du Temps et la Reprise sur le Temps en Orient" (The Notion of Time and Repetition in Oriental Time, August 11, 1928):

> For *Bushidō* it is the good will in-itself which has an absolute value. And it does not matter if it is an unsatisfied will, an unrealizable ideal —the life of misfortune and sadness, "the disconsolate empire of thirst and grief," in sum, that "time lost" perpetually repeating itself. Confront transmigration without fear, valiantly. Pursue perfection while maintaining a clear consciousness as to its "deception." Live in perpetual time, in *Endlosigkeit*, to use Hegel's terms. Find *Unendlichkeit* in *Endlosigkeit*, *infinity* in *endlessness*, *eternity* in *succession without end* (KSZ 5:22).[20]

The *bushidō* that Kuki describes here is not an ethic of self-sacrifice but an unlimited effort to confront an ideal that will never be realized. "Endlessness" *(Endlosigkeit)* is like a straight line stretched without a limit—an infinity that Hegel considered not a true infinity but rather a bad one. Kuki, however, argues that true infinity *(Unendlichkeit)* can only be found in endlessness *(Endlosigkeit)*. Consequently, the idealism of *bushidō* theorized by Kuki can also be called a self-overcoming of nihilism and a reversed infinity. Such an idealism eliminates unconditionally the tentacles of reality, thus becoming infinitely free. We see in the Pontigny lecture a strong influence of Nietzsche's theory of the eternal return. In this sense I believe that Nietzsche's active nihilism casts a shadow on Kuki's notion of *bushidō*. In fact, Kuki points out several analogies between the derivation of Nietzsche's ideas of "nobility" and "pathos of distance," from the Western code of chivalry, and the source of "brave composure" from the code of the samurai.

Kuki interprets in the shape of brave composure the existence of the self in the tensional relationship between a mutually confrontational self and other. To avoid falling into a fixed relationship between self and other, however, he talks about the idealism of infinity. By seeing in *bushidō* an infinite self-overcoming, Kuki tries to turn and give a positive meaning to the mourning of identity and the collapse of self-identity known as indefinite life. Moreover, this structure of

20. [The English translation is from Light, *Shūzō Kuki and Jean-Paul Sartre*, p. 49. I have changed Light's term "the indefinite" with "endlessness" to translate *"Endlosigkeit."* Ed.]

brave composure also projects on the "stylish" *(iki)* relationship be-
tween a man and a woman. In other words, since the self is an infinite
self-overcoming, male/female relationships as well become infinitely
dynamic relationships. Now Kuki is ready to identify the coquetry
occurring between men and women with "a relational and dynamic
possibility." To say that male/female relationships are "dynamic"
means that such relationships are objects of infinite change:

> Proximity increases the intensity of coquetry. . . . The essence of coque-
> try is that whilst approaching as far as distance allows, the difference
> in distance does not reach extreme limits. . . . The wanderer who con-
> tinues the "continuous finite," the villain who delights in bad infinity,
> Achilles who does not fall in pursuit of the immortal—only such people
> know true coquetry *(KSZ* 1:17).[21]

The argument that—while the difference in distance between a man
and a woman narrows infinitely—the two never become one indi-
cates that such a relationship finally becomes possible because of its
infinite change. The infinite self-overcoming that we find in Kuki's
exhortation to "find infinity *(Unendlichkeit)* in endlessness *(End-
losigkeit),* eternity in a succession without end," finds its projection
onto the relational space between self and other. "The wanderer who
continues the 'continuous finite,' the villain who delights in bad
infinity," take the form of someone who takes pleasure in the infi-
nitely changing relationships between different sexes.

The realization of the coming into being of such relationships
frees men from one-to-one closed relationships, thus producing innu-
merable dynamic relationships between self and other in which one is
not tied down in any specific relationship. *Iki* is not an earnest "love"
between two people; it is "a free and inconstant heart." In Kuki we
find a constant conflict between "the actual necessity of love" and
"the transcendental possibility of *iki.*" Love binds people because of
a dark passion. *Iki* requires "a light, refreshed, and stylish mood"
that casts away all affections binding the self to the other. The un-
ceasingly forming relationship between self and other, which is known
as *iki,* frees men from the kinds of closed-off relationships to which
they have been confined until now, guiding them toward innumer-
able dynamic relationships between self and other.

21. [Clark, *Reflections on Japanese Taste,* p. 39. I have changed Clark's "the evil
infinite" to the Hegelian expression "bad infinity." Ed.]

Resignation (Akirame)

Finally I want to examine the notion of resignation. The idea of brave composure already conceals at its bottom a tinge of resignation toward the powerlessness of the self. This becomes easier to understand when we think of the profound relationship between pride *(iji)* and brave composure *(ikiji)*. As I mentioned earlier, while seemingly looking like self-assertion, pride hides at its base the weakness of the self and a sense of helplessness. We can say that the strength and the unyielding boldness that is found in pride always possesses behind it something like a weakness, a lack of self-confidence, a sense of inferiority. We could call pride the strength that emerges to hide weakness. In brave composure we can see the same mixture of might and powerlessness that we find in pride. In a later essay titled "Nihonteki Seikaku" (The Japanese Character), Kuki argues that within brave composure, by which *bushidō* has no regard for death, can be perceived a clear resignation to death. He also observes that resignation and brave composure are "one and not two" as "powerlessness and ultrapower."

Not only Kuki but many others have pointed out the coexistence of might and powerlessness in the hearts of the Japanese. Watsuji, as well, sees a Japanese characteristic in the twofold nature of "gentle passion" (an emotion that, while being gentle, turns all of a sudden into a violent passion) and "militant indifference" (a frame of mind that, while being combative, shelters resignation at its bottom). In other words, in their passions the Japanese people do not possess the strength to maintain them tenaciously. Moreover, paradoxically, they do not possess a simple resignation that lacks from the beginning a combative spirit. While truly venerating upsurges of passion, the Japanese mourn obstinacy—the result of their complicated twofold nature. Here we find the paradox of seeing in a graceful resignation the need to further admire a stout resistance and combativeness.

Having pointed out the relation between brave composure and resignation, I now turn my attention to the content of resignation. With regard to *iki* and the issue of male/female relationships, resignation is above all a self-awakening in the form of resignation toward the betrayal of the companion. This kind of resignation, however, does not mean a total abstention from relationships between different sexes. Resignation and coquetry stand in a relationship of backside and frontside. By possessing resignation at the bottom

of their heart, people can step into more variegated male/female relationships:

> The third feature, "resignation," is also certainly not incompatible with coquetry. In not attaining its hypothetical aim coquetry remains loyal to the self. And for this reason not only is coquetry's resignation towards the object not irrational, it actually reveals coquetry's original quality as a state of being (*KSZ* 1:21).[22]

By possessing resignation, people avoid being tied down in fixed male/female relationships—and, thanks to such a broad vision, they are empowered to have free relationships. It goes without saying that the word "resignation," while having the meaning of "relinquishment," also possesses the original meaning of "clarifying the truth." Kuki bases his notion of resignation on "the Buddhist worldview of seeing the differentiated forms as constant mutation, impermanence, and of considering nirvana the principle of equality." By going though many meetings and separations, people, while ceaselessly realizing the "constant mutation and impermanence" of human relationships, eventually stop from being entangled in any accepted ideology sustaining such relationships. In other words, people come to see emptiness at the bottom of all human relationships. This means: to abandon worldly truths. In this case, emptiness is not simply "nothing." It is rather a sort of metaphysical horizon on which the separation between a man and a woman, no matter how tragic it might be, is actually affirmed as separation.

Here we are faced with the issue of nothingness *(mu)* as Kuki entertains it. Kuki realizes that nothingness is at the bottom of loneliness. He aims at finding out how people can hold an open relationship with others despite the presence of nothingness at the heart of human existence. Here Kuki uses the Buddhist notion of nothingness, transforming a nihilistic nothingness into a positive one. In fact, in that period, the philosophy of nothingness *(mu)* was quite popular in Japan's philosophical world revolving around the Kyoto school. In 1926, the same year Kuki's "Essence of *Iki*" appeared, Nishida Kitarō (1870–1945) wrote the essay "Basho" (Place) and opened the path to the logic of place as nothingness. Under the influence of Nishida's thought, Japan's leading philosophers of the time, such as Tanabe

22. [Ibid., p. 44. Ed.]

Hajime (1885–1962), Watsuji Tetsurō (1889–1960), and Miki Kiyoshi (1897–1945), grounded their philosophies in the concepts of emptiness *(kū)* and nothingness *(mu)* and developed their own original systems. To a certain degree, Kuki belongs to this philosophical lineage.[23] Although Kuki completed his philosophy of nothingness in the late book *Gūzensei no Mondai* (The Problem of Contingency, 1935), we can say that in this period he was already groping with this issue. For example, in this period Kuki wrote the following poem:

> A Minus Amount
> In a shadow there is the happiness of a shadow,
> It is not simply to say that it is not exposed to the sunlight.
> Ice has the taste of ice,
> It is not the same as cooled hot water.
> No matter whether you pull out your white hair,
> Black hair does not grow.
> A eunuch
> Does not become a lady-in-waiting.
> Plus and minus, extreme and extreme,
> They are both affirmations second to none.
> The principle of contradiction regrettably
> Is lame, one hand, one eye.
> There is glory in yin.
> There is glory in yang.
> Oh, good,
> Smell the fragrance!
> Oh, evil,
> Smell the flower.

In this poem, "shadow," "minus," "yin," and "evil" are not simply a lack of "sun," "plus," "yang," and "good." They all possess their own positive meaning. This is the principle of which Kuki sings in the poem. In the background of such thinking, we can see Kuki's effort to reform the notion of nothingness, transforming its meaning from a "lack" to a "positive opposite."

The object of Kuki's search in the world of *iki* is the affirmation by a "bewitching, lightly worn smile" of a male/female relationship,

23. On the relationship between Kuki's philosophy and the genealogy of thought centered on the notion of nothingness *(mu)* in modern Japanese philosophy with regard to Nishida, Tanabe, Watsuji, and others, see Shimomise Eiichi, "Kuki Tetsugaku to Gūzensei no Mondai," *Shisō* (March 1980); see also my article, "Nihon no Kindai Tetsugaku ni Okeru Bukkyō Keijijōgaku no Juyō to Sono Tenkai—*Mu* no Tetsugaku Shi," *Tōyō Gakujutsu Kenkyū* (November 1985).

which is premised on betrayal, through the grasping of nothingness as a positive ground. Kuki interprets resignation as "a well-formed and elegant disposition with a good grace,"[24] "an urbane and well-formed heart which has gone through the polishing of the hard and heartless floating world. It is a disinterested heart, freed from hindrances and separated from dogmatic attachments to reality, a heart elegant and not unrefined."[25] As an example of infinite overcoming in the reversed form of nihilism, brave composure as well is grounded upon this structure of nothingness.

Moreover, Kuki also uses the word "fate" to express the metaphysical horizon of nothingness that allows separation to be affirmed as such despite the tragic nature of separation in male/female relationships. He argues that resignation is "indifference which has renounced attachment and is based on knowledge of fate."[26]

> The fusion of coquetry with "resignation" means that the conversion to freedom is coerced by fate, and that the supposition of this possibility is determined by necessity. That is, one sees affirmation through this negation (*KSZ* 1:21).[27]

If we call "providence" and "karma" the thought by which, in the history of humankind and individuals, we understand the human journey as a determined one, then fate is neither providence nor karma. The innumerable dynamic relationships of becoming self and other are such that, fate willing, they are fulfilled and, if they are fulfilled, they break apart—that is, they are chance relationships. At all levels, the world is an accidental becoming that is difficult to predict. When it becomes difficult to withstand the unpredictability of these chance relationships, however, a necessity appears at the bottom of these relationships: fate. When we "resign" to such a fate we can live lightly the innumerable dynamic relationships between self and other. In *The Problem of Contingency* Kuki delved thoroughly into the issue of fate, which still remained unsolved in *The Structure of Iki*.

24. [Clark, *Reflections on Japanese Taste*, p. 41. Ed.]
25. [Ibid., pp. 42–43. Ed.]
26. [Ibid., p. 41. Ed.]
27. [Ibid., p. 44. Ed.]

Iki *and Play*

Kuki describes *iki* as "an amorousness (coquetry) which has pluck (brave composure) and is urbane (resignation)."[28] He also points out, however, that *iki* is not simply a "phenomenon of consciousness" but also appears on the outside by assuming several "objective expressions." Kuki discusses the objective expressions of *iki* from several perspectives. Here I will examine the physical expressions that I believe play a particularly important role in Kuki's philosophy.

According to Kuki, *iki* must find continuous expression through "physical statements" such as speech, posture, gesture, look, hairdo, and attire. *Iki* is composed of both body and spirit. Accordingly, *iki* should never be reduced simply to a "phenomenon of consciousness." It always requires a bodily expression. For Kuki, "the body" is neither simply a substance nor a metaphysical principle at the root of notions of nature and the earth. Kuki's body is an intellectual operation that is entirely woven by the spirit. Moreover, a human being must intentionally play the role of the "stylish woman" in this very body. Kuki goes into great detail in expressing the pleasure of "playing a woman of *iki*."

In order to make her speech stylish *(iki)*, for example, the lady must pronounce a word in a drawn-out way, then abruptly give it intonation and clip it off. Furthermore, she must speak like a mezzo-soprano with a touch of sadness added to the words. A stylish posture is a light and easy pose that shows coquetry to the other sex while maintaining control and moderation. Moreover, there is style *(iki)* in the quiet suggestion of nudity, as in the case of a figure wrapped in silk gauze or a woman coming out of the bath. While "speaking powerfully and wordlessly of an airy resignation and imperious pluck,"[29] the eyes must send a light sidelong glance to the other sex. A light smile must float on the mouth and the cheeks. Light makeup must be applied to the face. With regard to hairstyles, *iki* requires a slightly disarrayed round topknot and Shimada topknot. As for clothing, the kimono décolletage reveals the nape of the neck. Lifting the kimono skirt by the left hand barely reveals the shin. The feet

28. [Ibid., p. 46. Ed.]
29. [Ibid., p. 77. Ed.]

must always be bare, without the conventional white socks. *Iki* also requires the play of lightly bending and curving hands.

Moreover, Kuki argues that these physical expressions of *iki* are refined to the point that they come to resemble a dance:

> The physical statement of *iki* naturally tends towards dance, in a move-
> ment where there is no artificiality or excess. In raising a boundary
> between dance and gesture, when dance is first called art, there is arti-
> ficiality and excess. Albert Maybon, in *Le Théâtre Japonais,* after say-
> ing that the geishas of Japan have "ingenuity in decorative and descrip-
> tive gesture," says the following about Japanese dance: "With regard
> to the translation of thought and feeling by gesture the knowledge
> which the Japanese school has is inexhaustible": . . . the feet and legs
> perform the role of making clear and maintaining the keynote of the
> rhythm. The torso, shoulder, nape, neck, arm, hand, and fingers are
> the tools of psychical expression' (*KSZ* 1:50).[30]

We might say that play as the physical expression of *iki* is in essence deeply related to the structure of the self that Kuki describes in *The Structure of Iki.* As I mentioned earlier, the structure of the self that we find in *iki* is the result of a dual tensional relationship—that is, a delicate balance between a "disjunction of the self" and a "unifica-tion of self and other." It follows that, without the gaze of the other, the self does not come into being. In other words, the self comes to life by playing the self in front of the other. Play, therefore, is essen-tial to the formation of the self. In this case, "play" does not mean that an unalterable self exists prior to its relationship with the other; nor does it mean that this self plays a different self in front of the other by relying on various embellishments. Prior to play the self does not exist. For the first time self and other come into being thanks to the tensional relationship between self and other that is played out in front of the other. Therefore, without play we cannot think of a self.

Kuki points out the subtle balance between "the open path" and "the closed path" to the other sex as a characteristic of play in its form of physical expression of *iki.* Coquetry, a basic element of *iki,* requires an "opening of a way" to the other sex. The nonrealistic ide-ality of brave composure and resignation, however, puts on the brakes in this regard, bringing about a fixed "closing of the way." Kuki exercises extreme caution against an excessive overdoing of the

30. [Ibid., pp. 145–146. Ed.]

play of *iki*. He abhors as plain "uncouthness" *(yabo)* the "wiggling of the hips around" as well as the "coquetry" of "the winking eye, the pouting lips," the décolletage "which exposes the whole expanse from the shoulders to the breast and the back," and whose hem is "shortened almost to the knee," as was customary among Western women. Yamazaki Masakazu has argued that play is not a rivalry between self and other in order to establish control over the other. Nor is it a discarding of the self and a mutual union with the other. While being a confrontation between self and other, play points to a third path: a definite prudence toward the other. This definition of play might well apply to *iki*.[31] The play of *iki*, which is found between an "opening of the way" and a "closing of the way," is neither the one-sided expansion of an imposing self nor a simple fusion of self and other.

This issue of play is closely related to the problem of masks discussed by Watsuji Tetsurō. In his *Men to Perusona* (Mask and Person, 1937), Watsuji points out the meaning of the word "person" as a meaning that developed from "mask used in a play," to "the actor's role in a play," to "character in a play," and, finally, to "person." Watsuji argues that originally "person" did not indicate the modern subject. It was related, rather, to the notion of mask and the role based on such a mask. In the same way that Kuki arrives at the concept of play from the breakdown of identity caused by loneliness and nihilism, Watsuji arrives at the idea of masks from the anxiety resulting from the dissolution of the self.

Among the literary works Watsuji wrote in his youth, for example, we find *Yume no Samegiwa* (Awakening from a Dream, 1911) in which someone ends up killing his own son while asking questions on the meaning of a life lived in a world he does not understand; he is not sure whether it is real or just a dream. We also find a work titled *Aru Isho* (A Will) portraying a character who constantly hates himself. Moreover, in several other works Watsuji talks about a longing for death or, more precisely, a longing for a dead face, as an attempt to flee the anxiety following the dissolution of the self. In *Shukyū* (A Severed Head, 1911), we read the following statement: "Ah, such cold lips! The cheeks and the front as well have become cold! What kind of coolness is this? Nowhere on your body could I find the

31. Yamazaki Masakazu, *Engi Suru Seishin* (Tokyo: Chūō Kōron Sha, 1983).

splendid softness to the touch that I used to find when you were alive." In *Tokiwa* (Everlasting, 1910), we read: "I like to see the dead face of a woman. I like to see her pale face surrounded by that long, black hair." These expressions are related to Watsuji's description of nō masks in *Mask and Person:* "Here the vitality of the muscles which is ordinarily seen on the face of a person was carefully washed away. Therefore, the sense of flesh was very similar to the face of someone who had suddenly died. The mask of the old man and the old woman in particular strongly remind us of the seal of death." Watsuji's thought on masks is grounded in the paradox that "the nō mask, which is supposed to be deprived of expression, actually shows an infinite expressive richness" in comparison to the "poor-looking, shabby, lifeless" face of a living person. We find such a paradox at the heart of Watsuji's ethics seen as a "world of play" in which people play their own role by wearing the mask of competence.

Recently, in an attempt to rethink modern human values, "role theory" has made an appearance in American sociology—an interpretation of human behavior as play. Likewise, Watsuji's and Kuki's debates on play emerged from a critique of the modern self. In Watsuji's case, however, the mask is entrusted with the role of plunging man into a relational existence that predates man himself. In this regard, Watsuji's philosophy differs greatly from Kuki's position on play, which Kuki saw as dynamic, human relationships. In any event, Kuki's play theory is of great interest for its ability to grasp the issues of human emotions and gestures within the field of the becoming of the self—a position that philosophers had overlooked up to that time and only recently has become the object of speculation.

Culture and People

I have been examining the concrete meaning of *iki*. According to Kuki, *iki* stands for the culture of the Japanese people. First of all, Kuki turns his attention to language, which he considers to be the key to understanding the being of different peoples. He argues: "Language is nothing but the self-manifestation of the past and present mode of being of a people and the self-unfolding of a specific culture endowed with history."[32] Moreover, Kuki points out that particular words, found only in the language of a people, are capable of ex-

32. [Clark, *Reflections on Japanese Taste*, p. 28. Ed.]

pressing the specific culture of that people. The word *"esprit,"* for example, reflects the nature and whole history of the French people. We cannot find a word with the same meaning in the language of another people. Kuki says that equivalent words in the German language would be *"Geist"* and *"Sehnsucht."* Moreover, Kuki indicates that one of the Japanese words that best expresses the nation's peculiar culture is *"iki."* Consequently, the word *"iki,"* although similar to the French expressions *"chic"* and *"coquet,"* has a different meaning. It would be impossible to find a word with exactly the same meaning in the language of another people.

> There can be no objection if we were to consider *iki* as a remarkable self-manifestation of the specific mode of being of Oriental culture, or rather, of the Yamato people (*KSZ* 1:12).[33]

Thus Kuki pays attention to the notion of "people" *(minzoku),* and he points out the cultural specificity of every "peoples," as this is expressed by language. Moreover, Kuki contends that it is difficult to achieve a complete grasp of the specific culture of a people by means of conceptual analysis. The only way to reach such an understanding, he says, is by experience. He adds that the same rule applies to an understanding of *iki:*

> We must not just handle *iki* as a specific concept and seek the "essential insight" directed at the abstract universal of the generic concept that comprehends it. Understanding of *iki* as experiential meaning must be a concrete, factual, and specific "being-comprehension." Before we inquire about the *essentia* of *iki,* we must first inquire about the *existentia* of *iki.* In a word, the study of *iki* must not be "formal." That it must be "hermeneutic" is to be expected (*KSZ* 1:13).[34]

Kuki's point is that *iki,* as a cultural trait specific to a people, can only be understood by experience. It goes without saying that should a single wrong step be taken, such a way of thinking risks falling into a narrow nationalism. In fact, Sakabe Megumi has warned of this danger.[35] As I noted at the beginning of this essay, there are very few differences between the framework of "The Essence of *Iki,*" which Kuki wrote abroad, and the two versions of *The Structure of Iki*

33. [Ibid., p. 33. Ed.]
34. [Ibid., p. 34. Ed.]
35. Sakabe Megumi, *Fuzai no Uta—Kuki Shūzō no Sekai* (Tokyo: TBS Buritanika, 1990).

(essay and book) that he wrote after his return to Japan. According to Sakabe, however, there is a difference between the essays and the book in the conclusion—a difference that can hardly be ignored. The difference is the following statement, which I quote from the version of "The Structure of *Iki*" that appeared in *Shisō* and which we also find in "The Essence of *Iki*," although it was deleted from the book *The Structure of Iki*:

> Nevertheless, we can think that *iki* might well be transplanted in the cultural sphere of the West, wrapped in the very garb of the racial color of our country. It might well be that Western culture has already transplanted *iki* in some fashion and to some degree without our realizing it—the same Western culture that has introduced prints *(ukiyoe),* haiku, screens, lacquerwares, kimono, and livery coats *(happi)*. No one can deny that some kind of *iki* was imported in the glasswork of Lalique,[36] the paintings of Van Dongen,[37] the music of Debussy,[38] or Ravel. . . .[39] Even if we assume that *iki* has not yet been transplanted to the West, there is not doubt that the opportunity will certainly come in the future. Moreover, it might be that *iki* will be imported back to Japan once again. At that time, we ought to remember and to acknowledge *iki* again as *our product (KSZ, bekkan* 102).

Sakabe argues that the final removal of the section referring to the transplantation of *iki* into the West, and its possible reimportation, was due to a relaxation on Kuki's part, after his return to Japan, of the tension that had originated the philosophy of *iki*—"thinking of one's own homeland in a foreign country, thinking of Edo while being in Paris." Sakabe sees in this removal a "clear tendency toward a closed cultural distinctiveness and a sheer cultural nationalism."

We cannot deny the presence of such a danger. This is not to say, however, that Kuki argues that everybody should confine himself or herself to the national culture of his or her own country. Kuki points out that although ultimately it is impossible to understand *iki* without a fully experiential appreciation, the meaning of *iki* must be analyzed rationally and, if possible, with clear and unambiguous language:

36. [René Lalique (1860–1945), French maker of glasswork and ceramics. Ed.]

37. [Cornelis Dongen (1877–1968), known as Kees van Dongen, was a Dutch painter. Ed.]

38. [Claude Debussy (1862–1918), French composer. Ed.]

39. [Maurice Ravel (1875–1937), French composer. Ed.]

It is when the whole significance of an intellectual being depends on guiding experiential meaning towards conceptual self-awareness. The existence, or degree of practical value does not matter. Thus the significance of learning truly exists in "eternally" pursuing the "task" of actualizing logical expression in full consciousness of the discontinuous incommensurability between experiential meaning and conceptual recognition. I believe that understanding the structure of *iki* becomes significant when it is taken in this sense (*KSZ* 1:75).[40]

While realizing the deep gulf between experiential meaning and conceptual recognition, Kuki tried to pursue his search without ever discarding conceptual recognition. Moreover, we can also say that this tendency toward logicalization was further strengthened in the book he published after his return to Japan. Kuki aimed at presenting the meaning of *iki* in the most logical fashion and verifying whether this enterprise would find a response as a contemporary philosophical topic. This explains why *The Structure of Iki* was not simply a return to Japan but, rather, an avant-gardist work full of suggestions with regard to issues relevant to modern philosophy. Was this the result of Kuki's failure to find a peaceful living either in Japan or in the West and his living constantly in the tensional relationship between both?

Together with such a tension between East and West, we may also think of the presence in Kuki of a tensional relationship between past and present. At the end of *The Structure of Iki*, Kuki offers the following statement:

> There are many cases where we encounter the illusion of *iki* that has completely lapsed into the abstract formal world of emptiness. Now, noisy talkativeness and empty verbosity relate illusion as if it were reality. . . . Where we encounter such illusion we must recall "all that our spirit has seen" in its concrete and true appearance. . . . To what can we connect the possibility of the recollection *(anamnesis)* of this meaning? To nothing less than not consigning our spiritual culture to oblivion. There is nothing but to go on bearing an ardent Eros for our idealistic and nonrealistic culture (*KSZ* 1:80).[41]

Yasuda Takeshi sees in this passage "a sense of despair following the loss of the aesthetic consciousness known as *iki*." We might say that here we perceive Kuki's sense of crisis at the thought that the culture of *iki*, which ought to be the essence of Japanese culture, was

40. [Clark, *Reflections on Japanese Taste*, p. 114. Ed.]
41. [Ibid., pp. 120–121. Ed.]

becoming increasingly estranged from the contemporary Japanese.[42] In the background of such a crisis of traditional culture we can see the worldly effects of capitalism at the time as well as a consciousness of a movement toward the breaking down of cultural specificity and the homogenization of culture. In the essay "Time Is Money" from his *Things Japanese*, Kuki criticizes the tendency of beautiful European women to talk about money with such nonchalance. He says:

> Even with all good will it is difficult for us to imagine this kind of mentality which acts and speaks always according to the law to the dollar's weight, this necessity of the mind to bring everything down to the level of money. For our taste the ugliest proverb imaginable would be: Time is money. Nevertheless, it is this proverb which is adopted and worshipped in all parts of the world. Born in the new world, it victoriously invades the old (*KSZ* 1:450).[43]

For Kuki, foreign culture was not just Western culture. Japanese culture was becoming the foreign culture of the past. *Iki* was the tensional world of men and women who, no matter how close they got, would never be able to unite. At the same time, we can say that for Kuki *iki* was also the tensional relationship between Japan and the West, as well as between the present and tradition.

42. Yasuda Takeshi and Tada Michitarō, *"Iki" no Kōzō wo Yomu* (Tokyo: Asahi Shinbunsha, 1979).

43. [Light, *Shūzō Kuki and Jean-Paul Sartre*, p. 82. Ed.]

21
Aesthetics at the University of Kyoto after World War II

Iwaki Ken'ichi

Until his mandatory retirement in July 1946, Ueda Juzō (1886–1973)[1] taught a basic introductory course in aesthetics at the University of Kyoto, and, in special lectures, he concentrated on all issues related to aesthetics and to Eastern and Western art history. Until the end of 1946, he continued to guide students even after he retired. Accepting a request from the College of the University of Kyoto, Ueda was also in charge of courses on aesthetics for undergraduates. We can say that Ueda's role in conferring an autonomous status on the study of art, based on an original aesthetic system and a keen understanding of the fine arts, provided the field of aesthetics in Japan with everlasting achievements. Ueda developed his thought in his many publications. While he served as professor, he entrusted special courses in aesthetics to lecturers such as Suda Kunitarō (1891–1961), Minamoto Toyomune (b. 1895), Nakai Masakazu (1900–1952), Ijima Tsutomu (1908–1978), and Ueno Teruo (1907–1976). Ijima Tsutomu, who had been working at the University of Kyoto since 1937, was appointed associate professor in May 1943 and eventually succeeded Ueda Juzō to the post of professor in aesthetics in April 1947.

A new system was instituted at the university in 1949. Ijima continued Ueda's work by delivering the introductory course in aesthetics and lecturing on the methodologies of aesthetics and art history, as well as training students in the reading of Western materials. In 1949 Ueno Teruo was appointed lecturer in the college, and he became a professor in 1951. Every year Ueno also lectured on Japanese and Indian art in the Humanities Division.

In April 1953, an independent major in aesthetics and art history

Based on Iwaki Ken'ichi, "Bigaku Bijutsushigaku," in *Kyoto Daigaku Shi* (History of the University of Kyoto) (Kyoto: Kyoto Daigaku Shuppan, forthcoming), pp. 42–47.
1. [See Chapter 19. Ed.]

was recognized, one that included aesthetic theory and Eastern and Western art history. At the same time, the Graduate Department in Literature was founded. From the beginning, Ijima Tsutomu took upon himself the task of training the graduate students, joined in the effort by several part-time instructors from the college. To better serve an increasing number of majors, and to satisfy the needs resulting from increasingly diversified specializations, a second Chair in Aesthetics and Art History was granted to the university beginning in April 1956. Before any appointment was made, the university waited for Ijima to return from a series of field trips that saw him conducting surveys from March to April 1956 in several museums and institutes of fine arts in Asia, Europe, and the United States. In April 1957, Hasumi Shigeyasu (1904–1976), a curator at the Nara National Museum, was appointed associate professor to the second chair, eventually becoming a professor in 1961. While the first chair focused mainly on aesthetic theory (inclusive of all art sciences), the second chair dealt with the study of the history of Eastern and Western arts, so that the foundations of the discipline were further strengthened. After his appointment Hasumi took charge of lectures on Japanese, Eastern, and Western arts and, while providing bibliographic instruction to the students, he also gave practical training in art history.

After Hasumi retired in April 1968, Ueno Teruo left the college and occupied the second Chair in Art History. Together with Ijima Tsutomu, he supervised the training of graduate and undergraduate students, lecturing specifically in the history of Indian art and guiding fieldwork in the historiography of art. Ueno retired three years later, in 1971. In April 1968, Yoshioka Kenjirō (b. 1926) was called from Dōshisha University to become the associate professor of the first Chair in Aesthetics, so that responsibilities in the supervision of students shifted to him.

The wave of disorder spreading through university campuses all over the country reached the Department of Aesthetics and Art History as well, leading to fierce debates among students and teachers concerning the social role of the fields of aesthetics and art history. For a while, all lectures and training were suspended. At that time, from January 1968 to March 1969, Ijima Tsutomu was director of the Research Department and also the dean of humanities—a fact that led to the temporary occupation of his office by students. The graduate seminars took place off campus, while teaching assistants and student volunteers relocated the collection of rare materials away from the university.

After Ijima's retirement in 1972, Yoshioka was appointed professor of aesthetics, thus continuing supervision of students in the department. In May 1972, he received his doctorate in literature after completing *Kindai Geijutsu no Seiritsu to Sono Kadai* (Establishment of the Modern Science of Art and Its Subjects), which was published as a monograph in 1975.

In April 1971, following the retirement of Ueno Teruo, Shimizu Zenzō (b. 1931) from Seika Junior College in Kyoto (present-day Kyoto Seika University) was appointed associate professor of art history. Shimizu received his doctorate in 1980 with the publication of *Heian Chōkokushi no Kenkyū* (Study of the History of Sculpture in the Heian Period), and he was promoted to full professor in June of the same year.

We must also remember the role played by Nitta Hiroe (b. 1929), who was first appointed lecturer in the college in April 1966 and became associate professor in 1968 and professor in 1978. He took upon himself the responsibilities of the department for about a year from March 1976, when Yoshioka went overseas as a researcher. Nitta retired in March 1993.

Inui Yoshiaki (b. 1927), who was appointed associate professor in the college in 1970 and became a professor in 1975, was charged with the yearly lecture in Western art history until he retired in March 1991.

In 1980 Yoshioka Kenjirō was appointed director of the Research Department and dean of humanities—roles that increasingly engaged him in administrative duties for one year beginning in January 1980.

In April 1981, Sasaki Jōhei (b. 1941) from the Agency for Cultural Affairs was appointed associate professor of art history. Sasaki received his doctorate in 1990 with the dissertation "Maruyama Ōkyo Kenkyū" (Study of Maruyama Ōkyo), and he became a full professor in March 1991.

After Yoshioka retired in April 1990, Iwaki Ken'ichi (b. 1944) from the Kyoto Municipal University of Art (Kyōto Shiritsu Geijutsu Daigaku) was appointed associate professor of aesthetics and put in charge of courses in aesthetics and art theory. Since 1995 Iwaki has been professor of aesthetics at the University of Kyoto.[2]

2. [Iwaki Ken'ichi specializes in German idealism and has produced several works on Hegel and Schelling. He has edited *Kansei Ron: Ninshiki Kikairon to Shite no Bigaku no Konnichiteki Kadai* (Theories of Sensibility: Contemporary Topics on Aesthetics as a Cognitive Mechanism, 1997). Ed.]

GLOSSARY

Abe Jirō　阿部次郎

Abe Yoshishige　阿部能成

Aizu Yaichi　会津八一

akirame　諦め

Anezaki Chōfū　姉崎嘲風

Arisutoteresu no Geijutsu Riron
　アリストテレスの芸術理論

Arisutoteresu Shigaku Yakuchū
　アリストテレス詩学訳注

Aru Isho　ある遺書

Ashihara Yoshinobu　芦原義信

Awazu Suitō　粟津水棹

basho　場所

Bashō Igo　芭蕉遺語

Benshōhōteki Ippansha
　弁証法的一般者

bi　美

Bi Ishiki Ron Shi　美意識論史

Bi no Hihan　美の批判

Bi no Honshitsu　美の本質

Bi no Isō to Geijutsu
　美の位相と芸術

Bi no Kankaku　美の感覚

Bi no Setsumei　美の説明

Bi to Geijutsu no Riron
　美と芸術の理論

bigakka　美学科

Bigakkai　美学会

bigaku　美学

Bigaku Gairon　美学概論

Bigaku Genron　美学原論

Bigaku Jiten　美学事典

Bigaku Jiten　美学辞典

Bigaku Oyobi Geijutsu Shi Kenkyū
　美学及芸術史研究

Bigaku Sōron　美学総論

Bigaku to Sei no Kyōmi
　美学と生の興味

Bigakujō no Risōsetsu ni Tsuite
　美学上の理想説に就いて

Bigakushi Kenkyū Sōsho
　美学史研究叢書

bijutsu　美術

Bijutsu Shinsetsu　美術真説

Bijutsu Tetsugaku　美術哲学

Bijutsu to Shūkyō　美術と宗教

Bikan ni Tsuite no Kansatsu
　美感に就いての観察

Bimyōgaku Setsu　美妙学説

birei　美麗

bitai　媚態

biteki hanchū　美的範疇

botsurisō　没理想

Bungakkai　文学界

Bungei Gairon　文芸概論

Bungei no Janru　文芸のジャンル

Bungeigaku Gairon　文芸学概論

Bungeigaku Josetsu　文芸学序説

Bungeijō no Shizenshugi
　文芸上の自然主義

bunka 文化

Bunmei Hihyōka to Shite no Bungakusha
文明批評家としての文学者

bunmei kaika 文明開化

bushidō 武士道

Chikakuteki Keiken no Taikei—Seishin to Buttai, Ishi no Yūi
知覚的経験の体系・精神と物体・意志の優位

Chishikiron Ben 知識論弁

chōetsuteki kanōsei 超越的可能性

Chuang Tzu 莊子

Doi Bansui 土井晩翠

Doi Bansui ni Ataete Tōkon no Bundan wo Ronzuru Sho
土井晩翠に与へて当今の文壇を論ずる書

Dōissei no Jiko Sosei
同一性の自己塑性

Doitsu Nikki 獨逸日記

Dōteki Bigaku 動的美学

Engeki Goran no Koto wo Kikite Tenka no Haiyū ni Tsugu
演劇御覧の事を聞きて天下の俳優に告ぐ

Engeki Kairyō Iken 演劇改良意見

Engeki Kairyōron Shikō
演劇改良論私考

Engeki Kairyō Ronsha no Henken ni Odoroku
演劇改良論者の偏見に驚く

Fūdo: Ningengakuteki Kōsatsu
風土、人間学的考察

Fūga Ron 風雅論

Fujii Kenjirō 藤井健治郎

Fujishiro Teisuke 藤代禎輔

Fujita Kazuyoshi 藤田一美

Fujiwara Ariie 藤原有家

Fujiwara Teika 藤原定家

Fukada Yasukazu 深田康算

Fukuzawa Yukichi 福沢論吉

"Fureru" Koto no Tetsugaku
「ふれる」ことの哲学

furyū monji 不立文字

Futabatei Shimei 二葉亭四迷

Futatabi Rekishiga no Honryō wo Ronzu
再び歴史画の本領を論ず

Futatabi Rekishiga wo Ronzu
再び歴史画を論ず

Gakujutsu ni Okeru Sokuratesu no Jigyō
学術に於けるソクラテスの事業

gedatsu 解脱

Geibun 芸文

geidō 芸道

geijutsu 芸術

Geijutsu Ippan 芸術一般

Geijutsu ni Tsuite 芸術に就いて

Geijutsu no Ronri 芸術の論理

Geijutsu no Taishōkai 芸術の対象界

Geijutsu to Dōtoku 芸術と道徳

Geijutsu Shi no Kadai
芸術史の課題

Geijutsujō ni Iwaiuru Rekishiteki to Iu Go no Shingi Ikaga
芸術上に所謂歴史的といふ語の真義如何

geisha 芸者

Geiyō Dōbutsugaku 芸用動物学

Genbun Itchi 言文一致

Gendai Bigaku no Mondai
現代美学の問題

Gendai Bigaku Shichō 現代美学思潮

Gendai Geijutsu no Bigaku
現代芸術の美学

Gendai Nihon no Kaika
現代日本の開花

Genji Monogatari Tama no Ogushi
源氏物語玉の小櫛

genjitsuteki hitsuzensei 現実的必然性

Genshi Bukkyō no Jissen Tetsugaku
　原始仏教の実践哲学
*Genshi Kirisutokyō no Bunkashiteki
　Igi* 原始基督教の文化史的意義
Genshōgakuha no Bigaku
　現象学派の美学
gesaku 戯作
gigei 伎芸
gijutsu 伎術
*Gikyoku ni Okeru Hiai no Kaikan wo
　Ronzu*
　戯曲に於ける悲哀の快感を論ず
Gūzensei no Mondai 偶然性の問題
Haga Yaichi 芳賀矢一
Hakubutsugaku Kaitei 博物学階梯
Hakuin 白隠
*Harunoya Shujin no Maki no Kata wo
　Hyōsu*
　春のや主人の牧の方を評す
Haruma Wage 波留麻和解
Hasumi Shigeyasu 蓮実重康
Hataraku Mono kara Miru Mono he
　働くものから見るものへ
Heian Chōkokushi no Kenkyū
　平安彫刻史の研究
Heigen Zokugo Haikai Bigaku
　平言俗語俳諧美学
Henka no Tōitsu to Sō no Kagen
　変化の統一と想の化現
Higashi Ajia no Kaiga ni Okeru Shizen
　東アジアの絵画における自然
Higeki Ron 悲劇論
Hihyō Ron 批評論
Hijikata Teiichi 土方定一
Hinode Shinbun 日出新聞
Hirata Toshihiro 平田俊博
Hokushinkai Zasshi 北辰会雑誌
*Hōryūji, Hōkiji, Hōrinji Konryū
　Nendai no Kenkyū*
　法隆寺法起寺法輪寺建立年代の
　研究

Hōryuji Saiken Ronsō
　法隆寺再建論争
Hsieh shan shui chüeh 写山水訣
Huang Kung-wang 黄公望
Hyakka Zensho 百科全書
Hyakugaku Renkan 百学連環
Hyakuichi Shinron 百一新論
Hyōgen Ai 表現愛
Hyōgenteki Sonzai 表現的存在
Ida Shin'ya 井田進也
Ijima Tsutomu 井島勉
Ike no Taiga 池大雅
"Iki" no Honshitsu 「いき」の本質
"Iki" no Kōzō 「いき」の構造
ikiji 意気地
Imamichi Tomonobu 今道友信
Inamura Sanpaku 稲村三伯
Indo Shinbisetsu 印度審美説
Inoue Enryō 井上円了
Inoue Tetsujirō 井上哲次郎
Inui Yoshiaki 乾由明
Ishi Bigaku 維氏美学
*Ishiki no Mondai—Shukaku no
　Kankei* 意識の問題・主格の関係
Isozaki Arata 磯崎新
Itō Teiji 伊藤ていじ
Iwaki Ken'ichi 岩城見一
Iwamoto Yoshiharu 巌本嘉治
Jijoden no Kokoromi 自叙伝の試み
Jikaku ni Okeru Chokkan to Hansei
　自覚に於ける直感と反省
Jimon Jitō 自問自答
*Jinsei Hihyō no Genri to Shite no
　Jinkakushugiteki Kenchi*
　人生批評の原理としての人格主義
　的見地
Jinseikanjō no Shizenshugi
　人生観上の自然主義
Jintai no Bi 人体ノ美
Jintaibi ni Tsuite 人体美に就いて
Jisen Shika Shū 自撰詩歌集

Jōchō　定朝

Jōgaku wa Mote Kagaku to Shite
　　Rissuru ni Taru ka
　　情学は以て科学として立するに足
　　るか

junsui keiken　純粋経験

kagaku　歌学

Kagami no Naka no Nihongo
　　鏡のなかの日本語

Kagawa Kageki　香川景樹

Kaiga no Ronri　絵画の論理

Kajō Sanjin　霞城山人

Kambayashi Tsunemichi　神林恒道

Kamen no Kaishakugaku
　　仮面の解釈学

Kanbigokoro to Nikukan
　　観美心と肉感

Kaneda Tamio　金田民夫

Kaneko Chikusui　金子筑水

Kankōden　菅公伝

Kanraku　歓楽

Kanto Handanryoku Hihan no
　　Kenkyū　カント判断力批判の研究

Kantō Nichijō　還東日乗

Karaki Junzō　唐木順三

Karatani Kōjin　柄谷行人

karon　歌論

kashuron　佳趣論

Katsura Rikyū　桂離宮

Katsuragawa Hoshū　桂川甫周

Kawabata Yasunari　川端康成

Kawakami Tōgai　川上冬涯

Kēberu Hakase Shōhin Shū
　　ケーベル博士小品集

Kēberu Sensei　ケーベル先生

Kēberu Sensei no Kokubetsu
　　ケーベル先生の告別

Keiji Shin'in Shokuhai Bigaku
　　形似神韻触背美学

Keiken Naiyō no Shujunaru Renzoku
　　経験内容の種々なる連続

Keimō Tetsugaku to Higōrishugi no
　　Aida　啓蒙哲学と非合理主義の間

Kiin Seidō　気韻生動

Kikuchi Dairoku　菊地大麓

Kimura Motomori　木村素衛

Kindai Geijutsu no Seiritsu to Sono
　　Kadai
　　近代芸術の成立とその課題

Kindai Kaiga Shiron　近代絵画史論

Kindai no Kaiga no Hōkō
　　近代の絵画の方向

Kinrui no Bi　禽類之美

Kinsei Bigaku　近世美学

Kinsei Bigaku Shi　近世美学史

Kinsei Bigaku Shisō Ippan
　　近世美学思想一斑

Kōbu Bijutsu Gakkō　工部美術学校

kōgei　巧芸

Kōgei Bijutsu Genri Hanron
　　工芸美術原理汎論

Kōiteki Chokkan　行為的直感

Koizumi Yakumo　小泉八雲

Koji Junrei　古寺巡礼

Kojiki　古事記

Kokka　国華

Kokka Shijōshugi ni Taisuru Gojin no
　　Kenkai
　　国家至上主義に対する吾人の見解

Kokugogaku Genron　国語学原論

Kokugogaku Shi　国語学史

Kokumin no Tomo　国民の友

Konakamura Yoshikata　小中村義象

Kōno Hitoaki　河野仁昭

Kōsei Nikki　抗西日記

Kōsōryoku no Ronri　構想力の論理

Koyama Teiho wo Omou
　　小山鼎浦を懐ふ

Koyasu Nobukuni　子安宣邦

Kudara Kannon　百済観音

Kuki Shūzō　九鬼周造

Kurokawa Kishō　黒川紀章

Kusamakura　草枕

Kusanagi Masao　草薙正夫

Kutsugen　屈原

Kuwaki Gen'yoku　桑木厳翼

Kyōiku to Shūkyō no Shōtotsu
　教育と宗教の衝突

Kyokutei Bakin　曲亭馬琴

Kyōto Bijutsu　京都美術

Kyōto Bijutsu Kyōkai Zasshi
　京都美術協会雑誌

Kyōto Teikoku Daigaku Bunka
　Daigaku
　京都帝国大学文科大学

Li-chi Lu　臨済録

Maki no Kata　牧の方

Makura no Sōshi　枕草子

Man'yōshū no Shizen Kanjō
　万葉集の自然感情

Maruyama Masao　丸山真男

Matsumoto Matatarō　松本亦太郎

Matsuo Bashō　松尾芭蕉

Meiji Taishō Shi: Sesō Hen
　明治大正史世相編

Men to Perusona　面とペルソナ

Mikami Akira　三上章

Miki Kiyoshi　三上清

Mimoza Gensō　ミモザ幻想

Minamoto Toyomune　源豊宗

Mishima Yukio　三島由紀夫

Mori Ōgai (Rintarō)
　森鴎外 (林太郎)

Morita Yonematsu　森田米松

Mōsō　妄想

Motoori Norinaga　本居宣長

Motora Yūjirō　元良勇次郎

Mozume Takami　物集高見

mu　無

mu no basho　無の場所

Mu no Jikakuteki Taikei
　無の自覚的体系

muga　無我

mukanshin　無関心

mukei no bijutsu　無形の美術

Murakami Hidetoshi　村上英俊

myōsō　妙想

Nagai Kafū　永井荷風

Nakae Chōmin (Atsusuke)
　中江兆民 (篤介)

Nakagawa Shigeaki (Shimei)
　中川重麗 (四明)

Nakagawa Shimei no Tsuioku
　中川四明の追憶

Nakai Masakazu　中井正一

Nakai Sōtarō　中井宗太郎

Nankyō Shinshō　南京新唱

Nanshū to Heine　南州とハイネ

Nara Bijutsu Kenkyū Kai
　奈良美術研究会

Naruse Mukyoku　成瀬無極

Natsume Sōseki (Kinnosuke)
　夏目漱石 (金之助)

Nihon Bungei no Yōshiki
　日本文芸の様式

Nihon Bungei to Sekai Bungei
　日本文芸と世界文芸

Nihon Bungeigaku　日本文芸学

Nihon Fūkei Ron　日本風景論

Nihon Geijutsu Shi Kenkyū, 1:
　Kabuki to Ayatsuri Jōruri
　日本芸術史研究第一間、歌舞伎と
　操浄瑠璃

Nihon Geijutsu Shichō
　日本芸術思潮

Nihon Kaiga no Mirai
　日本絵画の未来

Nihon Kenchiku no Shōrai
　日本建築の将来

Nihon Kodai Bunka　日本古代文化

Nihon no Bi no Seishin
　日本の美の精神

Nihon Rinrigaku Shisō Shi
　日本倫理学思想史

Nihon Seishin Shi Kenkyū
日本精神史研究

Nihon Shinbun　日本新聞

Nihonfuku no Bijutsuteki Kachi
日本服の美術的価値

nihonga　日本画

Nihonga no Hyō　日本画ノ評

*Nihonjin wa Geijutsugokoro ni
Tomeru ka*
日本人は芸術心に富める乎

Nihonteki Seikaku　日本的性格

Niiche Kenkyū　ニイチェ研究

Ningengaku no Chihei
人間学の地平

Nishi Amane　西周

Nishida Kitarō　西田幾多郎

Nishida Kitarō Iboku Shū
西田幾田多郎遺墨集

Nishitani Keiji　西谷啓治

Nitta Hiroe　新田博衛

Nogi Maresuke　乃木希典

Nyogaku Zasshi　女学雑誌

Ogata Kōrin　尾形光琳

Okakura Kakuzō (Tenshin)
岡倉覚三（天心）

Okazaki Yoshie　岡崎義恵

Ōmori Ichū　大森惟中

Ōmura Seigai　大村西崖

Ongakubi no Kachi　音楽美の価値

Ōnishi Hajime (Sōzan)
大西祝（操山）

Ōnishi Yoshinori　大西克礼

Oranda Jii　和蘭字彙

Ōshū Bungei Shi　欧州文芸史

*Ōshū Kindai no Chōkoku wo
Ronzuru Sho*
欧州近代の彫刻を論ずる書

Ōtsuka Yasuji　大塚保治

*Ōtsuka Hakase Kōgi Shū 1: Bigaku
Oyobi Geijutsu Ron*
大塚博士講義集I、美学及芸術論

*Ōtsuka Hakase Kōgi Shū 2: Bungei
Shichō Ron*
大塚博士講義集II、文芸思潮論

Perusona no Shigaku
ペルソナの詩学

Rekishi Gadai Ron　歴史画題論

Rekishi Tetsugaku　歴史哲学

Rekishi to Benshōhō　歴史と弁証法

*Rekishiga no Honryō Oyobi
Daimoku*　歴史画の本領及び題目

Rekishiga no Shuhin Mondai
歴史画の主賓問題

rekishiteki jitsuzai　歴史的実在

*Rekishiteki Keisei Sayō to Shite no
Geijutsuteki Sōsaku*
歴史的形成作用としての芸術的
創作

Rikugō Zasshi　六合雑誌

Rinrigaku　倫理学

Rinrigaku no Konpon Mondai
倫理学の根本問題

Rinri Shinsetsu　倫理新説

Rippusu no Jinkakushugi ni Tsuite
リップスの人格主義に就いて

Risei no Fuan　理性の不安

risō　理想

Rokumei Shū　鹿鳴集

*Rōmanshugi no Bigaku to Geijutsu
Kan*　浪漫主義の美学と芸術観

Ryūchikai　龍池会

Saeki Junko　佐伯順子

Sakabe Megumi　坂部恵

Sakuhin no Tetsugaku　作品の哲学

Sakura no Mi no Juku Suru Toki
桜の実の熟する時

Sakutei Ki　作庭記

Sanchūjin Jōzetsu　山中人饒舌

Sango Benran　三語便覧

Sarutoru Shi　サルトル氏

Sasaki Jōhei　佐々木丞平

Sasaki Ken'ichi　佐々木健一

Satomi Hakkenden 里見八犬伝

Seiyō Chōkokujutsu 西洋彫刻術

Seiyō Gagaku Yōron 西洋画学要論

Seiyō Tetsugaku Shi 西洋哲学史

Sengai 仙崖

Serifu no Kōzō せりふの構造

Shi no Bi Ishiki 死の美意識

Shiga Shigetaka 志賀重昂

Shigarami Zōshi しがらみ草紙

Shigeki ni Kansuru Utagai wo Futatabi Taiyō Kisha ni Tadasu 史劇に関する疑ひを再び太陽記者に質す

Shigeki ni Tsukite no Utagai 史劇に就きての疑ひ

Shigeki Oyobi Shigekiron no Hensen 史劇及び史劇論の変遷

Shikaku Kōzō 視覚構造

Shimamura Hōgetsu 島村抱月

Shimazaki Tōson 島崎藤村

Shimei Rōjin 四明老人

Shimizu Zenzō 清水善三

Shimomura Toratarō 下村寅太郎

Shin Bijigaku 新美辞学

Shin Shichō 新思潮

Shinbi Kashōron 審美暇象論

Shinbi Kōryō 審美綱領

Shinbi Kyokuchi Ron 審美極致論

Shinbi Shinsetsu 審美新説

Shinbi Sōdan 審美叢談

shinbigaku 審美学

Shinbigaku Ippan Oyobi Sekai no Bijutsu Bungakuchū ni Okeru Nihon no Bijutsu Bungaku no Ichi 審美学一般及び世界の美術文学中に於ける日本の美術文学の位置

Shinbigaku Kaitei 審美学階梯

Shinbiteki Ishiki no Seishitsu wo Ronzu 審美的意識の性質を論ず

Shinbiteki Kankan wo Ronzu 審美的感官を論ず

Shinbiteki Kenkyū no Ippō 審美的研究の一法

shinjin ichinyo 心身一如

Shinki no Kaikan to Bi no Kaikan to no Kankei 新奇の快感と美の快感との関係

Shinmura Izuru 新村出

Shinrigaku 心理学

Shirakaba 白樺

Shirurā ga Bigakujō no Kōseki シルラーが美学上の功績

Shisō 思想

shisōga 思想画

Shiteki no Ryōmen to Sono Rihei 詩的の両面と其利幣

Shizen Kanjō no Ruikei 自然感情の類型

Shizenshugi no Kachi 自然主義の価値

Sho no Bi 書の美

Shōchō no Shin Igi 象徴の真意義

Shōjizaian Shimei 小自在庵四明

Shōsetsu Shinzui 小説神髄

Shōsetsu Sōron 小説総論

Shōsōin ni Hozon Serareru Kugen Karabitsu ni Tsuite 正倉院に保存せられる公験辛櫃について

Shūji Oyobi Kabun 修辞及華文

Shūkyo 秋挙

Shukyū 首級

Sōda Hakase ni Kotau 左右田博士 に答う

Sōmoku no Bi 草木之美

Sōtatsu 宗達

Suda Kunitarō 須田国太郎

Suematsu Kenchō 末松謙澄

Sugawara Kyōzō 菅原教造

Sugawara no Michizane 菅原道真

Suzuki Daisetsu 鈴木大拙

Tachibana no Toshitsuna 橘俊綱

Wakan no Biron wo Kenkyū Subeshi
　和漢の美論を研究すべし
Warera　我等
Waseda Bungaku　早稲田文学
Waseda Daigaku　早稲田大学
Watakushi no Kojinshugi
　私の個人主義
Watanabe Kazuyasu　渡辺和靖
Watsuji Tetsurō　和辻哲郎
Yamamoto Masao　山本正夫
Yamazaki Masakazu　山崎正和
Yanabu Akira　柳父章
Yanagi Muneyoshi　柳宗悦
Yanagita Kunio　柳田国男
Yasui Sokuken　安井息軒
yōga　洋画

Yōga Tebikisō　洋画手引草
Yokoyama Taikan　横山大観
Yomiuri Shinbun　読売新聞
Yosa Buson　与謝蕪村
Yoshikawa Itsuji　吉川逸治
Yoshioka Kenjirō　吉岡健二郎
Yūgen to Aware　幽玄とあはれ
Yume no Samegiwa　夢のさめぎわ
Zaidokuki　在徳記
Zen no Kenkyū　善の研究
zenbigaku　善美学
Zentai no Tachiba　全体の立場
Zettai Jiyū no Ishi　絶対自由の意志
zettai mujunteki jiko dōitsu
　　絶対矛盾的自己同一

CHRONOLOGY

1846 *Ästhetik oder Wissenschaft des Schönen* (Aesthetics or the Science of the Beautiful) by F. Th. Vischer—completed in 1858.

1857 *Sango Benran* (Handbook of Three Languages) by Murakami Hidetoshi. *Mental Philosophy: Including the Intellect, Sensibilities, and Will* by Joseph Haven.

1858 *Du Vrai, du Bien, et du Beau* (On the True, the Good, and the Beautiful) by Victor Cousin.

1859 *The Chambers' Encyclopedia* by Robert and William Chambers—completed in 1868.

1865 *Philosophie de l'Art* (Philosophy of Art) by Hippolyte-Adolphe Taine. *Kant und die Epigonen* (Kant and His Imitators) by Otto Liebmann.

1868 *Geschichte der Ästhetik in Deutschland* (History of Aesthetics in Germany) by R. H. Lotze.

1869 *Philosophie des Unbewussten* (The Philosophy of the Unconscious) by Eduard von Hartmann.

1870 Nishi Amane translates Joseph Haven's *Mental Philosophy: Including the Intellect, Sensibilities, and Will* (1857). The translation, *Shinrigaku* (Psychology), is completed in 1871. *Hyakugaku Renkan* (Encyclopedia) by Nishi Amane.

1871 *Geschichte der deutschen Dichtung neurer Zeit* (History of Modern German Poetry) by Karl von Lemcke. *Zur experimentalen Ästhetik* (Experimental Aesthetics) by Gustav Theodor Fechner.

1872 *Die Geburt der Tragödie* (The Birth of Tragedy) by Friedrich Wilhelm Nietzsche. *Kritische Geschichte der Ästhetik* (Critical History of Aesthetics) by M. Schasler. *Mental and Moral Science* by Alexander Bain.

1873 *Populäre Aesthetik* (Popular Aesthetics) by Karl von Lemcke.

1874 *Hyakuichi Shinron* (The New Theory of the Hundred and One) by Nishi Amane. *Outlines of the World's History, Ancient, Medieval, and Modern, with Special Relation to the History of Civilization and the Progress of Mankind* by William Swinton.

1876 *Vorschule der Ästhetik* (A Primer of Aesthetics) by Theodor Fechner.
 Zur Analysis der Wirklichkeit: Eine Erörterung der Grundprobleme der
 Philosophie (On the Analysis of Reality: An Articulation of the Basic Prob-
 lems of Philosophy) by Otto Liebmann.
1877 *Bimyōgaku Setsu* (The Theory of Aesthetics) by Nishi Amane—published
 in 1907.
 Hakubutsugaku Kaitei (A Primer of Natural History) by Nakagawa Shi-
 geaki—translation of F. Schoedler's *Das Buch der Natur* (The Book of
 Nature).
 Physiological Aesthetics by Grant Allen.
1878 *L'Esthétique* by Eugène Véron.
 Physiological Aesthetics by Grant Allen.
1879 "Shūji Oyobi Kabun" (Rhetoric and Belles Lettres) by Kikuchi Dairoku
 —translation of an anonymous article from Chambers' *Encyclopedia,*
 edited by Robert and William Chambers between 1859 and 1868.
 Die Phänomenologie des sittlichen Bewusstseins (The Phenomenology of
 Moral Consciousness) by Eduard von Hartmann.
 Education as a Science by Alexander Bain.
1882 "Bijutsu Shinsetsu" (The True Conception of the Fine Arts) by Ōmori Ichū
 from a lecture of Ernest Fenollosa.
 Die Religionen des Geistes (The Religion of Spirit) by Eduard von Hart-
 mann.
 Geschichte der Philosophie im Umriss (Outline of the History of Philoso-
 phy) by Albert Schwegler.
1883 Nakae Chōmin translates *Ishi Bigaku* (The Aesthetics of Mr. V.) Eugène
 Véron's *L'Esthétique*—first volume.
 Rinri Shinsetsu (The New Theory of Ethics) by Inoue Tetsujirō.
 "Tōkon no Shōtotsu Ron" (The Debate on the Present Conflict) by Ōnishi
 Hajime.
 Also Spracht Zarathustra (Thus Spake Zarathustra) by Friedrich Wilhelm
 Nietzsche—completed in 1892.
1884 Nakae Chōmin translates *Ishi Bigaku* (The Aesthetics of Mr. V.) Eugène
 Véron's *L'Esthétique*—second volume.
 Hyakka Zensho (Encyclopedia)—Japanese translation of *Chambers' Ency-*
 clopedia by Robert and William Chambers.
 L'Esthétique Contemporaine (Contemporary Aesthetics) by Jean-Marie
 Guyau.
 Das philosophische System Eduard v. Hartmanns (The Philosophical Sys-
 tem of Eduard von Hartmann) by Raphael von Koeber.
1885 *Shōsetsu Shinzui* (Essence of the Novel) by Tsubouchi Shōyō.
1886 "Bi to wa Nani zo ya" (What Is Beauty?) by Tsubouchi Shōyō.
 Engeki Kairyō Iken (Opinions on the Reform of the Theater) by Suematsu
 Kenchō.
 Engeki Kairyōron Shikō (A Personal View on the Reform of Drama) by
 Toyama Masakazu.
 Genbun Itchi (Unification of Spoken and Written Languages) by Mozume
 Takami.

"Shōsetsu Sōron" (General Theory of the Novel) by Futabatei Shimei.
"Katokofu-shi Bijutsu Zokkai" (Introduction to Katkov's Aesthetics) by Futabatei Shimei—a translation of M. N. Katkov's "Practical Significance of Art."
Testugaku Issekiwa (A Night of Philosophical Thoughts) by Inoue Enryō.
Jenseits von Gut und Böse (Beyond Good and Evil) by Friedrich Wilhelm Nietzsche.
Ästhetik by Eduard von Hartmann—completed in 1887.
Grundzüge der Wissenschaft des Schönen und der Kunst (Basic Elements of the Science of the Beautiful and of Art) by Max Schasler.
Ästhetik als Philosophie des Schönen und der Kunst (Aesthetics as the Philosophy of the Beautiful and of Art) by Max Schasler.
Blicke auf den gegenwärtigen Standpunkt der Philosophie in Deutschland und Frankreich (A Look at the Present Standpoint of Philosophy in Germany and France) by J. J. Borelius.
Die Entstehung der neueren Ästhetik (The Origin of Modern Aesthetics) by Heinrich von Stein.
Beiträge zur Analyse der Empfindungen (Contributions to the Analysis of Sensations) by Ernst Mach.

1887 "Kokugaku Waka Kairyō Ron" (Essay on the Reform of National Poetry) by Konakamura Yoshikata.
"Engeki Goran no Koto wo Kikite Tenka no Haiyū ni Tsugu" (Listening to the Debate on Drama and Announcing It to the Land's Actors) by Takada Hanbō.
"Waka ni Shūkyō Nashi" (There Is No Religion in *Waka*) by Ōnishi Hajime.
L'Art au Point de Vue Sociologique (Art from the Sociological Point of View) by Jean-Marie Guyau.
Philosophie des Schönen (Philosophy of Beauty) by Eduard von Hartmann.
Die Einbildungskraft des Dichters—Bausteine für eine Poetik (The Imagination of the Poet: Elements for a Poetics) by Wilhelm Dilthey.
Über den Ursprung der künstlerischen Tätigkeit (On the Source of Artistic Activity) by Konrad Fiedler.

1888 *Chōka Kairyō Ron* (Essay on the Reform of Long Poems) by Sasaki Hirotsuna.
"Hihyō Ron" (Essay on Criticism) by Ōnishi Hajime.
"Bijutsu to Shūkyō" (Art and Religion) by Ōnishi Hajime.
"Nihonjin wa Geijutsugokoro ni Tomeru ka" (Are the Japanese Rich with Artistic Spirit?) by Ōnishi Hajime.
Die Lehre von der Definition (The Theory of Definition) by Heinrich Rickert.

1889 "Bungaku to Shizen" (Literature and Nature) by Mori Ōgai.
"Engeki Kairyō Ronsha no Henken ni Odoroku" (Being Puzzled by the Prejudices of the Reformers of Drama) by Mori Ōgai.
"Wagakuni Bijutsu no Mondai" (The Problem of Art in Our Country) by Ōnishi Hajime.

Essai sur les Données Immédiates de la Conscience (Essay on the Immediate Givens of Conscience) by Henri Bergson.

Die reine Vernunftwissenschaft: Systematische Darstellung von Schelling rationaler oder negativer Philosophie (The Science of Pure Reason: A Systematic Presentation of Schelling's Rational or Negative Philosophy) by Karl Groos.

1890 *Nihon Bungaku Shi* (History of Japanese Literature) by Mikami Sanji and Takatsu Kuwasaburō.

Nihon Kagaku Zensho (Collection of Japanese Poetry) edited by Sasaki Hirotsuna and Sasaki Nobutsuna.

"Nihon Kaiga no Mirai" (The Future of Japanese Painting) by Toyama Masakazu.

"Toyama Masakazu Shi no Garon wo Bakusu" (A Confutation of Toyama Masakazu's Views on Painting) by Mori Ōgai.

"Toyama Masakazu Shi no Garon wo Saihyō Shite Shoka no Bakusetsu wo Bōkyūsu" (A New Critique of Toyama Masakazu's Views on Painting and Other Contrary Views") by Mori Ōgai.

Aesthetik in gemeinverstandlichen Vortragen (Aesthetics in Popular Terms) by Karl von Lemcke.

The Principles of Psychology by William James.

1891 "Ongaku Gakkō Ron" (Essay on the School of Music) by Yatabe Ryōkichi.

"Kokkei no Honsei" (The Real Nature of the Comic) by Ōnishi Hajime.

"Waseda Bungaku no Botsurisō" (The Hidden Ideas of Waseda Bungaku) by Mori Ōgai.

1892 *Bungaku Ippan* (Outline of Literature) by Uchida Rōan.

"Shika Ron" (Essay on Poetics) by Ōnishi Hajime.

"Kagawa Kageki Okina no Karon" (The Poetic Treatises of Master Kagawa Kageki) by Ōnishi Hajime.

Shinbiron (Discourse on the Investigation of the Beautiful) by Mori Ōgai —incomplete translation of Eduard von Hartmann's *Philosophie des Schönen* (Philosophy of the Beautiful), which Mori continued until 1895.

"Takai ni Taisuru Kannen" (Idea Against the Other World) by Kitamura Tōkoku.

"Gikyoku ni Okeru Hiai no Kaikan wo Ronzu" (Debate over Feelings of Pleasure Elicited by Sorrow in Drama) by Takayama Chogyū.

"Kōgei Bijutsu Genri Hanron" (Outline of the Principles of Applied Fine Arts) by Nakagawa Shigeaki.

"Seiyō Chōkokujutsu" (Western Sculpture) by Nakagawa Shigeaki.

"Bi no Kankaku" (The Sense of Beauty) by Nakagawa Shigeaki.

"Sōmoku no Bi" (The Beauty of Trees and Plants) by Nakagawa Shigeaki.

"Kinrui no Bi" (The Beauty of the Animal Species) by Nakagawa Shigeaki.

Einleitung in die Ästhetik (Introduction to Aesthetics) by Karl Groos (1861–1946).

Die drei Epochen der Modernen Ästhetik und ihre heutige Aufgabe (The Three Epochs of Modern Aesthetics and Its Present Task) by Wilhelm Dilthey.

Der Gegenstand der Erkenntnis (The Object of Understanding) by Heinrich Rickert.

1893 *Kyō no Shōsetsu Oyobi Shōsetsuka* (Novels and Novelists of Today) by Uchida Rōan.

"Chishikiron Ben" (Debate on Epistemology) by Ōnishi Hajime.

Das Problem der Form in der bildenden Kunst (The Problem of Form in the Plastic Arts) by Adolf von Hildebrand.

1894 *Kokugo Kenkyū ni Tsuite* (On the Study of National Language) by Ueda Mannen.

"Shinbiteki Ishiki no Seishitsu wo Ronzu" (Discussion of the Qualities of Aesthetic Consciousness) by Shimamura Hōgetsu.

"Nihonga no Hyō" (Critique of Japanese Painting) by Nakagawa Shigeaki.

Nippon Fūkei Ron (Essay on the Japanese Landscape) by Shiga Shigetaka.

Glimpses of Unfamiliar Japan by Lafcadio Hearn.

Katechismus der Malerei (A Catechism of Painting) by Karl Raupp.

Stilfragen (Questions of Style) by Alois Riegl.

1895 *Seiyō Tetsugaku Shi* (History of Western Philosophy) by Ōnishi Hajime.

"Kanbigokoro to Nikukan" (The Heart of External Beauty and Physical Sensations) by Ōnishi Hajime.

"Shinbiteki Kankan wo Ronzu" (Essay on Aesthetic Feelings) by Ōnishi Hajime.

"Gakujutsu ni Okeru Sokuratesu no Jigyō" (Socrates' Scientific Activity) by Ōnishi Hajime.

"Higeki Ron" (Essay on Tragedy) by Shimamura Hōgetsu.

"Kiin Seidō" (Lifelike Refinement) by Shimamura Hōgetsu.

"Henka no Tōitsu to Sō no Kagen" (The Unification of Change and the Apparition of Thought) by Shimamura Hōgetsu.

"Shinki no Kaikan to Bi no Kaikan to no Kankei" (The Relationship Between the Pleasure of Novelty and the Pleasure of Beauty) by Shimamura Hōgetsu.

Out of the East by Lafcadio Hearn.

Aesthetic Principles by Henry R. Marshall (1852–1927).

Ästhetische Zeitfragen (Current Questions in Aesthetics) by Johannes Volkelt.

1896 *Rinrigaku* (Ethics) by Ōnishi Hajime.

"Ongakubi no Kachi" (The Value of Musical Beauty) by Shimamura Hōgetsu.

"Shinbiteki Kenkyū no Ippō" (One Method of Aesthetic Research) by Shimamura Hōgetsu.

"Wakan no Biron wo Kenkyū Subeshi" (The Need to Study Debates on the Beauty of Japanese and Chinese) by Shimamura Hōgetsu.

"Indo Shinbisetsu" (Indian Interpretations of Art) by Mori Ōgai with Ōmura Seigai.

Engeki Kairyō Ron Shikō (Personal Views on the Reform of Theater) by Toyama Masakazu.

Kokoro by Lafcadio Hearn.

The Sense of Beauty by George Santayana.

La Psychologie des Sentiments (The Psychology of Feelings) by Théodule-Armand Ribot.

Essai Critique sur l'Esthétique de Kant (Critical Essay on Kant's Aesthetics) by Victor Guillaume Basch.

Die Spiele der Tiere (The Games of Animals) by Karl Groos.

Die Grenzen der naturwissenschaftlichen Begriffsbildung (Boundaries of the Formation of Natural Scientific Concepts) by Heinrich Rickert.

1897 "Kinsei Bigaku Shisō Ippan" (Outline of Early Modern Aesthetic Thought) by Ōnishi Hajime.

"Harunoya Shujin no *Maki no Kata* wo Hyōsu" (Review of Tsubouchi Shōyō's *Maki no Kata*) by Takayama Chogyū.

"Shigeki ni Tsukite no Utagai" (A Question on Historical Drama) by Tsubouchi Shōyō.

"Tsubouchi Shōyō ga 'Shigeki ni Tsukite no Utagai' wo Yomu" (Reading Tsubouchi Shōyō's "A Question on Historical Drama") by Takayama Chogyū.

"Shigeki ni Kansuru Utagai wo Futatabi Taiyō Kisha ni Tadasu" (Raising Another Question to the Journalist of *The Sun* on Historical Drama) by Tsubouchi Shōyō.

Gleanings in Buddha Fields by Lafcadio Hearn.

Vorlesungen über Aesthetik: Nach vorhandenen Aufzeichnungen bearbeitet (Lectures on Aesthetics Based on Extant Notes) by Heinrich von Stein.

1898 "Shinbi Shinsetsu" (A New Aesthetic Theory) by Ōnishi Hajime—continued in 1899.

"Rekishi Gadai Ron" (Essay on the Subject of Historical Paintings) by Takayama Chogyū.

"Shiteki no Ryōmen to Sono Rihei" (Two Aspects of the Poetic: Its Advantages and Abuses) by Takayama Chogyū.

"Kokka Shijōshugi ni Taisuru Gojin no Kenkai" (A Personal Opinion against State Supremacy) by Takayama Chogyū.

"Uchimura Kanzō Kun ni Atau" (Letter to Mr. Uchimura Kanzō) by Takayama Chogyū.

"Bungakushi Takayama Rinjirō Sensei ni Kotau" (Reply to Professor Takayama Rinjirō) by Uchimura Kanzō.

"Nanshū to Heine" (Southern Countries and Heine) by Takayama Chogyū.

"Yōga Tebikisō" (Introduction to Western Painting) by Mori Ōgai with Iwamura Tōru and Ōmura Seigai—adaptation of Karl Raupp's *Katechismus der Malerei*.

"Preliminary Lectures on the Theory of Literature" by Ernest F. Fenollosa —lectures delivered at the Higher Normal School of Tokyo.

Exotics and Retrospectives by Lafcadio Hearn.

Kulturwissenschaft und Naturwissenschaft (Cultural Science and Natural Science) by Heinrich Rickert.

1899 *Kokubungaku Shi Jukkō* (Ten Lectures on National Literature) by Haga Yaichi.

Mori Ōgai translates as *Shinbiron* Eduard von Hartmann's *Philosophy of Art.*

Shinbi Kōryō (Outline of Aesthetics) by Mori Ōgai together with Ōmura Seigai (1868–1927)—a translation of Eduard von Hartmann's *Philosophie des Schönen.*

Kinsei Bigaku (Modern Aesthetics) by Takayama Chogyū, based on Max Schasler's (1819–1879) *Kritische Geschichte der Ästhetik* (Critical History of Aesthetics) and Robert Zimmermann's (1824–1898) *Geschichte der Ästhetik als Philosophischer Wissenchaft* (History of Aesthetics as Philosophical Science).

"Rekishiga no Honryō Oyobi Daimoku" (The Function and Titles of Historical Paintings) by Takayama Chogyū.

"Tsukiyo no Bikan ni Tsuite" (On the Sense of Beauty in a Moonlight Night) by Takayama Chogyū.

In Ghostly Japan by Lafcadio Hearn.

Der Spiele der Menschen (The Games of Men) by Karl Groos.

1900 "Bikan ni Tsuite no Kansatsu" (Observations on Aesthetic Pleasure) by Takayama Chogyū.

"Shinbi Kyokuchi Ron" (Treatise on What Is Highest in Aesthetics) by Mori Ōgai—translation of Otto Liebman's *Zur Analyse der Wirklichkeit: Eine Erörterung der Grundproblem der Philosophie* (On the Analysis of Reality: An Articulation of the Basic Problems of Philosophy, 1876).

Shinbi Shinsetsu (New Theories on Aesthetics) by Mori Ōgai—a summary of Volkelt's *Aesthetische Zeitfragen.*

Shinrigaku (Psychology) by Motora Yūjirō.

"Geijutsujō ni Iwaiuru Rekishiteki to Iu Go no Shingi Ikaga" (What Is the True Meaning in Art of the Word "Historical"?) by Tsubouchi Shōyō.

"Futatabi Rekishiga no Honryō wo Ronzu" (Another Debate on the Function of Historical Paintings) by Takayama Chogyū.

"Futatabi Rekishiga wo Ronzu" (Another Debate on Historical Paintings) by Tsubouchi Shōyō.

"Tsubouchi Sensei ni Ataete Mitabi Rekishiga no Honryū wo Ronzu" (A Third Debate on the Function of Historical Paintings Addressed to Professor Tsubouchi) by Takayama Chogyū.

"Bigakujō no Risōsetsu ni Tsuite" (On Idealistic Theories in Aesthetics) by Takayama Chogyū.

"Doi Bansui ni Ataete Tōkon no Bundan wo Ronzuru Sho" (Essay on the Contemporary Literary Circles Addressed to Doi Bansui) by Takayama Chogyū.

"Kankōden" (The Biography of Sugawara no Michizane) by Takayama Chogyū.

"Bi no Setsumei" (An Explanation of Beauty) by Nishida Kitarō.

Shadowings by Lafcadio Hearn.

Origins of Art by Yrjö Hirn.

Le Rire by Henri Bergson.

1901 "Biteki Seikatsu wo Ronzu" (Debate on the Aesthetic Life) by Takayama Chogyū.

"Bunmei Hihyōka to Shite no Bungakusha" (A Man of Letters as a Critic of Civilization) by Takayama Chogyū.

"Seiyō Gagaku Yōron" (Essays on Western Painting) by Nakagawa Shigeaki—continued until 1904.

Shinbigaku Kaitei (Primer of Aesthetics) by Nakagawa Shigeaki—translation of Friedrich Theodor Vischer's *Beauty and Art* (1898).

A Japanese Miscellany by Lafcadio Hearn.

Das Wesen der Kunst (The Essence of Art) by Konrad Lange.

Allgemeine Ästhetik (General Aesthetics) by Jonas Cohn.

Die spätrömanische Kunstindustrie (Late Roman Art Industry) by Alois Riegl.

Experimental Psychology by Edward Bradford Titchener—completed in 1905.

1902 "Shinbi Kashō Ron" (Treatise on Aesthetic Appearance) by Mori Ōgai—partial translation of Karl Groos' *Einleitung in der Aesthetik* (Introduction to Aesthetics).

"Jōgaku wa Motte, Kagaku to Shite Rissuru ni Taru ka" (Can Aesthetics Be Established as a Science?) by Mori Ōgai—translation of a posthumous work by Heinrich von Stein.

Shin Bijigaku (New Rhetoric) by Shimamura Hōgetsu.

Shinbi Sōdan (On Beauty) by Nakagawa Shigeaki.

The Awakening of the East by Okakura Tenshin.

Japanese Fairy Tales by Lafcadio Hearn.

Kotto by Lafcadio Hearn.

E. v. Hartmanns philosophisches System im Grundriss (Outline of E. von Hartmann's Philosophical System) by Arthur Drews.

Der ästhetische Genuss (Aesthetic Pleasure) by Karl Groos.

1903 "Nihonfuku no Bijutsuteki Kachi (The Artistic Value of Japanese Clothes), lecture by Ōtsuka Yasuji.

The Ideals of the East by Okakura Kakuzō.

Leitfaden der Psychologie (Guide to Psychology) by Theodor Lipps.

Ästhetik (Aesthetics) by Theodor Lipps—completed in 1906.

Die Probleme der Geschichtsphilosophie (The Problem of the Philosophy of History) by Heinrich Rickert.

Geschlecht und Charakter (Race and Character) by Otto Weininger.

1904 *The Awakening of Japan* by Okakura Kakuzō.

Kaidan by Lafcadio Hearn.

Japan: An Attempt at Interpretation by Lafcadio Hearn.

Geiyō Dōbutsugaku (Zoology for Artistic Purposes) by Nakagawa Shigeaki—completed in 1906.

1905 *System der Ästhetik* (System of the Aesthetic) by Johannes Volkelt—completed in 1914.

Logique des Sentiments (The Logic of Feelings) by Théodule-Armand Ribot.

Erkenntnis und Irrtum (Understanding and Misunderstanding) by Ernst Mach.

Grundbegriffe der Kunstwissenschaft (Principles of Art Science) by August Schmarsow.

1906 "Dōteki Bigaku" (Dynamic Aesthetics) by Shimamura Hōgetsu—an introduction to *The Theory of Beauty* (*Die Theorie des Schönen*, 1903) by the German Theodor Dahmen.
Heigen Zokugo Haikai Bigaku (The Aesthetics of *Haikai* in Plain and Popular Words) by Nakagawa Shigeaki.
The Book of Tea by Okakura Kakuzō.
Ästhetik und Allgemeine Kunstwissenschaft (Aesthetics and General Art-Science) by M. Dessoir.

1907 "Bigaku to Sei no Kyōmi" (Aesthetics and the Zest for Life) by Shimamura Hōgetsu.
"Ōshū Kindai no Chōkoku wo Ronzuru Sho" (Debate on Modern European Sculpture) by Shimamura Hōgetsu.
Essai sur les Passions (Essay on the Passions) by Théodule-Armand Ribot.
L'Évolution Créatrice (Creative Evolution) by Henri Bergson.
Studie über Minderwertigkeit von Organen (Study on the Inferiority Complex) by Alfred Adler.

1908 "Bungeijō no Shizenshugi" (Naturalism in the Literary Arts) by Shimamura Hōgetsu.
"Shizenshugi no Kachi" (The Value of Naturalism) by Shimamura Hōgetsu.
Der ästhetische Gegenstand—Eine phänomenologische Studie (The Aesthetic Object—A Phenomenological Study) by Waldemar Conrad—completed in 1909.
Abstraktion und Einfühlung (Abstraction and Empathy) by Wilhelm Worringer.
Elementargesetze der bildenden Kunst (Elemental Laws of the Plastic Arts) by Adolf von Hildebrand.

1909 *Bigaku Gairon* (Outline of Aesthetics) by Shimamura Hōgetsu.
"Ōshū Kindai no Kaiga wo Ronzu" (Debate on Modern European Paintings) by Shimamura Hōgetsu.
"Jinseikan no Shizenshugi" (Naturalism in the Conception of Life) by Shimamura Hōgetsu.
"Nihon Kenchiku no Shōrai" (The Future of Japanese Architecture)—lecture by Ōtsuka Yasuji.
A Textbook of Psychology by Edward Bradford Titchener—completed in 1910.

1910 *Bungei Gairon* (Outline of the Literary Arts) by Shimamura Hōgetsu.
Tokiwa (Everlasting) by Watsuji Tetsurō.

1911 *Keiji Shin'in Shokuhai Bigaku: Ichimei Shin Haikai Bigaku* (The Aesthetics of Formal Elegance, or The New Aesthetics of *Haikai* by Nakagawa Shigeaki.
"Gendai Nihon no Kaika" (The Enlightenment of Contemporary Japan) by Natsume Sōseki.
Zen no Kenkyū (Inquiry into the Good) by Nishida Kitarō.
Yume no Samegiwa (Awakening from a Dream) by Watsuji Tetsurō.
Shukyū (A Severed Head) by Watsuji Tetsurō.
La Poétique de Schiller (The Poetics of Schiller) by Victor Guillaume Basch.

Form-problem der Gothic (The Problem of Form in Gothic Art) by Wilhelm Worringer.
Beiträge zur Phänomenologie der Wahrnehmung (Contribution to the Phenomenology of Perception) by Wilhelm Schapp.

1912 "Bigaku" (Aesthetics) by Shimamura Hōgetsu.
Epochs of Chinese and Japanese Art by Ernest Francisco Fenollosa.
Ästhetik das reinen Gefühls (Aesthetic of Pure Feelings) by Hermann Cohen.

1913 *Kokubungaku Shi Gairon* (Outline of National Literature) by Haga Yaichi.
Niiche no Kenkyū (A Study of Nietzsche) by Watsuji Tetsurō.
Beiträge zur Phänomenologie des ästhetischen Genusses (Contribution to the Phenomenology of Aesthetic Pleasure) by Moritz Geiger.
Ancient Art and Ritual by Jane Harrison.

1914 "Kēberu Sensei no Kokubetsu" (Farewell to Professor Koeber) by Natsume Sōseki.
Grundlegung der allgemeinen Kunstwissenschaft (Foundations of the Science of All Arts) by Emil Utitz.
Art by Clive Bell.

1915 "Ishiki no Mondai—Shukaku no Kankei" (The Issue of Consciousness—The Relationship of Subject and Object) by Nishida Kitarō.
Über Möglichkeit und Wahrscheinlichkeit (On Possibility and Probability) by Alexius Meinong.
Zeeren Kirukegōru (Søren Kierkegaard) by Watsuji Tetsurō.
Kultur und Mechanik (Culture and Mechanics) by Ernst Mach.
Kunstgeschichtliche Grundbegriffe (Fundamentals of Art History) by Heinrich Wölfflin.

1916 *Rinrigaku no Konpon Mondai* (Basic Problems in Ethics) by Abe Jirō.
"Chikakuteki Keiken no Taikei—Seishin to Buttai, Ishi no Yūi" (The System of Intellectual Experience—Spirit and Substance and the Superiority of the Will) by Nishida Kitarō.
Rembrandt—Ein kunst-philosophischer Versuch (Rembrandt—An Attempt at the Philosophy of Art) by Georg Simmel.

1917 *Bigaku Genron* (Theory of Aesthetics) by Ōnishi Yoshinori.
Bigaku (Aesthetics) by Abe Jirō.
Jikaku ni Okeru Chokkan to Hansei (Intuition and Reflection in Self-Consciousness) by Nishida Kitarō.
"Zettai Jiyū no Ishi" (The Will of Absolute Freedom) by Nishida Kitarō.

1918 "Shigeki Oyobi Shigekiron no Hensen" (Changes in Historical Drama and in the Debates on Historical Drama) by Tsubouchi Shōyō.
"Shōchō no Shin Igi" (The True Meaning of Symbols) by Nishida Kitarō.
Gewissheit und Wahrheit (Certainty and Truth) by Johannes Volkelt.
Idealismus und Naturalismus in der gotischen Skulptur und Malerei (Idealism and Naturalism in Gothic Sculpture and Painting) by Max Dvorák.

1919 *Kēberu Hakase Shōhin Shū* (Collection of Dr. Koeber's Small Pieces) by Raphael von Koeber.
Koji Junrei (Pilgrimage to Ancient Temples) by Watsuji Tetsurō.

"Keiken Naiyō no Shujunaru Renzoku" (Several Continuities in the Content of Experience) by Nishida Kitarō.

"Geijutsu no Taishōkai" (The Object World of Art) by Nishida Kitarō.

1920 *Nihon Kodai Bunka* (Japanese Ancient Culture) by Watsuji Tetsurō.

Das ästhetische Bewusstsein (Aesthetic Consciousness) by Johannes Volkelt.

Wesenhafte Kunst—Ein Aufbau (Substantial Art—A Synthesis) by Walter Meckauer.

Die Philosophie des Lebens (The Philosophy of Life) by Heinrich Rickert.

1921 "Jinsei Hihyō no Genri to Shite no Jinkakushugiteki Kenchi" (The Viewpoint of Personalism as a Principle of a Critique of Human Life) by Abe Jirō.

System der Philosophie (The System of Philosophy) by Heinrich Rickert.

Der Barok: Die Kunst der Gegenreformation (The Baroque: Art of the Counter-Reformation) by Werner Weisbach.

Die Kultur der Dekadenz (The Culture of Decadence) by Eckard von Sydow.

1922 *Kokubungaku Shi Kōwa* (Lectures on the History of National Literature) by Fujioka Sakutarō.

"Rippusu no Jinkakushugi ni Tsuite" (On Lipps' Personalism) by Takenouchi Masashi.

Zur Philosophie der Kunst (The Philosophy of Art) by Georg Simmel.

Beiträge zur Phänomenologie des Äesthetischen Genusses (Phenomenology of Aesthetics Appreciation) by Moritz Geiger.

Tractatus Logico-Philosophicus by Ludwig Wittgenstein.

1923 *Geijutsu to Dōtoku* (Art and Morality) by Nishida Kitarō.

Nankyō Shinshō (New Songs from the Southern Capital) by Aizu Yaichi.

"Shirurā ga Bigakujō no Kōseki" (Schiller's Achievements in Aesthetics) by Fukada Yasukazu.

1924 *Bijutsu Tetsugaku* (The Philosophy of Art) by Ueda Juzō.

Formen der Kunsterkenntnis (Form of Art Perception) by Heinrich Lützeler.

Kunstgeschichte als Geistesgeschichte: Studien zur abendlandischen Kunstentwicklung (The History of Art as the History of Ideas: Studies on the Development of Western Art) by Max Dvorák.

Kant als Philosoph der modernen Kultur (Kant as the Philosopher of Modern Culture) by Heinrich Rickert.

1925 *Kindai Kaiga Shiron* (A Historical Treatise on Modern Painting) by Ueda Juzō.

1926 *Bungaku Gairon* (Outline of Literature) by Honma Hisao.

" 'Iki' no Honshitsu" (The Essence of *Iki*) by Kuki Shūzō—unpublished.

Nihon Seishin Shi Kenkyū (Study of Japan's Intellectual History) by Watsuji Tetsurō.

Genshi Kirisutokyō no Bunkashiteki Igi (The Cultural Meaning of Original Christianity) by Watsuji Tetsurō.

"Basho" (Place) by Nishida Kitarō.

1927 *Gendai Bigaku no Mondai* (Problems in Contemporary Aesthetics) by Ōnishi Yoshinori.

Kanto Handanryoku Hihan no Kenkyū (A Study of Kant's *Critique of Judgment*) by Ōnishi Yoshinori—published in 1931.

Genshi Bukkyō no Jissen Tetsugaku (The Practical Philosophy of Original Buddhism) by Watsuji Tetsurō.

Hataraku Mono kara Miru Mono he (From the Actor to the Seer) by Nishida Kitarō.

"Sōda Hakase ni Kotau" (Reply to Dr. Sōda) by Nishida Kitarō.

Grundlegung einer ästhetischen Wert-theorie (Grounds for an Aesthetic Theory of Value) by Rudolf Odebrecht.

1928 *Die psychische Bedeutung der Kunst* (The Psychical Meaning of Art) by Moritz Geiger.

1929 "Shōsōin ni Hozon Serareru Kugen Karabitsu ni Tsuite" (On the Chinese Container of Official Documents Preserved at the Shōsōin) by Aizu Yaichi.

L'Avenir de l'Esthétique (The Future of Aesthetics) by Etienne Souriau.

Von der Hinfälligkeit des Schönen und der Abenteuerlichkeit des Künstlers (The Frailty of Beauty and the Adventurousness of the Arts) by Oskar Becker.

Gotik und Renaissance als Grundlagen der modernen Weltanschauung (Gothic and Renaissance as Foundations of Modern Views of the World) by Dagobert Frey.

"La Notion du Temps et la Reprise sur le Temps en Orient" (The Notion of Time and Repetition in Oriental Time) by Kuki Shūzō.

Gefühl und schöpferische Gestaltung—Leitgedanken zu einer Philosophie der Kunst (Empathy and Creative Configuration—Basic Ideas for a Philosophy of Art) by Felix Krueger.

1930 *Fukada Yasukazu Zenshū* (Collected Works of Fukada Yasukazu) by Fukada Yasukazu (posthumous, completed in 1931).

Geijutsu Ippan (A General Concept of Art) by Fukada Yasukazu (posthumous).

"Sho no Bi" (The Beauty of Calligraphy) by Nishida Kitarō.

1931 *Bigaku Oyobi Geijutsu Shi Kenkyū* (Studies in Aesthetics and Art History) —Festschrift in honor of Ōtsuka Yasuji.

Jisen Shika Shū (Collection of Personally Collected Poems) by Nishida Kitarō.

Iki no Kōzō (The Structure of *Iki*) by Kuki Shūzō.

1932 *Kanto: Handanryoku Hihan*—Ōnishi Yoshinori's translation of Kant's *Critique of Judgment*.

Mu no Jikakuteki Taikei (The Self-Conscious System of Nothingness) by Nishida Kitarō.

Zentai no Tachiba (The Position of the Whole) by Takahashi Satomi.

Rekishi Tetsugaku (The Philosophy of History) by Miki Kiyoshi.

Das Problem der geistigen Seins (The Problem of Spiritual Beings) by Nicolai Hartmann.

1933 *Ōtsuka Hakase Kōgi Shū* 1: *Bigaku Oyobi Geijutsu Ron* (Collected Lectures of Doctor Ōtsuka, vol. 1: Essays on Aesthetics and Art) by Ōtsuka Yasuji (posthumous).

Bi Ishiki Ron Shi (History of Debates on Aesthetic Consciousness) by Ōnishi Yoshinori.

Hōryūji, Hōkiji, Hōrinji Konryū Nendai no Kenkyū (A Study of the Date of the Construction of Hōryūji, Hōkiji, and Hōrinji) by Aizu Yaichi.

Tetsugaku no Konpon Mondai (Fundamental Problems of Philosophy) by Nishida Kitarō.

1934 "Benshōhōteki Ippansha" (The Dialectical Universal) by Nishida Kitarō.

1935 *Nihon Bungeigaku* (The Science of the Japanese Literary Arts) by Okazaki Yoshie.

Genshōgakuha no Bigaku (Aesthetics of the Phenomenological School) by Ōnishi Yoshinori.

Fūdo: Ningengakuteki Kōsatsu (Climate: An Anthropological Inquiry) by Watsuji Tetsurō.

Gūzensei no Mondai (The Problem of Contingency) by Kuki Shūzō.

"Hyōgen ni Okeru Shinri" (Truth in Expression) by Miki Kiyoshi.

Geijutsu Shi no Kadai (The Subject of Art History) by Ueda Juzō.

1936 *Taiken to Sonzai* (Experience and Existence) by Takahashi Satomi.

Geijutsu Shi no Kadai (The Subject of Art History) by Ueda Juzō.

1937 *Rinrigaku* (Ethics) by Watsuji Tetsurō—completed in 1949.

"Kōiteki Chokkan" (Action-Intuition) by Nishida Kitarō.

Men to Perusona (Mask and Person) by Watsuji Tetsurō.

1939 *Nihon Bungei no Yōshiki* (Styles of the Japanese Literary Arts) by Okazaki Yoshie.

Yūgen to Aware (Yūgen and *Aware)* by Ōnishi Yoshinori.

Rekishi to Benshōhō (History and Dialectics) by Takahashi Satomi.

Kōsōryoku no Ronri (The Logic of the Power of Ideas) by Miki Kiyoshi.

Bunka Kagaku to Shizen Kagaku—Japanese translation of *Kulturwissenschaft und Naturwissenschaft* (Cultural Science and Natural Science) by Heinrich Rickert.

1940 *Bi no Dentō* (The Tradition of Beauty) by Okazaki Yoshie.

Fūga Ron (Essay on Refinement) by Ōnishi Yoshinori.

Rokumei Shū (The Deer's Cries) by Aizu Yaichi.

Kokugogaku Shi (History of the Japanese Language) by Tokieda Motoki.

1941 *Geijutsu Ron no Tankyū* (Inquiry on Debates on the Arts) by Okazaki Yoshie.

Kokugaku: Sono Seiritsu to Kokubungaku to no Kankei (National Learning: Its Formation and Relationship with National Literature) by Hisamatsu Sen'ichi.

"Rekishiteki Keisei Sayō to Shite no Geijutsuteki Sōsaku" (Artistic Creation as an Act of Historical Formation) by Nishida Kitarō.

Shikaku Kōzō (The Structure of Visual Perception) by Ueda Juzō.

Kokugogaku Genron (Theory of the Japanese Language) by Tokieda Motoki.

1943 *Kokugaku no Gakuteki Taikei* (The Scholarly System of National Learning) by Miyake Kiyoshi.

Man'yōshū ni Okeru Shizen Kanjō (Feelings for Nature in the *Man'yōshū*) by Ōnishi Yoshinori.

Nihon Geijutsu Shichō (Currents of Japanese Art) by Okazaki Yoshie.

L'Être et le Néant (Being and Nothingness) by Jean-Paul Sartre.

1944 *Nihon no Bi no Seishin (The Spirit of Japanese Beauty)* by Ueda Juzō.

1947 *Nihon Bungaku no Fūdo to Shichō* (Climate and Trends of Japanese Literature) by Hisamatsu Sen'ichi.

Yuibutsuron to Ningen (Materialism and Man) by Umemoto Katsumi.

La Correspondance des Arts (Relationships of the Arts) by Etienne Souriau.

1948 *Bi no Hihan* (Critique of Beauty) by Ueda Juzō.

1949 *Shizen Kanjō no Ruikei* (Types of Feelings for Nature) by Ōnishi Yoshinori.

Mirē (Millet) by Ueda Juzō.

Yuibutsu Shikan to Dōtoku (Materialistic Views of History and Morality) by Umemoto Katsumi.

Grundlegung zu einer vergleichenden Kunstwissenschaft (Foundations for a Comparative Science of Art) by Dagobert Frey.

1950 *Nihon Bungei to Sekai Bungei* (Japan's Literary Arts and the World's Literary Arts) by Okazaki Yoshie.

1951 *Kokubungaku Tsūron: Hōhō to Taishō* (Introduction to National Literature: Method and Object) by Hisamatsu Sen'ichi.

Kindai no Kaiga no Hōkō (Directions in Modern Painting) by Ueda Juzō.

Bungeigaku Gairon (Outline of the Science of Literature) by Okazaki Yoshie.

1952 *Koten no Yomikata* (Reading of the Classics) by Ikeda Kikan (reprinted in 1991 as *Kotengaku Nyūmon*, or *An Introduction to the Study of the Classics*).

Nihon Bungaku Hyōron Shi: Kinsei Kindai Hen (History of Japanese Literary Criticism: Early Modern and Modern Periods) by Hisamatsu Sen'ichi.

Nihon Rinrigaku Shisō Shi (History of Japan's Ethical Thought) by Watsuji Tetsurō.

Bungeigaku Josetsu (Introduction to the Science of Literature) by Takeuchi Toshio.

1953 *Nihon Kodai Bungaku ni Okeru Bi no Ruikei* (Patterns of Beauty in Ancient Japanese Literature) by Hisamatsu Sen'ichi.

Feeling and Form by Susanne Langer.

Ästhetik (Aesthetics) by Nicolai Hartmann—posthumous.

1954 *Bungei no Janru* (Genres of the Literary Arts) by Takeuchi Toshio.

1955 *Nihon Geijutsu Shi Kenkyū, 1: Kabuki to Ayatsuri Jōruri* (Investigations in the History of Japan's Literary Arts: Kabuki and Puppet Theater) by Watsuji Tetsurō.

Katsura Rikyū (The Katsura Detached Villa) by Watsuji Tetsurō.

Geijutsu no Ronri (The Logic of Art) by Ueda Juzō.

1956 *Towards Science in Aesthetics* by Thomas Munro.

1958 *Kunst und Wahrheit* (Art and Method) by Hans Sedlmayr.

1959 *Bigaku: Jō, Ge* (Aesthetics; 2 volumes) by Ōnishi Yoshinori (posthumous; the second volume was published in 1960).

Arisutoteresu no Geijutsu Riron (The Art Theory of Aristotle) by Takeuchi Toshio.

Busshitsu no Tetsugaku Gainen (The Philosophical Category of Matter) by Kakehashi Akihide.

1960 *Wahrheit und Methode* (Truth and Method) by Hans-Georg Gadamer.

1961 *Jijoden no Kokoromi* (An Attempt at Autobiography) by Watsuji Tetsurō (posthumous).

 Bigaku Jiten (Dictionary of Aesthetics) by Takeuchi Toshio.

1965 *Kokugaku no Hihan: Hōhō ni Kansuru Oboegaki* (A Critique of National Learning: A Note on Method) by Saigō Nobutsuna.

 Gendai Bigaku Shichō (Trends in Contemporary Aesthetics) edited by Takeuchi Toshio—completed in 1968.

1966 "Ningengaku no Chihei" (The Horizon of the Human Sciences) by Sakabe Megumi.

 "Keimō Tetsugaku to Higōrishugi no Aida" (Between the Philosophy of Enlightenment and Irrationalism) by Sakabe Megumi.

1967 *Kaiga no Ronri* (The Logic of Painting) by Ueda Juzō.

 Gendai Geijutsu no Bigaku (The Aesthetics of Contemporary Art) by Takeuchi Toshio.

 Nihon Geijutsu no Rinen (The Concept of Japanese Art) by Kusanagi Masao.

 Yuibutsuron to Gendai (Materialistic Views of History and the Present) by Umemoto Katsumi.

 L'Écriture et la Differance (Writing and Difference) by Jacques Derrida.

 De la Grammatologie (Of Grammatology) by Jacques Derrida.

1968 *Rōmanshugi no Bigaku to Geijutsu Kan* (Aesthetics and Art Views of Romanticism) by Ōnishi Yoshinori (posthumous).

 Bi no Isō to Geijutsu (Phases of Beauty and Art) by Imamichi Tomonobu.

 Betrachtungen über das Eine (Studies on Unity) by Imamichi Tomonobu.

1971 *Tō to Hashi* (Tower and Bridge) by Takeuchi Toshio.

 Dōitsusei no Jiko Sosei (Plasticity of the Identical Self) by Imamichi Tomonobu.

 Arisutoteresu Shigaku Yakuchū (Annotated Translation of Aristotle's *Poetics*) by Imamichi Tomonobu.

 Geijutsu ni Okeru Mikansei (Incompleteness in Art)—Japanese translation of J. A. Schmoll ge. Eisenwerth, *Das Unvollendete als Künstlerische Form* (1959).

1972 "Yojō no Ronri" (The Logic of Passional Surplus) by Kusanagi Masao.

 Marges de la Philosophie by Jacques Derrida.

 La Dissémination by Jacques Derrida.

1973 *Yūgenbi no Bigaku* (Aesthetics of the Beauty of *Yūgen*) by Kusanagi Masao.

 Bi ni Tsuite (On Beauty) by Imamichi Tomonobu.

1975 *Nishida Kitarō Iboku Shū* (Collected Autographs of the Late Nishida Kitarō) by Nishida Kitarō (posthumous).

 Kindai Geijutsu no Seiritsu to Sono Kadai (The Establishment of Modern Art Science and Its Subjects) by Yoshioka Kenjirō.

1976 *Nihon Bungaku Hyōron Shi: Rinen, Hyōgen Ron Hen* (History of Japanese Literary Criticism: Concepts and Debates on Expression) by Hisamatsu Sen'ichi.
 Studia Comparata de Aesthetica (Comparative Studies of Aesthetics) by Imamichi Tomonobu.
 Kamen no Kaishakugaku (The Hermeneutics of Masks) by Sakabe Megumi.
 Risei no Fuan (The Anxiety of Reason) by Sakabe Megumi.
1978 *La Verité en Peinture* (Truth in Painting) by Jacques Derrida.
1979 *Bigaku Sōron* (Survey of Aesthetics) by Takeuchi Toshio.
1980 *Tōyō no Bigaku* (Aesthetics of the East) by Imamichi Tomonobu.
 Heian Chōkokushi no Kenkyū (Study of the History of Sculpture in the Heian Period) by Shimizu Zenzō.
 Nihon Kindai Bungaku no Kigen (Origins of Modern Japanese Literature) by Karatani Kōjin.
1981 *Tōzai no Tetsugaku* (Eastern and Western Philosophy) by Imamichi Tomonobu.
1982 *Serifu no Kōzō* (The Structure of Speech) by Sasaki Ken'ichi.
1985 *Sakuhin no Tetsugaku* (The Philosophy of Works) by Sasaki Ken'ichi.
1988 *Tōyōteki Geijutsu Seishin* (The Eastern Artistic Spirit) by Ōnishi Yoshinori (posthumous).
1989 *Kagami no Naka no Nihongo* (The Japanese Language in a Mirror) by Sakabe Megumi.
1990 *Maruyama Ōkyo Kenkyū* (Study of Maruyama Ōkyo) by Sasaki Jōhei.
 Eko Etika (Eco-Ethica) by Imamichi Tomonobu.
1993 *Shizen Tetsugaku Josetsu* (Introduction to the Philosophy of Nature) by Imamichi Tomonobu.
1995 *Bigaku no Jiten* (Dictionary of Aesthetics) by Sasaki Ken'ichi.
1997 *Kanseiron: Ninshiki Kikairon to Shite no Bigaku no Konnichiteki Kadai* (Theories of Sensibility: Contemporary Topics on Aesthetics as a Cognitive Mechanism) by Iwaki Ken'ichi.
 "Furumai" no Shigaku (The Poetics of "Behavior") by Sakabe Megumi.
1998 *Mimoza Gensō* (The Mimosa Illusion) by Sasaki Ken'ichi.
 Aesthetics on Non-Western Principles by Sasaki Ken'ichi.

BIBLIOGRAPHY

ABBREVIATIONS

BMS *Bijutsu Meicho Sensho*
CR *Chikuma Raiburarī*
GBS *Gendai Bigaku Sōsho*
GNBZ *Gendai Nihon Bungaku Zenshū*
MBZ *Meiji Bungaku Zenshū*
NKBT *Nihon Koten Bungaku Taikei*
NKBZ *Nihon Koten Bungaku Zenshū*
NKST *Nihon Kindai Shisō Taikei*
NM *Nihon no Meicho*
NST *Nihon Shisō Taikei*
SNKS *Shin Nihon Koten Shūsei*

WORKS IN JAPANESE

Abe Jirō. *Abe Jirō Zenshū*. 15 vols. Tokyo: Kadokawa Shoten, 1960–1963.
———. *Bigaku*. Tokyo: Iwanami Shoten, 1917.
———. *Gappon Santarō no Nikki*. Tokyo: Kadokawa Shoten, 1950.
Aizu Yaichi. *Aizu Yaichi Zenshū*. 12 vols. Tokyo: Chūō Kōronsha, 1982.
Amagasaki Akira. *En no Bigaku: Uta no Michi no Shigaku*, vol. 2. Tokyo: Keisō Shobō, 1995.
———. *Kachō no Tsukai: Uta no Michi no Shigaku*. GBS 7. Tokyo: Keisō Shobō, 1983.
———. *Nihon no Retorikku: Engi Suru Kotoba*. Tokyo: Chikuma Shobō, 1988.
Anezaki Chōfū and Sasakawa Rinpū, eds. *Chogyū Zenshū*. 7 vols. Tokyo: Hakubunkan, 1925–1933.
Aoki Shigeru and Sakai Tadayasu, eds. *Bijutsu*. NKST 17. Tokyo: Iwanami Shoten, 1989.
Aoki Takao. " 'Mitate' no Bigaku." *Nihon no Bigaku* 24 (1996):36–62.
Becker, Oskar. *Bi no Hakanasa to Geijutsuka no Bōkensei*. Translated by Kuno Akira. Tokyo: Risōsha, 1964.
Fukada Yasukazu. *Bi to Geijutsu no Riron*. Tokyo: Hakuōsha, 1971.

————. *Fukada Yasukazu Zenshū.* Vols. 1–3. Tokyo: Tamagawa Daigaku Shuppankyoku, 1973–1974.

Haga Tōru. *Kaiga no Ryōbun: Kindai Nihon Hikaku Bunkashi Kenkyū.* Tokyo: Asahi Shinbunsha, 1990.

Hani Susumu. *Bi no Shisō.* Tokyo: Chikuma Shobō, 1969.

Harada Heisaku. *Nihon no Kindai Bijutsu: Ōbei to Hikaku Shite.* Tokyo: Kōyō Shobō, 1997.

Hashimoto Masao. *Geijutsugaku: "Gaku" no Ninshiki to Kōsei Gainen.* Tokyo: Saitō Shoten, 1948.

Hatano Seiichi. *Toki to Eien.* Tokyo: Iwanami Shoten, 1943.

Hijikata Teiichi. *Kindai Nihon Bungaku Hyōron Shi.* Tokyo: Hōsei Daigaku Shuppankyoku, 1973.

————. *Meiji Geijutsu, Bungaku Ronshū.* MBZ 79. Tokyo: Chikuma Shobō, 1975.

————. *Nihon no Kindai Bijutsu.* Tokyo: Iwanami Shoten, 1966.

Hino Tatsuo, ed. *Motoori Norinaga Shū.* SNKS 60. Tokyo: Shinchōsha, 1983.

Hirai Hiroyuki. *Ranbō kara Sarutoru he.* Tokyo: Kiyomizu Kōbundō, 1968.

Hirata Toshihiro. "Yawarakai Sakabe Tetsugaku." *Risō* 646 (1990):67–75.

Hisamatsu Sen'ichi. *Nihon Bungaku Hyōron Shi: Kinsei Kindai Hen.* Tokyo: Shibundō, 1952.

————. *Nihon Bungaku no Fūdo to Shichō.* Tokyo: Shibundō, 1968.

Hisamatsu Sen'ichi and Nishio Minoru, eds. *Karonshū, Nōgakuronshū.* NKBT 65. Tokyo: Iwanami Shoten, 1960.

Ida Shin'ya. "Kaidai." *Nakae Chōmin Zenshū,* vol. 3. Tokyo: Iwanami Shoten, 1984.

Ijichi Tetsuo, Omote Akira, and Kuriyama Riichi, eds. *Rengaronshū, Nōgakuronshū, Haironshū.* NKBZ 51. Tokyo: Shōgakukan, 1973.

Ijima Tsutomu. *Bigaku.* Tokyo: Sōbunsha, 1958.

Imamichi Tomonobu. *Bi ni Tsuite.* Tokyo: Kōdansha, 1973.

————. "Bigaku Geijutsugaku." *Tokyo Daigaku Hyakunen Shi: Bukyoku Shi,* vol. 1. Tokyo: Tokyo Daigaku Shuppankai, 1986.

————. "Bigakusha Hyōden: Ōtsuka Yasuji." *Nihon no Bigaku* 2(8) (1986): 83–90.

————. *Eco-Ethica: Seiken Rinrigaku Nyūmon.* Tokyo: Kōdansha, 1990.

————. "Joron: Bi to wa Nani ka." In Imamichi Tomonobu, ed., *Kōza Bigaku,* vol. 1. Tokyo: Tokyo Daigaku Shuppankyoku, 1984.

Inagaki Taruho. "Bi no Hakanasa." *Inagaki Taruho Zenshū,* vol. 5. Tokyo: Gendai Shichōsha, 1970.

Inoue Shōichi. *Tsukurareta Katsura Rikyū Shinwa.* Tokyo: Kōbundō, 1986.

Ishikawa Jun, ed. *Motoori Norinaga.* NM 21. Tokyo: Chūō Kōron Sha, 1984.

Isoda Kōichi. "Okakura Tenshin: Sono Rekishiteki Ichi wo Megutte." *Nihon no Bigaku* 1(4) (Spring 1985):92–103.

————. *Ritsumeikan no Keifu.* Tokyo: Bungei Shunjūsha, 1983.

Iwaki Ken'ichi. "Bigaku Bijutsushigaku." In *Kyoto Daigaku Shi.* Kyoto: Kyoto Daigaku Shuppan, forthcoming.

————. "Gendai Kanseigaku to Futatsu no Shin Keijijōgaku—Sono Atarashisa to Mondaisei no Mekanizumu." In *Kansei Ron: Ninshiki Kikairon to Shite no Bigaku no Konnichiteki Kadai.* Tokyo: Kōyō Shobō, 1997.

———. "Nihon ni Okeru Fīdorā—Chokkanteki Genjitsu no Shinsō wo Megutte." *Sekai Shisō* 22 (1995).

———. "Nishida Kitarō to Geijutsu." In Iwaki Ken'ichi, ed., *Nishida Kitarō Senshū*. Vol. 6. Kyoto: Tōeisha, 1998.

———. "Shikaku no Ronri: Ueda Juzō." In Tsunetoshi Sōsaburō, ed., *Nihon no Tetsugaku wo Manabu Hito no Tame ni*. Kyoto: Sekai Shisōsha, 1998.

Kambayashi Tsunemichi. "Aizu Yaichi no Bigaku: Nanpō he no Dōkei." *Shūsō* 11 (1995):26–32.

———, ed. *Nihon no Bi no Katachi*. Kyoto: Sekai Shisō Sha, 1991.

Kaneda Tamio. *Bi to Geijutsu he no Joshō*. Tokyo: Hōritsu Bunka Sha, 1975.

———. *Nihon Kindai Bigaku Josetsu*. Tokyo: Hōritsu Bunka Sha, 1990.

Karatani Kōjin. "Bigaku no Kōyō: 'Orientarizumu' Igo." *Hihyō Kūkan* 2(14) (1997):42–55.

———. "Bijutsukan to Shite no Nihon: Okakura Tenshin to Fenorosa." *Hihyō Kūkan* 2(1) (1994):59–75.

Kinbara Seigo. *Nihon Geijutsu no Kadai*. Tokyo: Kawade Shobō, 1940.

———. *Tōyō Bigaku*. Tokyo: Kokon Shoin, 1932.

Kitamura Tōkoku. *Tōkoku Zenshū,* vol. 1. Tokyo: Iwanami Shoten, 1950.

Kobata Junzō. *Shinpan—Bi to Geijutsu no Ronri: Bigaku Nyūmon*. Tokyo: Keisō Shobō, 1986.

Kobayashi Hideo. *Geijutsu Zuisō*. Tokyo: Shinchōsha, 1966.

Kobori Keiichirō. "Ōgai Bigakujō no Gyōseki ni Tsuite." *Ōgai Zenshū Geppō* 21 (1973):8–15.

Koeber, Raphael von. "Eduard von Hartmann: Tsuioku." In *Koizumi Yakumo Shū, Rafaeru Kēberu Shū, Noguchi Yonejirō Shū*. GNBZ 57. Tokyo: Kaizōsha, 1931.

Kōsaka Masaaki. *Nishida Kitarō to Watsuji Tetsurō*. Tokyo: Shinchōsha, 1964.

Koyasu Nobukuni. "Watsuji Tetsurō—Sono Nihon Ninshiki no Arikata." In Osaka Daigaku Hōsō, ed., *Nihon Kenkyū no Sendatsu*. Osaka: Isshinsha, 1987.

Kubo Masaru. *Kēberu Sensei to Tomo ni*. Tokyo: Iwanami Shoten, 1951.

Kuki Shūzō Bunko Mokuroku. Kobe: Kōnan Daigaku Tetsugaku Kenkyūshitsu, 1976.

Kuki Shūzō. *Bungei Ron*. Tokyo: Iwanami Shoten, 1941.

———. *Iki no Kōzō*. Tokyo: Iwanami Shoten, 1979.

———. *Kuki Shūzō Zenshū*. 11 vols. Tokyo: Iwanami Shoten, 1980–1981.

———. *Ningen to Jitsuzon*. Tokyo: Iwanami Shoten, 1939.

Kurahara Korehito, ed. *Marukusu-Rēninshugi Bigaku no Kiso*. Vols. 1–3. Tokyo: Keiryūkaku, 1968–1969.

Kurata Yoshihiro. *Geinō*. NKST 18. Tokyo: Iwanami Shoten, 1988.

Kuriyama Riichi, ed. *Nihon Bungaku ni Okeru Bi no Kōzō*. Kyoto: Yūzankaku, 1991.

Kusanagi Masao. *Yūgenbi no Bigaku*. Tokyo: Hanawa Shobō, 1973.

Marra, Michele. "Yowaki Shii: Kaishakugaku no Mirai wo Minagara" (Weak Thought: A Look at the Future of Hermeneutics). *Nichibunken Forum* 95 (1997):1–38.

Maruyama Masao. *Nihon no Shisō*. Tokyo: Iwanami Shoten, 1961.

————. *Nihon Seiji Shisōshi Kenkyū.* Tokyo: Tokyo Daigaku Shuppankai, 1952.

Meiji Bungaku Zenshū. Tokyo: Chikuma Shobō, 1969.

Miki Kiyoshi. "Hyōgen ni Okeru Shinri." *Miki Kiyoshi Zenshū,* vol. 5. Tokyo: Iwanami Shoten, 1967.

Miki Teiichi. *Nihon Sumō Shi.* Tokyo: Banzaikan, 1909.

Minami Hiroshi. *Nihonjin Ron: Meiji kara Kyō made.* Tokyo: Iwanami Shoten, 1994.

Minamoto Ryōen. *Tokugawa Gōri Shisō no Keifu.* Tokyo: Chūō Kōronsha, 1972.

Miura Shin'ichirō. "Ningensei Kansei no Risō to Shite no Bi—Shirā no Bigaku." In Ōta Takao, Iwaki Ken'ichi, and Yonezawa Aritsune, eds., *Bi, Geijutsu, Shinri —Doitsu no Bigakushatachi.* Tokyo: Shōwadō, 1987.

Mizuo Hiroshi. *Bi no Shūen.* Tokyo: Chikuma Shobō, 1967.

Mori Ōgai. *Ōgai Zenshū Chōsaku Hen,* vol. 16. Tokyo: Iwanami Shoten, 1953.

Morikawa Keishō. *Nihonbi no Seikaku.* Tokyo: Asakura Shoten, 1984.

Morioka Kenji, ed. *Kindaigo no Seiritsu: Goi Hen.* Tokyo: Meiji Shoin, 1990.

Naitō Toshihito. "Kuki to Sarutoru." *Kuki Shūzō Zenshū, Geppō* 12. Tokyo: Iwanami Shoten, 1982.

Nakae Chōmin. *Nakae Chōmin Zenshū,* vol. 2. Tokyo: Iwanami Shoten, 1984.

Nakagawa Shimei. *Heigen Zokugo Haikai Bigaku.* Tokyo: Hakubunkan, 1906.

Nakai Masakazu. *Bi to Shūdan no Ronri.* Tokyo: Chūō Kōronsha, 1962.

Nakano Shigeharu. *Geijutsu ni Kansuru Hashiragakiteki Oboegaki.* Tokyo: Iwanami Shoten, 1978.

Nakao Tatsurō. *Sui, Tsū, Iki: Edo no Bi Ishiki Kō.* Tokyo: Miai Shoten, 1984.

Nishida Kitarō. *Hataraku Mono kara Miru Mono he.* Tokyo: Iwanami Shoten, 1927.

————. *Ippansha no Jikakuteki Taikei.* Tokyo: Iwanami Shoten, 1929.

————. *Nishida Kitarō Zenshū.* 19 vols. Tokyo: Iwanami Shoten, 1978–1980.

Nishimura Kiyokazu. *Fikushon no Bigaku.* Tokyo: Keisō Shobō, 1993.

Nishitani Keiji. *Nishitani Keiji Chosaku Shū,* vol. 13. Tokyo: Sōbunsha, 1987.

Ōhashi Ryōsuke. *"Kire" no Kōzō: Nihonbi to Gendai Sekai.* Tokyo: Chūō Kōronsha, 1986.

————. *Nihonteki na Mono, Yōroppateki na Mono.* Tokyo: Shinchōsha, 1992.

————. *Zettaisha no Yukue: Doitsu Kannenron to Gendai Sekai.* Kyoto: Minerva Shobō, 1993.

Ōhashi Ryōsuke and Noe Keiichi, eds. *Nishida Tetsugaku Senshū.* Vol. 6: *Geijutsu Tetsugaku: Ronbun Shū.* Kyoto: Tōeisha, 1998.

Ōka Shōhei. "Waga Biteki Sennō." *Geijutsu Shinchō* (May 1965).

Okazaki Yoshie. *Bi no Dentō.* Tokyo: Kōbundō, 1940.

————. *Geijutsu Ron no Tankyū.* Tokyo: Kōbundō, 1941.

————. *Nihon Bungei no Yōshiki.* Tokyo: Iwanami Shoten, 1939.

————. *Nihon Bungei to Sekai Bungei.* Tokyo: Hōbunkan, 1971.

————. *Nihon Bungeigaku.* Tokyo: Iwanami Shoten, 1935.

Okitsu Kaname. *Itan no Aruchizantachi.* Tokyo: Yomiuri Shinbunsha, 1973.

Ōkubo Tadashi, ed. *Motoori Norinaga Zenshū,* vol. 8. Tokyo: Chikuma Shobō, 1972.

Ōkubo Toshiaki, ed. *Nishi Amane Zenshū*. 4 vols. Tokyo: Munetaka Shobō, 1971.

Ōnishi Hajime. *Ōnishi Hajime Zenshū*. 7 vols. Tokyo: Nihon Tosho Sentā, 1982.

Ōnishi Sensei Seitan Hyakunen "Kaisō Roku" Henshū Iinkai, ed. *Ōnishi Sensei to Sono Shūhen: Kaisō Roku*. Tokyo: Toppan Insatsu Kabushiki Kaisha, 1989.

Ōnishi Yoshinori. *Bi Ishiki Ronshi*. Tokyo: Kadokawa Shoten, 1950.

———. *Bigaku: Jō, Ge*. Tokyo: Kōbundō, 1959–1960.

———. *Fūga Ron: Sabi no Kenkyū*. Tokyo: Iwanami Shoten, 1940.

———. *Gendai Bigaku no Mondai*. Tokyo: Iwanami Shoten, 1927.

———. *Genshōgakuha no Bigaku*. Tokyo: Iwanami Shoten, 1937.

———. *Man'yōshū no Shizen Kanjō*. Tokyo: Iwanami Shoten, 1943.

———. *Rōmanshugi no Bigaku to Geijutsu Ron*. Tokyo: Kōbundō, 1968.

———. *Shizen Kanjō no Ruikei*. Tokyo: Kaname Shobō, 1948.

———. *Tōyōteki Geijutsu Seishin*. Tokyo: Kōbundō, 1988.

———. *Yūgen to Aware*. Tokyo: Iwanami Shoten, 1939.

Ōno Michiko. " 'Tōshōdaiji no Marubashira' Eigoyaku ni Tsuite." *Shūsō* 11 (1995):19–22.

Orikuchi Shinobu. *Orikuchi Shinobu Zenshū*. Vol. 2: *Kodai Kenkyū (Minzoku Gakuhen* 1). Tokyo: Chūō Kōronsha, 1975.

Otabe Tanehisa. "Kindaiteki 'Shoyūken' Shisō to 'Geijutsu' Gainen: Kindai Bigaku no Seijigaku he no Joshō." *Hihyō Kūkan* 12 (1997):51–66.

Ōtsuka Yasuji. *Ōtsuka Hakase Kōgi Shū*. Vol. 1: *Bigaku Oyobi Geijutsu Ron*. Tokyo: Iwanami Shoten, 1933.

———. *Ōtsuka Hakase Kōgi Shū*. Vol. 2: *Bungei Shichō Ron*. Tokyo: Iwanami Shoten, 1936.

Rickert, Heinrich. *Bunka Kagaku to Shizen Kagaku*. Translated by Satake Tetsuo and Toyokawa Noboru. Tokyo: Iwanami Shoten, 1939.

Saeki Junko. " 'Bi' no Akogare." *Nihon no Bigaku* 21 (1994):178–190.

———. "Shizen to Shinjitsu." *Nihon no Bigaku* 19 (December 1992):142–158.

Sagara Tōru, Bitō Masahide, and Akiyama Ken, eds. *Kōza Nihon Shisō*. Vol. 5: *Bi*. Tokyo: Tokyo Daigaku Shuppankai, 1984.

Sakabe Megumi. *"Furumai" no Shigaku*. Tokyo: Iwanami Shoten, 1997.

———. *Fuzai no Uta—Kuki Shūzō no Sekai*. Tokyo: TBS Buritanika, 1990.

———. *Kagami no Naka no Nihongo: Sono Shikō no Shujusō*. CR 22. Tokyo: Chikuma Shobō, 1989.

———. *Kamen no Kaishakugaku*. Tokyo: Tokyo Daigaku Shuppankai, 1976.

Sakazaki Shizuka, ed. *Nihon Garon Taikan*, vol. 1. Tokyo: Arusu, 1927.

———. *Nihonga no Seishin*. Tokyo: Tōkyōdō, 1942.

Sasaki Ken'ichi. *Bigaku Jiten*. Tokyo: Tokyo Daigaku Shuppankai, 1995.

———. *Esunikku no Jigen: "Nihon Tetsugaku" Sōshi no Tame ni*. Tokyo: Keisō Shobō, 1998.

———. "Geijutsu." In *Kōza Bigaku*, vol. 2. Tokyo: Tokyo Daigaku Shuppankai, 1984.

———. *Mimoza Gensō: Kioku, Geijutsu, Kokkyō*. Tokyo: Keisō Shobō, 1998.

———. *Sakuhin no Tetsugaku*. Tokyo: Daigaku Shuppankai, 1985.

———. *Serifu no Kōzō*. Tokyo: Kōdansha, 1994.

Satake Hiroto and Nakai Hisao, eds. *"Iji" no Shinri*. Tokyo: Sōgensha, 1987.

Satō Dōshin. *Nihon Bijutsu Tanjō: Kindai Nihon no "Kotoba" to Senryaku*. Tokyo: Kōdansha, 1996.

Satō Haruo. *Bi no Sekai, Ai no Sekai*. Tokyo: Kōdansha, 1995.

Shimamoto Haruo. *"Ishi Bigaku to Nakae Atsusuke."* *Meiji Bunka Zenshū*, Addendum 1. Tokyo: Nihon Hyōronsha, 1970.

Shimamura Hōgetsu. *Hōgetsu Zenshū*. 8 vols. Tokyo: Tenyūsha, 1919–1920.

———. *Shimamura Hōgetsu Bungei Hyōron Shū*. Tokyo: Iwanami Shoten, 1954.

Shimomise Eiichi. "Kuki Tetsugaku to Gūzensei no Mondai." *Shisō* (March 1980):76–103.

Shimomura Toratarō. *Shizen Tetsugaku*. Tokyo: Kōbundō, 1939.

Shumoru, J. A., ed. *Geijutsu ni Okeru Mikansei*. BMS 17. Tokyo: Iwazaki Bijutsu Sha, 1971.

Tada Michitarō. "Kaisetsu." In Kuki Shūzō, *"Iki" no Kōzō*. Iwanami Bunko. Tokyo: Iwanami Shoten, 1979.

Takahashi Satomi. *Zentai no Tachiba*. Tokyo: Iwanami Shoten, 1932.

Takamura Kōtarō. *Bi ni Tsuite*. Tokyo: Chikuma Shobō, 1967.

Takashina Shūji. *Nihon Kaiga no Kindai: Edo kara Shōwa made*. Tokyo: Seidosha, 1996.

———. *Nihon Kindai Bijutsushi Ron*. Tokyo: Kōdansha, 1990.

Takasu Yoshijirō. *Takayama Chogyū*. Tokyo: Kaiseisha, 1943.

Takayama Chogyū Shū, Anezaki Chōfū Shū. GNBZ 13. Tokyo: Kaizōsha, 1956.

Takayama Rinjirō. *Chogyū Zenshū*. Vol. 1: *Bigaku Oyobi Bijutsu Shi*. Tokyo: Hakubunkan, 1914.

Takemiya Akira. "Erosu to Bi." In *Bigaku Shi Ronsō*. Tokyo: Keisō Shobō, 1983.

Takeuchi Toshio, ed. *Bigaku Jiten*. Tokyo: Kōbundō, 1974.

———. *Bigaku Sōron*. Tokyo: Kōbundō, 1979.

———. *Bungei no Janru*. Tokyo: Kōbundō, 1954.

———. *Bungeigaku Josetsu*. Tokyo: Iwanami Shoten, 1952.

———. "Nihon no Bigaku no Rekishi wo Kaerimite." *Bigaku* 100 (1975).

Tanaka Kyūbun. *Kuki Shūzō: Guzen to Shizen*. Tokyo: Perikansha, 1992.

———. "Nihon no Kindai Tetsugaku ni Okeru Bukkyō Keijijōgaku no Juyō to Sono Tenkai—*Mu* no Tetsugaku Shi." *Tōyō Gakujutsu Kenkyū* (November 1985).

Tanaka Yutaka, ed. *Zeami Geijutsu Ronshū*. SNKS 4. Tokyo: Shinchōsha, 1976.

Tanigawa Atsushi. *Bigaku no Gyakusetsu*. Tokyo: Keisō Shobō, 1993.

Taut, Bruno. *Nihon Bunka Shikan*. Translated by Mori Toshio. Tokyo: Meiji Shoin, 1936.

———. *Nihon no Geijutsu*. Translated by Shinoda Hideo. Tokyo: Ikuseisha, 1946.

———. *Nippon*. Translated by Mori Toshio. Tokyo: Kōdansha, 1991.

Terao Isamu. *Bi no Ronri: Kyo to Jitsu no Aida*. Tokyo: Sōgensha, 1971.

Tokieda Motoki. *Kokugogaku Genron: Gengo Kateisetsu no Seiritsu to Sono Tenkai*. Tokyo: Iwanami Shoten, 1941.

Tsunetoshi Sōsaburō, ed. *Nihon no Tetsugaku wo Manabu Hito no Tame ni*. Kyoto: Sekai Shisōsha, 1998.

Tsuzumi Hideyoshi. *Nihon Geijutsu Yōshiki no Kenkyū*. Tokyo: Naigai Shuppan Insatsu Kabushiki Kaisha, 1933.

Uchinuma Yukio. *Shōki no Hakken—Paranoia Chūkaku Ron*. Tokyo: Iwanami Shoten, 1987.

———. *Taijin Kyōfu*. Kōdansha Geidai Shinsho. Tokyo: Kōdansha, 1990.

———. *Taijin Kyōfu no Ningengaku*. Tokyo: Kōbundō, 1977.

Ueda Juzō. *Bi no Hihan*. Tokyo: Kōbundō, 1948.

———. *Nihon no Bi no Seishin*. Tokyo: Kōbundō, 1944.

———. *Shikaku Kōzō*. Tokyo: Kōbundō, 1941.

Ueda Shigeo. *Aizu Yaichi to Sono Geijutsu*. Tokyo: Waseda Daigaku Shuppanbu, 1971.

Ueda Shizuteru. *Nishida Kitarō wo Yomu*. Tokyo: Iwanami Shoten, 1991.

Watanabe Kazuyasu. *Meiji Shisō Shi: Jukyōteki Dentō to Kindai Ninshikiron*. Tokyo: Perikansha, 1978.

———. "Ōnishi Hajime: Hihyōshugi to Bigaku." *Nihon no Bigaku* 2(7) (1986): 105–112.

Watsuji Tetsurō. *Fūdo: Ningengakuteki Kōsatsu*. Tokyo: Iwanami Shoten, 1935.

———. *Katsura Rikyū: Yōshiki no Haigo wo Saguru*. Tokyo: Chūō Kōronsha, 1958.

———. *Koji Junrei*. Tokyo: Iwanami Shoten, 1979.

———. *Nihon Seishin Shi Kenkyū*. Tokyo: Iwanami Shoten, 1926.

———. *Watsuji Tetsurō Zenshū*. 27 vols. Tokyo: Iwanami Shoten, 1961–1963.

———. *Zoku Nihon Seishin Shi Kenkyū*. Tokyo: Iwanami Shoten, 1935.

Yamagiwa Yasushi. *Bigaku: Nihon Bigaku he no Rinen*. Tokyo: Asakura Shoten, 1941.

Yamamoto Masao. *Geijutsu Shi no Tetsugaku*. Tokyo: Bijutsu Shuppan Sha, 1962.

———. "Meiji no Bigaku—Bigaku to Nihon Seishin." *Kokubungaku Kaishaku to Kanshō* 1 (1960).

———. "Ōnishi Yoshinori Sensei no Bigaku Shisō." In Ōnishi Yoshinori, *Tōyōteki Geijutsu Seishin*. Tokyo: Kōbundō, 1988.

———. *Tōzai Geijutsu Seishin no Dentō to Kōryū*. Tokyo: Risōsha, 1965.

Yamano Tamotsu. *"Iji" no Kōzō*. Tokyo: Sōgensha, 1990.

Yamazaki Masakazu. *Engi Suru Seishin*. Tokyo: Chūō Kōron Sha, 1983.

———. *Geijutsu, Henshin, Yūgi*. Tokyo: Chūō Kōronsha, 1975.

———. *Yawarakai Kojinshugi no Tanjō: Shōhi Shakai no Bigaku*. Tokyo: Chūō Kōronsha, 1984.

Yanabu Akira. *Hon'yakugo no Ronri: Gengo ni Miru Nihon Bunka no Kōzō*. Tokyo: Hōsei Daigaku Shuppankyoku, 1972.

———. *Hon'yakugo Seiritsu Jijō*. Tokyo: Iwanami Shoten, 1982.

———. *Ichigo no Jiten: Bunka*. Tokyo: Sanseidō, 1995.

Yanagi Muneyoshi. *Bi no Hōmon*. Tokyo: Iwanami Shoten, 1995.

———. *Kōgei Bunka*. Tokyo: Iwanami Shoten, 1985.

Yasuda Takeshi and Tada Michitarō. *"Iki" no Kōzō wo Yomu*. Tokyo: Asahi Shinbunsha, 1979.

Yasuda Yojūrō. *Nihon no Bi to Kokoro*. Tokyo: Yomiuri Shinbunsha, 1970.

Yokoyama Kendō. *Nihon Sumō Shi*. Tokyo: Fusanbō, 1943.

Yoshioka Kenjirō. "Fukada Yasukazu no Shisō to Sono Jidai." In Fukada Yasukazu, *Bi to Geijutsu no Riron*. Tokyo: Hakuōsha, 1971.

Yuasa Yasuo. *Watsuji Tetsurō: Kindai Nihon Tetsugaku no Unmei*. Kyoto: Minerva Shobō, 1981.

WORKS IN WESTERN LANGUAGES

Abe Masao. "Nishida's Philosophy of 'Place.' " *International Philosophical Quarterly* 28(4) (1988):355–371.

Addiss, Stephen. *Zenga and Nanga: Paintings by Japanese Monks and Scholars.* New Orleans Museum of Art, 1976.

Adorno, Theodor W. *Kierkegaard: Construction of the Aesthetic.* Minneapolis: University of Minnesota Press, 1989.

Allioux, Yves-Marie. *Cent Ans de Pensée au Japon.* Vols. 1 and 2. Paris: Éditions Philippe Picquier, 1996.

Bambach, Charles R. *Heidegger, Dilthey, and the Crisis of Historicism.* Ithaca: Cornell University Press, 1995.

Barilli, Renato. *A Course on Aesthetics.* Translated by Karen E. Pinkus. Minneapolis: University of Minnesota Press, 1993.

Baumgarten, Alexander Gottlieb. *Aesthetica.* Frankfurt: Johann Christian Kleyb, 1750.

———. *Estetica.* Milan: Vita e Pensiero, 1993.

Bazin, Germain. *Histoire de l'Histoire de l'Art: De Vasari à nos Jours.* Paris: Albin Michel, 1986.

Beardsley, Monroe C. *Aesthetics from Classical Greece to the Present: A Short History.* University: University of Alabama Press, 1982. First published in 1966.

Becker, Oskar. *Von der Abenteuerlichkeit des Künstlers und der vorsichtigen Verwegenheit des Philosophen.* Berlin: Alexander Verlag, 1994.

Benedict, Ruth F. *The Chrysanthemum and the Sword: Patterns of Japanese Culture.* Boston: Houghton Mifflin, 1946.

Berger, Klaus. *Japonisme in Western Paintings from Whistler to Matisse.* Cambridge: Cambridge University Press, 1992.

Berque, Augustin. "Identification of the Self in Relation to the Environment." In Nancy R. Rosenberg, ed., *Japanese Sense of Self.* Cambridge: Cambridge University Press, 1992.

Bodei, Remo. *Le Forme del Bello.* Bologna: Il Mulino, 1995.

Bollea, L. C. *Antonio Fontanesi alla R. Accademia Albertina.* Turin: Fratelli Bocca, 1932.

Bowring, Richard J. *Mori Ōgai and the Modernization of Japanese Culture.* Cambridge: Cambridge University Press, 1979.

Brahimi, Denise. *Un Aller Retour pour Cipango: Essai sur les Paradoxes du Japonisme.* Paris: Noël Blandin, 1992.

Brüll, Lydia. *Die japanische Philosophie: Eine Einführung.* Darmstadt: Wissenschaftliche Buchgesellschaft, 1989.

Buchner, Hartmut, ed. *Japan und Heidegger: Gedenkschrift der Stadt Messkirch zum hundertsten Geburtstag Martin Heideggers.* Sigmaringen: Jan Thorbecke Verlag, 1989.

Bürger, Peter. *Theory of the Avant-Garde.* Translated by Michael Shaw. Minneapolis: University of Minnesota Press, 1984.

Calderini, Marco. *Antonio Fontanesi: Pittore Paesista.* Turin: Paravia, 1901.

Carchia, Gianni. *Arte e Bellezza: Saggio sull'Estetica della Pittura.* Bologna: Il Mulino, 1995.

Carter, Robert. *The Nothingness beyond God: An Introduction to the Philosophy of Nishida Kitarō*. St. Paul: Paragon House, 1997.

Chan, Wing-Tsit. *A Source Book in Chinese Philosophy*. Princeton: Princeton University Press, 1969.

Chisolm, Lawrence W. *Fenollosa: The Far East and American Culture*. New Haven: Yale University Press, 1963.

Clark, John, trans. *Reflections on Japanese Taste: The Structure of Iki*. Sydney: Power Publications, 1997.

Committee of Festschrift for Tomonobu Imamichi. *Aesthetica and Calonologia*. Tokyo: Bunkensha, 1988.

D'Angelo, Paolo. *L'Estetica del Romanticismo*. Bologna: Il Mulino, 1997.

De Man, Paul. "Sign and Symbol in Hegel's *Aesthetics*." *Critical Inquiry* 8(4) (1982).

Dessoir, Max. *Aesthetics and Theory of Art—Ästhetik und Allgemeine Kunstwissenschaft*. Translated by Stephen A. Emery. Detroit: Wayne State University Press, 1970.

Diderot, Denis. *Trattato sul Bello*. Milan: SE, 1995.

Dilthey, Wilhelm. *Poetry and Experience*. Edited by Rudolf A. Makkreel and Frithjof Rodi. Princeton: Princeton University Press, 1985.

Dilworth, David A. "Nishida Kitarō: Nothingness as the Negative Space of Experiential Immediacy." *International Philosophical Quarterly* 13(4) (1973): 463–483.

———, trans. *Nishida Kitarō's Fundamental Problems of Philosophy: The World of Action and the Dialectical World*. Tokyo: Sophia University, 1970.

Doak, Kevin Michael. *Dreams of Difference: The Japan Romantic School and the Crisis of Modernity*. Berkeley: University of California Press, 1994.

———. "Under the Banner of the New Science: History, Science, and the Problem of Particularity in Early Twentieth-Century Japan." *Philosophy East and West* 48(2) (1998):232–256.

Dobson, W. A. C. H., trans. *Mencius*. Toronto: University of Toronto Press, 1963.

Dufrenne, Mikel. *In the Presence of the Sensuous: Essays in Aesthetics*. Atlantic Highlands: Humanities Press International, 1987.

Eagleton, Terry. *The Ideology of the Aesthetic*. Oxford: Basil Blackwell, 1990.

Eisenwerth, J. A. Schmoll, ed. *Das Unvollendete als Künstlerische Form*. Bern: Francke AG Verlag, 1959.

Fechner, Gustav Theodor. *Vorschule der Aesthetik*. Leipzig: Breitkopf & Härtel, 1925.

Fenollosa, Ernest F. *Epochs of Chinese and Japanese Arts: An Outline History of East Asian Design*. Vol. 1. New York: Frederik A. Stokes, 1912.

Ferry, Luc. *Homo Aestheticus: The Invention of Taste in the Democratic Age*. Chicago: University of Chicago Press, 1993.

Fiedler, Konrad. *Aforismi sull'Arte*. Translated by Rossana Rossanda. Milan: TEA, 1994.

Focillon, Henri. *Vie des Formes Suivi de l'Éloge de la Main*. Paris: Presses Universitaires de France, 1943.

Franzini, Elio. *L'Estetica del Settecento*. Bologna: Il Mulino, 1995.

Frey, Dagobert. *Architecture of the Renaissance from Brunelleschi to Michael Angelo.* The Hague: G. Naeff, 1925.

Gadamer, Hans-Georg. *The Relevance of the Beautiful and Other Essays.* Translated by Nicholas Walker. Cambridge: Cambridge University Press, 1986.

——. *Truth and Method.* Translated by Joel Weinsheimer and Donald G. Marshall. New York: Crossroad, 1992.

Gilbert, Katharine Everett, and Helmut Kuhn. *A History of Esthetics.* Bloomington: Indiana University Press, 1954.

Goethe, Johann Wolfgang von. *Wilhelm Meister's Theatrical Calling.* Translated by John R. Russell. Columbia: Camden House, 1995.

Graham, A. C. " 'Being' in Western Philosophy Compared with *Shih/Fei* and *Yu/Wu* in Chinese Philosophy." *Asia Major* 7(1/2) (1959):79–112.

Griseri, Andreina. "Fontanesi a Tokyo: Pittura e Grafica, Nuove Proposte." *Studi Piemontesi* 7(1) (March 1978):50–58.

Groos, Karl. *Einleitung in die Aesthetik.* Giessen: Ricker'sche Buchhandlung, 1892.

Guyau, M. *L'Art au Point de Vue Sociologique.* Paris: Félix Alcan, 1914.

——. *Les Problèmes de l'Esthétique Contemporaine.* Paris: Félix Alcan, 1884.

Guyer, Paul. *Kant and the Claims of Taste.* Cambridge: Cambridge University Press, 1997.

Hartmann, Eduard von. *Ausgewählte Werke.* Leipzig: Wilhelm Friedrich, 1888.

——. *Philosophy of the Unconscious: Speculative Results According to the Inductive Method of Physical Science.* New York: Harcourt, Brace, 1931.

Hartmann, Nicolai. *Die Philosophie des Deutschen Idealismus.* Berlin: De Gruyter, 1960.

Hatano Seiichi. *Time and Eternity.* Translated by Ichiro Suzuki. New York: Greenwood Press, 1963.

Haven, Joseph. *Mental Philosophy: Including the Intellect, Sensibilities, and Will.* Boston: Gould & Lincoln, 1862.

Havens, Thomas, R. H. *Nishi Amane and Modern Japanese Thought.* Princeton: Princeton University Press, 1970.

Hegel, G. W. F. *Introductory Lectures on Aesthetics.* Translated by Bernard Bosanquet. London: Penguin, 1993.

Heidegger, Martin. *Basic Writings from Being and Time (1927) to The Task of Thinking (1964).* New York: HarperCollins, 1993.

——. *Being and Time: A Translation of Sein und Zeit.* Translated by Joan Stambaugh. Albany: SUNY, 1996.

——. *On the Way to Language.* New York: Harper & Row, 1971. First published in 1959.

Heisig, James W., and John Maraldo, eds. *Rude Awakenings: Zen, the Kyoto School, and the Question of Nationalism.* Honolulu: University of Hawai'i Press, 1994.

Helmholtz, Hermann von. *Science and Culture: Popular and Philosophical Essays.* Edited by David Cahan. Chicago: University of Chicago Press, 1995.

Hirakawa Sukehiro. "Japan's Turn to the West." In Bob Tadashi Wakabayashi, ed., *Modern Japanese Thought.* Cambridge: Cambridge University Press, 1998.

Hirota, Dennis. *Wind in the Pines: Classic Writings of the Way of Tea as a Buddhist Path.* Fremont, Calif.: Asian Humanities Press, 1995.

Hisamatsu Sen'ichi. *The Vocabulary of Japanese Aesthetics*. Tokyo: Centre for East Asian Cultural Studies, 1963.

Hogarth, William. *The Analysis of Beauty*. Edited by Ronald Paulson. New Haven: Yale University Press, 1997.

Hölderlin, Friedrich. *Scritti di Estetica*. Translated by Riccardo Ruschi. Milan: SE, 1987.

Howland, Douglas. "Nishi Amane's Efforts to Translate Western Knowledge: Sound, Written Character, and Meaning." *Semiotica* 83(3/4) (1991):283–310.

Hume, David. *A Treatise of Human Nature*. Edited by Ernest C. Mossner. London: Penguin, 1985.

Hume, Nancy G., ed. *Japanese Aesthetics and Culture*. Albany: SUNY Press, 1995.

Inaga Shigemi. "The Impossible Avant-Garde in Japan—Does the Avant-Garde Exist in the Third World? Japan's Example: A Borderline Case of Misunderstanding in Aesthetic Intercultural Exchange." *Comparative and General Literature* 41 (1993):67–75.

Iwakura, Shōko. "Note Biografiche Fontanesiane." *Il Giappone* 6 (1966):87–93.

Jackson, Earl Jr. "The Metaphysics of Translation and the Origins of Symbolic Poetics in Meiji Japan." *PMLA* (March 1990):256–272.

Jaspers, Karl. *Philosophy*. Vol. 1. Translated by E. B. Ashton. Chicago: University of Chicago Press, 1969.

Johnson, Galen A., ed. *The Merleau-Ponty Aesthetics Reader: Philosophy and Painting*. Evanston: Northwestern University Press, 1993.

Jones, Howard Mumford, trans. *Heine's Poem "The North Sea."* Chicago: Open Court, 1916.

Jullien, François. *Le Détour et l'Accès: Stratégies du Sens en Chine, en Grèce*. Paris: Bernard Grasset, 1995.

Jusdanis, Gregory. *Belated Modernity and Aesthetic Culture: Inventing National Literature*. Minneapolis: University of Minnesota Press, 1991.

Kant, Immanuel. *Critique of Judgment*. Translated by Werner S. Pluhar. Indianapolis: Hackett, 1987.

Karatani Kōjin. *Architecture as Metaphor: Language, Number, Money*. Cambridge, Mass.: MIT Press, 1995.

———. "One Spirit, Two Nineteenth Centuries." In Masao Miyoshi and H. D. Harootunian, eds., *Postmodernism and Japan*. Durham: Duke University Press, 1989.

———. *Origins of Modern Japanese Literature*. Durham: Duke University Press, 1993.

Kasulis, Thomas P. "The Kyoto School and the West: Review and Evaluation." *Eastern Buddhist* 15(2) (1982):125–144.

———. "Sushi, Science, and Spirituality: Modern Japanese Philosophy and Its Views of Modern Science." *Philosophy East and West* 45(2) (1995): 227–248.

Kaufman, Walter. *The Portable Nietzsche*. New York: Viking Press, 1954.

Keene, Donald. *Anthology of Japanese Literature: Earliest Era to Mid-Nineteenth Century*. New York: Grove Press, 1955.

———, trans. *Essays in Idleness: The Tsurezuregusa of Kenkō*. New York: Columbia University Press, 1967.

Kitamura Tōkoku. "Essai sur la Vie Intérieure." In Yves-Marie Allioux, ed., *Cent Ans de Pensée au Japon*. Vol. 1. Paris: Éditions Philippe Picquier, 1996.

Kohl, Stephen W. "Abe Jirō and *The Diary of Santarō*." In J. Thomas Rimer, ed., *Culture and Identity: Japanese Intellectuals During the Interwar Years*. Princeton: Princeton University Press, 1990.

Kuki Shūzō. "A Consideration of *Fūryū*." Translated by Michael Bourdaghs. Unpublished manuscript.

———. *Le Problème de la Contingence*. Translated by Omodaka Hisayuki. Tokyo: University of Tokyo Press, 1966.

———. *Reflections on Japanese Taste: The Structure of Iki*. Translated by John Clark. Sydney: Power Publications, 1997.

Kuo Hsi. *An Essay on Landscape Painting*. Translated by Shio Nakanishi. London: John Murray, 1935.

LaFleur, William R. "Buddhist Emptiness in the Ethics and Aesthetics of Watsuji Tetsurō." *Religious Studies* 14 (June 1978):237–250.

———. *The Karma of Words: Buddhism and the Literary Arts in Medieval Japan*. Berkeley: University of California Press, 1983.

Lambropoulos, Vassilis. *The Rise of Eurocentrism: Anatomy of Interpretation*. Princeton: Princeton University Press, 1993.

Legge, James. *The Chinese Classics*. Vol. 1: *Confucian Analects, The Great Learning, The Doctrine of the Mean*. Hong Kong: Hong Kong University Press, 1960.

———. *The Chinese Classics*. Vol. 3, pt. 1. London: Oxford University Press, 1939.

Lessing, Gotthold Ephraim. *Laocoön: An Essay on the Limits of Painting and Poetry*. Baltimore: Johns Hopkins University Press, 1984.

Lewin, Bruno. "Mori Ōgai und die Deutsche Ästhetik." *Japanstudien: Jahrbuch des Deutschen Instituts für Japanstudien der Philipp-Franz-von-Siebold-Stiftung* 1 (1989):271–296.

Liebmann, Otto. *Zur Analysis der Wirklichkeit: Eine Erörterung der Grundprobleme der Philosophie*. Strassburg: Trübner, 1911.

Light, Stephen. *Shūzō Kuki and Jean-Paul Sartre: Influence and Counter-Influence in the Early History of Existential Phenomenology*. Carbondale: Southern Illinois University Press, 1987.

Lipps, Theodor. *Psychological Studies*. Translated by Herbert C. Sanborn. Baltimore: Williams & Wilkins, 1926.

Löwith, Karl. *Martin Heidegger and European Nihilism*. Translated by Gary Steiner. New York: Columbia University Press, 1995.

Mallgrave, Harry Francis, and Eleftherios Ikonomu, eds. *Empathy, Form, and Space: Problems in German Aesthetics, 1873–1893*. Santa Monica: Getty Center for the History of Art and the Humanities, 1994.

Marquard, Odo. *Aesthetica und Anaesthetica: Philosophische Überlegungen*. Paderborn: Schöningh, 1989.

Marra, Michele. "Japanese Aesthetics: The Construction of Meaning." *Philosophy East and West* 45(3) (1995):367–386.

———. *Modern Japanese Aesthetics: A Reader*. Honolulu: University of Hawai'i Press, 1999.

————. "Nativist Hermeneutics: The Interpretative Strategies of Motoori Norinaga and Fijitani Mitsue." *Nichibunken: Japan Review* 10 (1998):17–52.

————. "The New as Violence and the Hermeneutics of Slimness." *PMAJLS* 4 (Summer 1998):83–102.

————. "Zeami and *Nō*: A Path towards Enlightenment." *Journal of Asian Culture* 12 (1988):37–67.

May, Reinhard. *Ex Oriente Lux: Heideggers Werk unter ostasiatischem Einfluss.* Wiesbaden: Franz Steiner Verlag, 1989.

————. *Heidegger's Hidden Sources: East Asian Influences on His Work.* Translated by Graham Parkes. London: Routledge, 1996.

Miyoshi, Masao, and H. D. Harootunian, eds. *Postmodernism and Japan.* Durham: Duke University Press, 1989.

Momokawa Takahito. " 'Mono no Aware'—The Identity of the Japanese." *Kokubungaku Kenkyū Shiryōkan Kiyō* 13 (1987):1–14.

Moritz, Karl Philipp. *Scritti di Estetica.* Translated by Paolo D'Angelo. Palermo: Aesthetica, 1990.

Morris, Ivan, trans. *The Pillow Book of Sei Shōnagon.* 2 vols. New York: Columbia University Press, 1967.

Munro, Thomas. *Oriental Aesthetics.* Cleveland: Press of Western Reserve University, 1965.

Murakata Akiko, ed. *The Ernest F. Fenollosa Papers: The Houghton Library, Harvard University.* 3 vols. Tokyo: Museum Press, 1987.

Nakamura, Hajime. *Ways of Thinking of Eastern Peoples: India, China, Tibet, Japan.* Honolulu: University of Hawai'i Press, 1964.

Nakano, Hajimu. "Kuki Shūzō and *The Structure of Iki*." In J. Thomas Rimer, ed., *Culture and Identity: Japanese Intellectuals during the Interwar Years.* Princeton: Princeton University Press, 1990.

Natsume Sōseki. *I Am a Cat.* 3 vols. Translated by Aiko Itō and Graeme Wilson. Rutland: Tuttle, 1972–1986.

Nietzsche, Friedrich. *The Birth of Tragedy and The Genealogy of Morals.* New York: Doubleday, 1956.

Ninomiya Masayuki. *La Pensée de Kobayashi Hideo: Un Intellectuel Japonais au Tournant de l'Histoire.* Geneva: Librairie Droz, 1995.

Nishida Kitarō. *An Inquiry into the Good.* Translated by Masao Abe and Christopher Ives. New Haven: Yale University Press, 1990.

————. *Art and Morality.* Translated by David A. Dilworth and Valdo H. Viglielmo. Honolulu: University of Hawai'i Press, 1973.

————. *Intelligibility and the Philosophy of Nothingness: Three Philosophical Essays.* Translated by Robert Schinzinger. Westport: Greenwood Press, 1958.

————. *Intuition and Reflection in Self-Consciousness.* Translated by Valdo H. Viglielmo with Takeuchi Yoshinori and Joseph S. O'Leary. Albany: SUNY Press, 1987.

————. *Last Writings: Nothingness and the Religious Worldview.* Translated by David A. Dilworth. Honolulu: University of Hawai'i Press, 1987.

Nishitani Keiji. *Religion and Nothingness.* Berkeley: University of California Press, 1982.

———. *The Self-Overcoming of Nihilism*. Translated by Graham Parkes with Setsuko Aihara. Albany: SUNY Press, 1990.

Notehelfer, F. G. "On Idealism and Realism in the Thought of Okakura Tenshin." *Journal of Japanese Studies* 16(2) (1990):309–355.

Odin, Steven. "An Explanation of Beauty: Nishida Kitarō's *Bi no Setsumei*." *Monumenta Nipponica* 42(2) (1987):381–387.

Okakura, Kakuzō. *The Awakening of Japan*. New York: Century, 1904.

———. *The Book of Tea*. New York: Fox Duffield, 1906.

———. *Collected English Writings*. 3 vols. Tokyo: Heibonsha, 1984.

———. *The Ideals of the East with Special Reference to the Art of Japan*. London: John Murray, 1903.

Okazaki Yoshie. *Japanese Literature in the Meiji Era*. Tokyo: Ōbunsha, 1955.

Pareyson, Luigi. *Estetica: Teoria della Formatività*. Milan: Bompiani, 1988.

Parkes, Graham, ed. *Heidegger and Asian Thought*. Honolulu: University of Hawai'i Press, 1987.

———, ed. *Nietzsche and Asian Thought*. Chicago: University of Chicago Press, 1991.

———. "The Putative Fascism of the Kyoto School and the Political Correctness of the Modern Academy." *Philosophy East and West* 47(3) (1997):305–336.

Paul, Jean. *Il Comico, l'Umorismo e l'Arguzia*. Translated by Eugenio Spedicato. Padua: Il Poligrafo, 1994.

Perniola, Mario. *L'Estetica del Novecento*. Bologna: Il Mulino, 1997.

Petralia, Randolph Spencer. "Nietzsche in Meiji Japan: Culture Criticism, Individualism, and Reaction in the 'Aesthetic Life' Debate of 1901–1903." Ph.D. dissertation, Washington University, 1981.

Philippi, Donald L., trans. *Kojiki*. Tokyo: University of Tokyo Press, 1968.

Pincus, Leslie. *Authenticating Culture in Imperial Japan: Kuki Shūzō and the Rise of National Aesthetics*. Berkeley: University of California Press, 1996.

Rimer, J. Thomas. *Mori Ōgai*. Boston: Twayne, 1975.

Rimer, J. Thomas, and Yamazaki Masakazu, trans. *On the Art of the Nō Drama: The Major Treatises of Zeami*. Princeton: Princeton University Press, 1984.

Ripa, Cesare. *Iconologia*. Milan: TEA, 1992.

Rosaldo, Renato. *Culture and Truth: The Remaking of Social Analysis*. Boston: Beacon Press, 1989.

Ross, Stephen David, ed. *Art and Its Significance: An Anthology of Aesthetic Theory*. Albany: SUNY Press, 1994.

Rubin, Jay. "My Individualism *(Watakushi no Kojinshugi)*." *Monumenta Nipponica* 34(1) (1979):26–48.

Sakabe, Megumi. "Dignité du Mot et Valeur de la Personne." *Acta Institutionis Philosophiae et Aestheticae* 1 (1983):21–27.

———. "La Métaphore et le Problème du Sujet." *Journal of the Faculty of Letters, University of Tokyo (Aesthetics)* 5 (1980):85–91.

———. "Le Masque, le Comportement, et le Jeu." *Revue d'Esthétique* 21 (1992): 99–105.

———. "Le Masque et l'Ombre dans la Culture Japonaise: Ontologie Implicite de la Pensée Japonaise." *Revue de Métaphysique et de Morale* 87(3) (July–September 1982):335–343.

———. " 'Modoki'—Sur la Tradition Mimétique au Japon." *Acta Institutionis Philosophiae et Aestheticae* 3 (1985):95–105.

———. "Notes sur le Mot Japonais *hureru*." *Revue d'Esthetique,* new series, 11 (1986):43–48.

———. "Sur le Fondement Affectif de l'Éthique et de l'Esthétique dans la Tradition de la Pensée Japonaise." *Acta Insititutionis Philosophiae et Aestheticae* 5 (1987):43–51.

———. "Surrealistic Distortion of Landscape and the Reason of the Milieu." In Eliot Deutsch, ed., *Culture and Modernity: East-West Philosophic Perspectives.* Honolulu: University of Hawai'i Press, 1991.

Sakai, Naoki. *Translation and Subjectivity: On "Japan" and Cultural Nationalism.* Minneapolis: University of Minnesota Press, 1997.

Santayana, George. *The Sense of Beauty: Being the Outlines of Aesthetic Theory.* Cambridge, Mass.: MIT Press, 1988.

Sartre, Jean-Paul. *What Is Literature?* Translated by Bernard Frechtman. New York: Harper & Row, 1965.

Sasaki Ken'ichi. *Aesthetics on Non-Western Principles.* Maastricht: Jan van Eyck Akademie, 1998.

Sato Tomoko and Toshio Watanabe, eds. *Japan and Britain: An Aesthetic Dialogue 1850–1930.* London: Land Humphries, 1991.

Saussy, Haun. *The Problem of a Chinese Aesthetic.* Stanford: Stanford University Press, 1993.

Schasler, Max. *Kritische Geschichte der Aesthetik: Grundlegung für die Aesthetik als Philosophie des Schönen und der Kunst.* Pt. 1: *Von Plato bis zum 19. Jahrhundert.* Reprint Aalen: Scientia, 1971. First published in 1872.

Schelling, F. W. J. *The Philosophy of Art.* Translated by Douglas W. Scott. Minneapolis: University of Minnesota Press, 1989.

———. *System of Transcendental Idealism (1800).* Translated by Peter Heath. Charlottesville: University Press of Virginia, 1978.

Schiller, Friedrich. *Essays.* New York: Continuum, 1993.

Schleiermacher, Friedrich Daniel. *Estetica.* Translated by Paolo D'Angelo. Palermo: Aesthetica, 1988.

Schumann, Hans Wolfgang. *Buddhism: An Outline of Its Teachings and Schools.* Wheaton, Ill.: Theosophical Publishing House, 1974.

Sedlymar, Hans. *La Luce nelle sue Manifestazioni Artistiche.* Translated by Roberto Masiero. Palermo: Aesthetica, 1989.

Solger, Karl Wilhelm Ferdinand. *Lezioni di Estetica.* Translated by Giovanna Pinna. Palermo: Aesthetica, 1995.

Stein, Heinrich von. *Vorlesungen über Aesthetik: Nach vorhandenen Aufzeichnungen bearbeitet.* Stuttgart: Cotta'sche Buchhandlung, 1897.

Stillinger, Jack, ed. *The Poems of John Keats.* Cambridge, Mass.: Belknap Press of Harvard University Press, 1978.

Suzuki, Tomi. *Narrating the Self: Fictions of Japanese Modernity.* Stanford: Stanford University Press, 1996.

Taine, Hippolyte. *Philosophie de l'Art.* Paris: Fayard, 1985.

Takeuchi Yoshinori. "The Philosophy of Nishida." In Frederick Franck, ed., *The Buddha Eye: An Anthology of the Kyoto School.* New York: Crossroad, 1982.

Tanabe Hajime. *Philosophy as Metanoetics.* Translated by Takeuchi Yoshinori. Berkeley: University of California Press, 1986.

Tanaka, Stefan. "Imaging History: Inscribing Belief in the Nation." *Journal of Asian Studies* 53(1) (February 1994):24–44.

Tsuchida Kyoson. *Contemporary Thought of Japan and China.* New York: Knopf, 1927.

Twine, Nanette. *The Essence of the Novel: Tsubouchi Shōyō.* Occasional Paper 11. University of Queensland, Department of Japanese, n.d.

Ueda, Makoto. "*Yūgen* and *Erhabene*: Ōnishi Yoshinori's Attempt to Synthesize Japanese and Western Aesthetics." In J. Thomas Rimer, ed., *Culture and Identity: Japanese Intellectuals During the Interwar Years.* Princeton: Princeton University Press, 1990.

Uyeno Naoteru, ed. *Japanese Arts and Crafts in the Meiji Era.* Tokyo: Pan-Pacific Press, 1958.

Vattimo, Gianni. *The Adventure of Difference: Philosophy after Nietzsche and Heidegger.* Cambridge: Polity Press, 1993.

———. *Beyond Interpretation: The Meaning of Hermeneutics for Philosophy.* Stanford: Stanford University Press, 1997.

———. *The End of Modernity: Nihilism and Hermeneutics in Post-Modern Culture.* Cambridge: Polity Press, 1988.

———, ed. *Estetica Moderna.* Bologna: Il Mulino, 1977.

Vattimo, Gianni, and Pier Aldo Rovatti, eds. *Il Pensiero Debole.* Milan: Feltrinelli, 1983.

Véron, Eugène. *Aesthetics.* Translated by W. H. Armstrong. London: Chapman & Hall, 1879.

———. *L'Esthétique.* Paris: C. Reinwald, 1878.

Viswanathan, Meera. "An Investigation into Essence: Kuki Shūzō's '*Iki*' no Kōzō." *Transactions of the Asiatic Society of Japan* 4 (1989):1–22.

Volkelt, Johannes. *Ästhetische Zeitfragen.* Munich: Beck, 1895.

Wackenroder, Wilhelm Heinrich. *Scritti di Poesia e di Estetica.* Translated by Federico Vercellone. Turin: Bollati Boringhieri, 1993.

Waley, Arthur, trans. *The Analects of Confucius.* New York: Vintage Books, 1938.

Wargo, Robert Joseph. "The Logic of Basho and the Concept of Nothingness in the Philosophy of Nishida Kitarō." Ph.D. dissertation, University of Michigan, 1972.

Wartofsky, Marx W. "Art, Artworlds, and Ideology." *Journal of Aesthetics and Art Criticism* (Spring 1980):239–247.

Watson, Burton, trans. *The Complete Works of Chuang Tzu.* New York: Columbia University Press, 1968.

Watsuji Tetsurō. *Climate and Culture: A Philosophical Study.* Translated by Geoffrey Bownas. New York: Greenwood Press, 1961.

———. *Watsuji Tetsurō's Rinrigaku: Ethics in Japan.* Translated by Robert E. Carter. Albany: SUNY Press, 1996.

Weisberg, Gabriel P., and Yvonne M. L. Weisberg. *Japonisme: An Annotated Bibliography.* New York: Garland, 1990.

Winckelmann, Johann Joachim. *Pensieri sull'Imitazione.* Translated by Michele Cometa. Palermo: Aesthetica, 1992.

Wölfflin, Heinrich. *Concetti Fondamentali della Soria dell'Arte.* Translated by Rodolfo Paoli. Milan: TEA, 1991.

Worringer, Wilhelm. *Abstraction and Empathy: A Contribution to the Psychology of Style.* Translated by Michael Bullock. New York: International Universities Press, 1953.

Young, Julian. *Nietzsche's Philosophy of Art.* Cambridge: Cambridge University Press, 1992.

Yuasa Yasuo. *The Body: Toward an Eastern Mind-Body Theory.* Translated by Nagatomo Shigenori and Thomas P. Kasulis. Albany: SUNY Press, 1987.

Yusa, Michiko. "Philosophy and Inflation: Miki Kiyoshi in Weimar Germany, 1922–1924." *Monumenta Nipponica* 53(1) (Spring 1998):45–71.

INDEX

ABOUT THE EDITOR

Michael F. Marra is professor of Japanese literature at the University of California, Los Angeles. He has served on the faculties of the Osaka University of Foreign Studies, the University of Tokyo, the University of Southern California, and the University of Kyoto. Among his numerous publications are *The Aesthetics of Discontent: Politics and Reclusion in Medieval Japanese Literature* (1991), which was named a finalist for the 1991 Hiromi Arisawa Memorial Award; *Representations of Power: The Literary Politics of Medieval Japan* (1993); and *Modern Japanese Aesthetics: A Reader* (1999), a companion volume to *A History of Modern Japanese Aesthetics*.